PROJECTIONS OF JERUSALEM IN EUROPE

Art&Religion

The series *Art&Religion* was founded in 2011 by the Iconology Research Group. The editor-in-chief is Barbara Baert (Leuven). The series welcomes monographs and themes in the interdisciplinary field of Christian iconography and religion of the Middle Ages and Early Modernity. *Art&Religion* focuses on how iconology as a field and method relates to recent developments in the humanities. Beyond methodological reflection, *Art&Religion* highlights the production of paintings and the techniques used (i), the significance and agency of images (ii), and the transfer and migration of motifs (iii) in Christian visual and material culture.

The editorial board consists of Claudia Benthien (Hamburg), Ralph Dekoninck (Louvain-la-Neuve), James Elkins (Chicago), Jeffrey Hamburger (Cambridge, MA), Bianca Kühnel (Jerusalem), Ann-Sophie Lehmann (Utrecht), John Lowden (London), Anneke Smelik (Nijmegen), Victor Stoichita (Fribourg), Jeroen Stumpel (Utrecht), Paul Vandenbroeck (Leuven), Jan Van der Stock (Leuven), Gerhard Wolf (Florence). The advisory editors are Reimund Bieringer (Leuven), Ivan Gerát (Bratislava), Victor Schmidt (Groningen), Hedwig Schwall (Leuven), György Endre Szönyi (Budapest) and Marina Vicelja (Rijeka).

— Art & Religion 14 —

Projections of Jerusalem in Europe

edited by

Bianca Kühnel, Neta Bodner, and Renana Bartal

PEETERS
Leuven – Paris – Bristol, CT
2023

Cover image: Gabriele Bertazzolo, *Urbis Mantuae descriptio,* 1628. Photo : Bibliothèque nationale de France, GE BB-246 (XIII, 96-97 RES).

A catalogue record for this book is available from the Library of Congress.

ISBN 978-90-429-4904-1
eISBN 978-90-429-4905-8
D/2023/0602/20

© 2023, Peeters, Bondgenotenlaan 153, 3000 Leuven – Belgium

No part of this book may be reproduced in any form or by any electronic or mechanical means, including information storage or retrieval devices or systems, without prior written permission from the publisher, except the quotation of brief passages for review purposes.

CONTENTS

Introduction . 1

Prologue
Portable Jerusalems and the Aesthetics of Displacement 5
 Alina Payne

The Toulouse Reliquary of the True Cross and the Transfer of Holy
 Power . 25
 Cynthia Hahn

Translating Jerusalem into Anglo-Norman Lordship 51
 Laura Slater

Jerusalem in the Landscape of Catalan Romanesque Architecture:
 From Evocation to Presence 79
 Gerardo Boto and Marc Sureda

The Chapel of the Holy Sepulchre in Medieval Saxony: Between
 Cloistered Community and Lay Parish 117
 Lotem Pinchover

In honorem Sanctae Crucis et Sancti Sepulchri: On the Eichstätt *Schottenkirche* and its Significance 145
 Shimrit Shriki-Hilber

A Singular Experience of Jerusalem: St. Sebald Church in Nuremberg . . 165
 Maria E. Dorninger

Prague in Jerusalem and Jerusalem in Prague: Kristof Harant describes
 the Holy Sepulchre (1598) 191
 Orit Ramon

Gijsbert Raet's Jerusalem Chapel in Late Medieval Gouda 215
 Claudia A. Jung

The Presence of Jerusalem in Mantua 243
 Neta Bodner

From Novgorod to Rome via Moscow: On Translations of Jerusalem
 to Russia 267
 Anastasia KESHMAN W.

EPILOGUE
Jerusalem in the Studio Yard: Adrian Paci's *Via Crucis* 299
 Kobi BEN-MEIR

LIST OF ILLUSTRATIONS 317
BIBLIOGRAPHY 325
INDEX 373
ACKNOWLEDGEMENTS 379

INTRODUCTION

The centrality of Jerusalem in Christian spirituality has been expressed in a spectrum of material and visual manifestations since biblical times. The presence of Jerusalem in Europe is the topic of the research project from which this collection of studies derives: the ERC-funded project *Spectrum: Visual Translations of Jerusalem* headed by Bianca Kühnel at the Hebrew University in Jerusalem. The project's members investigated Jerusalem's physical presence in Europe, manifested through spatial—architectural and topographic—representations of the city's different sacred sites and monuments.

Strategies of translating Jerusalem from its geographical and historical location and situating it elsewhere range from reproductions of key buildings representing its most sacred sites to clusters of topographical recreations of *loca sancta* compounds. The shifting of relics and memorabilia evoking Jerusalemite sites and events also plays an essential role in founding, motivating, and identifying sites as reproductions of Jerusalem.

This broad spectrum of monumental representations shares a primary agent of translation, namely architecturally defined space. The endurance of such Jerusalem recreations in urban or rural landscapes through the centuries gives them a vibrancy and a relevance that continued beyond the period of their initial foundation. They often held special meaning for individual patrons, groups, or even cities. Deciphering the stories behind their installation and continued existence, therefore, has immense potential to enrich local as well as pan-European narratives.

Publications by members and affiliates of the *Spectrum* project have demonstrated that the monumental projections of Jerusalem can take a variety of space-enclosing and space-creating forms, which induce a range of cultic manifestations.[1] Such sites exist in many regions of Europe, including England, France, Germany, Italy, Spain, and Russia, and they date from the Middle Ages, from the early modern period, and into modern and contemporary times.

Together with Bianca Kühnel's volume *Jerusalem Icons in the European Space*, Art & Religion 12, the present book serves as the concluding publication of the *Spectrum* project. In its final year, the project hosted the international conference "Glorious Cities: The Presence of Jerusalem in the Urban European

[1] See details about the group members and their publications at http://spectrum.huji.ac.il.

Space," held at the Israel Institute for Advanced Studies, which generated additional essays. While Kühnel's volume offers a theoretical, methodological, and historical overview of Jerusalem's monumental translations in Europe, the present volume attempts to zoom in through clusters of case studies. Some include new data on relatively well-known translations such as San Lorenzo in Mantua and the Schottenkirche in Eichstätt. Others uncover understudied Jerusalem translations. Laura Slater focuses on the foundation stories of pivotal Holy Sepulchre representations from Anglo-Norman England in Northampton and Ludlow. She shows the extent to which the patrons' individual life stories stood behind their Holy Sepulchre foundations. Gerardo Boto and Marc Sureda offer an overview of representations from medieval Catalonia, including Jerusalem translations to Tarragona, Girona, Castellnou, Palera, Amposta, Peralada, and more. They suggest a taxonomy of translation types, organized not only according to visual characteristics but also according to dedication and liturgical use. Anastasia Keshman traces monumental Jerusalem translations in Russia from the early Middle Ages until the twenty-first century. She provides the first integrative survey of Russian Jerusalem sites from Novgorod (1045) to Moscow (2015).

Jerusalem representations and their origins in urban or monastic contexts are the focus of several essays in the volume. Neta Bodner revisits Mantua's San Sepolcro, San Lorenzo, and Sant'Andrea, which all claimed affinities with Jerusalem's Holy Sepulchre. Her paper shows the inherent continuity between medieval and Renaissance representations of Jerusalem. Lotem Pinchover reveals the particular meanings that representations of Christ's tomb held for cloistered communities, specifically the convents of Gernrode, Diesdorf, Wienhausen, and Wöltingerode. Shimrit Shriki-Hilber uses two vedutas from Eichstätt, one of them new in this context, as witnesses to a now-lost church of the Holy Sepulchre in Eichstätt.

Another group of articles highlights the motivations of patrons and the use of pilgrimage narratives, diaries, and letters when comparing Jerusalem's Holy Sepulchre with local churches, both those founded as reproductions and those given the association in hindsight. The textual framing either reflects or contributes to turning these monuments into local icons of regional identity. Maria Dorninger discusses Hans Tucher's correspondence with his brother, in which an equation is established between the church of the Holy Sepulchre in Jerusalem and the well-known local parish Church St. Sebald in Nuremberg. Orit Ramon's paper likewise discusses a comparison, this time made by Kristof Harant, a century later, between the Holy Sepulchre of Jerusalem and his city's

church of St. Vitus in Prague, urging readers to give preference to the latter. Ramon argues that Harant's account is an example of the way Jerusalem descriptions are used to emphasize European identities. The use of analogy by both Tucher and Harant resulted in a local appropriation of the Holy Sepulchre, which acquired a lasting presence in Nuremberg and Prague, respectively. Both these textual accounts either reflect on or contribute to transforming the respective monuments into local icons of regional identity. Personal motivations are further examined by Claudia Jung in her consideration of the Jerusalem Chapel in Gouda. The chapel belongs to a group of six Jerusalem Chapels that are documented in the diocese of Utrecht between roughly 1400 and 1500. However, rather than being founded by a Jerusalem brotherhood like its contemporaries, the Gouda Chapel was erected by a private individual, the priest and Holy Land pilgrim Gijsbert Raet, and it was meant to house not only a copy of the Tomb of Christ but also its founder's grave.

While most articles in the volume are dedicated to architecture, they also address the translation of relics and memorabilia evoking Jerusalemite sites and narratives. Cynthia Hahn's contribution is a reminder of how architectural translations were inherently intertwined with representations in other media, in this case a Limoges casket containing relics of Jerusalem. Like its architectural counterparts, this small object functioned by connecting two locales: it was given by the monastery of Our Lady of Josaphat in Jerusalem's Kidron Valley as a gift to be taken to a monastery in Toulouse, France. This casket, like its monumental counterparts, includes a written record of the circumstances of translation, perhaps in thanks for the armies supplied by Toulouse, instrumental in the First Crusade.

The unique place of Jerusalem translations within the phenomenon of portability is the topic tackled by Alina Payne who contributes a theoretical approach as prologue to the volume. The epilogue is authored by Kobi ben Meir who introduces a contemporary photographic installation of the Stations of the Cross staged by Adrian Paci, an Albanian refugee artist in Italy.

While previous research has mainly been preoccupied with the historical circumstances of the establishment of Jerusalem sites in Europe, the present volume inquires into its existence on a *longue durée* basis, looking at the changing hands and faces of its creators and users, at the turns of fate and historical intervention (or neglect) that enabled the exportation of Christianity's most sacred space. The authors assembled here register important shifts in functioning patterns and theoretical approaches to taking Jerusalem abroad, attitudes often gestating over long periods of time and during changing historical

conditions. All these elements map the perspectives of societies across Europe and across the centuries to the holy city. Thus approached, Jerusalem sites are revealed to be much more than isolated phenomena; indeed they are a faithful mirror of European history, society, and politics.

PROLOGUE

PORTABLE JERUSALEMS AND THE AESTHETICS OF DISPLACEMENT

Alina PAYNE

I.

> One of the rarest and most delicate pleasures of the continental tourist is to circumvent the compiler of his guide-book ... distilled from the massive tomes of Kugler, Burckhardt and Morelli ... Those to whom one of the greatest charms of travel in over-civilized countries consists in such momentary escapes from the expected, will still find here and there, even in Italy, a few miles unmeasured by the guide-book; and it was to enjoy the brief exhilaration of such a discovery that we stepped out of the train one morning at Certaldo, determined to find our way thence to San Vivaldo.[1]

Thus wrote Edith Wharton around 1904 as she was preparing to escape the well-trodden path of the tourist and explore the Jerusalem of Montaione in deepest Tuscany, the Sacro Monte of San Vivaldo (fig. 1). Her expectations were not to be disappointed. Here was indeed something that had escaped Jacob Burckhardt and all other cicerones (and that was quite unusual): a site, founded in 1499 by Franciscan friar Tommaso da Firenze and attached to a Franciscan monastery that replicated the Christian holy sites of Jerusalem (the Holy Sepulchre, Mount Zion, and the Mount of Olives) in a topographically mimetic way and populated them with polychrome sculptures as *tableaux vivants* enacting the key moments of the Passion. Something of a rarity in Tuscany, such topomimetic Jerusalem sites were a well-known feature of the Piemontese pre-alpine landscape. There this type of *teatro montano* had evolved from the first example at Varallo, created in the last two decades of the fifteenth century by the Franciscan Bernardino Caimi (1425–1499/1500)—with the support of the Franciscan Pope Sixtus IV—into ever more complex and extensive arrangements that

I wish to thank David Kim and Maria Loh for productive conversations on the subject of Sacri Monti and portability more generally.

[1] Edith Wharton, *Italian Backgrounds* (New York: Macmillan and Co, 1905), pp. 83–106. For a recent reading of Wharton's "Backgrounds," see Medina Lasansky, "Beyond the Guidebook: Edith Wharton's Rediscovery of San Vivaldo," in *Edith Wharton and Cosmopolitanism*, ed. by Emily Orlando and Meredith Goldsmith (Gainesville: University Press of Florida, 2016).

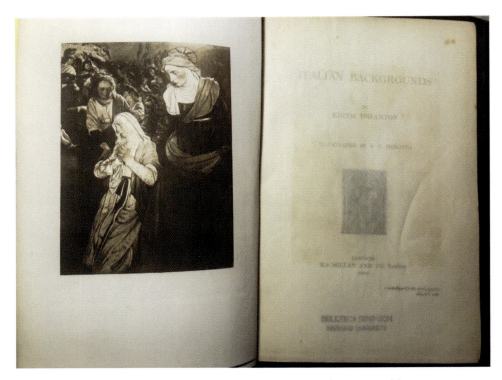

Fig. 1. Edith Wharton, Title page to *Italian Backgrounds*, 1905, Biblioteca Berenson, London.

extended beyond the Passion of Christ to include also the life of the Virgin and later, at the height of Counter-Reformation fervor, that of St. Charles Borromeo as well.² Stemming from a Franciscan devotion with late medieval roots in the

² The literature on the Sacri Monti is relatively meager though recent work, particularly publications arising from Bianca Kühnel's ERC project on Jerusalem sites, has added much to the few existing studies. The volumes arising from this project contain not only the most up-to-date research but also the most up-to-date bibliography on the subject (for references, see below). In addition, in the context of the recent scholarly interest in the senses, the sacri monti have regained some attention. See Christine Göttler, "The Temptation of the Senses at the Sacro Monte di Varallo," in *Religion and the Senses in Early Modern Europe*, ed. by Wietse de Boer and Christine Göttler (Leiden: Brill, 2013), pp. 393–451. San Vivaldo has received much less attention than its more famous siblings in Piedmont. For recent contributions, see particularly Kathryn Blair Moore, *The Architecture of the Christian Holy Land: Reception from Late Antiquity through the Renaissance* (Cambridge: Cambridge University Press, 2017). For the term *topomimesis* and development of the argument with reference to the Sacri Monti, particularly San Vivaldo, see Frida Forsgren, "Topomimesis: The Gerusalemme at San Vivaldo," in *Urban Preoccupations: Mental and Material Landscapes*, ed. by Per Sivefors (Pisa: Fabrizio Serra, 2007),

Fig. 2. View of Sacro Monte di Domodossola, Piemonte. Photo: Author.

Imitatio Christi and the *Devotio moderna* and referring to the order's custodianship of the sanctuaries of the Holy Land, these pocket Jerusalems on Italian soil had morphed into a strong Counter-Reformation type of Maginot Line that confronted the Protestant North at its borders with highly expressive and realistic enactments of religious episodes (fig. 2). In Tuscany the immediate impulse for the creation of the Sacro Monte was probably more a response to Savonarola (who had been executed in 1498) and thus an attempt to vindicate the Franciscan idea of the indulged pilgrimage to the Holy Land.[3]

As Wharton lyrically describes, these sites had been ignored by the historians of high art for being semifolkloric and mostly anonymous, and they were left off the histories and guidebooks that focused on genius artists and masterpieces,

pp. 171–96, and Michele Bacci, "Locative Memory and the Pilgrim's Experience of Jerusalem in the Late Middle Ages," *Visual Constructions of Jerusalem*, ed. by B. Kühnel et al. (Turnhout: Brepols, 2014), pp. 67–76. More generally, see the useful guide edited by Rosanna Caterina Proto Pisani, *La Gerusalemme di San Vivaldo* (Livorno: Polistampa, 2006).

[3] Moore, *Architecture of the Holy Land*, p. 211.

especially those that could be housed in collections and museums.⁴ For indeed such was the drawback of these peculiar art works or art assemblages: they could not be possessed, exhibited, or exchanged. Site specific—as they were, in fact, intended to be—they were rooted to their distant mountainous sites, difficult to access, a string of increasingly alien vitrines of a lost spirituality. They also hovered dangerously close to what is now known as the zone of Uncanny Valley, that dip in the pleasure curve well known in robotics, where lifelikeness (as mimesis and familiarity) crosses a threshold into the uncanny before becoming pleasurable again.⁵ Indeed, as *tableaux vivants* placed in the space of the viewer at one-to-one scale and complete with all naturalistic details—not only polychromy but real hair, real textiles and real props—they exceeded the abstraction of artistic representation that stops at close resemblance and crossed uncannily into the here and now. The distinction might be best observed when comparing a Renaissance polychrome sculpture to a wax effigy: one retaining the identity of an art work, the other causing a frisson for presenting the very person, as if a well-preserved corpse (fig. 3) To be sure, extremely expressive Italian sculpture did exist outside the Sacri Monti as did polychrome sculpture (both in Italian and Northern examples). But color, extreme movement, and expression did not coincide as a rule in the same work, hence avoiding that excessive realism, or hyper realism, that characterizes the staged dramas of the Sacri Monti and that shocks and pushes them into the Uncanny Valley territory.

One exception that preceded the Sacri Monti *tableaux* and may have influenced them was the phenomenon of the later Quattrocento Lamentations (*Compianti*) in polychrome terracotta by artists such as Niccolo dall'Arca (1435–1494), Guido Mazzoni (1450–1518), Vincenzo Onofrio (14??–ca. 1524), Alfonso Lombardi (1497–1537), and others, which has been described as arising from a new Gothic naturalism.⁶ Originating mostly in northern and central

⁴ Following Wharton, William Hood develops this argument. See William Hood, review of P. Bianconi, S. Colombo, A. Lozito, and L. Zanzi, *Il Sacro Monte sopra Varese* (1981), *Art Bulletin* 67, no. 2 (1985), 333–37.

⁵ The first to describe the phenomenon and name it was robotics professor Masahiro Mori in "The Uncanny Valley," *Energy* 7, no. 4 (1970), 33–35. For a recent analysis see Jun'ichiro Seyama and Ruth S. Nagayama, "The Uncanny Valley: Effect of Realism on the Impression of Artificial Human Faces," *Presence: Teleoperators and Virtual Environments* 16, no. 4 (2007), 337–51.

⁶ Massimo Ferretti, "Per la ricostruzione e la cronologia del 'compianto' di Santa Maria della Vita, in *Niccolò dell'Arca: Seminario di Studi*, ed. by Grazia Agostini and Luisa Ciammitti (Bologna: Nuova Alfa Editpriale, 1989), pp. 85–108. On the *Compianto* as a Quattrocento phenomenon, see Marco Albertario, "'Una gestualita resa imagine': Il Compianto sul corpo di Cristo tra i centri Padani e il Ducato Sforzesco," in *Il corpo e l'anima: Da Donatello a Michelangelo scultura*

Fig. 3. Attributed to Angelo Gabriello, Wax Effigy of architect Carlo Francesco Dotti, c. 1759, Palazzo Pepoli, Bologna.

Italy—in Modena, Ferrara, and Bologna—it reached as far as Naples and France (Mazzoni, for example, worked for both Louis XII and Charles VIII of France). Moreover, Niccolo dell'Arca's Lamentation in Bologna (ca. 1485) and Guido Mazzoni's groups in Modena and elsewhere may have been direct models for Caimi's Varallo.[7] However, for all their similarities, in the cases of the *Compianti*, there was neither a claim to site specificity nor were the scenes presented as part of a series with a connecting narrative (figs. 4 and 5).

In recent years the unusual ensembles of the Sacri Monti have been increasingly thought of as "Renaissance performance art." Scholars have read them mostly as representational sites evoking the Holy Land, that is, as so many stage sets or three-dimensional storytelling devices verging on theater and using mnemotechnical aids to elicit a heightened spiritual response from the viewer (fig. 6).[8]

italiana del rinascimento, ed. by Marc Bormand, Beatrice Paolozzi Strozzi, and Francesca Tasso (Milan: Officina Libraria, 2021), pp. 201–9.

[7] Moore, *Architecture of the Christian Holy Land,* pp. 214 and 346 n. 18.

[8] See especially the excellent essay by Alessandro Nova, "'Popular Art in Renaissance Italy: Early Response to the Holy Mountain at Varallo," in *Reframing the Renaissance*, ed. by Claire

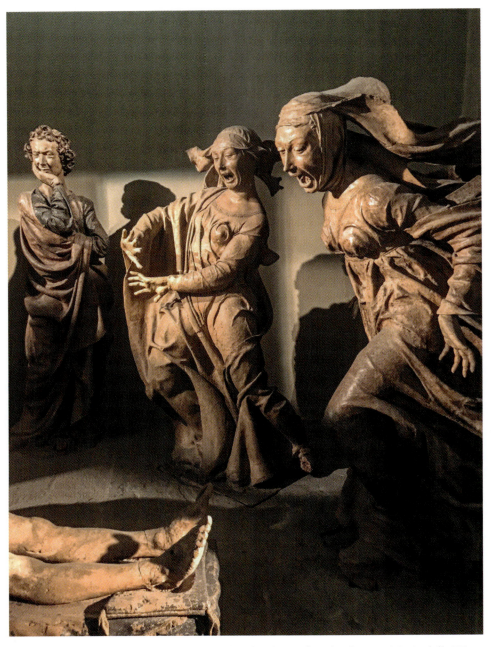

Fig. 4. Niccolo dell'Arca, Lamentation, detail, 1463, Church of Santa Maria della Vita, Bologna. Photo: Author.

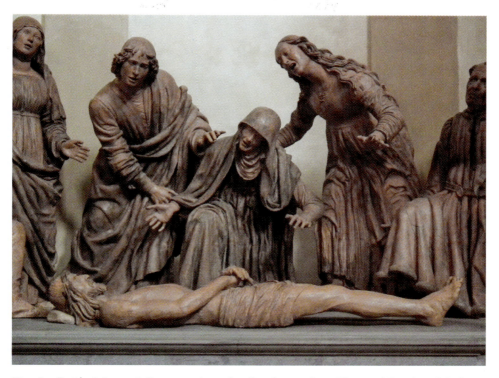

Fig. 5. Guido Mazzoni, Lamentation, detail, 1477-9, San Giovanni Battista, Modena. Photo: Wikimedia Commons.

This characterization is, of course, completely true, but what is additionally striking in this case is the effect of *portability* at work—the apparent (for it is not real) portable quality of a whole site (Jerusalem) that has been lifted and parachuted into alien bucolic environments, peaceful wooded hills, and monastic contexts. Indeed, the unique power of these Jerusalem enactments comes not, or not only, from the highly charged emotional displays of the figures but, equally, from the supposed authenticity of the site within which the Passion of Christ is permanently inscribed, as a film that is constantly being re-run. The effect is akin to Marcel Duchamp's *boite-en-valise*, his series of small architectural boxes that look like pieces of luggage yet contain whole worlds when they open and reveal their contents (fig. 7). Likewise, the miniature chapels of the Sacri Monti, whose intimacy insists on a compressed and highly charged personal experience of the

Farago (New Haven: Yale University Press, 1995), pp. 113–26, and more recently Bacci, "Locative Memory."

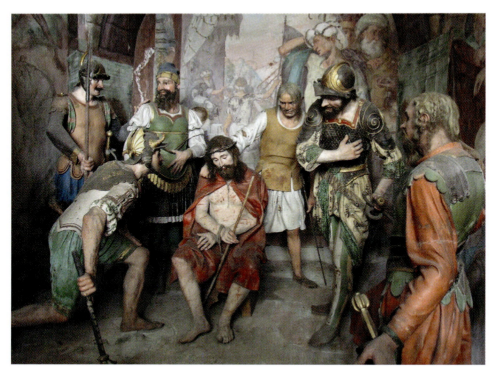

Fig. 6. Mocking of Christ, Sacro Monte of Varallo. Photo: Wikimedia Commons.

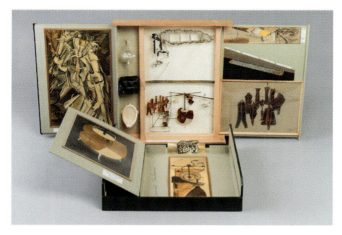

Fig. 7. Marcel Duchamp, Boite en valise, Museum of Art, Cincinnatti.

theatrical sets they house, link the viewer unexpectedly and almost shockingly to Jerusalem, to the Passion, and to all its emotions.

Thus a series of invisible threads bind these Italian and other European locations to the physical site of Christianity's origins via a convoluted web of frozen events, stage effects, and geographic validation. The claim to authenticity in the case of San Vivaldo is heightened by the fact that in 1515 Pope Leo X Medici granted indulgences to those who visited the site. Thus on a religious level, on the level of faith, the site was not presumed to be a mere proxy or a place of make-believe—that is, not a representation. Instead, it was deemed to be effectively the actual site of the Passion and a portal through which to access the Holy Land directly, functioning just like the relics of a saint, such as the blood of San Gennaro in Naples Cathedral or the stone of Unction in the Holy Sepulchre. The Christian religion required physical authenticity, objects that went back to the origins of the faith and could be touched, held, seen, and kissed, in other words, acknowledged bodily (fig. 8). And—such is the claim—at the Sacri Monti, despite the relocation, compression, and miniaturization, one beholds nonetheless the physical Jerusalem.

Fig. 8. Stone of Unction, Church of the Holy Sepulchre, Jerusalem.
Photo: Author.

It would appear then that it is precisely the implication of portability that allows for this sleight of hand. But what do I mean by portability? And how does thinking through this term modify how we might understand the Sacri Monti? How does it help unpack the complicated "invisible threads" that tie the recreations back to their origin in Jerusalem geographically and to the Passion temporally?

II.

Perhaps it is useful to digress and reflect briefly on the phenomenon of portability. As I have argued elsewhere, portability does not equal mobility.[9] The distinction is subtle but important: portable is what can be lifted and relocated by being carried, packed, and shipped, that is, what moves passively only through the agency of others rather than what can actively move on its own (such as people). All objects travel in this way, including all art objects. Indeed, given and traded, stolen and shipwrecked, inherited and ransomed, crated and packed, art objects have traversed space and time, encompassing a much larger geography than their current stability in museums and collections suggests.

But the phenomenon of portability does not stop at individual art objects. Architecture moves too, paradoxically it may seem, for out of all art objects, it is the most rooted to its soil, synonymous with permanence, and therefore surely the least portable. Yet, in the late 1870s, the remains of the Hellenistic Pergamon altar were lifted from their Anatolian hilltop by a German team of archaeologists, shipped by sea and by train after significant political negotiations, and installed in a museum in Berlin. So powerful was the effect of this transplantation of architecture within one of the capitals of Europe that it caused a *mise en abîme* of a long-established, neo-classical aesthetic, igniting a reevaluation not only of ancient art but also of the much-maligned baroque, with which it was suddenly seen to stand in positive synergy.[10] Closer to our own time, to pick just one example, Mies van der Rohe's Pavilion built for the International Exposition of 1929 in Barcelona was dismantled after the event

[9] On portability, see Alina Payne, "Portable Ruins: The Pergamon Altar, Heinrich Wölfflin and German Art History at the *fin de siècle*," *RES. Journal of Aesthetics and Anthropology* 54/55 (2008), pp. 168–89; for a broader discussion of its potential impact on the field of art history, see Alina Payne, "The Portability of Art: A Prolegomena of Art and Architecture on the Move," in *Territories and Trajectories: Cultures in Circulation*, ed. by Diana Sorensen (Durham: Duke University Press, 2018), pp. 91–109.

[10] On the aesthetic evaluation of the Pergamon altar and its consequences, see Payne, "Portable Ruins." On the strategies of display in Berlin, see Can Bilsel, *Antiquity on Display: Regimes of the Authentic in Berlin's Pergamon Museum* (Oxford: Oxford University Press, 2012).

and shipped away by sea. In the process, it was *lost*. That architecture could be lost like baggage in transit really dramatizes the fact that architecture *can* behave as an object, *can* be portable, and *can* be a part of all manner of networks.

Metaphors and stories of fictitious removal and transport in connection with architecture have abounded throughout history, and they confirm the fascination that the notion elicited across cultures. The transportation by angels of the Holy House of the Virgin—the house in Nazareth where the Annunciation and hence the Incarnation were thought to have taken place—to Loreto on the Adriatic coast was one such recurrent trope in the early modern imagination. Here, fact and fiction morphed into one: the stones of the house walls (believed to be of the house of the Annunciation) had been transported from the Holy Land to the coast of Italy at the time of the withdrawal of the crusaders probably in 1291 where it became the second most important site of pilgrimage in the country.[11] Although the angels said to have airlifted the house were a fifteenth-century invention, the legend stuck and was invoked as metaphor thereafter for other events when architecture was seemingly miraculously relocated (such as the erection of the Vatican obelisk by Domenico Fontana in the 1590s).

What these few examples suggest is that art objects—from paintings to architecture—have restless lives and, as a result, engage territory. And, by extension, that they have a geographical footprint. Portability thus offers us the opportunity to identify a "territory of agency" (within which the object caused a disturbance) and that is often at variance with latter-day borders and ethnic units.[12] And it is precisely here that we also touch on the current turn toward global or transnational history: looking at enmeshed history (which is what global art history seeks to do) is recognizing the intersecting lives of objects—the consequences of objects, people, and sites crossing paths.

Furthermore, such a reading is also about a way to identify geographic nodes, places where paths converged and things mutated. We can think about the operation of such unexpected geographic connections in terms of a wormhole (as per astronomy and relativity theory) that links separate points in space by

[11] See Hildegard Sahler, "Architektur als Objekt der Verehrung: Entstehung und Wirkung der Grossreliquien in Loreto, Assisi und Jerusalem," in *Architektur als Objekt/ Architecture as Object*, ed. by Alina Payne and Georg Satzinger, in *The Challenge of the Object: 33rd Congress of the International Committee of the History of Art, Nuremberg, 15th–20th July 2012,* Section 20 (Nüremberg: Deutsches Nationalmuseum, 2013), vol IV, pp. 1420–24. pp. 6–10.

[12] For a development of the concept of "territory of agency," see Alina Payne, "From Riverbed to Seashore: An Introduction," in *The Land Between Two Seas: Art on the Move in the Mediterranean and the Black Sea, 1300–1700*, ed. by Alina Payne (Leiden: Brill, 2022).

way of a vertiginous shortcut that collapses both time and distance. This collapse can be so extreme that it can cause a meltdown—an apt simile for the unexpectedness of the connection between peaceful little San Vivaldo in the Renaissance and deeply contested Jerusalem in the first year of the Common Era (fig. 9). An important consequence is that in so unexpectedly connecting places, portability also challenges the perennial concept of center and periphery that by its very dialectic structure assumes a static relationship between two locations. When things move and coalesce in constantly changing combinations, what is the center, and what is the periphery? Can we still talk in such terms? Perhaps instead a certain kind of simultaneity is instantiated.

Recognizing portability as a vector has three more important consequences for art history: it credits agency to the object over its *longue durée* existence; it invites rethinking the distinctions between high and low art; and it permits the exchanges between monumental and minor arts (the most portable of objects

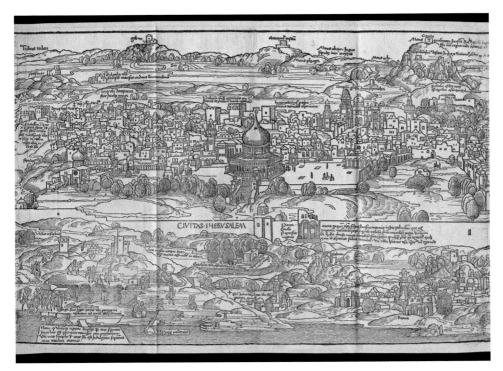

Fig. 9. Bernard von Breydenbach, View of Jerusalem, *Peregrinatio in terram sanctam*, 1486.

having always been the small crafts) to come into focus.[13] Such exchanges then also allow us to recognize intersections between scales and media—the micro and macro may be in dialogue at any point along the series of serendipitous encounters such as between textiles and architecture, glassware and sculpture, stone carving and goldsmithry, and so on.[14]

III.

What can such a vantage point offer to a reading of Sacri Monti and the export of Jerusalem as portable city? Clearly once we think of the Sacri Monti as portable Jerusalems, all of these issues become relevant: the exchanges between media and scale here expand to also include the site; the center and periphery question is raised by the relation of Jerusalem to some lost hamlet in northern Piemonte or Tuscany; and the high and low issue moves into the foreground when we seek to place the Sacri Monti as either folk art or art tout court. Perhaps at the most basic level, thinking in terms of portability in this instance means recognizing a condition of objecthood (real or imagined) for a whole site, for something finite that can be lifted, transported like *spolia* and possessed.[15]

So to return to the San Vivaldo that Edith Wharton encountered, perhaps one of the most important questions to ask is how does the implication of portability for the site function in association with the art on display? What is presented to the viewer are two interwoven but structurally different elements: on the one hand, topographic mimesis (the site) with small classicizing chapels marking accurate distances between the various locations of Christ's Passion and, on the other hand, lifelike scenes in painted terracotta illustrating the events that took place at each site at some distant historical moment in time (figs. 10 and 11). In effect this imagery comprises two levels of staging. While neither the site nor the events are real, they nevertheless reciprocally buttress each other's claims to reality: the staged scenes make the site resonant (elevating it from a mere walk in a park) while the site's Jerusalemite topography guarantees the veracity of the scenes, that they are what they claim to be: more than art,

[13] Alina Payne, "Wrapped in Fabric: Florentine Facades, Mediterranean Textiles and A-Tectonic Ornament in the Renaissance," in *Ornament: Between Local and Global*, ed. by Gulru Necipoğlu and Alina Payne (Princeton: Princeton University Press, 2017), pp. 274–89.

[14] On scale as a relative category, once exchanges between media are envisaged, see Alina Payne, "Materiality, Crafting and Scale," *Oxford Art Journal* 32, no. 3 (2009), 365–86.

[15] The term "objecthood" was famously coined—for an investigation of minimalist art—by Michael Fried, in *Art and Objecthood: Essays and Reviews* (Chicago: University of Chicago Press, 1998).

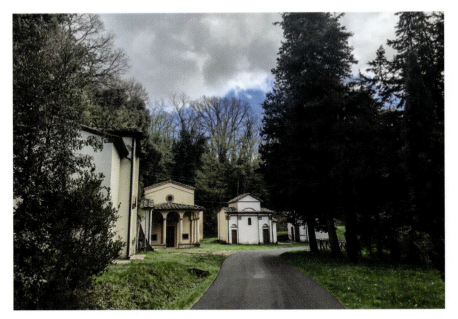

Fig. 10. Sanctuary view, San Vivaldo, Montaione, 1505-15. Photo: Author.

actual visions, events that actually are (or seem to be) happening before the viewer's eyes. A further effect of this imbrication of authentic site and scene is that it also does violence to the viewer's sense of temporality. On the one hand, the scenes are in the past (in the time of Christ's life), while on the other, the topography and site exist in the present or at the very least in a suspended state of permanence. Combined, the site conveys upon the scenes represented the quality of an eternal present, of a permanent vision. In short, the scenes confirm that the site has been airlifted, and the site confirms that the visions partake of reality. History and geography reinforce each other even if they operate on different registers. Portability creates a series of "thick" effects.

However, the sites in Palestine that truly "lived" in the sixteenth-century present—the Stone of Unction at the Holy Sepulchre, the Mount of Olives, Golgotha—were all bare of actors. They were also deeply contaminated with accumulated layers of history, of both significant and insignificant events, and with the present's banal interferences. Among these overlays were the Mamlouks and then the Franciscans, who controlled the pilgrims and gave them access; the noise and confusion of a living city; the mundane and the urbane factors that influence the search for the right place among dizzying streets; in short, distraction and dust. By contrast,

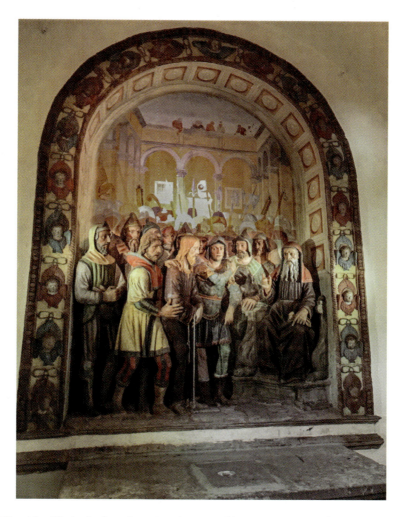

Fig. 11. Christ before Ananias, San Vivaldo, Montaione. Photo: Author.

in the wooded seclusion of San Vivaldo, the devotional experience is cleansed of all extraneous accumulations and therefore intensified, almost like in a museum. Once again site and representation act in tandem. The removal of distracting incident from the sites enhances the (hyper)realism of the ensembles. Ultimately the combination of a relocated site, with its implications of being the real thing, and the life-size figures, painted and clothed to seem alive, achieves an effect similar to that of an experiment in a laboratory: the data is removed from the site where it occurs in nature (as, for example, the rabies bacillus, eloquently described by Bruno Latour in his book on Louis Pasteur) and is placed under the microscope in the controlled

environment; it is here that it can be isolated and examined in its pure or essential state so that its significance can be truly recognized and experienced.[16]

However, this effect is not only achieved by removal. A more intense experience is also achieved though the miniaturization. The linear feet of distance between chapels may be accurate with respect to the real distances in Jerusalem, but the extension over the territory is not. Indeed, as Gaston Bachelard and Susan Stewart have argued, the small scale intensifies experience with its emphasis on the graspable and, with the density of information it offers, it "accelerates" details through scale compression.[17] In this case, the relocated Jerusalem becomes almost like a living, three-dimensional map: reduced in scale but proportional, allowing a holistic experience of a site that would otherwise be difficult to comprehend, bringing distant things into adjacency in a way that heightens the level of understanding and empathy with the events of the Passion. The miniaturization also produces an experience that partakes of the souvenir: a keepsake that one can hold and possess (by inhabiting) or survey, almost as if it were an object, an authentic piece from the original site.

Yet, for all the synergy between the site as portable object and the sculptural ensembles, they also create an ellipsis. The polychrome sculpture is an essential element in the highly effective mix of portability, miniaturization, and visionary narrative. It heightens reality but, at the same time, underscores the fact that it is an illusion, an artifact. The more hyperreal the sculpture is—with layers of color, real cloth, and real props and with intense expressions and gestures—the more the conceit is evident.

So how does this excessive *verismo* function? Why is so much realism used here in the Sacri Monti just as contemporary sculpture (around the early sixteenth century) was moving away from it? Folk art has been given as answer: an art for a lesser-educated audience that needed doll-like props as children would. But as many scholars have since noted, starting with Alessandro Nova, the audience for these Sacri Monti pilgrimages—and this includes San Vivaldo—were much more varied than had been supposed and included highly educated and sophisticated patrons as well.[18]

In my view the answer lies elsewhere. I would like to argue that such hyperrealism is necessary precisely because it is associated with a seemingly portable site: it is

[16] Bruno Latour, *The Pasteurization of France* (Cambridge: Harvard University Press, 1988).

[17] Susan Stewart, *On Longing* (Durham: Duke University Press, 1993), pp. 37–69, and Gaston Bachelard, *The Poetics of Space* (Boston: Beacon, 1994), pp. 148–82.

[18] Nova, "Popular Art," p. 116; with respect to San Vivaldo, where among the donors were the Salviati, Bardi, Michelozzi, and Pitti families, see Moore, *Architecture of the Christian Holy Land*, p. 217.

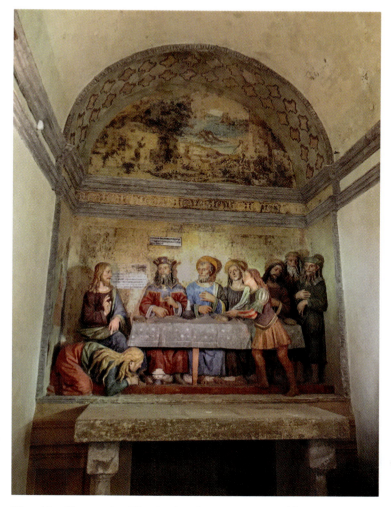

Fig. 12. Simon the Pharisee's House, San Vivaldo, Montaione. Photo: Author.

needed to compensate for the all-to-evident deceit of a geographic transposition through an *uber*reality (fig. 12). The sculptural scenes could have been made in terracotta without polychromy to add to the already highly charged realism of facial expression and movement following the trend toward monochrome sculpture, paradigmatically represented by Michelangelo's and his disciples' creations in white marble in the manner of ancient sculptors. Even terracotta figures were often and famously glazed in white (as in the work of the Della Robbia workshop), so this medium, too, participated in the same turn toward the abstraction of the

monochrome. Yet, although terracotta was the material of choice at San Vivaldo, it was neither left natural nor glazed white to become semiabstract. San Vivaldo's terracottas were covered completely and most realistically in colored glazes. The polychrome exaltation, even if anachronistic at this point, was necessary here precisely because the sculptural groups were intended to be the real thing. And yet, the more realistic the sculpture, the more it is clear that the depiction is neither the Passion nor Jerusalem—that there is a gap between what is seen and what is claimed.

Thus, the visions—for this is what they are—by their very presence, confirm that the site is authentic, that it has been airlifted from the Holy Land and that this is a case of portability rather than copying. To be true, the recreations must enmesh the viewer physically and entirely, not just spiritually as through an act of prayer before an altarpiece or miracle-making image. Indeed, most of the scenes in San Vivaldo are set at the level of the viewer, with the viewer as participant. The whole conceit depends on this physical dimension, otherwise the translation of Jerusalem as a site does not work. As such, the site presents almost a reverse act of portability: if the sleight of hand is successful (that is, if Jerusalem has been credibly transported to San Vivaldo), then paradoxically *the viewer* feels reciprocally transported to Jerusalem; the viewer has also become portable, if only metaphorically.

Thus in the end, having followed the many threads that portability allows us to travel, the question remains: just how is San Vivaldo different from the so-called Duplitecture (such as, for example, Tianducheng in China, whose center is an exact replica of the area around Paris's Tour Eiffel)? Neither is made of the real stones and materials of the original sites. The comparison is actually very telling because it allows us to zero in on the fact that unlike Tianducheng, San Vivaldo stays this side of the simulacrum, of the actual copy, of the wax effigy. And it is precisely in this negotiation between simulacrum and some level of authenticity that the power of the construct resides. As it oscillates between representation and portable artifact, the painted life-size sculptures constitute the difference. They add the visionary element and yet, at the same time, with their uncanny gestures frozen into immobility, they point to the deceit; they represent the gap between the real Jerusalem with its now long-gone Passion events and the reconstructed and reimagined versions. What they actually do is to call forth an exertion from the viewer to close that gap: a type of spiritual exercise *avant la lettre*, they require more work. Perhaps it is due to this extra effort that the San Vivaldo pilgrimage counts as a real pilgrimage and its visitors receive indulgences.

Of course, all religious images are about an in-between space, a liminal space between here and there, which is to be filled by faith. But in traditional religious art, there is no simulacrum at work. If anything, there are abstractions—of an image on

flat canvas, of marble or bronze in place of flesh. But San Vivaldo and the Sacri Monti are one level more intense not only because of their *tableaux vivants* but also because of the physical placement of the viewer—in this case the viewer is literally standing *in the midst* of the crowd judging and jeering Christ, with one scene opening in front and another behind (figs. 13 and 14). The viewer is thus not only seeing or touching an authentic relic. The viewer is inside the transposed site, as if bodily inside the relic, precisely because the site functions as a covenant that it is, and can stand in for, Jerusalem: a liminal space between representation and authenticity.

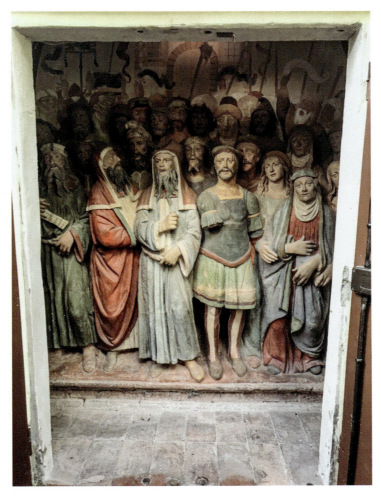

Fig. 13. Crowd gazing upon Christ before Pontius Pilate and Ecce Homo, San Vivaldo, Montaione. Photo: Author.

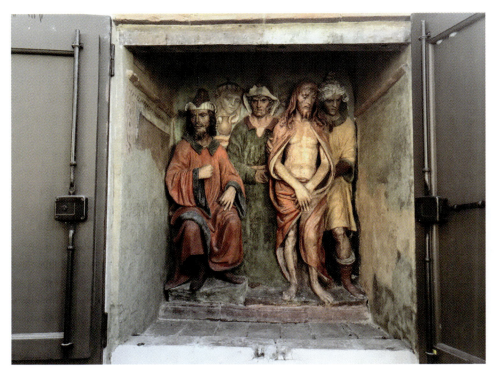

Fig. 14. Christ before Pontius Pilate and Ecce Homo, San Vivaldo, Montaione. Photo: Author.

THE TOULOUSE RELIQUARY OF THE TRUE CROSS AND THE TRANSFER OF HOLY POWER

Cynthia HAHN

The champlevé enamel reliquary in the treasury of Saint-Sernin in Toulouse (ca. 1178–98) includes very unusual iconography that has thus far gone unremarked.[1] In place of the typical Roman guards sleeping at the tomb of Christ, oblivious to the Resurrection as well as the presence of the angel and the arrival of the three Marys, the three soldiers on this reliquary are awake and aware. Indeed, these figures have been converted from the hostile soldiers of the Roman state, guarding against intruders, to a depiction of crusader custodians of the sacred site of the Holy Sepulchre. This very significant iconographic adjustment has important implications for the understanding of how crusaders and their European supporters used imagery and material culture to celebrate and maintain their connection to the Holy Land. An investigation into this unusual iconography involves a discussion of many aspects of the object's manufacture and possible use, and it demands a consideration of its cultural context both in in Jerusalem and in Toulouse.

The Object as Reliquary

The Toulouse reliquary is of modest size and Limoges manufacture, that is, it was made in neither of the cities at the center of our inquiry.[2] One of a large

[1] The reliquary, gilt copper with enamel, is 31 × 15 × 25 cm. It was restored and given its present supporting stand and lock in 1580. D. Watin-Grandchamp, P. Cabau, et al., "Le coffret reliquaire de la vraie croix de Saint-Sernin de Toulouse," *Les Cahiers de Saint-Michel de Cuxa* 38 (2007), 37–46 (p. 37). Other bibliography includes Holger Klein, *Byzanz, der Westen, und das Wahre Kreuz: Die Geschichte einer Reliquie und ihrer künstlerischen Fassung im Byzanz und im Abendland* (Wiesbaden: Reichert, 2004), pp. 226–29; Metropolitan Museum of Art, *Enamels of Limoges: 1100–1350*, ed. by Barbara Boehm (New York: Metropolitan Museum of Art, 1996), pp. 165–66, no. 40 (also see for earlier bibliography); Nikolas Jaspert, "The True Cross of Jerusalem in the Latin West: Mediterranean Connections and Institutional Agency," in *Visual Constructs of Jerusalem*, ed. by Bianca Kühnel, Galit Noga Banai, and Hanna Vorholt (Turnhout: Brepols, 2014), pp. 207–22.

[2] This complicates the study of the iconography of the chasse because the visual transmission of motifs comes into question. In the following, I do not directly engage with this problem (because I do not even presume to know who commissioned the chasse), but I would note here that the iconography of Jerusalem artifacts differs from the iconography of the chasse, so perhaps instructions were given rather than a model supplied.

number of *res sacra* manufactured in Limoges to satisfy the Church's ongoing need to ornament the house of God, this example takes a roofed "chasse" shape, as do many other reliquaries made in that French city. Intended to honor and encapsulate an ever increasing number of relics circulating in Europe, many coming from the Holy Land and Constantinople as a consequence of crusader gifts, the number of Limoges-made reliquaries multiplied in the late twelfth and thirteenth centuries.[3] Remarkably, in this case, the enameled coffer is not a primary reliquary but an outer box made to enclose and protect a cross-shaped reliquary that was itself made in the Holy Land. Although it no longer survives, that cross reliquary is pictured quite clearly and with significant details on the exterior of the Toulouse chasse.[4]

Limoges chasses generally featured somewhat generic and dogmatic Christian imagery. Only occasionally did they represent more specific detail, usually in the form of abbreviated lives of saints.[5] In contrast to this norm, the champlevé enamels on the sides of the Toulouse box depict highly detailed scenes and very specific inscriptions naming persons, places, and institutions; indeed, the imagery concerns the particulars of a donation of a relic of the True Cross in a reliquary—the very relic and reliquary that the box was intended to hold. Such self-reflexive imagery might seem unprecedented,[6] an anomolous case where, rather than the

[3] See Metropolitan Museum, *Enamels of Limoges,* passim.

[4] The 1245 inventory of the church of Saint-Sernin mentions two relics of the True Cross and three crosses. The 1468 inventory mentions a small silver cross, the 1489 inventory again mentions two with relics of the True Cross, both small and silver, one gilded. The latter inventory also records "un joli coffret en cuivre maillé, avec diverses images et plusiers reliques, sans étiquette, et dont le couvercle est rompu" (Célestin Douais, *Documents sur l'ancienne province de Languedoc 2: Trésor et reliques de Saint-Sernin de Toulouse; 1.2: Trésor et reliques de Saint-Sernin de Toulous* (Paris, 1904), p. 63, no. 24, cited by Watin-Grandchamp et al., "Le coffret reliquaire," p. 45. The presence of a random group of relics and a lack of authentics in the reliquary would imply to me that the reliquary was reused, and the cross had been long since removed, therefore also, that the special association of the reliquary cross with the Holy Land had been lost.

[5] Striking examples to the contrary include reliquaries of Valerie, Stephen, Martial, and Calminius, in Metropolitan Museum, *Enamels of Limoges,* nos. 16, 17, 20, and 45, as well as those of Thomas Becket. In each of these cases, there are specific ecclesiastical or political reasons for engaging with the narrative. See, for example, Cynthia Hahn, "Interpictoriality in the Limoges Chasses of Stephen, Martial, and Valerie," in *Image and Belief: Studies in Celebration of the Eightieth Anniversary of the Index of Christian Art,* ed. by Colum Hourihane (Princeton: Princeton University Press, 1979), pp. 109–24.

[6] Although modern scholars often argue that the exterior of reliquaries indicate their contents, this is usually only true in a very metaphorical sense. See arguments in Cynthia Hahn, *Strange Beauty: Issues in the Making and Meaning of Reliquaries, 400–circa 1204* (University Park: Penn State University Press, 2012), introduction.

typical focus on dogmatic and biblical scenes, the artist has documented contemporary events. That initial perception, however, is largely misleading, as we will see. An examination of the ramifications of the imagery on the object will clarify a unique combination of historical material and modified biblical representation, brought together to make a claim of exceptional grace and a place in salvation history granted to the crusaders and their supporters in Toulouse.

On the short end of the chasse, the narrative begins with hagiographic imagery from a story originating in the early Christian era, that is, a scene of the fourth-century discovery of the cross in Jerusalem by St. Helena.[7] The narrative is much condensed and, in effect, reversed. On the left, in the culminating moment of the episode, Helena reverently holds the True Cross while, on the right, an angel descends from the heavens and points to a spot where a man with a pick (labeled *IUDAS*) excavates three buried crosses (fig. 1). Helena's cross as well as the three revealed in the earth are all of Latinate form (with single crosspieces); the latter three also have tangs at the bottom, characterizing the objects as metal liturgical crosses rather than the wooden crosses used for capital punishment in the biblical narrative.

In contrast to this legendary and pious depiction, on the long side of the chasse, called in scholarship rather arbitrarily the front, the narrative turns to a contemporary ceremony of donation (fig. 2). A cross, now of the distinctively double-armed Eastern shape, undoubtedly a reliquary with a tiny sliver of the True Cross, is handed to a recipient.[8] The depiction is supplemented with multiple inscriptions that identify the primary actors, the location, and even the donating institution: */IER[USA]LEM / ABBAS DE IOSAPHAT DE CRUCE DAT/ OREMUS/ RAIMUNDO BOTARDELLI / HI[C] INTRAT MARE.*

The inscription informs us that the gift originated from the monastery of Saint-Mary of Josaphat in the Kidron valley (the location of Mary's tomb) and was given by the monastery's abbot (*ABBAS DE IOSAPHAT DE CRUCE DAT*) to a representative from Toulouse—Raymond Botardelli, a historically documented figure known as part of the Toulousan chancellery.[9] On the chasse, Raymond accepts the cross with a speech act, recorded on a scroll he holds in

[7] For the complex history of the legends and texts concerning the finding of the True Cross, see Jan W. Drijvers, *Helena Augusta: The Mother of Constantine the Great and the Legend of the Finding of the True Cross* (Leiden: Brill, 1992).

[8] Some might call this the "Jerusalem Cross" or the Orthodox cross as a particular shape. However, the shape first existed in Constantinople, and it is not what is called the Jerusalem Cross today.

[9] Botardelli's name appears twice in the cartulary of Saint-Sernin: Metropolitan Museum, *Enamels of Limoges*, p. 166. Watin-Grandchamp et al. discuss the documents on which is name

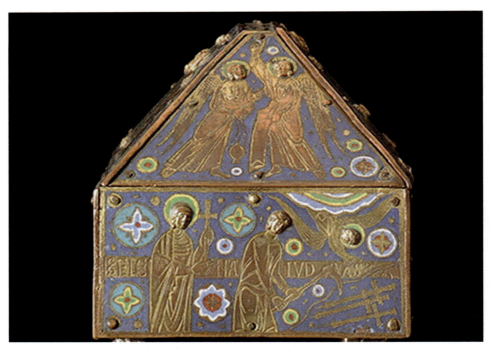

Fig. 1. St. Helena Discovering the True Cross, Reliquary of the True Cross (view of short side), 1178-98, gilded copper and champlevé enamel, 13 × 29.2 × 14 cm, Saint-Sernin, Musée Saint-Raymond, Toulouse.

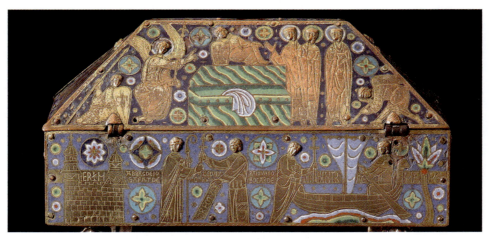

Fig. 2. Marys at the Tomb and other scenes of the Donation of a Cross, Reliquary of the True Cross, 1178-98, France, Haute Garonne, Toulouse. Photo: Hemis / Alamy Stock Photo.

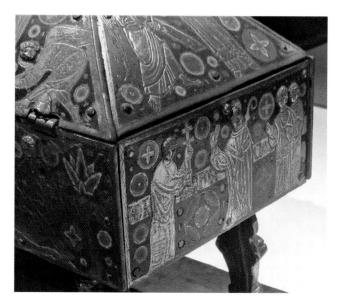

Fig. 3. Pons Accepting Cross from Raymond, Reliquary of True Cross, 1178-98, Saint-Sernin, Musée Saint-Raymond, Toulouse. Photo: Author.

his hand. This pronouncement, "Let us pray" (*OREMUS*), is the only part of the inscription to diverge from the insistent forward direction of the golden band and its highly abbreviated notations. Furthermore, its status as an act of speech places the cross and Raymond within the realm of holy action and prayerful reception, even liturgical action. Ultimately, this notation will prove central to our understanding of the narrative on the reliquary.[10]

Immediately after receiving the cross, Raymond is shown stepping onto a ship bound for a sea voyage to Toulouse (*INTRAT MARE*); the boatman already dips his oar. In the next scene of the narrative, on the short end of the reliquary, Raymond offers the cross to Abbot Pons of Saint-Sernin, who blesses him; the inscription reads, *HIC DAT ABBATI PONCIO* (fig. 3).

appears that are associated with the abbey and identify the abbot of Our Lady of Josaphat as Johannes ("Le coffret reliquaire," p. 41).

[10] Perhaps the notation is actually promising prayers in exchange as part of a prayer brotherhood. Although Watinchamp et al. understand it to be a letter or perhaps a laissez-passer ("Le coffret reliquaire," p. 39).

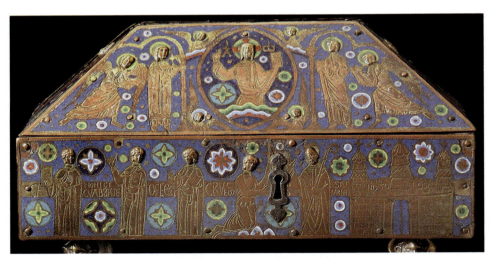

Fig. 4. Maiestas (Rev 12:15-19) and scenes of the Donation of a Cross, Reliquary of the True Cross, 1178-98, Saint-Sernin, Musée Saint-Raymond, Toulouse.

The formal acceptance of the gift and the completion of the narrative, however, does not end the story. Rather, its culmination is realized in the scene depicted on the final long side of the chasse (fig. 4). In that image, the Augustinian canons of the Abbey of Saint-Sernin come out of the church, indeed out of the city, to receive the cross arriving in Toulouse in a kind of *Adventus: CANONICI CUM ABBATE OFFERUNT CRUCEM SATURNINO.* The gates flung wide in welcome will admit the arriving relic to the city, which is labeled *TOLOSA.*

This ceremony of welcome can be identified as a variant of the *Adventus*, a Roman imperial staging of the welcome of an emperor to a city. Modified in the early medieval liturgies and thereafter to suit the "advent" of relics—or, as it is more commonly called, their translation—it eventually becomes a liturgical event.[11] Just as the coming of the emperor meant prosperity and fortune for the city, the arrival of relics, in this case of the True Cross, promised blessings and even salvation for the locale. In Jerusalem in the Crusader era, an *Adventus* was celebrated at the beginning of Passion week to commemorate Christ's entry into Jerusalem.

[11] Sabine MacCormack, *Art and Ceremony in Late Antiquity* (Berkeley: University of California Press, 1981); Nicholas Gussone, "Adventus-Zeremoniell und Translation von Reliquien: Vitricius von Rouen, De laude sanctorum," *Frühmittelalterliche Studien* 10 (1976), 129–30; Kenneth G. Holum and Gary Vikan, "The Trier Ivory, Adventus Ceremonial, and the Relics of St. Stephan," *Dumbarton Oaks Papers* 33 (1979), 115–33.

As Iris Shagrir argues, the *Adventus* liturgy of Palm Sunday was a procession that reiterated a long history of liturgical practice in Jerusalem but became, under the crusaders, a "high point" of the faithful representation of the biblical narrative (John 12:13); it also "highlight[ed] the collaboration between the churches of Jerusalem, and ... serv[ed] as a display of power directed toward the Christian and non-Christian world."[12] The crusader Palm Sunday ceremony in Jerusalem borrowed many of its practices from early Christian liturgies reported by the nun and pilgrim Egeria but supplemented them with Western customs as practiced at Chartres, as Shagrir explains.[13] One feature of the day's events stands out: the patriarch and his retinue carried the "life-giving" True Cross in procession, out of the city to Bethany (the place of the raising of Lazarus), to be greeted by a group of clerics including the abbot and monks of Our Lady of Josaphat in a moment of great rejoicing. Once there, the stage was set for a return procession, the entrance to the city, and the joining of all persons and institutions of the Jerusalem Church (many arriving in separate processions) in a meeting on the Temple Mount where the populace, waving newly blessed palms, greeted the patriarch who carried the cross with his own hands.

On the reliquary, a much simplified ceremony is depicted under the inscription, */CANONICI CUM ABBATE OFFERT CRUCEM SATURNINO/*. Three Augustinian canons of Saint-Sernin (the number, as we shall see, is significant) move out of the city holding ceremonial objects, in this case books, and making gestures of welcome.[14] Raymond alone represents the counter procession; he has already passed the three canons and is depicted on bended knee, proffering the cross to the abbot. The abbot, Pons himself, responds with a gesture of acclamation (rather spoiled by the later addition of the lock), accepting the cross on behalf of the saint and his church. Soon it will complete its journey to its new home.

It should be noted that the ribbon of "gold" upon which the text inscriptions are engraved, culminating in the word *TOLOSA*, wraps around the reliquary linking the events. The momentum of this inscriptional device gives the viewer the sense that the narrative is inevitable, predestined as part of salvational history. This linkage of otherwise disparate things, this forward impetus and

[12] Iris Shagrir, "*Adventus* in Jerusalem: The Palm Sunday Celebration in Latin Jerusalem," *Journal of Medieval History* 41(2015), 1–20 (p. 18).

[13] Shagrir notes that Ivo of Chartres may have been important in shaping the Jerusalem liturgy and notes that he requested a piece of the True Cross ("*Adventus* in Jerusalem," pp. 15–16).

[14] Watin-Grandchamp et al. describe the scene as a conversation ("Le coffret reliquaire," p. 40). The authors also identify the recipient as St. Saturninus personified and therefore the donor on bended knee as the abbot.

inevitable (divinely ordained) sequence of events, is a feature typical of liturgy. If we recall that the transfer of the cross began in Jerusalem and centered on the inscribed word *OREMUS*, I would argue that we must see this transfer as a processional enactment and completion of the liturgical celebration of *Adventus* beginning in Jerusalem. The cross is featured, held high; after its initial appearance as a simple ceremonial cross on the first panel with Helena, it takes the specific shape of the reliquary of the True Cross denoting Jerusalem's most important relic and significant gift.[15] The final scene marks a transfer, even an emanation of holy power, as Pons receives the gift for Saturninus, the saintly patron of Toulouse. Now possessed of a portion of the most powerful of Christian relics, Toulouse becomes, in effect, a new Jerusalem, the potent counterpoint to the city depicted on the other side of the chasse.

The Gift

Why, we might ask, would Toulouse merit this gift, this great blessing? The answer lies in its recent history and its political connections to Jerusalem, as well as in the effort by powerful new holy orders in Jerusalem to purposefully spread the salvific power of Jerusalem across Western Christendom through every possible means. The means included relics but also architecture, liturgy, and, less evident to the modern observer, prayer brotherhoods.[16]

Almost a hundred years before the manufacture of the Toulouse chasse, the French city supplied one of the greatest leaders of the crusades. Count Raymond IV (ca. 1041–1105), a hero of the siege of Antioch—who during his long life also served as the duke of Narbonne, the margrave of Provence, and the count of Tripoli and was once a candidate to be King of Jerusalem. Not

[15] See the discussion of the impact of gifts of the True Cross made by the Byzantine emperor in Holger Klein, "Eastern Objects and Western Desires: Relics and Reliquaries between Byzantium and the West," *Dumbarton Oaks Papers* 58 (2004), 283–314.

[16] Nikolas Jaspert, "Vergegenwärtigungen Jerusalems in Architektur und Reliquienkult," in *Jerusalem im Hoch– und Spätmittelalter: Konflikte und Konfliktbewältigung, Vorstellungen und Vergegenwärtigungen*, ed. by D. Bauer, (Frankfurt am Main: Campus, 2001), pp. 219–97. Also see Nikolas Jaspert, "Military Orders and Urban History: An Introductory Survey," in *Les ordres militaires dans la ville médiévale (1100–1350)*, ed. by D. Carraz (Clermont-Ferrand: Presses Universitaires Blaise-Pascal, 2013), pp. 15–34; and Nikolas Jaspert, "'Pro nobis, qui pro vobis oramus, orate': Die Kathedralkapitel von Compostela und Jerusalem in der ersten Hälfte des 12. Jahrhunderts," in *Santiago, Roma, Jerusalén: Actas del III Congreso Internacional de Estudios Jacobeos*, ed. by P. Caucci von Saucken (Santiago de Compostela: Xunta de Galicia, 1999), pp. 187–212. See also, M. Cecilia Gaposchkin, *Invisible Weapons: Liturgy and the Making of Crusade Ideology* (Ithaca: Cornell University Press, 2017), pp. 165–91.

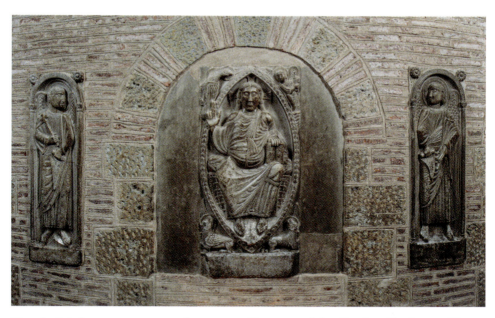

Fig. 5. Modern appearance of entry to Treasury, Saint-Sernin, Toulouse. Photo: Stephen Murray, 2011. Courtesy of the Mapping Gothic France Project, Media Center for Art History © The Trustees of Columbia University.

least for our concerns, Raymond was also an important patron of the monastery of Saint-Sernin. It was during his lifetime that the monastery was decorated with renowned early Romanesque sculptures at the apse and altar (fig. 5).[17]

Raymond's son and successor as count, Alphonse Jordan, was born in the Holy Land, baptized in the Jordan, and died when he returned to the Holy Land on crusade. Both Alphonse and his son Raymond V struggled to hold the lands once controlled by their ancestor. Raymond IV, therefore, it should be said, represented the apex of prestige of the powerful counts of Toulouse, so much so that his successors can be characterized as striving to follow his lead and to reestablish the glory of the city after his death. One scholar has even gone so far as to compare Raymond IV's reputation to that of Charlemagne—an earlier, legendary patron of Saint-Sernin—as the crusader visited both Jerusalem and Constantino-

[17] The restoration was begun under his brother. See Thomas Lyman, "The Sculpture Programme of the Porte des Comtes Master at Saint-Sernin in Toulouse," *Journal of the Warburg and Courtauld Institutes* 34 (1971), 12–39 (p. 38).

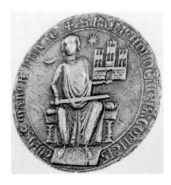

Fig 6. The Seal of Count Raymond VII of Toulouse. Photo: Public Domain.

ple and returned with holy offerings.[18] Inventories register an accumulation of a series of relic donations that were meant to draw attention to the city, the abbey treasury, and its importance following a pattern established in Western Europe in which crusader gifts were often celebrated to the benefit and glory of the noble families that had made the donations.[19]

On the chasse, Toulouse is imaged as a powerful city marked by three towers and an open gate, in much the same way as it is represented on the seal of Count Raymond VII (1197–1249; fig. 6).[20] The three towers in both images represent the Château Narbonnais, the residence of the count in Toulouse (no longer extant). The castle stood for the city's might and prestige and was built adjacent to the wall at one of the major gates—the Porte Narbonne. The twelfth-century building campaigns of the castle were the pride of the counts—especially Raymond IV's grandson and great grandson, Raymond V and VI.[21] (In contrast, Saint-Sernin's high tower was not completed until the thirteenth to fifteenth centuries and, in the twelfth century, would not have appeared as the distinctive landmark it is today).

Shagrir asserts that the *Adventus*/Palm Sunday liturgy was intertwined with ideas of crusader rule but also with the more general assertion of rule and

[18] Catherine Fernandez, "Quidem lapis preciousus qui vocatur Cammaheu: The Medieval Afterlife of the Gemma Augustea" (unpublished doctoral thesis, Emory University, 2012).

[19] On the 1247 inventory, see Douais, *Trésor et reliques de Saint-Sernin,* as discussed by Fernandez, "Quidem lapis," and N. Paul and S. Yeager, eds., *Remembering the Crusades: Myth, Image, and Identity (Rethinking Theory)* (Baltimore: Johns Hopkins University Press, 2012).

[20] The same imagery is used on other seals of the counts of Toulouse. See Laurent Macé, "*Castel Narbones*" La fierté monumentale de Raimond de Toulouse," *Patrimoine de Sud* 10 (2019), 1–18, http://journals.openedition.org/pds/2962.

[21] Macé, "*Castel Narbones.*"

sovereignty, that it had the "potential to represent and affirm authority."[22] Given that such associations were the primary meaning of the ancient Roman *adventus,* perhaps viewers in Toulouse (once an important Roman center) would also have associated the ceremony with secular power. It might well be productive to query the involvement of the counts, in cooperation with Abbot Pons, in the procurement of the cross.[23] Raymond VI is reported to have been tolerant of the apostolic movement that later was characterized as the Cathar heresy to his detriment. He may have been seeking means to consolidate power that tapped into the renown of his namesake and ancestor in making a strengthened connection to Jerusalem.[24] Even if the power of the counts of Toulouse was soon shattered by the early thirteenth-century Albigensian crusade against the Cathars and its repercussions, we must recognize this moment of twelfth-century importance and glory.[25]

Jerusalem Triumphant

But before we consider the ramifications of Toulouse's status as recipient of a True Cross relic, the so-called front of the reliquary complicates the message. On that side of the chasse, the image of Jerusalem and the gift of the cross is combined with a depiction of the Marys at the Tomb on the roof of the chasse. This imagery abruptly diverts our attention from historical details and redirects us to a larger context of sacred narrative with, again, a liturgical understanding. Specifically, the image of the tomb proclaims the sanctity of the place of the Holy Sepulchre in the holy city of the East, which is, of course, the origin of the gift.

In a study of the Easter liturgy in Jerusalem, Shagrir argues that the motif of the Three Marys at the Tomb was one that epitomized the crusaders' self-image, as such, occurring on the 1123 seal of the patriarch of Jerusalem (Garemond of Picquigny, 1119–28)[26] It was also featured in a mosaic over the tomb of the Holy

[22] Shagrir, "*Adventus* in Jerusalem," 13–14.

[23] Watin-Grandchamp et al. note that Pons was able to secure a bulla confirming the privileges of Saint-Sernin ("Le coffret reliquaire," p. 42). For a discussion of the complex interactions between Jerusalem and Santiago, see also Jaspert, "Pro nobis."

[24] For a discussion of Crusader legacies, see Paul, *Remembering the Crusades*, introduction.

[25] See, for example, Jonathan Sumption, *The Albigensian Crusade* (London: Faber & Faber, 2011).

[26] Iris Shagrir, "The 'Holy Women' in the Liturgy and Art of the Church of the Holy Sepulchre in Twelfth Century Jerusalem," in *The Uses of the Bible in Crusader Sources*, ed. by E. Lapina and N. Morton (Leiden: Brill, 2017), pp. 455–75 (pp. 465, 466–70).

Sepulchre described by Theodoric, a German pilgrim of circa 1172.[27] Theodoric records an inscription from the mosaic: "The place of the rising Christ and guardian of the monument, / the angel, and the [burial] cloth, were and are a proof of redemption."[28] The inscription comes together as a combination of place, person, thing (the cloth/clothes), and effect (redemption), described as all joining forces to bear witness. Megan Boomer emphasizes that such inscriptions in the Holy Sepulchre guided the understanding of the shrine and were used in conjunction with the liturgies occurring in the church, in which canons of the Holy Sepulchre played the parts of the Marys. Boomer further comments that reference to "the guardian of the tomb," and perhaps also the depiction of the angel of the Gospels, was here elided with the persons of the vigilant crusader soldier(s) stationed at the tomb. Shagrir argues that liturgical commentary emphasized the women's bravery for visiting the tomb despite their fear, and she therefore suggests that the three women are cast as surrogates for the crusaders in their fearless capture of Jerusalem as well as their continuing care for the city, the Holy Sepulchre, and its relics and testimonies to the Resurrection.[29]

Not only does the patriarchal seal mentioned above speak to the importance of the Holy Sepulchre but the image of the Three Marys on it focuses on the immediacy of its effect for contemporary viewers who would have experienced the tomb via liturgy and devotion. Rather than carry the incense jar of the biblical story, the foremost Mary on the seal perfumes the space with a censer. The tomb itself is represented with three small circles on its side. Those circles represent the *foramine* mentioned by Theodoric when he discusses the possibility of devout

[27] Shagrir argues the mosaic had three Marys, whereas the Byzantine iconography usually includes only two ("Holy Women," pp. 465, 466–70). The mosaic is also described by Quaresmius (1639) and Elzear Horn (1744), whose accounts provide the basis for the association with the extant image. On the discussion, see Jaroslav Folda, *Crusader Art in the Holy Land, From the Third Crusade to the Fall of Acre, 1187–1291* (Cambridge: Cambridge University Press, 2005), pp. 236–39. I thank Megan Boomer for a discussion of this material.

[28] "Christo surgenti locus et custos monumenti/angelus et vestis fuit estque redemptio testis." Translation by Boomer in "Architecture as Reliquary," in *Architecture and Visual Culture in the Late Antique and Medieval Mediterranean: Studies in Honor of Robert G. Ousterhout*, ed. by V. Marinis, A. Papalexandrou, and J. Pickett (Turnhout: Brepols, 2020), pp. 147–61 (p. 158). Also see Denys Pringle, *The Churches of the Crusader Kingdom of Jerusalem: A Corpus* (Cambridge: Cambridge University Press, 1993), p. 23, and *Theodericus Peregrinationes tres* (CCCM 139) ed. by R.B.C. Huygens (Turnhout: Brepols, 1994), p. 141.

[29] Shagrir, "Holy Women," p. 461; Iris Shagrir, "The Visitatio Sepulchri in the Latin Church of the Holy Sepulchre in Jerusalem," *Al-Masaq: Islam and the Medieval Mediterranean* 22 (2010), 57–77 (p. 74); Carol Heitz, "Sepulchrum Domini: Le sépulchre visité par les saintes femmes (IXe–XIe siècle)," in *Haut moyen-age: Culture, éducation et société; Études offertes à Pierre Riché*, ed. by M. Sot (Nanterre: La Garenne-Colombes, 1990), pp. 389–400.

pilgrims touching the tomb. The seal thus represents not the surface of the original sarcophagus but the situation of the tomb in the twelfth century: these are the holes that allow pilgrims to push past the surface to "kiss" the inner tomb.[30]

It must be emphasized that, for the crusaders and pilgrims, the imagery of the empty tomb was brought to vivid life by the Easter liturgy as well as by the theatrical elements that had been added to its performance from as early as the tenth century.[31] In the *Quem Quaeritis* drama (Whom do you seek?—the question the angel asks the Marys) and the *Elevatio* ceremony in which the cross (or host) was lifted from a "sepulchre," objects and spaces in the church became an important part of the celebration. Specifically, in the Western European liturgy before the Easter ceremony, the cross was buried in a space that varied from church to church.[32] Subsequently, in the *Visitatio Sepulchri* performed by three canons imitating the actions of the Marys, the cross was removed as "proof" of the Resurrection.

In Jerusalem during the crusader period, the Easter drama was performed in the Holy Sepulchre itself, using the very tomb of Christ. Indeed, the Easter liturgy was the first liturgy performed by the crusading victors on 15 July 1099, a week after the taking of the city, and came to be commemorated as the "Feast of the Liberation of Jerusalem."[33] Furthermore, elements of the Easter liturgy were repeated frequently during the year according to Sebastian Salvadó,[34] and the Holy Sepulchre was commonly called the church of the Resurrection by the crusaders. Shagrir argues that the *Quem Quaeritis* was performed as a dramatic crowd pleaser that moved across the space of the new choir in the twelfth century.[35] Amnon Linder even shows that parts of the ceremony were performed by crusaders just after the capture of the city in the church itself as a victory celebration, signifying their own pilgrimage and "resurrection," their own return as *filii apostolorum* (sons of the Apostles).[36]

Indeed, given that it was "the tomb" that the crusaders claimed to seek in their military campaign, it is no surprise that the liturgy developed thereafter by

[30] Theodorich 5.170, in Saewulfus, *Theodericus Peregrinationes tres*, p. 148.

[31] Shagrir, "Visitatio Sepulchri," and Karl Young, *The Drama of the Medieval Church*, 2 vols (Oxford: Clarendon, 1933).

[32] Pamela Sheingorn, *The Easter Sepulchre in England* (Kalamazoo: Medieval Institute Publications, 1987).

[33] Gaposchkin, *Invisible Weapons*, pp. 130–31.

[34] Sebastian Salvadó, "Rewriting the Latin Liturgy of the Holy Sepulchre: Text, Ritual and Devotion for 1149," *Journal of Medieval History* 43 (2017), 403–20.

[35] Shagrir, "Visitatio Sepulchri," pp. 69–70.

[36] Amnon Linder, "The Liturgy of the Liberation of Jerusalem," *Mediaeval Studies* 52 (1990), 110–31 (p. 110).

the European captors imagined the entire city as resurrected by means of the crusader victory.[37] The Church of the Holy Sepulchre was, moreover, itself resurrected through its rebuilding,[38] and both city and tomb are ultimately linked to the Heavenly Jerusalem through prophecy, its realization, and apocalyptic promise.[39] The imagery on the Toulouse chasse is suggestive and, indeed, ultimately representative of such triumphalist thinking. With, on one side, the Marys at the Tomb above a picture of the city /IER[USA]LEM/ and, on the other, the Heavenly Jerusalem above Toulouse, the program traces a trajectory that promises salvation and entry to paradise (see figs. 2 and 4).

The Object Again: Iconographic Adjustments

It is striking that the details of the representation of the scene of the Marys at the Tomb on the Toulouse reliquary are modified in significant ways, and it is further notable that these modifications differ from those of the patriarchal seals.[40] On the chasse, none of the Marys carries a censer, and the tomb does not have the three *foramine*. There are other details capture our attention instead.

The soldiers in the scene are clearly identified as crusaders. All three have shields with crosses prominently marked on their front surfaces. While none of these crosses is the two-armed relic cross (also called the Patriarchal or Jerusalem cross), they are nevertheless reiterations of the crusader commitment to the cross. One of the crosses, indeed, is the *Cross Fitchée*, particularly associated with the crusaders, a combination of cross and sword that was easy to fix in the ground in order to mark and claim holy ground. The other two crosses on the shields are made of spears with fleurons or lilies at their termini.[41]

[37] Gaposchkin, *Invisible Weapons*.

[38] Boomer, "Architecture as Reliquary." S. Schein notes that the shift from devotion to the tomb to devotion to the life of Christ and Resurrection was a product of twelfth-century papal and patriarchal rhetoric (*Gateway to the Heavenly City: Crusader Jerusalem and the Catholic West [1099–1187]* [Aldershot: Ashgate, 2005], pp. 66–70).

[39] Gaposchkin, *Invisible Weapons*, p. 148 and passim.

[40] Shagrir, "Holy Women," pp. 466–67.

[41] None is the "Toulouse Cross": The type of the small reliquary cross with double crosspieces were possibly made by Western artists whose presence is documented in the Holy Land. See Folda, *Crusader Art*, pp. 27–28; Bianca Kühnel, *Crusader Art of the Twelfth Century: A Geographical, an Historical, or An Art-Historical Notion?* (Berlin: G. Mann, 1994), pp. 141-43; H. Meurer, "Kreuzreliquiare aus Jerusalem," *Jahrbuch der Staatlichen Kunstsammlungen in Baden-Württemberg* 13 (1976), p. 42; and Jaspert, "True Cross of Jerusalem."

Notably, the angel holds a scepter but that scepter is not topped by a cross but by a fleur-de-lis.[42]

The most remarkable innovative aspect of the scene's depiction, however, is that the soldiers do not sleep. No longer clustered at the side or bottom of the tomb, they surround it. One solder even sits above and seems to participate in the series of gestures that knits the scene together, that is, the angel points, the crusader relays the message, and finally, the foremost Mary receives the news gratefully. I would suggest his gestures signify a bearing "witness" as in the inscription recorded by Theodoric. The other two soldiers are represented to the sides, framing the scene. One bows deeply over his lance, its tip at the feet of the Marys, his shield slung on his back: perhaps he is offering his services or pledging fealty to the women. The third soldier sits alert, holding shield and lance.

All of this marks a decided shift from the somnolent, unaware soldiers that are typical in the iconography of this scene. Now the men are cast as alert and markedly attentive "crusader" soldiers and caretakers. As noted above, the change decisively diverts the iconography from the biblical description of Roman military overlords who control the tomb through a show of force to the protective role of the crusaders in a Jerusalem liberated by Latin control.

I have found very few other instances of this iconography of soldiers who are awake. On an ivory plaque on the elaborate tabernacle probably from St. Pantaleon of Cologne (ca. 1180), now in the Victoria and Albert Museum in London, there are six soldiers rather than the usual three: four wearing mail, and two others holding shields but wearing cloaks (fig. 8).[43] Two figures in helmets and two in mail seem to be asleep, but at least two more, dressed in loose robes, are seemingly awake. One might speculate that these are canons and knights, the two types of servants of the Holy Sepulchre, and it is notable that the inscription associated with the tomb on the ivory is not the usual "He is arisen" but *Ecce Loco* (Here is the place), corresponding to the mosaic inscription in the Holy Sepulchre as recorded by Theodoric.[44] While there is no room here for a

[42] Perhaps the soldiers are even meant to be Frankish soldiers given the appearance of the fleur-de-lis on the shield, on the angel's scepter, and even in the hand of Mary supplicating before the judging Christ in heaven.

[43] Victoria and Albert Museum Collections, "Tabernacle," # 7650–1861: http://collections.vam.ac.uk/item/O81507/tabernacle-unknown/ (consulted May 31, 2018).

[44] Perhaps the tabernacle itself is representative of the tomb and Jerusalem. Also, Gaposchkin argues that the liturgy of the liberation emphasizes the prophecy of the Old Testament (*Invisible Weapons*). This tabernacle is structured with a series of prophets with scrolls of testimony.

thorough investigation of the meanings of the intriguing representation on the Cologne object, it should be noted that Cologne also had important crusader connections in this period.[45] Finally, I would add one other contemporary example. The "Temple Pyx" in Glasgow represents soldiers guarding the Holy Sepulchre who are seemingly wide awake.[46]

In returning to an examination of the Toulouse chasse, we note that the three soldiers on the reliquary conspicuously lack helmets and are dressed in loose robes or cloaks rather than mail. Furthermore, at least two are clearly barefoot (fig. 7 and upper right of fig. 3), surely a mark of the penitential nature of the crusade enterprise—soldiers processed barefoot and in humble clothing before being blessed for battle.[47] One might also remark that the Marys wear rather elaborate, even possibly liturgical, costume.[48] We must ask, are these soldier guardians not only crusaders but also the canon *custodes* of the Holy Sepulchre? Are they more generally the crusaders as *filii Apostolorum*, successors to the Apostles? It should be remembered that the Augustinians who presided at the monastery of Our Lady of Josaphat and at Toulouse aspired to an Apostolic ideal.

[45] And the inscriptions, especially that from Obadiah 20 (Obadja: TRANSMIGRATIO I[S] R[AHE]L), pictured next to the plaque, are suggestive; see n. 28 above.

[46] The Burrell Collection plaque is usually described as representing sleeping soldiers. Probably part of a "shrine," dated ca. 1150, and supposedly found in the Temple Church in London, it is a rather mysterious object usually noted for its accurate depiction of contemporary armor including kite shields. The soldiers would, instead of lying down, seem to be upright, standing under arches. One holds a spear to the ready and their eyes seem to be open. See: http://web.prm.ox.ac.uk/rpr/index.php/object-biography-index/7-farnhamcollection/791-three-bronze-sleeping-soldiers-add9455vol2p397-4.html and http://www.bbc.co.uk/ahistoryoftheworld/objects/2u2Cr-EIRKaHXrONp5UZsw.

[47] Gaposchkin, *Invisible Weapons*, p. 120.

[48] The only notation of the clothing is "pale" or white garments; see Shagrir, "Visitatio Sepulchri," 70. There may again be a liturgical connection in that the personae of the soldiers were used as a means to include lay people in the drama of the sepulchre visit in the *elevatio* ceremony. Later medieval evidence from English parish churches show the role of the soldiers to be a major focus of lay participation in "protecting" the contents of the tomb while the cross lay buried from Good Friday until Easter Monday. See Eamon Duffy, *The Stripping of the Altars: Traditional Religion in England, 1400–1580* (New Haven: Yale University Press, 1993), pp. 25 ff; "Angels" were also important parts of this drama and may explain the presence of two angels with an empty speech scroll at one end of the reliquary. The other small end holds a depiction of the Annunciation. Perhaps one might suggest this served as a Easter sepulchre for the church of Toulouse. The angels bearing crowns in the Majestas scene are also a significant addition. Holger Klein has suggested that the crowns are the holy rewards for the two main protagonists from Toulouse, Raymond and Pons (*Byzanz, der Westen, und das Wahre Kreuz*, pp. 226–29). An English alabaster is one of the few medieval objects with a similar iconography to our reliquary: Victoria and Albert Museum Collections, # 902–1905, http://collections.vam.ac.uk/item/O68889/the-resurrection-panel-unknown/ (consulted 31 May 2018.)

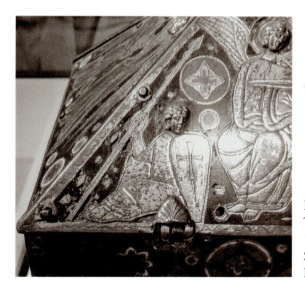

Fig. 7. Detail of Soldier at the Tomb, Reliquary of True Cross, 1178-98, Saint-Sernin, Musée Saint-Raymond, Toulouse. Photo: Author.

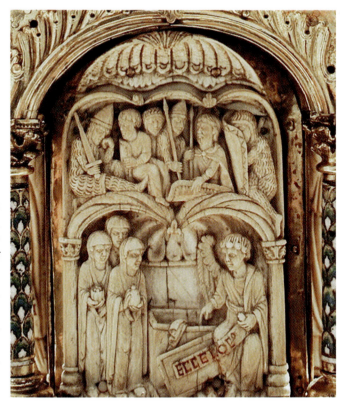

Fig. 8. Marys at the Tomb, detail from a tabernacle, probably from St. Pantaleon of Cologne, c. 1180, ivory, gilded silver, copper and champlevé enamel, height 54.5 cm, Victoria and Albert Museum, London. Photo: Victoria and Albert Museum, London.

Finally, in the center of the scene, the striking testimony of the tomb itself, with its draped cloth and brilliant curving lines of green and yellow, asserts itself against the azure background of the reliquary. One often thinks of blue as the color of the celestial realm but on this object, two bright green tones as well as yellow recur in the halos, in the heavens, and even in Christ's cruciform halo, seeming to make green the celestial color.[49]

Observations on Material Culture and Relics of the Crusades

The potent references to relics, liturgy, and sacred spaces, as well as, of course, the intended use of the chasse as the holder for the True Cross come together in making the Toulouse reliquary a very powerful object. This understanding encourages us to look further into the use of relics and sacred images during the crusades, as well as the migration and amplification of those customs and ideas as crusaders returned to Europe. Material culture was a powerful means for crusaders to spread their message, especially if combined with liturgy and architecture, as historians such as Nicholas Jaspert, Nicholas Paul, and Anne Lester argue.[50]

In turning to the story of the role of relics in the First Crusade, again we find that Raymond IV of Toulouse played a major role. One of the oldest and

[49] Yamit Rachman-Schrire has suggested that the coloration and prominence recalls the Stone of Unction—an important stone for pilgrim experience, especially in the crusade era. Rachman-Schrire has demonstrated that in the twelfth century, it was believed the Stone of Unction or anointing was part of an altar near the tomb and also near the mosaic of the Three Marys mentioned above. In the mid-fourteenth century, Niccolò of Poggibonsi describes the stone as being green porphyry. Although the Stone of Unction was later moved to its present location just inside the doors of the Holy Sepulchre and additionally covered by another stone, there is good reason to believe the stone relic was green and visible in the crusader era. See Yamit Rachman-Schrire, "The Stones of the Christian Holy Places of Jerusalem and Western Imagination: Image, Place, Text (1099–1517)" (unpublished doctoral thesis, Hebrew University of Jerusalem, 2015), p. 80, and email communication 24 May 2018; Saewulfus et al., Theodericus Peregrinationes tres, p. 151. And now also see Rachman-Schrire, "Christ's Unction and the Material Realization of a Stone in Jerusalem," in Natural Materials of the Holy Land and the Visual Translation of Place, 500–1500, ed. by Renana Bartal, Neta Bodner, and Bianca Kühnel (New York: Routledge, 2017), pp. 216–29. She notes that in the almost contemporary Ingeborg Psalter, a French manuscript of ca. 1200, both the tomb and the Stone of Unction are pictured as bright green, perhaps in reflection of the relic known in Constantinople (Rachman-Schrire, "Stones," p. 98).

[50] Jaspert, "Vergegenwärtigungen," Paul, *Remembering;* Anne E. Lester, "What Remains: Women, Relics and Remembrance in the Aftermath of the Fourth Crusade," *Journal of Medieval History* 40 (2014), 311–28; and Anne E. Lester, "Le trésor de Clairvaux," in *Clairvaux: L'aventure cistercienne; Catalogue de l'exposition organisée à l'Hôtel-Dieu-le-Comte à Troyes du 5 juin au 15 novembre 2015,* ed. by Arnaud Baudin et al. (Paris: Somogy-Éditions d'art, 2015), pp. 213–23.

wealthiest of his cohort and, according to a chronicler in his entourage, very pious,[51] Raymond traveled with the papal legate Adhemar, bishop of Le Puy (d. 1098). In the crucial battle of Antioch, it was Raymond's men who arrived first, and a relic played a key role in the subsequent siege of the city and its success. A peasant monk Peter Bartholomew claimed that in a series of visions, St. Andrew led him into the city of Antioch and revealed a precious relic—the lance that had pierced Christ's side. Andrew then told Peter that he should inform Raymond and finally that he should return after the capture of the city to retrieve the relic. Peter's visions were later realized in a series of dramatic events and "discoveries."[52] Despite the success of the visionary treasure hunt, Adhemar remained skeptical about the lance's authenticity. Even worse, members of the German and Norman nobility, especially Arnulf of Chocques (d. 1118), openly mocked Peter and challenged the relic's validity. Despite subsequent reverential treatment—wrapping the spear in cloth that had been bathed in the Jordan, ceremonies of kissing and processing, even crediting it with help in the siege, belief in the relic ultimately failed to gain traction with some factions among the crusaders. Perhaps it was Peter's rough manners and low status that doomed his credibility, but finally he was forced into a dramatic attempted proof of the relic. He volunteered to carry it while walking on burning coals and succeeded in doing so to great acclaim; but he died twelve days later. Raymond was so furious about Arnulf's criticism that he sent soldiers to hunt him down but was foiled by the protection offered by other factions. The questionable relic itself was eventually lost.

Perhaps of even greater interest, however, were the next steps in what one might term the material culture of the piety of the crusades. Arnulf and the bishop of Martirano had a golden image of Christ placed on Godfrey of Bouillon's siege engine during the attack on Jerusalem. Soon after the crusaders executed the momentous capture of the city, an even more significant relic was discovered and put into play. Again, like the lance, it was revealed in a vision and excavated from the very earth of the Holy Land. Arnulf himself "discovered"

[51] Frederic Duncalf et al. *The History of the Crusades* (Madison: University of Wisconsin Press, 1969), I: *The First Hundred Years,* ed. by M. W. Baldwin, pp. 272–75, 320–30.

[52] These events are discussed in multiple contemporary accounts: with great detail in Raymond d'Aguilers, *Historia Francorum qui ceperunt Iherusalem,* trans. by John Hugh Hill and Laurita L. Hill (Philadelphia: American Philosophical Society, 1968) pp. 51–100; many details repeated in William of Tyre's *Historia* or *Chronicle of the Crusades: Willemi Tyrensis Archiepiscopi Chronicon,* ed. by R. B. C. Huygens, 2 vols (Turnhout : Brepols, 1986) (CCCM 63 & 63a), see pp. 324 and 330. See the discussion in Thomas Asbridge, "The Holy Lance of Antioch: Power, Devotion and Memory on the First Crusade," *Reading Medieval Studies* (2007), 3–36 (p. 33).

a hidden relic of the True Cross "probably in the 'garden' of the Holy Sepulchre compound."[53] Perhaps because of his political connections, his ability to utilize church ceremony, and his higher clerical status (he was eventually appointed patriarch of Jerusalem[54]), Arnulf succeeded where Peter had failed. The True Cross relic became a new and potent battle standard for the crusaders and was kept in the Holy Sepulchre as the most significant Christian relic and a sign of victory for the crusaders.[55]

Arnulf, however, also found other ways to use its presence to great effect. He reorganized the Holy Sepulchre and its services, establishing a Latin crusader liturgy (aspects of which were discussed briefly above), ousted the Orthodox clerics, and instituted Augustinian canons following the Western model to celebrate services. He was able to win support for a monastery of the Cross established at the Holy Sepulchre, and other monasteries were endowed throughout Jerusalem. By midcentury, the patriarch Fulk of Angoulême (r. 1146–57) elaborated the liturgy even further and supervised the restoration of the Holy Sepulchre,[56] as well as the church of the Nativity and many other buildings, including the church at the monastery of Our Lady in Josaphat with the tomb of Mary, which was the origin of the Toulouse True Cross relic. Processions and newly instituted prayer brotherhoods linked these holy sites during this time, as Jerusalem was rebuilt and celebrated as a unified holy space.

But the crusaders were not satisfied to stop with these innovations in the holy city; they wanted to carry the sanctity of their new land back to their European homelands, forging unbreakable links to the Holy Land. This goal was accomplished in a number of ways: via relics, via copies of the Holy Sepulchre, and via religious ritual.[57] As a key part of this effort, the order of the canons of the Holy Sepulchre was founded, and dependent monasteries allied

[53] Jonathan Riley-Smith, *The First Crusade and the Idea of Crusading* (Philadelphia: University of Pennsylvania Press, 1986), p. 98.

[54] He was quickly replaced as patriarch and made archdeacon, but he recovered the post in 1112. David S. Spear, "The School of Caen Revisitied," *Haskins Society Journal* 4 (1992), 55–66.

[55] These, of course, are not the only relics used by crusaders. Apparently, in 1101 the bishop of Milan used the relic of the arm of St. Ambrose to bless the army after they confessed their sins (Gaposchkin, *Invisible Weapons*, p. 101).

[56] Robert G. Ousterhout, "Architecture as Relic and the Construction of Sanctity: The Stones of the Holy Sepulchre," *Journal of the Society of Architectural Historians* 62 (2003), 4–23 (p. 9), and Folda, *Art of the Crusaders*, pp. 175–245, with the chronology of construction.

[57] Jaspert, "Vergegenwärtigungen," p. 268–69; Richard Krautheimer, "Introduction to an 'Iconography of Medieval Architecture,'" *Journal of the Warburg and Courtauld Institutes* 5 (1942), 1–33; Robert G. Ousterhout, "The Church of Santo Stefano: A 'Jerusalem' in Bologna," *Gesta* 20 (1981), 311–21; and more recently, see articles and introduction in Bianca

to the order were established in locations as diverse as Barcelona and Paris (some still surviving today).[58] One important aspect of these linkages was that the canons of the order and their friends among the Augustinian canons prayed for one another—and the surviving book of prayer in Barcelona from the fifteenth century includes names from Toulouse and London.[59]

It is in this context that we should understand the outsize importance of the material objects that survive. The so-called Jerusalem crosses—silver reliquaries with double cross-pieces (like the one that was originally in the Toulouse chasse) although small—contain not only the most holy relics of the True Cross but also tiny stones that represent other locations in the Holy Land, such as the Nativity Church, the Holy Tomb, Calvary, and more.[60] More than a dozen still exist. An example in Conques shows on its obverse, in addition to two cross-shaped openings that hold slivers of the True Cross, a total of seven round compartments for relic pebbles from the Holy Land. Additionally, at the base of the cross, there is a schematic rendering of the holy tomb in relief (fig. 9).[61] A similar cross in the monastery of Scheyern was preserved with a letter that insisted it could serve as a substitute for pilgrimage to the Holy Land for anyone who promised to undertake the journey but found it impossible.[62] Clearly these little crosses had remarkable significance as representatives of the spaces and powers of the Holy Land—as newly envisioned and celebrated by the crusaders. Again, this highly recognizable cross type is surely the sort of cross for which the Toulouse reliquary case was made.

By the time of its facture in the last decades of the twelfth century, all the first generation of crusaders had died, and Jerusalem would not be in crusader hands much longer. The patriarch of Jerusalem was probably Amalric of Nesle, a Frenchman from Picardy. His successor, Heraclius, was still concerned with the "outreach" of the Order of the Sepulchre and consecrated the Temple

Kühnel, Galit Noga-Banai, and Hanna Vorholt, eds., *Visual Constructs of Jerusalem* (Turnhout: Brepols, 2014).

[58] Nikolas Jaspert, "Gedenkwesen und Erinnerung des Ordens vom Heiligen Grab," in *Wider das Vergessen und für das Seelenheil: Memoria und Totengedenken im Mittelalter*, ed. by Rainer Berndt S.J., Erudiri Sapientia, 9 (Münster: Böhlau, 2013), pp. 149–74.

[59] Ibid.

[60] See n. 41.

[61] Meurer, "Kreuzreliquiare," p. 69–70.

[62] On the Scheyern Cross, see ibid., p. 66: "Alle, die ein Kreuzfahrt gelobt hatten, diese jedoch ohne eigenes Verschulden nicht antreten konnten, gegen Gebet und Gütershenkung an die Grabeskirche von ihrem Gelübde gelöst."; see also Jaspert, "Gedenkwesen und Erinnerung," p. 66.

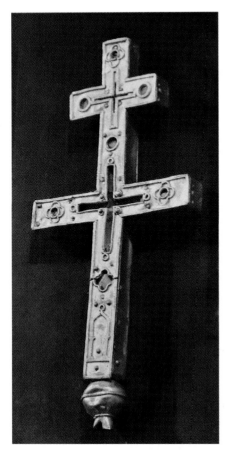

Fig. 9. Jerusalem Cross, first half the twelfth century, wood, silver plate, approx. 20 cm, Conques Treasury. Photo: Author.

Church in London on a trip to rally support.[63] By sending a cross to Toulouse (perhaps acceding to a request from Raymond or the canons of Saint-Sernin), the monastery of Our Lady of Josaphat along with the Order of the Sepulchre honored the city of Toulouse and sought the support of its wealth and power and the favor of its count.[64] Moreover, as a city linked via the holy city to the eternal city of Heavenly Jerusalem, Toulouse perpetuated and furthered the promise of salvation through the cross as imaged on the chasse.

[63] Jaspert, "Gedenkwesen und Erinnerung."
[64] Jaspert enumerates Spanish donations ("Pro nobis").

Jerusalem as the Goal

Finally, we turn to the last scene on the chasse, the depiction of Christ reigning in Heaven above the *adventus* into Toulouse. On what I would argue is the primary face of the chasse, the scene of the *Majestas* fulfills the vision of Revelation that follows the seventh trumpet:

> The kingdom of the world has become the kingdom of our Lord and of his Messiah, and he will reign for ever and ever ... Then God's temple in heaven was opened, and within his temple was seen the ark of his covenant. And there came flashes of lightning, rumblings, peals of thunder, an earthquake and great hail. (Rev 11:15–19)

The earlier trumpets awaken sinners, this seventh trumpet announces Christ's reign in heaven after the final judgment and as recognized by the elders.

In a fresco of circa 1180 that has relatively recently been uncovered in Saint-Sernin and even more recently restored, the Three Marys at the Tomb are paired with this same scene of the *Majestas* and depicted adjacent to a door that leads to a stair (fig. 10). The fresco, with an angel perched above the door as if it were the entrance to the tomb, has been taken as evidence of the performance of the theatrical liturgy of the *Quem Quaeritis* in Toulouse.[65] Although there is no indication that the soldiers in the fresco are "awake" (this portion is damaged), one does sit up, and the men have the characteristic kite shields of crusaders. Additionally, the wall paintings add a register with prophets and their testimonies—an important reference of the Holy Land liturgies.[66] Even with the differences, the iconographic parallels between the chasse and fresco are striking. Both include the scene at the tomb along with the Apocalyptic vision,[67] and in both the soldiers are emphasized as an important part of the story. If the reliquary box was used to entomb the Jerusalem relic cross, it is possible that this door and stair space were used to further "entomb" the reliquary in a dramatic reenactment of the Easter liturgy. [68]

[65] Thomas Lyman, "Theophanic Iconography and the Easter Liturgy: The Romanesque Painted Program at Saint-Sernin in Toulouse," in *Festschrift für Otto von Simson zum 65. Geburtstag*, ed. by L. Grisebach and K. Renger (Frankfurt am Main: Propyläen Verlag, 1977), pp. 72–93 (esp. pp. 85–88). See also by Lyman, "Raymond Gairard and Romanesque Building Campaigns at Saint-Sernin in Toulouse," *Journal of the Society of Architectural Historians* 37 (1978), 71–91.

[66] Gaposchkin, *Invisible Weapons*, p. 143.

[67] Gaposchkin notes the emphasis on apocalyptic promise (ibid., p. 147). Unfortunately in the limited space of this chapter, I cannot attempt a study of Toulousan liturgy. Lyman notes that the liturgical books do not survive ("Theophanic Iconography," p. 88).

[68] It is difficult to imagine the original state of the much changed altar and apse area. Major revisions occurred around 1300 and also in the baroque period. Most scholars imagine a cluster

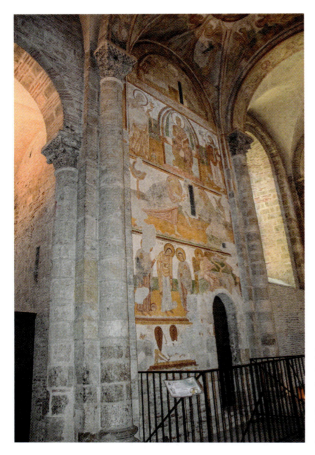

Fig. 10. Fresco in the North transept, Saint-Sernin, Toulouse. Photo: Chatsam, published under creative Commons Attribution-Share Alike 4.0 International license.

Above all, however, we must recognize that the image on the chasse emphasizes the kingship of Christ in the Heavenly Jerusalem. Crowned, Christ rules, in effect, over a Jerusalem whose sovereignty is dominant over the whole Christian world. The angels on either side of the lid testify to the connections between heaven and earth (see fig. 4), but on this reliquary, more specifically, it is Christ himself, in blessing and judging, who presides. On the other side of the chasse, Jerusalem is marked with a special grace as the location of the tomb

of ornament including sculpture in the apse and crypt area. Lyman notes reuse of the fragments as if they had been associated with a holy space. A dispute over the key to the treasury (Bishop Izarn) also indicates an important accumulation of holy material. See Lyman, "Raymond Gairard," pp. 87–89.

of the Lord, one guarded by vigilant crusaders.[69] But finally and more specifically, it is the gates of *Tolosa* that are thrown wide to receive grace, just as are the gates, structures, and arches of the Heavenly Jerusalem above. Christ, enthroned above, blesses the sacred translation of the relic of the True Cross from the holy city of Jerusalem to the newly sanctified city of Toulouse.[70] This is a transcendent iconography of salvation—a theme to be repeated over and over again—in the liturgy but also with the creation of spaces and the transfer of relics, which created a new Jerusalem that is nonetheless an extension of the old. Just as the earthly Jerusalem claimed the experiential presence of Christ in its spaces, in interactions with its surfaces and its objects, and in its liturgy that mirrored and restaged the events of Christ's life,[71] this object argues that authenticity could be imbued in a transferable object and then spread gloriously far and wide.

To return at last to a question posed at the outset, we must conclude that what we see on this reliquary is not the dry historical record and documentation of a gift but instead the evocation of a sacred transfer of the holy from one site to another. The now lost cross that was transferred was a sacred relic, but it was also a repository of social exchange, a sign of sacred history and sacred place, and a representation of a political gambit in a moment when Toulouse was still a powerful region of France and hoped to solidify and maintain that power. By means of its move and by means of its buttressing via prayer and liturgy—which invested it with ever-recurring and renewable power—the sacred object created a new center of sanctity. The three Marys at the Tomb and the three guardian soldiers hand over the testimony of Christ's Resurrection to the three canons who enact its reception. As Shagrir says of the imagery of the Three Marys at the Tomb, on account of "the penitential aspect of crusading and pilgrimage … the scene does not simply narrate, but unifies the community in a regenerative moment of redemption."[72] The advent of the cross in Toulouse is a proclamation to the Christian world of access to Jerusalem made possible by the crusaders, but it is ultimately the proclamation of the salvation promised by Christ as he reigns over his heavenly domain and all the world.

[69] Perhaps, these are particularly Frankish soldiers, given the recurrence of the fleur-de-lis on the angel's scepter, on the shields of the soldiers, and even in the hand of Mary supplicating the judging Christ in heaven.

[70] "Urbs beata", Gaposchkin, *Invisible Weapons*, p. 154, citing Rev. 21.

[71] Shagrir, "Adventus in Jerusalem," p. 17.

[72] Shagrir, "Visitatio Sepulchri," p. 68.

TRANSLATING JERUSALEM INTO ANGLO-NORMAN LORDSHIP

Laura SLATER

Monumental recreations of the holy places of Jerusalem in medieval England usually consisted of a circular or polygonal nave adjoining a more conventional apsidal, square, or rectangular chancel. The majority of these "round churches" were built in the twelfth century. Most can be associated with religious and military orders directly connected to the Holy Land: the Templars, the Hospitallers, the Lazars, and the Augustinian Canons of the Holy Sepulchre (figs. 1-6).[1] This paper discusses two round churches built by secular patrons acting independently of institutional collectives and exceptional for that reason: the church of the Holy

[1] My thanks to Hanna Vorholt, Glyn Coppack, and the editors for their help with this paper, including kind permission to use photographic images. Those of Ludlow Chapel were all taken by and remain copyright of Glyn Coppack. Those of Little Maplestead and Cambridge were all taken by and remain copyright of Hanna Vorholt. All other photographs are my own.

Examples include but are not limited to the pre-1144 Old Temple Church at Holborn in London, replaced by the New Temple Church at Fleet Street (ca. 1151–68) in London; the Templar preceptory of Temple Bruer (Lincolnshire; ca. 1150–69); the Templar preceptory of Temple Church in Bristol (1120–47); the Hospitaller headquarters at Clerkenwell in London (ca. 1135–54); the Templar preceptory of Aslackby (Lincolnshire; ca. 1164); the parish church of Garway (Herefordshire) associated with the Hospitallers (ca. 1165–90); the donation of the church of Little Maplestead (Essex) to the Hospitallers (1186), the round nave of which has been dated to ca. 1335–45; the Church of the Holy Sepulchre and St. Andrew in Cambridge (ca. 1113–31), tentatively associated with the Augustinian canons of the Holy Sepulchre; and the round hospital chapel of St. Giles in Hereford (ca. 1158), associated with the Lazars. For a full list of English round churches with further discussion, see Barney Sloane and Gordon Malcolm, *Excavations at the Priory of the Order of the Hospital of St. John Jerusalem, Clerkenwell, London* (London: Museum of London Archaeology Service, 2004), p. 4; Michael Gervers, "Rotundae Anglicanae," in *Evolution Générale et Développements régionaux en histoire de l'art: Actes du Xxiie Congrès International d'histoire de l'art*, ed. by György Rózsa (Budapest: Akadémiai Kiadó, 1972), pp. 359–76; Catherine E. Hundley, 'The English Round Church Movement," in *Tomb and Temple: Reimagining the Sacred Buildings of Jerusalem*, ed. by Robin Griffith-Jones (Woodbridge: Boydell and Brewer), pp. 352–75; Michael Gervers, "The Use and Meaning of the Twelfth- and Thirteenth-century Round Churches of England," in *Tomb and Temple: Reimagining the Sacred Buildings of Jerusalem*, ed. by Robin Griffith-Jones (Woodbridge: Boydell and Brewer, 2018), pp. 376–86; Catherine E. Hundley, "A New Jerusalem in Four Parts: The Holy Sepulchres of Twelfth-Century London," in *Visualising a Sacred City: London, Art and Religion*, ed. by Ben Quash, Aaron Rosen, and Chloe Reddaway (London: I.B. Tauris, 2017), pp. 52–65 (p. 61 n. 5).

Fig. 1. Little Maplestead, Essex, Church of St. John the Baptist, exterior view. Photo: Hanna Vorholt.

Fig. 2. Little Maplestead, Essex, Church of St. John the Baptist, interior view. Photo: Hanna Vorholt

Fig. 3. City of London, Temple Church, interior view. Photo: Author.

Fig. 4. City of London, Temple Church, exterior view. Photo: Author.

Fig. 5. Cambridge, Church of the Holy Sepulchre and St. Andrew ('Cambridge Round Church'), exterior view.
Photo: Hanna Vorholt.

Fig. 6. Cambridge, Church of the Holy Sepulchre and St. Andrew ('Cambridge Round Church'), interior view.
Photo: Hanna Vorholt.

Sepulchre at Northampton and the chapel of St. Mary Magdalene at Ludlow Castle in Shropshire. Although the churches have been long attributed to plausible personal patrons, the stylistic and documentary evidence for the dating of both structures complicates their patronal identification. An extended discussion of these buildings and their patrons sheds new light on how Jerusalem was imagined and understood in twelfth-century England. In the context of the insecurities and familial upheavals of the holders of early Anglo-Norman lordships, several political, personal, and devotional explanations can be offered as to why these patrons sought to recreate the holy city in monumental form in their locality.

Northampton: Pious Fame and Penitence

The dedication, architectural form, and dimensions of the round nave of the church of the Holy Sepulchre in Northampton (fig. 7), built in the first decades of the twelfth century, make it one of the earliest certain and extant architectural Jerusalem recreations in England.[2] In its original form, it consisted of a small oblong chancel with a probably apsidal east end and a two-storied round nave.[3] The upper story of the nave (fig. 8) was supported by an octagonal arcade dividing the central space from a circular groin-vaulted ambulatory and up to twelve shallow exterior buttresses (fig. 9).[4] The arrangement may echo the eight piers and twelve columns recorded in the eleventh-century Anastasis Rotunda, symbolizing the Resurrection and the twelve Apostles.[5] The arcade at Northampton originally terminated in round arches, rather than the pointed arches present today. The eight columns are topped by scalloped and divided

[2] Gervers notes four pre-Conquest English round churches known only from literary sources ("Rotundae," pp. 360–62). It is unknown if the buildings imitated Jerusalem sites or circular *martyria* structures on the continent.

[3] Nikolaus Pevsner and Bridget Cherry, *Northamptonshire* (Harmondsworth: Penguin, 1973), p. 323; William Page, ed. *The Victoria History of the Counties of England: A History of the County of Northampton* (London: Constable, 1930), III, p. 45 (henceforth: *VCH Northampton*); J. Charles Cox and Robert Meyricke Serjeantson, *A History of the Church of the Holy Sepulchre, Northampton* (Northampton: William Mark, 1897), p. 30; Royal Commission on Historical Monuments, *An Inventory of the Historical Monuments in the County of Northampton* (London: Her Majesty's Stationary Office, 1985),V: *Archaeological Sites and Churches in Northampton*, pp. 59–66 (henceforth: *RCHM*). Ground plans of the original and later church are available in *RCHM* and *VCH Northampton*.

[4] Cox and Serjeantson, *Northampton*, pp. 33–35; *VCH Northampton*, p. 45; Pevsner, *Northamptonshire*, p. 323; *RCHM*, p. 61.

[5] Robert G. Ousterhout, "The Church of Santo Stefano: A 'Jerusalem' in Bologna," *Gesta* 20 (1981), 311–21 (p. 313).

Fig. 7. Northampton, Church of the Holy Sepulchre, interior view. Photo: Author.

Fig. 8. Northampton, Church of the Holy Sepulchre, interior view of clerestory level. Photo: Author.

Fig. 9. Northampton, Church of the Holy Sepulchre, exterior view. Photo: Author.

capitals. The nave has been estimated at 17.678 meters (58 feet) in diameter, closely approximating the 20.422-meter (67-foot) diameter of the Anastasis Rotunda in Jerusalem.[6] There were originally two tiers of round-arched windows and a stone bench running along its circumference.[7] One lower window on the south side preserves a simple, semicircular hood mold, and original plasterwork in the splay is decorated with a zigzag edge.[8] There is no evidence at Northampton for further imitation of the Anastasis Rotunda, such as, for example, a replica tomb aedicula. The empty tomb recess on the exterior south side of the nave can be dated to circa 1400 (fig. 10).[9]

[6] Cox and Serjeantson, *Northampton*, p. 33.
[7] *VCH Northampton*, pp. 45–46; Pevsner, *Northamptonshire*, p. 323; Cox and Serjeantson, *Northampton*, pp. 33, 36, 40.
[8] Cox and Serjeantson, *Northampton*, pp. 33–34.
[9] Ibid., pp. 122–25.

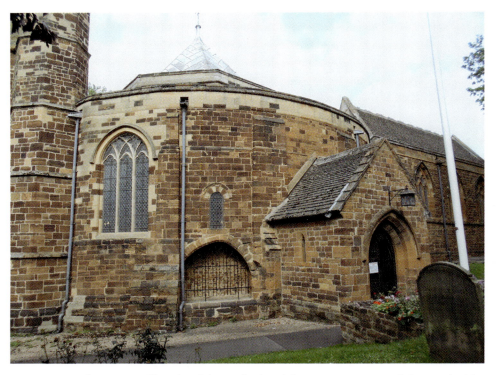

Fig. 10. Northampton, Church of the Holy Sepulchre, exterior view of the south side. Photo: Author.

Despite significant reconstruction in the fourteenth century and restoration between 1858 and 1873, the nave survives reasonably unaltered in comparison to other English architectural recreations of Jerusalem. The early twelfth-century Cambridge Round Church, for example, was subject to a drastic renovation by the Cambridge Camden Society between 1841 and 1843 (figs. 5 and 6).[10] Yet the extant early Norman fabric and detailing at Northampton can only indicate a date of origin in the first decades of the twelfth century. Surviving charters narrow the building's chronology further and, as previous scholarship has noted, suggest a probable patron for the building: Simon I de Senlis, earl of Northampton and Huntingdon. In 1107/8, Simon and his wife, Maud (Matilda), granted to their Cluniac foundation in Northampton, St. Andrew's Priory, "all the churches of Northampton," without

[10] *VCH Northampton*, p. 45; Cox and Serjeantson, *Northampton*, pp. 67–79; *RCHM*, pp. 61, 64.

explicit mention of any church of the Holy Sepulchre.[11] The earliest documentary reference to the church comes in 1122, when Henry I granted the church of "Sancti Sepulcri" to St. Andrew's Priory and confirmed all previous gifts made by the earl and his wife. The king may have been completing or confirming a prior gift of the earl, in the name of the crown, following the posthumous reversion of the earl's castles and estates.[12] The building can therefore be given a rough date of circa 1108 to 1122 and attribution to Simon I de Senlis.

Later assumed by monastic houses dependent on the family's patronage to have come to England with William the Conqueror, Simon de Senlis appears to have arrived only in the reign of William Rufus.[13] Distantly related by marriage to the Norman ducal clan, he became something of a royal favorite, acquiring valuable estates and his title as earl of Northampton and Huntingdon via his marriage to Matilda, a local heiress.[14] He died between 1111 and 1113, after which his widow married the future David I of Scotland. Unusually, the charter evidence for the career of this otherwise obscure nobleman can be supplemented by hagiographic texts. Taken together, these materials provide new information of importance for understanding the church of the Holy Sepulchre at Northampton. Their portrayal of Simon de Senlis and his family reveals several possible motivations for Simon's patronage, helps refine the church's date, and deepens our understanding of its architecture. Close examination of the texts and their contexts also suggests another plausible potential patron of the church: Simon's wife, Matilda.

[11] Charles Johnson and Henry Alfred Cronne, eds., *Regesta Regum Anglo-Normannorum, 1066–1154* (Oxford: Clarendon Press, 1956), II: *Regesta Henrici Primi, 1100–1135*, no. 833, p. 70; Cox and Serjeantson, *Northampton*, p. 24.

[12] Johnson and Cronne, *Regesta*, II: *Regesta Henrici Primi*, nos. 1317 n. 1, 1318, pp. 170–71; Gervers, "Rotundae," p. 371. *VCH Northampton* refers to a ca. 1111 grant of the church to St. Andrew's Priory by Earl Simon, but I have not found evidence for this. The last known charter recording earl Simon as witness appears ca. 1111: nos. 985, 996, pp. 101–3.

[13] Frank Barlow, *William Rufus* (London: Methuen, 1983), pp. 93, 172–73; Robert Meyricke Serjeantson assigns him an arrival date of ca. 1089 ("The Origin and History of the de Senlis Family, Grand Butlers of France and the Earls of Northampton and Huntingdon," *Northampton and Oakham Architectural and Archaeological Society: Associated Architectural Societies Reports and Papers* 31 [1912], 504–9); Matthew Strickland, "Senlis, Simon (I) de, earl of Northampton and earl of Huntingdon (d. 1111x13)," in *Oxford Dictionary of National Biography* (Oxford: Oxford University Press, 2004), http://www.oxforddnb.com/view/article/25091 (accessed 2 December 2013).

[14] Serjeantson, "Origins," p. 504.

Accounting for these texts requires an excursus into the prior history of the family. Through his marriage to Matilda, Simon de Senlis became the posthumous son-in-law of Earl Waltheof, one of the last Anglo-Saxon aristocrats. Of illustrious Anglo-Danish descent, Waltheof married Judith, the niece of William the Conqueror, in a peace-making strategic alliance brokered around 1070.[15] He was executed in 1076 for his part in an abortive rebellion against the king, while his Norman and Anglo-Breton co-conspirators, Roger of Hereford and Ralph of Norwich, escaped being put to death.[16] The earl became the focus of a local cult at the Benedictine abbey of Crowland in Lincolnshire.[17] By the early thirteenth century, the cult was in decline, and efforts were made to revive it.[18] In 1219, the earl's body was translated to a new marble tomb. A series of hagiographic texts were composed, copied, and updated by William of Ramsey, a monk of Crowland, around the same time. Collected alongside older works in the mid-thirteenth-century compilation now Douai, Bibliothèque Marceline Desbordes-Valmore MS 852 (formerly Douai, Bibliothèque municipale MS 801), they include an epitaph and *Vita et Passio* of Earl Waltheof; a *Gesta antecessorum Comitis Waldevi* relating the heroic deeds of his father, Siward; and a text known as *De Comitissa*.[19] *De Comitissa* narrates a colorful dynastic history of the de Senlis family over the course of the twelfth century, ending before the death of Simon III de Senlis without heirs in 1185. Although

[15] Marjorie Chibnall, ed. and trans., *The Ecclesiastical History of Orderic Vitalis* (Oxford: Clarendon Press, 1969), II, pp. 262–63 (henceforth *EH*); Forrest S. Scott, "Earl Waltheof of Northumbria," *Achaeologia Aeliana*, 4th ser., 30 (1952), 149–215.

[16] Ann Williams, *The English and the Norman Conquest* (Woodbridge: Boydell and Brewer, 1995), p. 59.

[17] Carl Watkins, "The Cult of Earl Waltheof at Crowland," *Hagiographica* 3 (1996), 95–96; C. P. Lewis, "Waltheof, earl of Northumbria (*c.* 1050–1076)," ODNB, http://www.oxforddnb.com/view/article/28646 (accessed 18 December 2013); Joanna Huntington, "The Taming of the Laity: Writing Waltheof and Rebellion in the Twelfth Century," in *Anglo-Norman Studies: Proceedings of the Battle Conference 2009*, ed. by C. P. Lewis (Woodbridge: Boydell and Brewer, 2010), pp. 79–95. A secondary cult at Romsey Abbey, near the site of Waltheof's execution, was actively suppressed by Anselm, archbishop of Canterbury: see Ann Williams, "The Speaking Cross, the Persecuted Princess, and the Murdered Earl: The Early History of Romsey Abbey," *Anglo-Saxon* 1 (2007), 1–18 (pp. 12–13); Emma Mason, "Invoking Earl Waltheof," in *The English and their Legacy: Essays in Honour of Ann Williams*, ed. by David Roffe (Woodbridge: Boydell and Brewer, 2012), pp. 185–203 (pp. 185–86).

[18] Emma Mason, "Invoking Earl Waltheof," 192.

[19] Timothy Bolton, "Was the Family of Earl Siward and Earl Waltheof a Lost Line of the Ancestors of the Danish Royal Family?," *Nottingham Medieval Studies* 51 (2007), 41–71 (p. 43); Watkins, "Cult," 96–97. A full discussion of the contents of MS 852 is given in Bolton, "Was the Family?," pp. 46–48.

its original composition date is unclear, Timothy Bolton persuasively assigns it to the first half of the twelfth century.[20]

The text opens with the information that after the death of Earl Waltheof, his widow, Judith, with her two daughters held the lordship of the honor of Huntingdon. It records the king's desire to marry her to "a certain French knight," Simon de Senlis.[21] Simon is presented arriving in England to serve the king with his older brother, one Guarner the Riche, and forty followers. On the death of their father, Ranulph the Riche, Guarner returned to take up his patrimony, and Simon remained in royal service.[22] The ancestral origins of Simon de Senlis as recorded by *De Comitissa* are fictional: the family were a cadet branch of the Bouteiller family of Senlis.[23] After Simon's arrival in England, the chronicle narrates how he received the town of Northampton and the hundred of Fawsley from the king, was the first builder of the castle of Northampton, and founded the Cluniac priory of St. Andrew at Northampton. Seeking further reward for his service, the newly established local landowner then requested the widow of Earl Waltheof in marriage.[24] Judith vehemently refused, on account of Simon's lameness (*claudicabat*).[25] To escape the wrath of the Conqueror, she fled into hiding with her daughters in the Ely marshes. The furious king settled all her lands on Simon, styling him earl of Northampton and Huntingdon from thence forward. At length, a compromise agreement was worked out. Simon's allies advised him to marry the eldest daughter of Waltheof, for if the Normans retained the realm, he would hold his lands by gift of the king. If the kingdom reverted to the English, he would still hold them by hereditary succession.[26] Simon duly married Judith and Waltheof's eldest daughter, Matilda.[27]

[20] Printed in Francisque Xavier Michel, ed., *Chroniques Anglo-Normandes: Recueil d'extraits et d'écrits relatifs à l'histoire de Normandie et d'Angleterre pendant les XIe et XIIe siècles / publié, pour la première fois, d'après les manuscrits de Londres, de Cambridge, de Douai, de Bruxelles et de Paris* (Rouen, 1836), II, pp. 123–31. For dating, see Bolton, "Was the Family?," 49–50: "between 1114 and 1130x31 ... it would also appear to be a product of the literary interest in Waltheof in Crowland in the first half of the twelfth century."

[21] Michel, *Chroniques*, pp. 123–24: "rex eam voluit trader nuptui cuidam militia francigene, nomine Simoni Silvanectensi de Seint-Liz."

[22] Ibid., p. 124.

[23] Serjeantson, "Origins," p. 504.

[24] Michel, *Chroniques*, p. 124.

[25] Ibid.

[26] Ibid., p. 126.

[27] Ibid., pp. 124–26.

Simon was almost certainly the founder of St. Andrew's Priory in Northampton, traditionally established around 1084 and historically perhaps somewhat later, circa 1093 to 1100. Its chartulary records the same ancestry from Guarner the Riche (here termed "Garnerius le Ryche") and Simon's marriage to Matilda, although there are no details of the Judith proposal.[28] Judith's flight to the fens and disseisin are difficult to accept without corroborating evidence, but she would have made a tempting marital prize. The 1086 Domesday Book records estates in at least eleven counties, far outclassing any other recorded female landowner.[29] Simon's construction of Northampton Castle at the same time as his Cluniac foundation is also highly probable. Norman lords commonly established monasteries and refashioned parish churches in close proximity to the castles at the core of their new estates. This created a distinctive zone of lordship demonstrative of political, military, and economic power, as well as of spiritual and moral legitimacy.[30] Located on the north side of the historic center of the town, the church of the Holy Sepulchre is minutes from the sites of Northampton Castle and St. Andrew's Priory.[31] Its rebuilding may be usefully placed in the context of construction of a magnificent new Senlis *caput*. In imaginatively relocating the holiest site in Jerusalem, the center of the world according to medieval interpretations of Ezekiel 5:5 and Psalm 73(74):12, to the center of his new English estates, Simon elevated his own "zone of lordship" to the most exalted spiritual level. Through his generous public foundation and benefaction of churches, he was also acting within his dominions as another Constantine the Great. The first Christian emperor was lauded from Eusebius onwards as an exemplary ruler, generous Christian patron, and original builder of the Church of the Holy Sepulchre in Jerusalem. Later medieval legends further amplify his heroic deeds, portraying

[28] "Houses of Cluniac monks: The priory of St. Andrew, Northampton," in *A History of the County of Northampton*, ed. by R. M. Serjeantson and W. R. D. Adkins (London, 1906), II, pp. 102–29, http://www.british-history.ac.uk/report.aspx?compid=40225 (accessed 4 March 2014).

[29] Ann Williams and G. H. Martin, eds. and trans., *Domesday Book* (London: Penguin, 2003): Middlesex, Buckinghamshire, Oxfordshire, Cambridgeshire, Huntingdonshire, Bedfordshire, Northamptonshire, Rutland, Leicestershire, Lincolnshire and Essex.

[30] Norman John Greville Pounds, *The Medieval Castle in England and Wales: A Social and Political History* (Cambridge: Cambridge University Press, 1990), pp. 222–45; Oliver Hamilton Creighton, *Castles and Landscapes* (London: Continuum, 2002), pp. 111–32; Abigail Wheatley, *The Idea of the Castle in Medieval England* (Woodbridge: Boydell and Brewer, 2004), pp. 89–91.

[31] See the 1610 map of Northamptonshire by John Speed. The church is shown close to the North Gate and city walls. For the Christological associations of the north side of churches, see Laura Slater, "Recreating the Judean Hills? English Hermits and the Holy Land," *Journal of Medieval History* 42, no. 5 (2016), 603–26 (pp. 611–12).

him as founder and guarantor of Christian orthodoxy and *imperium*.[32] As a means of communicating Simon's lordly power and Christian virtue to the locality, the church of the Holy Sepulchre in Northampton constitutes a formidable example of local political propaganda.

Once Simon and Matilda marry, *De Comitissa* continues its history of the deeds of Simon I de Senlis without further reference to the *comitissa* of the title. It records Simon's brokering of the marriage of his sister-in-law, Alice, and enumerates the offspring of his own marriage to Matilda: Simon II; Waltheof, who became abbot of Melrose; and Matilda, who married one Robert fitzRichard and bore him a son named Walter or Waltheof.[33] It then narrates how after many years, Simon took the cross, went on a successful pilgrimage to Jerusalem, and returned safely to his own land ("post multos annorum circulos, vexillo crucis insignitus, peregre proficiscens, Jerosolimam adiit").[34] Medieval sources do not distinguish between the form of war labeled "crusade" and the pious travel of "pilgrimage."[35] However, the author's equation of the military banner and the cross is strongly suggestive of devotional war, echoing a central theme of some of the liturgies composed for departing crusaders.[36] The text states that once again, stirred with godly zeal ("zela Dei accensus"), Simon began another journey to the holy city but was disappointed on this travel. He died and was buried at his supposed ancestral foundation of La Charité-sur-Loire, an important Cluniac priory.[37]

How seriously can this part of the family history be taken? Can we accept its claim that Simon traveled to Jerusalem? The date of the text is unclear, but for

[32] For the medieval "myth of Constantine," see Vacher Burch, *Myth and Constantine the Great* (London: Humphrey Milford, 1927); Ammon Linder, "The Myth of Constantine the Great in the West: Sources and Hagiographic Commemoration," *Studi Medievali*, ser. 3, 16 (1975), 43–95.

[33] Michel, *Chroniques*, p. 126. Simon's second son, Waltheof of Melrose (d. 1159), also became the subject of a cult, but Simon de Senlis features only briefly in the *Vita Waldevi*, written circa 1207–14 as part of a promotional campaign for his canonization. See Helen Birkett, *The Saints' Lives of Jocelin of Furness: Hagiography, Patronage and Ecclesiastical Politics* (Woodbridge: Boydell and Brewer, 2010), pp. 3–12.

[34] Michel, *Chroniques*, p. 126.

[35] Christopher Tyerman, *England and the Crusades, 1095–1588* (Chicago: University of Chicago Press, 1988), pp. 2–4, 24–29; M. Cecilia Gaposchkin, "The Place of Jerusalem in Western Crusading Rites of Departure (1095–1300)," *Catholic Historical Review* 99, no. 1 (2013), 1–28 (pp. 5, 10–11).

[36] M. Cecilia Gaposchkin, "From Pilgrimage to Crusade: The Liturgy of Departure, 1095–1300," *Speculum* 88, no. 1 (2013), 44–91 (pp. 53–57).

[37] Michel, *Chroniques*, p. 126.

the purposes of this paper, it is only necessary to establish that *De Comitissa* in its final form was written long after the circa 1111 to 1113 death of Simon I de Senlis.[38] The confused account of Simon's initial marriage proposal and Judith's flight into the fens indicate that the history was compiled without reference to his wife, Matilda (d. 1131) or her sister, Alice. Both might have been able to clarify the circumstances of Simon's arrival in England and the making of his alliance with Judith and her family. Yet the probably Crowland author does appear closely familiar with the Senlis family, discussing the wardship and education of Simon II after his father's death in some detail, for example.[39] These details suggest the children of Simon I de Senlis and Matilda were key informants for the author. On this basis, the two journeys to Jerusalem made by Simon I de Senlis can be accepted with some confidence.

Assessing when these pilgrimages could have been made is more problematic. Captured and ransomed by the French when fighting in the Vexin in 1098, Simon I de Senlis is unlikely to have joined the First Crusade.[40] *De Comitissa* states that his first successful pilgrimage to Jerusalem was made "after many years," making it implausible that Simon traveled to the East prior to his establishment as earl of Northampton and Huntingdon around 1090.[41] As he died when attempting to make a second journey, this again points to a date in the final decade of his life. Charter evidence can be brought into consideration here. Simon witnessed the 1100 coronation charter of Henry I and royal charters from between 1100 and 1103.[42] He witnessed further charters in 1106 and 1107, including one in Rouen, and charters between 1109 and 1111.[43] These dates provide brief windows for Simon's journeys to Jerusalem: between 1103 and 1105 for his first successful journey, and after 1111 for the journey ending with his death and burial in the Nièvre. However, the ancient registers of the bishops of Lincoln complicate matters further. These contain royal writs witnessed by Simon that

[38] Bolton, "Was the Family?," 46–50.

[39] Michel, *Chroniques*, p. 127.

[40] Henri Waquet, ed. and trans., *Vie de Louis VI le Gros* (Paris: Champion, 1929), pp. 8–9; Nicholas L. Paul, *To Follow in Their Footsteps: The Crusades and Family Memory in the High Middle Ages* (Ithaca: Cornell University Press, 2012), p. 105 (which interprets the text as referring to the First Crusade).

[41] Michel, *Chroniques*, p. 126: "post multos annorum."

[42] Johnson and Cronne, *Regesta*, I-II nos. 488, 489, 492; Strickland, "Senlis, Simon (I) de."

[43] Johnson and Cronne, *Regesta*, I-II, nos. 488, 489, 492, no. 832, pp. 69–70; no. 509, p. 6; no. 544, p. 12, no. 547, p. 13; no. 574, p. 19; no. 650, p. 33; no. 732, p. 49; no. 743, p. 51; no. 770, p. 57; no. 809, p. 64; no. 825, p. 67; nos. 826, 828, p. 68; nos. 919, 920, pp. 87–88; no. 929, pp. 89–90; no. 953, pp. 94–95; nos. 966, 967, p. 97; no. 985, p. 101; no. 996, p. 103.

can only be loosely dated: the grant of a manor by Queen Maud between 1104 and 1106, the grant of a church between 1106 and 1110, and the restoration of a church between 1100 and 1107.[44] The documents from 1104 to 1106 and from 1106 to 1110 further narrow the possible date for Simon's first Jerusalem pilgrimage, perhaps pushing both journeys into the period between 1111 and 1113. A successful journey to Jerusalem took at minimum a year. Passage out in the spring could be followed by a return trip the same autumn, narrowly allowing for a fit within the 1111 to 1113 date range.[45] If Simon began his second journey very soon after his first pilgrimage, perhaps before he had adequately recovered from a physically arduous trip, the chronology might help explain his death in France. Yet this is speculative. A pre-1108 journey is still a possibility when the dating is so inexact. In addition, Simon may have made his second journey precisely because his health was already in fatal decline. Anthony Bale has highlighted how to die in Jerusalem was to die well, with crusading or eschatological return to the holy city forming part of the famous medieval "good death."[46] Simon de Senlis might well have prepared to travel again in that devotional context, assuming the cross a second time in order to die as a simple penitent and so end his life in a state of grace.

De Comitissa raises the possibility that construction of the church of the Holy Sepulchre in Northampton on the model of the Anastasis Rotunda may have begun as a result of Simon's first trip to Jerusalem, either before or after 1108, or after 1111. The church in Northampton may have been designed according to measurements Simon obtained on his travels, accounting for the relatively narrow margin of error in its dimensions. It may also have been informed by his experience of the shrine in Jerusalem. Mosaic depictions of Constantine and Helena decorated the north and south sides of the eleventh-century Anastasis Rotunda.[47]

[44] C. W. Foster, ed. *The Registrum Antiquissimum of the Cathedral Church of Lincoln* I (Lincoln: Lincoln Record Society. Publications no: 27, 1931), pp. 18, 28, 32.

[45] The canons of Hereford Cathedral were allowed a year to go on pilgrimage to Jerusalem, in contrast with the sixteen weeks allotted for pious travel to Rome or Santiago. See Roger Stalley, *Early Medieval Architecture* (Oxford: Oxford University Press, 1999), p. 159.

[46] Anthony Bale, *Feeling Persecuted: Christians, Jews and Images of Violence in the Middle Ages* (London: Reaktion, 2010), p. 120.

[47] G. Kühnel, "Heracles and the Crusaders: Tracing the Path of a Royal Motif," in *France and the Holy Land: Frankish Culture at the End of the Crusades*, ed. by D. H. Weiss and L. Mahoney (Baltimore: Johns Hopkins University Press, 2004), pp. 63–76 (pp. 64–68); Denys Pringle, *The Churches of the Crusader Kingdoms of Jerusalem: A Corpus* (Cambridge: Cambridge University Press, 2007), III: *The City of Jerusalem*, p. 25.

Renewed consciousness of Constantine as an exemplary lord and builder might have been a product of Simon's visit to Jerusalem.

Imitation of the Anastasis can also be placed in the context of a desire to bring to Europe concrete physical witnesses of the Holy Land.[48] In addition to substituting for the structures and cult sites that unavoidably had to be left behind in Palestine, the church would serve as a fitting repository for any relics brought back by Simon from his travels.[49] There is no direct evidence for Simon returning with relics, but it would be extremely surprising if he had not taken advantage of the opportunity to acquire holy souvenirs. As the main altar of a church, usually dedicated to a church's patron saint, required the presence of relevant relics to support its consecration, it is highly probable that Simon did indeed return with material fragments of the Holy Land.

The account of Simon's earlier career as recorded in *De Comitissa* suggests further possible motivations for Simon's building work. Christopher Tyerman discusses how pilgrimage to Jerusalem could make (or break) a man's reputation in the aftermath of the First Crusade.[50] Recreation of Jerusalem at Northampton allowed Simon to lay public claim to the glamour and prestige attached to the First Crusaders, informing a wider public of his first successful pilgrimage to the Holy Land and/or commemorating his part in its continued defense. As well as establishing him as a landed magnate, his marriage to Matilda connected him dynastically with both the Conqueror and a supposed martyr. Having acquired his lordships in England only by royal favor, Simon's recent heroics in the Holy Land, as communicated and emphasized by the striking visual form of the new church at Northampton, would have assured local audiences that their new lord was a suitably worthy and pious successor to Earl Waltheof, "vir magnanimus et in armis strenus."[51] Multiple temporal eras thus converged in the replication of the Holy Sepulchre at Northampton. Its patron could recall the era of Christ's life on earth, contemplate present-day crusading heroics, and place himself imaginatively within later centuries of imperial Christian patronage.

[48] Tyerman, *Crusades*, p. 23.

[49] Ibid., p. 23; Robert G. Ousterhout, "Loca Sancta and the Architectural Response to Pilgrimage," in *The Blessings of Pilgrimage*, ed. by Robert G. Ousterhout (Urbana: University of Illinois Press, 1990), pp. 108–24 (pp. 109, 111).

[50] Tyerman, *Crusades*, pp. 22–24, 27–28; Holger Klein, ed., *Treasures of Heaven: Saints, Relics and Devotion in Medieval Europe* (London: British Museum, 2011).

[51] Michel, *Chroniques*, p. 99.

At this point, it may seem churlish to become more skeptical about such an accumulation of attractive circumstantial evidence. The church can be dated materially and documentarily to circa 1108–1122, coeval with the two recorded Jerusalem pilgrimages of its local lord. It was donated after his death to his own foundation of St. Andrew's Priory. *De Comitissa* also informs us that Simon had past experience as a builder and pious benefactor, constructing the castle at Northampton and establishing St. Andrew's Priory. Yet *De Comitissa* does not explicitly mention Simon's construction of the church at Northampton. In addition, the charters always refer to Earl Simon *and* his wife, Matilda. This is unsurprising when Simon's lands and title were acquired by marriage. Inheritance disputes after Matilda's death between Simon II de Senlis and his half-brother, Henry, would appear to have been triggered by the fact that her estates had previously been carried to both families in the female line.[52] The 1122 charters referring to the church of Holy Sepulchre were witnessed at St. Andrew's Priory, suggesting that the monks took advantage of the king's temporary presence to have a number of recent gifts confirmed.[53] The donation of "Sancti Sepulcri" is the first item on the list, presented to the monks in the name of the king. It is followed by confirmation of "all the gifts of earl Simon, his wife Matilda, and other barons and royal tenants; particularly the annual pension of 40s in Bedford which the Countess Matilda gave."[54]

The gift indicates significant personal agency on the part of Matilda in relation to her patrimony throughout her lifetime, activity that continued during her second marriage.[55] Nor should Simon's journeys to Jerusalem be seen in isolation. Travel to the East was a severe tax on capital and resources, making "the business of the cross," however understood by contemporaries, a communal

[52] Ibid., pp. 126–30; Keith Stringer, "Senlis, Simon (II) de, earl of Northampton and earl of Huntingdon (*d.* 1153)," in *Oxford Dictionary of National Biography* (Oxford: Oxford University Press, 2004), http://www.oxforddnb.com/view/article/25092 (accessed 2 December 2013).

[53] Johnson and Cronne, *Regesta*, pp. 170–71, nos. 1317, 1318.

[54] Ibid., p. 170.

[55] Alongside further donations to St. Andrew's Priory, Northampton, Matilda is also recorded as a benefactor, alongside both her first and second husbands, to St. Augustine's Priory at Daventry, in Northamptonshire, and to St. Neots Priory in Bedfordshire; see Archibald C. Lawrie, ed., *Early Scottish Charters: Prior to AD 1153* (Glasgow: James MacLehose and Sons, 1905), nos. L, LI (Daventry), LVI (St. Andrew's), XCVIII (a donation to Holy Trinity Priory, London), CXIII (St. Neots), CXIV (St. Andrew's, a grant continued by her son), pp. 50, 299, 305–6, 312, 339.

enterprise.⁵⁶ Matilda's activities beyond her marriages are not the focus of *De Comitissa*, but we can assume significant financial if not emotional investment in her husband's crusading or pilgrimage activities. Whether the church of the Holy Sepulchre at Northampton was built in direct response to contact with the Holy Land and/or in preparation for future journeys to Jerusalem, it is plausible that Matilda de Senlis played a major role in the church's construction and completion.⁵⁷ Her involvement is particularly likely if building work was initiated only shortly before the death of Simon de Senlis, perhaps around the period of his possible departure(s) for Palestine. Aristocratic women generally, and widows especially, were expected to ensure familial commemoration and work toward the salvation of their deceased kin.⁵⁸

A further motive for Matilda's patronage might have been as a response to and expiation of the activities of her mother, Judith. The earliest and most detailed account of Waltheof's rebellion in 1075 was written by Orderic Vitalis circa 1114 to 1124, based on information gained from a five-week stay at Crowland.⁵⁹ His work became the basis for later hagiographic accounts written at the abbey, including those that preface *De Comitissa*. For Orderic, Waltheof

⁵⁶ Tyerman, *Crusades*, pp. 188–89, 208. For female crusading activities generally, see Helen J. Nicholson, "Women on the Third Crusade," *Journal of Medieval History* 23 (1997), 335–49; Christoph T. Maier, "The Roles of Women in the Crusade Movement: A Survey," *Journal of Medieval History* 30 (2004), 61–82; Susan B. Edgington and Sarah Lambert, eds., *Gendering the Crusades* (Cardiff: University of Wales Press, 2001); Helen J. Nicholson, "Women's Involvement in the Crusades," in *The Crusader World*, ed. by Adrian J. Boas (London: Routledge, 2016), pp. 54–67.

⁵⁷ For a sample of the extensive scholarship on the cultural patronage of medieval noblewomen, see Jennifer C. Ward, *English Noblewomen in the Later Middle Ages* (Harlow: Longman, 1992); Frances A. Underhill, *For Her Good Estate: The Life of Elizabeth de Burgh* (Basingstoke: Macmillan, 1995); June Hall McCash, ed., *The Cultural Patronage of Medieval Women* (Athens: University of Georgia Press, 1996); Loveday Lewes Gee, *Women, Art and Patronage from Henry III to Edward III, 1216–1377* (Woodbridge: Boydell and Brewer, 2002); Mary C. Erler and Maryanne Kowaleski, *Gendering the Master Narrative: Women and Power in the Middle Ages* (Ithaca: Cornell University Press, 2003); Susan M. Johns, *Noblewomen, Aristocracy and Power in the Twelfth-Century Anglo-Norman Realm* (Manchester: Manchester University Press, 2003), pp. 36–43.

⁵⁸ Elisabeth M.C. Van Houts, *Memory and Gender in Medieval Europe, 900–1200* (Basingstoke: Macmillan, 1999), pp. 93–120, 141–42; Paul, *Footsteps*, pp. 145–49, 164–70; Anne E. Lester, "What Remains: Women, Relics and Remembrance in the Aftermath of the Fourth Crusade," *Journal of Medieval History* 40 (2014), 311–28; Nurith Kenaan-Kedar, "Pictorial and Sculptural Commemoration of Returning or Departing Crusaders," in *The Crusades and Visual Culture*, ed. by Elizabeth Lapina, April Jehan Morris, Susanna A. Throop, and Laura J. Whatley (Abingdon: Ashgate, 2015), pp. 91–104.

⁵⁹ *EH*, pp. xv, 324–25; Huntington, "Taming of the Laity," pp. 81–85.

was innocent of all charges of rebellion but "accused, on the deposition of his wife Judith, of being a party to the conspiracy and proving unfaithful to his lord."⁶⁰ In addition to emphasizing Waltheof's betrayal by his wife, Orderic gives further details of the fates of Waltheof's co-conspirators, Roger of Hereford and Ralph of Norwich. Roger forfeited his property and was condemned to life imprisonment. Ralph escaped with his wife to his lands in Brittany and "many years later, in the time of Pope Urban, took the cross and set out for Jerusalem with Robert the second, duke of Normandy, to fight against the Turks; as a pilgrim and penitent following the way of God he died, together with his wife."⁶¹ This account places the couple on the First Crusade, joining the army led by Robert Curthose. The twelfth-century *Vita et Passio* of Waltheof preserved in MS 852 is based on the major hagiographic accounts composed by Orderic Vitalis, William of Malmesbury, and John of Worcester in the 1120s.⁶² It depicts Judith as led by penitence ("ducta penitentia") to make offerings to her husband's tomb in the abbey chapterhouse, gifts rejected from beyond the grave by an unforgiving Waltheof.⁶³

Colin Morris considers the penitential element of the Christian pilgrimage to have been particularly prominent in the Holy Land, citing the popularity of the legend of the penitent Mary the Egyptian, the ceremony of bathing in the Jordan, and the prominence in pilgrim accounts of Mary Magdalene, another model penitent, and Rahab, the harlot of Jericho.⁶⁴ In his *Ecclesiastical History*, Orderic records several penitential Jerusalem pilgrimages made by monks, clerics, and laymen.⁶⁵ The existing strong association between pilgrimage to Jerusalem and penitence and the remission of sin was reinforced in the second decree of the 1095 Council of Claremont. It stated explicitly that those who traveled to Jerusalem "pro sola devotione ... ad liberandam Ecclesiam Dei Hierusalem profectus fuerit, iter illud pro omni paenitentia ei reputabitur."⁶⁶ The later imposition of a penitential crusading vow on convicted criminals, with crusading "exile" decreed as

⁶⁰ *EH*, pp. 320–21.

⁶¹ *EH*, pp. 318–19.

⁶² Bolton, "Was the Family?," pp. 48–50 (p. 49): "The *vita* is closely based, in part, on accounts written in the 1120s (those of Orderic Vitalis, William of Malmesbury and John of Worcester), and so must post-date these accounts."

⁶³ Michel, *Chroniques*, p. 118.

⁶⁴ Colin Morris, *The Sepulchre of Christ and the Medieval West: From the Beginning to 1600* (Oxford: Oxford University Press, 2005), p. 246. See also Tyerman, *Crusades*, pp. 62, 158–59.

⁶⁵ Williams, *English Norman Conquest*, p. 63; *EH*, pp. 14–15, 42–45, 66–75, 346–47.

⁶⁶ Cyrille Vogel, "Le pèlerinage pénitentiel," *Revue des Sciences Religieuses* 38, no. 2 (1964), 113–53 (p. 147).

punishment for offences as serious as murder, assault, rape, kidnapping, robbery, and defamation, legally formalized an enduring aspect of crusade spirituality.[67] I suggest that alongside commemorating the positive Christian *fama* and piety of Simon I de Senlis, the church of the Holy Sepulchre at Northampton might also have been intended by his wife, Matilda, as a powerful penitential offering in expiation of the perceived sins of her mother, Judith.

Aside from her presentation in Crowland hagiography, Judith was a major religious patron in her own right, founding the wealthy Benedictine nunnery of Elstow in Bedfordshire.[68] It was dedicated to St. Mary and St. Helen, mother of Constantine and finder of the True Cross (the name Elstow is thought to be a corruption of *Helenæ Statio*).[69] A fourteenth-century copy of a charter of circa 1126 to 1130 from the reign of Henry I confirming the property of the nuns contains a list of benefactors. It begins with gifts from Judith and ends with a record of "the gift of Countess Matilda [of the] land of William Medicus of Burn."[70] Matilda's involvement with Elstow indicates a concern to uphold her mother's memory and support her mother's religious foundation. Through the dedication of the convent to St. Helen and St. Mary, there is a dual female and maternal connection to the Holy Land. Just as Simon de Senlis might have envisaged himself as following the precedent set by Constantine the Great, Judith and Matilda might have imitated the pious example and generous Christian benefactions of Constantine's mother, Helena. Later tradition cast Judith's founding of Elstow as an act of reparation for her betrayal of her husband, once again linking penitential activity with the Holy Land.[71] The personal resonances of the church of the Holy Sepulchre in Northampton for its initiating patrons remain speculative, but it

[67] Tyerman, *Crusades*, pp. 221, 419–20; Gaposchkin, "Place of Jerusalem," pp. 2, 5; Gaposchkin, "Pilgrimage to Crusade," pp. 46, 55–57, 63, 70; Vogel, "Le pèlerinage pénitentiel," pp. 145–48.

[68] In later historical writing, the presentation of Judith became increasingly vituperative. The chronicle of the pseudo-Ingulf at Crowland narrates Waltheof's "most impious wife [who] desired to contract a new marriage, and therefore most wickedly hurried on his destruction … that most wicked Jezebel": *Ingulph's Chronicle of the Abbey of Croyland*, ed. and trans. by Henry T. Riley (London: G. Bell, 1908), pp. 145–46; David Roffe, "The *Historia Croylandensis*: A Plea for Reassessment," *English Historical Review* 110 (1995), 93–108.

[69] "Houses of Benedictine Nuns: The Abbey of Elstow," in *A History of the County of Bedford* (London, 1904), I, pp. 353–58, http://www.british-history.ac.uk/report.aspx?compid=40034&strquery=Elstow Abbey (accessed 13 February 2014); Spencer Robert Wigram, *Chronicles of the Abbey of Elstow* (Oxford: Parker, 1885), p. 3.

[70] Wigram, *Chronicles*, pp. 15–18, 22–23.

[71] "Houses of Benedictine Nuns: The Abbey of Elstow."

is fair to state that recreations of Jerusalem could have been viewed and used as easily in a penitential as in a commemorative or celebratory pious and crusading context.

Ludlow: Anticipating the Holy Land?

The surviving condition of the church of the Holy Sepulchre in Northampton and the relative wealth of extant documentation concerned with its founder(s) is exceptional. There is only one other certain instance of a twelfth-century English patron personally commissioning an architectural recreation of Jerusalem, and it is unclear who that patron was. The early twelfth-century chapel of St. Mary Magdalene at Ludlow Castle in Shropshire was built in the inner bailey of the castle, probably intended to serve now lost adjacent timber domestic buildings (fig. 11).[72] Detached stone castle chapels are rare in medieval England, with only three other known examples at Pevensey, Hereford, and Castle Rising. Ludlow is unique in containing a round nave.[73] The nave in its original form had an internal diameter of 8.30 meters (27 feet, 3 inches), less than half the size of the original Holy Sepulchre Church. A low stone bench runs the circumference of the nave, supporting a blind wall arcade of fourteen arches decorated with an alternating pattern of bead molding and chevron (fig. 12). The arches rise from detached round shafts topped by scalloped capitals, and at the outermost edges of the arcade, spring from plain responds. With no evidence for any inner arcade, as at Northampton, one can speculate if the internal wall arcade was intended to signal the interior of the Anastasis Rotunda. At ground level in the Anastasis Rotunda, there is a striking contrast between the round arches rising from simple responds at the outer edges of the square piers and the columnar arches supported by more elaborate Corinthian or foliate capitals. The wall arcade at Ludlow may have been intended to recreate this pattern of alternating decorative richness. Similarly elaborate, although heavily restored, blind wall arcading decorated with pointed arches, billet ornament, and grotesques is found at arcade level in the outer nave aisle of the New Temple Church in London (fig. 3). It springs from foliate capitals and is supported by a low stone bench that runs the full

[72] Glyn Coppack, "The Round Chapel of St. Mary Magdalene," in *Ludlow Castle: Its History and Buildings*, ed. by Ron Shoesmith and Andy Johnson (Little Logaston: Logaston, 2000), p. 145.
[73] Ibid., p. 145.

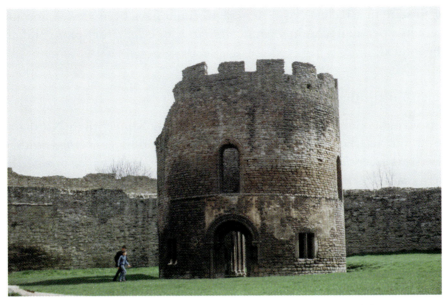

Fig. 11. Shropshire, Ludlow Castle, Chapel of St. Mary Magdalene, exterior view. Photo: Glyn Coppack.

Fig. 12. Shropshire, Ludlow Castle, interior detail of the arcade of the Chapel of St. Mary Magdalene. Photo: Glyn Coppack.

circumference of the nave. At triforium level in the New Temple, a second intersecting arcade is found.[74]

The chapel's dedication to St. Mary Magdalene is known only from the thirteenth-century text *Fouke le Fitz Warin*, an unreliable and confused account of events at Ludlow during the so-called Anarchy, the civil wars fought between Stephen of Blois and the empress Matilda and their supporters for the English throne between 1135 and 1154.[75] The fabric of the St. Mary Magdalene chapel has been dated on stylistic grounds to the second quarter of the twelfth century: Glyn Coppack assigns it to "no earlier than the 1120s or 30s."[76] This dating leads to difficulty in securely identifying its patron, as Ludlow and the Welsh Marches became key battlegrounds of the private aristocratic wars fought during the Anarchy. Once again, a review of family history reveals several potential patrons of the chapel: Gilbert de Lacy, Sybil de Lacy, and her two husbands, Payn fitzJohn and Jocelyn de Dinan.

Ludlow Castle was first built in the eleventh century by Walter de Lacy and his son Roger. Roger was disinherited and banished from the realm in 1096.[77] His lands passed to his brother Hugh, who died childless around 1115. Having devolved to the crown, control of Ludlow transferred via marriage with Sybil, daughter of Roger and Hugh's sister Agnes de Lacy, to one Payn fitzJohn, a household servant of Henry I. On his death in 1137, Stephen of Blois initially granted Ludlow Castle to a local magnate, Miles of Gloucester, and his son Roger, but in 1138, Stephen married Sybil to a Breton knight in his entourage, Joce or Jocelyn de Dinan.[78] Since 1136, Roger's eldest son, Gilbert de Lacy, had been pressing his claims to his inheritance, and by 1150, he had succeeded in regaining control of Ludlow Castle.[79] Sybil de Lacy and both her husbands, in addition to Gilbert de Lacy, can all be ranked as possible patrons of the chapel.

[74] Christopher Wilson, "Gothic Architecture Transplanted: The Nave of the Temple Church in London," in *The Temple Church in London: History, Architecture, Art*, ed. by Robin Griffith-Jones and David Park (Woodbridge: Boydell and Brewer, 2010), p. 35.

[75] Coppack, "Round Chapel," p. 145; Francisque Xavier Michel, ed., *Histoire de Foulques Fitz-Warin* (Paris: Silvestre Librarie, 1840), p. 19. It ascribes the construction of the chapel to Jocelyn de Dynan: "Joyce de Dynan leva matin; e s'en ala à sa chapele dedenz son chastel, qe fust fet e dedié en l'onour de la Magdaleyne."

[76] Coppack, "Round Chapel," p. 150.

[77] Bruce Coplestone-Crow, "From Foundation to Anarchy," in *Ludlow Castle: Its History & Buildings*, ed. by Ron Shoesmith and Andy Johnson (Little Logaston: Logaston, 2000), pp. 21–34 (pp. 21–22).

[78] Coplestone-Crow, "Anarchy," pp. 23–28.

[79] Ibid., pp. 22–34.

Gilbert de Lacy has been seen as the most probable patron of the chapel at Ludlow, as his commitment to regaining the castle is complemented by a documented concern for Jerusalem.[80] Gilbert donated land that became the preceptory of Temple Guiting to the Templars and is recorded resigning his lands to his eldest son circa 1158 to 1159 and joining the order.[81] By 1161 he had become a Templar preceptor at Tripoli and is last recorded fighting in the Holy Land in 1163.[82] The problem with this patronal identification lies in the stylistic dating of the chapel to the second quarter of the twelfth century, prior to de Lacy's recovery of the castle. It is possible that Gilbert de Lacy may have been securely in possession of Ludlow Castle earlier than the sources suggest.[83] It is also plausible for the chapel to have been built in a deliberately archaic style, perhaps in echo of the crusader rebuilding of the Holy Sepulchre from 1114 to 1120 and from 1140 to 1149, with its deliberate retention of antique forms.[84] One can speculate, in addition, how much masonic skill and ambitions might have fossilized in the locality after twenty years of conflict. Yet the issue remains unresolved.

Although later connected with the Templars, Gilbert de Lacy is unlikely to have been deliberately imitating Templar architecture or making a public statement of Templar affiliation. The founder of the Templars, Hugh de Payen and his colleagues arrived in England between 1127 and 1128. When the chapel at Ludlow was built, there was little sense of an established "Templar architecture" to imitate, whether in England or abroad, and only a restricted set of local exemplars. Precedents may have been available to the patron of Ludlow: the Old Temple headquarters in Holborn was built circa 1135 and contained a round nave, as did early preceptories such as Dover.[85] The foundations of a small, 35-foot (10.668 meter) diameter round church with a square-ended chancel still extant on the Western Heights at Dover have been interpreted as an initial settlement abandoned after the Templars removed to nearby Temple

[80] Ibid., p. 34; Coppack, "Round Chapel," p. 150.

[81] C. P. Lewis, "Lacy, Gilbert de (*fl.* 1133–1163)," in *Oxford Dictionary of National Biography* (Oxford: Oxford University Press, 2004), http://www.oxforddnb.com/view/article/15849 (accessed 26 March 2014).

[82] Coplestone-Crow, "Anarchy," p. 34; Lewis, "Lacy, Gilbert de."

[83] Ibid., pp. 31–34.

[84] Robert G. Ousterhout, "Architecture as Relic and the Construction of Sanctity: The Stones of the Holy Sepulchre," *Journal of the Society of Architectural Historians* 62 (2003), 9–20.

[85] Pál Ritoók, "The Architecture of the Knights Templars in England," in *The Military Orders: Fighting for the Faith and Caring for the Sick*, ed. by Malcolm Barber (Aldershot: Variorum, 1994), pp. 167–78 (p. 173); Sloane and Malcolm, *Excavations*, pp. 4–5.

Ewell.[86] Yet evidence for the initial foundation dates of Templar establishments, including that of the Old Temple, is scarce. Nor did Templar churches always include circular naves. Five have been recorded or excavated within known Templar preceptories. In addition to Dover (and the extant round-naved New Temple Church headquarters in London), circular naves have been found at Temple Bruer, founded circa 1150 by William of Ashby; Aslackby, founded circa 1164 by Hubert of Rye; Penhill, founded circa 1142 by Roger de Mowbray, and Bristol, founded circa 1147 by Robert, earl of Gloucester. The ruins surviving today at Penhill's "Temple Bank" were excavated in 1840 and consist of a rectangular chapel with stone coffins, assumed to be the second preceptory built circa 1202. In 1805, Charles Fothergill recorded an excavation around 1793 of a circular building with an inner arcade, which may have been the original preceptory building.[87] Yet many more preceptory chapels were built across England with conventional rectilinear chapels. Templar castles in the Holy Land rarely included round chapels either.[88] Denys Pringle identifies only two: the circa 1218 polygonal chapel built in the inner ward of Chastel Pèlerin (Atlit) and potentially that of Safad, built circa 1240 to 1260.[89] It is therefore unlikely that Ludlow was built in direct response to a specific Templar chapel. Its architectural sources instead come directly from Palestine: the Church of the Holy Sepulchre and the octagonal Templum Domini (the Dome of the Rock) in Jerusalem, in which space had been allotted to the Templars for their religious services.[90]

With the cruciform parish church of St. Laurence established in the eleventh century in close vicinity to the castle, it is improbable that Ludlow was ever routinely accessed by a wider public audience.[91] Unlike at Northampton, a

[86] Gervers, "Rotundae," p. 366; Anonymous, "Ruins of a Round Church, At Dover," *Archaeologia Cantiana* 11 (1877), 45–47; Hundley, "English Round Church Movement," pp. 365–67; Gervers, "Use and Meaning," p. 379.

[87] Paul Romney, ed., *The Diary of Charles Fothergill 1805: An Itinerary to York, Flamborough and the North-Western Dales of Yorkshire* (Leeds: The Yorkshire Archaeological Society Record Series 142, 1984), pp. 179–80; Sloane and Malcolm, *Excavations*, p. 5.

[88] Lord, *Knights*, p. 22.

[89] Denys Pringle, "Architecture in the Latin East, 1098–1571," in *The Oxford Illustrated History of the Crusades*, ed. by Jonathan Riley-Smith (Oxford: Oxford University Press, 2001), p. 169.

[90] Virginia Jansen, "Light and Pure: the Templars' New Choir," in *The Temple Church in London: History, Architecture, Art*, ed. by Robin Griffith-Jones and David Park (Woodbridge: Boydell and Brewer, 2010), pp. 45–66 (pp. 59–60, 65).

[91] George Thomas Clark, *Medieval Military Architecture in England* (London: Wyman, 1884), II, p. 273; Hundley, "English Round Church Movement," p. 360.

parish church, the round chapel at Ludlow cannot have been intended to communicate the good name and great deeds of its lord far afield. Such messages may have been conveyed but to a far more select group. We can consider instead the possible significance of its construction to Gilbert de Lacy, his family, and their closest household servants and retainers.[92] Since 1136, Gilbert had been physically fighting his own "crusade" to regain his patrimony at Ludlow. The construction of a replica of the Holy Sepulchre, itself so recently liberated by Christian warriors, might have fittingly commemorated his triumphant return to the secular "holy ground" of his de Lacy ancestors. We can also recall that in resigning his lands to his eldest son before joining the Templars, Gilbert was preparing to die in the Holy Land. Expecting to fall as a martyr to the crusading cause and so cleansed of his sins by the nature of his end, Gilbert de Lacy would have hoped to facilitate his individual salvation and honor the family name. Yet death in the Holy Land made it unlikely that his body would be transported home. Without a tomb in England to act as a site for prayer and dynastic memory, Gilbert risked being forgotten by his descendants.[93] Building Ludlow Chapel would ensure that Gilbert received commemorative prayers in his capacity as founder. And as a castle chapel used daily by those closest to him, it would encourage familial remembrance (both by blood relations and the wider lordly *familia*) of his heroic deeds.[94] Construction of the chapel may have offered Gilbert de Lacy an opportunity to preemptively commemorate his actions, communicate them to future descendants, and perhaps, in its connection to penitent Magdalene, explain his decision to enter what was effectively a form of Christian exile. As at Northampton, the building could function simultaneously as a political assertion of Anglo-Norman lordship, as a monument to dynastic glory and military heroism, and as a penitential token of noble sins. Unlike Northampton, Ludlow may have been built in architectural anticipation of travel to the Holy Land rather than in direct response to it.

Conclusions

Replicating the Holy Sepulchre at the centers of these two baronial estates powerfully localized Jerusalem, blurring temporal and spatial boundaries already

[92] Gervers, "Rotundae", p. 374 raises the possibility that Ludlow imitated royal round chapels as at Woodstock, first mentioned in 1186 and recorded as round in 1233.

[93] Paul, *Follow in Their Footsteps*, pp. 140, 149–64.

[94] Ibid., pp. 95–98, 115–23, 135, 140, 149–64.

strained by the earthly city. Northampton and Ludlow evoked a range of Christian histories for their patrons. Biblical and classical pasts, such as the apostolic era of Christ and the Constantinian epoch of Christian *imperium*, could be referenced alongside a more contemporary vision of Christian heroics inspired by the First Crusade. Although referencing past or future Jerusalem expeditions, these structures may also have accrued more personal significances for their patrons: marking Simon de Senlis's landed establishment in England, betokening Matilda de Senlis's atonement of her mother's sins, or recalling Gilbert de Lacy's triumphant recovery of the family patrimony. All such meanings took patron or visitor further and further away from the holy city and embedded a transcendent cult site more firmly into its local context. This shift may explain the clear concern demonstrated at Northampton and Ludlow for "accuracy" in their structure, plan, dimensions, internal features, and decoration. Both spaces demonstrate the approximate rather than exact nature of medieval architectural imitation.[95] By recalling rather than precisely quoting the architecture of the church of the Holy Sepulchre, Northampton and Ludlow adequately conveyed the spiritual authority of the prototype in Jerusalem while still encouraging the individual imagination to "fill in the gaps" when contemplating the Passion.[96]

A visitor's devotional reflections might have been interrupted by the extent to which these buildings became resonant of more personal agendas and lordly problems. Provoking memorial recollection of and prayers for the souls of local defenders of the Holy Land may have been a positive outcome from the point of view of these buildings' potential patrons. Other visitors may have found this aspect of the buildings to be an unfortunate spiritual distraction, returning them to social and temporal contexts that they were hoping to escape through virtual pilgrimage. In the context of these competing demands on the user, details such

[95] Richard Krautheimer, "Introduction to an 'Iconography of Medieval Architecture,'" *Journal of the Warburg and Courtauld Institutes* 5 (1942), 1–33; Paul Crossley, "Medieval Architecture and Meaning: The Limits of Iconography," *Burlington Magazine* 130, no. 1019 (1988), 116–21; Alexander Nagel and Christopher S. Wood, *Anachronic Renaissance* (New York: Zone, 2010), pp. 59–61.

[96] Robert G. Ousterhout, "'Sweetly Refreshed in Imagination': Remembering Jerusalem in Words and Images," *Gesta* 48, no. 2 (2009), 153–68 (esp. pp. 162–66). I paraphrase: "I suspect we should understand the building [imitating the Holy Sepulchre] to have functioned as a sort of *ad res* copy, that is, not an exact quotation but one that conveyed the spiritual authority of the prototype" (p. 162). See also Mary Carruthers, *The Craft of Thought: Meditation, Rhetoric, and the Making of Images, 400–1200* (Cambridge: Cambridge University Press, 2000), pp. 42–44; Bale, *Feeling Persecuted*, p. 121.

as the eight piers at Northampton or the decorated internal arcade at Ludlow could act as useful visual triggers for refocusing a visitor's personal meditations. Like the round form of the two structures, these features directly recalled architectural elements of the Anastasis Rotunda in Jerusalem, displacing the more familiar (and familial) aspects of these spaces. Direct visual translation thus enabled appreciation of copy and prototype simultaneously. A visitor could return to their religious meditations on the scriptural Jerusalem. Or they could remember and reimagine recent Anglo-Norman history, contemplating the lordly power that had transformed their own locality into "Jerusalem."

JERUSALEM IN THE LANDSCAPE OF CATALAN ROMANESQUE ARCHITECTURE: FROM EVOCATION TO PRESENCE

Gerardo Boto and Marc Sureda

> I give you the end of a golden string;
> Only wind it into a ball,
> It will lead you in at Heaven's gate,
> Built in Jerusalem's wall.
> – William Blake, 1808

Introduction

Jerusalem is a major reference point for Christian cosmovision and, thus, a historical and eschatological benchmark in Christian theological and exegetical traditions. Consequently, the city and some of its churches, particularly the Holy Sepulchre, generated a number of architectural counterparts that were used for liturgical and symbolic purposes throughout the Christian world during the Middle Ages and beyond.

This essay aims to analyse the architectural evocations of Jerusalem and of the Holy Sepulchre between the tenth and eleventh centuries in what is present-day Catalonia. During the period under discussion, Catalonia was a group of counties in the northeastern Iberian Peninsula on the edge of the Carolingian empire and on the margins of Christianity. In addition to studying the architectural arrangements, we will pay close attention to the documentary and liturgical sources illuminating certain contexts of interest for Jerusalem or the Holy Land often related to pilgrimage or the management of relics.

The study of the references to Jerusalem and the Holy Sepulchre in the Romanesque architecture of Catalonia offers a thematic panorama of a region in Western Europe that shows both differences and similarities with other European countries (see appendix). It demonstrates that after an initial period in which only relics appear as material connections to the Holy Land, by the eleventh century some altars dedicated to the Holy Sepulchre started to be built within larger churches. The most interesting were those located in westworks, for which the liturgical sources attest—or suggest—a Jerusalemite topo-liturgical

orientation as an effective scenic framework of the ritual with which the *Triduum Paschale* culminated, according to a Carolingian tradition for this type of construction. In the same century the first free-standing churches dedicated to the Holy Sepulchre appear, most of them related directly or indirectly to pilgrimages to the Holy Land undertaken by noble persons of the highest religious or political rank. A discussion of these constitutes the first part of the article.

The second part of the article shows that some new sanctuaries provided the opportunity for those with limited economic resources to undertake local or regional pilgrimages, by devotion or by vow. Two of the oldest of these churches, La Portella (1035) and Palera (1086), were built as substitutes for the actual Holy Sepulchre by granting equivalent spiritual benefits; *adire limina sepulcri Domini* and crossing their thresholds *were* Jerusalem, *hic et nunc*, constiuting equivalent gestures. These other Holy Sepulchres favored more accessible itineraries, *interponitur brevis circuitus*, to put it in the words that St. Augustine used in another context.[1]

One singularity of Catalonia, we argue, is the absence of what are commonly called "copies" of the Holy Sepulchre, in the sense of centrally planned chapels or churches with iconographic or numeric features that can be perceived as specific to the Anastasis Rotunda.[2] The architectural expression of the buildings preserved in Catalonia—and what we know about those that have disappeared—is based rather on dedications, liturgical attributions, primary texts that make the connection to Jerusalem, or the presence of relics from the Holy Land. These edifices, thus, do not constitute visual copies comparable with either the original in Jerusalem or with well-known examples like the Aquileia aedicula or the sepulchral churches in Cambridge, Segovia, or Tomar. However, the sum of all these cases is a rich and particularly dense European landscape evoking the Holy Sepulchre in other ways (fig. 1).

[1] Augustine, *De Doctrina Christiana* IV.40.

[2] Richard Krautheimer, "Santo Stefano Rotondo a Roma e la chiesa del Santo Sepolcro a Gerusalemme," *Rivista di archeologia cristiana* 12 (1935), 51–102; the classical reference for this concept of "copy" is still Richard Krautheimer, "Introduction to an 'Iconography of Mediaeval Architecture,'" *Journal of the Warburg and Courtauld Institutes* 5 (1942), 1–33. A critical examination in Catherine C. McCurrach, "'Renovatio' Reconsidered: Richard Krautheimer and the Iconography of Architecture," *Gesta* 50/51 (2011), pp. 41–69. See also Justin E. A. Kroesen, *The Sepulchrum Domini through the Ages: Its Form and Function* (Leuven: Peeters, 2000), pp. 12–44; *La fortuna del Santo Sepulcro nel Medioevo: Spazio, liturgia, archittetura* (Florence: Jaca, 2008), pp. 83–131, 147–55; Laura D. Gelfand, "Holy Sepulchre, Architectural Copies of," in *Encyclopedia of Medieval Pilgrimage*, ed. by Larissa Juliet Taylor and Leigh Ann Craig (Leiden: Brill, 2010–13), doi: 10.1163/2213-2139_emp_SIM_00389 (accessed 21 October 2019).

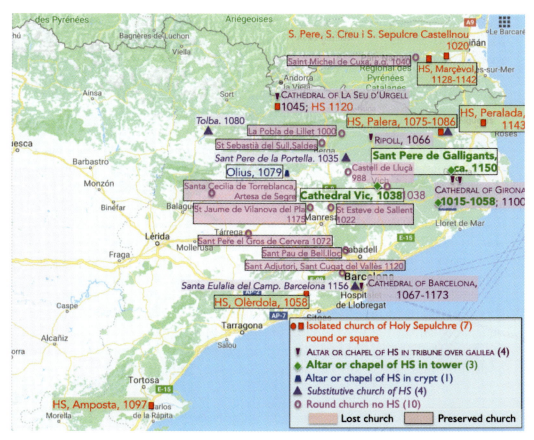

Fig. 1. Map of churches or altars with Jerusalemite dedications in Catalonia, eleventh-twelfth centuries. Photo: Gerardo Boto.

A Precedent: *Sancta Iherusalem* in Visigothic Tarragona

While we seek to deal with medieval cases, a precedent from late antiquity is worthy of note. A generic association between Jerusalem and the place of episcopal worship is documented in Tarragona, where the metropolitan see was emphatically called *sancta Iherusalem* according to the early eighth-century Verona Orational (or *Libellus Orationum*; cathedral of Verona, Biblioteca Capit., MS LXXXIX). The text describes the procession of the closing of the baptismal fonts just before Lent, a ritual typical of the Hispanic

liturgy.³ This was not a ceremony unique to Tarragona; the cathedrals of Mérida and Seville, two other metropolitan sees in the Visigothic kingdom, were referred to in the same terms during Late Antiquity.⁴ For other episcopal churches in the peninsula, however, other titles are documented. Since the title *Sancta Iheursalem* refers exclusively to the main church of the three metropolitan sees, it can be inferred that this title was reserved for the main episcopal church, although it was supplemented with another dedication, *Sancta Maria*.

The baptismal procession in Tarragona described in the Verona Orational is the first attestation of the phenomenon of stational liturgy in the region and also the only trace of the late antique stational system in this see. If such a procession was performed there on the closing of the baptismal fonts, it is possible that other similar itineraries were enacted on the most solemn occasions of the year around the main episcopal church or *sancta Iherusalem*, understood as the symbolic epicenter of the city. This is, then, an early example of a general phenomenon in the Christian urban world: the symbiosis between physical extension, scenic framework, and ritual temporality, which made the whole town a holy city with the main episcopal church at its center. This *civitas christiana* was understood in turn as a symbolical prediction of the Heavenly Jerusalem. In other words, the anagogic promise of urban perfection was projected as a figure of the historical and earthly city where Christ was resurrected.⁵

³ "vadunt usque ad sancta Iherusalem." *Libellus Orationum*, PL 80, cols. 135–36; *Oracional visigótico e hispano-romanos*, ed. by José Vives (Barcelona: nsejo Superior de Investigaciones Científicas, Instituto Enrique Flórez, 1966), p. 175, r. 523. Cristina Godoy and Miquel dels S. Gros, "L'oracional hispànic de Verona i la topografía cristiana de Tarraco a l'Antiguitat Tardana: possibilitats i límits," *Pyrenae* 25 (1994), p. 247; Miquel dels S. Gros, "Epíleg," in *Les dotalies de les esglésies de Catalunya (segles IX–XII)*, ed. by Ramon Ordeig (Vic: Estudis Històrics, 1993–2004), IV, p. 272. Tarragona Cathedral was later dedicated to St. Thecla.

⁴ "At ubi ingressus est ecclesiam santae Mariae quae Sancta Iherusalem nunc usque vocatur ...; in thesaurum ecclesiae senioris, quae vocarur Sancta Iherusalem." *Vitas Sanctorum Patrum Emeretensium*, ed. by Antonio Maya Sánchez (Corpus Christianorum, Series latina, CXVI) (Turnhout: Brepols, 1992), IV. IX, 3 and 7, pp. 41–43, p. 66. See also M. Alba Calzado, and Pedro Mateos, "El paisaje urbano de Emerita en época visigoda," in *Recópolis y la ciudad en la Época Visigoda*, ed. by Lauro Olmo Enciso, Zona Arqueología 9 (2008), p. 269; Rafael Puertas Tricas, *Iglesias hispánicas (siglos IV al VIII): Testimonios literarios* (Madrid: Ministerio de Educación y Ciencia, 1975), pp. 19 (Tarragona), 55 (Sevilla: see the conciles of 590 and 610), 58 (Mérida), and 151. However, we have not found usage of this denominación in the metropolitan sees of St. Mary of Toledo and St. Mary of Braga during the sixth to eighth centuries. Henrique Flórez, *España Sagrada*, t. XV: *De la provincia antigua de Galicia* (Madrid: Antonio Marin, 1787), p. 371

⁵ John F. Baldovin, *The Urban Character of Christian Liturgy* (Rome: Pontificio Istituto Orientale, 1987), pp. 35–40, 247–50; Marc Sureda, "*Lauda Iherusalem Dominum*. Liturgie stationnale et familles d'églises en Catalogne, XIe–XIVe siècles," *Quaestiones Medii Aevi Novae* 20 (2015), pp. 336–40.

Signs of a New Interest: Pilgrimages and Relics before the Crusades

With the disintegration of the Visigothic kingdom at the beginning of the eighth century, symbolic and ritual changes took place. We do not know how the Hispanic liturgy survived in the dioceses of Tarragona, Lleida, or Tortosa under Muslim rule until the mid-twelfth century. The northern dioceses (Elne, Girona, Urgell, and later Vic and Barcelona) were incorporated into the Carolingian empire from the end of the eighth century and introduced a Roman-Frankish liturgical framework, in which some standard Jerusalemite attributions of the place of worship were already consolidated. It seems, however, that this did not involve architectural counterparts until the eleventh century.[6]

Documents indicating a growing interest in the Holy Land are recorded from the second half of the tenth century onward. In line with the pilgrimage tradition from Spain already attested by Egeria in the fourth century (and presumably not interrupted),[7] some persons around the turn of the millennium

[6] Miquel Dels Sants Gros Pujol, "L'ordre catalano-narbonés per a la benedicció dels sants olis," *Revista catalana de teologia* 1 (1976), 231–58; Miquel Dels Sants Gros Pujol, "El antiguo ordo bautismal catalano-narbonense," *Hispania sacra: Revista española de historia eclesiástica* 28 (1975), 37–101; Miquel Dels Sants Gros Pujol, "La liturgia catalana dels segles X–XI: Una panoràmica general," *L'avenç. Història dels països catalans* 121 (1988), pp. 34–38; Miquel Dels Sants Gros Pujol, "Arquitectura i litúrgia entorn de l'any 1000, in *Catalunya en època carolíngia. Art i cultura abans del romànic (segles IX i X)* (Barcelona: MNAC, 1999), pp. 197–99; Miquel Dels Sants Gros Pujol, "L'antic 'Ordo Nubentium' gal·lícà i les seves adaptacions romano-franques d'època carolíngia," *Revista catalana de teologia* 29 (2004), 75–88. On the beginning of Romanesque architecture, see Friedrich Osten, *Die Bauwerke der Lombardei: VII. bis XIV. Jarhundert* (Darmstadt: Osten, 1847); Fernand De Dartein, *Études sur l'architecture lombarde et sur l'origine de l'architecture romano-byzantine* (Paris: Dunod, 1865–82); Edoardo Mella, *Elementi di architettura lombarda* (Turin: Bocca, 1885); G. Merzario, *I maestri comacini. Storia artistica di mille duecento anni (600–1800)* (Milan: Agnelli, 1893); Otto Stiehl, *Der Backsteinbau romanischer Zeit besonders in Oberitalien und Norddeutschland* (Leipzig: Baumgaertner, 1898); Geord Dehio and Gustav von Bezold, *Die kirchliche Baukunst des Abendlandes* (Stuttgart: Cotta, 1892–1901); Giovanni T. Rivoira, *Le origini dell'architettura lombarda* (Milan: Ulrico Hoepli, 1901); A. K. Porter, *Lombard Architecture* (New Haven: Yale University Press, 1917). Particularly in Catalonia, see Xavier Barral Altet, "Puig i Cadafalch: Le premier art roman entre idéologie et politique," in *Medioevo: Arte lombarda*, ed. by Arturo Carlo Quintavalle (Milan: Enaudi, 2004), pp. 33–42; Pere Freixas and Jordi Camps eds., *Els Comacini i l'arquitectura romànica a Catalunya* (Barcelona: Generalitat de Catalunya, 2010); Éliane Vergnolle, "Josep Puig i Cadafalch et la Lombardie. La construction historique du «premier art roman," in *Architettura dell'XI secolo nell'Italia del Nord: Storiografia e nuove ricerche*, ed. by Anna Segagni Malacart and Luigi Carlo Schiavi (Pisa: ETS, 2013), pp. 3–8.

[7] Josep Gudiol, "De peregrins i peregrinatges religiosos catalans," *Analecta Sacra Tarraconensia* 3 (1927), 93–120 (p. 94); for a recent new edition of Egeria's pilgrimage in Spanish, see Carlos Pascual, *Viaje de Egeria: El primer relato de una viajera hispana* (Madrid: La línea del horizonte, 2017).

express in their wills the intention of visiting Jerusalem, and specific mentions of the Holy Sepulchre become predominant throughout the eleventh century.[8] Many of the first documented pilgrims were such prominent figures as bishops, abbots, counts, and viscounts, in addition to other less public persons. Some of those who did not undertake the journey nevertheless showed their interest by means of donations to the Jerusalemite churches.[9] In certain cases, significant ensembles of relics were proudly displayed as the outcome of pilgrimage. An interesting example is that of Garí, abbot of St. Miquel de Cuixà and other monasteries in the region. Garí was a Cluniac-trained prelate with extensive contacts amongst the ruling elites in the Catalan counties and the Veneto, who traveled several times to Rome and at least once to Jerusalem around 988.[10] In the next century, the documents of Cuixà attest to the presence inside the high altar of the abbey church of relics that Garí had bought himself "in Rome, Jerusalem and in many other places," including fragments of Christ's cross, diaper, shroud, dress, the towel he used on Maundy Thursday, sepulchre and manger, as well as loaves from the feeding of the five thousand, pieces of the Virgin's dress, and many more tokens of a multitude of saints.[11]

[8] Gudiol, "De pelegrins," p. 95: "ad Sepulchrum Domini," in 969, and "visitare gloriosum Redemptoris nostri Sepulchrum," in 998; Pierre Ponsich, "Roussillonnais, cerdans et catalans du haut moyen-âge sur les routes des grandes pèlerinages," *Les Cahiers de St. Michel de Cuxa* 3 (2000), 85–96; recently, Francesca Español, *La Vera Creu d'Anglesola i els pelegrinatges de Catalunya a Terra Santa* (Solsona: Museu Diocesà, 2015), pp. 20–23 and 31–37; Nikolas Jaspert, "Eleventh-Century Pilgrimage from Catalonia to Jerusalem: New Sources on the Foundations of the First Crusade," *Crusades* 14 (2015), 1–47 (pp. 13–14); Nikolas Jaspert, "Cataluña y Jerusalén en el siglo XI: Testamentos, piedad y conectividad transmediterránea," in *Movilidad y religiosidad medieval en los Reinos Peninsulares, Alemania y Palestina*, ed. by Nikolas Jaspert (Granada, 2020), pp. 13-73; Nikolas Jaspert, "Un vestigio desconocido de Tierra Santa: la Vera Creu d'Anglesola," in *Movilidad y religiosidad*, ed. by Nikolas Jaspert, pp. 75-94.

[9] On donations, Español, *La Vera Creu*, pp. 22–23. A rather curious manifestation of interest is the name of a viscountess of Girona called *Ierosolima*, documented 962–993; see Pierre Bonnassie, *Catalunya mil anys enrere* (Barcelona: Edicions 62, 1979), I, p. 294.

[10] Ramon d'Abadal, *Com Catalunya s'obrí al mon mil anys enrera* (Barcelona: Dalmau, [1960] 1988), pp. 33–34; Bonnassie, *Catalunya*, I, pp. 294–95.

[11] "In medium siquidem altaris vivificae crucis modum intercludit terrigenum et profundiori loco in invisibiliorem quem ipse [Warinus] Hierosolymis et Romae vel in aliquibus locis, munis datus aliquando magnis pretiis adquisierat, visus est ordiri ... Sunt in hoc venerabile altari in primis reliquiae illius salutiferae crucis in qua Rex coelorum Dominus noster Dei Filius totius mundi passionis sacramentum complevit ... Insunt reliquiae de velamine pannis quibus susceptae Incarnationis decore puerili in corpore obsitus mansit homo et Deus. Sunt reliquiae de sudario capitis Domini ... Insunt reliquae de linteo unde Deus et homo sua membra circumdedit et discipulorum suorum pedes humiliter abluens tersit. Sunt reliquiae de sepulcro ubi dominica caro iuxta naturam quievit et vivificans mortem nostram ex ipso a mortuis resurrexit.

Similarly, the relics deposited in the main altar of Santa Maria de Ripoll in 977 and those found in the high altar of Girona Cathedral dedicated in 1038 formed a group attributed to the holy sites. The close similarity between those two ensembles may be explained by the figure of Arnulf, who was both abbot of Ripoll (r. 948–70) and bishop of Girona (r. 954–70), or of his successor Miro, count of Besalú and patron of Ripoll (r. 968-84) and bishop of Girona (r. 970-84). However, there is no documentary evidence that they ever went on pilgrimage to the Holy Land: Arnulf would have obtained the relics on his pilgrimage to Rome in 951.[12] Moreover, as for Ripoll, although an altar or chapel dedicated to the Savior was founded in 925, with funerary purposes within the monastic compound, and another dedicated to the cross before 977,[13] nothing confirms specific relations to those relics nor the assumption of special evocative properties in the possibly related buildings. Likewise, the few other similar dedications documented in the region before the year 1000 (the ephemeral monastery of St. Salvador de Mata named in 899 in the Berguedà region and the church of St. Salvador de les Gunyoles mentioned in 992 in the grounds of Olèrdola Castle) do not show any evident relationship with relics of this type.[14]

Relics from the Holy Land were still relatively scarce in the Catalan counties around the year 1000, and therefore very prestigious. A portion of the True Cross was brought to Besalú by Count Bernat Tallaferro in 1017 after a journey to Rome and immediately became its main relic. It still appears today on the town's coat of arms.[15] During the same journey, his brother Oliba, abbot of Ripoll and Cuixà, acquired other segments of the True Cross in Lodi, in addition to portions of the sepulchre and of the dress and footwear of the

Insunt reliquiae de praesepe … Sunt reliquiae ex fragmentis illius panis unde quinque milia hominum ex quinque panibus et duobus piscibus in deserto satiaverat Christus. Insunt reliquiae de vestimento beatissime Virginis Mariae," Eduard Junyent, *Diplomatari i escrits literaris de l'abat i bisbe Oliba* (Barcelona: Institut d'Estudis Catalans, 1992), pp. 372–73.

[12] Marc Sureda, "Un conjunt de relíquies del segle x a Santa Maria de Ripoll i a Santa Maria de Girona," *Miscel·lània litúrgica catalana* 29 (2021), pp. 117–155. The relationship between the Ripoll relics and those in Cuixà is discussed in Jaspert, "Eleventh-Century Pilgrimage," p. 29.

[13] Ordeig, *Les dotalies*, vol. I/1, doc. 46; Concepció Peig, "St. Maria de Ripoll: L'acta de consagració de l'any 977 i el problema dels *tituli*," in *Actes del Congrés Internacional Gerbert d'Orlhac i el Seu Temps: Catalunya i Europa a la fi del 1r. mil·leni, Vic-Ripoll, 10–13 de novembre de 1999*, dir. by Imma Ollich (Vic: Eumo, 1999), pp. 839–60.

[14] Ordeig, *Les dotalies*, vol. I/1, doc. 21; vol. I/2, doc. 108. Of the first building, only some ruins remain; no mediaeval elements of the second have survived.

[15] For a recent update of the traditional knowledge, see Eva Llansana, *La Santíssima Veracreu de Besalú: Història d'un millenari, 1017–2017* (Besalú: ELLB, 2017).

Virgin.[16] These relics were deposited in a cruciform wooden reliquary, an imitation of the Byzantine *staurothecae*, which was in itself a declaration of the relics' Eastern provenance, that was to be given by Oliba to the nobleman Arnau Mir de Tost for the dedication of a church he had promoted.[17] Such relics also continued to arrive directly from the Holy Land. Arnau Mir himself went on pilgrimage before his death in 1072 and personally brought back relics, including earth from the Holy Sepulchre and wax from the candles there.[18]

From the middle of the eleventh century, relics of this type became more abundant. Their presence naturally increased following the First Crusade, which could render them less significant, perhaps due to their sheer numbers. However, simultaneously and toward the middle of the eleventh century, the first architectural evocations of Jerusalem and the Holy Sepulchre in the region can be identified. They can be divided into two groups: altars or chapels within larger churches and free-standing buildings.

Altars and Chapels within Larger Churches: Architectural Design and Liturgical Evocation

In the first half of the eleventh century, at a time when the first Romanesque architecture in the Catalan counties was emerging, all the cathedral churches in the region and most of the great monastic installations were renovated. The new architectural designs included a rich range of forms, functions, and symbolism. Among the elements adopted were westworks with Carolingian origins, often given the name *galilea*, consisting of a porch with a high chapel.[19] In several cases (Girona, Ripoll, and perhaps Urgell, Barcelona, and Vic), the respective upper chapels contained altars dedicated to the Holy Sepulchre or the Holy Cross.

[16] The parchment strip accompaniging the relics bears the inscription: *"In ac + cruce sunt reliquie de ligno crucis Domini et de sepulcro, et de vestimento et calciamento sancte Marie matris Domini"* (Junyent, *Diplomatari*, p. 339). Oliba apparently added other relics of the cross and sepulchre of Crist, perhaps from the same ensemble bought on this occasion, to the altar of Ripoll when the church was rebuilt and reconsecrated by him in 1032, as stated a verse probably inscribed on the altar itself: "Hoc altare sacrum Domini venerabile lignum/continet atque sui fragmen de mole sepulchri/quod fide cum diva presul sacravit Oliba" (Junyent, *Diplomatari*, p. 308 and 369).

[17] See recently Marc Sureda, ed., *Oliba episcopus* (Vic: Museu Episcopal de Vic, 2018), cat. 29, p. 132 (Catalan version) and pp. 264–65 (English version).

[18] Español, *La Vera Creu*, p. 47, with bibliography.

[19] The first study of this typology in Catalan architecture is by Francesca Español, "Massifs occidentaux dans l'architecture romane catalane," *Les Cahiers de Saint-Michel de Cuxa* 27 (1996), 57–77.

Westworks in Cathedrals: Girona, La Seu d'Urgell, and Other Possiblities

Although the Romanesque building is not preserved, the case of Girona Cathedral offers most information among the Catalan episcopal churches. The building was begun shortly before 1015 and was consecrated in 1038 when it was still unfinished. In 1058 the first notice appears of an altar of the Holy Sepulchre on which oaths were sworn. Around 1100, the texts already refer to a space called *Sepulchrum* located over the western portico, flanked by two towerlike bodies and occupied by an altar of the Holy Cross (fig. 2).[20] Liturgical sources prove that the altar was used to celebrate the matutinal masses on Eastertide Sundays, including that of Easter Sunday, together with possibly the paraliturgical rites of *Visitatio sepulchri*. Moreover, the rites celebrated there on the fourth Sunday of Lent, *dominica Laetare*, with matitudinal mass and particular processions, accentuated the quality of the space as a representation of Jerusalem, explicitly linking this high chapel to the Holy City in two ways: it deliberately used the name *Sepulchrum* for the space, and liturgical texts and chants referred to Jerusalem. It also reproduced the church station in Rome, which on that same day took place in the Constantinian church of St. Croce in Gerusalemme.[21]

[20] Marc Sureda, *Els precedents de la catedral de St. Maria de Girona* (unpublished doctoral thesis, University of Girona, 2008), pp. 225–33; http://hdl.handle.net/10803/7853 (accessed 29 August 2018). The so-called Tapestry of the Creation (ca. 1100) preserved in Girona Cathedral, contains the now fragmented iconographic cycle of the *inventio* of the Holy Cross. The cloth and the scene have been the object of many interpretative hypotheses on location and functionality: Pere de Palol, *El tapís de la creació de la Catedral de Girona* (Barcelona: Edicions Proa, 1986) (as a wall decoration); Barbara Baert, "New Observations on the Genesis of Girona (1050–1100): The Iconography of the Legend of the True Cross," *Gesta* 38 (1999), 115–27 (as a canopy altarpiece for the Holy Cross altar); Joaquín Yarza Luaces, *Entre lo medieval y la tradición clásica: El 'tapiz' de la creación de Girona* (Barcelona: Amics de l'Art romànic, 2007); Manuel Castiñeiras, *El tapís de la Creació / El taipz de la Creación* (Girona: Capítol de la Catedral, 2011) (as a carpet to be placed in front of the high altar during the *Triduum Paschale*); Rebecca Swanson, "Broderie de la Création ou broderie du Salut? Propositions de lectura iconographique du 'Tapis de Girona,'" *Les Cahiers de Saint-Michel de Cuxa* 43 (2012), 95–100 (again as a hanging cloth); Carles Mancho, ed., *El brodat de la creació de la catedral de Girona* (Barcelona: Memoria Atrium, 2018), part. Xavier Barral i Altet, "El Brodat de la Creació. Un vel de Quaresma mòbil per a la catedral romànica de Girona," pp. 291–303 (as a *velum quadragesimale* or Lenten veil). The theological meaning and perception of the work can be understood in the conceptual framework proposed by Britta Dümpelmann, "Visual—Textile—Tactile: Touching the Untouchable in the Easter Liturgy and Works of Art," in *"Noli me tangere" in interdisciplinary perspective: Textual, Iconographic and Contemporary Interpretations*, ed. by Reimund Bieringer, Barbara Baert, and Karlijn Demasure (Leuven: Peeters, 2016), pp. 233–52. However, relevant as it is, the cloth does not provide any direct hint for architectural Jerusalemite implications in Girona Cathedral.

[21] Girona, Arxiu Capitular, MS 9 (costumary of 1360), fols. 43r–v, 58v, 70v, 80v; MS 10.c. 2 (chapter statutes), fol. 64v. Sureda, *Els precedents de la catedral*, pp. 239–66; Marc

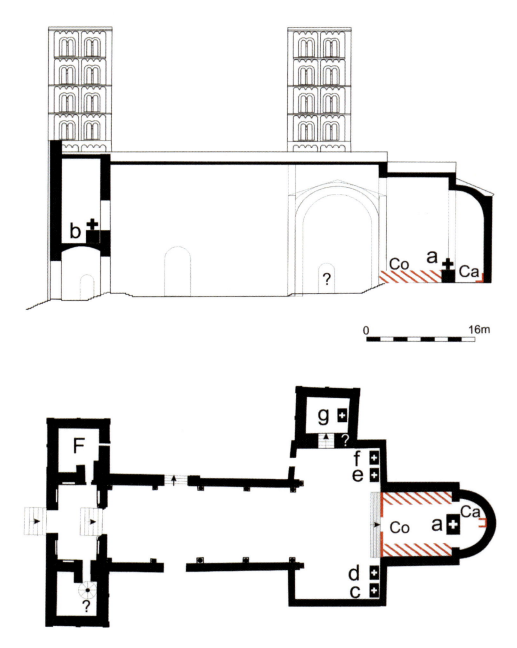

Fig. 2. Girona, restitutive scheme (section and layout) of the Romanesque cathedral dedicated 1038: g) possible position of a first altar dedicated to the Holy Sepulchre, 1058-ca.–1100; b) altar of the Holy Cross in the westwork chapel, dedicated to the Sepulchre, ca. 1100–sixteenth century. Photo: Marc Sureda.

The fourth abbey church in Ripoll, consecrated in 1032, offers a similar circumstance, today preserved under heavy restorations carried out in the late nineteenth century (fig. 3). There is reason to suppose that the old altar of the Savior, already documented within the monastic compound in 925, was installed in the high chapel of the new westwork finished around 1060,[22] where it received a reliquary cross containing fragments of the Holy Sepulchre and of Christ's manger.[23] This altar, moreover, was the probable site of the matitudinal mass on Easter Monday and of the monastery's regular funerary masses.[24]

The case of La Seu d'Urgell Cathedral is less certain in material terms than the aforementioned churches. An altar of the Holy Sepulchre is documented as early as 1017, and we know that the clergyman Miró Viven built an *ecclesia Sancti Sepulchri* in 1057 that probably coincides with the archaeological traces

Sureda, "Architecture autour d'Oliba: Le massif occidental de la cathédrale romane de Gérone," *Les Cahiers de Saint-Michel de Cuxa* 40 (2009), 221–36; Marc Sureda, "Sobre el drama pasqual a la seu romànica de Girona: Arquitectura i litúrgia (ss. XI–XIV)," *Miscel·lània litúrgica catalana* 16 (2008), 105–30; Marc Sureda, "The Sacred Topography of Girona Romanesque Cathedral (11th–12th centuries): Architectural Design, Saintly Dedications and Liturgical Functions," in *Material and Action in European Cathedrals (9th–13th centuries): Building, Decorating, Celebrating*, ed. by Gerardo Boto and C. García de Castro (Oxford: British Archaeological Reports, 2017), pp. 34–35. About the roman church, see Sible de Blaauw, "Jerusalem in Rome and the Cult of the Cross," in *Pratum Romanum: Richard Krautheimer zum 100. Geburtstag*, ed. by R. Colella et al. (Wiesbaden: Reichert, 1997), pp. 55–73; Sible de Blaauw, "Gerusalemme a Roma e il culto delle croci," in *Gerusalemme a Roma: La Basilica di Santa Croce e le reliquie della Passione*, ed. by Roberto Cassanelli and Emilia Stolfi (Milan: Jaca, 2012), pp. 27–39; Mariarosaria Barbera, "Aspetti topografici e archeologici dell'area di Santa Croce in Gerusalemme nell'antichità," in Cassanelli and Stolfi, *Gerusalemme a Roma*, pp. 1–11; Silvia Orlandi, "Elena e Santa Croce in Gerusalemme," in *L'impero costantiniano e i luoghi sacri,* ed. by Tessa Canella (Bologna: Il Mulino, 2016), pp. 273–92.

[22] Francesca Español and Joaquín Yarza, *El romànic català* (Manresa: Angle, 2007), pp. 85–91; Francesca Español, "Panthéons comtaux en Catalogne à l'époque romane: les inhumations privilégiées du monastère de Ripoll," *Les Cahiers de Saint-Michel de Cuxa* 42 (2010), 103–114.

[23] "In cruce sancti Salvatoris, in superiori parte, sunt reliquiae de sepulcro Domini, et de eius praesepio," Junyent, *Diplomatari*, p. 417. See also Español and Yarza, *El romànic català*, pp. 85–91.

[24] Vic, Arxiu Capitular, MS 66 (sacramentary from Ripoll abbey), fols. 58v–59r; Alejandro Olivar, ed., *Sacramentarium Rivipullense* (Madrid-Barcelona: CSIC, 1964), piece 422–24; Sureda, "Architecture autour d'Oliba," p. 232; Carles Mancho and Immaculada Lorés, "Hec domus est sancta quam fecit domnus Oliva: Santa Maria de Ripoll," *Les Cahiers de Saint-Michel de Cuxa* 40 (2009), pp. 205–19; Marc Sureda, "Santa Maria de Ripoll: Liturgie, identité et art roman dans une grande abbaye catalane," *Les Cahiers de Saint-Michel de Cuxa* 49 (2018), p. 221. About the portail, new studies and all previous literature in Marc Sureda, ed., *La portalada de Ripoll: Creació, conservació i recuperació*, (Rome: Viella, 2018). The funerary masses may reveal a link with the functions of the Cluniac galilees and high chapels; see Kristina Krüger, "Architecture and Liturgical Practice: The Cluniac Galilaea," in *The White Mantle of Churches*, ed. by Neil Hiscock (Turnhout: Brepols, 2003), pp. 138–59.

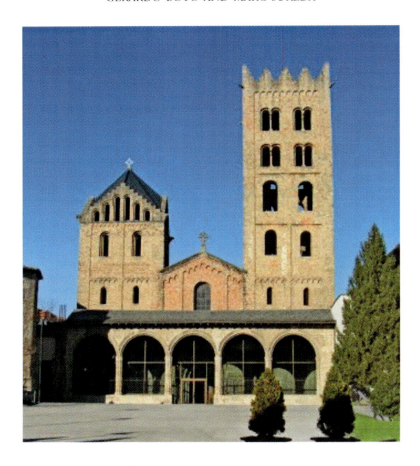

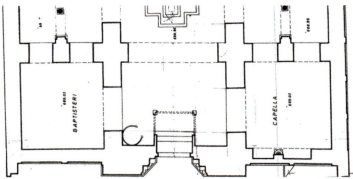

Fig. 3. Ripoll, façade and layout of the abbey church westwork, dedicated 1032 (towers and gable restored ca. 1890). The altar of the Saviour mentioned in 1066 was probably in the westwork's high chapel. Photo: Marc Sureda.

of a westwork added to the eleventh-century cathedral (fig. 4). But at the end of the same century, perhaps in time for the construction of the current cathedral, the altar had already been moved to an independent church. Nothing is known about the location or shape of this later building, part of the large *Kirchenfamilie* (family of churches) of Urgell until it disappeared in the late Middle Ages.[25] Other documents attest the presence of possibly similar westworks in the cathedrals of Barcelona (around 1170) and Vic (around 1212).[26]

More than half a century ago, Carol Heitz defined the Carolingian westwork as an architectural evocation of the Anastasis in the shape of a western tower with a high chapel, which was a liturgical focus during the celebrations of Passion and Easter and which gave way to simplified versions in post-Carolingian times.[27] Recent studies have taken up Heitz's theories, demonstrating the diversity of these kinds of structures throughout Carolingian and post-Carolingian Europe.[28] The Catalan cases seem indeed to unite an evident Carolingian architectural ancestry with a liturgical orientation close to that proposed by Heitz, within some variation (altars dedicated to the Holy Sepulchre, the Savior, or the cross), to which Girona adds a Roman nuance. The buildings in Girona and Ripoll, in addition, can be linked to the direct action or the entourage of the aforementioned abbot-bishop Oliba (971–1046), a prominent figure in the region in the first half of the eleventh century.[29]

[25] Eduardo Carrero, "La Seu d'Urgell, el último conjunto de iglesias: Liturgia, paisaje urbano y arquitectura," *Anuario de Estudios Medievales* 40, no. 1 (2010), 265–68; Gerardo Boto and Marc Sureda, "La cathédrale romane en Catalogne: Programmes, liturgie, architecture," *Les Cahiers de Saint-Michel de Cuxa* 44 (2013), pp. 83–84; Gerardo Boto, "Morfogénesis arquitectónica y organización de los espacios de culto en la catedral de La Seu d'Urgell: La iglesia de St. María (1010–1190)," in Boto and García de Castro, *Material and Action in European Cathedrals*, pp. 150–51.

[26] Español, "Massifs occidentaux," 65–72.

[27] Particularly in his dissertation: Carol Heitz, *Recherches sur les rapports entre architecture et liturgie à l'époque carolingienne* (Paris: Bibliothèque EPHE, 1963).

[28] Alain Dierkens, "Avant-corps, galilées, massifs occidentaux: Quelques remarques méthodologiques en guise de conclusions," in *Avant-nefs et espaces d'accueil dans l'église entre le IVe et le XIIe siècle: Actes du colloque international du CNRS Auxerre*, ed. by Christian Sapin (Paris: CTHS, 2002), p. 501; Gerardo Boto, "Capillas en alto y cámaras elevadas en templos románicos hispanos: Morfologías, usos litúrgicos y prácticas culturales," in *Espacios y estructuras singulares del edificio románico* (Aguilar de Campoo: Fundación Santa María la Real, 2008), p. 97; Eduardo Carrero, "Iglesias y capillas del Santo Sepulcro: Entre el lugar común historiográfico y la norma y práctica litúrgica," in *Congreso Internacional Arte y Patrimonio de las Órdenes Militares de Jerusalén en España*, ed. by Amelia López-Yarto and Wifredo Rincon (Zaragoza: Centro de Estudios de la Orden del Santo Sepulcro, 2010), pp. 321–34.

[29] Sureda, "Architecture autour d'Oliba," pp. 234–36; Sureda, "Oliba *sapiens architectus*," in Sureda, *Oliba episcopus*, pp. 57–65 (Catalan version) and pp. 214–21 (English version).

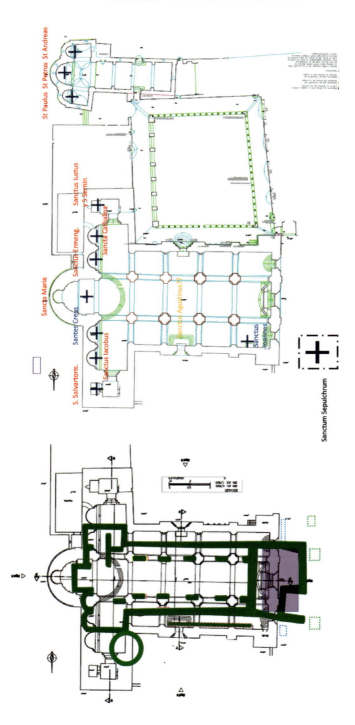

Fig. 4. La Seu d'Urgell, cathedral. Left: restitutive layout of the church dedicated in 1040; the altar of the Holy Sepulchre mentioned in 1057 was probably in the westwork's high chapel. Right: layout of the present church, ca. 1115-1175, without westwork. Black square: approximate position of the independent Holy Sepulchre Church. Photo: Gerardo Boto.

Chapels or Altars in Other Churches: St. Pere de Galligants and Olius

From the same period, there are records of other high chapels located inside towers on the northern flank of several churches, some of them dedicated to the Holy Sepulchre, including Vic Cathedral and St. Pere de Galligants, which is the most interesting case. This monastic church in Girona dates from the mid-twelfth century. The high chapel, with a square floor plan and a pair of little apses built in its eastern wall, is located in an intermediate level of the church's bell tower, which rises above the north arm of the transept, supported by two apses perpendicularly open on the east and north walls of the latter. Since the fourteenth century, the whole space of the chapel has been known by the name of *Sepulchrum*, as is the case, in a generic manner, of the cathedral in the same city; at least one of the two altars may have had a similar title (fig. 5). The narrow spiral staircase leading to the space likely allowed only the passage of the clergymen in charge of worship at its altars. But there is also a window in its south wall, opened in the nave vault and culminating in a small opening onto the area of the old monastic choir. Through this little window, the ceremonies held in that space—probably those of the *Visitatio sepulchri*—could not be seen from the church, but they were audible (fig. 6). Thus, the dedication of the chapel would become again an explicit topo-liturgical evocation.[30] In addition, the morphology of the chapel shows eloquent similarities with the image of Resurrection as codified through late antique ivory carvings to Romanesque sculpture, even if these do not display formal links with the Anastasis itself and hardly any with sepulchral edicules, such as those of Gernrode (ca. 1100) or Eichstätt (ca. 1147–65).[31]

[30] Gerardo Boto, "Articulación de los espacios cultuales en St. Pere de Galligants: Indagación acerca de una arquitectura con nexos sonoros," *Lambard* 19 (2006/07), 11–38; Boto, "Capillas en alto," pp. 100–108.

[31] Martin Biddle, "The Tomb of Christ," *Ariel: The Israel Review of Arts and Letters* 109 (1999), 17–31; Martin Biddle, "Old Minster at Winchester and the Tomb of Christ," in *The Middle Ages Revisited: Studies in the Archaeology and History of Medieval Southern England Presented to Professor David A. Hinton*, ed. by Ben Jervis (Oxford: Archaeopress, 2018), pp. 45–56; Rainer Kahsnitz, Hans-Joachim Krause, and Gotthard Voß, eds., *Das Heilige Grab in Gernrode: Bestandsdokumentation und Bestandsforschung*, 3 vols (Berlin: Deutscher Verlag für Kunstwissenschaft, 2007): Hans-Joachim Krause, "Zur architektonischen Gestalt und ihrer Geschichte: Dokumentation der bauarchäologischen Befunde," pp. 207–46; and Hans-Joachim Krause, "Zur entwicklungsgeschichtlichen Einordnung und Datierung der Arkosolnische und der Phasen des Grabbaus," pp. 264–310; Andreas Müller, *Das Heilige Grab in der Stiftskirche St. Cyriakus zu Gernrode* (Passau: Kunstverlag Peda, 2014); Matthias Friske, "Der Fund im Heiligen Grab von Gernrode—Ein Fixpunkt für die Datierung eines mittelalterlichen Kunstwerkes," in *Quedlinburger Annalen* 16 (2014/15), 46–59; Nicole Schröter, *Das Heilige Grab von*

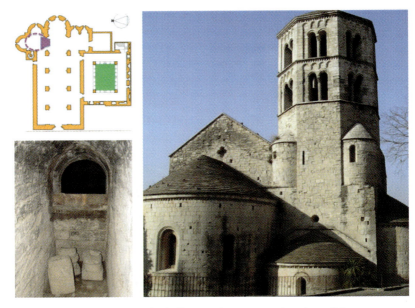

Fig. 5. Girona, Sant Pere de Galligants, layout, exterior view of the tower over the north transept and view of the acoustic channel. Photo: Gerardo Boto.

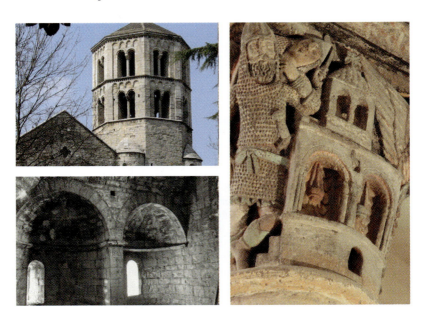

Fig. 6. Girona, Sant Pere de Galligants, external and internal view of the tower high chapel with two apses. Capital of the Holy Sepulchre in Saint–Nazaire (Auvergne). Photo: Gerardo Boto.

These two features—the sudden introduction of unprecedented models and the lack of formal quotations—can also be seen in the only case of a crypt altar dedicated to the Holy Sepulchre in Catalonia, that of St. Esteve d'Olius, consecrated in 1079.[32] The layout of this crypt derives from those built four decades earlier in Cardona and Vic, which, in turn, are of Lombardic descent.[33] Although we have no liturgical data concerning this building, for our purposes, it is important to mention that the crypt of Olius did not take on any specific Jerusalemite morphology.

All the cases mentioned so far are part of complex liturgical systems. In general, the titles of the Holy Sepulchre, the cross, or the Savior completed the list of dedications of each church with a Jerusalemite evocation. Furthermore, in the cases for which liturgical data are known, these altars could be activated within the framework of the specific Easter celebrations to *represent* the sepulchre of Christ, suggesting that the entire clerical community was *present*, in a symbolic way, in Jerusalem.[34] This connection was also reflected through the relative position of the given altar dedicated to the Holy Sepulchre, the cross, or the Savior: its orientation to the west indicated a canonical reference to the Anastasis, whereas an orientation to the north was an equivalent cardinal point according to the ancient symbolism of light;[35] even in the case of Olius, the subterranean position could have been considered significant. The establishment

St. Cyriacus zu Gernrode: Ausdruck der Jerusalemfrömmigkeit der Gernröder Stiftsdamen (Halle a. d. Saale: Mitteldeutscher Verlag, 2017); Franz Xaver Hödl, *Eichstätt, Heilig Kreuz: Kapuzinerkirche zum Hl. Kreuz und zum Hl. Grab Christi in Eichstätt* (Munich: Schnell & Steiner, 1955); Walter Haas, "Das Grab des Bischofs Gundekar II. im Eichstätter Dom," *Ars Bavarica* 4 (1975), 41–58; Franz Xaver Hödl, Michael Schmidt, and Roman von Götz, eds., *Eichstätt, Kapuzinerkirche zum Hl. Kreuz und zum Hl. Grab Christi* (Munich: Schnell & Steiner, 2000). See also the studies by Pinchover and Shriki-Hilber in this volume.

[32] Claustre Rafart and Joan-Albert Adell, "St. Esteve d'Olius," in *Catalunya Romànica* (Barcelona: Enciclopédia Catalana, 1987), XIII, pp. 220–31; Joan Duran-Porta, 'Les cryptes monumentales dans la Catalonge d'Oliva: De St. Pere de Rodes à la diffusion du modèle de crypte à salle," *Les Cahiers de Saint-Michel de Cuxa* 40 (2009), 325–39.

[33] Anna Segagni Malacart, "Cripte lombarde della prima metà del secolo XI," in *Medioevo: Arte lombarda*, ed. by Arturo Carlo Quintavalle (Milan: Einaudi, 2004), pp. 88–103.

[34] Carrero, "Iglesias y capillas," p. 334. Occasional penitentian connotations of this symbolic presence may derivate from the penitential features of the Easter liturgy at Jerusalem; see Sebastián Salvadó, "Rewriting the Latin: liturgy of the Holy Sepulchre: Text, Ritual and Devotion for 1149," in *Liturgy and Devotion in the Crusader States*, ed. by Iris Shagrir and Cecilia Gaposchkin, special issue, *Journal of Medieval History* 43/44 (2017), 403–20. For a useful conceptual framework, see Karen Wagner, "*Cum Aliquis Venerit ad Sacerdotem*: Penitential Experience in the Central Middle Ages," in *A New History of Penance* (Leiden: Brill, 2008), pp. 201–18.

[35] Sible de Blaauw, "En vue de la lumière: Un principe oublié dans l'orientation de l'édifice du culte paléochrétien," in *Art médiéval: Les voies de l'espace liturgique*, ed. by Paolo Piva (Paris: Picard, 2012), pp. 15–45.

of such symbolic links may have obviated the need for a reproduction or even for any formal quotation of the Anastasis Rotunda. It ought to be noted that these architectural and liturgical patterns developed in the Carolingian tradition suddenly appear in the eastern Pyrenean earldoms during the first half of the eleventh century in all their maturity, with no local precedents.

Free-Standing Churches: Believing without Seeing

The same spirit of deliberately foregoing formal copies seems to preside over the corpus of free-standing buildings related to the Holy Sepulchre. Unlike the aforementioned examples, these cases are not part of complex topo-liturgical systems; their relationship to the Holy Land lies only in the titles chosen by the patrons, and the only available clues to the puzzle concern pilgrimage. Thus far, no chronological and causal relationship has been established between these documentary data and the architectural initiatives. Nonetheless, in our view, the outcome of this correlation is significant. Both factors, the pilgrimages and the dedication of buildings to the Holy Sepulchre, are not merely contemporary expressions of an expansive devotion to the place of the death and Resurrection of Christ, but they are often reciprocal triggers of each other.

The list includes fewer than a dozen cases (chapels in larger churches set apart) north and south of the eastern Pyrenees. The oldest of these are dated to the second decade of the eleventh century, in the first wave of Romanesque architecture. We will discuss the most salient examples,[36] presenting substitute sanctuaries[37] in chronological order.

[36] The Catalan churches dedicated to the Holy Sepulchre are Castelnou (1020), Olèrdola (1058), Palera (1075–86), Amposta (1097), the church of Holy Sepulchre in the cathedral ensemble of La Seu d'Urgell (1120), Marcèvol (1128–42), and Peralada (1143). We can exclude from this list the church of Vilar de Renoall (proposed by Jaspert, "Eleventh-Century Pilgrimage from Catalonia," p. 25), indeed, the reference to the Sepulchre in the charter of 1029 describes a donation but not a dedication ("Asemarius facimus dedicare predictam ecclesiam Sancti Sylvestri pro amore Dei et Sancti Sepulchri et propter remedium animarum nostrarum," Ordeig, *Les dotalies*, II/1, p. 53). For its part, the now defunct church of St. Salvador d'Arraona (Sabadell), consecrated in 1076, although not dedicated to the sepulchre but to the Savior, could be added to the list, because it was explicitly related to the devotional intentions of its promoters, Guillem Bernat and Ermengarda d'Òdena, whose sons, Ramon Guillem and Pere Guillem, went on a pilgrimage to Jerusalem with their wives just after the conquest of the Holy City (1101); see Robert Baró, "Les esglésies d'Arraona: Aproximació a tres llocs de culte del segle XI," *Arraona* 35 (2015), pp. 192–207.

[37] Four sanctuaries: St. Peter of La Portella (1035), Holy Sepulchre of Palera (1075–86), Tolba (1080), St. Eulàlia del Camp in Barcelona (1156). See Español, *La Vera Creu*, p. 34.

St. Peter, Holy Cross, and Holy Sepulchre of Castellnou

The castle of Castellnou dels Aspres, that is, *castrum novum* or "new castle," was built by 990 in the Roussillon, in the eastern Pyrenees within the diocese of Elne and the county of Cerdanya. In 1020, it is documented as endowed with a castral chapel dedicated to St. Peter, the Holy Cross, and the Holy Sepulchre,[38] which are also mentioned the next year in the will of Earl Bernat Tallaferro of Besalú.[39] It is impossible to recreate the plan of the eleventh-century church, of which nothing remains, or to know which relics may have been deposited in its altar. However, it is noteworthy that the site is only a few kilometers from Cuxa, whose Abbot Garí led the first documented pilgrimage to Jerusalem from the Pyrenean area in 988. It may also be noteworthy that the church lies within the dominion of the aristocratic family of Bernat Tallaferro and Oliba, who brought to the region some of the first documented relics from the Holy Land. Moreover, Bishop Berenguer of Elna, the bishopric to which the church belongs, was the first prelate of a Pyrenean diocese to undertake the journey to Jerusalem some time later (1028).[40]

Olèrdola

The circular church of Olèrdola was built in the Penedès, in the southern region of the county of Barcelona.[41] The plan and structure of the building

[38] "Et ad Ecclesiam sancti Petri, Sanctae et Sepulchrum Domini qui est infra muros Castronovo carta faciant de alode suo quod habebat infra terminos de parroquia Ponteliano," Petrus de Marca, *Marca Hispanica sive limes hispanicus*, col. 1028, doc. 191.

[39] Jordi Bolós, "Vila fortificada i castell de Castellnou," in *Catalunya Romànica* (Barcelona: Enciclopèdia Catalana, 1993), XIV, *El Rosselló*, pp. 185–87.

[40] According to an anonymous account, Bishop Berenguer de Sendred de Gurb (1019–1030) requested, upon his arrival from the Holy Land, the construction of a new cathedral church according to the measurements of the Jerusalemite church of the Holy Sepulchre: "Pervenit ad dictum Dominum Berengarium espiscopum quod causa peregrinationis et devotionis accederet ad sanctam Hierusalem civitatem, ad quam ivit. Et visitata Ecclesia civitatis praedictae, quam satis aptam vidit et idoneam, sumpsit in pergameno et descripsit, pinxit seu pingi et describi fecit formam dictae Ecclesiae tam in forma latitudinis quam longitudinis et sub eadem forma, cum revenit, aedificavit seu aedificari et fundari fecit cum consensu sui capituli in villa superiori Elnensi Ecclesiam cathedralem," Petrus de Marca, *Marca Hispanica sive limes hispanicus*, cols. 1148–49, doc. 272. However, this project was never carried out. See also Jaspert, "Eleventh-Century Pilgrimage from Catalonia," p. 26.

[41] The first circular structure built in the Tarraconensis, the future Catalunya Nova, is one of the spaces in the controversial Centcelles complex; see Theodor Hauschild, "Centcelles: Exploraciones en la sala de la cúpula," in *Centcelles: El monumento tardorromano. Iconografía y*

suggest that it was constructed in the eleventh century; it has a cylindrical nave with two niches and seven other niches in the apse (fig. 7). The church is first mentioned in 1058 in the testament of Seniol Guillem, lord of La Tallada, the building's probable patron, who gave a sum of money for its dedication "ad ecclesia qui est edificata in onore Sancti Sepulcri Domini prope ipsa Taliata ... fiat predicta ecclesia dedicata, si fieri potest."[42] In 1128 the church is recorded as property of the Order of the Holy Sepulchre in a bull issued by Honorius II. The priory of St. Anna de Barcelona, which was to be the major headquarters of the order in Catalonia, was not founded until 1141, and Olèrdola submitted to its authority in 1175, perhaps because of the mediation of the lords of La Tallada. But this late submission to the order cannot explain the initial choice of the church's title.

The circular layout and the dedication to the Holy Sepulchre would immediately signal a direct link to the Anastasis, but this topic is under protracted scholarly debate. According to Duran-Porta, the church was conceived and arranged as a replica not of the Anastasis but of St. Mary la Rodona at Vic Cathedral, a round church dedicated to the Virgin, the first of this type to be built in the region, which was promoted again by the bishop-abbot Oliba between 1018 and 1046. The adoption of this plan in Vic has been related to the imitation of the church of St. Mary *ad Martyres* in Rome (that is, the Pantheon) and thus linked to the family of Marian *rotundae* rather than to those that refer to the Anastasis.[43] The same Oliba arranged in Cuixà by 1040 a

arquitectura, ed. by Javier Arce (Roma: L'Erma di Bretschneider, 2002), pp. 51–57; Josep Anton Remolà Vallverdú and Meritxell Pérez Martínez, "Centcelles y el *praetorium* del *comes Hispaniarum* Asterio en Tarraco," *Archivo Español de Arqueología* 86 (2013), 161–86. However, it bears no relation, either topographically or functionally, to the circular buildings with a hierasolimitan evocation, such as Olèrdola.

[42] Joan-Albert Adell and Manuel Loosvelt, *Catalunya Romànica* (Barcelona: Enciclopèdia Catalana, 1992), XIX, *El Penedés: L'Anoia,* p. 147–48; Joan Duran-Porta, "Santo Sepulcro de Olérdola," in *Enciclopedia del Románico en Cataluña: Barcelona* (Aguilar de Campoo: Fundación Santa María la Real, 2015), pp. 1959–63.

[43] Xavier Barral, "Du Panthéon de Rome a Sainte-Marie la Rotonde de Vic," *Les Cahiers de Saint-Michel de Cuxa* 37 (2006), 63–75, with bibliography. The rebuilding of the Rodona between 1140 and 1180 with a wider round plan has been related to the Anastasis according to the brotherhood established among the canons of Vic Cathedral and those of the Holy Sepulchre by Bishop Ramon Gaufred (1110–1145), who became representative of the Jerusalemite community in Catalonia for some years; moreover, some members of Vic clergy had visited the Holy Land by 1111. See Josep M. Masnou, "El bisbat de Vic durant l'Episcopat de Ramon Gaufred," *Revista catalana de teologia* 27 (2002), 269–71 and 293; Carme Subiranas, "L'església de Santa Maria de la Rodona," *Arqueologia Medieval* 1 (2005), 8–31. However, it is easier to consider that the round layout was simply inherited from the eleventh-century building, whose

JERUSALEM IN THE LANDSCAPE OF CATALAN ROMANESQUE ARCHITECTURE 99

Fig. 7. Olèrdola, Church of the Holy Sepulchre, ca. 1058, layout and elevation of the current state.

westwork with two superimposed round chapels, the lower dedicated to the Bethlehem manger and the upper to the Trinity. This last chapel already had an inner decoration of seven niches, apparently related to the Holy Spirit,[44] while the lower space dedicated to the manger has recurrently (and erroneously) been related to the Roman crypt of St. Maria Maggiore or to that of Bethlehem.[45]

Yet, for Olèrdola as well as for Vic and Cuixà, the round layout was a repertory architectural feature dating from late antiquity and does not necessarily indicate a copy of a specific building, unless other particular features justify this association.[46] Indeed, the cylindrical volume was later used for other Catalan rural churches that did not take any dedication to Jerusalem.[47] St. Esteve de

main altar's Marian title remained unchanged. Thus, as this pretended change of inspiration is not explicitly supported by any contemporary document, we see no reason to consider that the Rodona of the twelfth century was ever conceived as a direct evocation of the Anastasis Rotunda. Moreover, even if it had been the case, by that time it could not have exercised any influence on the church in Olèrdola, whose round plan had long since been established.

[44] Daniel Codina, "La chapelle de la Trinité de Saint Michel de Cuxà," *Les cahiers de Saint-Michel de Cuxa* 36 (2005), 81–88. A recent approach to the ensemble is found in Olivier Poisson, "L'église Saint-Michel de Cuxa, de Garin à Oliba," in *Le "premier art roman" cent ans après*, ed. by Eliane Vergnolle and Sébastien Bully (Besançon: Presses universitaires de Franche-Comté, 2012), pp. 287–98.

[45] Gerardo Boto, "Monasterios catalanes en el siglo XI: Los espacios eclesiásticos de Oliba," in *Monasteria et territoria: Elites, edilicia y territorio en el Mediterraneo medieval (siglos V–XI)*, ed. by Jorge López Quiroga, Artemio Manuel Martínez Tejera, and Jorge Morín de Pablos (Oxford: British Archaeological Reports, 2007), pp. 281–320 (pp. 292–93).

[46] Matthias Untermann, *Der Zentralbau im Mittelalter. Form—Funktion—Verbreitung* (Darmstadt: Wissenschaftliche Buchgesellschaft, 1989), p. 68; Nikolas Jaspert, "Vergegenwärtigungen Jerusalems in Architektur und Reliquienkult," in *Jerusalem im Hoch- und Spätmittelalter: Konflikte und Konfliktbewältigung; Vorstellungen und Vergegenwärtigungen*, ed. by Dieter Bauer, Klaus Herbers, and Nikolas Jaspert (Frankfurt am Main: Campus, 2001), pp. 232–34.

[47] Jordi Vigué, *Les esglésies romàniques catalanes de planta circular i triangular* (Barcelona: Edicions 62, 1975). In many cases the round layout was dedicated to martyrs or expressed a Marian devotion (Vic Cathedral, Île-sur-Tet, or Cuixà). In Palestine, the only central church linked to Mary—octagonal and noncircular—is the Kathisma: Rina Avner-Levy, "The Recovery of the Kathisma Church and Its Influence on Octagonal Buildings," in *One Land—Many Cultures: Archaeological Studies in Honour of Stanislao Loffreda OFM*, ed. by Giovanni Claudio Bottini, Leah di Segni, and Leslaw Daniel Chrupcala (Jerusalem: Franciscan Printing Press, 2003), pp. 173–86. About early Marian devotion in Holy Land, see Stephen J. Shoemaker, "The Cult of die Virgin in the Fourth Century: A Fresh Look at Some Old and New Sources," in *Origins of the Cult of the Virgin Mary*, ed. by Chris Maunder (London: Bloomsbury, 2008), pp. 71–88; Stephen J. Shoemaker, *Ancient Traditions of the Virgin Mary's Dormition and Assumption* (Oxford: Oxford University Press, 2002). On the sanctuary of Beth Shan/Beit She'an, see G. M. Fitzgerald, *Beth-Shan Excavations, 1921–1923: The Arab and Byzantine Levels* (Philadelphia: Museum of the University of Pennsylvania, 1931); Y. Tsafrir and G. Foerster, "Urbanism

Sallent is the largest of this group and the only one with three apses,[48] in a layout that may be related to the profiles of the late antique and medieval *ampullae* (fig. 8).[49]

Beyond the dedication to the Holy Sepulchre, the only known link between Olèrdola and the Holy Land is the attestation in 1046, twelve years before the mention of the church's title, of the first documented pilgrimage to Jerusalem by a noblewoman, the countess Ermessenda, widow of Count Ramon Borrell of Barcelona and sovereign of the county in which the church stands.[50] Even if the building was, in fact, promoted by another lineage, these chronological and geographic concomitances should not be simply dismissed as casual circumstances, especially considering that Ermessenda had been the main patron of the aforementioned Girona Cathedral, a building with remarkable Jerusalemite connections. Consequently, we consider this hypothesis: the Holy Sepulchre of Olerdola, which assumed the circular form as an echo of the Rodona of Vic and, further afield, of St. Maria Rotunda of Rome, sought to evoke the Anastasis of Jerusalem at least as a penitential and spiritual horizon.[51]

at Scythopolis-Bet Shean in the Fourth to Seventh Centuries," *Dumbarton Oaks Papers* 51 (1997), 85–146 (showing a topographical relationship with the Rodona of Vic, more explicit than any other Roman or Jerusalemite building). However, the title of the Rodona most likely takes its reference from the Pantheon in Rome (see n. 43); thus neither the dedication, nor the Marian nature, nor the iconographic disposition allow this circular church in Vic, the most notable of the Catalan Romanesque landscape, to be related to Jerusalem.

[48] Its first documentary mention dates from 1022, and before 1130, it had been assigned to the canonry of St. María de l'Estany; see Juan Antonio Olañeta, "San Sebastián de Sallent," in *Enciclopedia del Románico en Cataluña: Barcelona*, pp. 987–90. It is possible to recognise its starting point in the Rodona of Vic (ibid., p. 494–96) and in the crypt of the Manger at Cuixà (ca. 1028–40). However, the layout of its east end maintains an explicit relationship with that of the Vera Cruz church in Segovia.

[49] This comparison is perhaps not entirely coincidental for these ampullae were carriers of sacred water of St. Menas in Egypt or of oil from the lamps of the Holy Sepulchre, often showing on both sides a sacred geography typified in iconography. See William Anderson, "Menas Flasks in the West: Pilgrimage and Trade at the End of Antiquity," *Ancient West and East* 6 (2007), 221–43. About the renewed presence of such objects in twelfth-century Western Europe, see Katja Boertjes, "The Reconquered Jerusalem Represented Tradition and Renewal on Pilgrimage Ampullae from the Crusader Period," in *The Imagined and Real Jerusalem in Art and Architecture*, ed. by Jeroen Goudeau, Mariëtte Verhoeven, and Wouter Weijers (Leiden: Brill, 2014), pp. 169–89.

[50] Jesús Alturo, *L'arxiu antic de Santa Anna de Barcelona del 942 al 1200 (Aproximació històrico-lingüística)* (Barcelona: Fundació Noguera, 1985), doc. 52; Jaspert, "Eleventh-Century Pilgrimage from Catalonia," p. 21.

[51] Martin Leigh Harrison, "Penitential Pilgrimage," in *Encyclopedia of Medieval Pilgrimage*, https://referenceworks.brillonline.com/browse/encyclopedia-of-medieval-pilgrimage (accessed 27 August 2019).

Fig. 8. Sallent, Church of St. Sebastian, layout and view from East.

Palera

The Benedictine priory of St. Sepulcre de Palera was already established by 1075, and the consecration of the church "ad dedicationem Basilice ipsius scilicet Sancti Sepulcri Domini" was made in 1086 by Bishop Berenguer Guifré of Girona.[52] The affiliation of this priory to the Benedictine abbey of La Grasse in 1108 cannot thus be considered a determining factor in the execution or transformation of the building. Its shape does not evoke exotic forms; instead, it accommodates the conventional solution of three unequal vaulted naves separated by prismatic pillars and three semicircular apses open directly to the naves. This formula had been previously used in other churches with no Holy Land dedications.[53] A large galilea with three naves—destroyed in 1962—

[52] M. Lluïsa Ramos and Joan Adell, "St. Sepulcre de Palera," in *Catalunya Romànica* (Barcelona: Enciclopèdia Catalana, 1990), IV, *La Garrotxa*, pp. 231–36; Laura Bartolomé, "El St. Sepulcre de Palera: Un lloc de pelegrinatge al comtat de Besalú," *Quaderns de les Assemblees d'Estudis de Besalú* 1 (2014), pp. 119–30.

[53] Church as St. Julià de Ramis, Campmajor, Castellcir, Marcèvol or Amer; it was soon after reproduced in the nearby churches of St. Pere and St. Vicenç in Besalú and St. Feliu in Beuda.

whose building was started just after the completion of the church,[54] had only the lower level or portico without signs of any chapel above, and it thus cannot be considered similar to the cases of Girona, Ripoll, or Barcelona (fig. 9).[55] No direct association with Holy Land relics can be attested in this case, either: in the five reliquary boxes from the altars of Palera preserved in the Museu d'Art in Girona, there is no mention of the identity of the sacred fragments.

In this case, the mechanism at work for the association of the church to the Holy Sepulchre consists of its condition as a substitutionary sanctuary, mentioned in the consecration charter—that is, pilgrimage to Palera granted the same spiritual benefits as pilgrimage to Jerusalem.[56] Except for the coincidence of the dedication with the title of the Anastasis, this was not an innovation. In fact, the first substitute church of this kind attested in Catalonia was St. Pere de la Portella, consecrated by Bishop Ermengol of Urgell in 1035. Like the two others documented in the region, St. Maria de Tolba in the diocese of Roda (1080) and St. Eulàlia del Camp in Barcelona (1156),[57] it shows neither the dedication to the Holy Sepulchre nor specific architectural forms.

These substitute sanctuaries owe their origins to pilgrimage: they seem to have reflected a popular desire to imitate the real pilgrimages of noblemen and bishops. Within the same diocese of Urgell in which lies the church of La Portella, pilgrimages to Jerusalem were undertaken by Viscount Guillem de Castellbò (1037), Count Ermengol d'Urgell (1038), and Bishop Eribau d'Urgell

[54] Josep Puig i Cadafalch, Antoni de Falguera, and Josep Goday, *L'arquitectura romànica a Catalunya* (Barcelona: Institut d'Estudis Catalans, 1917), III.1, pp. 88–92, fig. 56, with a plan by Josep Domènech i Mansana (1913). Bartolomé, 'El St. Sepulcre de Palera', p. 126 states that the galilea was part of the church consecrated in 1086. Nevertheless, pictures taken before the demolition of this western structure (Arxiu del Col·legi d'Arquitectes de Catalunya, Girona, fons Joaquim Fort de Ribot, Reg. 36636) show that the walls of this portico were built against the preceding structure of the church, even though the ashlars of both building periods are analogous.

[55] Español, "Massifs occidentaux," pp. 57–77.

[56] About the medieval substitute artistic realities, see Herbert L. Kessler, *Spiritual Seeing: Picturing God's Invisibility in Medieval Art* (Philadelphia: University of Pennsylvania Press, 2000), esp. the chapter "Real Absence: Early Medieval Art and the Metamorphosis of Vision," pp. 104–48; Thomas E. A. Dale, "Transcending the Major/Minor Divide: Romanesque Mural Painting, Color, and Spiritual Seeing," in *From Minor to Major: The Minor Arts in Medieval Art History*, ed. by Colum P. Hourihane (University Park: Penn State University Press, 2012), pp. 22–42; Philip Booth, "Seeing the Saviour in the Minds Eye: Burchard of Mount Sion's Physical and Spiritual Travels to the Holy Land, c. 1174–1184," in *Soul Travel: Spiritual Journeys in Late Medieval and Early Modern Europe*, ed. by Jennifer Hillman and Elizabeth Tingle (Oxford: Peter Lang, 2019), pp. 181–206.

[57] A recent approach to this list of substitute sanctuaries can be found in Español, *La Vera Creu*, p. 34.

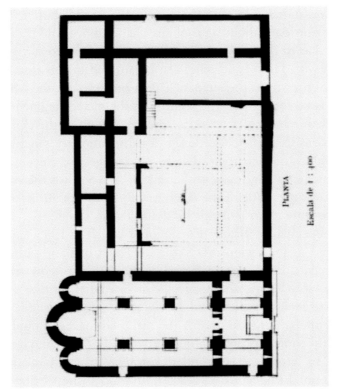

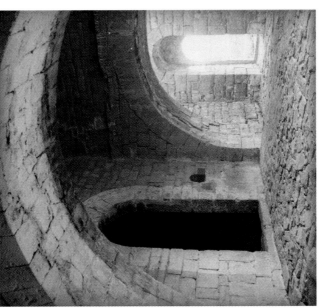

Fig. 9. Palera, Priory of the Holy Sepulchre, image of the now disappeared 'Western Galilea'. Photo: Joaquín Fort de Ribot. AHCOAC Girona. Palera, Sant Sepulchre, Reg. 36636. General layout of the priory (J. Domenech Mansana, 1913).

(1040). In that atmosphere, the dedication of an altar to the Holy Sepulchre in La Seu d'Urgell Cathedral (1017), the later possible westwork (1050), and the free-standing church at the end of the century may also be understood as accumulations of such devotional acts. As for Palera, Arnau Gaufred and his wife, Brunichilda, who signed the consecration act of 1086 among others, have been proposed as the patrons of the building, but this suggestion has no documentary basis.[58] Instead, there are reasons to consider a link to the counts of Besalú: Count Guillem II undertook in 1055 the first documented pilgrimage to the Holy Land in the history of his county. Upon Guillem's death eleven years later, his brother Bernat II may have started the construction of the substitute church at Palera, whose title is first mentioned in 1075 in a donation by the count himself.[59]

Amposta

The Church of the Holy Sepulchre of Amposta was founded in 1097. Archaeological research has not been able to reveal whether the original typology of the building was centralized or longitudinal. In 1148, after the conquest of the city and the restoration of the dioceses, Count Ramon Berenguer IV confirmed the foundation charter and assigned the church to the militia of the Holy Sepulchre.[60] It is rather striking to document the foundation of this church in Amposta, a town near the mouth of the river Ebro, half a century before the Christian conquest of the territory and the restoration of the old Visigoth diocese of Tortosa (1148).[61] The initial church was thus founded within Dar-al-Islam, next to a populated town. The initiative was perhaps related to the preaching of the crusade by Pope Urban II at Clermont (1095). Bishop Berenguer Sunifred de Lluçà of Vic, who pretended to restore in his person the archbishopric of Tarragona, was himself present at Clermont as the head of the

[58] Bartolomé, "El St. Sepulcre de Palera," pp. 121–22.

[59] Donation in 1055 by Earl Guillerm before going to Jerusalem: "ob honorem Dei ejusque gloriosissimi sepulchri, quod cupio adire," Petrus de Marca, *Marca Hispanica sive limes hispanicus*, col. 1105, doc. 243; Earl Bernat II made a donation in 1075: "et pervenit per Fedils usque in Fenano in alodio Sancti Sepulcri," ibid., col. 1166, doc. 286.

[60] Enrique Flórez, *España sagrada: Antigüedades civiles y eclesiásticas de las ciudades de Dertosa, Egara y Emporias* (Madrid, 1801), XLII, p. 103; Manuel Magallón, "Templarios y Hospitalarios: Primer Cartulario en el Archivo Histórico Nacional," *Boletín de la Real Academia de la Historia* 33 (1898), 257–62.

[61] Jesús Mestre, ed., *Diccionari d'història de Catalunya* (Barcelona: Edicions 62, 1992), p. 1058.

Spanish delegation,[62] and one year later the pope met again with Spanish prelates in Nîmes (the archbishops of Tarragona—that is, Berenguer—and Toledo and the bishops of Girona, Elna, and Burgos).[63] But the foundation of the church could have had even stronger motivations for the counts of Barcelona. At the end of 1096, at the court of King Alfonso VI of León, a trial took place in the form of a joust in which Count Berenguer Ramon II was forced to compete, being accused of having killed his twin brother, Ramon Berenguer II, in 1082. Upon losing the joust, Berenguer Ramon II was stripped of his title and condemned to a penitential pilgrimage to Jerusalem ("sub poenitentia Hierosolymis obiit peregrinus"). He did so as part of the First Crusade, when the army headed by Robert II of Normandy laid siege to Antioch and sighted Jerusalem in 1097.[64] The decision by his successor, Ramon Berenguer III, to promote the construction of a church of the Holy Sepulchre by the river Ebro, beyond the borders of his county and also of those of Christianity, in 1097 was most probably related to his family's affairs and to the then current pilgrimage of his uncle to Jerusalem to redeem himself and earn spiritual benefit.

Peralada

Although in 1143 Guillem Adalbert de Palau and his wife, Adalada, donated properties in Peralada to the Holy Sepulchre of Jerusalem ("donamus et offerimus Domino Deo et Sancto Sepulcro de Iherusalem"), the first formal documentary mention of the establishment dates from 1169,[65] when the priory was already incorporated into the constellation of houses of the Order of Holy Sepulchre, which were answerable to St. Anna of Barcelona (fig. 10). During the twelfth century, donations were given, confirming the constitution of a community of both canons and nuns; however, these were never of a quantity sufficient to undertake an ambitious architectural project. In fact, the building is

[62] Robert Somerville, "The Council of Clermont (1095), and Latin Christian Society," *Archivum Historiae Pontificiae* 12 (1974), pp. 65, 71, and 73; Pierre-Vincent Claverie, "La dévotion envers les lieux saints dans la Catalogne médiévale," in *Chemins d'outre-mer*, ed. by Damien Coulon et al. (Paris: Sorbonne, 2004), pp. 130–31; Jaspert, "Eleventh-Century Pilgrimage from Catalonia," pp. 1–47; Thomas Deswarte, "Rome et la spécificité catalane: La papauté et ses relations avec la Catalogne et Narbonne (850–1030)," *Revue historique* 295 (1995), 3–43.

[63] Jaspert, "Eleventh-Century Pilgrimage from Catalonia," p. 6.

[64] Ibid., p. 43: also in the same year 1097: "Bernardus Guillelmus [de Vilabertran] cupiens ire in servicium Dei ad expugnandam iherosolimam et ad liberationem sancti sepulcri."

[65] Miguel Galobardes, *El Sepulcre de Peralada* (Peralada: Biblioteca Palacio, 1955), pp. 13–5, 20–21.

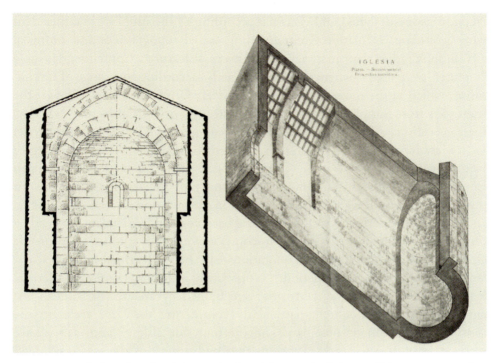

Fig. 10. Peralada, Church of the Holy Sepulchre, end of the twelfth century, section and axonometry.

an example of extreme simplicity and lacks any notable features, consisting solely of a single nave and apse, with only the chancel dating from the foundational period.[66]

Conclusions

In Catalonia during the tenth to twelfth centuries, the absence of material "copies" of the Holy Sepulchre or of any other church from Jerusalem contrasts with the presence of some spiritual representations of the sacred places. Jerusalem as a "visual image," in the modern and ordinary sense of the term, was not present in any part of the Catalan counties, but it was during this time that "scenic" quotations of the Holy City multiplied. Considering the most stimulating argument in Richard Krautheimer's famous article, we may say that the

[66] Joan Badia, "El Sepulcre [de Peralada]," *Catalunya Romànica* (Barcelona: Enciclopèdia Catalana, 1990), IX, *L'Empordà II*, pp. 620–21.

"replicas" were designed and executed according to the mind's eye rather than with geometric calculations, reinterpreting sacred topographies and liturgical attributions rather than material or architectural features. Consequently, these "replicas" were used—where it can be attested—according to a range of mechanisms, which in the most complex cases (namely Girona or Palera) allowed the transition from simple daily evocation to strong symbolic presence. Notably, these evocations were limited to the appropriate moments of the liturgical cycle.

In view of our survey, a question worth to be addressed is to what degree Rome may have played a role as a "surrogate Holy Land" for the Catalan Romanesque churches. The increasing intensity of the relationships between the Catalan counties and the Holy See, in substitution of the Carolingian emperors, particularly since circa 950, has been stressed by scholars for nearly a century;[67] correspondingly—and in contrast with our study—a reasonable amount of Roman architectural quotations have been identified in some Catalan churches of the studied period.[68] Noteworthy in Ripoll, the possible Jerusalemite implications of the westwork were framed by an explicit Vatican-oriented layout of the church, particularly considering the large transept, the central apse without chancel bay, and the four side aisles;[69] and, as we have seen, at least in one yearly occasion, the "activation" of the westwork high chapel in Girona was made through the reproduction of Roman liturgical habitudes. It is true that, while some of the identified magnates of the tenth and eleventh centuries had traveled in pilgrimage to both Jerusalem and Rome (including Abbot Garí of Cuixà and probably Countess Ermessenda of Carcassonne), some others had only arrived to the Holy See. During these travels, those who reached Palestine obtained relics from the Holy Land (for example, Count Bernat Tallaferro and Bishop-abbot Oliba), while those who only made it to Rome would have to settle for Italian versions of the Jerusalemite landscape.

[67] See, e.g., Paul F. Kehr, *Papsturkunden in Spanien: Vorarbeiten zur Hispania Pontificia*, I, *Katalanien* (Berlin: Abhandlungen der Gesellschaft der Wissenschaften zu Göttingen, Philologisch–Historische Klasse, 1926); Raimon d'Abadal i de Vinyals, "L'esperit de Cluny i les relacions de Catalunya amb Roma i Itàlia al segle X," *Studi medievali* 372 (1961), 3–41; Raimon d'Abadal i de Vinyals, *Com Catalunya s'obrí al món mil anys enrera* (Barcelona: Rafael Dalmau), 1987; Deswarte, "Rome et la spécificité catalane."

[68] Among many others, see Michel Zimmermann, "Le souvenir de Rome en Catalogne du IXe au XIIe siècle," in *La mémoire de l'Antiquité dans l'Antiquité tardive et le haut Moyen Âge*, ed. by Michel Sot (Paris: Picard, 2000), pp. 149–59; Barral, "Du Panthéon de Rome à Sainte-Marie la Rotonde," with bibliography.

[69] The traditional idea expressed by Puig i Cadafalch is nuanced in Boto, "Monasterios catalanes," pp. 295–96; see also Sureda, "Santa Maria de Ripoll," p. 220–23.

However, we must also admit that in some occurrences, the Roman architectural link has been overestimated by scholars (such as the crypt of the manger in Cuixà). It is also worth noting that the Lateran church, despite having been fashioned as a New Jerusalem from at least the Carolingian period,[70] finds no Catalan imitations.[71] The consideration of an occasional intermediate Roman presence, thus, would rather justify the indirect approach to Jerusalem apparently manifested by the Catalan cases studied here.

Without any direct knowledge of the Holy Land buildings that could be considered as architectural references, the Catalan churches with Jerusalemite implications of the tenth through twelfth centuries were limited to providing ceremonial frames with profiles completely autonomous with respect to their invisible, only imaginable models. Nevertheless, as it happened with cult images,[72] the substantial fact was that, through these ritual scenarios, the faithful were allowed a spiritual *transit* toward their architectural and historical prototype. After all, it was the ceremonies carried out in the different chapels or crypts dedicated to the Holy Sepulchre that managed to establish a relationship of consubstantiality between the material frames actually perceived by the faithful and the architectural prototypes of Jerusalem or Bethlehem. The churches and chapels dedicated to the True Cross or to the Holy Sepulchre were *images* of the fourth-century buildings erected in their moment to certify the veracity of the evangelical account and to revive the earthly presence of the son of God.

[70] Herbert L. Kessler, "Rome's Place between Judaea and Francia in Carolingian Art," in *Roma fra Oirente e Occidente 49 Settimane di studio* (Spoleto: CISAM, 2002), II, pp. 695–718; Mare Thérèse Champagne and Ra'anan S. Boustan, "Walking in the Shadows of the Past: The Jewish Experience of Rome in the Twelfth Century," in *Rome Re-Imagined: Twelfth-Century Jews, Christians and Muslims Encounter the Eternal City*, ed. by Louis I. Hamilton and Stefano Riccioni (Leiden: Brill, 2011), pp. 52–82, part. 64–67.

[71] The lack of Lateran imitations in church architecture is not exclusive of the Catalan panorama: Lex Bosman, "San Giovanni in Laterano and Medieval Architecture: The Significance of Architectural Quotations," in *Monuments & Memory: Christian Cult Buildings and Constructions of the Past; Essays in Honour of Sible de Blaauw*, ed. by Mariëtte Verhoeven, Lex Bosman, and Hanneke van Asperen (Turnhout: Brepols, 2016), pp. 43–51. Just like in the case of Jerusalem, the only Lateran evocations in Catalonia seem to be limited to the liturgical use of some altars dedicated to saint John in Vic and Tarragona: Marc Sureda, "Romanesque Cathedrals in Catalonia as Liturgical Systems. A Functional and Symbolical Approach to the Cathedrals of Vic, Girona and Tarragona (Eleventh-Fourteenth Centuries)," in *Romanesque Cathedrals in Mediterranean Europe. Architecture, Ritual and Urban Context*, ed. by Gerardo Boto and Justin E. A. Kroesen (Turnhout: Brepols, 2016), pp. 223–241.

[72] Alejandro García Avilés, "*Transitus*: Actitudes hacia la sacralidad de las imágenes en el Occidente medievali," in *Imágenes medievales de culto*, ed. by Gerardo Boto (Murcia: Conserjería de Cultura, 2010), pp. 25–35.

And since the churches of the Holy Sepulchre built in the Catalan counties—as in other latitudes of Christianity—moved the spirit of the pious toward the building they featured, it was inferred that the new buildings could provide equivalent benefits, thus becoming architectural substitutes and foci of regional pilgrimages. As these buildings were considered containers for the cult of Christ and suitable settings for the reenactment of his life, the geographical and theological distance between the new church and its prototype was tacitly minimized. The chapels of the Holy Sepulchre were obviously not the Holy Sepulchre of Jerusalem in itself, but they tried to grasp its meaning by making it present in time, space, and matter. The dedication of the buildings and chapels was the primary principle of similarity with their archetype. The aim of their construction—which was fully achieved, in metonymical terms—was to recreate remote and invisible architectural realities, evoking and exalting their inapprehensible transcendental energy.

All this, indeed, seems to articulate a subtle and mystical presence of a Jerusalem that could not be seen but whose fundamental events could be heard (in Galligants) and whose spiritual benefits could be gained (in Palera). One may liken it to a golden string connecting daily events with an archetype that was remote and invisible yet simultaneously glorious and mysteriously present. Perhaps without deliberate planning, such mechanisms were a full part of a core statement of the Christian faith, in which belief through the flesh had less value than that which was conveyed through the spirit: "Because you have seen me, you have believed; blessed are those who have not seen and yet have believed" (John 20:29).

Table of Evocations of the Holy Land in Catalan Romanesque Landscape

Town	Type of church	Dedication	Promoter	Type of link	Relics (if present)	Chronology
Tarragona	Cathedral	Sancta Maria et Sancta Iherusalem	Archbishops	Dedication		Early 8th C.
Ripoll	Abbey	Titulus sancti Salvatoris (within the monastic compound)	Sunyer and Riquilda, counts of Barcelona-Girona-Osona	Dedication		925
Sant Benet de Bages	Abbey	Sanctus Benedictus	Sal·la, nobleman	Relics	Two reliquary boxes with fragments of the Lignum Crucis	972
Cuxa	Abbey	Sanctus Michael, high altar	Garí, abbot of Cuxa	Relics	Fragments of the Cross of Christ, of his Tomb, and of his shroud, cloth, perizoma and manger, as well as loaves from the feeding of the five thousand, and the dress of the Virgin, in addition to those of a multitude of saints. Bought br Garí in Rome, Jerusalem and many other places.	974 (mentioned in 1040)
Ripoll	Abbey	Sancta Maria, high altar	Arnulf, bishop of Girona and abbot of Ripoll	Relics	Fragments of the stone where Mary sat during Incarnation, of the place where Christ was born and of the manger, from the rock of Transfiguration and from Mary's clothes and sepulchre, among many others	977
Ripoll	Abbey	Sancta Maria	Unknown	Relics	*crux de auro cum lapidibus in quo est lignum Domini*	1008
Besalú	Canon Church	Sanctus Genesius et Sanctus Michael	Bernat Tallaferro, count of Besalú	Relics	Portion of Holy Cross	1017

Seu d'Urgell	Cathedral	Sancta Maria, altare Sancti Sepulchri	Ermengol, bishop of Urgell?	Dedication		1017
Castellnou dels Aspres	Castle Chapel	Sanctus Petrus, Sancta Crux et Sanctum Sepulchrum	Bernat Tallaferro, count of Besalú	Dedication		1021
Ripoll	Abbey	Sancta Maria, high altar	Oliba, bishop of Vic and abbot of Ripoll and Cuixà	Relics (additions)	Pieces of the True Cross, the Holy Sepulchre and the Manger and the towel used by Christ in the Mandatum were laid under the altar	1032
Girona	Cathedral	Sancta Maria, high altar	Arnulf, bishop of Girona and abbot of Ripoll	Relics	Fragments of the stone where Mary sat during Incarnation, of the place where Christ was born and of the manger, from the rock of Transfiguration and from Mary's clothes and sepulchre, among many others	1038 (probably from the older church; see similarities with Ripoll 977)
Cuxa	Abbey	Sanctus Michael, chapel of the Manger	Oliba, bishop of Vic and abbot of Ripoll and Cuixà	Dedication / Architecture (crypt)	(relics of the Manger were in the high altar in 974)	1040 ca
Montmajor	Parish Church	Sancta Maria de la Torreta	Arnau Mir, lord of Tost and Àger	Relics	Earth from the Sepulchre, wax ignited by the supposedly miraculous "Easter fire" and frankincense	1040-1072
La Seu d'Urgell	Cathedral	Sancta Maria, ecclesia Sancti Sepulchri (westwork?)	Miró Viven, clergyman	Dedication		1057
Olerdola	Parish/Canon Church	Sanctum Sepulchrum	Guillem, lord of La Tallada	Dedication		1058

Location	Type	Dedication	Patron	Category	Notes	Date
Girona	Cathedral	Sancta Maria, altare Sancti Sepulchri (in the westwork)	Ermessenda, countess of Barcelona-Girona-Osona	Dedication / Architecture		1058
Ripoll	Abbey	Sancta Maria, altare Sancti Salvatoris (in the westwork?)	Oliba, bishop of Vic and abbot of Ripoll and Cuixà	Relics / Dedication / Architecture	*In cruce sancti Salvatoris, in superiori parte, sunt reliquie de sepulcro Domini, et de eius praesepio...*	1066 (mentioned)
Cornellà de Conflent	Canon Church	Sancta Maria	Guillem, count of Cerdanya?	Relics	"relic of the 'True Cross'"	a.q. 1068
Palera	Benedictine priory	Basilica Sancti Sepulcri Domini	Guillem II, count of Besalú / Arnau Gaufred and Brunichilda, nobles	Dedication / pilgrimage substitution		1075 (consecration 1086)
Olius	Parish Church	Sanctus Stephanus, altare Sancti Sepulchri (in the crypt)		Dedication		1079
Amposta	Parish/Monastery?	Sanctum Sepulchrum	Ramon Berenguer III, count of Barcelona-Girona-Osona	Dedication		1097
Vic	Cathedral	Sanctus Petrus, altare Sancti Sepulchri (in the tower?)	Abbot and bishop Oliba?	Dedication / Architecture		a.q. 1090
Banyoles	Abbey	Sanctus Stephanus, altare Sancti Sepulchri		Relics	Relics of the Holy Sepulchre, the Manger, and the dresses of the Virgin	1100

Sant Joan de les Abadesses	Canon Church	Sanctus Ioannes, altare sancti Mathei (four secondary altars)		Relics	*IIII cruces que vocantur ligna domini in quibus revera cum tesis argenteis deuratis et lapidibus preciosis continetur lignum crucis Jesuchristi*	1115
Barcelona	Cathedral	Sancta Eulalia et Sancta Crux, altare Sancti Sepulchri	Oleguer, bishop of Barcelona and archbishop of Tarragona	Dedication		1123
Barcelona	Parish	Sanctus Andreas del Palomar		Relics	*ex petra gloriosi sepulcri Domini nostri*	1132
Peralada	Parish/ Monastery?	Sanctum Sepulchrum	Guillem Adalbert de Palau and Adalada, nobles	Dedication		1143
Ainet de Cardós	Parish	Sanctus Martinus del Pui		Relics	*salutiferi Ligni Domini Iesu Xpristi*	1145
Girona	Abbey	Sanctus Petrus Gallicantus, altare Sancti Sepulchri		Dedication		Middle 12th C.
La Seu d'Urgell	Cathedral	Sancta Maria, ecclesia Sancti Sepulchri (within the cathedral compound)		Dedication		12th C.
Anglesola	Parish Church	Sanctus Paulus Narbonnensis, altare Sanctae Crucis		Relics	Portion of Holy Cross	a.q. 1170

Poblet	Abbey	Sancta Maria		Relics	de sepulcro Domini, de bombice quando Christus fuit baptizatus, et de terra sepulcri, de lapidibus quibus lapidaverunt iudei Ihesum seu noluerunt lapidare	1200
Vic	Cathedral	Sancta Maria, altare Sancti Sepulchri (in a westwork?)		Dedication		ca. 1212
Sant Cugat	Abbey	Sanctus Cucuphas	Pere d'Amenys, abbot	Relics	de ligno Sancte Crucis, de ligno Domini, de vestibus beate Marie, de velo beate Marie virginis	1238

THE CHAPEL OF THE HOLY SEPULCHRE IN MEDIEVAL SAXONY: BETWEEN CLOISTERED COMMUNITY AND LAY PARISH

Lotem PINCHOVER

Medieval representations of Christ's tomb in Europe took a special form within the monastic space, and their foundation was driven by specific objectives. Examining the location of chapels of the Holy Sepulchre in several convents from medieval Saxony,[1] I will argue that a particular architectural pattern emerges. I aim to discuss four representations of Christ's tomb in four different convents in order to show the existence of this pattern: the canonesses' chapter in Gernrode, the Augustinian convent of Diesdorf, and the Cistercian convents of Wienhausen and Wöltingerode.

All four convents are home to representations of the tomb aedicula and/or of Christ's tomb within it, while the Anastasis Rotunda itself is not represented.[2] In contrast to the empty tomb in Jerusalem, Christ's tomb in Western churches

[1] This study has been made as part of two research groups: "Spectrum: Visual Translations of Jerusalem," ERC-funded project directed by Bianca Kühnel, The Hebrew University of Jerusalem, and "Practicing Love of God: Comparing Women's and Men's Practice in Medieval Saxony," financially supported by the State of Lower-Saxony, Hannover, Germany, directed by Hedwig Röckelein, Georg-August-University Göttingen, and Galit Noga-Banai, The Hebrew University of Jerusalem. The author is grateful to the Azrieli Foundation for the award of an Azrieli Fellowship and to the Jack, Joseph and Morton Mandel School for Advanced Studies in the Humanities at The Hebrew University of Jerusalem.

The area of medieval Saxony (Sachsen) consisted of what is today Lower Saxony, Saxony-Anhalt, and parts of Schleswig-Holstein and Westphalia as well as the cities of Bremen and Hamburg. On the borders of medieval Saxony, see Hedwig Röckelein, *Schriftlandschaften, Bildungslandschaften und religiöse Landschaften des Mittelalters in Norddeutschland*, Wolfenbütteler Hefte 33 (Wiesbaden: Harrassowitz, 2015). See also the map in *Geschichtlicher Handatlas von Niedersachsen*, ed. by Gudrun Pischke (Neumünster: Wachholtz, 1989), map no. 32: "Kirchliche Gliederung um 1500. Stifte und Klöster vor der Reformation."

[2] For a general bibliography on Holy Sepulchre translations, see the following with further bibliography: *Visual Constructs of Jerusalem*, ed. by Bianca Kühnel, Galit Noga-Banai, and Hanna Vorholt, Cultural Encounters in Late Antiquity and the Middle Ages 18 (Turnhout: Brepols, 2014); Colin Morris, *The Sepulchre of Christ and the Medieval West: From the Beginning to 1600* (Oxford: Oxford University Press, 2005); Justin E. A. Kroesen, *The Sepulchrum Domini through the Ages: Its Form and Function* (Leuven: Peeters, 2000).

outside the Holy Land often had Christ's effigy enclosed within.³ While this sculpture could be removed for a short while during Easter, for most of the year, the figure of Christ could be worshiped and touched as it lay in the grave. The cases examined in this chapter are dated to a time span of about three hundred years and belong to different dioceses and orders but are, nevertheless, related to one another.⁴ Though the monuments are in a fragmentary state of preservation, they manifest variation in detail and thus hint at a regional phenomenon.

In what follows I will argue that in all four cases, the Holy Sepulchre monuments were intentionally positioned in locations to which both the nuns and the parishes had access, thus functioning as liminal spaces, both cloistered and public. This fact has been noted by scholars regarding Gernrode and, to some extent, Wienhausen but has never been discussed as a wider tendency with broader implications on the movement of nuns inside their enclosures and on the architectural settings of the monastic complexes.⁵

³ For example, see the cases below; on Diesdorf, Wienhausen, and Wöltingerode, and other examples, see Kroesen, *Sepulchrum Domini*; Annemarie Schwarzweber, *Das Heilige Grab in der deutschen Bildnerei des Mittelalters* (Freiburg: Albert, 1940); Peter Jezler, "Ostergrab und Depositionsbild" (doctoral thesis, Universität Zürich, 1982).

⁴ The canonesses' chapter in Gernrode was under the diocese of Halberstadt; the Augustinian convent of Diesdorf was under the diocese of Verden; the Cistercian convents of Wienhausen and Wöltingerode were under the diocese of Hildesheim. It should be noted that the convents of Wienhausen and Wöltingerode identified themselves as Cistercian but were probably never fully incorporated to the order. On this, see Ida-Christine Riggert, *Die Lüneburger Frauenklöster*, Veröffentlichungen der Historischen Kommission für Niedersachsen und Bremen 37 (Hannover: Hahnsche Buchhandlung, 1996), pp. 41, 245–58; June L. Mecham, "Sacred Vision, Sacred Voice: Performative Devotion and Female Piety at the Convent of Wienhausen, circa 1350–1500" (doctoral thesis, University of Kansas, 2004), pp. 50–59; Gerd Ahlers, *Weibliches Zisterziensertum im Mittelalter und seine Klöster in Niedersachsen*, Studien zur Geschichte, Kunst und Kultur der Zisterzienser 13 (Berlin: Lukas, 2002), pp. 197–205; Jessica Kreutz, "Wöltingerode," in *Niedersächsisches Klosterbuch: Verzeichnis der Klöster, Stifte, Kommenden und Beginenhäuser in Niedersachsen und Bremen von den Anfängen bis 1810*, ed. by Josef Dolle, Veröffentlichungen des Instituts für Historische Landesforschung der Universität Göttingen 56, 4 vols (Bielefeld: Verl. für Regionalgeschichte, 2012), III, 1555–61 (p. 1556); Heinrich Rüthing, "Die mittelalterliche Bibliothek des Zisterzienserinnenklosters Wöltingerode," in *Zisterziensische Spiritualität: Theologische Grundlagen, funktionale Voraussetzungen und bildhafte Ausprägungen im Mittelalter*, ed. by Clemens Kaspar and Klaus Schreiner, Studien und Mitteilungen zur Geschichte des Benediktinerordens und seiner Zweige, Ergänzungsband 34 (St. Ottilien: EOS, 1994), I, 189–216 (p. 193). For the sake of convenience, I will normally use the term "nuns" when relating to the population of the discussed female communities.

⁵ See bibliography below.

'Holy Sepulchres' within Female Monasteries

In the high and late Middle Ages, cloistered nuns could not normally embark on actual pilgrimage and visit the Holy Tomb of Christ in Jerusalem. Thus, chapels of the Holy Sepulchre in medieval convents were used by the nuns to represent the *locus sanctus* in their own liturgical and devotional spaces. Sepulchre monuments were used as an integral part of the Easter liturgy and Paschal plays at the convent's church.[6] In addition, these monuments were often used in the daily life of the nuns, for example, as relics' chapels with weekly masses.[7] Yet, as I will show, the monastic Holy Sepulchre chapels served other audiences as well: parishioners and visitors to the convent church. In fact, financial considerations dictated the foundation of Holy Sepulchre chapels within monastic complexes. Once these chapels were opened for public use, indulgences were granted to the chapel visitors, and donations were given to it; both supplemented the income of the convent.[8] While such a "shared sphere" is not exclusive to chapels dedicated to Christ's tomb, it is nevertheless a marked pattern in

[6] "The focal point of the action in the *Visitatio Sepulchri* is the tomb itself," Dunbar H. Ogden, *The Staging of Drama in the Medieval Church* (Newark: University of Delaware Press, 2002), p. 39. See also June L. Mecham, *Sacred Communities, Shared Devotions: Gender, Material Culture, and Monasticism in Late Medieval Germany*, ed. by Alison I. Beach, Constance H. Berman, and Lisa M. Bitel, Medieval Women: Texts and Contexts 29 (Turnhout: Brepols, 2014), pp. 25–56; Werner Jacobsen, "Die Stiftskirche von Gernrode und ihre liturgische Ausstattung," in *Essen und die sächsischen Frauenstifte im Frühmittelalter*, ed. by Jan Gerchow and Thomas Schilp, Essener Forschungen zum Frauenstift 2 (Essen: Klartext, 2003), pp. 219–46; Jürgen Bärsch, "Liturgy and Reform: Northern German Convents in the Late Middle Ages," in *A Companion to Mysticism and Devotion in Northern Germany in the Late Middle Ages*, ed. by Elizabeth A. Anderson, Henrike Lähnemann, and Anne Simon (Leiden, Brill, 2014), pp. 21–46 (p. 44).

[7] In Gernrode, for example, the relic of the Crown of Thorns was kept in the antechamber of the Holy Sepulchre. A charter from the convent (24 June 1410) states that a mass for the relic was celebrated every Friday (Dessau, Landesarchiv Sachsen-Anhalt [LASA DE], Z 2, Nr. 69. See transcription in *Das Heilige Grab in Gernrode*, ed. by Hans-Joachim Krause and Gotthard Voss, 3 vols [Berlin: Deutscher Verlag für Kunstwissenschaft, 2007], p. 35, no. 5 and p. 326). This compilation includes a text volume and two volumes of figures and drawings. All cited articles and all figures are taken from the text volume. When a citation is taken from several papers in the text volume, it is cited as a whole.

[8] Monasteries could be even relocated closer to a pilgrimage destination in order to improve their financial situation. See, for example, the case of the Benedictine convent of Neuenwalde, moved to Altenwalde in 1282 (Heinz-Joachim Schulze, "Neuenwalde," in *Die Frauenkloster in Niedersachsen, Schleswig-Holstein und Bremen*, ed. by Ulrich Faust, Germania Benedictina 11 [St. Ottilien: EOS, 1984], pp. 429–46 [p. 437]). See more below.

these cases. Chapels dedicated to saints, by contrast, show no similar recurring tendency.⁹

The Holy Sepulchre in the Former Convent Church of St. Cyriacus, Gernrode

The earliest-known, extant representation of the Holy Sepulchre aedicula in Germany is found at the former convent church of St. Cyriacus in Gernrode.¹⁰ From its earliest construction phases, this monument was designed to be viewed by the enclosed canonesses even though it was positioned inside the church. Its southern wall, which was shared with the adjacent cloister, was pierced with small windows (figs. 1 and 2).¹¹

⁹ See below the case of the chapel dedicated to Sts. Fabian and Sebastian in Wienhausen. While this chapel was opened to the parish, other chapels at the convent were inside the cloister for the nuns' use only, for example, the All Saints' Chapel.

¹⁰ There are several examples of a written evidence of an earlier tomb aedicule, but no surviving example is reserved in Germany (Krause and Voss, *Das Heilige Grab in Gernrode,* pp. 15, 339–45; Heidrun Stein-Kecks, "Bilder im heiligen Raum," in *Geschichte der bildenden Kunst in Deutschland,* ed. by Susanne Wittekind (Munich: Prestel, 2009), II, 264–355 (p. 247); Katharina Ulrike Mersch, *Soziale Dimensionen visueller Kommunikation in hoch- und spätmittelalterlichen Frauenkommunitäten: Stifte, Chorfrauenstifte und Klöster im Vergleich,* Nova Mediaevalia 10 (Göttingen: V&R Unipress, 2012), p. 68). The inner chamber of the Gernrode aedicule measures ca. 2.7×2.7×3 meters, and the antechamber, ca. 3.5×4×2.9 meters. Selected bibliography about the Holy Sepulchre of Gernrode includes Krause and Voss, *Das Heilige Grab in Gernrode*; Charlotte Warnke, "Das Kanonissenstift St. Cyriakus zu Gernrode im Spannungsfeld zwischen Hochadel, Kaiser, Bischof und Papst von der Gründung 961 bis zum Ende des Investiturstreits 1122," in *Studien zum Kanonissenstift,* ed. by Irene Crusius (Göttingen: V&R, 2001), pp. 201–74 (pp. 258–62); Ogden, *Staging of Drama,* pp. 55–56; Stein-Kecks, "Bilder im heiligen Raum," II, pp. 346–47; Mersch, *Soziale Dimensionen,* pp. 68–72; Nicole Schröter, *Das Heilige Grab von St. Cyriacus zu Gernrode: Ausdruck der Jerusalemfrömmigkeit der Gernröder Stiftsdamen,* Quellen und Forschungen zur Geschichte Sachsen-Anhalts 11 (Halle [Saale]: Mitteldeutscher Verlag, 2017); Clemens Kosch, "Zur zeichnerischen Veranschaulichung der sakralen Binnentopographie von St. Cyriakus in Gernrode während des 11. und 12. Jahrhunderts," in *Vom Leben in Kloster und Stift: Wissenschaftliche Tagung zur Bauforschung im mitteldeutschen Raum vom 7. bis 9. April 2016 im Kloster Huysburg; Festschrift für Reinhard Schmitt,* ed. by Elisabeth Rüber-Schütte, Arbeitsberichte des Landesamtes für Denkmalpflege und Archäologie Sachsen-Anhalt 13 (Halle [Saale]: Landesamt f. Denkmalpflege u. Archäologie Sachsen-Anhalt, 2017), pp. 65–94.

¹¹ The existing cloister is from the twelfth century but was most probably built on top of an older Ottonian cloister; see Klaus Voigtländer, Hans Berger, and Edgar Lehmann, *Die Stiftskirche zu Gernrode und ihre Restaurierung, 1858–1872,* 2nd ed. (Berlin: Akademie Verlag, 1982), p. 121; Wolfgang Erdmann et al., "Neue Untersuchungen an der Stiftskirche zu Gernrode," in *Bernwardinische Kunst: Bericht über ein wissenschaftliches Symposium in Hildesheim vom 10.10. bis 13.10.1984,* ed. by Martin Gosebruch and Frank N. Steigerwald (Göttingen: Goltze,

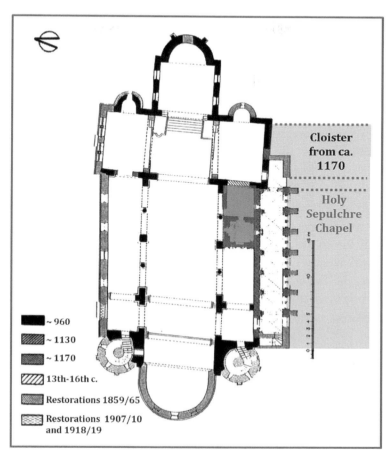

Fig. 1. Gernrode, St. Cyriacus, ground plan and building phases, founded 961, and the Holy Sepulchre Chapel, 1090–mid. twelfth century. After Jacobsen, 'Die Stiftskirche von Gernrode und ihre liturgische Ausstattung', p. 225, fig. 4.

The convent of Gernrode was founded as a canonesses' community by Margrave (*Markgraf*) Gero I in 961.[12] The community belonged to daughters of local noble families and was among the richest land holders in the eastern Harz region.

1988), pp. 245–85 (pp. 281–82); Krause and Voss, *Das Heilige Grab in Gernrode,* p. 262. Regarding the windows, see below.

[12] The foundation date is disputed, but according to Warnke's convincing assertion, it must have been in the summer of 961 ("Das Kanonissenstift St. Cyriakus," p. 217). For selected bibliography on Gernrode, see Hans K. Schulze, *Das Stift Gernrode* (Cologne: Böhlau, 1965); Voigtländer, Berger, and Lehmann, *Die Stiftskirche zu Gernrode*; Erdmann et al., "Neue Untersuchungen"; Christian Günther, *Stiftskirche St. Cyriakus Gernrode* (Halle: Im Schulhaus, 1995).

The construction of the church dedicated to St. Cyriacus began in 961 and continued in several stages until the second half of the twelfth century.[13] The church building consists of a wide nave flanked by an aisle, a gallery, and a clerestory. A wide transept crosses the eastern end. The transept arms each include a small apse, while the main apse is located at the end of the elevated choir, in line with the nave. Until the Reformation, the church of Gernrode was a convent church, used only by the canonesses and their supporting clergy. While the canons used the main eastern choir, the canonesses used the nuns' choir at the southern part of the church. The Holy Sepulchre chapel was built at the end of the eleventh century in the church's southern aisle. It is believed that the monument dates to around 1100 with later extensions,[14] although it is first firmly documented only in 1485, at which time it was also a pilgrim destination.[15]

The sepulchre chapel, a rectangular stone monument consisting of two rooms, occupies the two easternmost bays of the church's southern aisle. In their exhaustive work on the Holy Sepulchre of Gernrode, Hans-Joachim Krause and Gotthard Voss offer five phases for the chapel's construction.[16] A niche for the sarcophagus existed at the southern wall of the church already during the nave construction in the latter half of the tenth century. In the first phase of the chapel, presumably at the end of the eleventh century, a domed burial chamber was built around the niche in the southern aisle wall, which was pierced with a small quatrefoil window. The entrance from the nave to the burial chamber was

[13] Exact dates cannot be given. See Erdmann et al., "Neue Untersuchungen," p. 263; Voigtländer, Berger, and Lehmann, *Die Stiftskirche zu Gernrode*, pp. 15, 130–31, 161–62; Krause and Voss, *Das Heilige Grab in Gernrode,* pp. 288–300.

[14] The dates and number of the building phases of the Holy Sepulchre of Gernrode is subject to various suggestions and interpretations and vary between 980 to 1180. Since textual sources mentioning the Holy Sepulchre date from the fifteenth century, the date of this monument must rest on stylistic and material-archaeological analysis. Some details show that the chapel had several building phases. I chose to adopt the standpoint of Krause and Voss, based on their material gathered between the years 1994 and 2006, the most exhaustive research on the chapel so far. They reconstructed five different phases according to stylistic comparisons of the reliefs, architectural design, and wall paintings, combined with material evidence. I will follow their assumptions for each building period, basing on the chapters and plans' reconstructions: Hans-Joachim Krause and Gerhard Leopold, "Die Ergebnisse der Bauuntersuchungen," in Krause and Voss, *Das Heilige Grab in Gernrode*, pp. 247–302; Rainer Kahsnitz, "Die Plastik," in Krause and Voss, *Das Heilige Grab in Gernrode*, pp. 311–83.

[15] See a charter of indulgences from 26 March 1485, issued in Rome (LASA DE, Z 2, Nr. 998). List of documents mentioning the sepulchre is found in Hans-Joachim Krause and Reinhard Schmitt, "Quellen zur Geschichte des heiligen Grabes," in Krause and Voss, *Das Heilige Grab in Gernrode*, pp. 33–74 (pp. 36–37, no. 7).

[16] Krause and Leopold, "Die Ergebnisse der Bauuntersuchungen."

just across from the niche, in the northern wall. An antechamber was built to the east of the burial chamber, with a small door connecting the two. There was another entrance from the arch between the transept arm and the antechamber.[17] In the second building phase, in the first quarter of the twelfth century, the sarcophagus was relocated to the northern chamber wall, and the entrance to the chapel was a door in the antechamber's northern wall, where it remains today. The third building phase took place at the same time as the construction of the cloister and a new nuns' choir, around 1150. It involved a reconstruction of the aisle's wall, including the Holy Sepulchre's southern wall. The early quatrefoil window was embedded in the new wall. Another window, round and framed by a square, was added to the southern wall of the antechamber (fig. 2).[18] The new nuns' choir, at the gallery level of the southern transept arm, had a direct passage to the convent's dormitory.[19] The choir was located to the east of the chapel of the Holy Sepulchre, and an arched opening in the area of the choir's staircase lent the nuns a better vantage point to the liturgy within the church and specifically to the Holy Sepulchre.[20] In this way, the existing link between the enclosed canonesses and the Holy Sepulchre chapel was enhanced. The fourth and fifth construction phases did not include dramatic changes to the twelfth-century chapel. Thus, from its first building phase, the small chapel consisting of two chambers, one of which was originally topped by a dome, functioned as a piece of "miniarchitecture" within the church building (fig. 2).[21] All external walls of the monument were lavishly adorned with colored reliefs present from its initial phase. The interior was also decorated with stucco sculpture and frescoes, including the niche for Christ's sarcophagus.[22] The floor of the sarcophagus is still preserved in the burial chamber.

[17] This entrance was concealed at some point in the twelfth century (Stein-Kecks, "Bilder im heiligen Raum," II, p. 346; Voigtländer, Berger, and Lehmann, *Die Stiftskirche zu Gernrode*, p. 99; Günter Wilhelm Vorbrodt, "Die Stiftskirche in Gernrode: Ein kunstgeschichtlicher Beitrag," in Schulze, *Das Stift Gernrode*, pp. 91–129 (p. 114).

[18] Krause and Leopold, "Die Ergebnisse der Bauuntersuchungen," pp. 259, 284.

[19] Jacobsen, "Die Stiftskirche von Gernrode," pp. 235–36.

[20] This is the so-called Oswald arch. Krause and Leopold, "Die Ergebnisse der Bauuntersuchungen," p. 261, fig. 147.

[21] Krause and Voss, *Das Heilige Grab in Gernrode*, p. 124; Christian Günther, *Das Heilige Grab in der Stiftskirche Gernrode*, 2nd ed. (Halle a.d. Saale: Stekovics, 1998), p. 8; Kroesen, *Sepulchrum Domini*, p. 47; Ogden, *Staging of Drama*, p. 56.

[22] The decoration of the Holy Sepulchre of Gernrode is extremely elaborate and cannot be discussed within the scope of this paper. See discussion on the reliefs as well as the wall paintings in Krause and Voss, *Das Heilige Grab in Gernrode*, pp. 115–17, 247, 311–91.

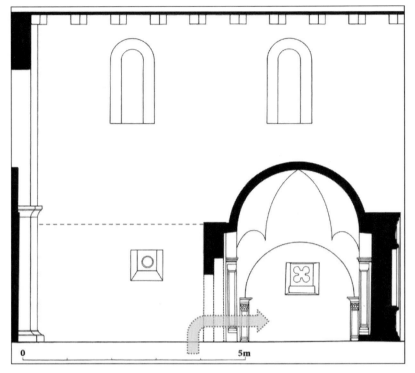

Fig. 2. Gernrode, Holy Sepulchre Chapel, third phase, isometric plan (reconstruction). After Krause, *Das Heilige Grab in Gernrode*, p. 258, fig. 144.

The Holy Sepulchre of Gernrode was presumably used in Easter plays and in processions. The most important source regarding the liturgy at the church of Gernrode and the Holy Sepulchre chapel is a processional from 1502 probably based on an earlier medieval version; it is preserved in two manuscripts now in Berlin.[23] Using the processional text as a guide, scholars have reconstructed the Easter processions that took place at the church of Gernrode and illustrated the route taken

[23] Berlin, Staatsbibliothek (SBB, Mus. MS 40081 (Processional and *Liber Ordinarius* of the Convent of Gernrode), fols. 16v–18v, 93v–95v, 239v–240r, 241v–243v. Another very similar and slightly later example is Mus. MS 40080 at the same library (fols. 109v–112r, 223v, 225v–228r, esp. 223v, 225v–227r). Both are transcribed in Walther Lipphardt, *Lateinische Osterfeiern und Osterspiele (LOO)*, 9 vols (New York: De Gruyter, 1975), V (1976), 1524–30, VIII (1990), 729–33, nos. 786, 786a. The first is also transcribed in Krause and Schmitt, pp. 39–40, no. 12; Voigtländer, Berger, and Lehmann, *Die Stiftskirche zu Gernrode*, pp. 141–42; Walther Lipphardt, "Die Visitatio sepulchri (III. Stufe) von Gernrode," *Daphnis* 1 (1972), 1–14. See also Jacobsen, "Die Stiftskirche von Gernrode," p. 235; Mersch, *Soziale Dimensionen*, pp. 68–69.

by the canons and the canonesses on Good Friday and Easter Eve.[24] Two starting points for the route were identified: the canonesses began the procession at the nuns' choir, while the male participants began the route at the high choir. Both routes led the participants through the nave and the Holy Sepulchre chapel, so that both canonesses and canons used the sepulchre during the Easter liturgy.

However, the sepulchre chapel additionally functioned on other occasions throughout the year as a place of devotion and cult. It played a role in the liturgy of other feast days.[25] Also, since the chapel held a relic of the Crown of Thorns, it was a devotional center all year round.[26] Despite its importance, the canonesses of the adjacent cloister did not have access to the sepulchre chapel on a daily basis. Nevertheless, the architectural structure made it possible for them to view the chapel without entering the church and without breaking the monastic rules of segregation—through the small openings inside the wall shared between the church and cloister.[27] The relocation of the sarcophagus to the northern wall of the chamber already in the second building phase made its positioning ideal for the nuns; they were able to peek into the sepulchre at any time from their enclosure, even when no service was taking place. In fact, the nuns were the closest to the sepulchre and likely made greater use of it than anyone else.

The Holy Sepulchre in the Former Convent Church of St. Mary and the Holy Cross in Diesdorf

The nuns of the Augustinian convent of Diesdorf near Salzwedel were also the main beneficiaries of a Holy Sepulchre chapel at their convent church. The convent of Diesdorf was founded in 1161 by Count Hermann von Warpke-Lüchow, probably at first as a male monastery and later changing into a female convent.[28] The convent,

[24] Jacobsen, "Die Stiftskirche von Gernrode," pp. 240–41, figs. 11–13. Ogden offers a plan of the movement at the church, which is inaccurate since he positions St. John's altar in a very improbable location (*Staging of Drama*, p. 57, fig. 20). I refer to Jacobsen as a better source for the position of the altars and the path at the church.

[25] Jacobsen, "Die Stiftskirche von Gernrode."

[26] Ibid., pp. 234–35, 244–45. See also the use of the chapel during the celebration of the jubilee in Gernrode; Lotem Pinchover, "A Tale of Three Cities: Between Jerusalem and Gerusalemme—Gernrode of (St.) Scholastica," *21: Inquiries into Art, History, and the Visual* 1, no. 1 (2020), 97–125.

[27] See more on the *cura monialium* below.

[28] Selected bibliography includes Eberhard Borrmann, Joachim Stephan, and Tilo Schöfbeck, "Diesdorf," in *Brandenburgisches Klosterbuch: Handbuch der Klöster, Stifte und Kommenden bis zur Mitte des 16. Jahrhunderts*, ed. by Heinz-Dieter Heimann et al., Brandenburgische historische Studien 14, 2 vols (Berlin: be.bra-Wissenschaft, 2007), I, 412–24; Georg G. Dehio, Ernst Gall, Ute Bednarz, et al., *Handbuch der deutschen Kunstdenkmäler: Sachsen-Anhalt I: Der Regierungsbezirk*

founded on fertile grounds surrounded by water, was a home for daughters of low aristocratic and bourgeois families from the area until its dissolution in 1810.

The building of the convent church of Diesdorf began in the first half of the thirteenth century. The church is a compact cruciform basilica made of red brick in a style typical of Saxon Romanesque churches (fig. 3).[29] The nuns' choir was located, at least from the fifteenth century, in the upper story of the northern transept arm, next to the late Gothic *Mariensaal* and above a vaulted space used as a crypt in the first floor.[30] A gate opening (now walled shut) at the northern wall of the choir once led to cloister, which was situated, before being completely destroyed in 1862, to the north of the church, so that the nuns had access to their choir directly, just as described in the case of Gernrode.[31] The Holy Sepulchre chapel is located just below the Mariensaal, in the two eastern-most bays of the northern aisle; a passage that led to it from the nave is now blocked by a modern grille (figs. 3–5).[32] The chapel, like in Gernrode, consists of two chambers and shared a wall with the cloister. Also as in Gernrode, the external wall of the chapel had two small windows that permitted the nuns a private view of the sepulchre chapel without disturbing their enclosure or the use of the parish.[33]

Magdeburg (Munich: Dt. Kunstverlag, 2002), pp. 168–72; Peter Seyfried and Jutta Brüdern, *Die Klosterkirche zu Diesdorf*, Grosse Baudenkmäler 463, 3rd ed. (Munich: Dt. Kunstverlag, 1998); Claudia Mohn, *Mittelalterliche Klosteranlagen der Zisterzienserinnen: Architektur der Frauenklöster im mitteldeutschen Raum* (Petersberg: Michael Imhof, 2005), pp. 358–59, no. C07. Regarding the monastery's initial affiliation and the gender of its inhabitants, see Joachim Homeyer, "Zur Gründung des Stiftes Diesdorf im Jahre 1161," *Jahresbericht des Altmärkischen Vereins* 73 (2001), 84–98; Hellmut Müller, "Insula Sanctae Mariae: Zur Frühgeschichte des Augustiner-Chorfrauenstiftes Diesdorf," *Aus der Altmark* 66 (1986), 127–50; Carl Gehrcke, "Die Grafen zu Lüchow," in *Chronik der Stadt Lüchow*, ed. by Ernst Köhring (Lüchow: Köhring, 1949), pp. 10–21 (p. 11).

[29] Borrmann, Stephan, and Schöfbeck, "Diesdorf," I, p. 416.

[30] Dehio, Gall, Bednarz, et al., *Handbuch der deutschen Kunstdenkmäler*, p. 168. While there is no actual underground crypt at the church, there is a room called "the crypt" that is located at the northern transept, just before the chapel, on the same floor level. This room was probably built together with the eastern portion of the church, around 1200 (ibid., pp. 168–71).

[31] Borrmann, Stephan, and Schöfbeck, "Diesdorf," I, pp. 413, 416; Mohn, *Mittelalterliche Klosteranlagen*, p. 359; Seyfried and Brüdern, *Die Klosterkirche zu Diesdorf*, 6, 14; Dehio, Gall, Bednarz, et al., *Handbuch der deutschen Kunstdenkmäler*, pp. 168, 170.

[32] Borrmann, Stephan, and Schöfbeck, "Diesdorf," I, pp. 416–17; Seyfried and Brüdern, *Die Klosterkirche zu Diesdorf*, pp. 6, 14; Dehio, Gall, Bednarz, et al., *Handbuch der deutschen Kunstdenkmäler*, p. 170.

[33] Although the current row of windows is not the original (Seyfried and Brüdern, *Die Klosterkirche zu Diesdorf*, p. 8), they likely replace older windows, such as those that are found today west of the southern aisle. However, to establish that the new windows in the northern aisle replace the original ones requires further investigation of the building.

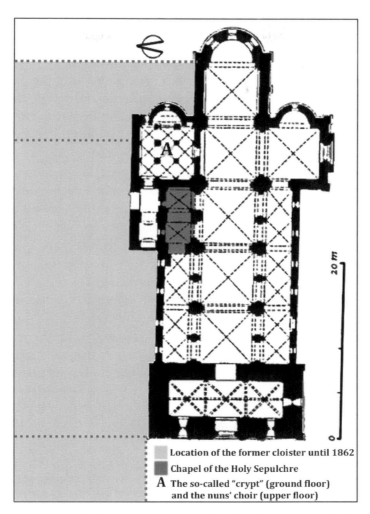

Fig. 3. Diesdorf, Former Convent Church of St. Mary and the Holy Cross, founded 1161, and the Holy Sepulchre Chapel, before 1332. Ground plan after Borrmann, Stephan, and Schöfbeck, 'Diesdorf', p. 424, fig. 3.

Neither the Diesdorf nor the Gernrode chapels were identical copies of the Holy Sepulchre aedicula in Jerusalem. Rather, each shares some essential elements of the original. Both buildings consist of an antechamber and a burial chamber, as was true of the structure in Jerusalem since the eleventh century.[34]

[34] See plan in Martin Biddle, *The Tomb of Christ* (Stroud: Sutton, 1999), p. 82, fig. 66B.

In Gernrode, the burial chamber was topped by a small dome, alluding to the cupola of the Holy Sepulchre in Jerusalem (fig. 2). In Diesdorf, the higher vault and arch of the inner chamber achieves the same effect (fig. 5).

Both the Gernrode and Diesdorf chapels were added to a preexisting, older church building, but each relates to its parent structure differently. In Gernrode, the sepulchre monument is obviously differentiated from the church edifice through its decoration. In Diesdorf, the chapel was completely integrated into the preexisting church, occupying two bays in the aisle, and was differentiated from the church through specific architectural elements (fig. 3). The arches between its two chambers and the other bays of the church are much thicker than the arches separating the rest of the aisle's bays, and they are also of decreased height. The southern walls of the chapel are thus lower than the regular arches of the aisle. Additionally, the capitals and piers between the two chambers and the nave are of special form and size, drawing attention to this part of the church. In fact, these are the only decorated capitals in the entire church (fig. 5).

The low vaults of the chapel lend it a somber, cryptlike impression. Indeed, in the 1332 document that mentions the sepulchre for the first time and gives the chapel its *terminus ante quem*, the chapel is described as the "Cripta, ubi requiescit Corpus Ihesu Christi." This document, today kept in Magdeburg, reports a donation of eternal light to the chapel by a nun from the convent of Diesdorf.[35]

The chapel, sarcophagus, and effigy have been preserved, but their decoration is now lost (fig. 4).[36] The mentioned *Corpus Ihesu Christi* is preserved in a simple gable-roof wooden sarcophagus. It is a statue of the dead Christ, his

[35] The document mentioning the chapel and tomb is a report of a donation of eternal lamp to the chapel from 1 May 1332. Today it is deposited in Magdeburg, Landesarchiv Sachsen-Anhalt (LASA MA), U 21 II 6, Nr. 109. See transcription in Johann Christoph Becmann and Bernhard Ludwig Beckmann, *Historische Beschreibung der Chur und Mark Brandenburg: Nach ihrem Ursprung ...* (Berlin: Voß, 1751), II.V.I, chap. X.II, pt. 149. This transcription is more accurate than that of Adolph Friedrich Riedel, *Codex diplomaticus Brandenburgensis: Sammlung der Urkunden, Chroniken und sonstigen Quellenschriften für die Geschichte der Mark Brandenburg und ihrer Regenten* (Berlin: F. H. Morin, 1859), XVI, p. 418, no. 44. For translation, see Lotem Pinchover, "The Presence of Jerusalem in Medieval Saxon Convents: Art and Cult" (unpublished doctoral thesis, The Hebrew University of Jerusalem, 2020), app. C.1.

[36] Both sarcophagus and effigy are made of wood, dating before 1332. The length of the effigy is ca. 100 centimeters. For bibliography, see Hans Georg Thümmel, "Das Heilige Grab: Liturgie und Ikonograpie im Wandel," in *Kunst—Kontext—Geschichte: Festgabe für Hubert Faensen zum 75 Geburtstag*, ed. by Tatjana Bartsch and Jörg Meiner (Berlin: Lukas, 2003), pp. 67–83 (pp. 74–75); Borrmann, Stephan, and Schöfbeck, "Diesdorf," I, p. 416; Kroesen, *Sepulchrum Domini*, pp. 67–68; Dehio, Gall, Bednarz, et al., *Handbuch der deutschen Kunstdenkmäler*, p. 170; Seyfried and Brüdern, *Die Klosterkirche zu Diesdorf*, p. 18.

Fig. 4. Diesdorf, Former Convent-church of St. Mary and the Holy Cross, Christ's Sarcophagus and Effigy, mid-fourteenth century, wood, ca. 100 centimeters length. Photo: Tilo Schöfbeck.

Fig. 5. Diesdorf, Former Convent-church of St. Mary and the Holy Cross, view from the nave towards north. Photo: Author.

hands crossed upon his pelvis, wearing the Crown of Thorns and wrapped in a small shroud. The representation is realistic although the proportions are somewhat distorted. Christ bears a suffering expression: his eyebrows press together, his eyes are shut, he has bags under the eyes, and the sides of his mouth pull down. His five wounds are depicted, cutting deep into his meager body.[37]

The chapel of the Holy Sepulchre at the former convent church of Diesdorf is relatively unknown and quite understudied.[38] Architectural research is needed to accurately date the chapel vaults, arches, piers, and windows as they appear today. Important questions abound: Where was the sarcophagus originally located? Was the passage between the chapel and the nave always blocked by a grille? No records regarding the use and function of the sepulchre are known.[39] It is possible to learn more about the use of the sepulchre through comparison with other cases: effigies of the dead Christ exist from two other convents at the area, the Cistercian convents of Wienhausen and Wöltingerode. Although neither effigy carries decisive information regarding its original location and use, they provide, especially in the case of Wienhausen, other hints about the use of the Holy Sepulchres in a monastic context.

The Holy Sepulchre of the Former Convent of Wienhausen

The Cistercian convent of Wienhausen was founded in the 1220s near the city of Celle by Duchess Agnes von Landsberg, a daughter-in-law of Henry the Lion.[40] From its establishment and throughout the Middle Ages, the convent

[37] For some decades, the sculpture was presented as a standing figure of the Man of Sorrows. A depiction of the former manner of representation can be found in Seyfried and Brüdern, *Die Klosterkirche zu Diesdorf*, p. 15. For the reasons for this display, see Pinchover, "The Presence of Jerusalem," pp. 89–121.

[38] When it is mentioned, it is discussed only very briefly (see n. 36). The citation from the Magdeburg document, for example, is mentioned only in Borrmann, Stephan, and Schöfbeck, "Diesdorf," I, pp. 416–18, but is accompanied by an incorrect reference giving the wrong date. Others who mention the Diesdorf chapel cite the date correctly as 1332 but do not refer to primary sources.

[39] A visit to the church with Tilo Schöfbeck, scholar of architecture, was carried out by the author in March 2015. While some portions of the chapel walls and vaults were definitely part of the church's initial plan (including the piers and parts of the arches), other portions were heavily renovated (e.g., the windows, floor, and bench on which the sarcophagus lies). Further research is needed.

[40] Wolfgang Brandis, "Wienhausen," in *Niedersächsisches Klosterbuch: Verzeichnis der Klöster, Stifte, Kommenden und Beginenhäuser in Niedersachsen und Bremen von den Anfängen bis 1810*, ed. by Josef Dolle, Veröffentlichungen der Historischen Kommission für Hessen 56, 4 vols (Bielefeld: Verl. für Regionalgeschichte, 2012), III, 1518–29 (pp. 1518–19).

was patronized by the Welfs and inhabited by nuns from noble families; it was a successful, rich institution. The extant buildings are mostly from the fourteenth through sixteenth centuries. They include the nuns' choir to the west of the parish church and two cloisters to the north of the church and choir (fig. 6).[41]

The Holy Sepulchre monument with its Christ effigy is one of Wienhausen's most important works of art (fig. 7).[42] It is an elaborated form of Diesdorf's version: the sarcophagus is a larger and more highly decorated and sophisticated structure that includes two compartments and multiple openings.

[41] For selected bibliography, see my first comment Mecham, *Sacred Communities, Shared Devotions*; Heiko Leerhoff, "Wienhausen," in *Die Männer- und Frauenklöster der Zisterzienser in Niedersachsen, Schleswig-Holstein und Hamburg*, ed. by Ulrich Faust, Germania Benedictina 12 (St. Ottilien: EOS, 1994), pp. 756–96; Konrad Maier, *Die Kunstdenkmale des Landkreises Celle im Regierungsbezirk Lüneburg*, part 2, *Wienhausen. Kloster und Gemeinde*, Die Kunstdenkmale des Landes Niedersachsen 34.2 (Hannover: Niedersächsisches Landesverwaltungsamt, 1970); Horst Appuhn, *Kloster Wienhausen*, 2nd ed. (Wienhausen: Kloster Wienhausen, 1986); *Chronik und Totenbuch des Klosters Wienhausen*, ed. by Horst Appuhn (Wienhausen: Kloster Wienhausen, 1986); Riggert, *Die Lüneburger Frauenklöster*, pp. 41–44; Konrad Maier, *Kloster Wienhausen: Geschichte, Architektur und bildene Kunst; Ein Überblick*, Kloster Wienhausen 1 (Wienhausen: Kloster Wienhausen, 2007); Brandis, "Wienhausen," III; Olaf Siart, *Kreuzgänge mittelalterlicher Frauenklöster: Bildprogramme und Funktionen* (Petersberg: Imhof, 2008), pp. 21–89; Mohn, *Mittelalterliche Klosteranlagen*, pp. 234–45.

[42] The effigy is oak wood, ca. 1290, length: 2.45 meters, width: 0.58 meters. The sarcophagus is painted oak wood, 1448, 1.75×0.775×2.52 meters. For selected bibliography, see Maier, *Die Kunstdenkmale*, pp. 115–18, no. III.1; Appuhn, *Chronik und Totenbuch*, pp. 15, 287, XL (February 18); Horst Appuhn, "Der Auferstandene und das heilige Blut zu Wienhausen: Über Kult und Kunst im späten Mittelalter," *Niederdeutsche Beiträge zur Kunstgeschichte* 1 (1961), 73–138 (pp. 100, 126–38); Appuhn, *Kloster Wienhausen*, pp. 24–30; Johannes Tripps, *Das handelnde Bildwerk in der Gotik: Forschungen zu den Bedeutungsschichten und der Funktion des Kirchengebäudes und seiner Ausstattung in der Hoch- und Spätgotik*, 2nd ed. (Berlin: Mann, 2000), pp. 135–38; Kroesen, *Sepulchrum Domini*, pp. 63–68; Mersch, *Soziale Dimensionen*, pp. 210–26; Mecham, "Sacred Vision, Sacred Voice," pp. 102–56; Babette Hartwieg, "Drei gefaßte Holzskulpturen vom Ende des 13. Jahrhunderts im Kloster Wienhausen," *Zeitschrift für Kunsttechnologie und Konservierung* 2 (1988), 187–262 (pp. 197–212); Jeffery F. Hamburger, "Art Enclosure and the Pastoral Care of Nuns," in *The Visual and the Visionary*, by Jeffery F. Hamburger (New York: Zone, 1998), pp. 35–109 (pp. 83–85); Sabine Wehking, *Die Inschriften der Lüneburger Klöster: Ebstorf, Isenhagen, Lüne, Medingen, Walsrode, Wienhausen* (Wiesbaden: Reichert, 2009), pp. 107–13, no. 44; Hedwig Röckelein, "The Cult of the Invisible—Relics in the Cistercian Houses Loccum and Wienhausen," in *Devotional Cross-Roads: Practicing Love of God in Medieval Jerusalem, Gaul and Saxony*, ed. by Hedwig Röckelein, Galit Noga-Banai, and Lotem Pinchover (Göttingen: University Press, 2019), pp. 161–209; Kerstin Hengevoss-Dürkop, *Skulptur und Frauenkloster: Studien zu Bildwerken der Zeit um 1300 aus Frauenklöstern des ehemaligen Fürstentums Lüneburg* (Berlin: Akademie Verlag, 1994), pp. 45–51, 139–45; Amy Knight Powell, *Depositions: Scenes from the Late Medieval Church and the Modern Museum* (New York: Zone, 2012), pp. 64–65; Jezler, "Ostergrab und Depositionsbild," pp. 35, 38–52.

Fig. 6. Wienhausen, Former Convent. After Maier, *Kloster Wienhausen*, p. 15, fig. 7a.

Its remarkably rich and well-preserved decoration has drawn a great deal of scholarly interest. This sarcophagus was donated to the convent by Abbess Katharina of Hoya in 1448.[43] The wooden coffin has a gabled roof, painted on

[43] The donation is according to charters from the convent archive (Wienhausen, Klosterarchiv [KlA WIE], U. 470/Or. 423 [13 March 1448[and U. 471/Or. 424 [28 August 1448]) and a comment from Wienhausen's necrology (Appuhn, *Chronik und Totenbuch*, XLI [February 18]). See Mecham, *Sacred Communities, Shared Devotions*, p. 37; Röckelein, "Cult of the Invisible," 180 n. 112.

Fig. 7. Christ's Sarcophagus and Effigy, Lüneburg (?), 1448, painted oak wood, 1.75 × 0.775 × 2.52 meters; effigy: oak wood, ca. 1290, length: 2.45 meters, Convent of Wienhausen. Photo: Courtesy of the Convent of Wienhausen © Kloster Wienhausen.

both its interior and exterior. It likely replaces an older sarcophagus since it fits perfectly the figure of Christ's effigy, which has an earlier date.[44] The convent possessed this wooden effigy soon after it was founded. It is dated through stylistic analysis to the end of the thirteenth century.

The depiction on the inner side of the sarcophagus includes thirty-one scenes mainly from the life and works of Christ, the Passion, and the Resurrection. The outer part bears a depiction of the sleeping guards.[45] The ornate decoration provides a clue as to the use of the sarcophagus, as both a devotional tool

[44] Appuhn, "Der Auferstandene," pp. 129–32; Hengevoss-Dürkop, *Skulptur und Frauenkloster*, 45–47 n. 101; Jezler, "Ostergrab und Depositionsbild," p. 43; Hartwieg, "Drei gefaßte Holzskulpturen," pp. 191–92.

[45] A detailed description of each scene and inscription is found in Maier, *Die Kunstdenkmale*, pp. 115–18, no. III.1. In total there are thirty-one scenes on the inner lids, two saints' figures on the inner side doors of the gables, and eight guards' figures on the outer boards. On the inscriptions, see also Wehking, *Die Inschriften*, pp. 107–13, no. 44.

throughout the year (with its pictorial cycle and Christ's effigy) and as a paraliturgical tool during Easter.⁴⁶ The two-story structure allowed the sarcophagus to be used as the empty tomb, when the upper compartment was closed hiding the effigy in it, and the lower remained vacant. The effigy retains some traces of ointment on it, probably as a result of an anointing practice done by the nuns during the Paschal period.⁴⁷ The figure was also used as a reliquary containing a large number of relics belonging to the convent; the house additionally possessed a relic of the Holy Blood, kept elsewhere in the building.⁴⁸ These factors suggest daily devotional activity. The elaborate cycle of images on the interior of the upper lid suits this function as well. Large Christological cycles are not common depictions on preserved Easter sepulchres. The Easter sepulchre from Maigrauge (Magerau) in Fribourg, Switzerland, and from Lichtenthal convent in Germany both depict Mary, John, and the visiting women (as well as an Entombment scene in Maigrauge).⁴⁹ However, scenes related to Easter

⁴⁶ Jezler, "Ostergrab und Depositionsbild," pp. 44, 48, 50–51; Appuhn, *Kloster Wienhausen*, p. 28; Appuhn, "Der Auferstandene," pp. 128–32; Tripps, *Das handelnde Bildwerk*, p. 137; Hartwieg, "Drei gefaßte Holzskulpturen," p. 192. On Wienhausen's Easter plays (two fragments from 1350–1400, KlA WIE, MSS 36 and 80). see Mecham, "Sacred Vision, Sacred Voice," pp. 102–56, app. 1–2, 401–8; Walther Lipphardt, "Die Visitatio sepulchri in Zisterzienserinnenklöstern der Lüneburger Heide," *Daphnis* 1 (1972), 119–28; Jörn Bockmann, "Bemerkungen zum 'Wienhäuser Osterspielfragment' und zur Erforschung der Geistlichen Spiele des Mittelalters," in *Passion und Ostern in den Lüneburger Klöstern*, ed. by Linda Maria Koldau (Ebstorf: Kloster Ebstorf, 2010), pp. 81–104 (pp. 81–104); Tanja Mattern, "Liturgy and Performance in Northern Germany: Two Easter Plays from Wienhausen," in *A Companion to Mysticism and Devotion in Northern Germany in the Late Middle Ages*, ed. by Elizabeth A. Andersen, Henrike Lähnemann, and Anne Simon, Brill's Companions to the Christian Tradition 44 (Leiden: Brill, 2014), pp. 285–315.

⁴⁷ Mecham, "Sacred Vision, Sacred Voice," pp. 102–56; Mersch, *Soziale Dimensionen*, pp. 210–26. See discussion on the ointment material in Hartwieg, "Drei gefaßte Holzskulpturen," pp. 197–212.

⁴⁸ The relic of a drop of the Holy Blood was probably kept elsewhere. It was brought to the convent from Rome by its founder, Agnes von Landsberg (d. 1248–53/1266). On this relic, see Appuhn, "Der Auferstandene," pp. 87, 98; Horst Appuhn, *Einführung in die Ikonographie der mittelalterlichen Kunst in Deutschland* (Darmstadt: Wissenschaftliche Buchgesellschaft, 1979), pp. 69–71; Appuhn, *Kloster Wienhausen*, p. 25; Appuhn, *Chronik und Totenbuch*, pp. v–xxvii, 140); and Mai-Britt Wiechmann, "Witnesses of Passion in Cistercian Houses—The Veneration of Christ's Relics in Walkenried, Mariengarten and Wienhausen," in *Devotional Cross-Roads: Practicing Love of God in Medieval Jerusalem, Gaul and Saxony*, ed. by Hedwig Röckelein, Galit Noga-Banai, and Lotem Pinchover (Göttingen: University Press, 2019), pp. 125–60. On additional relics from Wienhausen, see Appuhn, "Der Auferstandene," pp. 127–38; Appuhn, *Kloster Wienhausen*, pp. 24–30; Röckelein, "Cult of the Invisible."

⁴⁹ Both date to the fourteenth century, and both originate from Cistercian female monasteries. See Kroesen, *Sepulchrum Domini*, pp. 64–65.

depicted on the Wienhausen Sepulchre (for instance Doubting Thomas, the *Noli me tangere*, and the supper at Emmaus) do appear on the outer lids and inside the lower compartment, both of which were exposed during the Paschal liturgy. Each position of the tomb, then, revealed a set of paintings on the interior of the sarcophagus that corresponded in meaning.[50] Songs and texts of liturgical dramas were preserved in the convent library and support the assumption that paraliturgical activity took place at the convent of Wienhausen, as well as in other convents of the Lüneburg Heath.[51]

These devotional and paraliturgical practices appear in the scholarly literature in relation to the nuns. But was it only the convent members who used this Holy Sepulchre? The nuns were indeed the primary possessors of the sepulchre in Wienhausen. As already mentioned, the sarcophagus was donated by the convent's abbess. It is also referred to as "nostrum sepulcrum dominum" in texts written by the nuns, implying that the women saw themselves as its holders.[52] It is most likely that the sarcophagus had its own chapel that was part of the convent complex, although its location has not been traced. Wherever the chapel may have been, the nuns could not have been its only users. According to reports regarding

[50] These display options are also presented by Jezler, "Ostergrab und Depositionsbild," pp. 40–41; Hartwieg, "Drei gefaßte Holzskulpturen," pp. 193–94.

[51] Texts of Passion and Easter plays were extremely popular in German-speaking areas, especially from female monasteries: "Thus far we have knowledge of some seven hundred Easter offices, and three-quarters of them originate in German-speaking regions," Hansjürgen Linke, "A Survey of Medieval Drama and Theater in Germany," *Comparative Drama* 27, no. 1 (1993), 17–53 (p. 22). The same is stated by Brooks, *Sepulchre of Christ*, p. 37. See also Lipphardt, "Die Visitatio sepulchri in Zisterzienserinnenklöstern"; Ursula Hennig, "Die Beteiligung von Frauen an lateinischen Osterfeiern," in *Geist und Zeit: Wirkungen des Mittelalters in Literatur und Sprache; Festschrift für Roswitha Wisniewski zu ihrem 65. Geburtstag*, ed. by Carola L. Gottzmann, Herbert Kolb, and Roswitha Wisniewski (Frankfurt am Main: Peter Lang, 1991), pp. 211–27 (p. 212); Elizabeth A. Andersen, Henrike Lähnemann, and Anne Simon, "Introduction: Mysticism and Devotion in Northern Germany," in *A Companion to Mysticism and Devotion in Northern Germany in the Late Middle Ages*, ed. by Elizabeth A. Andersen, Henrike Lähnemann, and Anne Simon, Brill's Companions to the Christian Tradition 44 (Leiden: Brill, 2014), pp. 1–19 (p. 9); *Passion und Ostern in den Lüneburger Klöstern: Bericht des VIII. Ebstorfer Kolloquiums Kloster Ebstorf, 25. bis 29. März 2009*, ed. by Linda Maria Koldau (Ebstorf: Kloster Ebstorf, 2010). Indeed, texts of Easter plays were preserved in Gernrode (in the processional, see above), Wienhausen (see n. 46 above), and Wöltingerode (see below).

[52] For example, in the texts of spiritual pilgrimage at the convent, from the end of the fifteenth or the beginning of the sixteenth century, Wienhausen, Klosterarchiv (KlA), MSS 85 and 86. Mecham, "Sacred Vision, Sacred Voice," pp. 440–55, app. 7; Lotem Pinchover, "The *via crucis* in Wienhausen: Visual Witnesses," in *Jerusalem Elsewhere: The German Recensions; Proceedings of the Minerva-Gentner Mobile Symposium, October 2011*, ed. by Bianca Kühnel and Pnina Arad (Jerusalem: Spectrum, 2014), pp. 91–98.

indulgences and donations granted to or given by visitors of the Holy Sepulchre from the fourteenth and fifteenth centuries, the parish also had access to this chapel.[53] This hypothesis is not far-fetched: another chapel, which was dedicated Sts. Fabian and Sebastian (now lost), gave access to both parishioners and nuns as is documented in the convent chronicle. According to the account, this chapel was dedicated in the fourteenth century amid an epidemic.[54] In 1531, during the Reformation, it was burned down by Duke Ernest the Confessor, together with other parts of the convent.[55] This chapel was probably located on the northeastern corner of the complex, between the nuns' and parishioners' cemeteries, where, to this day, a door named "the Fabian" can be found (fig. 6, letter E).[56]

The above information, coupled with primary sources from 1314 and later discussing the sepulchre, indicates that the Holy Sepulchre of Wienhausen was used both by the parish and by the cloistered community. Thus, while the

[53] It is unknown where the monument was positioned before 1448; the option of the chapel of the Holy Cross, proposed by Appuhn, is not supported by evidence. As of 1448, although the chronicle states that the new Holy Sepulchre with the sarcophagus donated by Abbess Katharina of Hoya stood in the choir, it can be understood from the convent's necrology that it was positioned, at least at the beginning, in the newly dedicated chapel of St. Anne, founded by the same abbess. Primary sources from 1314 point that the monument was visited by both nuns and laity (for example, KlA WIE, U. 189/Or. 158 [12 January 1314]; U. 404/Or. 363 [13 June 1399]; U. 438/Or. 393 [14 October 1417]; 470/Or. 423 [13 March 1448]; U. 471/Or. 424 [28 August 1448]; U. 498/Or. 447 [11 September 1470]; *Notizbuch der Äbtissin Katharina von Hoya*, Fach 33, Nr. 1/1, 3, p. 35). St. Anne's Chapel was accessible to both audiences until it was moved inside the enclosure after the monastic reform. It is unknown exactly where within the enclosure it was repositioned and whether the Holy Sepulchre was transferred to this new chapel or moved to a separate site altogether. For discussions on the location of the Holy Sepulchre of Wienhausen and St. Anne's Chapel, see especially Appuhn, "Der Auferstandene," pp. 132, 134; Appuhn, *Chronik und Totenbuch*, pp. 14–15, 28, 37, 39, XLI (February 18), XIV, n. 23; Mecham, "Sacred Vision, Sacred Voice," pp. 109, 119–21, 280–88, 302–3, 310, 341–44; June L. Mecham, "Katharina von Hoya's Saint Anne Chapel: Female Piety, Material Culture, and Monastic Space on the Eve of the Reformation," in *Frauen—Kloster—Kunst: Neue Forschungen zur Kulturgeschichte des Mittelalters, Papers Presented at a Colloquium Held in May 13–16, 2005 in Connection with a Special Exhibit "Krone Und Schleier,"* ed. by Jeffery F. Hamburger et al. (Turnhout: Brepols, 2007), pp. 177–185; Maier, *Die Kunstdenkmale*, pp. 61, 115; Hartwieg, "Drei gefaßte Holzskulpturen," pp. 192, 251 n. 47.

[54] The chapel of Sts. Fabian and Sebastian was founded by Abbess Lutgard of Delmenhorst (r. 1343–59) around 1350, during years of crisis and dedicated to the two saints. A change effected in the chapel in the late fifteenth century in response to reformers' demands indicates that, prior to the monastic reform, the chapel must have had two entrances, one for nuns and one for parishioners (KlA WIE, U. 554 [7 July 1483], integrated into a copy book, KlA WIE, MS 24/1). The chapel was demolished in 1531. See Appuhn, *Chronik und Totenbuch*, pp. 9–10, 26–28, 63, LXII (July 31); Maier, *Die Kunstdenkmale*, p. 61; Mohn, *Mittelalterliche Klosteranlagen*, p. 242; Mecham, "Sacred Vision, Sacred Voice," pp. 27, 120–21, 231, 431.

[55] Appuhn, *Chronik und Totenbuch*, p. 63.

[56] Maier, *Die Kunstdenkmale*, pp. 4, 61.

chapel of the Holy Sepulchre did not survive in Wienhausen, texts fill in missing details. We can conclude that the use of the chapel can be paralleled to the use of the chapels of Diesdorf and Gernrode, even though it was not located within the parish church.

The Holy Sepulchre of the Convent of Wöltingerode

The case of the convent of Wöltingerode is the most challenging of our four examples since very little is known about it. It was founded in 1174 as a Benedictine male monastery by the counts of Wohldenberg; soon after, it was turned (although informally) into a Cistercian convent.[57] The convent became powerful quickly; already in the century following its establishment, it contributed to the founding of other communities, among them the convent of Wienhausen. Since 1438, Wöltingerode was involved in monastic reform, at which time it served as a pilgrimage destination thanks to its relic of the Holy Blood.[58] The medieval convent complex was almost completely ruined in a fire in 1676, but the small cruciform church, consecrated in 1244, survived. The nuns' choir, today decorated in a baroque style and divided into two floors, on the upper level of the western end of the church.[59] Almost nothing remains from the medieval material life of the convent, although its exceptionally rich library can be largely reconstructed.[60] An inventory written by Protestant reformers in 1572 helps to envision the now-lost medieval decor and religious implements. Among the different objects mentioned in the inventory is "unsers Hergotts Grab."[61] The text refers to a sheet (*Lacken*) that is still preserved, which probably belonged to the sculpture of Christ's effigy at the tomb (fig. 8).

[57] See n. 4 above. For selected bibliography on Wöltingerode, see Jessica Kreutz, *Die Buchbestände von Wöltingerode: Ein Zisterzienserinnenkloster im Kontext der spätmittelalterlichen Reformbewegungen* (Wiesbaden: Otto Harrassowitz, 2014); Ulrich Faust, "Wöltingerode," in *Die Männer- und Frauenklöster der Zisterzienser in Niedersachsen, Schleswig–Holstein und Hamburg*, ed. by Ulrich Faust, Germania Benedictina 12 (Ottilien: EOS, 1994), pp. 797–831; Ahlers, *Weibliches Zisterziensertum*, 182–89; Mohn, *Mittelalterliche Klosteranlagen,* pp. 350–52, no. B90; Rüthing, "Die mittelalterliche Bibliothek," I; Oskar Kiecker, Carl Brochers, and Hans Lütgens, *Die Kunstdenkmäler der Provinz Hannover* (Hannover: Selbstverlag Der Provinzialverwaltung, 1937), II, 7, pp. 270–84.

[58] Kreutz, "Wöltingerode," III, pp. 1556–57.

[59] Kirsten Poneß, *Klostergut Wöltingerode*, DKV–Kunstführer 650 (Munich: Dt. Kunstverlag, 2011), p. 11.

[60] Kreutz, *Die Buchbestände von Wöltingerode*; Rüthing, "Die mittelalterliche Bibliothek," I.

[61] Wolfenbüttel, Niedersächsisches Landesarchiv (NLA WO), 41 Alt, Fb. 3, Nr. 289. See transcription in Kreutz, *Die Buchbestände von Wöltingerode*, pp. 208–38, app. 7.3. The citation is taken from fol. 9v.

Fig. 8. Wöltingerode, Former Convent, Christ's Sarcophagus and Effigy, second half of the fifteenth century, linden wood, length: 1.85 meters. Photo: Courtesy of the Klosterkammer Hannover © Klosterkammer Hannover.

Wöltingerode's Christ effigy is a larger version of Diesdorf's.[62] It shows Christ with his hands crossed upon his pelvis, wearing the Crown of Thorns, and shrouded in a small loincloth, his wounds cutting deep into his skin. The figure is of high quality and very realistic; it is dated on stylistic and historical grounds to the latter half of the fifteenth century. The sculpture was likely made during the abbacy of Elisabeth von Burgdorf (r. 1463–89) as part of the intensified piety encouraged during the monastic reform, and it was used especially during feast days.[63] The figure is now held in a wooden sarcophagus of

[62] The effigy is made of linden wood, original coloring is lost, second half of the fifteenth century, length: 1.85 meters, inv. no. Wöl. AC 1. It is mentioned shortly in Kreutz, *Die Buchbestände von Wöltingerode*, pp. 144–45; Kreutz, "Wöltingerode," III, p. 1560; Poneß, *Klostergut Wöltingerode*, p. 19; Kiecker, Brochers, and Lütgens, *Die Kunstdenkmäler*, II, PART 7, p. 281.

[63] Kreutz, *Die Buchbestände von Wöltingerode*, pp. 144–45. A text of a *Visitatio Sepulchri*, dated to the thirteenth or fourteenth centuries, was preserved from Wöltingerode, today in Wolfenbüttel, Herzog August Bibliothek (HAB), Cod. Guelf. 1014 Helmst. fols. 41v–42r. See Lipphardt, "Die Visitatio sepulchri in Zisterzienserinnenklöstern," p. 119; Lipphardt, *LOO*, no. 76, IV, pp. 1443–4. Kreutz mentions the text to support the use of the figure during Easter (*Die Buchbestände von Wöltingerode*, p. 193). However, while the text indeed mentions a *sepulcrum*, no reference is made to an *imago* of Christ. Moreover, it predates the figure, making a direct relation impossible.

1990, but although the original sarcophagus is lost, the Wöltingerode church priest of the 1970s confirmed that a medieval sarcophagus once belonged to the church.[64]

The original location of the Holy Sepulchre in Wöltingerode is unknown, as is whether or not it had its own chapel. The 1572 inventory mentions a sheet belonging to the Christ figure kept in a closet at the nuns' choir, leading to Jessica Kreutz's assumption that this was the location for the sepulchre.[65] I would like to challenge this assumption. First, the inventory dates to at least one hundred years after the probable date of the effigy's origin, and its location could have changed during this period. Second, it refers to the storing place of a sheet and not to the sculpture itself, which could have been kept elsewhere. And finally, in light of the three other convents cited above, it is more probable that the Wöltingerode's sepulchre would have been located where it could serve both the nuns and the parish, not exclusively the former.

The convents of Wöltingerode and Wienhausen maintained contact on an ongoing basis. The first nuns to reside in the Wienhausen convent were sent from Wöltingerode, and both convents were home to relics of the Holy Blood.[66] Moreover, both were noninkorporated Cistercian nunneries in the diocese of Hildesheim. Both had a Holy Sepulchre, although the Christ effigy in Wöltingerode differs in style and iconography from Wienhausen's and is dated to a later period. It is possible that the Wöltingerode nuns knew about the Wienhausen sepulchre and that, in the fifteenth century, they wished for similar effigy to be installed in Wöltingerode.[67] It is notable to mention the variation in representations of the dead Christ between the convents, which may indicate

[64] See the restoration report by Jirina Lehmann, 25 November 1985, now in the Klosterkammer Hannover; Kreutz, *Die Buchbestände von Wöltingerode*, p. 144 n. 496.

[65] Kreutz, *Die Buchbestände von Wöltingerode*, p. 144.

[66] Regarding the relic of Wienhausen, see above, n. 49. In the fourteenth and fifteenth centuries, the Wöltingerode convent was a pilgrimage destination due to its relic of the Holy Blood which was preserved at the church choir, and also due to a certain image of Mary. These items were documented (Kreutz, "Wöltingerode," III, p. 1557). See also Wiechmann, "Witnesses of Passion."

[67] The most significant details which make the Wienhausen effigy special are the habits and the arm position. This figure is more of a relief than a sculpture, as its back side is completely flat (Mecham, "Sacred Vision, Sacred Voice," p. 112; Mecham, *Sacred Communities, Shared Devotions*, p. 41; Hartwieg, "Drei gefaßte Holzskulpturen," pp. 199–200). Mecham interprets the special depiction of the Wienhausen figure in context of other depictions of Christ at the convent in other types of media.

that the use of effigies went beyond a small sphere and was rather a phenomenon that extended beyond a certain religious orders' affiliation.[68]

Conclusions

Considering the fragments presented here, it appears that chapels of the Holy Sepulchre in medieval Saxony were more common than previously thought. Strikingly, the preserved cases all come from female monasteries.[69] The enclosed nuns, bound to the *stabilitas loci*, did not take part in actual pilgrimages,[70]

[68] Some scholars wrongly claim that Wienhausen's effigy is the earliest sculpture representing this iconography; see Ulla Haastrup, "Medieval Props in the Liturgical Drama," *Hafnia: Copenhagen Papers in the History of Art* 11, no 11 (1987), 133–70 (p. 141); Gesine Taubert and Johannes Taubert, "Mittelalterlichen Kruzifixe mit schwenkbaren Armen: Ein Beitrag zur Verwendung von Bildwerken in der Liturgie," in *Farbige Skulpturen: Bedeutung, Fassung, Restaurierung*, ed. by Johannes Taubert (Munich: Callwey, 1978), pp. 38–50 (p. 45). A stone figure from the last quarter of the thirteenth century is still preserved at the former Dominican convent of Maria-Medingen in Mödingen, and a wooden effigy is preserved from Visby, Gotland (Sweden). Both are sculpted together with the surface on which they lie. For Maria Medingen, see Werner Noack, "Ein erstes Heiliges Grab in Freiburg," *Zeitschrift für Kunstgeschichte* 23, nos. 3/4 (1960), 246–52; Peter Rummel and Konrad Rainer, *Das Heilige Grab in Maria Medingen* (Lindenberg: Kunstverl. Fink, 2000), pp. 1–2. For Visby, see Franz Niehoff, "Das Kölner Ostergrab—Studien zum Heiligen Grab im hohen Mittelalter," *Wallraf-Richartz-Jahrbuch* 51 (1990), 7–68 (pp. 45–46); Tripps, *Das handelnde Bildwerk*, p. 144, fig. 40d. In addition, there are fragments of twelfth-century sepulchres, which today are missing the figures of Christ, in Cologne and perhaps also in Gernrode and Hildesheim; the same period also produced several Entombment groups. As Jezler shows, textual evidence regarding these items had survived from as early as 1160. See Tripps, *Das handelnde Bildwerk*, pp. 138–41, pls. 40b–40c, 147–49; Franz Niehoff, "Das Ostergrab in St. Michael," in *Der vergrabene Engel: Die Chorschranken der Hildesheimer Michaeliskirche; Funde und Befunde; Katalog zur Ausstellung des Dom- und Diözesanmuseums Hildesheim*, ed. by Michael Brandt (Hildesheim: Dom- und Diözesanmuseum Hildesheim, 1995), pp. 127–33; Peter Jezler, "Bildwerke im Dienste der dramatischen Ausgestaltung der Osterliturgie—Befürworter und Gegner," in *Von der Macht der Bilder*, ed. by Ernst Ullmann (Leipzig: Seemann, 1983), pp. 236–49 (p. 246 n. 20).

[69] I am not familiar with any existing examples of male monasteries in the area, but scholarly literature suggests that at least two Holy Sepulchres existed in the twelfth century—in monasteries in Hildesheim and Goslar: see Niehoff, "Das Ostergrab in St. Michael"; Cai-Olaf Wilgeroth, "Goslar—Johanniter," in *Niedersächsisches Klosterbuch: Verzeichnis der Klöster, Stifte, Kommenden und Beginenhäuser in Niedersachsen und Bremen von den Anfängen bis 1810*, ed. by Josef Dolle, Veröffentlichungen des Instituts für Historische Landesforschung der Universität Göttingen 56, 4 vols (Bielefeld: Verl. für Regionalgeschichte, 2012), II, 519–22 (p. 522); Hans-Günther Griep, "Das Heilige Grab in Goslar," *Harz-Zeitschrift* 7 (1955), 101–28.

[70] Some exceptions are of note. The most famous is the case of Margery Kempe, who was not a nun but an English female mystic. She traveled to Jerusalem in 1414 and reported her experience in an exceptionally emphatic style. See Margery Kempe, *The Book of Margery Kempe*, ed. by Lynn Staley (Kalamazoo: TEAMS, 1996); Albrecht Classen, "Die Mystikerin als

although the spirit of the crusades was alive in the world around them in the form of either crusading family members or disseminated pilgrims' accounts.[71] For those who could not undertake a pilgrimage to the Holy Land or join a crusade, a replica of Christ's tomb closer to home made it possible to attain spiritual and penitential merit on a comparable scale. The growing desire among pious Christians to obtain salvation in exchange for a "virtual" pilgrimage may account for the popularity of such replicas.[72] Similarly, guides to virtual pilgrimages gained popularity from the fifteenth century onward and were particularly cherished by cloistered populations, especially in the wake of the monastic reforms that swept throughout Germany in the second half of the fifteenth century. The constraints on the nuns' physical movement impelled them to extend their restricted environment via guides to virtual pilgrimages to Jerusalem and by visiting replicas within these imaginary routes inside the boundaries of their enclosures.[73] In this way, the nuns could express their piety

Peregrina: Margery Kempe—Reisende in corpore—Reisende in spiritu," *Studies in Spirituality* 5 (1995), 127–45; Hope Phyllis Weissman, "Margery Kempe in Jerusalem: Hysteria Compassio in the Late Middle Ages," in *Acts of Interpretation: The Text in Its Contexts, 700–1160: Essays on Medieval and Renaissance Literature in Honor of E. Talbot Donaldson*, ed. by Mary Carruthers and Elizabeth D. Kirk (Norman: Pilgrim, 1982), pp. 201–17. See also Leigh Ann Craig, *Wandering Women and Holy Matrons: Women as Pilgrims in the Later Middle Ages* (Leiden: Brill, 2009). On women crusaders and nunneries in the Holy Land, see Natasha R. Hodgson, *Women, Crusading and the Holy Land in Historical Narrative* (Woodbridge: Boydell, 2007).

[71] To give a few examples, see the 1105 pilgrimage of Henry V via Gernrode, after his father's praise for the crusades in 1103 (Warnke, "Das Kanonissenstift St. Cyriakus," pp. 258–62). The family members of the nuns of Wienhausen are known to have participated in the crusades, as well as the northern crusades. See Kerstin Hengevoss-Dürkop, "Der Wienhauser Auferstehungs-Christus: Überlegungen zum Frauenkloster als Formgelegenheit," in *Studien zur Geschichte der europäischen Skulptur im 12./13. Jahrhundert*, ed. by Herbert Beck and Kerstin Hengevoss-Dürkop, 2 vols (Frankfurt am Main: Henrich, 1994), I, 483–94 (pp. 483–93).

[72] This motive is mentioned, for example, by Jonathan Z. Smith, "Constructing a Small Place," in *Sacred Space: Shrine, City, Land; Proceedings from the International Conference in Memory of Joshua Prawer*, ed. by Benjamin Z. Kedar and R. J. Zwi Werblowsky (New York: New York University Press, 1998), pp. 18–31 (pp. 19–20); Hamburger, "Art Enclosure," pp. 44–57; Nine Robijntje Miedema, *Rompilgerführer in Spätmittelalter und Früher Neuzeit: Die "Indulgentiae ecclesiarum urbis Romae"; Edition und Kommentar*, Frühe Neuzeit 72 (Tübingen: Niemeyer, 2003), p. 85; June L. Mecham, "A Northern Jerusalem: Transforming the Spatial Geography of the Convent of Wienhausen," in *Defining the Holy: Sacred Space in Medieval and Early Modern Europe*, ed. by Andrew Spicer and Sarah Hamilton (Aldershot: Ashgate, 2005), pp. 139–60 (pp. 140–41).

[73] Late fifteenth- and early sixteenth-century Germany was rich in such texts (Miedema, *Rompilgerführer*, pp. 22 n. 23, 400). Regarding spiritual pilgrimages, in general and at the convent, see Kathryn M. Rudy, *Virtual Pilgrimages in the Convent: Imagining Jerusalem in the Late Middle Ages* (Turnhout: Brepols, 2011); Kathryn M. Rudy, "A Guide to Mental Pilgrimage: Paris, Bibliotheque de L'Arsenal Ms. 212," *Zeitschrift für Kunstgeschichte* 63, no. 4 (2000), 494–515; Miedema,

and also gain penitence. Some churchmen even preached in favor of these local experiences over real pilgrimage, and a spiritual visit in a holy place sometimes even offered a greater amount of indulgences.[74]

It was only natural for the parish to also show interest in chapels of the Holy Sepulchre in the neighboring convents. Hence, it seems that, far from being coincidental, the location of holy sepulchres within convent churches was designed to fit the needs of both the parishioners and the cloistered, both during Easter and throughout the year.

In each of the convents discussed, the Holy Sepulchre chapel and the effigy of Christ were central devotional entities. It was, in fact, the economic benefits of the chapel that allowed the convents to function as places of piety: a common statement in indulgence charters is that they would be granted to "all those who, on specific feast days … make a pilgrimage to the chapel called Jerusalem, or those who help [the chapel] in any way."[75] Donations to the

Rompilgerführer, pp. 399–431; Nine Robijntje Miedema, "Following in the Footsteps of Christ: Pilgrimage and Passion Devotion," in *The Broken Body: Passion Devotion in Late-Medieval Culture*, ed. by Alasdair A. MacDonald, Bernhard Ridderbos, and Rita Schlusemann (Groningen: Egbert Forsten, 1998), pp. 73–92; Ursula Ganz-Blättler, "Unterwegs nach Jerusalem. Die Pilgerfahrt als Denkabenteuer," in *Symbolik: Von Weg und Reise*, ed. by Paul Michel (Bern: Peter Lang, 1992), pp. 82–107; Leigh Ann Craig, "'That You Cannot See Them Comes Only from an Impossibility': Women and Non-Corporeal Pilgrimage," in *Wandering Women and Holy Matrons: Women as Pilgrims in the Later Middle Ages*, by Leigh Ann Craig (Leiden: Brill, 2009), pp. 221–60; Holly Flora, "'Pause Here for Awhile First': Imagined Pilgrimage, Holy Feasts, and Moral Models," in *The Devout Belief of the Imagination: The Paris Meditationes Vitae Christi and Female Franciscan Spirituality in Trecento Italy*, ed. by Holly Flora (Turnhout: Brepols, 2009), pp. 117–86; Mitzi Kirkland-Ives, "Alternative Routes: Variation in Early Modern Stational Devotions," *Viator* 40 (2009), 249–70; Giles Constable, "Ideal of the Imitation of Christ," in *Three Studies in Medieval Religious and Social Thought*, ed. by Giles Constable (Cambridge: Cambridge University Press, 1995), pp. 143–248; Sandro Sticca, "The 'Via Crucis': Its Historical, Spiritual and Devotional Context," *Mediaevalia* 15 (1985), 93–126. Such documents are preserved in two copies in Wienhausen (KlA WIE, MSS 85 and 86), and a similar practice was documented also in Gernrode and other convents in the area. See Mecham, Poppenrod, Andreas. "Annales Gernrodensium," in *Accesiones Historia Anhaltinae*, ed. by Johann Christoph Beckmann (Zerbst: Zimmermann, 1716), pp. 27–82 (pp. 62–63).

[74] For example, Preacher Felix Fabri in his *Sionpilger* claims that the "Sion pilgrims, in particular, could gain more indulgences than the knightly ones, because God himself, not popes, bishops, and prelates, granted the spiritual rewards" (Kathryne Beebe, "Reading Mental Pilgrimage in Context: The Imaginary Pilgrims and Real Travels of Felix Fabri's 'Die Sionpilger,'" *Essays in Medieval Studies* 25, no. 1 (2008), 39–70 (p. 43). The original is in *Felix Fabri, Die Sionpilger*, ed. by Wieland Carls (Berlin: Erich Schmidt, 1999), pp. 79, 83–84. See more examples in Miedema, *Rompilgerführer*, pp. 79, 84, 88, 400, 412–14.

[75] "allen denjenigen, welche an bestimmten Tagen … zu der in der Kirche St. Ciriaci zu Gerenrode gelegenen Kapelle, Jerusalem genannt, Wallfahrten oder derselben in irgend welcher Weise hilfreiche Hand leisten," from the indulgences' charter in LASA DE, Z 2, Nr. 998,

chapels, given by the visiting pilgrims, made it possible for all four convents of Gernrode, Diesdorf, Wienhausen, and Wöltingerode to keep large property holdings and to function as homes for daughters of noble families. In this way, abbesses could carry out renovations to the conventual buildings, refurbish chapels, and commission devotional artwork. The convents thus gained income that could not be obtained otherwise—as opposed to male communities who were less limited in pursuing charity outside the cloister.[76] The locations of the chapels within the churches or complexes attest to the special meaning such commemorative spaces had in the monastic space.

transcribed in Hermann Wäschke, *Regesten der Urkunden des Herzoglichen Haus- und Staatsarchivs zu Zerbst aus den Jahren 1401–1500* (Dessau: C. Dünnhaupt, 1909), pp. 461–62, no. 998. See more on the economy of pilgrimage in Esther Cohen, "Roads and Pilgrimage: A Study in Economic Interaction," *Studi Medievali* 21 (1980), 321–41; O. K. Werckmeister, "Cluny III and the Pilgrimage to Santiago de Compostela," *Gesta*, 27, nos. 1/2 (1988), 103–12.

[76] Already in the thirteenth century a papal decretal instructed nuns to stay within the walls of the convent at all times and thus limited their access to the outside world and to society. The fifteenth century is characterised by many reform movements, which arose after the Black Death and the Great Schism, and they reinforced the supervision of convents by the so-called *cura monialium*. These reforms reached Wienhausen, Wöltingerode, and apparently also Diesdorf. See visitation reports in KlA WIE, U. 554 (7 July 1483) (integrated into a copy book, KlA Wienhausen, MS 24/1); Johannes Busch, *Des Augustinerpropstes Johannes Busch Chronicon Windeshemense und Liber de reformatione monasteriorum*, ed. by Karl Grube (Halle: Hendel, 1886), pp. 629–32 (Cap. XXXII); HAB, Cod. Guelf. 95 Helmst. fol. 125r; LASA MA, U 21 II 6, Nr. 427 and 429). See also Mecham, "Sacred Vision, Sacred Voice," pp. 121, 271–304, 341, 343–44; Appuhn, *Chronik und Totenbuch*, pp. 28–29, 141; Ahlers, *Weibliches Zisterziensertum*, p. 188 n. 990; Rüthing, "Die mittelalterliche Bibliothek," I, pp. 189–216; Pinchover, "Presence of Jerusalem," pp. 101–2, app. C2.

On the enclosure and the monastic reforms, see the following with further bibliography: Heike Uffmann, "Inside and Outside the Convent Walls: The Norm and Practice of Enclosure in the Reformed Nunneries of Late Medieval Germany," *Medieval History Journal* 4, no. 1 (2001), 83–108 (pp. 90–91); Jeffery F. Hamburger, Petra Marx, and Susan Marti, "The Time of the Orders, 1200–1500: An Introduction," in *Crown and Veil: Female Monasticism from the Fifth to the Fifteenth Centuries*, ed. by Jeffery F. Hamburger and Susan Marti (New York: Columbia University Press, 2008), pp. 41–75; *Frauen–Kloster–Kunst: Neue Forschungen zur Kulturgeschichte des Mittelalters, Papers Presented at a Colloquium Held in May 13–16, 2005 in Connection with a Special Exhibit "Krone und Schleier,"* ed. by Jeffery F. Hamburger et al. (Turnhout: Brepols, 2007), pp. 143–209 (part 4, "Reformen"); Jo Ann McNamara, *Sisters in Arms: Catholic Nuns through Two Millennia* (Cambridge: Harvard University Press, 1996), pp. 353–418; Bertram Lesser, "Zwischen Windesheim und Bursfelde: Klosterreformen in Hildesheim im 15. Jahrhundert," in *Schätze im Himmel, Bücher auf Erden: Mittelalterliche Handschriften aus Hildesheim; Ausstellung der Herzog-August-Bibliothek Wolfenbüttel (Bibliotheca Augusta: Augusteerhalle, Schatzkammer und Kabinett) vom 5. September 2010 bis 27. Februar 2011*, ed. by Monika E. Müller (Wolfenbüttel: Herzog-August-Bibliothek, 2010), pp. 31–40; Nicolaus C. Heutger, *Bursfelde und seine Reformklöster in Niedersachsen* (Hildesheim: Lax, 1969).

IN HONOREM SANCTAE CRUCIS ET SANCTI SEPULCHRI: ON THE EICHSTÄTT SCHOTTENKIRCHE AND ITS SIGNIFICANCE

Shimrit SHRIKI-HILBER

On 31 March 2010, the Domschatz- und Diözesanmuseum Eichstätt exhibited, for the first time publicly, a late Gothic panel painting (*Tafelbild*) titled *The Raising of Lazarus* (fig. 1). In the foreground is an illustration of the miracle described in John 11:1–44; in the background is one of the earliest *vedute* (city views) of Eichstätt.[1]

The panel painting, which was commissioned and probably also executed in Eichstätt, is assumed to have been displayed in the cloister of the city's cathedral. During secularization, it was sold to a private collector[2] and then hung in the staircase of an Amsterdam apartment until it was finally acquired by the Diözesanmuseum of Eichstätt in 2009.[3] Although unsigned, the painting is attributed on stylistic grounds to the so-called Master of the Oberschönenfelder Altar, iden-

[1] I wish to deeply thank Bianca Kühnel, my doctoral advisor and head of this project, for advising me to visit the exhibition *Stadtansichten des 15. bis 19. Jahrhunderts* at the Diözesanmuseum Eichstätt. Without her ongoing encouragement, this article would not have been written. My gratitude also goes to the students of the "Kolloquium der Spätantiken byzantinischen Kunstgeschichte in Tirol" (22–25 May 2014) and to Franz-Alto Bauer (LMU München) for allowing me to participate and present my work in progress. Moreover, I wish to sincerely thank Emanuel Braun, former director of the Domschatz- und Diözesanmuseum Eichstätt for sharing his knowledge on the provenance of the painting, as well as some interesting research directions and bibliography.

The earliest city view of Eichstätt is documented in the *Schedelsche Weltchronik*; see Hartmann Schedel, Michael Wolgemut, and Wilhelm Pleydenwurff, *Liber chronicarum 1493.07.12* (Nürnberg, 1493), fol. 162. On the tradition of city views in late medieval and renaissance paintings, see Simone Unger, "Eichstätt in Stadtansichten: Von der graphischen Darstellung Eichstätts in Hartmann Schedels Weltchronik 1493 bis zu Maurizio Pedettis Stadtplan und -ansicht 1796" (unpublished master's thesis, University of Eichstätt, 2006), esp. pp. 9–21; Simone Hartmann, "Das Bild der Stadt: Wie Städte darstellungswürdig wurden," in *Eichstätt: Stadtansichten des 15. bis 19. Jahrhunderts*, ed. by Claudia Grund and Simone Hartmann, Begleitkatalog zur gleichnamigen Ausstellung 18. Juli bis 3. November 2013 Domschatz- und Diözesanmuseum Eichstätt (Regensburg: Schnell & Steiner, 2013), pp. 14–17.

[2] The painting reappeared twice in Sotheby's auction catalogues from 1974 and 1976, in London and Amsterdam respectively: Sotheby's auction catalogue, London, 24 March 1974, p. 22, nr. 25; Sotheby's auction catalogue, Amsterdam, 21 June 1976, p. 12, nr. 1.

[3] *Eichstätt: Stadtansichten*, p. 26.

Fig. 1. Attributed to Sigmund Holbein, The Raising of Lazarus, ca. 1503, oil painting on wood, 152 × 106.5 cm, Domschatz- und Diözesanmuseum Eichstätt, Inv. Nr. M 2009/3.

tified with Sigmund Holbein (1470–1540), who was active in the workshop of his brother, the well-known painter Hans Holbein the Elder (ca. 1460–1524).[4]

An analysis of the *veduta* makes a significant contribution to the research of the urban history of Eichstätt by investigating its central buildings erected throughout the Middle Ages, some of which no longer exist. Particularly important among them is the Schottenkirche, a Romanesque round church built in imitation of the Anastasis Rotunda in Jerusalem. Prior to the rediscovery of this panel painting, the visual knowledge on the Schottenkirche, which was razed in 1611 due to its poor structural state, was based on only a single source, a watercolor in the illustrated album of the journey of Count Palatine Ottheinrich (fig. 2).[5] Thus, the discovery of the *veduta* adds new insights to the interpretation of the Schottenkirche, pertaining both to its architecture and its function in shaping the city's sacred topography. Therefore, the aim of this chapter is twofold. First, I will examine the two currently available city views, the Ottheinrich aquarelle and what I will call the Lazarus veduta, comparing the two depictions of the Schottenkirche. This investigation will enable us to confirm or reject previous conceptions (mainly based on travel accounts and the Ottheinrich sketch) and thus elucidate the enigmatic structure. Second, I address the panel painting as a whole, analyze its iconography, and suggest a reading that takes into consideration the significance of the Schottenkirche within the painting's symbolic program and for the city of Eichstätt itself.

History of the Schottenkirche

The Eichstätt Schottenkirche, a local representation of Jerusalem, was dedicated *in honorem S. Crucis et S. Sepulchri*,[6] as part of a larger donation by the cathedral provost Walbrun of Rieshofen, who also deposited a relic of the True

[4] Guido Messling, *Augsburger Maler und Zeichner Leonhard Beck und sein Umkreis: Studien zur Augsburger Tafelmalerei und Zeichnung des frühen 16. Jahrhunderts* (Dresden: Thelem, 2006), pp. 163–72, esp. pp. 165f.

[5] Universitätsbibliothek Würzburg, Delin. VI, fol. 49. See also Josef H. Biller, "Beschreibung der Darstellung von Eichstätt aus 'Die Reisebilder Ottheinrichs aus den Jahren 1536/1537,'" *Sammelblatt des Historischen Vereins Eichstätt* 94 (2001), 25–35; *Die Reisebilder Pfalzgraf Ottheinrichs aus den Jahren 1536/1537 von seinem Ritt von Neuburg a.d. Donau über Prag nach Krakau und zurück über Breslau, Berlin, Wittenberg und Leipzig nach Neuburg*, ed. by Angelika Marsch, Josef H. Biller, and Frank-Dietrich Jacob (Weißenhorn: Konrad, 2001).

[6] Franz Heidingsfelder, *Die Regesten der Bischöfe von Eichstätt: Bis zum Ende der Regierung des Bischofs Marquard von Hagel 1324,* Veröffentlichungen der Gesellschaft für fränkische Geschichte: Reihe 6, Regesten fränkischer Bistümer 1 (Erlangen: Palm & Enke, 1938), p. 161, reg. no. 499.

Fig. 2. Eichstätt, City-view from *Die Reisebilder Pfalzgraf Ottheinrichs aus den Jahren 1536-1537*, water colour on parchment, 28.7 × 41.5 cm, Universitätsbibliothek Würzburg, Delin. VI, fol. 49.

Cross within the church.[7] The ground plan of the Schottenkirche referred to that of the Anastasis Rotunda of the Holy Sepulchre in Jerusalem, the place of Christ's burial and Resurrection.[8] It also had a small structure at its center, evoking the Holy Tomb aedicula over Christ's empty tomb in Jerusalem. This tomb aedicula in Eichstätt survives, despite the later changes and eventual destruction of the church.

The original centralized structure was built in the middle of the twelfth century. Walbrun had likely participated in the Second Crusade (1145–49)[9] and,

[7] Ibid.

[8] See a conjectural reconstruction of the Schottenkirche in Diarmuid Ó Riain, "An Irish Jerusalem in Franconia: The Abbey of the Holy Cross and Holy Sepulchre at Eichstätt," *Proceedings of the Royal Irish Academy* 112C (2012), 1–52 (p. 23, fig. 3).

[9] For a discussion on Walbrun's origin and the dedication date of the Schottenkirche in Eichstätt, see Helmut Flachenecker, "Das Schottenkloster Heiligkreuz in Eichstätt," *Studien und Mitteilungen zur Geschichte des Benediktinerordens* 105 (1994), 66–70.

after his return, initiated the building of an architectural complex east of the city walls, including a hospital, a church, and a monastery for Irish Benedictine monks (the Schottenkloster).[10] The complex can be dated between 1149, the approximate year of Walbrun's return from the Holy Land, and his death in 1166.[11] Walbrun supplied the monastery with seventeen lots of land given through Count Gebhard to Abbot Gregor of Regensburg.[12] In 1194, the Irish Benedictine monastery church was consecrated by Bishop Otto, a relative of Walbrun.[13]

The Irish monastery in Eichstätt, under the supervision of the Irish Benedictine monastery of Regensburg, St. Jacob, belonged to a network of monasteries in the area of southern and central Germany, including Erfurt, Würzburg, Nuremberg, Kelheim, Memmingen, Constance, and Vienna. Their function was to serve routes for trade and pilgrimage in the region. The complex in Eichstätt was built during a prosperous period for the monastery in Regensburg, when the number of brothers was on the rise.[14] Yet already during the fourteenth century, the monastery was downgraded to a provostry, and by the end of the century, there was not one Irish monk left in Eichstätt. Around the mid-fifteenth century, the monastery stood empty due to lack of funding. In 1483, the provostry was occupied solely by a friar and a secular priest.[15] Almost a century later, the head of the monastery, Johannes Jungwirt, requested indulgence letters to generate funds for a restoration of the church.[16] In 1611, on the orders of Bishop Johann Konrad von Gemmingen, mass ceased to be held in the church due to its precarious structural state, and it was probably in that

[10] On the history of the Irish Benedictine monasteries in Germany, see Helmut Flachenecker, *Schottenklöster: Irische Benediktinerkonvente im hochmittelalterlichen Deutschland* (Paderborn: Schöningh, 1995); Diarmuid Ó Riain, "Schottenklöster: The Early History and Architecture of the Irish Benedictine Monasteries in Medieval Germany" (unpublished doctoral thesis, University College, School of Archaeology, 2008); Stefan Weber, *Iren auf dem Kontinent: Das Leben des Marianus Scottus von Regensburg und die Anfänge der irischen "Schottenklöster"* (Heidelberg: Mattes, 2010).

[11] Alfred Wendehorst, *Das Bistum Eichstätt: Die Bischofsreihe bis 1535,* Germania sacra: Die Bistümer der Kirchenprovinz Mainz, Neue Folge, 45 (Berlin: De Gruyter, 2006), p. 88.

[12] *De B. Mariano Scoto (Vita Mariani Scotti)*, in *Acta Sanctorum: Februarius* (Paris, 1864), II, *Editio novissima curante Ioanne Carnandet,* ed. by Ioannes Bollandus and Godefridus Henschenius, pp. 361–65.

[13] Heidingsfelder, *Die Regesten der Bischöfe von Eichstätt,* p. 161, reg. no. 501.

[14] *Vita Mariani Scotti,* pp. 361–65.

[15] Flachenecker, "Das Schottenkloster Heiligkreuz in Eichstätt," pp. 81f.

[16] Transcriptions of the letters accompany Priefer's visitation report in Ó Riain, "Schottenklöster," p. 47; Diözesanarchiv Eichstätt, B231/1, pp. 384–85. See also Gustaf Dalman, *Das Grab Christi in Deutschland* (Leipzig: Dieterich, 1922), p. 59.

same year that the medieval church was removed.[17] Apparently, the bishop had planned to restore the building to its previous state and reinvigorate its monastic life.[18] Accordingly, he commissioned the builder Elias Holl from Augsburg to erect a centralized church and invited Franciscan monks to Eichstätt. As the Franciscan order was the *custodia terrae sanctae*, it would have been appropriate for it to continue the heritage of the Schottenkirche and its Holy Tomb. But the death of Bishop von Gemmingen led to the abandonment of those plans, and in place of a central-plan structure, a single-nave baroque church was erected between 1623 and 1625 under his successor, Bishop Johann Christoph von Westerstetten. This is the structure extant today. The medieval tomb aedicula was dismantled and reassembled in the south annex of the newly erected church.[19] The Capuchin order was appointed by von Westerstetten to take over the new church and its surroundings.

Since the tomb aedicula has remained intact despite the removal of the church around it, we can perhaps deduce the degree of similarity between the Schottenkirche and the Anastasis Rotunda in Jerusalem by comparing the extant tomb aedicula and its prototype. We can also use pilgrims' accounts to gage their impressions of the similarities between the two respective surrounding structures, such as the pilgrimage account of the Nuremberg merchant Hans Tucher, who visited the Holy Land in the years 1479 and 1480. Tucher notes that the large circular church in Jerusalem is "akin to the one in Eichstätt," amusingly phrasing it thus and not the other way around.[20] A similar impression is reported by Tucher's contemporary Sebald Rieter Junior.[21] Jakob Gretser, a Jesuit priest

[17] Michael Schmidt, "'Neues Aychstättisches Jerusalem': Das Heilige Grab in der Kapuzinerkirche von Eichstätt; Bau und Ausstattung," *Jahrbuch der Bayerischen Denkmalpflege* 58/59 (2007), 19–43 (p. 25).

[18] "nach voriger Art," Johann Konrad von Gemmingen, quoted in Johann H. von Falckenstein, ed., *Antiquitates Nordgavienses oder Nordgauische Alterthümer und Merckwürdigkeiten: Fortgesetzet in dem Hochwürdigen Dom-Capitel der Aureatensischen Kirche, oder Hochfürstlichen Hochstiffts Eichstett ... Zweyter Theil* (Frankfurt: Johann Georg Lochner, 1733), p. 383.

[19] One can still see the numbering on the stone bricks, which were engraved to allow an exact reassemblage of the tomb aedicule.

[20] "an der selben statt da steht ein weyte runde Kirchen / gleich als die Kirch zu Eychstett zum heyligen Creuz / welche ein Bischoff von Eychstett nach dem heyligen Grab hat bauwen lassen / ist im auch sehr gleich," "hinden an der selben statt da stehet ein weyte runde Kirchen / gleich als groß und weyt die Kirch zu Eychstett vor der Statt als ich vorne im anfang geschrieben hab / und in mitte der selben runden Kirchen stehet das heylig Grab," in Hans Tucher, *Gründtlicher vnd Eigentlicher Bericht der Meerfart* (Frankfurt am Main: Rab und Han, 1561), fols. 11v, 13v.

[21] "Und wie das löblieh heylig grab gestaltt ist, des ist vast ein gleichformlich pildung und beczaichnung zu Eystett vor der statt," in Reinhold Röhricht and Heinrich Meisner, eds., *Das Reisebuch der Familie Rieter,* Bibliothek des Literarischen Vereins in Stuttgart 168 (Tübingen, 1884), p. 74.

and theologian from Ingolstadt, mentions, in his 1617 publication on the church history of Eichstätt, the circular shape of the Schottenkirche.[22] The comparison with the Jerusalem prototype was known to some visitors who had not traveled to Jerusalem themselves but referenced others' impressions. For example, Friedrich Earl von Dohna, a noble student at the University of Ingolstadt, went on a journey through Bavaria and in 1593 visited the episcopal city of Eichstätt. In his account, he describes the church as a round structure in which a tomb stands, similar to the Holy Tomb in Jerusalem, "as can be testified by those who had visited it."[23] Von Dohna's description is also valuable because it provides us with information on the setting of the tomb aedicula within the church. By mentioning that the entrance to the holy tomb is located toward the rising sun, he indicates an eastern orientation of the tomb monument within the church, similar to the setting in Jerusalem.[24] On 21 October 1725, at the centenary celebration of the new Capuchin church, the auxiliary bishop of Eichstätt, Johann Adam Nieberlein, glorified the church as the "Neues Aychstättisches Jerusalem."[25] With this reference to the Apocalypse, he simultaneously signaled a continuation

[22] "In finibus fuburbij orientalis fuit olim Monasterium Scotorū, cum Templum formæ cyclicæ & rotundæ, quod à Dominico Sepulchro nomē habebat," in Jakob Gretser, *Philippi Ecclesiae Eystettensis XXXIX: Episcopi de eiusdem ecclesiae divis tutelaribus* (Ingolstadt, 1617), p. 243.

[23] "Außerhalb der Stadt steht eine Kapelle, und in ihr befindet sich ein steinernes Grabmal als Gleichnis jenes Jerusalemer, in welchem unser Herr Christus begraben war und aus welchem er am dritten Tage feierlich aufzuerstehen geruhte: was diejenigen, welche einmal in Jerusalem waren und dort das Grab Christi sahen, bezeugen können. Die Kapelle ist ein Rundbau, vor längerer Zeit errichtet, aus ihr gelangt man in eine Art Höhle oder Kellergewölbe gegen Sonnenaufgang; in ihr sind kleine Türen, durch die man in kleine Gewölbe in der Art des Gottesgrabes gelangt, und sie sind so eng, niedrig und klein, daß ein Mensch dort kaum durchkommt, und diese Türen waren mit einem ähnlich großen Stein verschlossen, zu welcher Tür einst Maria sagte: 'Und wer wälzt uns den Stein von dieser Grabtür weg?' So beim hl. Markus im 16. Kapitel," in Rainer A. Müller, "Friedrich von Dohnas Reise durch Bayern in den Jahren 1592/3," 101 (Oberbayerisches Archiv), pp. 301–13 (p. 313); Schmidt, "Neues Aychstättisches Jerusalem," p. 28. This similarity to the prototype in Jerusalem and the authenticity that is attributed to the holy tomb aedicule in Eichstätt even has contemporary evidences. In 2018 a tomb aedicule was consecrated in Ukraine. In the building of the Ukrainian structure, the monument in Eichstätt was selected as a prototype over the current one in Jerusalem since the latter had gone through many architectural changes throughout the years, while the former portrayed a supposedly more reliable, earlier image of the Holy Tomb. See Oleksander Petrynko, "Heiliges Grab aus Eichstätt wird in der Ukraine nachgebaut," in *Weitblick: Blog der Diözese Eichstätt*, 6 August 2018, http://weitblick.bistum-eichstaett.de/author/oleksandr-petrynko/page/3/.

[24] Müller, "Friedrich von Dohnas Reise durch Bayern in den Jahren 1592/3," p. 313.

[25] Schmidt, "Neues Aychstättisches Jerusalem," p. 34; Johann Adam Nieberlein, *Aufwarter und treue Diener Deß Neuen Aychstättischen Jerusalem: Das ist, Lob- und Danck-Predig Bey Feyerlicher Begehung deß Ersten Jubel-Jahrs, Oder Hundert-Jährigen Welt-Gangs der P.P. Capuccinorum in Aychstätt* (Aychstätt: Strauß, 1725). This axis has changed to south-north in the current Capuchin church.

of the salutary powers of the mediaeval predecessors and articulated the continuously flourishing tradition of Eichstätt as Jerusalem.

The Eichstätt Schottenkirche in Visual Depictions

While the written sources offer information on the central plan of the Schottenkirche and its similarity to the Anastasis Rotunda in Jerusalem, they lack specifics on the scale of the church, the number of storys, and its appearance. Visual evidence is thus critical. Isolating the depictions of the church from the Ottheinrich aquarelle and the Lazarus veduta allows us to focus entirely on its architectural manifestation.

Die Reisebilder Pfalzgraf Ottheinrichs aus den Jahren 1536–1537,[26] a collection of fifty watercolor paintings, contains views of cities in Germany and Bohemia that Count Palatine Ottheinrich visited during his journey.[27] Among these aquarelles is a view of Eichstätt as seen from the south, comprising the walled city and its environs. Some of the city's prominent buildings are easily recognizable. To the west are Willibald Castle (Willibaldsburg), the Heilig-Geist-Spital church, and the Spitalbrücke, crossing the river Altmühl. At its center is the cathedral dedicated to Sts. Salvator, Willibald, and Mary (the Dom zu Eichstätt). To the east, at the right edge of the painting, is the monumental Schottenkirche. The church appears significantly larger than the surrounding buildings. It is depicted as a one-story round structure with a conically roofed tambour and a lantern with a pointed roof.

Unlike the Ottheinrich aquarelle, the painter of the Lazarus veduta was situated westward of the city, most likely at the southern part of the Geisenberg, below the Hohe Kreuz. The most prominent building in the veduta is the Willibald Castle situated on a hill at the right side of the painting. The castle is also considerably lighter colored than the other buildings of the city, which could be explained by the position of the painter in relation to the castle. To the left of the castle is the Altmühltal. Eichstätt Cathedral can be recognised by its two towers. One also notices its basilical shape with a high nave and a lower choir, the Willibaldschor, at its western end. To the left of the cathedral is a lower basilica, which appears to be under construction, for the main beams of the

[26] Universitätsbibliothek Würzburg, Delin. VI, fol. 49.
[27] Eva Pleticha-Geuder and Angelika Pabel, *Reise, Rast und Augenblick: Mitteleuropäische Stadtansichten aus dem 16. Jahrhundert*, Ausstellung der Universitätsbibliothek Würzburg (Dettelbach: J. H. Roll, 2002).

roof are lying bare without tiles. This is the former parish church dedicated to St. Mary, which is known to have been built as a three-nave hall church between 1472 and 1546.[28] Almost at the center of the veduta is the city hall, identified by its monumental lateral tower at the northern side, with a steep roof and a dominant Gothic facade to the west. More toward the western part of the city is the monastery dedicated to St. Walburg, the sister of Bishop Willibald of Eichstätt, here recognizable also thanks to its outstanding tower. The city walls, along with several towers, surround the city. At the entrance to Eichstätt from the west is the city gate, a plain structure. In a straight line to the east are two massive towers with a dark roof, most likely representing the eastern city gate. Continuing to the east, outside of the city walls and at the center of the veduta, a hill is noticeable with a round, two-storied structure at its top, undoubtedly the Schottenkirche.

As noted above, the two paintings provide different perspectives of the Schottenkirche: the Ottheinrich aquarelle provides a view from the south, while the Lazarus veduta offers a view from the west/northwest. Nevertheless, one can see that they reproduce the same structure (fig. 3). In both paintings, we see the lower story of the church with its large arched openings. In the Ottheinrich watercolour, seven such openings are clearly depicted. In the Lazarus veduta, it is more difficult to identify the exact number, but one can vaguely note seven openings and perhaps also parts the eighth and ninth openings facing the sides. In the Ottheinrich aquarelle, pilasters separating the arched openings and a Lombard cornice runs above them; in the Lazarus veduta, no detailed architectural elements can be identified. The red roof is similar in both depictions, but it appears steeper in the Ottheinrich aquarelle than in the Lazarus veduta. In both representations, a fenestrated tambour with a red conical roof rises from the center of the roof of the lower level. In the Ottheinrich aquarelle, ten pointed-arch openings can be counted, while there appear to be seven in the Lazarus veduta. Here, as well, the plain stringcourses bordering the tambour at bottom and top, discernable in the watercolour, are omitted. The tambour in the Lazarus veduta is considerably higher than in the Ottheinrich aquarelle. Like the relation between the roofs of the lower level, the roof of the tambour is steeper in the Ottheinrich aquarelle than in the Lazarus veduta. Furthermore, the stripes on the roof in the Ottheinrich aquarelle, possibly imitating the wooden beams of the roofing, are absent in the Lazarus veduta.

[28] *Handbuch der deutschen Kunstdenkmäler: Bayern IV; München und Oberbayern*, 3., ed. by Dehio-Vereinigung, aktualisierte Auflage (Munich: Deutscher Kunstverlag, 2006), p. 247.

Fig. 3. Eichstätt Schottenkirche (ca. 166–1611), Details from the Raising of Lazarus panel painting (l.) and the Ottheinrich aquarelle (r.).

The most obvious difference between the two depictions is at the tops of the structures. In the Ottheinrich watercolor, rising from the center of the tambour, a lantern is portrayed, pierced by four openings and crowned by a pointed roof. In the Lazarus veduta, the lantern is much less dominant, openings cannot be identified, and it is difficult to determine whether it carries a small dome or a pointed roof. But it is unlikely that the lantern was enlarged sometime between 1500 and 1537. As mentioned above, already at the beginning of the fourteenth century, due to lack of funding and its problematic location, the monastery lost its power and ceased to function as an independent abbey.[29] Its decline continued during the fifteenth century, when the status of the monastery decreased to a provostry. Under these financial and administrative difficulties, it is highly unlikely that the church undertook important building measures at the beginning of the sixteenth century. A more reasonable explanation attributes the differences to the painters' individual approaches. In the Ottheinrich watercolor, the lengthy and stretched representation of the church with its steep roofing seems slightly exaggerated. While it is difficult to determine whether the painter of the Lazarus veduta produced a more reliable representation, a tendency toward inaccuracy is displayed by the artist of the Ottheinrich aquarelle in several other cases. This

[29] This is according to a visitation report of a member of the Regensburg Abbey St. Jakob. See Flachenecker, "Das Schottenkloster Heiligkreuz in Eichstätt," p. 74.

recurrent inclination can only partially be explained by an artistic intention to emphasize specific characteristics.[30] The lantern in the Lazarus veduta is similar to that represented in depictions of the medieval Holy Grave chapel in Augsburg, which still stood at the Weinmarkt around 1503, the year to which the panel painting is dated.[31] Perhaps, if the artist is indeed the Augsburg painter Sigmund Holbein or one of his circle, he might have been influenced by the Anastasis translation in his home town while painting the Eichstätt rotunda.

One of the questions that preoccupies the research is the exact location of the Schottenkirche and its surrounding monastic buildings. In spite of the visual evidence of the Ottheinrich aquarelle, this question cannot be answered conclusively. According to the model of other Schottenkirchen, the monastic buildings should be located to the north, as is also the case for today's Capuchin church.[32] Nevertheless, this assumption was disproven through extensive excavations carried out within the Capuchin cloister in 1986.[33] The Lazarus veduta can be used as additional evidence against a location in the north since it does not show any structures to the north of the rotunda. The 1986 excavations led to the conclusion that the cloister of the Irish monastery must have stood to the south of the current church. This proposition is contradicted by the depiction of the church in the Ottheinrich aquarelle, which was not yet known at the time of excavations.[34] The Ottheinrich depiction of the Schottenkirche does not allow any conclusion regarding the eastern termination of

[30] For instance, the eastern choir of the cathedral is too long, while the nave is too short, and the transept is missing entirely. Moreover, the location and the perspective of the Dominican church are incorrect.

[31] For further reading on the tradition of Jerusalem representations in Augsburg in general and the holy grave chapel at Weinmarkt in particular, see Dalman, *Das Grab Christi in Deutschland*, pp. 44–56; Tilman Falk, "Notizen zur Augsburger Malerwerkstatt des Älteren Holbein," *Zeitschrift des Deutschen Vereins für Kunstwissenschaft 30 (1976)*, pp. 13-16; and Renate Mäder, "'…dem Grab Christi gantz ähnlich und gleich': Die Tradition von Heilig-Grab-Bauten in Augsburg," in *Barfuß vor St. Max: Von der Klosterkirche der Franziskaner zur Pfarrkirche St. Maximilian; Katalog zur Sonderausstellung im Diözesenmuseum St. Afra, 18. Oktober 2013–12. Januar 2014*, ed. by Melanie Thierbach (Augsburg: Wißner, 2013), pp. 60–70.

[32] Hans Reiß, "Die Ausgrabungen im Kapuzinerkloster," in *Eichstätt: 10 Jahre Stadtkernarchäologie, Zwischenbilanz einer Chance*, ed. by Karl H. Rieder and Ute Blenk (Kipfenberg: Hercynia, 1992), pp. 120–22.

[33] Ibid.

[34] The album, with fifty aquarelles of European city views, castles, and residences, arrived at the university of Würzburg in 1803, following the disestablishment (secularization) of the Cistercians Abbey of Ebrach, where it was kept until then. It was not until the early 1990s that research by Angelika Marsch and Josef Biller attributed the album to the journey of Ottheinrich in the first half of the sixteenth century (*Die Reisebilder Pfalzgraf Ottheinrichs*).

the church because its edge adjoins the black frame. In his reconstruction, based on written accounts and the Ottheinrich aquarelle, Diarmuid Ó Riain places a large apse to the east, which held the altar of the Holy Cross as well as a painted Christ, similar to the one in the contemporary church in Jerusalem.[35]

The west/northwest view toward the church offered by the Lazarus veduta reveals a lengthy building with a pitched red roof, partially hidden by the church (fig. 4). It is almost impossible to discern any further architectural characteristics of this building, besides perhaps a large arched opening to its right. It is thus unclear if the building is a partial depiction of the monastic complex or the church's apse—or both. While buildings encircle the church in the Ottheinrich aquarelle as well, they clearly do not represent religious structures, and they are not annexed to the church. On the contrary, in the Lazarus veduta, the Schottenkirche is isolated from any of the secular buildings that surely stood in its vicinity. Therefore, the annexed structure must have had a certain significance for the artist to include it in his painting. With some reservation, one can carefully conclude that the Lazarus veduta strengthens Ó Riain's assumption about a continuation of the Schottenkirche toward the east. The visual evidence of the Lazarus veduta suggests that the apse actually stood east of the church, like its prototype, the crusader version of the Holy Sepulchre Church in Jerusalem.[36]

The Lazarus Veduta: Portraying Eichstätt as the New Jerusalem

The panel painting is outstanding for its rare documentation of the Schottenkirche. Furthermore, the context in which the church is portrayed is significant and can shed light on the people and ideology in Eichstätt around the turn of the fifteenth century. In order to discuss these topics, I now turn to the foreground of the painting and the representation of the biblical scene.

At the center of the scene, Christ stands in dark-blue garments at the brink of Lazarus's tomb. To his left, the young man wearing a green robe, folding his hands in a gesture of devotion, is the apostle John. With his right hand, Christ blesses the rising Lazarus, who gazes at him. Lazarus ascends, gaunt and disheveled, from his tomb wearing a white cloth. An elderly man, probably St. Peter, wearing a dark-blue tunic and a red robe, is kneeling next to him to loosen his hands. On top of the open grave, the removed tombstone lies at a right angle. It is engraved with a modification of a verse from the book of

[35] Ó Riain, "An Irish Jerusalem in Franconia," p. 23.
[36] Ibid.

Fig. 4. The Raising of Lazarus panel painting, detail: the Schottenkirche with the annexed building.

Psalms 51:1–3,[37] in Hebrew letters: "Have mercy upon me God according to your great graciousness and erase all my sins, our Lord."[38] At the center of the tombstone, a coat of arms is depicted in relief: a fish below a man in profile wearing a Phrygian cap. To the right, also on the tomb's brink, are Lazarus's sisters, Mary Magdalene and Martha. One gazes at Christ while leaning toward her brother while the other, who can be identified as Mary Magdalene due to her long hair partly visible underneath her white veil, looks at her resurrected brother, crossing her hands over her chest in a gesture of reverence. Behind them are three men, wearing variously shaped hats, most likely portraying the Jews who followed the sisters to the grave. They are looking at the resurrected Lazarus and at each other in astonishment, while covering their noses with garments, referring to John 11:39: "Lord, by this time he stinketh: for he hath been dead four days."

Behind Mary Magdalene stands a woman dressed as a contemporary medieval nun, wearing a blue robe and a white veil. Behind her, to the right, is an

[37] 'חָנֵּנִי אֱלֹהִים כְּחַסְדֶּךָ; כְּרֹב רַחֲמֶיךָ, מְחֵה פְשָׁעָי'

"Have mercy upon me, O God, according to thy lovingkindness: according unto the multitude of thy tender mercies blot out my transgressions" (KJV).

[38] My translation of: 'חנני אלוהים כגדול חסדך: ותמחה כל פשעי יהוה אלהינו'.

aged man; only his torso is shown, and he is depicted in three-quarter profile, looking toward another man. These two men under the arch to the left of the scene also seem to represent contemporary late medieval people, as evident from their clothing—buttoned shirts and scarves. Another contemporary and quite enigmatic figure stands behind Jesus, to his left: an elderly man with long grey hair and a beard, who wears a black robe. He is looking away, his head and body reaching the opposite direction from the standing group. One of his arms is held up, while his hand is parallel to his chest.

The identification of the two contemporary figures to the left of Jesus is important for questions of dating, patronage, and motivation. At the bottom to the left, holding a black hat between his hands and kneeling in the pose typical of patrons in the Northern Renaissance of the fifteenth century, we see a man wearing a white robe over brown garments, as would befit a member of the Augustinian canons. Next to him we see a coat of arms showing a fish on blue background. On the basis of this emblem, the patron of the painting can be identified as Willibald Fischl, a chancellor and a member of the Augustinian canons at Eichstätt Cathedral.[39] Fischl was born in Dollnstein and served in Eichstätt as provost under Bishops Wilhelm von Reichenau (r. 1464–96) and Gabriel von Eyb (r. 1496–35). He was an important figure with influential contacts including the Holy Roman Emperor Maximilian I.[40] Fischl's patronage could also explain the prominent place of the Willibaldsburg within the veduta, as it is from this castle, named after his patron, St. Willibald, that he exerted his influence.

The elderly man standing to the left of the patron and wearing red garments can be identified as Bishop Gabriel von Eyb. His identity is confirmed by a comparison with his portrait in a miniature in the bishop's feudal register, from circa 1500 (fig. 5).[41] The miniature depicts the list of fiefs at the bishop's court.

[39] Grund and Hartmann, *Eichstätt: Stadtansichten*, p. 26. To confirm, one can compare this coat of arms with the one depicted in a miniature (ca. 1500) from the feudal register of Bishop Gabriel von Eyb, in the Staatsarchiv Nürnberg, Hochstift Eichstätt, Lehenbücher Nr. 8, as well as the one on Fischl's tombstone in the *mortuarium* of the Eichstätt Cathedral. In the Diözesanarchiv Eichstätt (DAEi) are three records (nos. 462, 491, and 492) mentioning Willibald Fischl ("Kanzel und Hl. Willibaldchorherr") between the years 1491 and 1501. In another manuscript (DAEi, no. 124), Fischl's epitaph is documented: "Willibaldus Vischel Cano: choris S. W. ac Cancellarius Eyste A° 1503–13 Aprilio: corpus Sic inclusit te pecor, ora, redeat spiritus ad Dm qui dedit illum."

[40] Franz X. Buchner, *Archivinventare der katholischen Pfarreien in der Diözese Eichstätt*, Inventarien Fränkische Archive 2 (Munich: Duncker & Humblot, 1918), 482, reg. no. 297. The Diocesan Archiv of Eichstätt holds a certified copy of this document in the inventory of Stift Herrieden.

[41] Isabelle Schürch, "Herrschaft inszenieren: Das Lehensbuch des Eichstätter Bischofs Gabriel von Eyb," Staatsarchiv Nürnberg, Hochstift Eichstätt, Lehenbücher No. 8 (Fig. 5).

IN HONOREM SANCTAE CRUCIS ET SANCTI SEPULCHRI

Fig. 5. Attributed to Ulrich Taler, A miniature in the feudal register of Bishop Gabriel von Eyb, ca. 1500, water colour on parchment, 37 × 26.5 cm, Staatsarchiv Nürnberg, Hochstift Eichstätt, Lehenbücher No. 8.

At the center of the miniature, to the right of his emblem, Bishop von Eyb is depicted, sitting at a table, addressing three dignitaries of his court. Willibald Fischl, who was a member of the administration of Bishop von Eyb from 1496 until his death in 1503, is also shown with his coat of arms in this image, the second from the right. In the painting, Bishop von Eyb holds with his left hand onto Christ's robe, and with his right hand, he almost touches the head of the patron, Willibald Fischl. Von Eyb thus functions as a mediator between Christ and Fischl, as expressed through his touch. Since the mediation takes place at the very moment in which Christ performs the miracle, not only holiness but also the blessing of Resurrection is being transferred through the bishop to the painting's patron.

At the same time, this scene is reminiscent of another miracle told in the Synoptic Gospels (Mark 5:21–43, Matthew 9:18–26, Luke 8:40–56), namely, the healing of the bleeding woman (*haemorrhoissa*). According to the Gospels, a great crowd followed Jesus to the house of Jairus, whose daughter was dying. Among them was a woman who suffered from a sickness since the age of twelve from which no doctor could cure her. When she saw Christ, she came behind him, touched the fringes of his garment and, according to the scriptures, was instantly healed. This brings us one step closer to understanding the motivation behind this painting as an epitaph honoring its patron. The iconography indicates that the painting was commissioned in Willibald's later days. This is also what has led scholars to date the painting to 1503, the year Willibald died.[42]

The scene of the resurrection of Lazarus takes place simultaneously indoors and outdoors. According to the Gospels, the grave was outside, and in the paining, patches of green grass surround it. This location likely depicts a *mortuarium*, a special burial place within a church or a monastery dedicated to the entombment of distinguished public figures, such as abbots and relatives of benefactors or protectorates. I would suggest that this *mortuarium* alludes to the one found at Eichstätt Cathedral, situated to the south of the main apse. It is in this *mortuarium* that Fischl is actually buried and where his gravestone, with a relief of the family emblem, can be seen today.

Alongside the reference to the Old Testament, through the paraphrasing from Psalms in Hebrew letters, the painting encloses another representation of the Jewish Bible. The area surrounding the resurrection scene is walled, and to the left is a building with an arched opening. Peering through the aperture, we see a double column bearing a sculpture of a bearded figure (fig. 6). The carved man wears a

[42] Grund and Hartmann, *Eichstätt: Stadtansichten*, p. 23.

Fig. 6. The raising of Lazarus panel painting, detail: Moses.

pointed hat, widespread in medieval Germany and known as the "Jew's hat" (*Judenhut*). In his hands he carries two tablets, rounded at the top: the Ten Commandments. The depiction of Moses in this context reveals that the foreground of the painting depicts the "old world." The structural surroundings in which the scene takes place can be likened to a ruin: they are only partly built, and bits of vegetation sprout from the floor and the walls. The Old Testament, represented through the Hebrew text and the figure of Moses, contributes to this sense of antiquity. Situating the scene in ancient times underscores the location of the foreground as Bethany near Jerusalem, the place where the miracle of Lazarus's resurrection occurred. Additionally, the distance of this site from the city of Eichstätt in the background seems to coorespond to the distance of Bethany from Jerusalem (about fifteen furlongs, according to John 11:18).

In this point, it might be helpful to speculate whether Willibald Fischl visited the Holy Land. We know that his fellow canon, Kaspar Marschall von Pappenheim (1477–1511), went on a pilgrimage to the Holy Land in the 1480s. His journey did not result in written documentation but rather in a visual record, the so-called Pappenheimer Altar, a monumental relief situated at the eastern end of the northern aisle of Eichstätt Cathedral.[43] Although nothing points to Fischl himself having participated in a pilgrimage to the Holy Land, the Pappenheimer Altar is an indication of the European Zeitgeist around the turn of the fifteenth century, characterized by widespead pilgrimage to the Holy Land,[44] as well as that attendant accessibility of knowledge regarding the Holy Land, its sacred places, and its architecture.

[43] The eleven-meter-high Jura stone altar, erected between 1489 and 1497, was donated by its patron as an expression of gratitude for safely returning home from his journey to the Holy Land. The central theme is the Crucifixion; at the foreground we see a depiction of Jesus on the cross, flanked by the two thieves. Below is a great crowd. Identifiable are the grieving Maria, Maria Magdalena, and the Apostle John, who stand in contrast to the Roman soldiers, fighting over Jesus's garment. The event takes place in an urban scene, with four cities depicted in its background. To the right is Pappenheim, hometown of the donor, recognizable by the castle complex. Next is Venice, the departure point of the sea route to the Holy Land, with monuments such as the remarkable Doge's Palace and the Campanile at St. Mark's Square. To the left of the crucified Jesus, the journey's destination, the Holy Land, is represented through its iconic city, Jerusalem, with a depiction of the Dome of the Rock (Templum Salomonis). The medieval city to the left of Jerusalem is most likely the city of Nuremberg with its imperial castle, hometown of the attributed artist, Hans Paur. Paur arrived in Eichstätt around 1475 and served as the master builder of the city's cathedral (Dombaumeister) until 1500. The altar is framed by sculptural depictions of the twelve apostles and above them, Christophorus, the patron saint of travellers. At the lower part of the altar are portraits of the donors in relief.

[44] "Deutsche Reiseberichte," in Christian Halm, ed., *Europäische Reiseberichte des späten Mittelalters: Eine analytische Bibliographie* (Frankfurt am Main: Peter Lang, 1994), I.

The Schottenkirche had a significant role in establishing a connection to the Holy Land, not just within the painting but also for the city of Eichstätt. Together with three other churches that were founded in Eichstätt before the twelfth century, an arrangement forming the shape of a cross was established. This arrangement, also known as the *Kirchenkreuz*, sanctified the city's landscape.[45] The location of the Schottenkirche to the east reflects a conscious decision to relate the site to Jerusalem and to the prophecy of Christ's Second Coming. The Schottenkirche should therefore be seen as part of a special sacred landscape in Eichstätt.

The painting belongs to a Jerusalem tradition that has its roots in the establishment of the diocese of Eichstätt by Bishop Willibald (700–787). In the year 740, Willibald joined the Anglo-Saxon mission in Germany, where he served for more than forty-five years as the (founding) bishop of the diocese of Eichstätt until his death in 787. Willibald went on a pilgrimage to the Holy Land between the years 724 to 726. The journey was documented and is known from the *Vita Willibaldi*, one of few Christian pilgrimage accounts of a visit to the Holy Land during the early Islamic period.[46] A vast part of the vita is dedicated to the pilgrimage, although it was dictated to the Heidenheimer nun Hygeburg almost forty years after Willibald's return from the Holy Land following a long and significant mission in Bavaria.[47] Together with relics brought from the Holy Land,[48] this account has a long history of reception (*Wirkungsgeschichte*), as it must have been very important for the community in Eichstätt and forged a link with the Holy Land that remained potent over many centuries.

[45] Erich Herzog, *Die ottonische Stadt: Die Anfänge der mittelalterlichen Stadtbaukunst in Deutschland*, Frankfurter Forschungen zur Architekturgeschichte 2 (Berlin: Mann, 1964); Richardt Krautheimer, "Introduction to an 'Iconography of Medieval Architecture,'" *Journal of the Warburg and Courtauld Institutes* 5 (1942), pp. 1–33 (p. 8).

[46] Translated by Jakob Brückl (Heidenheimer Nonne), *Hodoeporicon S. Willibaldi: Oder S. Willibalds Pilgerreise* (Eichstätt: M. Däuntler, 1880/81); Rodney Aist, *The Christian Topography of Early Islamic Jerusalem: The Evidence of Willibald of Eichstätt (700–787 CE)*, Studia Traditionis Theologiae, Explorationa in Early and Medieval Theology 2 (Turnhout: Brepols, 2009).

[47] Ora Limor, "Willibald in the Holy Places," in *East and West in the Early Middle Ages: The Merovingian Kingdoms in Mediterranean Perspective*, ed. by Stefan Esders et al. (Cambridge: Cambridge University Press, 2019), pp. 230–44 (p. 232f.). In her article, Limor observes the depiction of St. Willibald as a pilgrim rather than a bishop in a mosaic (ca. 1930?) at the Dormition Abbey in Jerusalem. This is the starting point of an analysis of the *Vita Willibaldi* "tackling mainly problems of memory, selection and transmission."

[48] Julia Smith, "Eleventh-Century Relic Collections and the Holy Land," in *Natural Materials of the Holy Land and the Visual Translation of Place, 500–1500*, ed. by Renana Bartal, Neta Bodner, and Bianca Kühnel (London: Routledge, 2017), pp. 19–35 (p. 25f.).

A detailed description of the holy places was especially significant at times when pilgrimage to the Holy Land was not achievable. In this way, the vita can be considered as a source and an example that inspired later generations to follow the tradition and even re-create Jerusalem in Eichstätt.

Conclusions

For research on visual translations of Jerusalem in general and that of the Schottenkirche in particular, the return of the *Raising of Lazarus* panel to the public domain is of appreciable value. Its study, together with the Ottheinrich aquarelle, illuminates the architecture of the Schottenkirche as well as its significance in Eichstätt's sacred landscape.

In comparing the two depictions, we have detected several differences that might result from their particular purposes: while the Ottheinrich aquarelle solely shows the city and its surroundings as a sort of documentation of the town, the Lazarus veduta gives Eichstätt a role as part of the painting's iconography. Hence, the artist of the Ottheinrich aquarelle documents in detail the buildings of the city, including the Schottenkirche, whereas the same building in the Lazarus veduta receives a central yet simplified treatment. Examining the panel painting as a whole reveals a fascinating iconographic program, associating the city of Eichstätt with both the earthly and the heavenly Jerusalem, with the river Altmühl as the river of life and the central Schottenkirche as the temple. The painting not only depicts the biblical miracle of Lazarus's resurrection as an aspirational model for its donor, Willibald Fischl, but it also indicates the Resurrection of Christ through his empty tomb, the Schottenkirche. And since the church is located in the east, it may also allude to Christ's Second Advent. Thus, three miracles of resurrection appear in this painting: the aspired future one of the patron, as represented through his emblem on the tombstone; the biblical prototype of the Raising of Lazarus; and the salvational event that made it all possible, the Resurrection of Christ, all arranged in a respectively ascending axis with the Schottenkirche at the top.

A SINGULAR EXPERIENCE OF JERUSALEM: ST. SEBALD CHURCH IN NUREMBERG

Maria E. Dorninger

It may have been the 28 October 1479 that Endres Tucher received a letter from the Holy Land, written by his brother Hans.[1] An unusual piece of correspondence, the letter was largely dedicated to a comparison of the church of the Holy Sepulchre with the well-known parish church St. Sebald, located in Nuremberg. In this chapter, I investigate this description and the special function of the rhetorical device of analogy or comparison, along with its singular use in Tucher's missive and pilgrimage account. I preface this examination with remarks on the historical, social, and mental context of Hans Tucher, his brother Endres, and the Tucher dynasty.

Endres Tucher was a member of a famous patrician family in Nuremberg that was engaged in long-distance trade, holding business offices in cities such as Lyon and Venice. In 1476, Endres, formerly a building inspector and member of the city council in Nuremberg, became a lay brother in the Carthusian

[1] Hans Tucher wrote six letters during his sojourn in the Holy Land (1479/80). Only two of them are preserved. The second letter, which was written to Endres two days after the first (6 August, in Jerusalem), addresses the son of Hans's cousin, Anton II, who saw to Tucher's wife and business during his absence. Anton Tucher recorded the exact date the letter had been delivered, 28 October (LT2, 655), whereas Endres Tucher noted the delivery of his brother's letter taking twelve weeks (LT1, 648). Randall Herz edited both letters (LT1, 648–54; LT2, 655) and the account of Hans Tucher (TA 337–638) in the same publication: Randall Herz, *Die "Reise ins Gelobte Land" Hans Tuchers des Älteren, 1479–1480: Untersuchungen zur Überlieferung und kritische Edition eines spätmittelalterlichen Reiseberichts*, Reihe Wissensliteratur im Mittelalter 38 (Wiesbaden: Reichert, 2002). Hereafter, this edition will be referred to as LT, with the number of the letter and page in the publication, and as TA for the account followed by the page. All other (introductory) chapters of this edition will be referred to as "Herz, *Die 'Reise.'*" Endres's note seems to provide more information and be more precise. Counting the days of the twelve weeks, Endres received Hans's letter on the last day of the twelfth week, that is, on 28 October. Obviously, the patron's ship must have left on 8 or 9 August, and it delivered both letters. Regarding the departure of the ship; see Hans Tucher's notes (LT2, 654, 655), who, in his letter to Anton, refers to the time: "This very day or tomorrow morning" (noch heutt oder morgen frue). The letter to Anton is much shorter; its tone is friendly but not as affectionate as the one sent to Endres. One can speculate that this tone was related to a sense of pressure Hans might have felt while writing to Anton. At this moment, it was uncertain when the main group of pilgrims would leave Jerusalem and the Holy Land. The patron planned to leave on the same day or the day after Hans's writing. If Hans wanted to pass him another letter, he had to do so before the departure.

monastery of his hometown, ceding his high position in the family and honorary municipal office in the city council to his younger brother Hans (VI).[2] Three years later, Hans Tucher traveled to the Holy Land for the honor and glory of God and for the sake of his own salvation. On 5 May 1479, Hans, Sebald Rieter, and Valentin Scheuerl, all of them Nuremberg patricians, joined a larger pilgrim group in Venice. As he is eager to state at the beginning of his travel account (TA 339), Hans was prompted by pure intentions rather than by ambition or curiosity. Thus, his other motivations, such as to be knighted in the Holy Land, can only be presumed implicitly in his account.

By autumn 1479, Endres, like the other members of his family, longed to hear about Hans's adventures in the holy city of Jerusalem. In his letter, Hans remarks on his personal condition and, most notably, provides a detailed description of the Holy Sepulchre Church. In ending his portrayal of the church, Hans vows to develop this description: "If the Lord helps me, I will bring all of that in a better form by the Lord's help" (LT1, 653).[3] Shortly after his return in 1480, he realized this intention, penning a pilgrimage report that became a bestseller already in his lifetime. The letter, too, earned a large readership. Indeed, interest in the story was such that the original letter was, literally, read to pieces. A copy thus became necessary, which Endres provided and added to the printed edition of his brother's account:[4] "After the original letter arrived, clerical and lay persons [alike] wanted to hear [or read] it. Thus, it became totally torn and damaged. So, I copied it and placed it [here] for [the sake of] memory" (LT1, 654).[5]

Hans's pilgrimage account was printed in 1482. As promised, this text contained the letter with an expanded description of the Holy Church, which was now accessible to a broader readership.[6] The popularity of this published account may have been enhanced by its handy size, the practical and personal

[2] Herz, *Die "Reise,"* p. 680. See also, especially for the office of a building inspector and its obligations in Nuremberg, Ludwig Grote, *Die Tucher: Bildnis einer Patrizierfamilie* (Munich: Prestel, 1961), p. 47.

[3] "Wene mir Got heim hilfft, so wil ich das als mit Gocz hilff jn ein pesser [sic] furm prengen [sic]."

[4] For this edition, see Herz, *Die "Reise,"* p. 648 n. 645.

[5] "Jtem noch dem der hie vorgeschriben prieff also her kum, wolt jn jederman horen von geistlichen vnd weltlichen persunnen also, das er gancz zw rÿssen vnd beschedigt wardt, das ich jn doch abgeschriben vnd do her czw eÿner gedechtnuß geseczet hab *etc.*" All italics in the Randall Herz edition.

[6] Printed by Johann Schönsperger in 1482 in Augsburg, by Konrad Zeninger in Nuremberg, and again in the same year in Augsburg as a second print using improvements of the Nuremberg edition. See Herz, *Die "Reise,"* pp. 229–50; in regard to the numerous prints at that time and later; see Randall Herz, *Studien zur Drucküberlieferung der "Reise ins gelobte Land" Hans Tuchers*

information provided, and its fuller description of the church of the Holy Sepulchre, a site of intense interest in the Holy Land, as well as the use of St. Sebald Church as a major point of reference. We are left wondering what prompted this choice for the comparison and what functions were fulfilled by this description. To address these questions, I turn to the motives of the writer himself, the desires of his addressee(s), and the structure and rhetorical aspects of Hans's description of the church of the Holy Sepulchre by first giving some notes on the relationship between the Tucher dynasty and St. Sebald Church.

St. Sebald Church and the Tucher Dynasty

St. Sebald, the old parish church in Nuremberg, was built in the first half of the thirteenth century. This church had long been of major interest to the Tucher family. The family's oldest house was situated at the Milchmarkt, not far from the church.[7] From 1326 through Hans Tucher's time and even beyond, St. Sebald served as a burial place for the Tuchers. In 1524, the Tuchers received new burial grounds at the Johannis Cemetery in Nuremberg. The names of deceased family members were listed on a wooden panel in the northeastern part of the church, accompanied by a *memento mori* portrait.[8] The Tuchers also sponsored different parts of the church, such as the Passion window and the statues of Sts. Bartholomew and John the Baptist, whose consoles are decorated with the Tuchers' coat of arms.[9] In the fourteenth century, Berthold I became the first of the Tuchers to assume the honorable office of church administrator (*Pfleger*) of St. Sebald.[10] Time and again, Tucher family members fulfilled this function for the church.[11] At the end of the Middle Ages, St. Sebald Church was still flourishing, as attested by its numerous altars and clergy members: the church had twelve altars and thirty clerics, among them one provost, one preacher, nine chaplains for pastoral care, and nineteen priests for reading the

des Älteren: Bestandsaufnahme und historische Auswertung der Inkunabeln unter Berücksichtigung der späteren Drucküberlieferung (Nürnberg: Selbstverlag des Stadtarchivs Nürnberg, 2005).

[7] Grote, *Die Tucher,* p. 21. This house also featured a chapel.

[8] Wilhelm Schwemmer and Lagois Martin, *Die Sebalduskirche zu Nürnberg* (Nürnberg: Alber Hofmann, 1979), p. 16. Anton II (d. 1524) was the first of the Tuchers to be buried at Johannisfriedhof in Nuremberg. Still today, the names of the deceased family members are recorded on wooden tableaus in St. Sebald; see Grote, *Die Tucher,* pp. 52, 58.

[9] Grote, *Die Tucher,* pp. 55–56.

[10] Ibid., p. 55.

[11] Ibid., p. 52. Anton II was also a special patron of Veit Stoß (p. 70).

church services.¹² The altars of Sts. Erhard, Catherine, Stephan, and Nicholas, still extant in part or in whole, and the mensa of the high altar remain today as they were in Hans Tucher's time.¹³

Hans Tucher: Life, Pilgrimage, Motives, and Intentions

When Hans Tucher undertook his pilgrimage to the Holy Land, Sinai, and Egypt, he was fifty-one years old, had been married twice, and had achieved considerable mercantile and political status. His patrician lineage in Nuremberg had opened career doors for him,¹⁴ and he was a member of the smaller city council, a so-called Alter Genannter.¹⁵ In the Middle Ages, pilgrimage to Jerusalem was a risky but highly respected journey to the religious center of the Christian world, where Christ was born, lived, was crucified and resurrected, and finally ascended to heaven. Pilgrims were challenged by exorbitant travel costs (particularly those who wanted to enjoy a little more comfort), long distances, and maritime dangers, including the possibility of pirates; in the Holy Land itself, they met an unfamiliar climate and incessant uncertainties.¹⁶ Not many could risk such a perilous voyage, during which imprisonment, slavery, and death were possible.

Like Hans Tucher, some pilgrims recounted and recorded their experiences.¹⁷ Hans himself met some of the aforementioned difficulties, as we read in his published letter: he had witnessed the death of the duke of Mecklenburg's

¹² Schwemmer and Lagois, *Die Sebalduskirche*, p. 8.

¹³ Ibid., pp. 8–9. Peter's altar still exists; the shrine, which can be seen today, was completed between 1480 and 1490. Only a few details were altered after the Reformation in Nuremberg. On the retable, St. Peter was deprived of his crown, which two angels held. For Peter's altar, see also Walter Fries, *Die St. Sebalduskirche zu Nürnberg* (Burg bei Magdeburg: August Hopfer, 1928), p. 24. For the St. Sebald Church, its unity of architecture and interior elements, and its importance for the patricians of Nuremberg, see the extensive study of Gerhard Weilandt, *Die Sebalduskirche in Nürnberg: Bild und Gesellschaft im Zeitalter der Gotik und Renaissance*, Studien zur internationalen Architektur- und Kunstgeschichte 47 (Petersberg: Michael Imhof, 2007).

¹⁴ Grote, *Die Tucher,* pp. 47–48. For Nuremberg's political constitution, see ibid., pp. 41–42.

¹⁵ For Hans Tucher's life, see also Herz, *Die "Reise,"* pp. 680–81, and TA 338: Tucher proudly mentions his exact age at his departure. He was fifty-one years and five weeks old.

¹⁶ Jonathan Sumption, *Pilgrimage: An Image of Medieval Religion* (London: Faber & Faber, 1975), p. 93; Norbert Ohler, *Pilgerstab und Jakobsmuschel: Wallfahren in Mittelalter und Neuzeit* (Dusseldorf: Artemis und Winkler, 2000), pp. 103–43.

¹⁷ See, for example, the pilgrim accounts of Sebald Rieter Jr. (or of members of his family), Felix Fabri, and Konrad von Grünemberg. *Das Reisebuch der Familie Rieter,* ed. by Reinhold Röhricht and Heinrich Meisner (Tübingen: Litt. Verein Stuttgart, 1884); Felix Fabri, *Evagatorium in Terrae Sanctae, Arabiae et Egypti peregrinationem,* ed. by Cunradus Dietericus Hassler,

chaplain, who had suffered from dysentery and was buried on the shores of Jaffa (TA 369; LT1, 649). Tucher overcame seasickness (LT1, 649) and, upon arrival in the Holy Land, experienced the intense heat of the Levant summer and was briefly imprisoned in Jerusalem.[18] However, adversities were only one side of the pilgrimage experience; there were also honors for noblemen to receive, such as being knighted at the Holy Sepulchre Church and, as a result, obtaining the privilege to display in public the Cross of Jerusalem, St. Catherine's half-wheel of Bethlehem, and the Holy Sword from the Isle of Cyprus, together with their own coats of arms.[19]

Upon return from the Holy Land, a pilgrim could be honored in different ways. When Hans arrived home with his friend Sebald Rieter, they were received by friends and members of the city council and by both mayors of the city of Nuremberg. The welcoming crowds were like those that met royal visitations.[20] A votive painting of the Crucifixion that Hans sponsored in St. Sebald Church (1485) shows not only the Tuchers' commitment to the church but also how Hans was permitted to display all the pilgrim signs together with his family coat of arms (fig. 1).[21] He was dubbed a knight in the church of the Holy Sepulchre, as the Cross of Jerusalem shows, although he does not indicate this event explicitly in his letter or travel account, which instead emphasizes his

3 vols (Stuttgart: Soc. Litt. Stuttg., 1843–49); Konrad Grünemberg, *Pilgerreise ins Heilige Land 1486*, ed. and comm. by Andrea Denke (Cologne: Böhlau, 2011).

[18] Hans Tucher and other pilgrims (e.g., Sebald Rieter and Otto Spiegel) had been imprisoned because of political shifts in Jerusalem. The new lord of Jerusalem charged pilgrim taxes, although they had been paid before, TA 444.

[19] The full wheel was only allowed to be displayed after a visit to the monastery at Sinai, which Hans Tucher had completed. A half wheel could be presented after a visit in Bethlehem. See Wolfgang Ludwig Schneider, *Peregrinatio hierosolymitana: Studien zum spätmittelalterlichen Jerusalembrauchtum und zu den aus der Heiliglandfahrt hervorgegangenen nordwest-europäischen Jerusalembruderschaften* (Paris: Éditeur inconnu, 1980), pp. 216–18. The honor of the sword was bestowed by the King of Cyprus; see Christiane Hippler, *Die Reise nach Jerusalem* (Frankfurt am Main: Lang, 1987), p. 76. For the honors achieved by Hans Tucher; see Grote, *Die Tucher*, p. 63.

[20] Grote, *Die Tucher*, p. 60.

[21] Ibid., p. 63. The Tuchers' coat of arms holds a "blackamoor" on yellow background under a black-and-white striped field. The "blackamoor" also appears in the crest. Grote also mentions the Tau Cross or Antonius's Cross (with a bell) of Cairo, which also had been given to Hans Tucher. This cross is also painted on Hans's Calvary tableau. In Nuremberg, not all citizens were permitted to present their coat of arms and their sign of knighthood on devotional objects. For example, the Jerusalem pilgrim Georg Ketzel was forbidden to place the Jerusalem Cross and his coat of arms on the copy of the chapel of the Holy Sepulchre in the Holy Spirit Hospital in Nuremberg, which he had sponsored; see Hippler, *Die Reise*, p. 75.

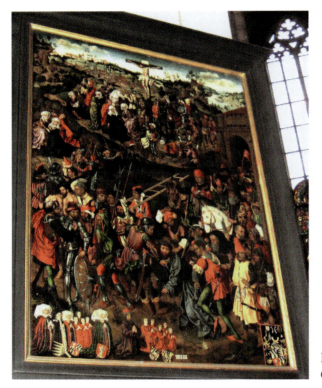

Fig. 1. Nuremberg, St. Sebald, Crucifixion. Photo: Author.

pious intentions.²² And, upon his return, Hans became an Elder Mayor (*Älterer Bürgermeister*) of Nuremberg.²³ In view of such honorifics, one might harbor a suspicion about the purity of a pilgrim's intent. A contemporary of Tucher, the mystic Thomas of Kempen, succinctly expressed this sentiment: "He who goes on frequent pilgrimages will seldom become holy."²⁴ In his account, Hans proactively deflects such reproach, maintaining that his motives were untainted by material gain (TA 339).

²² Tucher himself mentions the names of the knighted noblemen in a note; TA 441.
²³ See Ernst Mummenhof, "Hans Tucher," *Allgemeine Deutsche Biographe (ADB)* 38 (1894), 765–67 (pp. 765–66). The Inner Council of Nuremberg consisted of twenty-six mayors (thirteen elder and thirteen younger mayors) and eight old appointed members ("Alte Genannte"). One elder and one younger mayor always ruled the city for a period of four weeks. For the government of Nuremberg, see the section "Der Aufstieg des Rates" in Michael Diefenbacher, "Nürnberg, Reichsstadt: Verwaltung," in *Historisches Lexikon Bayerns* (2010), http://www.historisches-lexikon-bayerns.de/Lexikon/Nürnberg,_Reichsstadt:_Verwaltung (accessed 8 June 2018).
²⁴ "Qui multum peregrinantur, raro sanctificantur." Thomas of Kempen, *De imitatione Christi Libri Quatuor* IV.1.38, ed. by Tiburzio Lupo (Vatican City: Libr. Ed. Vaticana, 1982).

The Addressees of Hans Tucher's Letter and Comments Concerning His Piety

Although some of Hans Tucher's motivations and intentions, overt and covert, may be understood as worldly ambitions, he appears to have possessed real piety. The letter he sent to his brother Endres contains not only common phrases like "God be praised" and "with God's help" (LT1, 649.653) but also expressions of deep personal belief. The pilgrim presents himself as connected in prayer with Endres, whom he remembers and prays for at the holy places. Hans is aware of the daily prayers of his brother to uphold him in his fears, sorrows, and difficulties, as he writes in his letter to him, before traveling to Sinai and St. Catherine's Monastery. Here, we read of his anxiety about the upcoming leg of the journey:

> And I am worried about this [travel]. I take comfort in knowing yours, and your fathers', and brothers' daily prayer, which supported me up to this hour. Therefore, I ask you not to desist from it. I remembered all of you in my little prayer at the holy sites, where it may please the Lord. We will have to stay here till approximately eight or ten days into September, when cooler days will come. Now it is too hot for this travel. ... I trust in your prayer. And dedicatedly give greetings to the father prior, and all fathers [= priests] and brothers [of the Order of Chartusians] and ask them not to desist from remembering me in their prayers. Thus, the Lord may protect us, so that we will meet again with joy.[25] (LT1, 654)

Hans Tucher trusts in the prayers of his friends and relations. Recalling his comments to Endres, he tells his cousin's son Anthony II, in a shorter correspondence, how he thinks of him, his father, and his family at the holy places.[26]

[25] "Vnd mir ist das hercz gering dor czw. Jch thröste mich ewr vnd ewr vetter vnd pruder teglicheß gepecz das mich piß her wol gefurdert hot. Dor vmb so pitte jch euch, ir losset nit ab. Jch hab eur aller auch gedocht an den heiligen stetten, wo es Got angeneme wer, mit meinem klein gepet. So werde wir noch hie mussen pleyben piß auf acht oder czegen tag jm setemper, das die kulen wieder anget. Jeczundt ist es zw heiß, disse reiß czw thun. ... Jch befilch mich jn eur gepet. Vnd grust mir den wirdigen vatter prior vnd vetter vnd pruder alle fleissig, vnd pitt sie nit noch czw lossen, mein czw gedencken mit jrem gepet. Da mit spar vns Got der almechtig gesunt, das wir mit freuden wider an einander sehen mugen." At this time, the father prior was Georg Pirckhamer; see Herz, *Die "Reise,"* p. 654 n. 6.

[26] In Hans Tucher's letter to his relative Anthony, who took care of Hans's affairs in Nuremberg during his absence, he also mentions his prayers for him and his family at the holy places: "So pit ich dich, du lost dir mein weib vnd gesind pefolhen sein vnd vnsserm handell, wan ich ein besonder vertrauen zw dir hab. Du thust an mir, alß ich an euch gethon hab zc. So hab ich deinß votter seligen, meinß guten freuntz, vnd eur aller, ouch gedacht on den heiligen stetten hie mit meinem slechten einfeltigen klein gepett, woe das gott genem wer" (Thus, I ask you to care for my wife and household, and business, for I particularly trust you. You do to me as I did to you etc. So I remembered yours blessed passed away father, my good friend, and all of you by my little simple small prayer at the holy sites, where it pleased the Lord) (LT2, 655).

Endres and Anthony, recipients of spiritual and secular status, stand for the extended public but also for the communities invested in pilgrimage. Endres notes explicitly the general interest in Hans's letter and explains: "Everybody … religious and secular persons [alike]" (LT1, 654) wanted to hear.[27] The tattered page bespeaks the human desire to touch such a missive when it is being read aloud. The content seems to become more real when the tactile sense is engaged, and listeners clearly wanted not only to hear but also see and touch the writing.

In his letter, Hans's personal experience in the Holy Land frames the portrayal of the church of the Holy Sepulchre; in the printed report, the description of the church nearly disappears amid the enormous volume of information. However, the status accorded to the church of the Holy Sepulchre in Christianity renders it the climax of every pilgrimage. In Tucher's report, the description of this church is placed between the visit to Mount Zion and the presentation of the Christian nations in the church of the Holy Sepulchre, followed by a short description of the square and of the sites in front of the church. The church of the Holy Sepulchre was the first stop for pilgrims when entering the city of Jerusalem. They stood before the closed church to receive the common Jerusalem indulgence, after which they looked for accommodations. Pilgrims would generally return to the church of the Holy Sepulchre three times more during their stay, also visiting the sites of Mount Zion, the Via Dolorosa, the exterior of the Dome of the Rock, the Mount of Olives, the Valley of Josaphat, Bethlehem, Emmaus, and Bethpage, as well as, if circumstances allowed, the Jordan Valley. Tucher, unlike most pilgrims, traveled further, visiting Mount Sinai and St. Catherine's Monastery and travelling back via Cairo and Alexandria to Venice and Nuremberg.

The Church of the Holy Sepulchre and the St. Sebald Church

Like most pilgrims, Hans paid three visits to the church of the Holy Sepulchre during the official stay of his pilgrim group.[28] Upon arriving in Jerusalem early on the morning of 2 August, the group walked to the square in

[27] "jederman … von geistlichen vnd weltlichen persunnen." This remark suggests a broad reception of the letter in Nuremberg. With regard to the addressees of writings, Kathryne Beebe distinguishes bweeen intended and actual audience (*Pilgrim and Preacher: The Audiences and Observant Spirituality of Friar Felix Fabri (1437/8–1502)* [Oxford: Oxford University Press, 2014], p. 125).

[28] See his remark in TA 440.

front of the south entrance of the church. Only afterward did the pilgrims repair to their *Spital*, that is, a guesthouse, to rest (LT1, 649; TA 379). On 3 August, two hours before nightfall, the pilgrims were led into the church of the Holy Sepulchre to remain for the whole night. It is here that Tucher's description starts in his letter and in his account (LT1, 649–53; TA 390–404). On the night of 5 August, the pilgrims were again allowed to visit the church (LT1, 653; TA 440–41). During this visit, several pilgrims were dubbed as knights of the Holy Sepulchre, probably including Tucher.[29] Finally, on 9 August, they were again let into the church by the Ottoman rulers of Jerusalem (TA 448).

Tucher, as he informs us in his letter, intended to portray the church through "a comparison to St. Sebald's Church, though the Temple [the Church of the Holy Sepulchre] is not as long as the church [St. Sebald], so it is after all wider, etc." (LT1, 650).[30] Back in Nuremberg, the dimensions do not seem to be as clear as they were earlier: far from the Holy Land, he is not as sure about the width of the church of the Holy Sepulchre. He thinks that "[St. Sebald] is longer and may be a little wider."[31] In the letter, Tucher complains about time constraints preventing him from writing more extensively; this time pressure appears again when he briefly mentions the seven Christian *nationes* or denominations and their locations in the church at the start of his description. At the end of the letter, he again refers to a better or more elaborated description yet to come. In this forthcoming version, he promises to discuss special indulgences he had noted for himself but not written down in the letter (other than the indulgence at the Holy Sepulchre). Thus, Tucher was not altogether content with the depiction and comparison of the church he offered in his correspondence. Nonetheless, he provides an impressive review of this most important Christian church by encouraging the imagination of the reader. As the table below shows, for each site in the church of the Holy Sepulchre, he presents an equivalent in his own parish church. Sites of the church of the Holy Sepulchre

[29] Tucher tells of a certain note he had containing the names of all the candidates that were to be dubbed as knights (TA 441). In his letter to Endres, he tells of the presence of the Duke [Balthasar] of Mecklenburg (LT1, 654). The duke had participated in the whole program for the pilgrims, and during the ritual, he was the first one to accept and then pass on the accolade due to his social rank.

[30] "ein *gleichnuß* von Sant Sebolcz kirchen, wie wol der thempel nicht als langk ist, so ist er doch weitter *etc.*" St. Sebaldus Church today is around 87.5 meters long and 25.5 meters wide. For slightly different measurements, see Fries, *St. Sebalduskirche*, p. 15.

[31] "sie [St. Sebald's Church] jst lenger vnd mag auch ein wenyg preytter sein."

in Jerusalem are compared to sites of the St. Sebald's Church in Nuremberg in LT1, 650–53:

Church of the Holy Sepulchre	St. Sebald
1) the entrance porch	"vnter vnser lieben Frawen thur" (=Porch of the Three Kings)
2) the Stone of Unction	(entering the church straight on)
3) the Tomb of Christ or Aedicula	West Choir/Choir of St. Catherine
4) the Chapel of Apparition	Porch of St. Mary
5) the Altar of St. Magdalene	(after site 4 then 3 steps down)
6) the Holy Prison (Prison of Christ)	Sacristy
7) the (Chapel of the) Division of Robes	Niche of the Holy Sacrament
8) the Chapel of St. Helena	St. Peter's Altar
9) the Derision Chapel (Crown of Thorns)	Altar of St. Stephan
10) Calvary	Close to the porch of the Three Kings

All told, Tucher mentions ten holy sites in the church of the Holy Sepulchre, usually pairing them with their corresponding places in the St. Sebald Church, presented in the order in which they were seen by pilgrims entering the church on their processional path. He starts at the south entrance porch compared to today's Porch of the Three Kings (1);[32] he then follows the pilgrims' path to the west, where the aedicula site corresponds to the place of St. Catherine's altar in St. Sebald (3); next he moves to the north to the chapel of Apparition, comparable to the baptism area in St. Sebald (4), where the official procession starts; then he goes east to the site of St. Helena's Chapel, which he compares to St. Peter's altar in St. Sebald (8); then on to the southeast to Calvary site, comparable to St. Stephan's altar (10); then back to the Stone of Unction (2) to the south; then west to the aedicula (3); and finally ending up again to the north at the chapel of Apparition (4). In so doing, Tucher gives a lucid picture of the structure and

[32] Tucher refers to this porch as "the Porch of Our Lady" due to Mary's image at the tympanum inside. Today's Porch of Mary is the one in the north of the church, showing scenes of Mary's death. See St. Sebald Church, https://sebalduskirche.de/sebalduskirche/ (accessed 30 October 2021).

arrangement of the sites in the church of the Holy Sepulchre (figs. 2 and 3; and see the ground plans of the two churches in figs. 6 and 7).[33]

However, when comparing the description with that found in his later printed report, it appears that Tucher had already mentioned all ten important sites the pilgrims visited within the Holy Sepulchre Church in his letter. His sole omissions concern procedures about the entrance fee, the burials of the kings of Jerusalem within the church, and the navel of the world. The core of the pilgrim's description, the comparison of the church of the Holy Sepulchre with St. Sebald Church, was already contained in the letter, which featured all the holy sites he would later depict more precisely in the pilgrim account, where he tripled the length of his analogy. In the letter, the Stone of Unction and the altar of St. Magdalene are the only sites missing specific points of comparison to St. Sebald. In his account he provides two comparable sites in St. Sebald. Tucher had written his letter to Endres on August sixth. It may be that he realized he was missing concrete equivalents and measures. His third visit to the church of the Holy Sepulchre on August ninth (TA 448) and his longer stay in Jerusalem (TA 461) offered further opportunity to revise his measurements. Most likely it was back in Nuremberg in St. Sebald, where he applied his comparative details by walking around and finding the missing sites for his analogies. Therefore, he compares the site of the Stone of Unction to the place where the seats end in St. Sebald after one enters the church and walks about ten paces straight on (TA 392). Similarly, he gives the exact measurements to reach the altar of St. Magdalene and an equivalent site in St. Sebald, the altar of St. Erhard (TA 396). In his letter, Tucher also did not explain why he used the form of "gleichnuß" (LT1, 650), a term with a wide range of meanings, among them, *imago, figura, similitudo, simulacrum, effigies,* or the rhetorical *comparatio*.[34] In his printed account, he gives more information on his use of comparison:

> Jtem, so I planned to write a comparison of the Church of the Holy Sepulchre and reckon it as the church of the holy main patron Saint Sebald in Nuremberg ...

[33] For the whole description and analogy of the church, see Maria E. Dorninger, "St. Sebald Church and the Church of the Holy Sepulchre: Retracing the Path of Jerusalem's Holy Places in Nuremberg," in *Jerusalem Elsewhere—The German Recensions*, ed. by B. Kühnel and P. Arad (Jerusalem: Spectrum, 2014), pp. 83–90 (pp. 84–89).

[34] Regarding the multiple meanings of "Gleichnis," see Jacob and Wilhelm Grimm, *Deutsches Wörterbuch: Der Digitale Grimm; Version 05-04*, ed. by Hans-Werner Bartz et al., 1st ed. on CD-Rom (Frankfurt a. M.: Zweitausendeins, 2004) VII (2004) 8184–205. The term implies a comparative and figurative likeness as well. It requires two correlated dimensions of meanings showing a measure of similarity, which allows for the act of comparison.

Fig. 2. Nuremberg, St. Sebald, St. Peter's Altar.
Photo: Author.

But so the holy sites in the Temple will be better remembered, I undertook this analogy.[35] (TA 390–91)

In Tucher's view, analogy facilitates recall of the holy sites within the church. Immediately following this statement, he describes how the pilgrims enter and walk through the church. Therefore, in the description, the order of the holy sites follows the pilgrims and their procession, starting at the main entrance. St. Sebald is presented in a slightly more detailed way in the printed account than in the letter, a fact that can be explained by the different addressees of the two texts. The letter was to be read in Nuremberg, so Tucher had no need to specify

[35] "Jtem so hab jch mir furgenomen, ein gleichnuß von dem tempel deß Heiligen Grabs zu schreiben vnd geschatzt den alß die kirchen deß heiligen haubtheren Sant Seboltz zu Nuremberg … Aber darvmb, das die heiligen stet jm tempel einem desterpaß jngedenck sein zu mercken, so hab jch dise geleichnuß fur mich genommen."

Fig. 3. Jerusalem, Church of the Holy Sepulchre, view of the stairs down to the Chapel of St. Helen. Photo: Author.

where St. Sebald's Church is located. The pilgrim report, for its part, addresses a larger community of recipients in the German-speaking area who are interested in Holy Land pilgrimage. Therefore, Tucher adds the name of the city, Nuremberg, to his description of the St. Sebald Church (TA 391).

Let us compare how Tucher presents the main entrance of the church of the Holy Sepulchre and the Stone of Unction in the letter and in the account. In the lettter, he begins by mentioning the "Temple," that is, the church of the Holy Sepulchre, comparing it to the St. Sebald Church by using the comparative conjunction "as" (underlined twice in the following table) or a similar expression to draft the analogy between the two churches. As is very obvious in

German, he also employs the subjunctive (underlined) to signal the point of reference. The letter's description is shorter and less elaborated but highly informative with respect to the pilgrims' path. Concise architectonical elements, measurements, and deictic notes disclose a focus on the path of the procession and the religious event. Below, I present a comparative table of the analogous descriptions of the main entrance and the Stone of Unction in the church of the Holy Sepulchre to sites in the St. Sebald's Church in Hans Tucher's letter and in his travel account:

paragraph of Tucher's letter to Endres Tucher (LT1, 650)[36]	extended version of the paragraph in Tucher's travel account of 1482 (TA 391–92)[37].
"Item, the Temple [= the Church of the Holy Sepulchre] shows only one door, where you enter. This is always closed and sealed by two heathens. … Item, the door leads into the Temple, as if it were the door in St. Sebald Church leading under the Porch [of the Three Kings, whose tympanum inside is showing the	"If St. Sebald Church had also only one door to enter, as the Temple has only one door to enter in. And this would be the door under the Porch [of the Three Kings whose tympanum inside is showing the image] of Our Lady at St. Sebald Church, when you climb up the stairs from the city scale to the cemetery and

[36] "Jtem der thempel hot newer ein tor, do man hin ein get, das versliessen vnd versigeln die heiden albegen. … Jtem das thor get jn den thempel, als wer es die thur czw Sant Sebolcz kirchen, die do vntter vnsser lieben Frawen thur jn die kirchen get. Vnd als man gerichcz hin ein get, do ist die stat, do vnsser lieber here hin gelegt wardt, als er von dem heyligen kreucz genummen waß." The particle of comparison "as" is underlined twice, the subjunctive (underlined) signals the point of reference. All underlined text here and in quotations below are additions by the author.

[37] "Sant Seboltz kirchen, ob die auch neuer ein thur hett, alß der tempel neuer ein thure hatt hynein zugeen. Vnd das were die thure an Sant Seboltz kirchen vntter vnser Frawen thure, alß man von der wag herauff get die stiegen auff den kirchoff vnd zu derselben thure pey der stygen jn Sant Seboltz kirchen. Also jst die thure am tempel. Jtem alß man vns pilgram zu derselben thur jn den tempel ließ geen, gyng der gardian mit dem maisten teyl seiner bruder auch mit vnß jn den tempel von monte Syon. Wann die bruder durffen nichtz geben, wenn man den tempel auff schleust, sunder sie mugen mit den pilgrammen hynein geen. Vnd komen wir auf den berg Caluarie, darauff Got alßpald ein jetlich cristenlich mensch, der cristenlichs gelaubenß vnd jn gutem fursacz ist, jn den tempel sein fuß seczt vnd hynein geet, der hot verdynt vergebung aller sunde von pein vnd schuld. Vnd alß man jn tempel kumpt vnd schlechts hynein geet pei × schrytten, als do die stülle ein end haben, vngeuerlichen alß man zu Sant Sebolt die vorgeschriben thure hynein geet, doselbst jst ein stein an der erden. Do jst die stat, do vnser lieber herre vnd Got gelegt, alß er von dem heiligen creucz genomen ward. Do will jch nachvolgend paß von schreiben, so jch mit der processen an das ende kum."

image] of Our Dear Lady, into the church. And if you [enter and] go straight ahead, there is the site, where our dear Lord was laid, when he had been taken from the cross."	along the stairs to the same door in St. Sebald Church. <u>Corresponding [to this]</u> is the door of the Temple. Item when we pilgrims were allowed to enter the Temple through the same door, the guardian [head of the Franciscans] and most of his Franciscan brothers from Mount Zion went together with us into the Temple. Because the brothers need not pay anything, when the Temple is opened, but they may enter together with the pilgrims. And we came about Calvary, where God [died. And] as soon as every Christian person of Christian belief and with good intentions places his foot in the Temple and enters it, forgiveness of all sins of pain and of guilt is given. And when you have entered the Temple and go straight ahead about ten paces, where the seats end, approximately <u>if</u> you <u>enter</u> the aforementioned door at St. Sebald, there lies a stone on the earth. There is the place, where our dear Lord and God laid, when he had been taken from the Holy Cross. About this I will write more later on, when I will come to an end with the [description of the] procession."

While the letter provides basic measurements and information, the pilgrimage report extends them and outlines the locations more exactly.[38] Beyond that, the report contains narrative elements about the experience of the pilgrims and supplies more explanatory and religious information.

Regarding the Stone of Unction, too, Tucher offers two different descriptions, one in the letter and the other in the report. In the former, he stresses drafting the pilgrims' path and refers to events in the life of Christ while in the

[38] For the ritual act of measurement in the Holy Land using the example of Jerusalem, see Zur Shalev, "Christian Pilgrimage and Ritual Measurement in Jerusalem," *Micrologus/La misura* 19 (2011), 131–50.

latter, he highlights the Stone itself, detailing the colors, circumstances (Mary cradling her dead son), and the proper indulgence (the indulgence and forgiveness of all sins of pain and guilt) (LT1, 652; TA 402). As he remarks in his letter to Endres, he noted all of the indulgences for the proper places, but he did not specify them in the letter (LT1, 653).

Hans, however, does not limit himself to one point of reference throughout the analogy. At two places, he refers to other buildings known to his addressees, both in the letter and in the report. When describing the chapel of the Virgin in his letter, he relates its dimension to the chapel of the Twelve Brothers' House in Nuremberg. This charitable foundation for retired craftsmen, donated by Conrad Mendel at the end of the fourteenth century, has not survived.[39] The second reference is included in the elaborate analogy of the site of the Tomb of Christ:

> Then, where the choir of S. Catherine is located, there is, moreover, a rotund church [in the Church of the Holy Sepulchre] like the one in Eichstätt, which is [the Eichstätt-Church] situated in front of the city. This one [in Eichstätt] is a copy of it [in Jerusalem] in the middle of the church [of Eichstätt] itself. There [in the middle of the church] the Holy Tomb [in Jerusalem] is situated.[40] (LT1, 651)

This description of the Holy Tomb is remarkable for its switch from subjunctive to indicative mood, signaling the close resemblance of the two objects in the comparison. Obviously, Tucher is not aiming to provide an architectural

[39] For the chapel, see conf. LT1, 651: "Dor noch get man wider, als ob man von Sant Kathreyn kor herab ging, vnd als pei der thauff thur man hin auß ging jn ein kapellen. Die selbige kapelle ist als groß als vngeferlich der Czwelf Pruder Kirch vnd heist vnsser lieben Frawen kapellen. (Then you go as if you would go coming from the S. Catherine's Choir and off the baptism door into a chapel. This chapel is approximately as large as the Church of the Twelve Brothers and is called the Chapel of Our Dear Lady [Chapel of Apparition])." See also the same description in the report TA 393: "do stet ein cappellen alß groß vngeuerlich alß der zwelff bruder kirch zu Nuremberg."

[40] "Dor noch, do Sant Kathreyn kor stet, do ist ein sinbelle kirch hin auß geleich, wie die ist czw Eistet, die vor der stat stet. Die ist dor noch gemacht mitten jn der selben kirchen. Do stet das Heilige Grab." The phrase "mitten jn der selben kirchen" (in the middle of the church itself) looks as if it refers to the Holy Tomb copy in Eichstätt. This copy was originally surrounded by a round church; see Michael Rüdiger, *Nachbauten des Heiligen Grabes in Jerusalem in der Zeit von Gegenreformation und Barock* (Regensburg: Schnell und Steiner, 2003), p. 14. But this phrase seems to refer to the following sentence regarding the Holy Tomb in Jerusalem, too. If this double reference did not exist, an element describing the original tomb's location would be lacking. Therefore, this syntactic element indicating the special site should be considered as a rhetorical *apo koinou* construction.

lesson but to allude to the well-known Holy Tomb copy in Eichstätt, which gives him an opportunity to spotlight the building of the Holy Sepulchre in Jerusalem.

In the pilgrimage report, Tucher describes the Holy Tomb three times: when the pilgrims enter the church of the Holy Sepulchre on 3 August (TA 392–93); in the chronology of the pilgrims' procession within the church, where he refers to the likeness of Eichstätt but also to the stone that closed the Holy Tomb and to basic architectural elements (TA 402–03); and close to the end of his account (TA 617–18).[41] There, Tucher presents the shape of the Holy Sepulchre, supplying the exact measurements of the different elements of the chapel and the tomb itself.[42] The most interesting reference to Eichstätt is the first mention of the aedicula in the account:

> Item, then, if you were to go from the same place to S. Catherine's Choir back in the church [St. Sebald], at the same place in the Temple, there is situated a wide, rotund church <u>identical in size and width to the church at Eichstätt in front of the city</u>, which is called [Church] of the Holy Cross. This [church], a bishop of Eichstätt had built like that [in Jerusalem]. In the midst of the same rotund church or chapel itself is situated the <u>Holy Sepulchre [in Jerusalem], which is then very much like the one at Eichstätt</u>.[43] (TA 392–93)

Tucher's method here recalls that used in the letter, and again he chooses the indicative mood for the church of the Holy Sepulchre. He compares the site

[41] This portrayal is placed after the end of Tucher's explicit pilgrim account and as the first part of informative instructions for future Jerusalem pilgrims (TA 617–38). This additional information includes: 1) form and shape of the Holy Sepulchre (without reference to Eichstätt), 2) distances within twenty European kingdoms and two empires starting in Nuremberg and also including distances from Venice to Jaffa and Jerusalem and from there to Constantinople, 3) practical instructions concerning money exchange, clothing, medicine to take, food, and items for personal use, 4) information on conditions during sea travel, and 5) an example of a contract between clients and a ship patron.

[42] He had based his description on the report of Sebald Rieter the Elder; see Randall Herz, "Briefe Hans Tuchers d. Ä. aus dem Heiligen Land und andere Aufzeichnungen," *Mitteilungen des Vereins für Geschichte der Stadt Nürnberg* 84 (1997), 61–92 (pp. 80–81). See also the description of the Holy Tomb by Sebald Rieter the Elder, "Sebald Rieters Reisen," in *Das Reisebuch der Familie Rieter*, ed. by Reinhold Röhricht and Heinrich Meisner (Tübingen: Litt. Verein Stuttgart, 1884), pp. 10–36 (pp. 16–18).

[43] "Jtem darnach so man von derselben stat gyng zu Sant Katherina kor hyntten jn die kirchen, an derselben stat jm temple, do stet ein weite, runde kirchen gleich jn der größ vnd weyt als die kirch zu Eistet vor der stat, die zu dem Heiligen Creucz genant ist, die ein bischoff von Eystett nach dieser hat pawen lassen. Mitten jn derselben runden kirchen, oder cappellen, do stet das Heilig Grab, das dann auch dem zu Eystet seer geleichet."

of the Tomb Chapel and its arrangement to the copy in Eichstätt. When it comes to the comparison of the original Holy Sepulchre, he seems to shift his perspective. The Holy Sepulchre in Eichstätt is again compared to the one in Jerusalem, but copy and original seem to switch positions. The Eichstätt copy, so famous in German-speaking regions, seems to have influenced Tucher's perception to the point that he reversed original and copy. Thus, for a moment, the Holy Sepulchre in Jerusalem seems to be the copy of Eichstätt.[44] The only hint that the reader is given to restore the proper positions of original and copy is the little word "dan*n*" (then), which can also be interpreted as "consequently" within the analogy. So, having perceived Eichstätt as a Jerusalem copy in the account, the reader grasps (the text in brackets included) "the Holy Sepulchre [in Jerusalem], which is then [=consequently, because the bishop built a copy] very much like the one at Eichstätt."[45] The syntax is unexpected as it emphasizes Eichstätt. Through it, however, we can discern the writer's own attitudes and impressions, as well as his struggle between emotion and intellect. Specifically, we witness how he is emotionally drawn to grant the well-known copy primacy and assign the original a subordinate status, while he is rationally inclined to take precisely the opposite view (figs. 4 and 5).[46]

[44] The copy of the Holy Sepulchre in Jerusalem in Eichstätt (ca. 1160) was the project of Walbrun of Rieshofen, provost of the cathedral; see Rüdiger, *Nachbauten*, p. 14, and the article by Shimrit Shriki-Hilber in this volume.

[45] Tucher seems to have been rather precise about the shape of the Holy Tomb. Another merchant of Nuremberg, Jörg Ketzel, had traveled to Jerusalem in 1453 and devoted a Holy Sepulchre copy to the Heilig Geist-Spital in Nuremberg. Tucher measured the Holy Tomb in Jerusalem and showed Ketzel's measures to be inaccurate, as he stated in a note. This note was transmitted by Hartmann Schedel in his own print of Tucher's pilgrim account; see Randall Herz, "Hans Tuchers d. Ä. 'Reise ins Gelobte Land,'" in *Wallfahrten in Nürnberg um 1500*, Akten des interdisziplinären Symposions vom 29.–30. September 2000 im Caritas Pirckheimer-Haus in Nürnberg, ed. by Klaus Arnold (Wiesbaden: Harrassowitz, 2002), pp. 79–104 (p. 82 n. 9). The shape of Ketzel's Holy Sepulchre seems to have been based more on the Constantine model or on the model of the Holy Sepulchre in Aquileia (about 1050). For Aquileia, see Justin E. A. Kroesen, *The Sepulcrum Domini through the Ages* (Leuven: Peeters, 2000), p. 47, and Rüdiger, *Nachbauten*, p. 13. Rüdiger links the shape of Aquileia's tomb to drafts of Arculf transmitted in Abbot Adamnan's description (seventh century) (ibid., p. 13 n. 24).

[46] Similar phenomena seem to be experienced by pilgrims today. While on an impressive and informative excursion led by Bianca Kühnel in Germany in 2010, a guide said something intriguing about Jerusalem pilgrims coming from Görlitz, a town containing famous copies of the Holy Sepulchre and Calvary. When these pilgrims return, the guide related, they like "their crack in Calvary rock" more and experience it as more real. Here again, the crack at home or the familiar copy seem to be (emotionally) more real than the original.

Fig. 4. Eichstätt, Holy Tomb aedicule. Photo: Author.

Epilogue

Hans Tucher employed an extended analogy as a rhetorical means to support his memory of the holy sites (TA 391).[47] By means of comparison, he also brought the unfamiliar to life for him and his recipients. A tried and true method in travel reports, comparison was applied frequently to illustrate distances or measurements and to establish similarities, as Arnold Esch has ably shown. He supposed, regarding the given information in analogies, that a comparison demonstrates what an observer seeks to grasp and convey. Consequently, he considers the *tertium comparationis* as a constitutive element that cannot be neglected.[48] This *tertium comparationis* may consist of measurements,

[47] The notion of memory will be investigated in another article that deals specifically with St. Sebald and the church of the Holy Sepulchre.

[48] Belonging to the ornatus of speech, comparison (in the form of *similitudo*) is a basic rhetorical method (Marcus Fabius Quintilianus, *Institutio oratoria* V.11.22–24, ed. and trans. by Helmut Rahn, *Ausbildung des Redners*, 12 vols. (Darmstadt: Wissenschaftliche Buchgesellschaft,

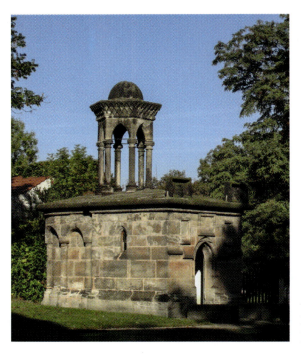

Fig. 5. Görlitz, Holy Tomb. Photo: Author.

colors, or other properties. Esch holds that comparison reveals how a writer or observer receives impressions and, by expressing and transmitting them, conveys his point of reference. This point of reference is where writer and recipient meet; it is the point that provides data about the cultural characteristics of writer and recipient, such as patria or home country, social status, interests, and mentality.[49] All of these aspects influence perception.[50]

2011); see Gert Ueding and Bernd Steinbrink, *Grundriss der Rhetorik: Geschichte, Technik, Methode* (Stuttgart: J. B. Metzler, 1986), p. 286. The *tertium comparationis* can be mentioned or omitted. Ueding gives as example: Her hair is as brilliant as the sun, or Her hair is like the sun (p. 286). Ueding defines *comparatio* as linguistic comparison and as referring to another subject that is larger and higher. The object of comparison may be viewed as a kind of *exemplum* (p. 273). Close to *similitudo* is the metaphor that is described by Quintilian VIII.6.8, as a shortened *similitudo*, whereas allegory is viewed as a continuous metaphor (Quintilian VIII.644) (p. 295–96).

[49] Arnold Esch, "Anschauung und Begriff: Die Bewältigung fremder Wirklichkeit durch den Vergleich in Reiseberichten des späten Mittelalters," *Historische Zeitschrift* 253, no. 2 (1991), 281–312 (pp. 287–89).

[50] For the aspect of perception and that of the mental map that forms perception, see Bernhard Jahn, *Raumkonzepte in der frühen Neuzeit: Zur Konstruktion von Wirklichkeit in Pilgerberichten, Amerikareisebeschreibungen und Prosaerzählungen* (Frankfurt: P. Lang, 1993), pp. 13–21. See also for the term "knowledge of topos," which may be helpful with regard to perception, in the study of Friederike Hassauer, "Volkssprachliche Reiseliteratur: Faszination des Reisens und

A SINGULAR EXPERIENCE OF JERUSALEM 185

Fig. 6. Nuremberg, St. Sebald Church, ground plan with imagined path of pilgrims or of the procession in the Church of the Holy Sepulchre in Jerusalem, adjusted to St. Sebald. After Schwemmer and Lagois, *Die Sebalduskirche*, p. 14.

Fig. 7. Jerusalem, Ground plan of the Church of the Holy Sepulchre with path of pilgrims. After Gorys, *Heiliges Land*, p. 98.

In regard to Tucher, the comparison shows his familiarity with the St. Sebald Church and also his knowledge of other churches in Nuremberg and beyond. Esch demonstrates that the use of familiar objects and buildings as points of reference in comparisons is not exceptional in travel reports. He points to the humanist Gabriele Capodilista of Padua and and the canon lawyer Santo Brasca of Milan, who used analogies in ways that recall Tucher. In his *Itinerario* (Pilgrimage) of 1458, Capodilista compares the church of the Holy Sepulchre to the church of St. Antonio in Padua. He is writing to the nuns of St. Bernardino in Padua, addressees with spiritual backgrounds like the recipient of Tucher's letter, his brother Endres. Capodilista's description enables the nuns to find or imagine the Holy Sepulchre exactly before the choir in their church in Padua "as if it would be situated before the cross hanging above the access to the choir." The phrase "as if it" in combination with the subjunctive used in the comparison is precisely the phrase that Tucher used later.[51] Like Capodilista, the statesman Santo Brasca compares the site of the Holy Sepulchre to a corresponding site in St. Lorenzo in Milan.[52] Tucher had close contacts to Italian merchants, particularly in Venice for his family business, the Tucher Trade

räumlicher Ordo," in *La littérature historiographique des origines à 1500*, ed. by Hans Ulrich Gumbrecht, Ursula Link-Heer, and Peter-Michael Spangenberg, Grundriss der romanischen Literaturen des Mittelalters XI.1 (Heidelberg: Winter, 1986), pp. 259–83. According to Friederike Hassauer, knowledge of topos can be understood as cultural knowledge from written sources, as knowledge from antiquity and the Bible, see ibid, pp. 269–73. This knowledge also influences the perception of the traveler; see also Maria E. Dorninger, "Memory and Representations of Jerusalem in Medieval and Early Modern Pilgrimage Reports," in *Visual Constructs of Jerusalem*, ed. by B. Kühnel et al. (Turnhout: Brepols, 2014), pp. 421–28. (pp. 424–26).

[51] The quote follows Esch, "Anschauung," p. 306. For a description of the church of the Holy Sepulchre, see Gabriele Capodilista, "Itinerario," in *Viaggio in Terrasanta di Santo Brasca 1480. Con l'Itinerario di Gabriele Capodilista 1458*, ed. by Anna Laura Momigliano-Lepschy (Milan: Longanesi, 1966), pp. 161–241 (pp. 201–3); and for his description of the site of Holy Tomb, see p. 202: "El sepulchro del nostro Signor è denanti dal coro in mezo la chiesia come seria ne la predicta chiesia di Sancto Antonio denanzi al crucifixo che è sopra la porta che va in coro."

[52] Quoted in Esch, "Anschauung," p. 306. On Santo Brasca's *Viaggio in Terrasanta*, see ibid., pp. 306–7. In regard to the presentation of the church of the Holy Sepulchre, see Santo Brasca, "Viaggio in Terrasanta," in Momigliano-Lepschy, *Viaggio in Terrasanta di Santo Brasca*, pp. 45–150 (pp. 91–93), Likewise, Felix Fabri, in his *Evagatorium* (written about 1485), portrays the hills of Jerusalem by comparing them to hills in Basel; see Fabri, *Evagatorium*, II, note on p. 204: "Sicut enim Basileensis montuosa est, sic et haec. Habet enim Basilea montem sancti Leonhardi pro monte Syon, et montem sancti Petri pro monte Calvariae, et montem sancti Martini pro monte Moria, quamvis sit longa dissimilitudo in figura et situatione inter illam et istam. (For as [the city] of Basel is rich with mountains, so is she [Jerusalem]. For Basel exhibits, like Mount Syon, the mount of St. Leonhard, and as Calvary the mount of St. Peter, and the mount of St. Martin for mount Moria, although there is a large dissimilarity in shape and site between this and that [city]."

Company, as he states in his travel account (TA 578).[53] Consequently, he may have read Italian pilgrim accounts. However, it seems that Tucher's rather extended analogy sets another standard. Whereas the Italian writers engage only sporadically in comparison, Tucher's text compares consistently all the important sites within the church of the Holy Sepulchre, establishing a real pathway through the church of St. Sebald. Measurements including distances between sites and the position of places are mainly his *tertium comparationis* that constitutes the bond between the churches. By imagining a real walk, these measurements transfer the pilgrims' procession, which linked the holy sites of the church to salvational history, to another site. This imagined procession activated well-known biblical or legendary knowledge. Although the church of the Holy Sepulchre has undergone changes through the ages, the most important measurements, sites, and relics have stayed the same. Step by step, the recipient of Tucher's letter or account could retrace the pilgrims' holy procession in the church of the Holy Sepulchre and meditate on the events in the life of Christ and the history of salvation. By walking the transferred path, a kind of coexperience and co-Passion could arise via the imagination. As Esch remarks in reference to Tucher: "Heilsgeschichte wird abschreitbar" (Salvation history is to be paced)."[54] Not only salvation history, however, but the very path of the pilgrims can be paced in Tucher's analogy. As with prayers, which connected Tucher and his kin at home, transcending time and space in their thoughts, his analogical travelogue enabled them to share the same path. The pilgrim transcends time and space by sharing his experience, and the addressees do so by receiving the measurements, which constitute a real medium for coexperience with the pilgrim.

The sites within the church of the Holy Sepulchre refer to the final days of Christ and his Resurrection.[55] They comprise also stations in the developing meditations of the Way of the Cross, as discussed in the *Kreuzwegbüchlein* of the Priest Bethlem, written after 1471.[56] The priest drafted a meditation of the life of Christ that covers the course of the week. The events to meditate on Friday and Saturday correspond mainly to sites in the church of the Holy

[53] Grote, *Die Tucher*, pp. 32–33.

[54] Esch, "Anschauung," p. 294.

[55] The most holy sites in the church of the Holy Sepulchre are Christ's Apparition to his mother and Mary Magdalene, his holy prison, the division of his robes, the Crown of Thorns, the site of his dying on Calvary (thematically related to it is the site of the discovery of the Holy Cross by Empress Helena and typologically to Adam's Chapel or burial), the Stone of Unction, and the Tomb of Resurrection.

[56] Karl Alois Kneller, *Geschichte der Kreuzwegandacht von den Anfängen bis zur völligen Ausbildung* (Freiburg: Herder, 1908), pp. 153–55.

Sepulchre.[57] Beyond that, Priest Bethlem measures the distance between the sites. As would a pilgrim to the Holy Land, he marks the achievement of all indulgences by pious meditation. In doing so, he equates spiritual and physical pilgrimage, an approach that can also be deduced from hermeneutic methods in biblical exegesis, where allegory plays a major and valuable part.

In his letter to Endres, Hans Tucher notes, at the end of his analogy:

> In that way, the procession was finished. And at each just-mentioned site, altar prayers were read and sang, and then a monk recounted, first in Latin, then in Italian, and then in German. At these sites, there are many indulgences of pain and guilt. Of these I did not write before, though I took notes of them.[58] (LT1, 653).

Here, Tucher paints a vivid picture of the procession itself and of its meditative and pious character. While he does not explicitly invite Endres to retrace his path in the St. Sebald Church,[59] his lines could be interpreted as a kind of suggestion to do so since he provided the means. Discussing spiritual pilgrimage, Wieland Carls claims: "Spiritual pilgrimages [the genre] are to be understood as a special form of Christian meditation. During meditation, while travelling in imagination, preferably in collective, events of salvation history are spiritually witnessed after or co-experienced."[60] Endres's stress on the letter's strong attraction is worth pondering. We might speculate that in addition to being read and meditated upon in the Carthusian house, this missive might have been brought to the church and used as a sort of guide. With respect to the special place of analogy in the letter, it seems clear that it functioned not only as a rhetorical means to better recall the holy sites in the church of the Holy Sepulchre but also as a text for spiritual pilgrimage.

[57] Friday: Calvary, derision of Christ, the nailing of Christ to the cross, Mary and John before the cross; Saturday: to the Stone of Unction and the tomb of Christ; see ibid., p. 156. For Priest Bethlem, see also Nicky Zwijnenburg-Tönnies, "Die Kreuzwegandacht und die deutschen Pilgertexte des Mittelalters," in *Fünf Palästina-Pilgerberichte aus dem 15. Jahrhundert*, ed. by Randall Herz, Dietrich Huschenbett, and Frank Szcesny (Wiesbaden: Reichert, 1998), pp. 225–60 (p. 226). His *Kreuzwegbüchlein* (*Dit is een devote meditatie op die passie ons liefs Here*) was first transmitted in manuscripts. It was printed in Antwerp since 1510. For Antwerp as a place of interest for the Tucher dynasty, see Grote, *Die Tucher*, pp. 35–37.

[58] "Do mit so het die proczesse ein ende. Vnd pei jeder vorgeschribener stat do laß vnd sang man ein colecten, vnd es saget dor auff ein munich waß, do waß jn lathein, dor noch jn welisch vnd dor noch jn deutschcz. Es ist auch an vil der enden aplaß von pein vnd schuldt, do von ich oben her ab nit geschriben hab, wie wol ich das sust eingeczeichent hab."

[59] Felix Fabri did this. In his *Sionpilger*, he invites nuns to spiritual pilgrimage; Felix Fabri, *Die Sionpilger*, ed. by Wieland Carls (Berlin: Erich Schmidt, 1999), p. 77.

[60] Ibid., p. 36. The earliest transmitted manuscript of the *Sionpilger* dates from 1493 (p. 61). On the discussion of the term "spiritual pilgrimage" and problems of a certain genre of "gaistlich bilgerfart," see pp. 23–24.

Path of the pilgrims (TA 390-403, 405) in the CHURCH OF HOLY SEPULCHRE	Analogue sites (TA 390-403, 405) in the St. SEBALD CHURCH
1) Entrance	1) Porch of the Three Kings or Magi
2) Stone of the Unction	2) (close to painting of Calvary)
3) Tomb of Christ (Aedicule)	3) West Choir (Choir of St. Catherine)
4) Chapel of the Apparition (=Franciscan Church)	4) Porch of St. Mary
5) Altar of Mary Magdalene	5) Altar of St. Erhard
6) Holy Prison (Prison of Christ)	6) Sacristy (Large vestry)
7) Chapel: Division of Holy Robes	7) Niche of the Holy Sacrament
8) St. Helena Chapel	8) Altar of St. Peter
9) Derision Chapel (crown of thorns)	9) Altar of St. Stephan
10) Calvary (Golgotha)	10) In the direction of Porch of the Three Kings
11) Entrance	11) Porch of the Three Kings
12) Stone of the Unction	12) (close to painting of Calvary)
13) Tomb of Christ (Aedicule)	13) West choir (Choir of St. Catherine)
14) Chapel of the Apparition (=Franciscan Church)	14) Porch of St. Mary
15) Navel of the world only described, not visited in the procession	15) In the choir (on *pulpitum*, where choirboys sing)

PRAGUE IN JERUSALEM AND JERUSALEM IN PRAGUE: KRISTOF HARANT DESCRIBES THE HOLY SEPULCHRE (1598)

Orit RAMON

Kristof Harant and his fellow pilgrims spent the night of 5 September 1598, in the Church of the Holy Sepulchre in Jerusalem. They arrived in the early evening and were allowed in by the Ottoman guards after checking that the entrance fees had been paid. The door was closed behind them, and they were left there until noon the following day. During the night they held a procession, visited the holy sites in the church, and held prayers and ceremonies. While the pilgrims were given an hour of rest, Harant roamed around the church, punctiliously taking its measurements for a ground plan, and wrote a meticulous comparison of the Holy Sepulchre with the church of St. Vitus, Prague's cathedral.[1]

Harant was not the only traveler to compare the Holy Sepulchre with St. Vitus, and he was not the first to draw an analogy between the church in Jerusalem and a European church. However, as I will argue in the following chapter, the comparison he made is an excellent example of the change in the Christian pilgrimage writing tradition in the early modern era, and more important, it is an example of the way Jerusalem descriptions came to reflect European identities, in this case, Czech identity.

Harant, of Polžice and Bezdružice (fig. 1), was born in Klenová Castle, not far from Klatovy, Bohemia, in 1564. He was the son of a nobleman of the lower aristocracy who served the emperor Rudolf II from 1583—the year in which the capital of the Habsburg Kingdom and the German Empire moved from Vienna to Prague. Kristof received a broad humanistic education, studying of seven languages, music, and painting. At the age of twelve, he joined the

[1] Kryštof Harant z Polžic a Bezdružic, *Cesta z Království Českého do Benátek, odtud do Země Svaté, země Judské a dále do Egypta, a potom na horu Oreb, Sinai a Sv. Kateřiny v Pusté Arabii* [A journey from the Czech kingdom to venice, from there to the Holy Land, the land of Judea, and further on to Egypt, then to Mount Horeb, Sinai and St. Catherine in the Arabian Desert], ed. by Karel Jaromír Erben (Prague: Czech Museum Pub., 1854), chaps. 19–22, pp. 115–33. All references are to the above mentioned edition. All quotations were compared with the 1608 edition.

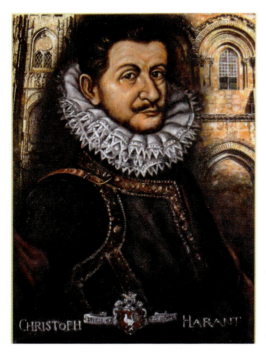

Fig. 1. Kristof Harant (1564-1621) with the Church of the Holy Sepulchre (right) and St. Vitus Church (left) in the background, acrylic on canvas. Drawing: Avi Khatam © Open University Publishing House.

court of Ferdinand of Tyrol, the emperor's uncle, in Innsbruck. He continued his education there and traveled throughout Germany and Italy.[2]

In 1591, after the Ottomans had conquered most of Hungary, Harant returned to Bohemia, joined the war as an artillery officer in Rudolf II's army and, thanks to his heroism in battle, was awarded an annual imperial pension of 700 ducats in 1597. Less than a year later, after the death of his first wife, he left his children with relatives and embarked on a journey to the Holy Land, Sinai, and Egypt.[3] He set out on 2 April 1598, accompanied by another nobleman, a relative twelve years younger than himself, Heřman Černín of Chudenic, and one servant.

Harant published his travel impressions in 1608 with the printing house of Daniel Adam of Veleslavín.[4] A second addition in Czech was printed in 1668. The publication was translated into German in 1638 by his younger brother, Jan Jiří,

[2] Marie Koldinská, *Kryštof Harant z Polžic a Bezdružic: Cesta intelektuála k popravišti* [Kristof Harant of Polzice and Bezdruzice: An intellectual's way to the gallows] (Paseka: Praha & Litomyšl, 2004), pp. 17–43.

[3] Koldinská, *Kryštof Harant*, pp. 60–61. Both his children died in 1601.

[4] Daniel Adam of Veleslavín (1546–1599) was a professor at the Charles University in Prague. After retiring from his post at the university, he married the daughter of a printing

who was exiled to Saxony after the defeat of the Czech estates in the Battle of the White Mountain in 1620. The translation, titled *Der Christliche Ulysses,* was printed in Nuremberg only in 1678 and was dedicated by the translator's son to Emperor Leopold I. Harant's travelogue was republished between the years 1854 and 1855 by Karel Jaromír Erben and the Matice Česká association,[5] as part of the Czech national-cultural revival. The log in its entirety was not published in other languages,[6] and the excerpts in this essay appear in English for the first time.

Harant and Černín started their journey at Bystřice, traveled through Tyrol, and arrived, on 19 April 1598, in Venice, where they were joined by five other pilgrims. They sailed, made stops in Crete and Cyprus, and reached Jaffa on a Syrian boat, after suffering a severe storm at sea. The group hired the services of a Franciscan translator and guide,[7] and left Jaffa on donkeys for Ramla. The day after, escorted by an Ottoman horseman and a few foot soldiers, they arrived in Jerusalem, where they stayed at the Franciscan monastery of St. Savior. Harant's overall stay in the city lasted for two weeks, from September third to the nineteenth.

While visiting Jerusalem, Harant entered the Church of the Holy Sepulchre twice.[8] The first visit, with the entire group of pilgrims, was guided by a Franciscan monk and lasted the whole night. The second visit took place only with Černín and an Italian nobleman with whom they traveled so that the men

house owner, Jan Melantrich, who printed travel books, Czech history, and Czech translations of humanist literature.

[5] Matice Česká was a national sociocultural Czech association, founded by František Palacký, who is considered to be the Czech national historian. The association acted as part of the Czech National Museum in Prague and was aimed at publishing Czech literature and Czech translations of world literature. See Zdeněk V. David, *Realism, Tolerance and Liberalism in the Czech National Awakening: Legacies of the Bohemian Reformation* (Washington, DC: Woodrow Wilson Center and Johns Hopkins University Press, 2010), pp. 83–105; Rita Krueger, *Czech, German, and Noble: Status and National Identity in Habsburg Bohemia* (New York: Oxford University Press, 2009), pp. 161–90; Matice Česká, http://snm.nm.cz (accessed 11 April 2022).

[6] Except for the German version, only parts were translated into French: *Voyage en Egypte de Christophe Harant de Polžic et Bezdružic 1598,* trans. by C. & A. Brejnik (Cairo: Institut français d'archéologie orientale du Caire, 1972).

[7] On this occasion, Harant used "de la centura" when mentioning the Franciscans. On other occasions, he, like other pilgrims, applied this term to Christians who were named after Mary's belt that was found by St. Thomas and conducted their lives according to the Syrian rite of Antioch. See N. Chareyon, *Pilgrims to Jerusalem in the Middle Ages* (New York: Columbia University Press, 2005), p. 97 n. 29. For the confusing use of the term, see Andrew Jotischky, "The Mendicants as Missionaries and Travelers," in *Eastward Bound: Travel and Travellers, 1050–1550,* ed. by Rosamund Allen (Manchester: Manchester University Press, 2004), p. 93.

[8] The church received most of Harant's attention. Its description is found in four out of sixteen chapters dedicated to Jerusalem in Harant's first volume.

could be dubbed as Knights of the Order of the Holy Sepulchre.[9] During the overnight stay at the Holy Sepulchre, Harant toured the church and measured it, writing a detailed comparison between the Holy Sepulchre and the St. Vitus Cathedral in Prague that I quote in translation below.

Translation of Harant's Comparison between St. Vitus Cathedral and the Church of the Holy Sepulchre: *A Journey*, volume 1, chapter 22, pages 131–33 (figs. 2–3)

The doors [leading] into the church [face] south and are placed like the doors of St. Vitus,[10] [that open] out toward the palace. Except for these doors, there are none others to it. (1)[11]

Inside the church of St. Vitus, in the chapel of St. Sebastian, there is now a sacristy.[12] It can be compared to the chapel of the Blessed St. Mary[13] in the

[9] Opinions differ regarding the origins of the Order of the Holy Sepulchre. Some tried to tie it to the crusader knights, especially to Godefroy de Bouillon, but, in fact, the first evidence of dubbing for knighthood is that of Wilhelm von Boldensel in 1336, and the founding of the Order is probably related to the nomination of the Franciscans as the guardians of the Holy Land (Custodia Terrae Sanctae). Joining the Order did not require an ongoing commitment, but it was a tribute to the pilgrim as well as, simultaneously, an inexhaustible source of income for the Custody. In the absence of a secular authority, it was the Custos that dubbed the knights. See "Knights of the Holy Sepulchre," in *Catholic Encyclopedia*, http://www.newadvent.org/cathen/07427c.htm (accessed 11 April 2022). The Order still exists today.

[10] St. Vitus died a martyr in Sicily in the fourth century. The arm of the Italian saint was given by Heinrich I, king of the Germans, to Wenceslas, duke of Bohemia (who became a saint himself), in the tenth century. Wenceslas dedicated the central church at the Prague Castle to the relic and made St. Vitus one of the Czech saints. David Ch. Mengel, "Bones, Stones, and Brothels: Religion and Topography in Prague under Charles IV (1346–78)" (unpublished doctoral thesis, University of Notre Dame, 2003), p. 267; on St. Wenceslas, see n. 74.

[11] The numbers in brackets refer to the churches' ground plans.

[12] St. Sebastian, who propagated Christianity within the Roman army, was caught and executed. At the St. Vitus sacristies, along with vestments, holy vessels and church records were kept as well as the relics that were not transferred to Karlštejn Castle by Emperor Karel IV. See Mengel, "Bones, Stones, and Brothels," pp. 267–324; Iva Rosario, *Art and Propaganda, Charles IV of Bohemia, 1346–1378* (Woodbridge: Boydell, 2000), pp. 27–46.

[13] This chapel is one of the northern chapels at the Holy Sepulchre, mentioned in the twelfth century as owned by the Greek Orthodox church and from the fourteenth century on by the Latin church. Processions started there. Denys Pringle, *The Churches of the Crusader Kingdom of Jerusalem* (Cambridge: Cambridge University Press, 2007), III, pp. 26, 34; See also M. Biddle, G. Avni, J. Seligman, and T. Winter, *The Church of the Holy Sepulchre* (New York: Rizzoli in cooperation with Israel Antiquities Authority, 2000), pp. 86–87.

Fig. 2. Jerusalem, Church of the Holy Sepulchre. Drawing: Author.

church of the Holy Sepulchre, which also has a sacristy in it, and behind it is the refectorium.[14] (2)

From there, when walking in St. Vitus eastward, around the organ's gallery, the first chapel after the sacristy is consecrated to St. Anne, and it is like the chapel of Christ's prison and resembles it in its plan.[15] (3)

[14] According to Harant's description, the refectorium was a small room, adjacent to St. Mary's Chapel, which belonged to the Franciscans. The pilgrims and monks took a break in it for eating and resting during their overnight stays at the church. Harant I.21, p. 129.

[15] The tradition regarding the place where Christ was imprisoned while waiting for his Crucifixion was first mentioned in the ninth century. The site was a station in the Greek Orthodox Good Friday processions and was adopted by the Latins and approved by Pope Alexander III. The chapel was one of the three in the ambulatorium. See Anthony Bale, "God's Cell: Christ as Prisoner and Pilgrimage to the Prison of Christ," *Speculum* 91, no. 1 (2016), 1–35; See also Pringle, *Churches of the Crusader Kingdom*, p. 13: It seems that Harant marked the chapel where it is today and noted that it was under Greek and Georgian control (I.19, pp. 116–17). See also Biddle et al., *Church of the Holy Sepulchre*, p. 86.

Fig. 3. Prague, St. Vitus Church. Drawing: Author.

The second chapel after it at St. Vitus is called Ursula and the Eleven Thousand Virgins,[16] in which the Lords of Perštejn[17] are buried. [This chapel] is like the place where Christ was given the sponge soaked in vinegar and gall.[18] (4)

At the third chapel, that of St. John,[19] lie buried St. Břetislav, who was killed on a hunt or a chase in 1100,[20] and his brother Bořivoj, who was a singer at

[16] The "old Archbishop's chapel" of today's church.

[17] The Perštejns were a Moravian noble family that became one of the leading families in the Czech court, thanks mainly to their support of the Hussites and, later on, their support of the Czech king Jiří of Poděbrady. The family held many estates in Moravia and southern Bohemia. The burial site of the Moravian branch of the family is, to this day, in Doubravník, and members of the Bohemian branch are buried in Pardubice. Nowadays, only Vratislav of Perštejn is buried at St. Vitus. On sixteenth-century Czech noble families, see Jaroslav Pánek, "The Nobility in the Czech Lands, 1550–1650," in *Rudolf II and Prague—The Court and the City*, ed. by E. Fučíková (London: Thames & Hudson, 1997), pp. 270–86; Jaroslav Pánek et al., *A History of the Czech Lands* (Prague: Karolinum, 2009), pp. 204–6.

[18] John 19:34. According to tradition, based on the fourth-century (presumably) Gospel of Nicodemus, it was a Roman soldier named Longinus who saved Jesus from misery with his lance. "The Gospel of Nicodemus, or Acts of Pilate," in *The Apocryphal New Testament*, trans. by M. R. James (Oxford: Clarendon Press, 1924), 16:7.

[19] John the Evangelist (?).

[20] Břetislav II, duke of Bohemia (1060–1100) was murdered while on a hunting trip west of Prague by assassins sent by his opponents. His biography was written by Cosmas of Prague (1045–1125) as part of his Czech chronicles. On his death and burial, see Cosmas of Prague,

this church of St. Vitus and passed away in 1124.[21] These Czech princes were the sons of Vratislav, the first Czech king.[22] [This chapel] is like the one in Jerusalem where they cast lots on Christ's garments.[23] (5)

The fourth chapel is called St. Apollinář[24] and in it the masters of Berka[25] hold their funerals. [The chapel] is at exactly the same place where the doors, [leading] down to the chapel of St. Helena, are, where the three crosses were found.[26] (6)

The fifth is called St. Stanislav,[27] in which the masters of Šternberk are buried.[28] In it also lie buried two Czech kings—both named Přemysl Otakar. One of them was killed in battle against Emperor Rudolf I in 1278.[29] [This chapel]

The Chronicle of the Czechs, trans. by Lisa Wolverton (Washington, DC: Catholic University of America, 2009), pp. 194–96.

[21] Bořivoj II (1064–1124), duke of Bohemia and Břetislav II's brother, who ruled Bohemia after his death, was exiled by his younger brother Vladislav, and then returned to co-rule with him. Ibid., pp. 233–34.

[22] King Vratislav II (?–1092), duke of Bohemia, was recognized king by the German Emperor Heinrich IV in 1086. Ibid., pp. 161–64.

[23] Matthew 27:35. The Chapel of the Garments was one of the five eastern chapels at the Monomachian church (1048). Today it is the chapel for the commemoration of the Armenian genocide.

[24] St. Apollinář was the first bishop of Ravenna. According to tradition, he was appointed bishop by Paulus and died as a martyr.

[25] The Berkas were a noble family that held large estates in northern Bohemia, in Lípa and Dubá. The family had built its position, in part, by kinship ties to Jiří of Poděbrady, the Czech king. Like other Czech noble families, it lost all its possessions through confiscation after the battle of the White Mountain (1620). See Pánek, "Nobility in the Czech Lands," pp. 270–86; Pánek, *History of the Czech Lands*, pp. 196–98.

[26] Jacobus a Voragine, *Legenda aurea*, ed. by Th. Graesse (Leipzig, 1850), pp. 303–16. The chapel of St. Helena was built during the twelfth century and from the fourteenth century on was held by the Franciscans. Pringle, *Churches of the Crusader Kingdom*, pp. 12, 15, 33.

[27] St. Stanislav (1030–1079), bishop of Krakow, was executed by Boleslaw II, king of Poland, and canonized as a martyr and saint in Assisi in 1253.

[28] The beginnings of the Šternberk family, which had most of its lands in central Bohemia, were in the twelfth century, and the family had an ancestor who was, apparently, one of King Přemysl Otakar II's men. Later, one of the ladies of the family supported the Hussite cause and married Jiří of Poděbrady (in spite of the fact that some members of the family remained loyal to the Catholic Church and even fought the Hussites). Although a number of family members returned to Catholicism, the Šternberk properties were also confiscated after the White Mountain. A few family members are still buried at the Saxon Chapel at St. Vitus. See Pánek, "Nobility in the Czech Lands," pp. 270–86; Pánek, *History of the Czech Lands*, pp. 104–5.

[29] Přemysl Otakar I (1155–1230) crowned himself king of Bohemia and won recognition by politically maneuvering between Otto IV and Philip of Swabia, who fought for the imperial German crown. Přemysl Otakar II (1233–1278), king of Bohemia, enlarged the kingdom to the Adriatic. He fought Rudolf of Habsburg for the imperial crown and eventually was killed in one of the battles against him. See Pánek, *History of the Czech Lands*, pp. 91, 95–96, 101–2.

is like the chapel in which underneath the altar stands the column on which Christ sat when they crowned him with the Crown of Thorns.[30] (7)

The sixth was called St. Elisabeth.[31] There are stairs there toward the east, upward to the gallery, to the place where His Royal Highness, the Emperor, and his men stand and where they have their seats. [This chapel] is like the upper gallery where there was the chapel of Mount Calvary.[32] (8)

The seventh is, when walking farther west in St. Vitus, opposite the church's doors. There, on the ground, is a marble stone on the tomb of the memorable brave knight, Master Mikuláš Miřkovský of Tropčice and Miřkově, a man of His Royal Highness, governor of the Prague Castel, and the highest scribe in the Czech kingdom.[33] He was buried in 1575 and the place is like the one on which Christ was anointed before he was put into his grave.[34] (9)

The eighth is, at the center of this place, in front of the choir and beneath the organ, where the graves of Emperor Charles IV and other Czech kings are. They are made of white alabaster and are behind iron bars, and [placed] according to the same plan of the Holy Sepulchre, where the chapel and the burial cave of Christ are.[35] (10)

[30] The chapel with the column on which Christ sat when he wore the Crown of Thorns was identified in the thirteenth century at the east side of the ambulatory. According to Pringle, it was probably the central chapel, but in Harant's description it is the southern chapel, the one Pringle suggested as the chapel of the Flagellation (*Churches of the Crusader Kingdom*, p. 27).

[31] St. Elisabeth (1207–1231) was the daughter of András II, the Hungarian king who married the Duke of Thuringia. At 20, she was widowed and was one of the first to join the Third Order of St. Francis. She was canonized by Gregory IX.

[32] In the sixteenth century, there were stairs leading to the Calvary only from the ambulatory. Fra Bernardino Amico, *Plans of the Sacred Edifices of the Holy Land* (Jerusalem: Franciscan Printing Press, 1997), p. 89. In the sixteenth century the Ottomans recognized the Greek Orthodox holding of the northern part of the Crucifixion Chapel, while the Latins remained with the two southern altars: the Stabat Mater and the Nailing to the Cross. See Raymond Cohen, *Saving the Holy Sepulchre—How Rival Christians Came Together to Rescue their Holiest Shrine* (Oxford: Oxford University Press, 2008), pp. 6–7.

[33] Mikuláš Miřkovský was appointed governor of the Malá-Strana in Prague in 1561, then promoted to be the commander of the King's Castle in Karlštejn and the governor of Prague's castle. *Historický Archiv* (v Praze: České Akademie Cisaře Františka Josefa, 1904), Let 1526–1627.

[34] John of Wurzburg (1165) was the first to tie, in his description, the site of Jesus's anointment with the site where the center of the world was marked at the center of the choir. Harant saw the Anointment Stone after the renovations that were done in the church in the sixteenth century. See Pringle, *Churches of the Crusader Kingdom*, pp. 26, 35.

[35] Although Harant did not compare the Czech kings' graves with those of the Frankish kings of Jerusalem, Bianca Kühnel claims that Charles IV himself planned his burial site, referring to the Frankish site in Jerusalem (Bianca Kühnel, "Monumental Representations of the Holy Land in the Holy Roman Empire," in Die Kreuzzugsbewegung im römisch-deutschen

The ninth is, when walking from here back northward to the sacristies or to [the chapel] of St. Sebastian, next to St. Dorothy's altar.[36] It looks like the place where there were the two stones, out of which on one stood Christ when he appeared before Mary Magdalene and spoke to her, after he had risen from the dead. Mary Magdalene stood on the second.[37] (11)

In general, this main church of God's tomb is built artistically in expansive marble (it has ten marble pillars, each made out of one rounded piece, and six others built as squares) and sometime in the past, under Christian rule, it was enriched with gold and silver. The places indicating Christ's deeds, martyrdom, burial, and Resurrection are all under one roof and in one closed construction. It is similar to the chapels mentioned above at the church of St. Vitus, but the distance of one chapel from the other in Jerusalem is bigger than in the church of St. Vitus, as can be seen from the recording of the steps, mentioned above.[38] The building of the cathedral, including the choir within, is rounded as in St. Vitus (12), but the one in Jerusalem is more spacious and the height, from the ground to the choir, is a little smaller than in St. Vitus. At its center there is a hole, lined with marble, which we were told is supposed to be at the center of the world. But I mentioned above the most probable place which is more likely to be the center of the earth and the world.[39] This choir is held by the Greeks, and they are the only ones to hold [ceremonies] there.

Reich (11.–13. Jahrhundert), ed. by Stefan Tebruck and Nicolas Jaspert (Sigmaringen: Thorbecke, 2014), p. 167. I thank Prof. Kühnel for sharing a preliminary version of this article with me. The fourteenth-century royal necropolis at St. Vitus was replaced in 1589 by the Habsburg mausoleum. See Petr Uličný, "The Choirs of St. Vitus's Cathedral in Prague: Marriage of Liturgy, Coronation, Royal Necropolis and Piety," *Journal of the British Archeological Association* 168, no, 1 (2015), 168–233 (esp. p. 208).

[36] Dorothea of Caesarea of Cappadocia, a martyr.

[37] The construction of the chapel, dedicated to the meeting between Jesus and Mary Magdalene, was part of the construction of the whole church in the eleventh century. The chapel has been held by the Latins ever since. Jerome Murphy O'Connor, *The Holy Land—An Oxford Archeological Guide, From Earliest Times to 1700* (Oxford: Oxford University Press, 2008), p. 58; Pringle, *Churches of the Crusader Kingdom*, p. 26.

[38] During his voyage, and especially during his visit to the Holy Sepulchre, Harant measured (in miles, steps, arms, etc.) each and every site. The results of his measurements at the Holy Sepulchre are written in detail and are integrated into his description of the procession in the church.

[39] From the fourth century on, the Golgotha was identified by Christians as the center of the world. The crusaders relocated the site and identified it with the center of the crusaders' church—the Catholicon. See Sylvia Schein, *Gateway to the Heavenly City: Crusader Jerusalem and the Catholic West (1099–1187)* (Aldershot: Ashgate, 2005), pp. 141–57. According to Harant's description, the site of the center of the world was identified at the Catholicon and was

The church in Jerusalem, like the church of St. Vitus, has no window but a large hole, rounded, not roofed, in the west, through which, down at the church, you can see the sky. There is enough light coming in from above. There is an opening in the width of two sáh,[40] built in wooden beams and cement, integrated into the church's wall, which looks like chimneys or round and large ventilation holes. It is in the center of the pillars' hall, right above the chapel of God's tomb. In other places all the building is covered with rounded thin plates of copper.

The Holy Sepulchre and Other Analogies

Harant, as noted, was not the first to compare St. Vitus with the Holy Sepulchre. Oldřich Prefát of Vlkanova (who visited the Holy Land from 1546 to 1547, and whose travel book was published in Prague in 1563), made a similar analogy.[41] Harant notes in the introduction to his book that he was following the footsteps of other Czech travelers who preceded him (Prefát included), in the journey itself and in the manner it should be written. In his preface to the comparison between the churches, he writes:

> As was already mentioned, in regard to the description of the church in which God's tomb is, there are other [descriptions] of it, especially the one of Oldřich Prefát, who described in his travelogue, thoroughly and with many details, the whole building for the sincere reader. Nonetheless, I will write a few more words as an addition.[42]

in the hands of the Greeks. See also Sylvia Schein, "Jerusalem in Christian Spirituality in the Crusader Period," in *The History of Jerusalem: Crusaders and Ayyubids (1099–1250)*, ed. by Joshua Prawer (Jerusalem: Yad Ben-Zvi, 1991), pp. 252–54 (Hebrew); Pringle, *Churches of the Crusader Kingdom*, pp. 35–36; Harant insisted on identifying the center of the world with the Temple Mount (I.22, p. 122).

[40] One old Czech sáh (Přemysl Otakar II's period) is 1.7928 meter.

[41] Oldřich Prefát (1523–1565), a mathematician and a writer, was the son of a wealthy burgher family of textile merchants from Prague. His travelogue was published as *Cesta z Prahy do Benátek a odtud potom pomoří až do Palestyny, to jest do krajiny někdy Židovské, země Svaté, do města Jeruzaléma k Božímu hrobu, kteraužto cestu s pomocí Pána Boha všemohúcího šťastně vykonal Voldřich Prefát z Vlkanova léta Páně MDXXXXVI* (A journey from Prague to Venice, and then by sea to Palestine, Judea, the Holy Land, to the city of Jerusalem to Our Lord's grave, which, with the help of the Lord Almighty, was done happily by Oldřich Prefát of Vlkanova in the year of the Lord 1546]. Chapters 23 to 31 describe of the Holy Sepulchre. For a new edition of the book, see *Oldřich Prefát z Vlkanova: Cestaz Prahy do Benátek a odtud potom po moři až do Palestiny* [Oldřich Prefát of Vlkanova: A journey from Prague to Venice, and then by sea to Palestine], ed. by Hana Bočková (Praha: Nakladatelství Lidové noviny, 2007).

[42] Harant I.22, p. 131.

Actually, it was Přefát who broadened the comparison between the Holy Sepulchre and St. Vitus, as well as between Prague and Jerusalem, in which he also included the Mount of Olives, the Mount of Zion, and the Cedron.[43]

The two Czechs were not the first nor the only travelers to compare the Holy Sepulchre to other churches in Europe. After visiting Jerusalem, Anthony de Reboldis wrote an analogy between the Holy Sepulchre and the church of Santo Stefano in Bologna.[44] In his travelogue, penned in 1350 in Latin, Ludolph von Suchem compared it with St. Paul's Cathedral in Münster, Westphalia.[45] William Wey, who visited Jerusalem twice, in 1458 and 1462, compared the Holy Sepulchre to San Marco in Venice.[46] Gabrielle Capodilista, his 1458 voyage companion, made a similar comparison with the church of San Antonio in Padua.[47] The German merchant Hans Tucher (1482) compared the church of the Holy Sepulchre with Nuremberg's central church of St. Sebald,[48] and three other travelers—Fancesco Suriano (1485), George Sandys (1610), and William Lithgow (1614)—compared the church in Jerusalem with Santa Maria Rotunda in Rome.[49] In the

[43] Přefát's comparison of the churches is in chapter 31, and the analogy between the Mount of Olives and Mount Zion with the Strahov and Karlův Monasteries is mainly in chapter 47. Přefát was accompanied in his travels by a Venetian painter and woodcut artist named Domenico dalle Greche. In 1546, on dalle Greche's return, he was appointed by the Venetian senate to publish his *Particularis et vera descriptio plateae sancti sepulcri*, which included drawings from his travels. A year later, he contributed some of the drawings and a map to Přefát's book.

[44] Reboldis, a Franciscan from Cremona, made a pilgrimage to the Holy Land and Egypt in 1331. Jotischky, "Mendicants as Missionaries," pp. 91–92; On the construction of the church of Santo Stefano in Bologna as Jerusalem, see R. G. Ousterhout, "The Church of Santo Stefano: A 'Jerusalem' in Bologna,'" *Gesta* 20, no. 2 (1981), 311–21.

[45] Not much is known of Ludolph von Suchem except that he was a church rector in Suchem (Sudheim) Paderborn, Germany. He visited and stayed in the Holy Land for five years (1331–36), and his description of it is considered the most important of the fourteenth century. He is often quoted by Felix Fabri and others. On the analogy to Münster, see *Ludolph Von Suchem's Description of the Holy Land and of the Way Thither*, trans. by Aubrey Stewart (Cambridge: Cambridge University Press, 2013), p. 103.

[46] William Wey was an Oxford English scholar and a member of the Augustinian abbey in Abingdon, who, after his return from his pilgrimage to Jerusalem, redesigned the abbey in light of the Holy Sepulchre. See Pnina Arad, "Pilgrimage, Cartography and Devotion: William Wey's Map of the Holy Land," *Viator* 43, no. 1 (2012), 301–22.

[47] Gabrielle Capodilista, son of one of the distinguished families in Padua, went on a pilgrimage with Antonio, his cousin. See R. J. Mitchell, *The Spring Voyage—The Jerusalem Pilgrimage in 1458* (New York: C. N. Potter, 1964), pp. 40–41; For the analogy of the churches, see Gabrielle Capodilista, *Itinerario in Terra Santa* (Perugia: Pietro da Colonia, 1475), p. 100.

[48] See, Maria E. Dorninger, in this volume, "A Singular Experience of Jerusalem: St. Sebald Church in Nuremberg".

[49] Fancesco Suriano was a traveler and a merchant who joined the Franciscan order and was appointed in 1493 to head the Mount Zion Monastery in Jerusalem as the Custos. See Deborah

sixteenth century, a comparison of the Jerusalem church was made with the Temple in London by Sir Richard Guylforde (1506), followed by Sir Richard Torkington (1517),[50] to name but a few.

Harant and the Christian Pilgrimage Writing Tradition

The equating of sites in Europe with those in Jerusalem was not necessarily due to accurate physical resemblance. In the Middle Ages, similarities between two buildings were based, first and foremost, on the way these structures functioned and especially on the way they were understood.[51] Only in the early modern era did the physical characteristics of buildings—their ground plans, measurements, and practical functions—became essential for comparisons, with measurement being the main tool used.[52] At this time, systematic attempts at accurate measurements came to characterize descriptions of the holy places. In an era when

Howard, "Venice as Gateway to the Holy Land: Pilgrims as Agents of Transmission," in *Architecture and Pilgrimage, 1000–1500: Southern Europe and Beyond*, ed. by P. Davies, D. Howard, and W. Pullan (Farnham: Ashgate, 2013), p. 100; on the comparison, see Francesco Suriano, *Il Trattato di Terra Sancta e dell'Oriente*, ed. by G. Gulobovich (Milan: Tipografia Editrice Artigianelli, 1900), ch. 19. George Sandys was the seventh and youngest son of the archbishop of York and an Oxford graduate. See Jonathan Haynes, *The Humanist as a Traveler—George Sandys's Relation of a Journey begun An. Dom. 1610* (Rutherford: Fairleigh Dickinson University Press, 1986), pp. 13–15; on the comparison, see George Sandys, *Relation of a Journey begun An. Dom. 1610* (London: Thomas Cotes, 1637), p. 166. William Lithgow was a Scot traveler and maybe even a spy. See Francis Hindes Groome, "Lithgow William," in *Dictionary of National Biography, 1885–1900*, XXX, pp. 359–61, http://en.wikisource.org/wiki/Lithgow,_William_(DNB00) (accessed 11 April 2022); on the comparison, see *William Lithgow" The Rare Adventures and Painefull Peregrinations of Long Ninteene Yeares Travayles from Scotland to the Most Famous Kingdomes in Europe, Asia and Affrica* (Glasgow: Glasgow University Press, 1906), part 6, p. 237.

[50] Torkington was an English priest and a relative of the Boulains. See *Ye oldest diarie of Englysshe travell: Being the Hitherto Unpublished Narrative of the Pilgrimage of Sir Richard Torkington to Jerusalem 1517*, ed. by W.J. Loftie (London, c. 1900), p. 39. Richard Guylforde, an English noble who served Henry VII, died on his arrival to Jerusalem. The description of his voyage was published in 1511 by the priest who accompanied him. On the comparison with the Temple, see *The Pilgrimage of Sir Richard Guylforde to the Holy Land*, ed. by H. Ellis (London: J. B. Nichols & Son, 1851), p. 24; see also E. Gordon Duff, *Information for Pilgrims unto the Holy Land* (London: Lawrence & Bullen, 1893), pp. ix–x.

[51] Richard Krautheimer, "Introduction to an 'Iconography of Medieval Architecture,'" *Journal of the Warburg and Courtauld Institutes* 5 (1942), pp. 1–33; Nora Laos, "The Architecture and Iconographical Sources of the Church of Neuvy-Saint-Sépulcre," in *Art and Architecture of Late Medieval Pilgrimage in Northern Europe and the British Isles Texts*, ed. by S. Blick and R. Tekippe (Leiden: Brill, 2005), p. 316.

[52] Krautheimer, "Introduction," p. 20; measurements were copied in the Middle Ages as well but they were used selectively and usually had a symbolic meaning.

curiosity was no longer associated with sin, accurate measurement became both an expression of the authenticity of both the site and the report about it, as well as an expression of the measurer/believer's religious devotion. Measurement thus became part of the pilgrim's sacred practices.[53]

In this context, one can understand the strictness with which Harant measured each and every chapel, hall, and pillar at the Holy Sepulchre and wrote a detailed registry of distances, sizes, and lengths. A striking example is his description of the procession to Calvary:

> When we arrived at about eighteen steps [distance] we turned a bit southward and reached a stone step that was not so wide. From there we went up nine steps eastward to a door, through which we passed. Behind it we turned south and again climbed nine other steps and went through another door, and entered the chapel named Mount Calvary *(montis Calvariae)* or *Golgatha*—the mountain of the scull or the execution. There, we went singing around the chapel, approximately sixteen steps.[54]

Measurement was part of Harant's pilgrimage to the Holy Sepulchre and a reliable basis for comparison with the measurements and ground plans of St. Vitus Cathedral, confirming the sacredness of the latter. It seems that even in those places where Harant himself admitted the discrepancy between the dimensions of the Holy Sepulchre and those of St. Vitus (as in the case of the choir mentioned above), the divergence did not detract from the analogy between the two churches. On the contrary, it could serve as evidence for the accuracy of the measurement itself, which strengthened the overall parallelism.

Pilgrimage Writing and Identity

An explanation for the analogies between the Holy Sepulchre and churches in Europe, as well as the analogy with St. Vitus, can be found in words written by the aforementioned Hans Tucher, a wealthy merchant from Nuremberg who visited the Holy Land from 1479 to 1480, accompanied by a group of fellow citizens.[55]

[53] Justin Stagl, *A History of Curiosity—The Theory of Travel, 1550–1800* (London: Routledge, 1995), pp. 48–49 ff.; Zur Shalev, "Christian Pilgrimage and Ritual Measurement in Jerusalem," *Micrologus/La misura* 19 (2011), 131–50 (pp. 131, 141); Anke Naujokat, "Imitations of the Holy Sepulchre and the Significance of 'Holy Measures,'" in *Jerusalem Elsewhere—The German Recensions*, ed. by B. Kühnel and P. Arad (Jerusalem: Spectrum, 2014), pp. 13–21.

[54] Harant I.20, p. 122.

[55] On Tucher's pilgrimage, see Maria E. Dorninger, "St. Sebald Church and the Church of the Holy Sepulchre: Retracing the Path of Jerusalem's Holy Places in Nuremberg," in *Jerusalem*

Tucher's mediation of his experience in the Holy Sepulchre can be used as a model through which to understand Harant's experiences in the same church. After visiting the church three times and being dubbed Knight of the Order of the Holy Sepulchre, Tucher wrote a letter to his brother Endres describing the church to him. Tucher, already well acquainted with the church, explicitly asked his brother the question he had actually referred to himself: How could he convey the experience of visiting the holy places to those who remained in Nuremberg? In his answer, written as an explanation of the description that follows and as a way of bringing the church and its sites closer to his brother, he compared the Holy Sepulchre to Nuremberg's church of St. Sebald (St. Sebaldus). Tucher, like Harant, connected the familiar and known with the unknown and thus brought Jerusalem and the Holy Sepulchre closer to the readers'/believers' hearts.[56]

Tucher's travelogue was published in 1482 in Augsburg. There, he repeated and extended the analogy he had used in his letter to his brother. Ten stations were recalled in this published description, following the path of pilgrimage at the Holy Sepulchre.[57] Thus, a pilgrimage inside St. Sebald Church could become, with the appropriate imagery and by reading the text, an echo of pilgrimage to the Holy Sepulchre in Jerusalem.[58] Moreover, while attempting to bring the church of the Holy Sepulchre into the hearts of his brother and the other believers, Tucher turned, in his analogy, the church in Nuremberg into a sacred memorial site that represented the holy sites in Jerusalem. Thus, not only were the sacred sites of the Holy Sepulchre transferred and displayed at Nuremberg, but St. Sebald Church itself "became" the Holy Sepulchre, with its own route of the history of salvation.

Elsewhere—The German Recensions. ed. by B. Kühnel and P. Arad (Jerusalem: Spectrum, 2014), pp. 83–90; Maria E. Dorninger, "Memory and Representations of Jerusalem in Medieval and Early Modern Pilgrimage Reports," in *Visual Constructs of Jerusalem*, ed. by B. Kühnel et al. (Turnhout: Brepols, 2014), pp. 421–28. See also this volume, pp. 165–189.

[56] See also Bianca Kühnel, "The Holy Land Beyond the Sea" (Hebrew), in *Ut videant et contingant—Essays on Pilgrimage and Sacred Space in Honour of Ora Limor*, ed. by Iris Shagrir and Yizhak Hen (Raanana: The Open University Press, 2011), pp. 255–56.

[57] There are a few fifteenth-century examples for the Stations of the Cross in Germany and Italy. The Franciscan activity as well as the canonization of the Way of the Cross in Jerusalem contributed to the fixating of the stations in Europe. Bianca Kühnel, "Virtual Pilgrimages to Real Places: the Holy Landscapes," in *Imagining Jerusalem in the Medieval West*, ed. by Lucy Donkin and Hannah Vorholt (Oxford: Oxford University Press, 2012), pp. 251–52, 257–59, 261; William Wey was the first to use the term "stations": *The Itineraries of William Wey, Fellow of Eton College* (London: J. B. Nichols and Sons, 1857), p. 20. See also S. A. Lenzi, *The Stations of the Cross: The Placelessness of Medieval Christian Piety* (Turnhout: Brepols, 2016).

[58] Krautheimer, "Introduction," p. 20.

In fact, Tucher offered his brother and his townspeople a visit, like the visits offered by others to corresponding sites of Jerusalem. He thus presented believers with an intermediary option for pilgrimage—something between the real, difficult, and dangerous journey to Jerusalem and a meditative "armchair journey," achieved through reading or studying maps.[59] The analogical journey, like the real one, was embedded in similar liturgy, and the indulgences that were given at the European sites equaled those of the Holy Land and strengthened the perception of them as holy sites in their own right.[60]

An explanation for the proliferation of analogies between Jerusalem and the European sites is the development of local municipal and/or national identities and the ongoing centralization of governmental powers.[61] From the very outset, Christian identity in Europe was ambivalent: on the one hand, it reflected tension between the perception of the Holy Land as the Christian homeland and Christians as the chosen people while, on the other hand, it fostered bonds to local homeland (*patria natalis*) and identity. The inclination toward a particular and local identity opened a broad and important field for local European interpretations of Jerusalem and its holy sites and for using features of universal Christianity for the construction of local identity.[62]

There are European precedents for using all-Christian terms to define unique local identity. The terms "Holy Land," "chosen people," and "most Christian king" were used as local markers—rather then universal ones—already in thirteenth-century France. The holiness of the Holy Land was woven into French identity through relic collections, saint veneration, and architecture linked to that of Jerusalem, which were all utilized to help centralize governmental power.[63] English identity went through similar processes, mirroring

[59] Neta Bodner, "Transcending Geography: The Transportation of Sanctity from the Holy Land to the Homeland," in *United in Visual Diversity. Images and Counter-Images of Europe*, ed. by Benjamin Drechsel and Claus Leggewie (Innsbruck: Routledge, 2010), pp. 245–47.

[60] In some cases, the indulgences granted in Europe were of lesser value, but they were extended during the sixteenth century. See F. Thomas Noonan, *The Road to Jerusalem: Pilgrimage and Travel in the Age of Discovery* (Philadelphia: University of Pennsylvania Press, 2007), p. 106.

[61] Glenn Bowman, "Pilgrim Narratives of Jerusalem and the Holy Land: A Study in Ideological Distortion," in *Sacred Journeys: The Anthropology of Pilgrimage*, ed. by Alan Morinis (Westport: Greenwood, 1992), pp. 149–68 (esp. p. 150).

[62] Noonan, *Road to Jerusalem*, pp. 113 ff.

[63] Norman Housley, "Holy Land or Holy Lands? Palestine and the Catholic West in the Late Middle Ages and Renaissance," in *The Holy Land, Holy Lands, and Christian History*, ed. by R. N. Swanson (New York: Boydell & Brewer, 2000), pp. 235–36; J. R. Strayer, "France: The Holy Land, the Chosen People, and the Most Christian King," in *Action and Conviction in Early Modern Europe*, ed. by T. K. Rabb and J. E. Siegel (Princeton: Princeton University Press,

those across the channel. Edward III's successes were understood as the deeds of God's grace, the English people were the "new Israel," their kingdom was the *héritage de Dieu*, and London became Jerusalem.[64]

Jerusalem, Prague, and Czech Identity

The explanations offered above for the analogies between Jerusalem's sites and their European representations can partially explain Harant's description of the Holy Sepulchre: the parallelization of the Holy Sepulchre with St. Vitus drew the Holy Sepulchre and the Christian holy sites closer to Harant's Czech readers. He thus enabled them to have both a concrete and spiritual "visit" to Jerusalem in an equivalent site in Prague, possibly promoting local pilgrimage. The issue of identity is paramount, even if it superficially seems that Harant was interested exclusively in the physical resemblance between the churches.

Harant's deeper interest becomes clear when considering the broader context. At the end of the sixteenth century, Prague was already identified with Jerusalem and consequently charged with corresponding spiritual and political resonance. As in France and England, the Czech lands, especially Bohemia, had held since the fourteenth century a political identity based on the sanctity of the land and the nation.[65] It seems that Harant's comparison of the churches, beginning each phase of his comparison first with a description of St. Vitus (and only then the Holy Sepulchre), was meant to reassure the a priori identification of the churches through accurate measurements and to stress the physical resemblance between the cities' central sites. His specificity was intended only to "complete" a known, preexisting equivalence between Prague and Jerusalem.

Charles IV, Prague and Jerusalem

In this final section, I will argue that the identification of Prague with Jerusalem arose from the way Prague's urban space and St. Vitus Cathedral were planned,

1969), pp. 3–16; See also Paul Crossley, "The Politics of Presentation: The Architecture of Charles IV of Bohemia," in *Courts and Regions in Medieval Europe*, ed. by A. J. Minnis (New York: Boydell & Brewer, 2000), p. 112.

[64] Housley, "Holy Land or Holy Lands?," pp. 237–38; J. W. McKenna, "How God Became an Englishman," in *Tudor Rule and Revolution*, ed. by D. J. Guth and J. W. McKenna (Cambridge: Cambridge University Press, 1982), pp. 31–33. London was presented as Jerusalem at the victory celebrations in Agincourt. See Housley, "Holy Land or Holy Lands?," p. 239.

[65] Housley, "Holy Land or Holy Lands?," pp. 239–41. See also Thomas A. Fudge, *The Crusade Against Heretics in Bohemia, 1418–1437* (Aldershot: Ashgate, 2002), pp. 65–66.

designed, and conceptualized by Charles IV (1316–1378), King of Bohemia and Holy Roman Emperor[66]—an identification that was later strengthened by the Czech Hussites and became an anchor for Czech unity and identity. Charles, who received his education in France at the court of his uncle, King Charles IV, understood the political potential in having a royal capital representing the royal administration, the royal mythology, and the appropriate royal figure. He envisioned Prague as the right place to realize these interests for the house of Luxemburg. Although Prague's centrality in the Czech lands can be traced back to the eleventh century, it was Charles IV who made the city a "holy capital" for his dynasty and the Holy Roman Empire. In Prague he initiated the conceptual link, essential to the history of Jerusalem as well, between a royal family (he stressed his Přemyslid ancestry), sacred traditions, and a site of worship. He built Prague as a visual translation of his political theology, with its twofold agenda: the sacralization of Bohemia and its royal family under the protection of St. Wenceslas and the recognition of the emperor as ruler of the world in God's grace.[67]

Immediately upon being appointed King of the Germans, Charles announced new initiatives, including the construction of a new city in Prague with a wide square at its center, named after himself (fig. 4).[68] The square was an important station on the ceremonial route (of the coronation procession), leading from Višehrad, the old Slavonic site of worship, to Prague Castle at Hradčany, the significant Christian site of worship that had been under construction since the tenth century. Thus, the sacred center of the city was realized at Hradčany and was connected to both the royal palace and the new metropolitan church.[69] Prague Castle was destined to become a united political and religious center.[70]

[66] Charles was the son of John of Luxemburg and Elisabeth from the Czech house of Přemysl. He was appointed king of Bohemia after his father died in 1346 and was crowned in 1347. He was elected king of the Germans in 1349 and was made emperor in 1355. See Crossley, "Politics of Presentation," pp. 111–12.

[67] Ibid., pp. 120, 123.

[68] This paper is not aimed at presenting the whole of Charles IV's enterprises but only those that tie Prague to Jerusalem and could have influenced Harant's comparison. On Charles IV, see, for example, Pánek, *History of the Czech Lands*, pp. 123–45.

[69] The recognition of Prague as an archbishopric in 1344 was also due to Charles's efforts. He collaborated with Archbishop Arnošt of Pardubice to enlarge Prague's ecclesiastical authority. See Pánek, *History of the Czech Lands*, pp. 138–40.

[70] Crossley, "Politics of Presentation," pp. 128–30; Charles saw himself as Charlemagne, as well as a descendant of Constantine the Great. The tie with Constantine was also visually represented at Hradčany by the representation of Constantine, Helena, and the Finding of the True Cross, at the St. Wenceslas Chapel in St. Vitus. Other researchers pointed to the similarities Charles created between himself and Heraclius, the Byzantine emperor who reinstated the True

Fig. 4. Prague, 1400, town scheme. Drawing: Author.

Around Charles Square, the emperor founded the church of St. Stephan; the Jerusalem Chapel, dedicated to St. Longinus and probably a burial site for pilgrims who died in Prague on their way to or from Jerusalem; and the church of Sts. Peter and Paul, which was under the auspices of the Franciscan Terra Sancta Custody and displayed a replica of Jesus's Holy Tomb in Jerusalem.[71] During processions that went from Višehrad to Hradčany, new relics that were acquired by Charles IV were presented, and indulgences that were confirmed by Pope Clement VI (Charles's tutor) and reconfirmed by Innocentius IV were

Cross in Jerusalem. See Rosario, *Art and Propaganda*, pp. 44–45; Paul Crossley, "'Bohemia Sacra': Liturgy and History in Prague Cathedral," in *Études d'histoire de l'art du Moyen Âge en l'honneur d'Anne Prache* 5 (1999), ed. by P. Lumière, p. 346.

[71] Paul Crossley and Zoë Opačić, "Prague as a New Capital," in *Prague—The Crown of Bohemia, 1347–1437*, ed. by Barbara Drake Bohm and Jiří Fajt (New York: Metropolitan Museum of Art, 2005), pp. 65–66.

given. It was Innocentius IV who approved indulgences to be given on a new holy day as well, the Day of the Holy Spear and Holy Nail, which was established in 1335 and became one of the most important celebrations in the city. The celebrations took place on the Friday following Octave Easter, and a large part of Charles's relic collection was brought for the occasion from Karlštejn Castle and St. Vitus Cathedral for display in the square. At the center of the square, above the podium where the relics were presented, the Corpus Christi Rotunda was built.[72] The peak was at the All Saints Chapel at Hradčany, in which the two most important relics were kept: a thorn from Jesus' Crown of Thorns that had been given to Charles in France and the skull of St. Procopius that Charles himself bought and donated to the chapel.[73] An indulgence that was confirmed by Clement VI was offered to visitors in the chapel.[74] The Prague Cathedral of St. Vitus was gradually being built above the tenth-century St. Wenceslas Rotunda by order of the emperor on the occasion of the coming affirmation of Prague as an archbishopric.

It was Wenceslas, the Czech saint, whose veneration Charles most promoted.[75] For Charles, Wenceslas was the eternal overlord of Bohemia and a worthy namesake for the Czech crown. Moreover, Wenceslas was understood as an "alter Christus" and the veneration he promoted therefore had the Passion at its center.[76] As early as 1333, Charles donated twelve statues of the Apostles to be placed around St. Wenceslas's tomb, presumably as an echo of the twelve columns around Christ's tomb at the Constantinian Holy Sepulchre. The construction of

[72] Crossley, "Politics of Presentation," pp. 130–31.

[73] Paul Crossley, "Our Lady in Nuremberg, All Saints Chapel in Prague, and the High Choir of Prague Cathedral," in *Prague and Bohemia: Medieval Art, Architecture and Cultural Exchange in Central Europe*, ed. by Zoë Opačić (Leeds: Routledge, 2009), pp. 73–75. Charles maintained a careful balance between Western and Eastern saints and between local Czech and universal Christian saints. Procopius was venerated by the Přemyslids as the patron saint of the Old Slavonic liturgy. See Kühnel, "Monumental Representations," p. 164.

[74] At the same time (1365), the Karlštejn Castle's construction, including the Chapel of the Holy Cross, was finished. The royal and the imperial treasures were gathered in Karlštejn, including, among others, two thorns of Jesus' crown, a piece of the True Cross, relics of St. Wenceslas and St. Stephan, as well as the Holy Spear, the Nail, the crown and sword of Charlemagne, etc. Karlštejn Castle became a pilgrimage site in itself, in which indulgences were given. Kühnel, "Monumental Representations," p. 165.

[75] Wenceslas I, duke of Bohemia (907–935), was murdered by his brother for his adherence to Christianity. He was canonized a martyr and saint. His hagiography was written by Charles IV: *Autobiography of Emperor Charles IV and His Legend of St. Wenceslas*, ed. by B. Nagy and F. Schaer (Budapest: CEU Press, 2001). The legend was originally written in Latin but was translated into Slavonic and became widely known.

[76] Rosario, *Art and Propaganda*, pp. 59–60; Crossley, "Politics of Presentation," p. 158.

St. Wenceslas's Chapel in the cathedral of St. Vitus—perhaps corresponding to Mount Calvary at the Holy Sepulchre[77]—was completed in 1366.

The setting of tombs and altars within St. Vitus Cathedral combined the history of local sanctity with the history of the universal Church and the empire. A reference to John the Evangelist was added to St. Wenceslas's Chapel, special devotion was paid to St. Adalbert's tomb, the second bishop of Prague and a missionary in Prussia , and the remains of St. Sigismond of Burgundy were brought by the emperor himself to be venerated as an additional patron saint of Bohemia.[78] The processions used to enter the church and walk around the choir while displaying the relics took the exact route Harant described, wending from north to south. At their conclusion, they would enter St. Wenceslas's chapel amid the scenes painted on the walls depicting Wenceslas's passion and the Ascension and Heavenly Jerusalem, according to John's Apocalypse.[79] Even the miracle of the Holy Fire occurred there on Wenceslas's saint day (September 28).[80] The exit of the liturgical route was through the southern doors, as described by Harant. These doors, built by Charles IV, were completed between 1371 and 1372 and were named the "Golden Gate" (Porta Aurea). They were decorated with a mosaic depicting the Day of Judgment. The coronation processions passed through these doors, just as the Frankish kings' coronation processions passed through the Golden Gate, which was translocated by the crusaders from the Temple Mount and was associated with the Holy Sepulchre's southern doors.[81]

Charles IV's Prague became a "New Jerusalem" thanks to the set of relics and the pertinent liturgy but also due to the copying of sites connected to Jerusalem

[77] Kühnel, "Monumental Representations," p. 167.

[78] Crossley, "'Bohemia Sacra,'" pp. 350–52.

[79] Rosario, *Art and Propaganda*, p. 59; Crossley, "Politics of Presentation," p. 165; See also Hana Šedinová, "The Symbolism of the Precious Stones in St. Wenceslas Chapel," *Artibus et Historiae* 20 (1999), pp. 75–94.

[80] Mengel, "Bones, Stones, and Brothels," p. 345.

[81] Crossley, "'Bohemia Sacra,'" p. 344; The Golden Gate was one of the gates to the Temple through which Jesus, and Heraclius after him, entered. See Nurit Kenaan, "Local Christian Art in Twelfth-century Jerusalem," *Israel Exploration Journal* 23 (1973), esp. pp. 221–27. Of the importance of the southern entrance to St. Vitus, see Kühnel, "Monumental Representations," p. 167. On the coronation processions in St. Vitus, see Crossley, "'Bohemia Sacra,'" pp. 357–58. The first to be crowned according to Charles IV's regulations was his son Wenceslas IV. He spent the night before the coronation in Višehrad and started there the procession to St. Vitus via Charles Bridge. A relief of this coronation is carved on the eastern tower of the bridge. See ibid., p. 363.

and their display around the city, even if in name only.⁸² Moreover, Prague was presented in sermons and hymns as "Jerusalem," and Bohemia was "the Holy Land" in the spiritual reform that Charles engendered in the Czech lands—reform that would eventually lead to the Czech Reformation and to the establishment of an independent Czech church.⁸³ It was Charles who approved, in 1372, the transformation of a brothel named Venice on the margins of the Old Town into a community house named "Jerusalem," under the leadership of Jan Milíč of Kroměříž. This "Jerusalem" community was supposed to purge the church and society and set an example for repentance. The women there were supposed to abstain from sin by frequently receiving the Lord's Supper, a liturgical act that would become the symbol of the Czech Reformation.⁸⁴ Prague as "Jerusalem," in the eyes of the reformers, became a reflection of the kingdom of God on earth, and signs of it were present in the city: the transformation of lives, the cohabitation of people from different social classes, and the prevailing attitude of peace and charity.⁸⁵ Thus the spiritual reform, added to the physical reconstruction of the city, made the identification of Prague as Jerusalem absolute.

Though the "Jerusalem" community ceased to exist, at least as a visible entity, near the time of Milíč's death in 1374, it inspired the reform movement and gave it the needed legitimization. The "Jerusalem" community, which encompassed only twenty-nine houses at its start, expanded to include all of Prague as the city of the Lord, of which Matěj of Janov wrote that the "Jerusalem" experiment was only the beginning of a divine action through Christ to create Prague, the city of light upon a hill, as Jerusalem.⁸⁶ The Czech patrons of "Jerusalem" went seeking for a new center, and in 1391 the Bethlehem community was established, slightly south of Milíč's "Jerusalem," as one of the reformed churches in Prague. Jan Hus was to be appointed preacher there.⁸⁷

⁸² In the long list of sites connected to Jerusalem there are also two chapels dedicated to the Holy Cross at the Old Town and the Chapel of the Loreto. See Mengel, "Bones, Stones, and Brothels," p. 36.

⁸³ David Ch. Mengel, "Emperor Charles IV (1346–1378) as the Architect of Local Religion in Prague," *Austrian History Yearbook* 41 (2010), pp. 15–29.

⁸⁴ David Ch. Mengel, "From Venice to Jerusalem and Beyond: Milíč of Kroměříž and the Topography of Prostitution in Fourteenth Century Prague," *Speculum* 79 (2004), pp. 407–42.

⁸⁵ Th. A. Fudge, *The Magnificent Ride—The First Reformation in Hussite Bohemia* (Aldershot: Ashgate, 1998), pp. 50–52, 60–62.

⁸⁶ Fudge, *Magnificent Ride*, p. 189.

⁸⁷ For more on the Bethlehem chapel, see Otakar Odložilík, "The Chapel of Bethlehem in Prague—Remarks on its Foundation Charter," in *Studien zur älteren Geschichte Osteuropas*, ed. by G. Stökl (Graz-Cologne: H. Böhlaus, 1956), pp. 125–41.

Later on, the communities of Tabor and Horeb were established in southern Bohemia, as well as Zion, the last bastion of the Hussites in their battle against the Catholic crusades. The Czech lands became the Promised Land, the Czechs became the chosen people, and Prague was the holy city.

When countering the accusations against the Czech reform in a disputation that was held at Charles University (1409), Hieronymus of Prague used these terms and argued in favor of the purity of faith of the "Sacrosancta natio bohemica" in its homeland (*vlast*).[88] Moreover, when crusades were sent to oppress the Hussites, they called for the protection of "the most Christian kingdom" in the name of St. Wenceslas, its patron saint, and for the protection of Prague—the New Jerusalem—against Babel—Rome. Prague as Jerusalem, theologically, as well as historically, became an emblem of Czech unity and of anti-crusade ideology, as shown, for example in the next Hussite call for arms:

> Arise, arise great city of Prague! / With all loyal subjects of Bohemia, / The order of knights and all who bear arms. / Rise up against the king of Babylon / Who threatens the new Jerusalem, Prague, / And all her faithful people /.../ Give glory to the God of Israel / Who surpasses all other gods / Implore him to grant peace to the Czechs.[89]

In a way, Prague as Jerusalem gave Czech reform its identity, its legitimacy, its sense of righteousness, and its eschatological dimension. Although a few confessions evolved from the reform, they were all Czech.[90]

Conclusions

For the Czechs, Catholics and reformists alike; for the people of Prague; and for Harant and Přefat as their representatives, Prague indeed was Jerusalem. As the universal cradle of Christianity, Jerusalem was represented and translated into the local Czech language in a visual and religious-cultural way. The translation of Jerusalem into Czech was already made in the fourteenth century,[91]

[88] Housley, "Holy Land or Holy Lands?," p. 239

[89] Fudge, *Crusade Against Heretics*, pp. 65–66.

[90] Even the Czech Jesuit Bohuslav Balbín (1621–1688) would later define Bohemia as the Holy Land in his book on Bohemian history: *Epitome historica rerum Bohemicarum* (Prague, 1677); See also Noonan, *Road to Jerusalem*, p. 107.

[91] Although in the twelfth century a new convent of German Praemonstratenses was built on Mount Zion in Prague (later called Strahov) by the Bishop of of Olmutz, who returned from a pilgrimage to Jerusalem, the city of Prague was identified with Jerusalem from the fourteenth century. See Klára Benešovská, "De la circulation des *'locis sanctis'*—le Mons Sion à Prague,"

but Harant articulated the old translation in sixteenth century's tools: first and foremost, he completed and strengthened the correlation between the Holy Sepulchre and St. Vitus Cathedral, and between Jerusalem and Prague, using precise physical comparison.

But the "translation" Harant presented encompasses much more than just visual precision. He actually offered a parallel between the chapels in the Holy Sepulchre that mark a Christian salvation route and a Czech route, that linked the chapels in St. Vitus that commemorate Czech saints and a few memorable Czechs, both past and present. The two Czech kings bearing the same name are mentioned as being buried in a chapel parallel to the chapel in Jerusalem where Jesus was crowned with the Crown of Thorns, and the peak is the center of the cathedral, paralleled to the center of the Holy Sepulchre, where Harant identified Christ's tomb with the tomb of Charles IV, later defined as "the Father of the Nation" (*otec národa*). The comparison between the churches, although made by others before him, was meticulously done by Harant and was used to reaffirm Czech uniqueness:[92] equalizing Prague with Jerusalem ensured the Czech identity as particularly chosen by God.[93]

Harant made his agenda quite clear in the introduction to his travel book, when stressing the importance of the Czechs in world history as well as in the history of travel and by repeatedly using the words "our beloved homeland." For Harant, the homeland was Bohemia, the land of the Czechs, where Czech—the language in which he wrote his book—was the most important language spoken.[94] It is interesting to note that Martin Kabátník, another Czech traveler who visited the Holy Land in 1492, summarized his journey by saying how glad he was to return to his homeland, adding that the Holy Land is the Jew's homeland, as Bohemia is the Czechs'.[95]

Convivium 1 (2014), pp. 50–62; Peter Demetz, *Prague in Black and Gold: A History of a City* (London: Penguin, 1997), pp. 30–32, 77–82.

[92] Housley, "Holy Land or Holy Lands?," pp. 239–41. Housley identified these components of Czech identity as early as the fifteenth century.

[93] See also Laura Lisy-Wagner, *Islam, Christianity and the Making of Czech Identity, 1453–1683* (Farnham: Routledge, 2014), pp. 144–45, 154–56.

[94] Harant I.introduction, pp. xxx–xxxii

[95] M. Kabátník, *Cesta z Čech do Jerusalema a Kaira, r. 1491–92* [A journey from the Czech lands to Jerusalem and Cairo, 1491–1492], ed. by Justin V. Prášek (Praha: České Akademie Cisaře Františka Josefa, 1900), pp. 77–78; Martin Kabátník of Litomyšl was sent by the "Bohemian Brethren" (one of the churches that evolved from the Hussite movement). The story of his journey was written before he died, in Litomyšl in 1503, by Adam Bakalář, who added an introduction to the story. The book was first printed in 1539.

Harant went on his pilgrimage as a Christian, but more than anything, his travel book mirrors his Czech identity. This particular identity would later on be realized when Harant joined the Czech Protestant aristocrats' rebellion against the Catholic Habsburgs, leading to his execution in the Old Town square in 1621, after the Czechs were defeated at the Battle of the White Mountain.

GIJSBERT RAET'S JERUSALEM CHAPEL IN LATE MEDIEVAL GOUDA*

Claudia A. Jung

Six "Jerusalem chapels" or "chapels with the Holy Sepulchre"[1] are documented in the diocese of Utrecht between circa 1400 and 1500.[2] These were separate chapels in the urban landscape, displaying architectural features that referenced the church of the Holy Sepulchre in Jerusalem and contained a replica of the tomb of Christ. The first chapel was founded in the diocesan capital by the local Jerusalem brotherhood around 1394 and was situated in the Nieuwe Weerd, just outside the city walls of Utrecht.[3] By 1544, the brotherhood's place

* An earlier version of this article was delivered at the conference 'Glorious Cities – The Presence of Jerusalem in the European Urban Space' at The Hebrew University of Jerusalem (30.04.-03.05.2018). It can be regarded as a preview of some of the main ideas of my PhD thesis, which I have just completed at the University of York. My primary aim is to introduce the various findings from my extensive examination of the archival sources. However, due to the limited scope of this paper, it is not possible for me to give a detailed discussion of all the aspects here. The complete analysis together with the full supporting evidence can be found in my doctoral dissertation, which I intend to get published as a book at some later point. I would like to thank my supervisors, Dr Hanna Vorholt and Dr Jeanne Nuechterlein, for reading and commenting on early drafts of the article. The research leading to these results has received funding from the European Research Council under the European Union's Seventh Framework Programme (FP7/2007-2013) / ERC grant agreement no. 249466. I also gratefully acknowledge the financial support I received from the Erasmus+ programme during my study placement at Leiden University. All transcriptions and translations are my own, unless otherwise stated.

[1] In the following, I use the term Jerusalem chapels, because they are mostly referred to as *Jeruzalem* in the written sources. As these are separate chapels, this is also to distinguish them from contemporary Holy Sepulchre chapels or Easter Sepulchres within parish churches. In some cases, the altar in the respective Jerusalem chapels was dedicated to a particular patron saint, under which name the chapels are also known.

[2] For literature on the chapels, see E. de Jongh and J. A. L. de Meyere, *Een schilderij centraal: De Jeruzalemvaarders van Jan van Scorel* (Utrecht: Centraal Museum, 1979), pp. 17–21; E. J. Nusselder, "De Marthakapel te Delft: Een onderzoek," *Bulletin KNOB* 79 (1980), 51–87 (pp. 57–87); D. E. H. de Boer, "Jherusalem in Leyden," *De Leidse Hofjes* 8 (1979), 40–57 (pp. 50–53); R. Meischke, "De Oude Zijds Kapel," *Amstelodamum* 43 (1956), 160–62; Ronald Glaudemans and Rob Gruben, "De bouwgeschiedenis," in *De Jeruzalemkapel in Gouda*, ed. by Chris Akkerman et al. (Gouda: Stichting Spoor, 1998), pp. 37–65; Koen Goudriaan, "Gijsbert Raet en zijn Jeruzalem," *Tidinge van die Goude* 17 (1999), 15–29.

[3] Jerusalem brotherhoods were a characteristic feature of late medieval Christian devotional life in the Netherlands. Returned Holy Land pilgrims organized locally into lay confraternities for the purpose of religious worship. The ones in Utrecht, Leiden, and Amsterdam had a

of worship was in a state of dilapidation, causing the group to move to St. John's Chapel in the St. John churchyard within the city walls of Utrecht. The chapel in Delft (St. Martha's Chapel) can be dated to circa 1430. Due to the loss of written sources, both the founder and a potential link with the city's Jerusalem brotherhood remain unknown. The wealthy cloth merchant and Jerusalem pilgrim Wouter Coman IJsbrantsz. established the chapel in Leiden (the Holy Cross Chapel) in 1467. It was associated with the local Jerusalem brotherhood. The one in Amsterdam (as part of St. Olaf's Chapel) can be dated to circa 1498 and was maintained by the city's Jerusalem brotherhood. In Gouda, however, the chapel (consecrated in 1504) was founded by the priest and Holy Land pilgrim Gijsbert Willemsz.[4] Raet and not affiliated to the local Jerusalem brotherhood. Marking the end of this regional architectural phenomenon, it stands out among it contemporaries. Not only was it initiated by a private individual, but it was also devised as the founder's burial chapel—a fact that cannot be proved with regard to the other chapels.[5] This situation raises two questions that are central to this chapter: why had Gijsbert Raet specifically chosen a Jerusalem chapel as his final resting place, and does this aspect affect our understanding of the chapel's function?

The chapels, of which only the ones in Delft and Gouda have partially survived, were of similar design. According to the written sources, the chapel in the Nieuwe Weerd was constructed "ad formam et similitudinem templi sancte Jherusalem" (in the form and likeness of the Holy Temple in Jerusalem).[6] St. John's Chapel in Utrecht, as surviving ground plans show, was a twelve-sided, central-plan building with conical roof linked to a rectangular choir with a three-sided apsis.[7] The Amsterdam chapel was erected as an extension to the previously existing St. Olaf's Chapel at a 90-degree angle. Both archaeological

separate Jerusalem chapel as their place of worship. The brothers were also known as Knights of the Holy Sepulchre or Knights of Jerusalem. They walked in the annual Palm Sunday procession through their city, displaying their pilgrimage insignia, a palm, and a Jerusalem cross. For more information on Jerusalem brotherhoods in the northern Netherlands, see Wolfgang Schneider, "Peregrinatio Hierosolymitana" (unpublished doctoral thesis, Freie Universität Berlin, 1982).

[4] The abbreviation "-sz." or "dr. at the end of a middle name or last name stands for the patronym suffix "-zoon" (= son of) or "-dochter" (= daughter of).

[5] Although the chapel in Leiden, for example, was established by a wealthy merchant, it was not meant to be his burial chapel.

[6] Gisbert Brom, *Archivalia in Italië* (The Hague: Nijhoff, 1909), I.2, p. 489 (no. 1358). No structural or visual evidence is available.

[7] For the ground plans, see De Jongh and De Meyere, *Schilderij centraal*, figs. 41 and 47.

findings and visual sources confirm that it had an eight-sided rotunda with conical roof joined to a quadrangular space.[8] Archival sources in Leiden as well as structural data in Delft and Gouda indicate that, in particular, the chapels in Delft, Leiden, and Gouda were based on the same architectural concept: a twelve-sided rotunda with a conical roof linked to a quadrangular chancel with a gable roof.

The main common feature of all chapels (although in the case of the Nieuwe Weerd Chapel, this cannot be concluded with absolute certainty) was a polygonal rotunda with conical roof. The written sources pertaining to the chapels further testify to the existence of a replica of the "Heilig Graf" or "Sepulchrum Domini" within the rotunda. In Leiden and in both cases in Utrecht, the descriptions suggest that these imitated the appearance of the tomb aedicula. This link is supported by archaeological findings in Amsterdam that confirm the existence of a monument inside the rotunda, recalling the form of the aedicula.

Raet's chapel originally comprised two building parts: a twelve-sided rotunda, or nave, with a conical roof, which housed the replica of Christ's tomb in its center, and a chancel of trapezoidal shape with gable roof and bell cot, which contained the altar and the founder's tomb (figs. 1–3).[9] The late medieval rotunda is still extant in its basic form, making the Gouda Chapel the best-preserved monument of its kind in the Netherlands.[10] Despite its survival and a host of written sources pertaining to both Raet and the chapel, the monument has escaped the attention of the broader body of scholarship on Jerusalem translations and has only been researched by a number of Dutch specialists. These studies have focused on the biographical background of the founder[11] and the building history of the chapel.[12] The founder's motivation behind the

[8] For a reconstruction of the Amsterdam chapel, see Jan Baart, "Jerusalem aan de Zeedijk," *Ons Amsterdam* 43 (1991), 254–57 (pp. 256–57, reconstruction no. 6).

[9] In accordance with architectural terminology of ecclesiastical buildings, the rotunda can be described as a "nave" as it contained the "Holy Sepulchre" and was accessible to the laity. I have termed the adjoining building part "chancel" as it was of quadrangular shape and housed the sanctuary with the altar and the founder's tomb, separated by a screen from the rest of the chapel and accessible only to the clergy. This terminology can also be applied to the other chapels, except for St. John's Chapel, where the building part with the sanctuary was smaller and had a three-sided apsis. Therefore, it is named "choir."

[10] In comparison, the original structure of the Delft Chapel has been significantly altered and is not recognizable from outside.

[11] Goudriaan, "Gijsbert Raet," pp. 15–29.

[12] Glaudemans and Gruben, "Bouwgeschiedenis," pp. 47–58.

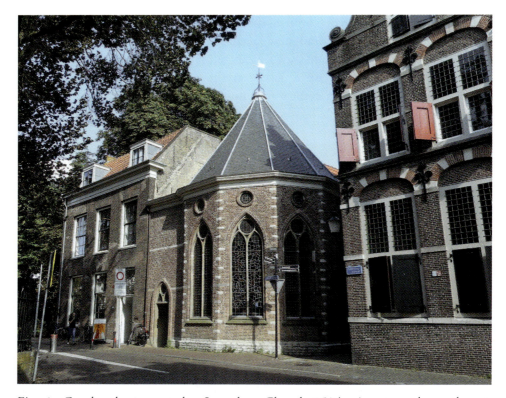

Fig. 1. Gouda, the present-day Jerusalem Chapel, 1504, view towards north-east. Photo: Author.

establishment of his chapel has been generally understood as an expression of gratitude for his safe return from a long and perilous pilgrimage[13] or as a commemoration of the trip.[14] In the following, I investigate the chapel in the

[13] J. H. Carlier, "Het Fraterhuis of Collatiehuis op de Jeruzalemstraat," in *Oudheidkundige Kring "Die Goude": Vijfde verzameling bijdragen* (Gouda: Oudheidkundige Kring 'Die Goude', 1947), pp. 71–76 (p. 71); Schneider, "Peregrinatio Hierosolymitana," p. 114; Ingeborg Laarakkers, "De Jeruzalemkapel," in *De Jeruzalemkapel in Gouda*, ed. Chris Akkerman et al. (Gouda: Stichting SPOOR, 1998), pp. 23–36 (pp. 23 and 26); Henkjan Sprokholt and Henny van Dolder-de Wit, *Op gewijde grond gebouwd* (Gouda: Stichting Open Monumentendag, 2005), p. 39; Jacques Akerboom, ed., "Religieus erfgoed: De Jeruzalemkapel te Gouda," *Monumenten* 27, no. 3 (March 2006), 16–17 (p. 17); Maarten Groenendijk and Diederick Habermehl, "Ondergronds," *Tidinge van die Goude* 25 (2007), 63–68 (p. 63).

[14] Koen Goudriaan, "Kapellen, gasthuizen en andere instellingen van liefdadigheid," in *Gouda*, ed. by Wim Denslagen (Zeist: Rijksdienst voor de Monumentenzorg; Zwolle: Waanders, 2001), pp. 139–70 (p. 165); Marcel van Dasselaar, "Resten van Raet," *Erfgoed* 2 (2008), 54–55 (p. 54).

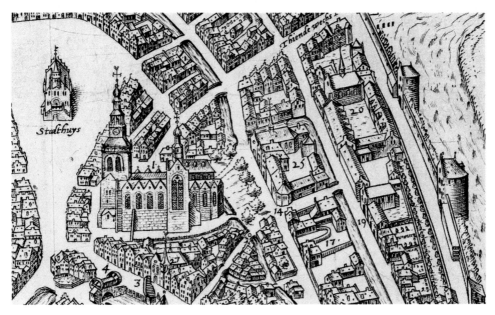

Fig. 2. G. Braun and F. Hogenberg, Map of Gouda, 1585, detail showing the Jerusalem Chapel (no. 14), St. Paul's Convent of the Brethren of the Common Life (no. 25) and St. John's Church (no. 1). Photo: Public Domain.

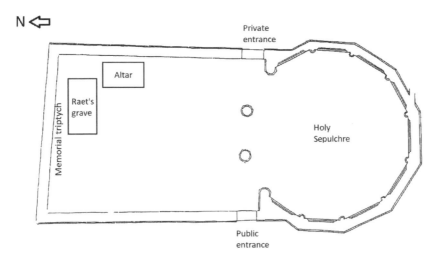

Fig. 3. Gouda, Jerusalem Chapel, 1504, ground plan showing Gijsbert Raet's grave and the hypothetical position of the altar at the east wall. Photo: Collectie Rijksdienst voor het Cultureel Erfgoed, BT-022935, original drawing by A. Viersen, amended by author.

context of contemporaneous conceptions of death and the afterlife and, in particular, analyze the written sources in light of late medieval commemoration practices, or *memoria,* as conceived by Otto Gerhard Oexle.[15] I reassess the motivations behind Raet's foundation and will argue that the priest devised the monument as his burial and chantry chapel from the onset. I first present new information about the priest's early provisions concerning his death and afterlife and about the chapel's history, which my analysis of the written sources has uncovered. Following a description of both the chapel's original appearance and its post-Reformation changes, I compare the late medieval monument to the church of the Holy Sepulchre in Jerusalem (as it appeared at the time) in order to establish what type of architectural copy the Gouda Chapel represents. The study of both the primary sources and the structural data pertaining to the other Jerusalem chapels in the diocese of Utrecht has enabled me to examine these particular chapels as a group, which are here considered as potential architectural models for Raet's monument. It has also allowed me to investigate the interior decoration of the rotunda and the nature of the Holy Sepulchre in Gouda, providing insight into the function of this building in the context of late medieval memorial practice. Finally, I will discuss, based on documentary evidence, the characteristic elements of late medieval *memoria* inherent in the concept of the Gouda Chapel, the position of Raet's tomb in accordance with Christian beliefs common at the time, and the iconography of his funerary monuments in their spatial context.

New Perspectives on Gijsbert Raet and the Building's History

Gijsbert Willemsz. Raet (ca. 1437[16]–1511) was a "vicarius perpetuus," a permanent chantry priest at the altar of St. Andrew,[17] one of the many side altars in St. John's Church in Gouda, the city's only parish church that dates back to 1278.[18] Instituted in 1473 or 1474,[19] he presumably celebrated "perpetual

[15] Otto Gerhard Oexle, "Die Gegenwart der Toten," in *Death in the Middle Ages,* ed. H. Braet and W. Verbeke (Leuven: Leuven University Press, 1983), pp. 19–77; Otto Gerhard Oexle, "Memoria und Memorialbild," in *Memoria: Der geschichtliche Zeugniswert des liturgischen Gedenkens im Mittelalter,* ed. K. Schmid and J. Wollasch (Munich: Fink, 1984), pp. 384–440.

[16] Goudriaan, "Gijsbert Raet," p. 18.

[17] Streekarchief Midden-Holland (hereafter SAMH), 91, inv. 58, fol. 3v. "Perpetual" meant that the office was a position for life.

[18] The grave register (1438–89) of the parish church lists thirty-three side altars in 1489, for example. SAMH, 90, inv. 24.

[19] Het Utrechts Archief (hereafter HUA), 223, inv. 1738-1, fol. 75r.

masses" for the soul of Heinric Allartsz. (including his family and friends), who had founded the altar and endowed it with a chantry in 1353, thereby providing annual revenues for the benefice holder.[20]

The written sources reveal that Raet was a wealthy and well-connected clergyman[21] who was concerned with making provisions for his death and afterlife. In 1473, he founded a "perpetual chantry," a permanent liturgical service, in the convent church of St. Mary Magdalene in Gouda, nominating a high-ranking cleric, Jacob van der Goude Claesz. from Leiden, as the first incumbent to this office, and stipulating a weekly *Miserere mei deus* during his lifetime and two weekly "perpetual masses" after the death of both himself and the office holder.[22] In accordance with late medieval Christian belief, the liturgy was initially intended to be performed until the day of the Last Judgment. However, in 1488, the nuns of St. Mary Magdalene's Convent officially returned Raet's chantry, renouncing all their rights with regard to the endowment and allowing him to use it for another purpose.[23] This must have happened at the instigation of Raet, indicating a change of plan regarding the priest's commemorative provisions.

Likewise, the fifteenth-century grave register of St. John's Church, which recorded the ownership of graves in the parish church between 1438 and 1489, discloses that the priest owned three burial plots within the parish church, indicating his desire for a prestigious final resting place: one at the western end of the north aisle, one directly behind the high altar in the east, and one next to the side altar of St. Peter in the new north aisle (added as a consequence of the extension of the church around 1475).[24] Although the subsequent grave register is lost, it is reasonable to assume that Raet gave up these plots once his chapel was built.

[20] SAMH, 90, inv. 41. "Perpetual masses" were celebrated for an indefinite period. The notion of perpetuity in the documentary sources usually referred to the Christian belief in the Last Judgment, which was expected to take place at the end of time. Cf. Matthew 24:27–31 and 25:31–46, John 5:22–30, for example. Since the Bible does not reveal when exactly the world would end, wealthy late medieval patrons usually intended their foundations to last indefinitely or "in perpetuity."

[21] While the written sources offer little information regarding the priest's family background, they provide many details on his real estate, income from rents on houses and land, and ecclesiastical matters.

[22] SAMH, 76, inv. 641, and SAMH, 91, inv. 87.

[23] SAMH, 91, inv. 88.

[24] SAMH, 90, 24, fols. 21r, 49r, 50r and 70r.

At the age of about fifty-four,[25] Raet undertook a pilgrimage to the Holy Land and to the monastery of St. Catherine on the Sinai Peninsula.[26] As a Knight of the Holy Sepulchre and of St. Catherine[27] now in possession of relics from the tomb of Christ ("modicum de sepulchro domini"),[28] he returned to Gouda and initiated the establishment of his Jerusalem chapel. On 25 February 1494, he purchased a house and yard, including two "cameren" (chambers)[29] and small yards, from Geertruid Florisdr., an elderly woman of more than seventy years of age at that time.[30] The property was located in the city center, directly opposite the choir of St. John's Church, at the corner of the current Patersteeg and the former Spieringstraat.[31] The St. Paul's Convent of the Brethren of the Common Life directly adjoined the property at its north side (fig. 2). Through this acquisition, Raet secured the building plot for the erection of his future chapel. Geertruid Florisdr., on the other hand, retained the right to live in her house until her death and would afterward be perpetually remembered by an annual requiem mass, held in the Jerusalem chapel on the anniversary of her passing.[32] In this mutually beneficial agreement, Raet obtained a building plot in a favorable location, and Geertruid Florisdr. further provided rent for the maintenance of the chapel in case of financial difficulties,[33] thereby securing her

[25] Considering all known documentary sources related to Raet in a chronological order, it seems likely that he made the pilgrimage around 1491 or 1492, where there is a gap in the records, lasting long enough to allow for the roughly year-long round-trip journey to Jerusalem and Mount Sinai that was standard in the late Middle Ages.

[26] SAMH, 91, inv. 58, fol. 1r.

[27] SAMH, 91, inv. 19, between fols. 51v and 52r.

[28] "A little of the tomb of the Lord," SAMH, 91, inv. 58, fol. 1r. These may have been small white stones taken from the tomb of Christ, similar to the ones that have been preserved in the Jerusalem chapel in Bruges. Cf. Nadine Mai, "Place and Surface: Golgotha in Late Medieval Bruges," in *Natural Materials of the Holy Land and the Visual Translation of Place, 500–1500*, ed. by Renana Bartal, Neta Bodner, and Bianca Kühnel (Oxon: Routledge, 2017), pp. 190–206 (p. 200 nn. 55–56).

[29] "Chambers" were usually one-room dwellings, which offered free accommodation for poorer people.

[30] SAMH, 2, inv. 319, fol. 171v, and SAMH, 91, inv. 58, fol. 5v. In a document of 7 April 1490, Geertruid Florisdr. is described as "out wesende bouende tseuentich Jaren" (more than seventy years old) (SAMH, 75, inv. 38.086). Very little information is known about her: Floris Pietersz., her father, was one of three churchwardens of St. John's Church in 1450. See SAMH, 2, inv. 319, fol. 8v, and HUA, 223, inv. 1893-1.

[31] The former Spieringstraat from the Lange Tiendeweg to the Jerusalem chapel is now called Jeruzalemstraat. The earliest record of this name dates from 1759. See A. Scheygrond, *Goudsche Straatnamen* (Alphen aan den Rijn: Canaletto, 1979), pp. 77–79.

[32] She still lived in the house on 20 April 1497, and she died on 31 August 1497. Cf. SAMH, 91, inv. 56 and inv. 58, fol. 4v. SAMH, 76, inv. 33.

[33] Cf. SAMH, 91, inv. 56.

liturgical commemoration. Raet's decision to buy this particular property was well considered, evidently motivated by the close proximity of the people who were meant to take over the chapel after his death: the Brethren of the Common Life, who would be responsible for its liturgy and maintenance, and the authorities of St. John's Church, who would supervise the whole foundation. Furthermore, the site allowed for the chapel to be aligned along the Spieringstraat, one of the main streets of the city, which led from the port to the center and was accompanied by a canal. The rotunda was strategically positioned at the street corner, including a small square, so that it was easily visible to passersby in the nearby streets or in the boats on the canal. It also profited from the unobstructed view that was provided by the open space of St. John's Churchyard on the opposite side (fig. 2).

The written sources offer limited information on the actual building campaign. The death of Geertruid Florisdr. on 31 August 1497[34] provides a *terminus post quem* for a possible start of construction, which involved the demolition of her house, including the "chambers," and the subsequent building of the Jerusalem chapel as well as Raet's private house. In 1504, the altar and the founder's future burial place were consecrated by Adrianus de Appeltern, titular bishop of Sebaste and suffragan to the bishop of Utrecht, as described in the chapel's cartulary by the eyewitness Johannes van Emmerik, later rector of the convent of the Brethren of the Common Life.[35] This dating suggests that the works on the chapel had proceeded sufficiently to allow the celebration of masses. The name of the architect, who delivered the design for the chapel, remains unknown. However, a note by Raet, written on or shortly after 21 March 1507, concerning a salary payment to the Delft master painter Timan Henricx.,[36] lists several artists who attended the contracting as witnesses.[37] They were presumably employed at the same time to carry out final embellishments in the chapel: Philip the "metselaer,"[38] who is known to have worked in St. John's Church in Gouda during the rebuilding of the choir between 1485 and

[34] See n. 32 above.
[35] SAMH, 91, inv. 58, fol. 1r.
[36] The suffix -cx. is another form of the patronym -sz. No further information about the artist is known. Raet had engaged him to paint the "taeffel in myn kapelle" (panel in my chapel). No further details are provided. It may have been the altarpiece or Raet's epitaph (a wall-mounted memorial triptych), which are both lost but mentioned in the cartulary. See SAMH, 91, inv. 58, fol. 1r.
[37] SAMH, 91, inv. 84.
[38] "Mason (or bricklayer)."

1510;[39] Pouwels Jansz., the "steenhouder"[40] from Delft, who had supervised building projects in both the Old Church (1494–95), and the New Church in Delft (ca. 1515);[41] Brother Cornelis, glassmaker with the Brethren of the Common Life in Gouda;[42] and Claes Willemsz. the embroiderer.[43] Interestingly, Raet engaged skilled and experienced workmen both from Gouda and Delft. It is not certain whether some of them had already been involved during the construction of the chapel, however, the fact that the priest knew established Delft craftsmen suggests that he was familiar with the city and its monuments and that the local Jerusalem chapel may have served as a model for the Gouda Chapel.

Appearance: Now and Then

Raet's late medieval chapel has not completely survived the course of time. Major post-Reformation structural changes include the construction of an adjoining building along the Patersteeg around 1580,[44] covering four sides of the rotunda in the east, the replacement of the chancel by a residential building in the eighteenth century, the installation of neo-Gothic windows (three large ones into the front of the rotunda at the street corner, topped by three small round windows, and another small one above the entrance door) around 1860,[45] and the loss of the original furnishings and decoration except for a fragment of the founder's tombstone made of dark-grey hardstone and its brass

[39] Bianca van den Berg, *De Sint-Janskerk in Gouda* (Hilversum: Verloren, 2008), pp. 201–2.

[40] "Stonemason (or stonecutter)."

[41] D. P. Oosterbaan, "Kroniek van de Nieuwe Kerk te Delft," *Haarlemse Bijdragen: Bouwstoffen voor de geschiedenis van het bisdom Haarlem* 65 (1958), 4–336 (pp. 243–45 n. 255). Stadsarchief Delft (hereafter SAD), 435, inv. 173. On the reverse of the document is written "pouwels graefmaker" (Paul the grave maker).

[42] Brother Cornelis Volpartsz. (d. 1529) is known to have supplied four windows for the town hall in Gouda in 1501 and restored eight windows of the same building in 1518. SAMH, 1, inv. 1163 (1501), fol. 21v, and inv. 1177 (1518), fol. 54v. Jan Taal, *De Goudse kloosters in de Middeleeuwen* (Hilversum: Paul Brand, 1960), pp. 146–47. He may have provided stained-glass windows for the original chapel.

[43] No further information about the artist is known. He may have embellished the two chasubles, which are mentioned in the cartulary. See SAMH, 91, inv. 58, fol. 1r.

[44] In 1572, the city of Gouda came under the rule of William I, Prince of Orange, main leader of the Dutch Revolt against the Catholic King Philip II of Spain, which accompanied the Reformation.

[45] For more information on the post-Reformation structural changes, see Glaudemans and Gruben, "Bouwgeschiedenis," pp. 47–58.

inlays (figs. 1–2 and 5–6).⁴⁶ However, the primary sources in conjunction with the available structural data enable us to reconstruct, to some extent, the chapel's original appearance, facilitating in turn our understanding of its late medieval function. The chapel originally encompassed a twelve-sided rotunda, or nave, with a conical roof; it housed the "Holy Sepulchre" in its center; the chancel was of trapezoidal shape with a gable roof and bell cot, which contained the altar and the founder's tomb (figs. 1–3).⁴⁷ Two entrances, positioned opposite each other in the side walls of the chancel, provided access to the chapel:⁴⁸ a private one from the back yard (for Raet and the Brethren) and a public one from the Spieringstraat. Four walls of the rotunda bore small, pointed-arch windows positioned up high,⁴⁹ providing a limited amount of daylight for this room; on the inner walls of the rotunda, set within circular blind niches were nine tondi, "excellenter depictis,"⁵⁰ surrounding the replica of the tomb of Christ (fig. 4).⁵¹ Twelve columns, placed in the corners of the dodecagonal rotunda (two within the opening to the chancel), supported the ribs of a stellar vault with oculus (figs. 3, 4, and 7). A screen separated the altar and the founder's grave from the rest of the chapel. The altar was well equipped with liturgical paraphernalia, a winged altarpiece,⁵² silver ampoules, and a silver

⁴⁶ In 2007, archaeologists found Raet's burial cavity during excavations in the chapel, and in 2011, his tombstone fragment was restored to its original position in the former chancel—now the ground floor of the eighteenth-century residential building, which is part of the present-day Jerusalem chapel complex. Groenendijk and Habermehl, "Ondergronds," pp. 64–65; Groenendijk, *Graven in Gouda*, pp. 46–47. The brass inlays are now part of the metal collection of the Rijksmuseum in Amsterdam (object number BK-NM-32, http://hdl.handle.net/10934/RM0001.COLLECT.14501 [accessed 19 April 2021]).

⁴⁷ The "Holy Sepulchre," the altar, the founder's tomb and the bell cot are mentioned in the written sources. SAMH, 91, inv. 58, fols. 1r and 4r. The gable roof with bell cot can be seen on the city map by Braun and Hogenberg (1585). It was a standard feature of late medieval chapels in the northern Netherlands. For a summary of the building history following the structural survey of the rotunda in 1996, see Glaudemans and Gruben, "Bouwgeschiedenis," pp. 37–65.

⁴⁸ Ibid., 40.

⁴⁹ After the survey of 1996, two of the four late medieval pointed arch windows were uncovered from layers of plaster and restored to their original state. See Glaudemans and Gruben, "Bouwgeschiedenis," pp. 39–42.

⁵⁰ "Excellently painted."

⁵¹ SAMH, 91, inv. 58, fol. 1r. The circular blind niches were uncovered from layers of plaster and restored to their original state following the survey of the rotunda in 1996. See Glaudemans and Gruben, "Bouwgeschiedenis," p. 42.

⁵² Its description as "tabula depicta posita supra altare duplicibus valvis" (a painted panel placed above the altar with twofold wings) suggests that it was a pentaptych.

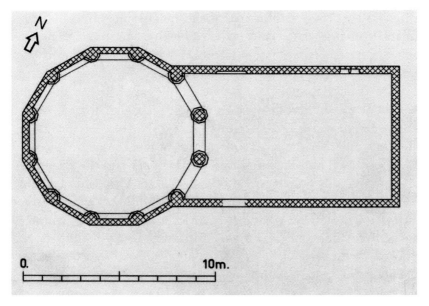

Fig. 4. Delft, late medieval Jerusalem Chapel, c. 1430, ground plan. Photo: Collectie Rijksdienst voor het Cultureel Erfgoed, BT-003806, drawing by Th. van Straalen.

Fig. 5. Amsterdam, foundations of the replica of the tomb aedicula within the foundations of the rotunda, former Jerusalem Chapel, c. 1498. Photo: Stadsarchief Amsterdam/Ino Roël.

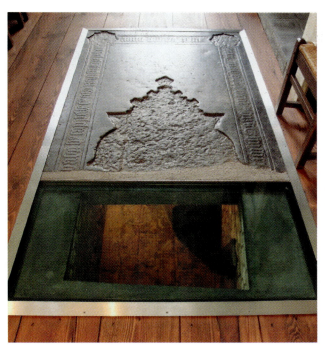

Fig. 6. Gouda, Jerusalem Chapel, fragment of Gijsbert Raet's tombstone (d. 1511), showing the border inscription and the indents of three brasses. A glass plate, replacing the missing part of the slab, allows a glimpse into the original burial cavity. Photo: Author.

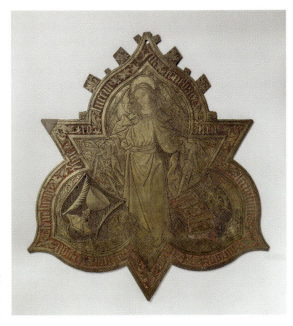

Fig. 7. Main brass of Gijsbert Raet's tombstone, Rijksmuseum, Amsterdam. Photo: Author.

cross displaying relics from the tomb of Christ.[53] A sculpted and polychromed memorial triptych, or epitaph, "ex lapide albo laboriose et artificiose sculptam et varijs coloribus depictam cum suis valvis a foris et ab intus,"[54] was fixed to the rear wall of the chancel, showing "historiam resurrectionis domini."[55]

The Gouda Chapel and Its Relation to the Church of the Holy Sepulchre in Jerusalem

The late medieval chapel displayed characteristic architectural features that referenced the Church of the Holy Sepulchre in Jerusalem. Notably, the twelve-sided rotunda with a conical roof and cylinder-shaped top allude to the late medieval Anastasis with its conical roof and oculus (fig. 1).[56] Likewise, inside the Gouda Chapel, the twelve columns that were positioned in the corners of the polygonal rotunda, and the vault with the circular opening in its apex referred to the columns and the dome with oculus inside the Anastasis (figs. 4 and 7).[57] When comparing the respective ground plans, one may conclude that the layout in Gouda was intended to evoke the outline of the inner space of the Anastasis that was attached to the two-bayed sanctuary of the crusader choir (fig. 3).[58] It is evident, however, that Raet's late Gothic brick chapel is not an exact copy of the church in Jerusalem.

[53] SAMH, 91, inv. 58, fol. 1r. The reliquaries are described as "ampullas argenteas et crucem argenteam continentem reliquas, modicum scilicet de sepulchro domini" (silver ampoules and a silver cross containing relics, namely a little of the Sepulchre of the Lord). For contemporary examples of reliquaries displaying relics from the Holy Land, including small stones from the Holy Sepulchre, see the ones preserved in the Jerusalem chapel in Bruges: a silver cross reliquary containing a splinter of the Holy Cross and a sculptural ensemble depicting Christ rising from his tomb and exhibiting two small white stones from the Holy Sepulchre in its pedestal. Mai, "Place and Surface," pp. 200–202, fig. 11.7. See n. 28 above.

[54] "Laboriously and skilfully sculpted out of white stone, and painted in various colors, together with its wings on the outside and on the inside."

[55] "The story of the Resurrection of the Lord." SAMH, 91, inv. 58, fol. 1r.

[56] For more information on the appearance of the church of the Holy Sepulchre before the fire of 1808, see the drawings by the Franciscan friar Bernardino Amico of Gallipoli, who became Guardian Father of the Holy Sepulchre during his stay in Jerusalem between 1593 and 1597. He made accurate drawings "according to the rules of perspective and their true size" of all the shrines in the Holy Land with the object of supplying models to those who wished to reproduce them in Europe. See Bernardino Amico, *Plans of the Sacred Edifices of the Holy Land* (Jerusalem: Franciscan Press, 1953), pp. 1–2, 13–18.

[57] See n. 56 above.

[58] For more information on the history of the Church of the Holy Sepulchre and a plan of the crusader church, see Denys Pringle, "The Crusader Church of the Holy Sepulchre," in *Tomb and Temple: Re-imagining the Sacred Buildings of the Holy Land*, ed. by Robin Griffith-Jones and Eric Fernie (Woodbridge: Boydell, 2018), pp. 76–94 (fig. 3.1).

Only certain characteristic architectural features of the prototype, which were essential for identifying it as an emulation of the church of the Holy Sepulchre—notably, the twelve-sided centrally planned building housing the tomb of Christ, with a conical roof and oculus—have been translated in the Gouda Chapel.[59]

Jerusalem Chapels in the Diocese of Utrecht and Their Influence on the Gouda Chapel

With an estimated foundation date of circa 1394,[60] the chapel in the Nieuwe Weerd is the earliest known example of this type of ecclesiastical building. Since the capital of the diocese played a leading role in the religious life and the production of art and architecture in the northern Netherlands, it probably served as an exemplary model that inspired the design of the later established Jerusalem chapels within the diocese. Being erected approximately a hundred years later, around 1500, Raet's chapel, which marks the end of this architectural phenomenon, was certainly influenced by its forerunners. An analysis of the known sources pertaining to the chapels reveals that their main common feature was a rotunda that housed a replica of the Holy Sepulchre. Apart from the Nieuwe Weerd Chapel, where this cannot be concluded with absolute certainty, the rotunda was polygonal. In particular, the layout of the chapels in Delft, Leiden, and Gouda are strikingly similar: a two-part edifice consisting of a polygonal central-plan building with conical roof and a cylinder-shaped top, adjoining a rectangular chancel with gable roof and bell cot. While the rotunda, or nave, housed the tomb of Christ, the chancel contained the altar of the chapel.[61] The dodecagonal rotunda in Gouda even shows the same interior arrangement as the one in Delft: the twelve columns in the corners (fig. 8) which represented the twelve columns inside the Anastasis in Jerusalem. It is evident that the

[59] Cf. Richard Krautheimer, "Introduction to an 'Iconography of Medieval Architecture,'" *Journal of the Warburg and Courtauld Institutes* 5 (1942), 1–33 (pp. 13–14).

[60] Its foundation was linked to the establishment of the local Jerusalem brotherhood in 1394. For an edition of the foundation charter of the brotherhood, see C. J. Gonnet, "Bedevaart naar Jerusalem in 1525," *Bijdragen voor de geschiedenis van het Bisdom van Haarlem* 11 (1884), 195–201.

[61] The altar in Gouda was most likely dedicated to the Holy Sepulchre, the one in Delft to St. Martha (hence St. Martha's Chapel) and the one in Leiden to the Holy Cross (hence Holy Cross Chapel). The altar dedication in the Nieuwe Weerd Chapel is unknown. The altar in the second Utrecht chapel was dedicated to St. John and taken over as such by the local Jerusalem brotherhood in 1544. Likewise, the one in Amsterdam was dedicated to St. Olof and presumably taken over as such by the local Jerusalem brotherhood.

Fig. 8. Gouda, the present-day Jerusalem Chapel, interior of the rotunda, view towards south-east, showing the original windows and circular blind niches. The door and cupboards are later additions. Photo: Author.

chapels, although differing in decorative details like the form of the column capitals, shared the same architectural concept. They can therefore be identified as a distinct regional architectural phenomenon that occurred in the diocese of Utrecht during a time span of roughly a hundred years at the end of the Middle Ages. Interestingly, the comparison has shown that Raet's chapel was primarily modeled on contemporaneous local translations of Jerusalem. Hence, we can conclude that the Gouda Chapel contained a double reference: its design imitated the basic shape of the earlier Jerusalem chapels in the diocese as well as the prototype of the Church of the Holy Sepulchre in Jerusalem.

The Veneration of the Holy Sepulchre

In accordance with the church of the Holy Sepulchre, the Jerusalem chapels in the diocese of Utrecht held a copy of the tomb of Christ in the centers of their rotundas. None of these Dutch Holy Sepulchres have survived. However, the

documentary sources and, most importantly, the archaeological evidence found in the Amsterdam Chapel suggest that the original concept of a miniature temple enclosing the tomb of Christ was translated into the basic concept of the Jerusalem chapels. While the written sources related to Delft and Leiden mention a "heylich graf"[62] or "sepulchrum sanctum"[63] inside the rotunda without further specification, the ones related to Gouda mention "tres lampades in circuitu sepulchri sancti" (three lamps in the circuit of the Holy Sepulchre),[64] indicating an ambulatory, or round walkway, around the replica of Christ's tomb, including three ever-burning lamps.[65] The latter is another similarity to the situation in Jerusalem at the time, as both pilgrim accounts and depictions of the Holy Sepulchre record oil lamps hanging outside and inside the tomb aedicula.[66] The Utrecht sources describe the Holy Sepulchre monument in the Nieuwe Weerd as "ad instar sepulchri eius quod est in Hierusalem"[67] and in St. John's Chapel as "exacte formam sepulcri dominici."[68] In Amsterdam, the foundations of a tomb replica were found during excavations in 1991, at the center of the rotunda.[69] The grave contained an imitation of Christ's burial shelf within the tomb chamber and an antechamber (fig. 9).

The image of the tomb aedicula necessary for such local recreations was transmitted to Europe through various means. Several Jerusalem pilgrims, for instance, provided depictions of it, notably, the woodcut by the Utrecht artist Erhard Reuwich, which experienced a wide diffusion in Bernhard von Breydenbach's *Peregrinatio in terram sanctam* (1486);[70] the drawing in Konrad Grünemberg's

[62] SAD, 202, inv. 62 (1551 and 1552).

[63] Erfgoed Leiden (hereafter EL), 0513, inv. 1, fols 13r–16r.

[64] A similar description is used later in the same document: "illas tres lampades prescriptas in ambitu sepulchri sancti" (those aforementioned three lamps in the ambulatory around the Holy Sepulchre). SAMH, 91, inv. 58, fol. 4r.

[65] In his will, Raet stipulated that these three lamps were to burn each night and only one in the daytime, except on feast days, when all three lamps were to burn day and night. Ibid.

[66] Cf. Isolde Mozer, *Bernhard van Breydenbach: Peregrinatio in Terram Sanctam* (Berlin: De Gruyter, 2010), fig. 21; Andrea Denke, *Konrad Grünembergs Pilgerreise ins Heilige Land 1486* (Cologne: Böhlau, 2011), fig. 15.

[67] "Like His Tomb, which is in Jerusalem," Karl Grube, *Des Augustinerpropstes Iohannes Busch Chronicon Windesheimense und die Liber de Reformatione Monasterium* (Halle: Hendel, 1886), p. 364.

[68] "In the exact form of the Sepulchre of the Lord," S. Muller, "Arnoldus Buchelius: Traiecti Batavorum Descriptio," *Bijdragen en Mededelingen van het Historisch Genootschap* 27 (1906), 131–268 (p. 220).

[69] Baart, "Jerusalem," p. 256.

[70] The book was immensely successful owing to Reuwich's illustrations. It was reprinted several times over the next decades and translated into German, Dutch, French, and Spanish. Mozer, *Breydenbach: Peregrinatio*, pp. XXX–XXXI, fig. 21.

Fig. 9. Gouda, Jerusalem Chapel, interior of the rotunda, stellar vault with oculus. Photo: Author.

pilgrimage account (1487);[71] and Jan van Scorel's representation within the group portrait of the Haarlem Jerusalem brotherhood (ca. 1529).[72] Pilgrims could also bring back small-scale models of the tomb aedicula as a souvenir from the Holy Land, such as the sixteenth-century stone model that was discovered during excavations in Amsterdam in 1977. The model is made of veined pink limestone from the Jerusalem/Bethlehem area and is composed of nine removable sections.[73]

Moreover, several architectural replicas of the tomb aedicula have survived. They either included the tomb chamber and antechamber, as, for instance, in Eichstätt (ca. 1160) or Görlitz (1481–1504), or they only contained the tomb chamber, as, for instance, in Augsburg (1508).[74] Interestingly, although their overall size and layout varied, presumably depending on the available space within their original site, the imitations show that there was a tendency to design the burial chamber in accordance with the original measurements in Jerusalem.[75] Wouter IJsbrantsz., the founder of the Jerusalem chapel in Leiden, for example, noted in his will of 1467 that he had taken the measurements of

[71] Denke, *Grünembergs Pilgerreise*, fig. 15.
[72] Frans Hals Museum, Haarlem, inv. os I-310. N. Köhler et al., *Painting in Haarlem, 1500–1850: The Collection of the Frans Hals Museum* (Ghent: Ludion, 2006), p. 603.
[73] Museum Catharijneconvent, Utrecht, inv. RMCC v314.
[74] Cf. Gustaf Dalman, *Das Grab Christi in Deutschland* (Leipzig: Dieterich, 1922), pp. 56–65, 81–87, and 96–102.
[75] Cf. ibid., pp. 24–25.

the Holy Tomb during his pilgrimage to Jerusalem and that he had left them in his office so that they could be used for the construction of the "Holy Sepulchre."[76] All in all, various sources, ranging from depictions and small-scale models to local replicas and self-taken measurements of the original tomb, could have influenced the appearance of the tomb copy in Gouda.

As has been observed, the Jerusalem chapels in the diocese of Utrecht, notably the ones in Delft, Leiden, and Gouda, were based on the same architectural concept. The structural evidence found in the Jerusalem chapel in Amsterdam suggests that a replica of the tomb aedicula positioned in the center of the rotunda, in analogy to the original church in Jerusalem, was part of the overall concept of the chapels. Therefore, it seems likely that such a replica once stood in the center of the rotunda in Gouda. Given that the diameter of the latter is about 7 meters and that some space must have remained empty for the ambulatory around the tomb, keeping in mind that the original tomb chamber in Jerusalem measures 202 × 184 centimeters,[77] it is possible that there was an emulation of the tomb aedicula without the antechamber due to limited space.[78] A monument like the contemporaneous one-roomed aedicula in Augsburg, for example, would have had the right size to occupy the rotunda in Gouda. It might give us an idea of its appearance (fig. 10).

Furthermore, as stated in the cartulary of the Jerusalem chapel in Gouda, Raet "adornauit quoque sepulchrum domini tabulis rotundis ligneis excellenter depictis" (adorned the Sepulchre of the Lord with round wooden tables, excellently painted).[79] Thus, there were originally nine tondi on the walls of the rotunda, which surrounded the tomb. Of this decoration, only the round blind niches, which framed the tondi, have survived (fig. 4). It is plausible that the paintings depicted scenes related to the holy sites in and around Jerusalem. The founder of the Jerusalem chapel in Leiden, for instance, prescribed in his will of 1467 that the walls of the rotunda should be decorated with seven paintings

[76] EL, 0513, inv. 1, fols 13r–16r. A few years later, Claes van Duesen, who was born in Leiden and who organized pilgrimage tours from Holland to the Holy Land at the end of the fifteenth century, wrote in his pilgrimage account, perhaps with a note of patriotism, that he had been to many cities but nowhere was the Holy Sepulchre better represented than in Leiden. See Ludwig Conrady, *Vier Rheinische Palaestina-Pilgerschriften des XIV., XV. und XVI. Jahrhunderts* (Wiesbaden: Feller & Gecks, 1882), p. 14.

[77] Cf. H. Vincent and F.-M. Abel, *Jérusalem: Recherches de topographie, d'archéologie et d'histoire* (Paris: Librairie Victor Lecoffre, 1914), fig. 59.

[78] The Amsterdam rotunda, in comparison, had a diameter of 12 meters and contained a tomb aedicule with antechamber.

[79] SAMH, 91, inv. 58, fol. 1r.

Fig. 10. Stone model of the tomb aedicula as rebuilt in 1555, late sixteenth century, 13.2 cm high × 17 cm long, limestone, probably from the Jerusalem/Bethlehem area, Museum Catherijneconvent, Utrecht. Photo: Author.

depicting biblical scenes related to the Valley of Jehoshaphat, namely, the stoning of St. Stephen, the Assumption of the Virgin Mary, Jesus praying in the Garden of Gethsemane, the Ascension of Jesus, the resurrection of Lazarus, the decapitation of St. James the Martyr, and the descent of the Holy Spirit on the Apostles.[80] The Holy Sepulchre in the center of the rotunda, as mentioned above, should be constructed according to the measurements that he had taken

[80] EL, 0513, inv. 1, fols 13r–16r.

Fig. 11. Augsburg, St. Anne's Church, replica of the tomb aedicula, 1508.
Photo: Shimrit Shriki-Hilber.

at Christ's tomb during his pilgrimage. He also stipulated that eighteen steps should lead from the north side (of the chancel) to an arrangement evoking Mount Calvary above the altar, which showed a Crucifixion group, with the cross of Jesus being higher than those of the two murderers; and in the recess on the south side (of the chancel), a stone crib should be built "op die manier van Bethleem."[81] The decorative scheme in Leiden is striking. Emulations of the three most significant Christian pilgrimage shrines stood inside the chapel, each one reflecting characteristic features of the original site (measurements of the marble slabs covering the burial shelf of Christ's tomb, eighteen steps to the

[81] "In the manner of Bethlehem," EL, 0513, inv. 1, fols. 13r–16r.

chapel of Golgotha, the marble slabs covering the grotto of the Nativity). The scenes of the seven paintings were related to the Valley of Jehoshaphat, where Christ's Second Coming was expected to take place, thematically providing an appropriate setting for the replica of the Holy Sepulchre. Moreover, the scenes represented holy sites that Jerusalem pilgrims usually visited during their journey. Taken together, the decoration inside the Leiden chapel would have enabled worshippers to undertake a spiritual pilgrimage to the Holy Land.

Having this in mind, the evidence that we have on the interior decoration of the rotunda in Gouda facilitates our understanding of the chapel's function. As stipulated by Raet, his Jerusalem chapel was to be opened for public worship during the day.[82] Thus, the furnishings and decoration of the rotunda in Gouda would have offered the visitors of his chapel, who were not able to undertake the long, dangerous, and expensive journey to Jerusalem, an ersatz pilgrimage site, enabling them to experience and venerate the Holy Sepulchre in their hometown. Likewise, returned Jerusalem pilgrims from Gouda and its surroundings would have been able to relive the memories of their pious journey in the mnemonic environment of the rotunda. While processing around the tomb of Christ, they would have meditated at the scenes that were depicted on the nine tondi. Like in the church in Jerusalem, they would have probably entered the replica of the tomb aedicula through a low entrance and then prayed at the burial shelf. Through this monument, Raet created a permanent presence of the Holy Sepulchre in Gouda, thereby promoting a special devotion to Christ's sacrificial death and Resurrection. In Utrecht, for instance, the written sources reveal that the visitors of the Jerusalem chapel in the Nieuwe Weerd earned indulgences of seven years on particular feast days, encouraging them to visit and pray in the chapel.[83] With his sumptuous chapel, Raet enriched the liturgy of the parish, inspiring people to devotion. In the late medieval Low Countries, a generous benefaction was considered as a good deed that deserved commemoration.[84] In return for the extraordinary benefaction of the Jerusalem chapel, the visitors would have prayed for the benefit of Raet's soul. Not only would the intercessory prayers of the congregation have expedited the progress of his soul through purgatory, but they would have also

[82] The Brethren of the Common Life were responsible for the daily opening and closing of the monument. See SAMH, 91, inv. 58, fol. 1r.

[83] Brom, *Archivalia*, I.2, p. 489 (no. 1358).

[84] Cf. Clive Burgess, "'Longing to be prayed for': Death and Commemoration in an English Parish in the Later Middle Ages," in *The Place of the Dead*, ed. by Bruce Gordon and Peter Marshall (Cambridge: Cambridge University Press, 2000), pp. 44–65 (pp. 49–54, 64).

ensured that the deceased remained present within the community of the living. Hence, the public opening of his burial chapel for the veneration of the Holy Sepulchre can be regarded as a strategy for the afterlife.

Eternal Remembrance of the Founder

Two documentary sources reveal striking information about the personal motivations behind Raet's foundation and the function of the chapel. On 20 April 1497, Raet made a written agreement with the Brethren of the Common Life, binding them to take care of the planned chapel after his death "ten ewighen daghen" (until the end of time).[85] At that time, construction on the chapel had not started yet since, as stated in the document, Geertruid Florisdr. was still living in her former house. It is intriguing to note that the terms of the agreement indicate in detail what type of chapel the priest (or, on his behalf, the executors of his will) intended to found and how it should be maintained: "een kapelle van ons lyefts heren graf" (a chapel of the tomb of our most beloved Lord) should be erected and fully equipped for the celebration of masses. An annual income of forty Rhenish guilders from "perpetual rents" on houses and land would fund the performance of twelve weekly masses, and one additional yearly Flemish pound from "perpetual rents" would finance the candlelight during masses and any necessary repairs.[86] In case these funds lost value, Raet's trustees (the vicecurate and two senior chantry priests of St. John's Church in Gouda)[87] would instruct the Brethren to reduce the number of masses, and in case the Brethren failed their duty, the responsibility of the chapel, including all its possessions, would devolve upon Raet's trustees, who would then decide how to best administer it in Raet's interests.

This document is vital for the understanding of the chapel's raison d'être. We learn that Raet had ensured the coming into being of his foundation: either he or, in the case of his death, the executors of his will would initiate the

[85] SAMH, 91, inv. 56.

[86] In the late Middle Ages, "perpetual rents" (referred to as *ewighe renten* or *redditus perpetui* in the written sources) were long-term or permanent rents that were valid until the houses or land lost value. Wealthy patrons usually provided this type of rent to support a long-lasting maintenance of their foundations. In line with late medieval Christian belief, they were intended to last until the end of days. Cf. n. 25.

[87] In the agreement of 1497, Raet names the vice-curate and the chantry priests of St. John's Church in Gouda as his trustees. In his will of 1505, he specifies them as the vice-curate and two senior chantry priests. SAMH, 91, inv. 58, fol. 4v.

construction of the monument. Furthermore, he already had clear ideas about the appearance of his chapel and had calculated the total cost of its maintenance. By committing the Brethren of the Common Life to act as the future caretakers of the chapel, he arranged the liturgical service and its upkeep in advance. Even before his chapel was built, the priest was taking every possible precaution for guaranteeing the erection and "perpetual" existence of his foundation. Raet's will, which he drew up on 13 February 1505, officially secured the chapel's maintenance. It was based on the same stipulations that had been demanded in the agreement of 1497, confirming how accurately Raet had planned the eternal presence of his foundation in advance.[88]

In this context, the oft-repeated adjectives "perpetuus" or "ewigh"[89] are key in the documentary sources, providing a significant clue to Raet's motivations and the underlying concept of the chapel. In medieval times, any notion of perpetuity was used to refer to the Christian doctrine of purgatory and eternal life after death. Thus, Raet's efforts to secure the everlasting existence of his chapel must have been linked to his belief in the afterlife, spurring us to further investigate the written sources with regard to the concept of *memoria*. In the agreement of 1497, Raet specified that the Brethren should "perpetually" read twelve weekly masses. Nearly eight years later, in his will of 1505, he repeated the same stipulation and additionally ordered that a requiem mass should be sung on his death anniversary and on those of his parents and Geertruid Florisdr. Besides, once a week, the Brethren should distribute twelve alms, each worth one *stuiver*, to twelve poor, old men after the latter had attended mass in the chapel.[90] The arrangement of eternal masses, requiem masses, and almsgiving during one's lifetime were typical elements of late medieval commemorative practice among the wealthier circles, with the purpose of shortening the deceased's suffering in purgatory and ensuring the salvation of the soul in the afterlife. The more masses said, the more alms given, the less time spent in purgatory.[91] It is evident that Raet had arranged the masses in his chapel, including the requiem ceremonies

[88] As announced in the agreement of 1497, Raet contractually bound the Brethren of the Common Life by a will, once the chapel was erected.

[89] Both translate as "perpetual."

[90] The will of 1505 stipulates alms to twelve poor men. In the cartulary of the Brethren of the Common Life of ca. 1516, it is specified that alms should be given to twelve poor old men. SAMH, 91, inv. 19, between fols. 51v and 52r.

[91] Cf. Peter Jezler, "Jenseitsmodelle und Jenseitsvorsorge: Eine Einführung," in *Himmel Hölle Fegefeuer: Das Jenseits im Mittelalter*, ed. by Peter Jezler (Zürich: Neue Zürcher Zeitung, 1994), pp. 13–26. Truus van Bueren, *Leven na de dood: gedenken in de late Middeleeuwen* (Turnhout: Brepols, 1999), pp. 21–34.

and the almsgiving, for the salvation of his soul after his death. The fact that he had planned his liturgical commemoration even before the chapel was built allows us to draw the conclusion that the priest had planned the Jerusalem chapel as his personal chantry chapel from the beginning. Although Raet followed the current trend of commemorative practice of his time, his preparations were extreme. The well-to-do citizens in Gouda, for instance, usually founded an annual requiem mass or a weekly mass at one of the altars in the parish church, local convents, or hospitals.[92] The wealthier among them founded an altar or even a side chapel in an ecclesiastical institution, such as the "IJzeren Kapel"[93] in St. John's Church, for example, initiated by Jan "the Bastard" of Blois in 1417.[94] Founding a separate individual Jerusalem chapel was a prestigious and extraordinary undertaking. On top of that, Raet apparently possessed the right of burial in his chapel since, in 1504, not only the altar but also his future burial place was consecrated.[95] No evidence of another separate chantry chapel in Gouda has survived. By choosing a Jerusalem chapel and not a regular chapel as the place of his final rest and liturgical commemoration, the priest associated his own death with that of Christ, expressing his hope for salvation. Conforming with late medieval Christian belief, being interred and remembered next to relics of the Holy Sepulchre and a replica of the tomb aedicula, which had been devised to promote Christian worship, must have been considered a very effective means of reaching Heavenly Jerusalem in the afterlife.

Recognizing the Jerusalem chapel as Raet's chantry and burial chapel enables us to investigate more closely the location of the priest's tomb in relation to the altar and the copy of the tomb of Christ inside the chapel. As indicated in the notes on the foundation, Raet's tomb was located along the northern wall of the chancel, within the sanctuary, which, together with the altar, was separated by a screen from the rest of the chapel.[96] The excavations inside the chancel in 2007 revealed the exact position of the burial cavity, in the northeastern corner of the room (fig. 3).[97] The altar, however, has not survived, and its precise position is

[92] See, for instance, the inventory of the medieval documentary sources related to the convents in Gouda by Jan Taal. It includes a *regestenlijst*, a calendar of the documents in chronological order, providing a brief summary of nearly each file. *De archieven van de Goudse kloosters* (The Hague: Ministerie van Onderwijs, Kunsten en Wetenschapen, 1957).
[93] "Iron Chapel."
[94] Berg, *Sint-Janskerk*, p. 48.
[95] SAMH, 91, inv. 58, fol. 1r.
[96] Ibid.
[97] Groenendijk and Habermehl, "Ondergronds," pp. 64–65.

unknown. Regarding the north-south axis of the chapel, one would assume that the altar was positioned in front of the main wall of the chancel, the northern wall. However, this would be against Christian tradition, and more importantly, the striking position of the founder's tomb in the northeastern corner of the room suggests that the altar was not located at the northern main wall but at the eastern side wall. Hence, although the chapel was not aligned in accordance with Christian tradition, the altar was likely orientated toward the east. The fact that Raet chose a resting place at the northern side of the altar was motivated by the late medieval Christian belief in the Last Judgment. Christ was expected to come from the east and divide humankind into the blessed at his right side and the damned at his left.[98] The archaeological evidence reveals that the priest intended to be interred at the right side of the Savior, ready to rise among the blessed and proceed toward heaven. Moreover, the altar was the place, where the relics of the Holy Sepulchre, which Raet had brought back from his pilgrimage, were displayed in a silver reliquary on the mensa[99] and where the twelve weekly masses were performed. During the celebration of the Eucharist, the altar symbolically transformed into Mount Calvary when the sacrificial death of Christ was repeated by the mystical conversion of the bread and wine into the body and blood of Christ: the moment when Christ became present. It is likely that Raet chose a burial place next to the altar instead of a burial place next to the copy of the tomb of Christ, for example, in order to benefit from the salvific power of the relics and the relatively high number of masses.

Moreover, Raet communicated his deep concern for the afterlife through the funerary monuments in his chapel. The center brass on his tombstone depicted an angel holding two heraldic shields: two palm branches flanking a chalice on the left shield, and a Jerusalem cross above the empty tomb of Christ and the wheel of St. Catherine pierced by two swords on the right shield (fig. 6). The scene is surrounded by two quotations from the Book of Job: "In tenebris straui lectulum meum. Et rursum post tenebras spero lucem."[100] The iconography on the two shields identifies Raet as a priest and Knight of the Holy Sepulchre and of St. Catherine, testifying to his piety and his particular devotion to these sites, thereby constructing a permanent identity for the founder as a cleric and pilgrim. Since the sanctuary of the chapel enclosed the tomb slab,

[98] Matthew 25:31–46.
[99] SAMH, 91, inv. 58, fol. 1r.
[100] "I have made my bed in darkness. After darkness I hope for light again" (Job 17:13; 17:12; Douay-Rheims).

only the Brother celebrating mass at the altar would have seen it. Nevertheless, in accordance with Christian tradition, Raet's corpse and the tombstone covering the burial cavity would have been orientated east-west, with the head of the deceased in the west, in order to face Christ at the moment of the Last Judgment. At the expected end of the world, the angel would have presented the shields displaying Raet's most pious achievements to the Judge. Therefore, the tombstone may be interpreted as a means to please God. The personal motto that Raet chose for his tombstone expressed his hope for salvation in the hereafter through a metaphor of darkness and light, alluding to death and resurrection: in the darkness of the grave (physically represented by the dark tombstone), Raet would rest until he would be awakened by the heavenly light (physically represented by the gleaming surface of the brass).

In addition, the notes on the foundation reveal that a memorial triptych was fixed to the main wall of the chancel in the north, near the founder's tomb. It consisted of a sculpted, polychromed center piece and wooden painted wings, depicting "historiam resurrectionis domini."[101] This kind of memorial panel or epitaph was usually installed above graves in churches in the late Middle Ages, showing the patron kneeling in front of a personally chosen religious scene, devised to encourage intercessory prayers by churchgoers.[102] Raet's epitaph was positioned opposite the replica of the Holy Sepulchre, forming a visual axis between the depiction of Christ rising from the dead and the replica of his tomb, symbolically offering a promise of resurrection to the visitors of his chapel. Through the iconographical program of his wall memorial and its spatial connection to the tomb aedicula, the priest identified himself with Christ's death and Resurrection, thereby communicating his hope for salvation to the chapel's visitors and inspiring them to pray for the benefit of his soul.

Conclusions

As has been shown above, Raet had meticulously planned the Jerusalem chapel in Gouda as his chantry and burial chapel from early on, motivated by his deep concern for the afterlife. Evidently, Raet took various precautions during his lifetime to secure the salvation of his soul after his death, notably the foundation of the chantry in the convent of St. Mary Magdalene, the acquisition of burial

[101] "The story of the Resurrection of Our Lord," SAMH, 91, inv. 58, fol. 1r.
[102] Cf. Bueren, *Leven na de dood*, pp. 65–127; Douglas Brine, *Pious Memories: The Wall-mounted Memorial in the Burgundian Netherlands* (Leiden: Brill, 2015), pp. 1–55.

places in the parish church, his pilgrimage to the Holy Land and monastery of St. Catherine on the Sinai, and finally, the establishment of his Jerusalem chapel. The latter included a conglomerate of investments for the hereafter, aimed at shortening his time in purgatory and ensuring a positive outcome at the Last Judgment: a Jerusalem chapel to last until the end of days, well-equipped and lavishly decorated, allowing public worship at a replica of the Holy Sepulchre, and thereby promoting a special veneration for Christ's sacrificial death and Resurrection. In addition, Raet arranged for his own eternal liturgical commemoration in the form of masses, requiem masses, and almsgiving, as well as the positioning of his tomb at Christ's right. The iconography of his funerary monuments also reflected Raet's optimistic attitude to his own resurrection. The rotunda of the Jerusalem chapel, strategically positioned at the street corner, echoed the general shape of the Anastasis in Jerusalem and held out the message of eternal life to the medieval beholder. All in all, Raet's chapel was a prestigious and extraordinary form of late medieval *memoria*, intended as the ultimate provision for the afterlife.

THE PRESENCE OF JERUSALEM IN MANTUA

Neta BODNER

Two eleventh- or twelfth-century round churches in Mantua have been theorized to be translations of the Holy Sepulchre's Anastasis Rotunda: the rotunda of San Lorenzo and the lost rotunda of San Sepolcro.[1] Both churches were granted around 1151 to Sant'Andrea, then a Benedictine abbey in the center of Mantua.[2] Sant'Andrea itself was a vibrant pilgrimage center because it housed a relic of the blood of Christ.[3] In this article I will present visual and written evidence that helps substantiate the relationship between San Lorenzo, San Sepolcro, and two other Mantuan churches with Jerusalem. I will also argue that Sant'Andrea was linked to Jerusalem and especially to Golgotha by virtue

[1] I warmly thank Prof. Caroline Bynum and Prof. Julia Smith for their comments on an earlier draft of this paper, and Prof. Elisheva Baumgarten, head of the ERC funded project 'Beyond the Elite: Jewish Daily Life in Medieval Europe' and the Rothschild Yad Hanadiv foundation for their support of my research. San Lorenzo is listed by Richard Krautheimer as a copy of the Holy Sepulchre, in "Introduction to an 'Iconography of Medieval Architecture,'" *Journal of the Warburg and Courtauld Institutes* 5 (1942), 1–33 (p. 10). Robert Tavernor and Paolo Piva likewise take the architectural similarity between the two buildings as evidence of a copy-prototype relationship; see Robert Tavernor, *On Alberti and the Art of Building* (New Haven: Yale University Press, 1998) and Paolo Piva, "Le copie del Santo Sepolcro nell'Occidente romanico: Varianti di una relazione problematica," in *Il Mediterraneo e l'arte nel Medioevo*, ed. by Roberto Cassanelli and Maria Andaloro (Milan: Jaca, 2000), pp. 97–117 (pp. 106–8 and 111–12).

[2] Piva, "Le copie del Santo Sepolcro," p. 111. The Benedictine abbey was in charge of San Lorenzo in the Middle Ages, when the church had no independent priestly attendance (Tavernor, *On Alberti*, p. 143).

[3] Luciana Rodighiero Astolfi, "The History and Tradition of the Precious Blood of Christ in Mantua," *International Journal for the Study of the Christian Church* 17, no. 4 (2017), 224–27 (p. 227). Other studies of Matua's blood relic include Norbert Kruse, "Der Weg des Heiligen Bluts von Mantua nach Altdorf-Weingarten," in *900 Jahre Heilig-Blut-Verehrung in Weingarten, 1094–1994: Festschrift zum Heilig-Blut-Jubiläum am 12 März 1994*, ed. by N. Kruse and R. Schaubode (Sigmaringen: Jan Thorbecke, 1994), pp. 57–76; L. Weichenrieder, "Das Heilige Blut von Mantua," in Kruse and Schaubode, *900 Jahre Heilig-Blut-Verehrung*, pp. 331–36; Luigi Bosio, "I Reliquiari del Preziosissimo Sangue Custoditi nella Basilica di Sant'Andrea in Mantova," in *Il Sant'Andrea di Mantova e Leon Battista Alberti: Atti del convegno di studi organizzato dalla Città di Mantova con la collaborazione dell'Accademia Virgiliana, nel quinto centenario della basilica di Sant'Andrea e della morte dell'Alberti, 1472–1972* (Mantua: Edizione della Biblioteca comunale di Mantova, 1974), pp. 409–24; Caroline Walker Bynum, "The Blood of Christ in the Later Middle Ages," *Church History* 71, no. 4 (2002), 685–714 (pp. 692–93). On the baroque reliquary, see David Chambers and Jane Martineau, eds., *Splendours of the Gonzaga* (London: Victoria and Albert Museum, 1981), cat. nos. 211, 213, 205–6.

of its relic. Mantua possessed the relic of the Holy Blood, soaked into the earth from Golgotha, making it a relic of topographical place as well as the historical event of the Crucifixion.[4] Home to the earth and blood relic, Sant'Andrea will cautiously be considered here as a third representation of the Holy Sepulchre in Mantua, which functions differently from both rotundas. In addition, two other possible evocations of Jerusalem and the Passion will be presented: Sta. Maria *di monte Olivetto in gradaro* (St. Mary of the Mount of Olives in Gradaro, on a site previously called Camposanto) and an adjacent column of St. Longinus, marking the place of the saint's martyrdom in Mantua after he brought the relic of the blood from Jerusalem.

With San Lorenzo and San Sepolcro being dependencies of Sant'Andrea,[5] it is possible to ask whether all three were part of a local Jerusalem representation via multiple buildings that functioned together. Robert Tavernor has already proposed that they could have acted as a multistational pilgrimage path within Mantua, beginning at San Sepolcro outside the city and ending either at San Lorenzo or Sant'Andrea, at its heart. In this paper, I would like to present some visual evidence to strengthen Tavernor's claim, specifically maps of Mantua that accentuated the visual affinity between the three churches and a direct connecting path. The same images are used here to ask whether other churches in the city were part of the same evocation of Jerusalem. Examining the later evidence regarding Sant'Andrea and San Lorenzo in the fifteenth and sixteenth centuries, I propose that echoes of a Jerusalem network can be seen in the *longue durée*. This network, I argue, seems intertwined with the cult of the relic of the blood of Christ, in both the Middle Ages and the early modern period. Relics of place are increasingly recognized as a category with its own characteristics and mechanisms.[6] Examining the possible role of the relic of the blood of Christ within architectural evocations of Jerusalem is an aim of this paper.

[4] On earth relics as relics of place, see Bruno Reudenbach, "Holy Places and Their Relics," in *Visual Constructs of Jerusalem*, ed. by Galit Noga-Banai, Hanna Vorholt, and Bianca Kühnel (Turnhout: Brepols, 2014), pp. 197–206; and Renana Bartal, Neta Bodner, and Bianca Kühnel, "Natural Materials, Place and Representation," in *Natural Materials of the Holy Land and the Visual Translation of Place, 500–1500*, ed. by. Renana Bartal, Neta Bodner, and Bianca Kühnel (New York: Routledge, 2017), pp. xxiii–xxxiii.

[5] Antonio Nerli, *Breve Chronicon monasterii mantuani sancti Andree ord. Bened* (London: Forgotten Books, 2016), p. 7, lines 10–11.

[6] Reudenbach, "Holy Places and Their Relics," pp. 203–6, Caroline Walker Bynum, foreword to *Natural Materials of the Holy Land and the Visual Translation of Place, 500–1500*, ed. by Bianca Kühnel, Renana Bartal, and Neta Bodner (New York: Routledge, 2017), pp. xix–xxii.

The Church of San Lorenzo

The church of San Lorenzo is an eleventh- or twelfth-century round brick church located in the center of Mantua immediately to the south of Sant'Andrea.[7] The spatial connection of San Lorenzo to Sant'Andrea is evident in a city view of Mantua from 1628, the *Urbis Mantuae descriptio* by Gabriele Bertazzolo (fig. 1).[8] The two churches are connected by today's adjacent Piazza delle Erbe and Piazza Alberti, with the main facades of both churches situated along the square's northwest side. Apart from their physical proximity and shared open space, there used to be other connections between the two churches as well. San Lorenzo was not an independent church but a dependency of Sant'Andrea.[9] San Lorenzo was used to house the body of St. Longinus—the Roman centurion credited with bringing Christ's blood to Mantua—when Sant'Andrea was being enlarged.[10] San Lorenzo was also the site of some of Sant'Andrea's Easter liturgy.[11] These relations between the church housing the blood relic and San Lorenzo as a possible representation of the Anastasis Rotunda seem significant.

Indeed, San Lorenzo has been compared with the church of the Holy Sepulchre on the basis of a number of architectural similarities between the two buildings. San Lorenzo is a round church with an ambulatory surmounted by a gallery, with a flattened cone tambour (now reconstructed) over the central space (figs. 2–3), all features shared with the Jerusalem Anastasis rotunda.[12] San

[7] Massimo de Paoli, "Rotonda di S. Lorenzo a Mantova rapporto tra apparato pittorico e membratura architettonica," in *Rotonde d'Italia: Analisi tipologica della pianta centrale*, ed. by Valentino Volta (Milan: Jaca, 2008), pp. 67–69 (p. 67), Piva, "Le copie del Santo Sepolcro," p. 107.

[8] Gabriele Bertazzolo (1570–1626), *Urbis Mantuae descriptio / Ab olim D. Gabriele Bertazzolo Laurentii filio sciographice, et chronologice descripta ; atque sub felicissimis auspiciis ser. ducis Caroli Gonzagae aeneis tabulis aeternitati tradita anno humanae salutis M.D.CXXVIII*, open access (public domain) on Gallica, Bibliothèque Nationale de France, https://gallica.bnf.fr/ark:/12148/btv1b55004772h/f1.item (accessed 8 March 2021).

[9] Piva, "Le copie del Santo Sepolcro," p. 111. A document from 1152 shows that Sant'Andrea was in charge of a number of major churches including S. Lorenzo, S. Salvatore, S. Matino and S. Ambrogio. Gianna Suitner Nicolini, "Il Monastero Benedettino di Sant'Andrea in Mantova: L'evoluzione dell'Organismo ed il suo Ruolo nella Formazione della Città Medievale," in *Il Sant'Andrea di Mantova e Leon Battista Alberti*, pp. 35–50 (p. 38). Antonius Nerlius lists several dependencies, granted to Sant'Andrea in ca. 1153: St. Salvatore, St. Laurence (San Lorenzo), St. Ambrose, S. Maria of Famigosa, St. Martin, the Holy Sepulchre (sancti Sepulcri), St. George and Nicolai of Fornicada, St. George of Curte Angulfi, St. Mary of Soave, St. Peter of Burgo Alii in Aureo, St. Andreae de Sarcinischo, St. Clement in Persiceto and St. Peter of Galera (*Breve Chronicon*, p. 7).

[10] Arthur Kingsley Porter, *Lombard Architecture* (New Haven: Yale University Press / London: Oxford University Press), VII, *Monuments: Abbazia di Albino-Milan*, p. 513.

[11] Tavernor, *On Alberti*, p. 143.

[12] Piva, "Le copie del Santo Sepolcro," p. 111.

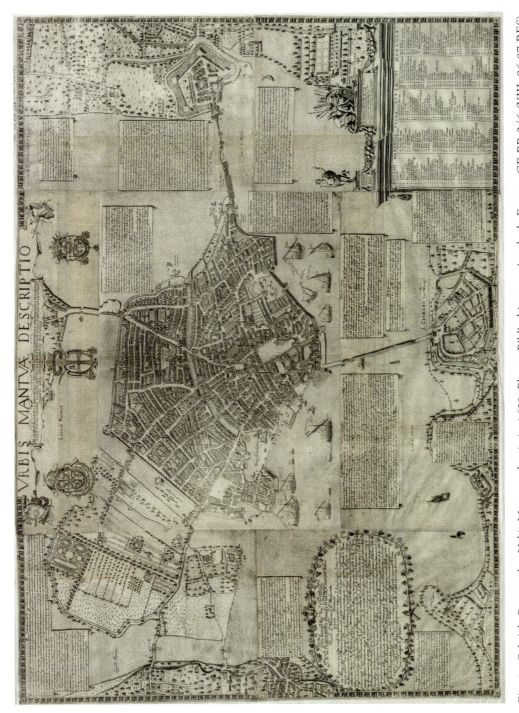

Fig. 1. Gabriele Bertazzolo, *Urbis Mantuae descirptio*, 1628. Photo: Bibliothèque nationale de France, GE BB-246 (XIII, 96-97 RES).

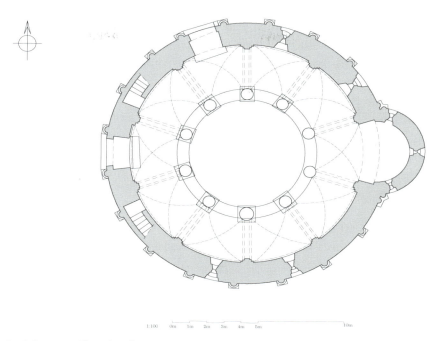

Fig. 2. Mantua, Church of San Lorenzo, ground plan. Drawing: Moriya Erman.

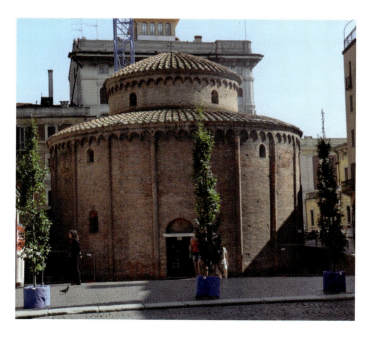

Fig. 3. Mantua, Church of San Lorenzo, exterior, view from North. Photo: Shimrit Shriki-Hilber.

Lorenzo further has a double-shell wall, within which stairs connect the ground and gallery levels. This functional element, too, is found both in Jerusalem and in such copies as the baptistery of Pisa.[13] In the vaults of San Lorenzo, there are a few highly damaged remains of Romanesque frescoes. Paolo Piva assumes these to be the remains of a cycle depicting the life of Christ, culminating in the Crucifixion and Resurrection.[14] For him this is another piece of evidence linking San Lorenzo with the Anastasis Rotunda.[15] Additionally, the total number of internal columns in San Lorenzo—twenty, with ten on each level—is the same as the number of supports on each level in the Anastasis Rotunda. The choice of ten supports is not common, with six, eight, or twelve being easier and more common divisions of the circle. This decision in San Lorenzo presumably demanded careful planning and complicated calculation, meaning that it was intentional, even evocative—certainly not a default choice.[16]

In the lower level of San Lorenzo, two marble *spolia* columns flank the eastern apse and frame the altar (fig. 4). Being monolithic marble columns of two different colors, they stand out from the other columns, which are of reddish brick like the church itself. Situated directly in front of the only entrance, the marble columns draw attention to the altar and the apse. Could these two irregular columns have a symbolic reference? There are known examples among Jerusalem translations—a *spolia* marble column in San Sepolcro (within Santo Stefano) in Bologna is a *similitudine* of the column of Christ's Flagellation.[17] The column in Bologna is conspicuously placed outside the circle of supports of the ambulatory, visually marking its significance. It is possible some kind of

[13] For this element in Pisa, see: Neta Bodner, "The Baptistery of Pisa and the Rotunda of the Holy Sepulchre: a Re-consideration," *Visual Constructs of Jerusalem*, ed. by Galit Noga-Banai, Hanna Vorholt and Bianca Kühnel (Turnhout: Brepols, 2014), pp. 95–108.

[14] Piva, "Le copie del Santo Sepolcro," p. 112. For him this is a sign that San Lorenzo represented the Holy Sepulchre.

[15] Ibid. Another fresco, perhaps from the fifteenth century, depicts the martyrdom of St. Lawrence. G. Giovannoni, *Considerazioni sugli affreschi della Rotonda di S. Lorenzo a Mantova: In occasione del restauro* (Mantua: Museo Civico Polironiano, 1985).

[16] The exterior of San Lorenzo is divided by brick round pilasters into nineteen bays (fig. 4), that do not match the interior division into ten, further indicating that the number of internal columns was significant and not a result of functional considerations.

[17] According to Nadine Mai, its dark hue, large size, and marked location within the church translate the column visually as a "relic" though it was only fashioned in imitation of the Flagellation column, with no claim to material authenticity ("Place and Surface: Golgotha in Late Medieval Bruges," in *Natural Materials of the Holy Land and the Visual Translation of Place, 500–1500*, ed. by Renana Bartal, Neta Bodner, and Bianca Kühnel [London: Routledge, 2017], pp. 190–206 [p. 128]).

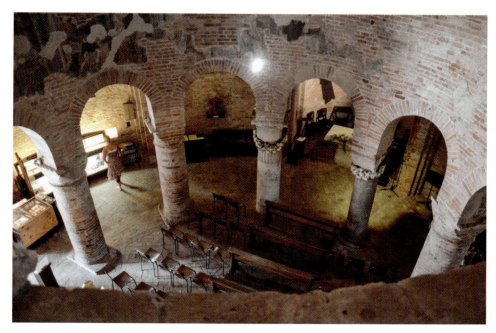

Fig. 4. Mantua, Church of San Lorenzo, interior, view from gallery towards the east. Photo: Shimrit Shriki-Hilber.

similar signification accompanied the *spolia* columns in San Lorenzo as well, since their placement indicates they were more than functional pieces.

The altar in San Lorenzo was dedicated to the Holy Sepulchre in 1535.[18] This dedication evidences a *longue durée* association between the Holy Sepulchre and San Lorenzo, supported by their architectural similarities. These fragments of evidence are strengthened by the known administrative connections between San Lorenzo and the adjacent Sant'Andrea, home to the relic of the blood of Christ. San Lorenzo was, as aforementioned, used for some Easter rites of Sant'Andrea.[19] One can imagine processions between the site of the blood relic from Golgotha in Sant'Andrea to a representation of the Anastasis Rotunda in San Lorenzo.[20] The combination of a longitudinal building with a centralized one further evokes the arrangement of the Holy Sepulchre in Jerusalem.

[18] Piva, "Le copie del Santo Sepolcro," pp. 107 and 112.
[19] Ibid., p. 112; and Tavernor, *On Alberti*, p. 143.
[20] Tavernor assumes that pilgrimage activity was conducted around Sant'Andrea and maybe between it and San Lorenzo (*On Alberti*, p. 143). Using San Lorenzo to house the precious relic

'Holy Sepulchre' by Name – Mantua's Church of San Sepolcro

These connections become more complicated (and interesting) when considering that there was a round church specifically dedicated to the Holy Sepulchre in Mantua: San Sepolcro. The church, now destroyed, is depicted in several early modern maps of Mantua (San Sepolcro is found in the top part of the maps, oriented to the west): *Urbis Mantuae descriptio,* Gabriele Bertazzolo (1628) (fig. 5), *Mantova assediata dall'esercito Imperiale Anno 1629 presa 1630* (fig. 6), *Sacco di Mantova nel 1630,* Matthäus Merian, (1638) (fig. 7), and *Eine Uhr alte Statt* [sic] *in dem Obern theil Italiens* (1700). It is identified as "S. Sepolcro fuori alla pretella" in the legend of Gabriele Bertazzolo's map from 1628, the aforementioned *Urbis Mantuae descriptio.*[21] As can be seen in all of the pictorial depictions, San Sepolcro was situated beyond the lagoon across a bridge connecting it to the Porta della Predella. This area is west of Mantua, in a suburb now called Belfiore. This path was one of the main routes to the city from the west.[22] Thus a direct, wide path connected San Sepolcro with Sant'Andrea and San Lorenzo. The Porta della Predella is the biggest of the gates shown in these maps, articulated by twin towers. If this entrance to the city was also architecturally defined in the Middle Ages, then it could have served as an ad hoc Golden Gate through which processions could either enter or leave the city.

Apart from its dedications, there are other ties linking San Sepolcro with the Holy Sepulchre, most significantly a round floor plan and what seems from the maps to be an ambulatory. The maps show a rotunda of two stories with an ambulatory (indicated by the meeting of a drum and lower roofing around it). There are windows in the ground floor and in the drum, which would have created a well-lit space with particular architectural emphasis on the central space that was illuminated from above. The building is topped either by a cupola or a conical roof; the image could be read either way. There seem to have been windows in the drum and in the ground level, interspersed between what could be brick pilasters similar to those on the exterior of San Lorenzo. It is hard to know whether they were on comparable scale.

Surrounded mostly by trees, the isolated round church is a prominent element in all the maps, situated right under the title in the center of the top register. In the *Mantova assediata dall esercito imperiale* from 1629, San Sepol-

of Longinus also assumes some affinity between the two churches (Kingsley Porter, *Lombard Architecture,* VII, p. 513).

[21] It is marked as number 188, identified in a legend at the bottom right-hand corner.
[22] Tavernor, *On Alberti,* p. 143.

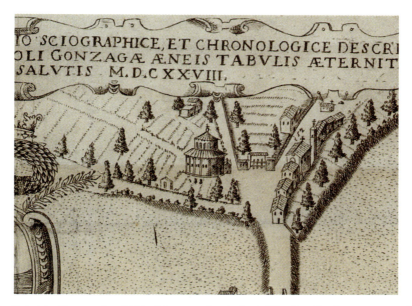

Fig. 5. Gabriele Bertazzolo, *Urbis Mantuae descriptio*, 1628. Detail of top-center: the lost church of San Sepolcro. Photo: Bibliothèque nationale de France.

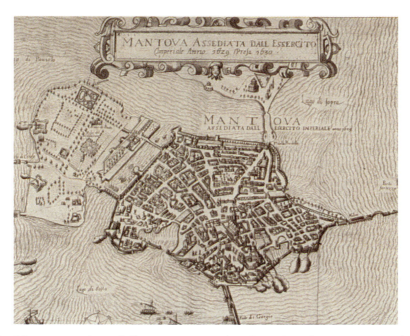

Fig. 6. *Mantova assediata dall essercito imperiale 1629 1630* Photo: Comune di Mantova, Musei Civici.

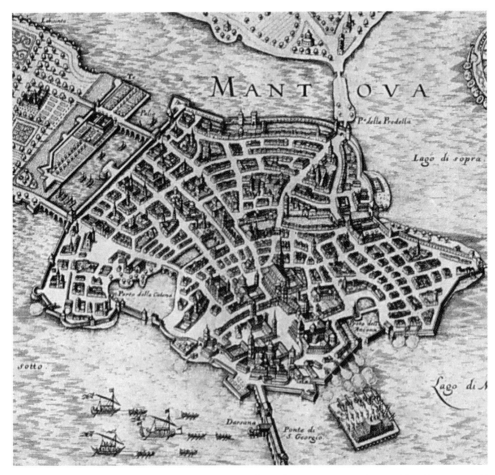

Fig. 7. Matthäus Merian, *Pianta topografica di Mantova*. Photo: © Comune di Mantova, Musei Civici.

cro is pictured surrounded by trees, not far from the shores of the lake and the pathway connecting the bridge to the main city (see fig. 6).[23] While the scale of the trees and the few surrounding houses cannot be taken as true to life, it nevertheless indicates that the mapmaker wanted to present the round structure as large or substantial.

[23] Teresiana Library, *Mantova assediata dall esercito imperiale, anno 1629*, http://digilib.bibliotecateresiana.it/sfoglia_stampe.php?g=AlbumB&sg=ALB004&identifier=MN0035-STM1-ALB004 (accessed 9 March 2021).

Apart from the identification of this building on the 1628 map as 'San Sepolcro', a church by the same name is recorded by Nerlius in an entry regarding years 1129-1169 (the abbacy of Azo over Sant'Andrea).[24] It, too, was a dependency of Sant'Andrea.[25] A short history of the church is found in a text describing the area of Predella in the top right of the map.[26] San Sepolcro is identified as an antique round temple to Mars ("un tempio rotondo antico ... il tempio di Marte"). The text assumes that "San Sepolcro" is a rededication of the same building ("hora si dice il S. Sepolcro").

The maps by Matthäus Merian from 1638 (fig. 7),[27] and a map from 1700 by Bodenehr show a road leading directly from San Sepolcro outside Mantua to Sant'Andrea and San Lorenzo at the city's core.[28] A centralized structure midway between San Sepolcro and San Lorenzo is identified in the *Urbis Mantuae descriptio* as San Vicenzo.[29] The three centralized monuments lie across one path, which ends at a column marking the martyrdom of Longinus (who brought the blood relic to Mantua) and the church of Santa Maria di Monte Oliveto in Grandaro.[30]

The path and the distant location of San Sepolcro, outside the city and across the lake, suggests that it may have been part of a pilgrimage or a processional route. If

[24] Antonio Nerlius, Breve Chronicon Monasterii Mantuani Sancti Andreae ord. Benedict. Ab Anno MXVII usque ad MCCCCXVIII, in *Rerum Italicarum Scriptores*, ed. by Ludovico Antonio Muratori (Milan, 1738), XXIV, pp. 1071–84 (p. 1076). A more recent edition of Nerlius' chronicle is: Antonio Nerlius, *Breve Chronicon Monasterii Mantuani Sancti Andree, ord. Benedictini* [AA. 800-1431], ed. by Orsini Begani (Città di Castello: Forgotten Books, 2016), p. 7.

[25] On San Sepolcro and San Lorenzo as dependencies of Sant'Andrea, see ibid., p. 111, and Ercolano Marani, "Tre Chiese di Sant'Andrea nella storia dello svolgimento urbanistico mantovano," in *Il Sant'Andrea di Mantova e Leon Battista Alberti: Atti del convegno di studi organizzato dalla Città di Mantova con la collaborazione dell'Accademia Virgiliana, nel quinto centenario della basilica di Sant'Andrea e della morte dell'Alberti, 1472–1972* (Mantua: Edizione della Biblioteca comunale di Mantova, 1974), pp. 71–109 (pp. 88–89).

[26] "Ha questa porta nella prima terra ferma, ch[e] si trova andando verso ponente il borgo di case, con un buila paroccia dedicata a'S. Lazaro vicino la quale e'anco un tempio rotondo antico, ch[e] avanti l'avvenimento di N. S. Soleva essere il tempio di Marte et hora si dice il S. Sepolcro poco fa donato alli R.di Chierici del Seminario."

[27] Teresiana Library, *Carta topografica all'epoca della guerra di successione del ducato, 1630*.

[28] Teresiana Library, *Eine Uhr alte Statt [sic] in dem Obern theil Italiens*. See also: Teresiana Library, Leopold, Joseph Friedrich, Mantua, 1630 (?).

[29] Gabriele Bertazzolo (1570–1626), Urb*is Mantuae descriptio / Ab olim D. Gabriele Bertazzolo Laurentii filio sciographice, et chronologice descripta ; atque sub felicissimis auspiciis ser. ducis Caroli Gonzagae aeneis tabulis aeternitati tradita anno humanae salutis M.D.CXXVIII*, open access (public domain) on Gallica, Bibliothèque Nationale de France, https://gallica.bnf.fr/ark:/12148/btv1b55004772h/f1.item (accessed 8 March 2021).

[30] This church stands on a site formerly called the Camposanto, a term usually dedicated to cemeteries in Italy whose soil originates in Jerusalem.

one did exist in Mantua, it would have provided a highly effective pilgrimage experience, connecting several locations that were all linked by various means to the Holy Sepulchre or to Jeruslaem: San Sepolcro through its shape and dedication, San Lorenzo through its facilitation of the blood relic and its shape, Sant'Andrea as the locus of the blood soaked in earth, Santa Maria di Monte Olivetto through its dedication to the Mount of Olives, and the column of Longinus to the story of the arrival of the blood from Jerusalem to Mantua. The exact nature of the relationships betweem these sites remains an open question. San Lorenzo had an altar of the Holy Sepulchre since 1535. It can be stated, therefore, that by the sixteenth or seventeenth centuries, both the round churches of San Lorenzo and San Sepolcro had concrete dedications to the Holy Sepulchre.[31] How could they have been related? Why would a city want more than one copy of a Jerusalem prototype?[32] Perhaps Mantua wanted to re-create on a small scale the stations along the way to Jerusalem, knowing that local Holy Sepulchre representations would have met pilgrims at such places as Pisa's port en route to the Levant. In such a scenario, San Sepolcro would have been a station on the way to San Lorenzo and Sant'Andrea, where pilgrims would have come into contact with the relics of the blood and earth, encountering material remnants (and not just representations of) the Holy Land and the Passion. Or, conversely, in light of the emphasis in the Gospels on the Holy Sepulchre's location outside of Jerusalem, processions could have departed from the city and headed toward San Sepolcro.

If such a path existed and if it continued to Sta. Maria di Monte Olivetto (number 118 on Bertazzolo's map, at the center left), then it is further possible to detect an overlay of meaningful locations connected to both the story of Christ's Passion and Resurrection in Jerusalem and to that of the blood's arrival from Jerusalem to Mantua. Number 184 on the map is "S. Trinita Casa de cathecumini e peregrini." Assuming that few catechumens were current in seventeenth-century Mantua, this title may also be considered to reflect some evocation of the past in Mantua. Arguably the attribution of the rotunda of San Sepolcro to an ancient temple of Mars by Bertozzolo is as ideological as it is possibly historical.[33] Both dedications could have helped bridge Mantua's present with Christianity's glorious late antique past.

[31] The name "San Sepolcro" appears in the legend and explanatory paragraph in the *Urbis Mantue Descriptio* from 1628 and as "sancti Sepulcri" in the fifteenth-century *Breve Chronicon*.

[32] For this question regarding medieval Pisa, which also had two centralized churches affiliated with the Holy Sepulchre since the Middle Ages, see Neta Bodner, "Why Are There Two Medieval Copies of the Holy Sepulcher in Pisa? A Comparative Analysis of San Sepolcro and the Baptistery," *Viator* 48, no. 3 (2017): 103–24.

[33] This is the case, for example, in the ancient attribution for the baptistery of Florence, likewise a medieval centralized structure.

Sant'Andea in Mantua: Home to the Earliest Relic of the Blood of Christ in the West

Sant'Andrea is one of Mantua's oldest and most important churches, despite not being the city's cathedral (figs. 8–10).[34] The existing building stands on the site of a previous Benedictine abbey.[35] The abbey, in turn, was built on the site of a Carolingian oratory[36] to house the relic of the precious blood when it was discovered during the reign of Charlemagne.[37] There are almost no physical

[34] Research on the architecture of the church has focused on Renaissance architecture and classical influences and less on the relic and its cult. The major monograph on the church is Eugene J. Johnson, *S. Andrea in Mantua: The Building History* (University Park: Pennsylvania State University Press, 1975). A large edited volume was produced following a conference marking five hundred years from Alberti's death in 1470: *Il Sant'Andrea di Mantova e Leon Battista Alberti*. For classical influences on Alberti, see James Lawson, "The Extrinsic in the Architectural Thinking of Leon Battista Alberti: A Reading of Sant'Andrea in Mantua," *Renaissance Studies* 27, no. 2 (2013), 253–69 (pp. 266–67 and 269); Michael Ytterberg, "Alberti's Sant'Andrea and the Etruscan Proportion," in *Nexus VII: Architecture and Mathematics,* ed. by Kim Williams (Turin: Kim William's Books, 2008), pp. 201–16; Richard Krautheimer, "Alberti's Templum Etruscum," *Münchner Jahrbuch der Bildenden Kunst* 4 (1961), 65–72, reprinted in Richard Krautheimer, *Studies in Early Christian, Medieval and Renaissance Art* (New York: New York University Press, 1969), 333–44. For consideration of the relic as a factor in the lighting scheme at Sant'Andrea, see Howard Saalman, Livio Volpi Ghirardini, and Anthony Law, "Recent Excavations under the 'Ombrellone' of Sant'Andrea in Mantua: Preliminary Report," *Journal of the Society of Architectural Historians* 51, no. 4 (1992), 357–76.

[35] The eleventh-century basilica occupied the site of the present building and was served by a Benedictine monastery, and a monastic complex grew up to the north of the present church. See Johnson, *S. Andrea in Mantua*, pp. 5–6.

[36] In 804 Charlemagne built an oratory on the site in its honor; Marani, "Tre Chiese di Sant'Andrea," pp. 73–79. According to Chiara Perina, Pope Leo III dedicated an oratory to the blood relic when he came to Mantua at the invitation of Charlemagne to authenticate it (*La basilica di S. Andrea in Mantova* [Mantua: Istituto Carlo d'Arco per la Storia di Mantova, 1966], p. 3). For the description of the 804 invention in the fifteenth-century Cronica di Mantova, see Renata Salvarani, "La reliquia del preziosissimo Sangue di Cristo conservata a Mantova: Aspetti politici e dottrinali tra IX e XI Secolo," *Studi Ecumenici* 24 (2006), 563–84 (p. 566).

[37] Nerlius, *Breve Chronicon*, p. 1071 in the 1738 (Rerum Italicarum Scriptores) edition. An early source for the blood of Mantua is the *Annales Regni Francorum* for year 804, which describes Pope Leo III arriving in Mantua (at the request of Charlemagne) to verify rumors of the newly discovered relic. See also Marani, "Tre Chiese di Sant'Andrea," p. 74. Apparently Pope Leo IX wanted to take the relic to Rome, but resistance by the Mantuans prevented it. See Heiner Mühlmann, "Albertis St.-Andrea-Kirche und das Erhabene," *Zeitschrift für Kunstgeschichte* 32, no. 2 (1969), 153–57 (p. 153); and Mark Daniel Holtz, "Cults of the Precious Blood in the Medieval Latin West" (unpublished doctoral thesis, University of Notre Dame, 1997), p. 20. For medieval traditions regarding Longinus and Mantua, see Roberto Capuzzo, "The Precious Blood of Christ: Faith, Rituals and Civic and Religious Meaning during the Centuries of Mantuan Devotion," *International Journal for the Study of the Christian Church* 17, no. 4 (2017), 228–45 (p. 230).

Fig. 8. Mantua, Church of Sant'Andrea, ground plan. Drawing: Moriya Erman.

Fig. 9. Mantua, Church of Sant'Andrea, interior. Photo: Tango7174, published under GNU Free Documentation License.

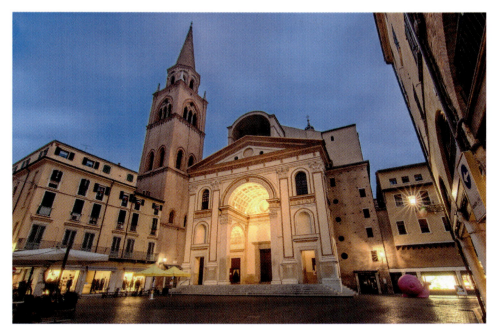

Fig. 10. Mantua, Church of Sant'Andrea, exterior. Photo: Paolo Tralli at Sutterstock images.

remains of the earlier phases of Sant'Andrea's construction from the ninth, eleventh, and twelfth centuries.[38] Little is known about the form of the eleventh-century church except that it had a two-story loggia that faced a small piazza[39] and that the relic was held in an underground crypt.[40]

It is hard to claim specific signification tying Sant'Andrea to Jerusalem when the blood relic in itself was solid grounds for pilgrimage and cult

Antonio Nerlius, or Nerli, was abbot of Sant'Andrea who initiated a renovation of the church in 1392 (carried out in 1413–14) when it was part of the Benedictine monastery. See Perlina, *La basilica di Sant'Andrea*, p. 5.

[38] For evidence of the medieval phase, see Dino Nicolini, "Il Ritrovamento e il Restauro delle testimonianze architettoniche del Monastero di Sant'Andrea in Mantova," in *Il Sant'Andrea di Mantova e Leon Battista Alberti*, pp. 51–70. According to *De inventione*, the relic was held in a crypt beneath the altar in the new church. See Holtz, "Cults of the Precious Blood," p. 21. A modest chapel was built within Sant'Andrea when it was a monastery church and consecrated in the name of St. Longinus. See Sally Anne Hickson, *Women, Art and Architectural Patronage in Renaissance Mantua: Matrons, Mystics and Monasteries* (Surrey: Ashgate, 2012), p. 18.

[39] Tavernor, *On Alberti*, p. 159.

[40] Capuzzo, "Precious Blood of Christ," p. 235

activity. However, the idea should be explored due to Sant'Andrea's many links to San Sepolcro and San Lorenzo and due to its location right in the path between the two churches. I contend that the "Jerusalem network" in Mantua rests on the connection formed between the two churches in the story of the arrival of the blood relic. The fifteenth-century *Breve Chronicon Monasterii Mantuani Sancti Andreae* by Antonio Nerlius recounts how the blood was brought to Mantua by the Roman soldier Longinus.[41] Longinus, the centurion who pierced Christ's side with the lance, collected the blood with a handful of earth in his helmet and transported it himself in an inscribed casket to Mantua.[42] The relic was later buried to protect it during the Hungarian invasion[43] and was rediscovered in 1048 by a blind local man called Adilbert.[44] It was St. Andrew who led Adilbert to the precious relic,[45] which accounts for the church's dedication.[46]

The local context seems imperative to how the different edifices in Mantua functioned. The story of Longinus's translation bridges time and space. Longinus was present at the Crucifixion and brought the blood to Mantua directly from the historical event when it was shed, traveling himself, with his precious cargo from Jerusalem to Mantua. His own martyrdom in Mantua,

[41] Nerlius, *Breve Chronicon*, p. 1071.

[42] Capuzzo, "Precious Blood of Christ," p. 229. The relic was reportedly hidden upon arrival but then found in 804 by the pope and the emperor Charlemagne. See Nerlius, *Breve Chronicon*, p. 1071.

[43] According to Perina, in 924 the people of Mantua, under threat of Hungarian attack, divided the relic into two containers. Then in 1048 a second apparition of the Apostle Andrew, to a Mantuan named Adalbert, led to its re-discovery in that year (*La basilica di S. Andrea*, p. 3).

[44] Capuzzo, "Precious Blood of Christ," p. 233.

[45] See W. Braghirolli, "Leone Battista Alberti a Mantova," *Archivio storico italiano*, ser 3, 9 (1869), 3–31. For a discussion of the 804 and 1048 inventions, see Salvarani, "La reliquia del preziosissimo," pp. 563–84. For the eleventh-century invention in the early twelfth-century *De inventione sanguinis domini*, see Holtz, "Cults of the Precious Blood," pp. 18–19. For a reference to the 1048 finding in the German *Chronicon* by Hermann of Reichenau (Herimanni augiensis, *Chronicon*, p. 127), see Astolfi, "History and Tradition of the Precious Blood," p. 225. According to Gianna Suitner Nicolini, the Benedictine urban monastery of Sant'Andrea was founded in 1037, a decade before the legendary reinvention of the relic ("Il Monastero Benedettino di Sant'Andrea in Mantova: L'evoluzione dell'Organismo ed il suo Ruolo nella Formazione della Città Medievale," in *Il Sant'Andrea di Mantova e Leon Battista Alberti*, pp. 35–50 (p. 37).

[46] In the twelfth century, a parchment of the *Archivio Storico Diocesano*, dated 1135, also locates the body of Longinus as an important relic in the church of Sant'Andrea. See Molly Bourne, "The Art of Diplomacy: Mantua and the Gonzaga, 1328–1630," in *The Court Cities of Northern Italy*, ed. by Charles M. Rosenberg (Cambridge: Cambridge University Press, 2010), pp. 138–96 (p. 138).

marked by a column in the southern part of the city, became a local continuation to the story.⁴⁷ Already in the Middle Ages, the body of Longinus was revered as the second most important relic of the church of Sant'Andrea within its own chapel.⁴⁸ This early Christian history of Mantua with the martyrdom of the saint may have been evoked by the claim of a pagan origin for San Sepolcro.

Since the beginning of the fifteenth century, the cult of the Holy Blood relic became increasingly prominent in Mantua, with some changes to its display. In 1401 Francesco I Gonzaga altered the dynamics of veneration when he decided upon an annual showing of the relic (which was otherwise concealed from sight in a closed compartment in the crypt) on the day of Ascension.⁴⁹ That same year, Francesco also commissioned a grand new receptacle for the relic.⁵⁰ The new reliquary and viewing practices elevated the relic's status and fame in the first half of the fifteenth century, when the church was still a part of a Benedictine monastery.⁵¹ The current receptacle is made of red marble, giving a tactile sense of dripping blood.

⁴⁷ The narration of *De inventione Sanguinis Domini*, also dated to the middle or end of the twelfth century, locates the martyrdom of the saint in Mantua; see Capuzzo, "Precious Blood of Christ," p. 229.

⁴⁸ Ibid., p. 229.

⁴⁹ Although the relic had been annually venerated since the rule of the Bonacolsi family, it remained at all times locked and hidden from view in the crypt of Sant'Andrea. In 1401 Francesco I decided to have it publicly displayed once a year for the feast of the Ascension. Spectators flocked to venerate the Blood and to attend the sermon delivered in honor of the special event. This tradition became one of the most important rituals used by the Gonzaga to demonstrate their power and control of key ecclesiastical institutions. See Bourne, "Art of Diplomacy," pp. 146–47.

⁵⁰ The receptacle could only be opened using eight different keys held by eight different people. See Johnson, *S. Andrea in Mantua*, p. 10. According to Caroline Bynum, the hiding away of the relic throughout most of the year was characteristic of piety towards the blood of Christ in the fifteenth century in general. Because of the theological precariousness of blood relics there was a general tendency to keep the physical objects (blood relics and their reliquaries) hidden, with even their containers only rarely available to the laity. See Bynum, "The Blood of Christ," p. 699.

⁵¹ By 1460, as evident in the letters published by Chambers and Martineau (*Splendours of the Gonzaga*), the Gonzaga family showed a keen interest in abolishing the monastery that ran Sant'Andrea and in renovating the church for veneration of the relic. This was subsequent to Gonzaga investments in kindling and rekindling pilgrimage sites before the fifteenth century. In 1399, for example, Francesco I Gonzaga founded the sanctuary of Santa Maria della Grazia in the environs of Mantua, for a miraculous image of the Virgin credited with saving him and his subjects from plague that year. See Bourne, "Art of Diplomacy," p. 147.

In the late fifteenth century, both San Lorenzo and Sant'Andrea were renovated following commissions by the marquises of Mantua, the Gonzaga family.[52] Their concurrent redesigns by the same architect, none other than Leon Battista Alberti, is another connection between Sant'Andrea and San Lorenzo. In February 1460, Alberti wrote to Ludovico Gonzaga that his designs for several buildings, including San Lorenzo, were ready.[53] In 1470, Alberti submitted a design for Sant'Andrea, which was partially realized after his death in 1472.[54] Research on the fifteenth-century phase of Sant'Andrea has concentrated on the innovative architectural design and classical influences.[55] However, the increased interest in

[52] In 1460 Leon Battista Alberti had already been approached to renovate the Romanesque round church of San Lorenzo and the piazza between it and Sant'Andrea. By 1461 Bonatto was negotiating a plan to reform San Lorenzo on a collegiate basis and to rebuild the church as part of a repaving and overall redesign of the surrounding piazza. See Chambers and Martineau, *Splendours of the Gonzaga*, pp. 103, 106. In February 1460 Alberti wrote to Ludovico Gonzaga that his designs for several buildings, including San Sebastiano and San Lorenzo were ready (though the latter was never realized). See Tavernor, *On Alberti*, p. 143. On Alberti's plans for San Lorenzo see: Marzio Dall'Acqua, 'Storia di un progetto albertiano non realizzato: La ricostruzione della rotonda di San Lorenzo in Mantova', in *Il Sant'Andrea di Mantova e Leon Battista Alberti*, pp. 229–36.

[53] In February 1460, Alberti wrote to Ludovico Gonzaga that his designs for several buildings, including San Sebastiano and San Lorenzo were ready (though the latter was never realized). See Tavernor, *On Alberti*, p. 143. On Alberti's plans for San Lorenzo, see Dall'Acqua, "Storia di un progetto albertiano," pp. 229–36.

[54] Completed in various stages, the church was finalized in its current form only in the last decades of the eighteenth century, with the dome only begun in 1732. See Erich Hubala, "L. B. Albertis Langhaus von Sant'Andrea in Mantua," in *Festschrift Kurt Badt zum siebzigsten Geburtstage: Beiträge aus Kunst- und Geistesgeschichte*, ed. by Martin Gosebruch (Berlin: De Gruyter, 1961), pp. 83–119 (pp. 83–85). The building chronology according to Johnson (following Ernst Ritscher) is as follows: in 1470, the design was submitted by Alberti to Lodovico Gonzaga. In June 1472, the cornerstone was laid. Between 1472 and 1492, construction of the nave and western porch ensued. In 1475, the walls were presumably completed up to the cornice, ready to receive the barrel vault by summer. In 1481, a chapel in St. Andrea was dedicated to the Blood of Christ on the 22 August. In 1488, Andrea Mantegna frescoed the roundel of the tympanum. In circa 1534, decoration for the chapel of St. Longinus was carried out under Giulio Romano. In circa 1780, restoration and decoration of the interior was held under Paolo Pozzo. See Johnson, *Sant'Andrea in Mantua*, pp. i and ii, based on Ernst Ritscher, *Die Kirche S. Andrea in Mantua* (Berlin: Wilhelm Ernst, 1899).

[55] A primary question in scholarship of Sant'Andrea is whether the present church faithfully reflects Alberti's original design or not. See Johnson, *S. Andrea in Mantua*, p. 1. Other major discussions include the relationship between Alberti and the building's patron, Ludovico Gonzaga, and classical influences on Alberti's design. For the architecture of Sant'Andrea as deriving from classicism in Alberti's theory, see Lawson, "The Extrinsic in the Architectural Thinking," pp. 265–66, and Rudolf Wittkower, *Architectural Principles in the Age of Humanism*, Studies of the Warburg Institute 19 (London: Warburg Institute, 1949), p. 47. The first phase of construction (1472–93) was overseen by Luca Fancelli. See Michael Oppenheimer, *Monuments of*

the elevation of the relic was an equally influential factor that affected the timeline of the renovation. In the 1450s, the Gonzaga family were already looking to renovate the church. Letters published by D. S. Chambers reveal these intentions clearly.[56] First, the Gonzaga family tried to convince Abbot Francesco Nuvolini (head of the Benedictine monastery in charge of Sant'Andrea) to renovate the church.[57] They expressed their devotion to the blood relic and their commitment to contribute financially to the restoration.[58] Upon Nuvolini's adamant refusal, the Gonzagas tried to act against his authority (claiming that he was unfit to run Sant'Andrea) and abolish the monastery. However, the pope did not agree to intervene.[59] It was only after a decade of failed appeals that in 1470, upon Nuvolini's death, the Gonzaga family were able to take over control of the church.[60]

In a well-known letter to Ludovico from 1470, Alberti explicitly cited the relic as the motivation for the redesign, stressing that the marquis and the populace sought a space where many people could view the relic ("molto populo capesse a vedere el sangue de Cristo").[61] The plans seem to have involved the public to some extent, at least as implied in Alberti's remark that both the marquis and the citizens were interested in a rebuilding of the church ("S.V. et questi vostri cittadini Ragionavano de edificare qui a Sancto Andrea").[62]

Italy: A Regional Survey of Art, Architecture and Archaeology from Classical to Modern Times (London: Tauris, 2002).

[56] See D. S. Chambers, "Sant'Andrea in Mantua and Gonzaga Patronage, 1460–1472," *Journal of the Warburg and Courtauld Institutes* 40 (1977), 99–127, and Bourne, "Art of Diplomacy," pp. 138–95.

[57] Chambers, "Sant'Andrea in Mantua," pp. 138–95

[58] On 21 April 1470, Francesco Gonzaga wrote to Rome, expressing his own devotion to the Holy Blood and acknowledging the pledge of both his parents to contribute two hundred ducats a year towards the building. He promised to lay down the same amount himself and to accelerate collection of debts from the income of the monastery or from his other benefices. See Archivio Storico Diocesano di Mantova, Fondo del Capitolo della Cattedrale, B. XXIII, parchment 2590, published in Chambers, "Sant'Andrea in Mantua," doc. 20.

[59] A certain Bonatto reported that Pius II was unwilling to act over the abbot's head on this matter. See Chambers, "Sant'Andrea in Mantua," p. 106.

[60] After the death of the abbot, Cardinal Francesco Gonzaga (the son of the Marquis) petitioned to have Sant'Andrea for himself, and once the papal bull was issued, his common services tax was paid. On 23 April, four proctors in Mantua were appointed for the administration of Sant'Andrea. These included the archdeacon and archpriest of the cathedral, so that the monks of Sant'Andrea were not placed directly under the episcopal administration. See ibid., p. 111.

[61] Alberti, *Scrittori d'Italia: Leon Battista Alberti*, Opere Volgari, ed. by Cecil Grayson (Bati: Gius. Laterza & Figli, 1973), III, *Trattati d'arte, Ludi rerum mathematicarum, Grammatica della lingua toscana, Opuscoli amatori, Lettere*, p. 295 (letter 6).

[62] Ibid.

The letter frames the display of the relic as the principal motivation behind the renovation. Viewing the relic has already been theorized by Howard Saalman, Livio Volpi Ghirardini, and Anthony Law as the major factor behind the design of some spaces in the western part of the church.[63] They suggest that the *ombrellone* window over the western porch was built to dramatically light the area in which the relic was raised during private viewings or in times of plague or war.[64] Other scholars have noted that the barrel-vaulted nave, devoid of any piers or columns, allowed uniquely unencumbered views to the east where the relic was held.[65] The omission of columns and the use of the walls of the side chapels to support the vault was one of the innovations of Alberti's design, allowing for an unobstructed interior space from west to east within the church.[66] The result was an intricate dynamic between seeing and not seeing. On the one hand, there were open views to the direction of the relic. On the other, the relic was kept out of sight in a closed receptacle in the crypt, exposed only on its annual showing the Ascension. This tension between what was being revealed and what was hidden may have been echoed in the building's unique architectural design.

In considering layers of connection between Sant'Andrea and the Holy Sepulchre, it is also noteworthy that Alberti was the architect of two further likely representations of Jerusalem in Italy: the tribune of Florence's Santissima Annunziata, theorized as a copy of the Anastasis Rotunda, and the Rucellai tomb in San Pancrazio in Florence (fashioned after the tomb aedicula in Jerusalem).[67] Alberti, alongside his humanist interests, held clerical

[63] Saalman, Ghirardini, and Law see the round "ombrellone" window above the western porch as an architectural element used for the annual viewing of the relic on Ascension day ("Recent Excavations," pp. 357–76).

[64] Ibid.

[65] Bourne understands the spatial solution as providing a free path of sight to see the relics, while reducing building costs (for lack of columns) ("Art of Diplomacy," p. 156). Lawson agrees and writes: "Columns, especially expensive to quarry, transport and raise in the flat lands of the Po, would obstruct the view of the relic and deprive it of focal eminence, contribute to a general gloominess, and be part of a frail structure that could not risk large arched and vaulted spaces. Alberti's brick church, by contrast, would be *capace, eterno, degno* and *lieto*" ("The Extrinsic in the Architectural Thinking," p. 266). It is worth reiterating that on all but one day of the year, the relics were kept in the crypt rather than the nave.

[66] Johnson notes that the huge nave, over 50 meters long and over 18 meters wide, is completely unencumbered and thus able to hold many people, every one of whom could see the relics when they were displayed (*S. Andrea in Mantua*, p. 13).

[67] The Rucellai tomb was begun shortly after 1458 and probably completed in 1467. Christine M. Sperling, "Leon Battista Alberti's Inscriptions on the Holy Sepulchre in the Cappella Rucellai, San Pancrazio, Florence," *Journal of the Warburg and Courtauld Institutes* 52 (1989), 221–28, (p. 223). On the Rucellai tomb, see Anke Naujokat, "Kopie de Kopie: Das Heilige

roles throughout his life and was employed at the papal court of Pope Pius II.[68] He accompanied the pope to Mantua for a congress discussing a crusade against the Turks in 1460.[69] Perhaps hoping to exploit his marital ties to the emperor, Ludovico promised the pope that Frederick III would attend, although in the end he never arrived. The entire papal court spent nearly nine months in Mantua waiting, placing the city in the spotlight of a wider European audience.[70]

When it became clear that there was no political support for the crusading idea, the initiative was set aside. The decision to embark on a large-scale renovation of Sant'Andrea seems to have been reached right after it became clear that there was not enough support for the crusading idea. Renovation of a local church associated with Jerusalem and home to a major relic from the Holy Land may have been seen as an acceptable alternative. The renovation of Sant'Andrea, it can be argued, became a surrogate for the Holy Sepulchre in Jerusalem, which could no longer be physically liberated since there was to be no crusade.[71] A hint that this was the case can be gleaned from a letter by the Gonzaga family asking for permission to allocate the crusading funds to the renovation of Sant'Andrea.[72] Swapping financial support between the two projects indicates their perceived connection, even if they were not fully interchangeable.

An earlier European parallel shows that similiar connections existed elsewhere. The patriarch of Jerusalem sent a relic of the Holy Blood, now in Westminster, to the king of England, begging him to send troops to assist the clergy in the

Grab von San Rocco, Sansepolcro," in *Raubkopie* (Aachen: Redaktion Archimaera, 2009), pp. 18–23; Anke Naujokat, *Non est hic: Leon Battista Albertis Tempietto in der Cappella Rucellai* (Aachen: Geymüller, 2011); On Santissima Annunziata, see Tavernor, *On Alberti*.

[68] Alberti was educated in canon law at Bologna University, took up holy orders, and held ecclesiastic positions all his life; Tavernor, *On Alberti*, p. iv.

[69] Between May 1459 and January 1460, Ludovico Gonzaga initiated a papal congress in Mantua. Alberti arrived in Mantua for a papal congress initiated by the Gonzaga family with the aim of instigating crusade against the Turks in the Holy Land. On Pius II and the congress in Mantua, see also Creighton, *Castles and Landscapes*, pp. 365–70. Some of the congress proceedings were held in the Romanesque Sant'Andrea.

[70] Bourne, "Art of Diplomacy," p. 153.

[71] Ibid.

[72] Ludovico was succeeded by his son, Federigo, who seems to have turned much of the supervision of work at Sant'Andrea over to his brother, Cardinal Francesco. In 1480 Federigo wrote to Francesco that the church was ready to receive the vault. He suggested a scheme for raising money for this project: persuading the pope to donate part of the funds that had been collected and deposited by Pius II in Mantua for the latter's proposed crusade against the Turks. See Johnson, *S. Andrea in Mantua*, p. 15.

Holy Land.[73] The relic was originally placed in London's Temple Church, a local representation of the Holy Sepulchre.[74] Throughout the thirteenth century, this affinity between the relic and an architectural evocation of the Holy Sepulchre existed in London. Sant'Andrea in Mantua had at least two dependencies that were directly tied by architecture and dedication to the Holy Sepulchre, thus also wedding the blood relic with some form of Jerusalemite architectural translation.

Aside from the local transition of enthusiasm (and funds) from crusade to the renovation of Sant'Andrea and San Lorenzo, there seems to have also been a wider European context that has not been considered in research on Sant'Andrea. Sant'Andrea's renovation is concurrent with rising interest in the relic of the blood of Christ in Northern Europe. During the fourteenth and fifteenth centuries, many blood cults grew across Europe, above all in northern Germany.[75]

The tradition of Mantua's blood relic is one of the oldest recorded in Western Europe.[76] However there were other prominent sites in Europe that held relics of the blood of Christ. By the early fifteenth century, more than two hundred shrines devoted to the miraculous blood existed in Western Europe, mainly in Italy, Austria, and northern Germany.[77] Some of these, most notably the Holy Blood at Weingarten, traced their own blood relics to gifts from Mantua.[78] In the fifteenth century, many of the medieval sites of blood relics saw a new flowering of interest, including Weingarten, Orvieto, Andechs, Wilsnack, and Schwerin.[79]

[73] Nicholas Vincent, *The Holy Blood: King Henry III and the Westminster Blood Relic* (Cambridge: Cambridge University Press, 2001), p. 3.

[74] Ibid.

[75] Bynum, *Wonderful Blood*, pp. 96–111. See also Annemarie C. Mayer, "Most Precious Blood: Pilgrimage and Veneration of the Relic in Weingarten and Mantua," *International Journal for the Study of the Christian Church* 17, no. 4 (2017), 208–17 (pp. 213–14), and Karl A. Zaenker, "The Cult of the Holy Blood in Late Medieval Germany," *Mosaic: An Interdisciplinary Critical Journal* 10, no. 4 (1977), pp. 37–46.

[76] Richard Barber, *The Holy Grail: Imagination and Belief* (Cambridge: Harvard University Press, 2004), p. 128, Capuzzo, "Precious Blood of Christ," p. 229.

[77] Donald Sullivan, "The Holy Blood of Wilsnack: Politics, Theology and the Reform of Popular Religion in Late Medieval Germany," *Viator* 47, no. 2 (2016): 249–76 (p. 252).

[78] The claim that the relic at Weingarten derived from the relic in Mantua was maintained both by the monks at Weingarten and their brethren in Mantua; see Holtz, "Cults of the Precious Blood," pp. 18–19. See also Bynum, "The Blood of Christ," p. 692. For the distribution of the relic to Paris, Rome, and Weingarten, see Astolfi, "History and Tradition of the Precious Blood," p. 226. Part of it was given as a present to Judith of Flanders; Mayer, "Most Precious Blood," p. 212.

[79] See Bynum, "The Blood of Christ," pp. 685–714, esp. p. 699. Bynum also listed sites that boasted "altar relics" of the blood: Münchmünster, Oberlonon, Trier, Himmerod, Wettingen, Echternach, and Baruweiler.

The European increase in attention to relics of the blood of Christ was echoed by the Gonzaga family, the patrons of the renovation of Sant'Andrea. In parallel to the Northern European architectural revival of sites holding the blood of Christ, theological debates about such relics were held in Italy throughout the fifteenth century.[80] They questioned the hypostatic union, with some theologians rejecting this suggestion entirely.[81] However three popes—Nicolas V (r. 1447–55), Pius II (r. 1458–64), and Paul II (r. 1464–71)—permitted and encouraged the veneration of relics of the blood of Christ.[82] Major papal support of the relic overlaps with Gonzaga aspirations for Sant'Andrea and the decision to renovate the church. The key moment was less than a decade before Alberti's involvement in the project when Pope Pius II convened a meeting to dispute the topic at his court in Rome in 1462 and ruled in favor of relics of the blood of Christ.[83] The influence on Mantua was immediate: with the papal approbation of the relic, a secular confraternity of the Sacred Blood was founded;[84] in 1472, indulgences to the confraternity were granted by none other than Cardinal Francesco Gonzaga, first *primicerio* of the newly established canonicate of Sant'Andrea; they were reaffirmed in 1489 by Cardinal Paolo Fregaso, and again in 1510 by Cardinal Sigismondo Gonzaga, second *primicerio* of Sant'Andrea.[85]

Conclusions

I examined the case study of Mantua in order to argue for a connection between piety directed toward the blood of Christ and the representation of Jerusalem in Europe. I looked at the establishment in medieval Mantua of both cults in tandem, examining the imitations of the church of the Holy Sepulchre in parallel with changes to the cult of the blood of Christ, particularly focused around Sant'Andrea. I followed the concurrent development of devotion to local

[80] For a comprehensive overview of theological debates on Christ's Blood, Bynum, *Wonderful Blood,* pp. 96–111.

[81] Ibid., p. 695.

[82] Ibid., p. 698.

[83] The disputation began on Christmas Day 1462. See Mandell Creighton, *A History of the Papacy during the Period of the Reformation* (Cambridge: Cambridge University Press, [1882] 2011), VII, p. 448.

[84] According to the Mantuan church historian Ippolito Donesmondi, writing in 1616, a secular confraternity of the Sacred Blood was founded by Pius II following this theological disputation and subsequent papal approbation of the relics in 1462; Saalman, Ghirardini, and Law, "Recent Excavations," pp. 357–76.

[85] Ibid.

Jerusalem representations and to the relic of the blood of Christ in the late fifteenth century, arguing that renewed local interest in the relic held at Sant'Andrea coincided with similar trends in Northern Europe as well as key historical occurrences, such as the decision to not pursue crusade to Jerusalem and instead fund renovations to Mantuan churches. Using primary visual sources, especially Gabriele Bertazzolo's *Urbis Mantua descriptio*, I noted other buildings in Mantua that could have been part of a local representation. Despite the fragmentary character of the evidence I have amassed, it seems that an architectural presence of Jerusalem in Mantua coincided with an increased zeal for the city's prized relic of Christ's blood.

FROM NOVGOROD TO ROME VIA MOSCOW: ON TRANSLATIONS OF JERUSALEM TO RUSSIA

Anastasia Keshman W.

Replicating the Holy Land is a centuries-old tradition in Orthodox Russia. In this chapter, I would like to outline the development of the Russian tradition of copying the Holy Land from the early Middle Ages. I begin with contemporary translations, showcasing the longevity of the phenomenon, and then look backward to its origins, exploring its evolution throughout the centuries. A special effort will be made to trace the origins of this tradition, quite atypical of Orthodox culture. Specifically, I will explore the crucial importance of Novgorod in establishing this particular Russian practice, which spread from the northern city first to Moscow and from there diffused throughout Russia.

Russian Copies of the Holy Land

A new tourist attraction was recently added to the well-known places of interest in Moscow: the Church of the Veil of the Holy Virgin, located in the sleepy suburb of Yasenevo (Храм Покрова Пресвятой Богородицы в Ясенево). The church is situated on a traffic island between two busy highways (fig. 1).[1] Even before the upper church was complete, the lower one, dedicated to the Archangel Michael and originally designed as a baptistery, become one of the most popular pilgrimage sites in Moscow.[2] It houses eight three-dimensional reproductions, some with actual relics of Holy Land sites: the birth cave in Bethlehem with the star, an exact replica of the wine jar from the Greek Orthodox church in Cana, the tomb of the Virgin in the Valley of Jehoshaphat, the Greek Orthodox chapel of the prison of Christ from the Via Dolorosa, and a number of copies from the Holy Sepulchre Church in Jerusalem, including Golgotha, the aedicula of the Holy Tomb, the Stone of Unction, and the Pillar of the Holy Fire from the entrance portal to the church. The copies of the holy

[1] The decision to construct the church was made in 2001; actual construction began in 2008. The official site of the church is "Храм Покрова Пресвятой Богородицы в Ясеневе," http://www.hrampokrov.ru (accessed 26 September 2021).

[2] The upper church was officially inaugurated by the patriarch of Moscow and all Rus' Kirill on 27 December 2015.

Fig. 1. Yasenevo, The Church of the Veil of the Holy Virgin (Храм Покрова Пресвятой Богородицы в Ясенево), exterior view. Photo: Mos.ru. (The Government of Moscow Press centre), published under the Creative Commons Attribution 4.0 International license.

sites were made with computer precision thanks to measurements taken with laser technology. A free-standing, two-dimensional crucifix that marks the place of Christ's death, behind the altar of the Golgotha chapel, is a copy of the one that stands in Jerusalem precisely on that spot. Beneath the altar, a stone relic from the original Golgotha is housed within a silver reliquary, as the church's official website informs the reader. Made of new materials, the recreations obviously look fresher and cleaner than the originals.

All explanatory Greek inscriptions identifying the original holy places in Jerusalem are translated into the Slavonic language, but they preserve precisely the content of the originals. Even *sanctuaria* (contact relics), such as the oil poured on the Stone of the Unction, were transferred to Moscow, allowing local pilgrims to participate in the Jerusalemite practice. Stating that "this project allows everyone who wishes to touch the Holy Places of the Holy Land in Moscow,"[3] the website of the Church of the Veil of the Holy Virgin makes it

[3] Икона Святой Земли (Icon of the Holy Land), "Храм Покрова Пресвятой Богородицы в Ясеневе (Church of the Veil of the Most Holy Virgin in Yasenevo)," https://hrampokrov.ru/o-khrame/arkhitektura-i-ubranstvo/ikona-svyatoy-zemli-2/ (accessed 26 September 2021).

clear that the complex claims to contain not copies but originals. While it is the newest, Yasenevo's copy is not at all an unicum on Russian land. Reproduction of the Holy Land is a centuries-old and well-rooted tradition in Russia.

Early Modern Copies: Nikon and His Followers

The most famous Russian copy of the Holy Land is undoubtedly Patriarch Nikon's "New Jerusalem" (Новый Иерусалим), founded in 1656 on the Istra River near Moscow (fig. 2).[4] According to the original plan, the copy should have expanded across several kilometers to include not only Jerusalem but also the Mount of Olives, Bethany, Bethlehem, the Jordan River, and Mount Tabor (these sites are no longer extant).[5] The central church of this complex was a copy of the Holy Sepulchre of Jerusalem, made in accordance

[4] Nikon dedicated the entire monastery and its main church to Christ's Resurrection, similar to the dedication of the Anastasis Rotunda of the Holy Sepulchre in Jerusalem. However, from the day of its construction, the place was referred to by another name preferred by many: the New Jerusalem. A selected bibliography for the Russian New Jerusalem includes: Галина Митрофановна Зеленская [Galina M. Zelenskaya], *Святыни Нового Иерусалима* [Sacred sites and objects of the New Jerusalem] (Moscow: Severny Palomnik, 2002) (with early Russian bibliography); Галина Митрофановна Зеленская [Galina M. Zelenskaya], *Новый Иерусалим—Путеводитель* [The new Jerusalem—A guidebook] (Moscow: Наука, 2003); Hubert Faensen, "Patriarch Nikon als Bauherr: Das Kloster Neu-Jerusalem—Eine Grabeskopie des 17. Jahrhunderts," *Wiener Jahrbuch für Kunstgeschichte* 44 (1991), 175–90; Ирина Леонидовна Бусева-Давыдова [Irina L. Buseva-Davidova], "Об Идейном Замысле 'Нового Иерусалима' Патриарха Никона» [On the ideological concept of the 'New Jerusalem' of Patriarch Nikon], in *Иерусалим в Русской Культуре*, ed. by Andrei Batalov and Alexei Lidov (Moscow: Наука, 1994), pp. 174–81 (English translation: *Jerusalem in Russian Culture,* ed. by Andrei Batalov and Alexei Lidov [New York: A. D. Caratzas, 2005]); Robert Ousterhout, "Building the New Jerusalem," in *Jerozolima W Kulturze Europejskiej / Jerusalem in European Culture: Akten der Tagung 14.–17. Mai 1996 in Warschau,* ed. by Piotr Paszkiewicz and Tadeusz Zadrozny (Warsaw: Institut Sztuki Polskiej Akademii Nauk, 1997), pp. 143–53; Wojciech Bobersky, "Jerusalem in Post-Medieval Russian Architecture," in Paszkiewicz and Zadrozny, *Jerozolima w Kulture Europejskiej,* pp. 297–320; Robert Ousterhout, "Flexible Geography and Transportable Topography," in *The Real and Ideal Jerusalem in Jewish, Christian and Islamic Art,* ed. by Bianca Kühnel, *Jewish Art* 23/24 (1997/98), 393–404 (pp. 402–4); Jürgen Krüger, *Die Grabeskirche Zu Jerusalem: Geschichte—Gestalt—Bedeutung* (Regensburg: Schnell & Steiner, 2000), pp. 207, 209; Галина Митрофановна Зеленская [Galina M. Zelenskaya], *Новый Иерусалим: Образы Дольнего и Горнего* [New Jerusalem: The terrestrial and celestial images] (Moscow: Design, 2008); Галина Митрофановна Зеленская, Людмила Викторовна Куликова, С. Б. Павлищева, А. А. Притворова, and А. В. Чепурной [Galina M. Zelenskaya et al.], *Новый Иерусалим: Альбом-Антология* [New Jerusalem: An anthology album] (Moscow: Feoria, 2010).

[5] The concept of the New Jerusalem was probably based on the Italian prototypes of *sacri monti*.

Fig. 2. Patriarch Nikon's "New Jerusalem" (Новый Иерусалим), founded in 1656 on the Istra River near Moscow, exterior view. Photo: Andrei Kolesnikov, published under the Creative Commons Attribution-Share Alike 3.0 Unported license.

with the prints of the Franciscan father Bernardino Amico and an olive-wood model brought from Jerusalem.⁶

While Nikon's ambitious project is the most monumental and, as noted, well-known Russian copy, it is far from the only one. A number of other sanctuaries were constructed to recall the Holy Land and its *loca sancta*. At least one other was made by Nikon himself, a replica of the tomb and Golgotha in the Terem Palace of the Moscow Kremlin in 1678 to 1682 (demolished shortly after the death of its patron, Tsar Fyodor Alexeevich).⁷

⁶ Michele Piccirillo, *La Nuova Gerusalemme. Artigianato palestinese al servizio dei Luoghi Santi; Edizioni custodia di terra santa* (Regione Piemonte: Centro di Documentazione dei Sacri Monti, Calvari e Complessi devozionali europei, 2007), pp. 88–91.

⁷ Ирина Михайловна Соколова [Irina M. Sokolova], "Новый Иерусалим в Кремле: Незавершенный Замысел Царя Федора Алексеевича" [New Jerusalem in Kremlin: Unfinished plan of Tsar Fyodor Alexeevich], in *Художественные Памятники Московского Кремля*, Материалы и Исследования 16 (Moscow: Moscow Kremlin Museum, 2003), pp. 1–7; Zelenskaya et al., *New Jerusalem*, pp. 489–90.

It is not surprising then that the vast majority of Russian copies known today postdate Nikon's highly influential prototype. However, one should note that all post-Nikon monuments were made only after 1681, when the name of the disgraced patriarch was rehabilitated. The copy of the New Jerusalem was one of the main reasons for Nikon's abdication from the Patriarchal primacy and deposition to a status of a simple monk.[8] The following list includes the monuments that were influenced by Nikon's re-creation idea, especially on the monumental scale: all the following examples are complexes of chapels or large-scale churches with elements of close copies of the original *loca sancta* of the Holy Land.[9]

- a copy of Golgotha with a wooden church of the Elevation of the Cross (built 1715, replaced by a stone church in 1830) and the Resurrection Church on Anzer Island, and the Eleon Mountain (Mount of Olives) with the church of the Ascension on the Great Solovetsky Island of Solovetsky Archipelago;[10]
- the church of the Dormition of the Virgin in Gethsemane in the Trinity Lavra of St. Sergius near Moscow (built 1850), with a relic of the True Cross, an icon of the sleeping Virgin, and a stone and an olive-tree root brought from the corresponding Jerusalem sites;[11]
- the lower church of the Resurrection in the Spaso-Jakovlev Dimitriev Monastery in Rostov (dedicated in 1912), built as a copy of the Holy Sepulchre in Jerusalem, housing a great number of Holy Land replicas, including the cave in Bethlehem, the prison of Christ with a wooden sculpture of a seated Christ, Golgotha, the tomb of Christ, which replicated its prototype in measurements

[8] I will refer to the theological discussion regarding the disapproval of Nikon's New Jerusalem further in this paper.

[9] For extended construction context and for further bibliography, see especially Галина Метрофанова Зеленская и др. [Galina M. Zelenskaya et al.], "Новый Иерусалим и Образы Святой Земли в России" [New Jerusalem and images of the Holy Land in Russia], in Zelenskaya et al., *New Jerusalem*, pp. 486–527.

[10] Ibid., pp. 492, 524–27, after Вячеслав Павлович Столяров [Vyacheslav P. Stolyarov], "Образы Святой Земли на Соловецких Островах" [Images of the Holy Land on Solovetsky Islands], *Соловецкое море: Историко-литературный альманах* 2 (2003), 99–112; Ольга Валерьевна Чумичева [Olga V. Chumicheva], "Соловецкий Монастырь как старообрядческая альтернатива Новому Иерусалиму Патриарха Никона" [Solovetsky monastery as an Old Believer's alternative to the new Jerusalem of Patriarch Nikon], in *Новые Иерусалимы—Иероптория и иконография сакральных пространств*, ed. by Алексей Михайлович Лидов (Moscow: Indrik, 2009), pp. 829–36. The new meaning of "Solovki" as the New Golgotha came during the Soviet period, when the monastery was turned into a prison camp where thousands of innocent victims of the Soviet regime, including clergy, met an excruciating death.

[11] Zelenskaya et al., *New Jerusalem*, pp. 498–501.

and decorative detail and which incorporated a stone from the Holy Tomb in Jerusalem;[12]
- the Church of the Resurrection on Valaam Island (built 1901–6), whose lower church is constructed in the form of the aedicula of the Holy Tomb in Jerusalem. The church contains an altar of the Angel in its antechamber with a stone relic from its Jerusalem prototype and burial chapel with low entrance that copies the Stone of Unction (of red granite) and the tomb of Christ (of Finnish and Italian marble with a tiny particle of the original stone from the Jerusalem tomb).[13] The Valaam project grew into a monumental copy of the Holy Land when Abbot Mavriki (d. 1918) reconstructed the topography he had witnessed during his pilgrimage in Palestine, including Mount Zion with the church of the Resurrection, the Kidron Valley, Gethsemane with the church of the Dormition of the Virgin, the Mount of Olives with the Ascension Church, the Jehoshaphat Valley, the Jordan River, the Dead Sea and Mount Tabor with the church of the Transfiguration;[14]
- an exact copy of the burial cave with a tomb of Christ in the church of the Tikhvin Theotokos in Alexeevsk Village (today Moscow) (the church itself was built between 1673 and 1680, but the tomb of Christ added in the lower church, most probably dates to only 1922).[15]

The tradition of constructing monumental copies of the Holy Land was eventually brought to an end by the Russian Revolution and the Soviet State (to be revived one century later in Yasenevo).

The Tomb of Christ in Moscow in the Sixteenth and Seventeenth Centuries

Despite the buzz around his name, Nikon was not the first who came up with the idea of copying the *loca sancta* of the Holy Land in Russia in the

[12] Алла Евгеньевна Виденеева [Alla E. Videneyeva], "Храм-Реликварий Спасо-Яковлевского Димитриева Монастыря" [Church-reliquary of the Spaso-Jakovlev Dimitriev Monastery], *Ярославский педагогический вестник* 3 (2010), 260–65; Zelenskaya et al., *New Jerusalem*, pp. 508–9. The "cave" Church of the Resurrection in Spaso-Yakovlev Monastery is the closest parallel to the newly built Yasenevo Church.

[13] Zelenskaya et al., *New Jerusalem*, pp. 510–23, after s.a., *Воскресенский Скит на Валааме и в нем Кувуклия с Подобием Гроба Господня* [The skete of the Resurrection on Valaam and a cubiculum with an image of the tomb of the Lord] (St. Petersburg: Publishing House of the Valaam Monastery, 1911).

[14] See the map in Zelenskaya et al., *New Jerusalem*, p. 513; contributing authors offer further examples of churches that could have been seen as Holy Land copies, especially since they housed relics from the Holy Land (pp. 502–8).

[15] Zelenskaya et al., *New Jerusalem*, p. 490.

seventeenth century; he continued an existing and growing trend. A cult centered on Jerusalem was active in Moscow in the early modern period (most probably already in the sixteenth, surely in the seventeenth centuries), its peak usually coinciding with Easter. During the feast of the Entry of Christ into Jerusalem (known in the Western tradition as Palm Sunday), a "Donkey Walk" procession (Шествие на осляти) would take place. The patriarch of Moscow would sit in the manner of Christ on the back of a horse that had been draped in a white cloak with long ears sewn onto its hood, while the Russian tsar personally led the "donkey" by the bridle. The procession started from the church of the Entrance to Jerusalem, which is one of the chapels of the church of the Veil of the Virgin on the Moat (or St. Basil's Cathedral), built in the 1560s.[16] The procession passed through St. Frol's (the Savior's) Gate to the Kremlin in the Old City of Moscow until it reached the main church of the city, the Dormition Cathedral.

The destination of the procession was the "tomb of the Lord" (Гроб Господень) in the Dormition Cathedral. The tomb was situated to the right of the western entrance, that is, in the southwest corner of the church.[17] Today, one can see the rectangular baldachin with a triangular roof that was originally erected around the tomb. An elaborately decorated metal grille forms the walls of the baldachin, which prevented access but allowed a glimpse of the tomb inside. The roof of the baldachin is painted with scenes from the Passion of Christ. In 1913, the baldachin was moved from the southern wall to enclose the tomb of the early seventeenth-century patriarch of Moscow, Hermogenes (Эрмоген/Гермоген). A luxurious sarcophagus with the remains of the patriarch was installed within, in place of Christ's tomb, adjacent to the north wall of the grille. The original location of the tomb of Christ can still be seen from the exterior of the cathedral since a large stone cross adorns the southern corner of its exterior western wall near the location of the early seventeenth-century tomb. This cross permitted believers to venerate the tomb without even entering

[16] Probably the earliest evidence for the existence of such a procession is found in an anonymous English description of 1558. The procession changed its route a number of times, but it always ended at the Dormition Cathedral; for sources and bibliography, see Майкл С. Флайер [Michael S. Flier], "Образ государя в московском обряде Вербного Воскресенья" [The image of the tsar in the Muscovite Palm Sunday ritual], in *Пространственные иконы: Перформативное в Византии и Древней Руси*, ed. by Алексей Михайлович Лидов (Moscow: Indrik, 2011), pp. 533–62.

[17] The main entrance to the church was not from the west but from the south, so the tomb is situated to the left of the main entrance.

the church.[18] The original inscription that runs around the grille leaves no doubt as to the original purpose of this structure:

> By God's mercy and benediction and by order of the great Lord the most holy Patriarch Filaret ... at the time of the rule of the most Orthodox and noble-born Christ-loving great sovereign ... Michail Fyodorovich autocrat of All Rus' ... at the sixth year of the patriarchate of Filaret the Patriarch of Moscow and All Rus' made this grille for the cathedral church around the Lord's tomb in the year 1633 in the month of September on the 30th day [30 September 1624].[19]

Traditionally, the work of this baldachin has been attributed to the artist Dimitri Sverchkov (Димитрий Сверчков).[20] According to Leonid Beliaev and Andrei Batalov, the tomb of Christ was made some years before its metal canopy, probably between 1611 and 1620/21.[21]

[18] There is still a possibility that the rest of the original tomb of Christ is not lost and is, in fact, preserved under the metal sarcophagi of the patriarchs, in the Dormition Cathedral's most southwestern corner, the original place of the tomb.

[19] Андрей Леонидович Баталов [Andrey L. Batalov], "Гроб Господень в сакральном пространстве русского храма XVI–XVII вв," [Holy Tomb within the sacred space of the Russian church in the sixteenth to seventeenth centuries], in *Восточнохристианские Реликвии*, ed. by Алексей Михайлович Лидов (Moscow: Progress-Tradition, 2003), pp. 513–32 (p. 520): "Божию милостию по благословению и по повелению великого господина святейшего патриарха кир Филарета ... при державе благоверного и благородного христолюбивого великого государя ... Михаила Федоровича Всея Руси самодержца ... в трое на десятое лето государства ... в шестое лето патриаршества Филарета Патриарха Московского и Всея Руси зделана бысть сия решетка в соборную церковь около Гроба Господня в лето ЗРЛГ [7133] го месяца сентября Л [30] дня."

[20] Андрей Леонидович Баталов [Andrey L. Batalov], "Гроб Господень в замысле 'Святая Святых' Бориса Годунова" [Holy Tomb in the concept of the Holy of Holies of Boris Godunov], in *Иерусалим в Русской Культуре*, ed. by Андрей Леонидович Баталов and Алексей Михайлович Лидов (Moscow: Nauka, 1994), pp. 154–73. I do not know in which written source the name of the artist was mentioned as the one who produced the grille as it is not discussed explicitly in bibliographical sources available to me. Batalov also suggested the metal fence replaced a wooden prototype that stood here before ("Holy Tomb within the Sacred Space of the Russian Church," p. 521). According to the seventeenth-century redaction of the "Tale on the Present of Shah Abbas" from the Solovetsky Monastery, a wooden "little castle" (*teremets*) "decorated with gold inside and mica(?)" was built by Patriarch Filaret, as published by С. Н. Гухман [S. N. Gukhman], "Соловецкая редакция 'Документального' сказания о даре шаха Аббаса России" [Solvetsky edition of the 'documental' tale of the Gift of Shah Abbas to Russia], in *Исследования по истории русской литературе XI–XVII вв.*, ed. by Дмитрий Сергеевич Лихачев, *Труды Отдела древнерусской литературы* (Leningrad: Nauka, 1974), pp. 376–84 (pp. 383–84). This passage, absent from the original version of this source, should be treated cautiously.

[21] Леонид Андреевич Беляев [Leonid A. Beliaev], "Гроб Господень и Реликвии Святой Земли" [Holy Tomb and relics of the Holy Land], in *Христианские Реликвии в Московском*

Batalov suggests a link between the appearance of the tomb in the Dormition Cathedral and the ambitious project of Boris Godunov some twenty years earlier. Around 1600, Godunov planned to build a monumental copy of the church of the Holy Sepulchre in the Moscow Kremlin. His death put an end to this ambitious project, and the church was never built. Yet, as can be discerned from a number of written sources, Godunov succeeded in creating the tomb itself, which was intended to stand at the heart of his large-scale project. It included free-standing cast figures of nearly human scale (about 140 centimeters high): Christ, two angels, Mary, Nicodemus, and Joseph of Arimathea.[22] According to Batalov, this work was a copy of a European sculptural group, either of the Entombment of Christ (*depositio*) or the Three Marys at the Tomb (*visitatio*)—or else a combination of the two. Such a three-dimensional metal sculptural group of monumental proportions was unprecedented in the Orthodox Russian visual culture of the time. This artwork was destroyed during the Polish invasion of Moscow between 1610 and 1612. While it is not known if anything survived of the original work, there is a good chance that the tomb of the Dormition Cathedral, built just a decade later, was influenced by the previous one, possibly in its shape or position in the church if not its decoration.

The seventh-century Muscovite translations of Jerusalem were based on an earlier mediaeval Russian tradition. No doubt, this tradition adopted by the capital city originates from the medieval Jerusalem at Novgorod.

Кремле, ed. by Алексей Михайлович Лидов (Moscow: Radunitsa, 2000), pp. 94–102 (p. 98); Batalov, "Holy Tomb within the Sacred Space of the Russian Church," p. 519. Both suggested dates are speculative, and thus they should be treated cautiously. The year 1611 follows the latest possible dating of Borisova, who suggested dating the earliest preserved "early seventeenth-century" inventory of the Dormition Cathedral to just prior to or during the Polish invasion of Moscow, that is, between 1609 and 1611; see Татьяна Сергеевна Борисова [Tatyana S. Borisova], "О датировке древнейшей из сохранившихся описей Успенского собора" [On the dating of the oldest preserved inventory of the Dormition Cathedral of the Moscow Kremlin], in *Успенский собор Московского Кремля: Материалы и исследования* (Moscow: Наука, 1985), pp. 246–59, Описи московского Успенского собора, от начала XVII века по 1701 год включительно [Inventories of the Moscow Dormition Cathedral, form the beginning of the seventeenth century up to 1701], in *Русская историческая библиотека 3* (Санкт Петербург: Archaeological Commission, 1876), cols. 295–1000, here col. 312 (a "measurement of the tomb" [мера Гроба Господня] is mentioned in this earliest inventory, which can theoretically already be a tomb of Christ). The year 1620/21 was suggested by Batalov, who interprets a note in the inventory of 1627: "in the earlier copied books under the year 129 it is written: tomb of the Lord." Batalov interprets the year [6]129 as [1]620/21, in Batalov, "Holy Tomb in the Concept of the Holy of Holies of Boris Godunov," p. 170 n. 70, according to "Inventories of the Moscow Dormition Cathedral," cols. 414–17.

[22] Batalov, "Holy Tomb within the Sacred Space of the Russian Church," pp. 518–19.

Jerusalem in Novgorod

It might seem improbable, but before Moscow, the cult of Jerusalem existed in only one place in medieval Rus': Novgorod, a city in northeastern Russia (situated some 550 kilometers from Moscow and about 200 kilometers from St. Petersburg). According to Novgorodian chronicles preserved in copies dating back to the thirteenth century, the connection between Novgorod and Jerusalem dates back to the early days of Novgorod's Christian history, with the building of its first stone cathedral dedicated to Hagia Sophia, echoing those in Constantinople and Kiev. The laying of its foundation stone took place on the twenty-first of May 1045, the Feast of Constantine and Helena.[23] Furthermore, according to a number of Novgorodian sources, the consecration of the cathedral, which took place either in 1050[24] or 1052,[25] fell on the fourteenth of September, the Feast of the Revelation of the True Cross (Въздвижения честнаго креста), which originated in Jerusalem.[26] As suggested by Vera Briusova, it is more likely that the actual consecration ceremony took place on the preceding day, on the thirteenth of September, known as the day of the Dedi-

[23] Вера Григорьевна Брюсова [Vera G. Briusova,] "О содержании росписей XI-XII вв. Мартирьевской паперти Софийского собора Новгорода" [On the meaning of the wall paintings from the eleventh to twelfth centuries in the Martyrius Parvis of the Hagia Sophia Cathedral of Novgorod], in *Древнерусское Искусство, Художественная культура X–первой половины XIII в.*, ed. by Алексей Ильич Комеч and Ольга Ильинична Подобедова (Moscow: Nauka, 1988), pp. 165–76 (p. 167); Вера Григорьевна Брюсова [Vera G. Briusova], "О времени освящения Новгородской Софии" [On the consecration of Hagia Sophia of Novgorod], in *Культура средневековой Руси—Сборник статей, посвящается 70-летию М. К. Каргера*, ed. by Анатолий Николаевич Кирпичников and Павел Александрович Раппопорт (Leningrad: Nauka, 1974), pp. 111–13 (p. 111).

[24] On the *First Novgorod Chronicle*, see Арсений Николаевич Насонов [Arseny N. Nasonov], ed., *Новгородская Первая Летопись Старшего и Младшего Изводов* [First Novgorod Chronicle of the early and late manuscript copies] (Moscow and Leningrad: Academy of Sciences, 1950), p. 181. And on its offspring, the *Fourth Novgorod Chronicle*, "Полное собрание русских летописей" (St. Petersburg: Eduard Pratz, 1853), V, p. 130.

[25] Новгородская Третья Летопись; see Briusova, "On the Consecration of Hagia Sophia of Novgorod," p. 111, according to НЛ, СПб, 1879, p. 184. "Летописный сборник Авраамки" [Avraamka's Chronicle Collection], in "Полное собрание русских летописей" (St. Petersburg: Eduard Pratz, 1899), XVI, p. 41.

[26] Ирина Анатольевна Стерлигова [Irina A. Sterligova], "Иерусалимы как литургические сосуды в Древней Руси [Jerusalems as liturgical vessels in Old Rus'], in *Иерусалим в Русской Культуре*, ed. by Andrei Batalov and Alexei Lidov (Moscow: Nauka, 1994), pp. 46–62 (pp. 51, 57); Татьяна Юрьевна Царевская [Tatiana Y. Tsarevskaya], "О Царьградских Реликвиях Антония Новгородского" [Relics of Anthony], in *Восточнохристианские Реликвии*, ed. by Alexei M. Lidov (Moscow: Progress-Tradition, 2003), pp. 398-414 (p. 406 n. 39).

cation of the Holy Sepulchre of Constantine and Helena in Jerusalem.[27] All three feasts mentioned in conjunction with the building of the Novgorod Cathedral (Constantine and Helena, the Revelation of the True Cross, and the Dedication of the Holy Sepulchre) suggest that Novgorod's Hagia Sophia had stronger bonds with Jerusalem and the Holy Sepulchre than with its Constantinopolitan namesake.

The connection between Novgorod and Jerusalem grew stronger during the following centuries. If the information in the *Primary Chronicle* (Повесть временных лет)[28] is accepted as trustworthy, it is probable that relics from the Holy Land were brought to the city in the first half of the twelfth century. According to the Hypathian version,[29] "in the year 1642 [1134] ... a slab[30]

[27] Sterligova, "Jerusalems as Liturgical Vessels," p. 51; Tsarevskaya, "Relics of Anthony," p. 406 n. 39. Thus, Briusova suggests that the year 1052 is more likely since that year the day fell on a Sunday, the most appropriate day for church consecration, while in 1050 it fell on a Thursday, see Briusova, "On the Consecration of Hagia Sophia of Novgorod," p. 112.

[28] The [Russian] *Primary Chronicle*, also known as "Tale of Bygone Years" and written in Old Slavonic, is the oldest chronicle to tell the story of the formation of Rus' from the ninth until the twelfth centuries. Its two oldest copies are the Laurentian Chronicle (Лаврентьевская летопись), preserved in the late fourteenth-century manuscript, and the Hypathian Chronicle (Ипатьевская летопись) from the early fifteenth-century manuscript. Although considered to preserve the original text that should not be dated after the early twelfth century, the gap between the actual writing and the preserved copies, as well as the discrepancies between the two earliest versions, suggests that one ought to exercise considerable caution while dealing with the information found in this text.

[29] The second copy of the *Primary Chronicle* dates to 1420 from the Hypathian Monastery.

[30] In the Russian original, the phrase that describes what exactly was brought from Jerusalem is "доска оконечная," which has no clear meaning. *Doska* can be a slab or a plate, usually wooden but not necessarily, while *okonechnaja* means "at the end, of the border, edge, side, part, piece, cut of piece." According to Aynalov, this was a marble side plate of the sarcophagus in the aedicule as described by the Abbot Dainiel; see Дмитрий Власьевич Айналов [Dmitri V. Aynalov], "Примѣчанія къ тексту книги 'Паломникъ' Антонія Новгородскаго (part 1)" [Annotations to the text of the 'Pilgrim Book' of Anthony of Novgorod], *Журнал Министерства народного просвещения*, n.s., 6, no. 3 (1906), 233–76 (pp. 244–45). Nazarenko suggested this was one of the pieces left from the early Christian aedicule destroyed by the caliph Al-Khakim on 28 September 1009, which was kept in the Holy Sepulchre as a relic ever since; Александр Васильевич Назаренко [Alexander V. Nazarenko], *Древняя Русь на Международных Путях: Междисциплинарные Очерки Культурных, Торговых, Политических Связей IX-XII веков* [International relations of ancient Rus': The multidisciplinary studies on the cultural, commercial, and political connections of Russia in the ninth to twelfth centuries), *Studia historica* (Moscow: Languages of the Russian Culture, 2001), p. 629 n. 2.

from the tomb of the Lord was brought by Dionisi that was sent by Miroslav,"[31] probably from the Holy Land itself.[32]

It is also possible that this very relic brought by Dionisi precipitated the installation of the tomb of Christ in the cathedral. It is true that the physical presence of a tomb, its location behind a pillar to the south to the main western entrance, as well as its liturgical function, was not recorded until the sixteenth century in Novgorodian books of liturgical order.[33] However, reinterpreting the existing archaeological findings in the church of Hagia Sophia in Novgorod, Tatiana Tsarevskaya suggests that the tomb of Christ might already have been in situ by the middle of the twelfth century.[34] In 1955, archaeologist Michail Karger discovered in the southwestern corner of the church the remains of an elevated structure adjacent to the southern wall of the eleventh-century church. The walls in this area still bear traces of plaster and fresco covering the wall up to forty centimeters from the ground.[35] The plaster with the traces of painting corresponds to extant wall paintings behind the same wall (in the Martyrius Parvis),[36] which dates to the mid-twelfth century.[37] Tsarevskaya suggests that these findings were the remains of the tomb of Christ, which stood in the southwest corner of the church from the mid-twelfth century.[38] She envisions the original structure as a canopy supported by four pillars demarcating an area of roughly 2 × 2 meters, with visual parallels in the pictorial art and funeral

[31] Sterligova, "Jerusalems as Liturgical Vessels," pp. 52, 57 n. 44; Beliaev, "Holy Tomb and Relics," pp. 96, 100 n. 7: 'В лето 6642 [1134] ... принесена бысть доска оконечная Гроба Господня Дионисием, послал бо бе." Miroslav was, most probably, the Novgorodian chosen prince (*posadnik*, посадник); Nazarenko, "International Relations of Ancient Rus'," p. 629. Interestingly, in the parallel text of the Laurentian chronicle, this information is missing.

[32] On a similar practice of bringing the most holy relic of the tomb of Christ, we read in the itinerary of Abbot Daniel, who arrived in the Holy Land most probably from Southern Rus' (near Chernigov, today's Ukraine) some twenty-five years earlier; Гелиан Михайлович Прохоров [Gelian M. Prokhorov], ed., *'Хожение' игумена Даниила в Святую Землю в начале XII в.* [Itinerary of the Abbot Daniel to the Holy Land at the beginning of the twelfth century], Древнерусские сказания о достопамятных людях, местах и событиях (St. Peterburg: Oleg Abyshko Print, Imperial Orthodox Palestine Society, Literary Museum of the Institute of Russian Literature, 2007), pp. 266–67; "Daniel the Abbot, The Life and Journey of Daniel, Abbot of the Russian Land," in *Jerusalem Pilgrimage, 1099–1185*, ed. by John Wilkinson, Joyce Hill, and William Francis Ryan (London: Hakluyt Society, 1988), pp. 170–71.

[33] See Tsarevskaya, "Relics of Anthony," for sources and information.

[34] Ibid.

[35] Ibid., p. 403.

[36] Briusova, "Wall Painting of the Martyrius Parvis."

[37] On the basis of stylistic analysis and of the graffiti on the painting.

[38] Tsarevskaya, "Relics of Anthony," p. 403.

practices of the Middle Byzantine era but with no exact Eastern analogue of a three-dimensional aedicula identified as the tomb of Christ.[39] The absence of such Byzantine parallels is indicative of the complete absence of the phenomenon of recreating the tomb within the church space in medieval Byzantine ecclesiastical practice, as will be shown below.

The Cult of Jerusalem in Byzantine and Orthodox Tradition[40]

The Holy Land was symbolically present in the Byzantine church since Iconoclasm, when the church building was interpreted as a space connected to the Holy Land and its topography,[41] as recorded in the *Historia mystagogica*, a treatise on liturgical exegesis attributed to the eighth-century patriarch of Constantinople, St. Germanus I.[42] According to this text, the apse of every church symbolized both the birth cave of Christ in Bethlehem and his burial cave in Jerusalem.[43] The main altar of the church was the Holy Tomb,[44] while the

[39] On the basis of another reconstruction of a Middle Byzantine twelfth-century canopy from Thessaloniki that did not serve as a tomb of Christ, since no such practice was known in Byzantium, as already mentioned. See ibid., p. 413, ill. 6.

[40] Алексей Мстиславович Пентковский [Aleksey M. Pentkovskiy], "'Иерусалимизация' литургического пространства в Византийской тридиции ["Jerusalemization" of the liturgical space in Byzantine tradition], in *Новые Иерусалимы—Иеротопия и иконография сакральных пространств*, ed. by Alexei M. Lidov (Moscow: Indrik, 2009), pp. 58–77 (Russian with English summary); Batalov, "Holy Tomb within the Sacred Space of the Russian Church," esp. pp. 513–14. See also Holger A. Klein, "Sacred Relics and Imperial Ceremonies at the Great Palace of Constantinople," in *Visualisierungen von Herrschaft: Frühmittelalterliche Residenzen, Gestalt und Zeremoniell*, ed. by Franz Alto Bauer, BYZAS, Veröffentlichungen des Deutschen Archäologischen Instituts Istanbul 5 (Istanbul: Ege Yayınları, 2006), pp. 79–99 (p. 89); Alexei Lidov, "A Byzantine Jerusalem: The Imperial Pharos Chapel as the Holy Sepulchre," in *Jerusalem as Narrative Space*, ed. by Annette Hoffmann and Gerhard Wolf, Visualising the Middle Ages 6 (Leiden: Brill, 2012), pp. 63–104.

[41] Pentkovskiy, "Jerusalemization," p. 68. According to Pentkovskiy, this interpretation is of fifth-century Syriac origin. The text was translated into Old Church Slavonic already in the late ninth to early tenth centuries (some hundred years before Christianity officially reached Russia) ("Jerusalemization," p. 69 n. 6).

[42] Cyril Mango, *The Art of the Byzantine Empire, 312–1453: Sources and Documents* (Englewood Cliffs: Prentice-Hall, 1972), pp. 141–43, according to Frank Edward Brightman, "The Historia Mystagogica and Other Greek Commentaries on the Byzantine Liturgy," *Journal of Theological Studies* 9 (1908), 248–67 and 387–97; see also Paul Meyendorff, *St. Germanus of Constantinople on the Divine Liturgy—Greek Text with Translation, Introduction and Commentary* (Crestwood: St. Vladimir's Seminary Press, 1984).

[43] Meyendorff, "St. Germanus on the Divine Liturgy," pp. 58–59, nos. 3–4.

[44] Ibid., pp. 60–61 n. 6.

ciborium above it was Golgotha, the place of the Crucifixion.[45] The chancel screen that separated the sanctuary from the naos was interpreted as the copper grille around the Holy Sepulchre,[46] while the ambo was the stone upon which an angel sat to proclaim the Resurrection to the myrrh-bearing women.[47] Thus, until the late Byzantine period, the cult of Jerusalem in the Byzantine liturgy was based on the symbolic interpretation of the integral parts and furnishings of the church; no supplementary objects were necessary to create the link.[48] The reenactment of the Holy Land and history was mainly the task of the spoken word of the liturgy, supported by visual images (icons on the walls or on moveable panels of wood) and by the regular liturgical furniture.[49]

[45] Ibid., pp. 58–59 n. 5.

[46] Ibid., pp. 62–63 n. 9. In view of this statement, one is directed to an association with the grille around the Holy Tomb in Moscow's Dormition Cathedral.

[47] Meyendorff, "St. Germanus on the Divine Liturgy," pp. 62–63 n. 10.

[48] On the use of liturgy and pictorial programs instead of architectural copies in the Byzantine practice, see Robert G. Ousterhout, "Visualizing the Tomb of Christ: Images, Settings, and Ways of Seeing," in *Visual Constructs of Jerusalem*, ed. by Bianca Kühnel, Galit Noga-Banai, and Hanna Vorholt (Turnhout: Brepols, 2014), pp. 439–50 (p. 442).

[49] In recent years, several scholars have proposed that one can see copies of the Holy Sepulchre Church made in medieval Constantinople. For instance, the private chapel of the Great Palace, known as the church of the Virgin of the Pharos, was built after the era of Iconoclasm and used as the most important treasury of holy relics of the Byzantine Empire. The treasury was ever-growing until the disastrous pillage of the crusaders. The treasury contained a large number of holy relics, including wood of the True Cross, the crown of thorns, the nails, the purple mantle that Christ was wearing at the time of the Crucifixion, the lance of Longinus, the holy Mandylion and the Keramidion, and also a stone from the Holy Tomb. The concentration of all these relics in one place led scholars to see in this church "The New Jerusalem" or the copy of the Holy Tomb in Constantinople. But even if this is the case, it is a symbolic copy of the "holy space," which makes Constantinople the New Jerusalem, not a tangible physical copy of any specific building or structure in Jerusalem. Second, a number of years ago, Robert Ousterhout proposed that the complex of churches of the Pantokrator Monastery of Constantinople constituted a copy of the crusader complex of the Holy Sepulchre in Jerusalem. Built by Manuel Comnenos in the twelfth century, the Pantokrator Monastery displayed the Stone of Unction, near which Manuel Comnenos requested to be buried. Like the crusader church, the Pantokrator Monastery had two domes and a similar decoration program, according to Robert Ousterhout, "Architecture, Art, and Komnenian Ideology at the Pantokrator Monastery," in *Byzantine Constantinople: Monuments, Topography and Everyday Life*, ed. by Nevra Necipoğlu (Leiden: Brill, 2001), pp. 133–50. Ousterhout himself questioned the validity of his statement that the Pantokrator Monastery was a copy of the crusader Holy Sepulchre; see Robert Ousterhout, "Sacred Geographies and Holy Cities: Constantinople as Jerusalem," in *Hierotopy—the Creation of Sacred Spaces in Byzantium and Medieval Russia*, ed. by Alexei Lidov (Moscow: Indrik, 2006), pp. 98–116. In this case, too, no copy of the tomb of Christ as a physical body existed within the church. The latter article of Ousterhout, in which he explains why physical copies were not necessary, is the most comprehensive description of the topic of Constantinople as Jerusalem.

Hence, the Russian tradition first seen in Novgorod, most probably in the mid-twelfth century, cannot be considered to have originated in Byzantium. Rather, I believe its roots are in the medieval West, where the recreations of the tomb of Christ and the Holy Sepulchre flourished from the tenth century.[50]

The Novgorod Tomb of Christ and the Medieval West Tradition

One possible prototype for the reconstructed Novgorodian tomb may be the "Heiliges Grab" in the basilical church of St. Cyriakus in Gernrode, dated to the year 1100.[51] Like in Novgorod, this tomb structure has a rectangular form achieved by a demarcation of the inner space of the church by means of straight walls between the columns or pillars of the church (rather than a free-standing structure within the church interior, as in Constance).[52] In Novgorod, Tsarevskaya saw only one part of the alleged tomb, namely its burial chamber, situated between the pillar and the southern wall of the Hagia Sophia. However, she also notes the position of a double sarcophagus to the east of the supposed tomb location, which served the secondary burial of the founders of Hagia Sophia: Vladimir, son of Yaroslav, and his mother, Anna.[53] Probably, this double sarcophagus can also be seen as part of the original tomb complex, which

Most significant is that all manner of "Jerusalemite" phenomena in Constantinople remained firmly within the boundaries of the city, with no resonance in the Byzantine world, as far as can be seen from the sources.

[50] Typically, these were centralized structures that imitated the form of the Anastasis Rotonda in Jerusalem, such as the St. Michael's Church in Fulda. Sometimes it was only the aedicule that was copied, as in Mainz—in this case, too, the copy was a small centralized structure.

[51] St. Cyriakus in Gernrode is an Ottonian church of the second half of the tenth century. The tomb of Christ was added to the church around the year 1100. It is arguably one of the two earliest copies of the tomb of Christ in Germany (especially if Fulda's dating as the copy of the Holy Sepulchre is postponed to its Ottonian rededication in 1092/93, as was suggested in Otfried Ellger, *Die Michaelskirche zu Fulda als Zeugnis der Totensorge: Zur Konzeption einer Friedhofs- und Grabkirche im karolingischen Kloster Fulda* [Fulda: Parzeller, 1989]). On Gernrode, see Hans-Joachim Krause et al., *Das Heilige Grab in Gernrode: Bestandsdokumentation und Bestandsforschung*, 2 vols, Beiträge zur Denkmalkunde in Sachsen-Anhalt (Berlin: Deutscher Verlag für Kunstwissenschaft, 2007).

[52] In Gernrode, the tomb is adjacent to a chapel in the east, where the original entrance to the tomb stood. In the twelfth century, the chapel to the east of the tomb was turned into the chapel of St. Aegidus. This is most probably when the entrance to the tomb was moved from its original eastern to the northern wall, where it can still be seen today; see ibid.

[53] Across from where Vladimir and Anna, the founders of the cathedral, are buried on the outside of this wall, there is a depiction in the "Martyrius Parvis" of Constantine and Helena, the founders of the Holy Sepulchre in Jerusalem; this interpretation was first proposed by Tsarevskaya, "Relics of Anthony," pp. 405–6.

would mean that Novgorod, like Gernrode and other Western medieval Holy Tombs, had a double-chamber structure.[54]

An additional unique art form, without parallel in the East or the West, developed in Novgorod: small-scale portable stone double-sided icons depicting the tomb of Christ.[55] According to the scholarly literature,[56] these icons first appeared in the twelfth century, parallel to the first instances of the cult of the Holy Tomb in Novgorod.[57] They were made of local stone—gray, green, or brown in color[58]—with a depiction of the Holy Tomb on one side and saints or other scenes on the other. At the center of the composition, the tomb appears with the inscription "Tomb of the Lord" (Гроб Господень), an angel (or two), the three Marys, and sometimes also the apostles Peter and John the Evangelist. The scene is situated within an architectural frame that, over time,

[54] Arguments for the possibility of a double-room structure in Novgorod can be seen in the "Martyrius Parvis," the southern gallery turned into the southern-most aisle of the church in the mid-twelfth century. The wall opposite the proposed antechamber carries the earliest wall paintings in Novgorod Cathedral: Constantine and Helena with the True Cross and the Deesis with Christ, Mary, John the Baptist, Archangels Michael and Gabriel, St. Peter, [and St. Paul].

[55] The dimensions of the stone icons vary from slightly less than 4 centimeters up to almost 9 centimeters, and the majority are around 6 centimeters high.

[56] Анна Вадимовна Рындина [Anna V. Ryndina], *Древнерусская мелкая пластика: Новгород и Центральная Русь XIV–XV веков* [Old Russian small-scale sculpture: Novgorod and central Russia in fourteenth to fifteenth centuries] (Moscow: Nauka, 1978); Анна Вадимовна Рындина [Anna V. Ryndina], "Древнерусские паломнические реликвии: Образ Небесного Иерусалима в каменных иконах XIII-XV вв. [Old Russian pilgrim's relics: An image of the Heavenly Jerusalem in small stone icons in thirteenth to fifteenth centuries], in *Иерусалим в Русской Культуре*, ed. by Andrei L. Batalov and Alexei M. Lidov (Moscow: Nauka, 1994), pp. 63–85 (translated in Anna Ryndina, "Old Russian Pilgrims' Relics: An Image of the Heavenly Jerusalem in Small Stone Icons in 13th to 15th Centuries," in *Jerusalem in Russian Culture*, ed. by Andrei Batalov and Alexei Lidov (New Rochelle: A. D. Caratzas, 2005); Татьяна Васильевна Николаева [Tatiana V. Nikolajeva], *Древнерусская мелкая пластика из камня XI–XV вв* [Plastic art of old Russia: Small carvings and castings, eleventh to sixteenth centuries], ed. by Boris A. Rybakov, vol. E1-60, Археология СССР, Свод археологических источников, (Moscow: Nauka, 1983); Leonid Beliaev, "Russian Pilgrim Art from the 12th to the 15th Century—Archeological Elements and Problems of Romanesque Influence," *Journal of the British Archaeological Association* 151 (1998), 203–19; Леонид Андреевич Беляев [Leonid A. Beliaev], "Пространство как реликвия: о назначении и символике каменных иконок Гроба Господня" [Space as relic: On the symbolic meaning of carved stone icons of the Holy Sepulchre], in *Восточнохристианские реликвии*, ed. by Alexei Lidov (Moscow: Progress-Tradition, 2003), pp. 482–512.

[57] Their peak is evident in the fourteenth century.

[58] This is exactly the color of the stone bench inside the Holy Tomb that was present in the eleventh- and twelfth-century Holy Sepulchre, which was recently discovered during the restoration works that took place in 2017; for photos and number of articles, see *The Holy Land Review—The Franciscan Journal of Faith, Culture and Archaeology* 10, no. 3 (2017).

became a five-domed church that evokes the Hagia Sophia in Novgorod and not the church of the Holy Sepulchre in Jerusalem. Above, Christ blesses the assembly between two bowing angels. I wish to cautiously suggest that this scheme reflects the iconographic program in or around the lost tomb in Novgorod. Many of the elements in this program are common to the elaborate sculptural decoration of the tomb in Gernrode: the blessing Christ; Peter and John the Evangelist rushing into the tomb on the outside of its northern wall, rendered in low relief; and an angel (or two?) with the three Marys inside the burial chamber, carved in high relief. These parallels suggest a direct influence from Germany. The rectangular form of the Moscow baldachin with a conical roof likewise corresponds to the one in Gernrode, while the sculptural decoration of the German tomb is paralleled in Godunov's Western-style project.[59] A connection of Novgorod with Germany is explained by the historical and economic background of the northern capital of Rus'. Research on medieval Russian art stresses that in Old Rus', Novgorod, more strongly than any other center, was influenced by Catholic visual culture.

More evidence, mostly focused on the so-called Martyrius Parvis, supports Tsarevskaya's view that a tomb of Christ stood in the southwest corner of the cathedral already in the mid-twelfth century. At that time, the southern part of the church, right behind the wall of the supposed tomb of Christ, was changed, and the open gallery was closed to become part of the church interior. The earliest wall paintings here depict Constantine and Helena flanking the True Cross (in *secco*, a technique unprecedented in Russia but familiar in contemporary Europe and in Jerusalem[60]) and the Deesis.[61] A great concentration of graffiti is also apparent, including images of a cross under the arch. This site was the preferred burial place of the Novgorodian patriarchs, including a certain Martyrius,

[59] Of all other known medieval copies of the tomb of Christ, Gernrode is the closest to the two earliest Russian examples (first Novgorod and later also Moscow). The rectangular shape of the tomb in Gernrode, exceptional also in Western medieval practice, can most probably be explained by its early date. Previous research failed to see this possible connection since it traditionally compared the Russian sites to the extant Western round examples, which predominated from the twelfth century.

[60] Although in Jerusalem they appear as Heraclius and Helena. See Gustav Kühnel, "Das restaurierte Christusmosaik der Calvarienberg-Kapelle und das Bildprogramm der Kreuzfahrer," *Römische Quartalschrift* 92 (1997), 45–71 (pp. 56–60).

[61] Good reproductions can be found in Дмитрий Сергеевич Лихачев et al. [Dmitry S. Likhachev et al.], *Русь: История и художественная культура X–XVII веков* [Russia: History and art in the tenth to seventeenth centuries] (Moscow: Iskusstvo, 2003), p. 116, ill. 18.

who gave his name to the whole area.⁶² In fact, the symbolism of the tomb of Christ is so dense in this relatively small space that one should also consider the possibility that it was indeed situated in the Martyrius Parvis, at least at some point in time. In this case, the whole renovation of that area that transformed the gallery into part of the church proper ought to be seen as indicative of the tendency to incorporate the tomb into the cathedral's inner space or the desire to enlarge its structure to enable more visitors. This suggestion runs counter to Tsarevskaya's proposed reconstruction, but it should be considered carefully in light of recent excavations in the area.⁶³

Relics and St. Anthony's "Pilgrim Book" at Novgorod

Further methods of bringing Jerusalem to Novgorod emerged after the twelfth century. In the process, Western traditions were transformed and adapted by the Russian Orthodox liturgy, thus becoming estranged from their Catholic origins.

Archaeological excavations of the sanctuary area in Hagia Sophia of Novgorod indicate that the main altar was enlarged in the early thirteenth century. The new altar's measurements (175 × 98 centimeters)⁶⁴ match the dimensions of the marble slab of the Holy Tomb in Jerusalem. This change was likely made using the precise measurements (themselves a type of relic) available at that time. According to the *First Chronicle of Novgorod*, in the year 1211, Dobrynia Yadreikovich (Добрыня Ядрейкович), the future Archbishop Anthony of Novgorod, returned from pilgrimage to Constantinople bringing with him nothing less than the tomb of Christ and the True Cross.⁶⁵ According to Tatiana Tsarevskaya, this declaration should be understood as the "measurement of the tomb" (мера гроба)⁶⁶ in the form of a

⁶² It should be noted that the "Martyrius Parvis" evokes the name of the *Martyrium*, the great Constantinian basilica in the Jerusalem complex of the Holy Sepulchre. This could be coincidental but probably is not.

⁶³ Regrettably, I was not able to gain access to original documentation or publications relating to the new excavations. Thus, this suggestion is theoretical, based on available earlier materials.

⁶⁴ Tsarevskaya, "Relics of Anthony," p. 402.

⁶⁵ "Тъгда же бяше пришьл … Добрына Ядреиковиць из Цесаряграда и привезе с собою Гроб Господень, а сам пострижеся на Хутине у святого Спаса," according to the *First Novgorod Chronicle* (year 1211), in Nasonov, *First Novgorod Chronicle*, p. 52; Beliaev, "Holy Tomb and Relics," pp. 96, 100 n. 8; Nazarenko, "Internatonal Relations of Ancient Rus," p. 638. On the interpretation of the "Holy Tomb" of Anthony of Novgorod, see Tsarevskaya, "Relics of Anthony" (with earlier bibliography).

⁶⁶ On the importance of ritual measurements taken from the holy sites to strengthen the significance of a transported measurement of the tomb, see Zur Shalev, "Christian Pilgrimage and Ritual Measurement in Jerusalem," *Micrologus/La misura* 19 (2011), 131–50.

light-blue ribbon with pink stripes, its ends sealed with wax, which measured the length of the slab of the tomb (175 centimeters); this ribbon was kept in the cathedral treasury in a Western European reliquary until the year 1901.[67] Thus the Byzantine idea that the main altar of every church is a tomb of Christ was modified to accord with the dimensions of the actual tomb in Jerusalem, thus evoking the Western tradition of translating holy places to Europe.

Anthony's visit to Constantinople deserves closer attention in our context. He left a highly detailed *Pilgrim Book* (Книга Паломник),[68] considered one of the major sources of knowledge on the relics of Constantinople at the eve of the crusader conquest of the city.[69] Two notes in this text mentioning the relics of the tomb of Christ in the Hagia Sophia of Constantinople are of utmost importance. One appears in the opening sentence of the text and refers to the first relic venerated by the author: "I am unworthy, much sinful Anthony Archbishop of Novgorod, with the mercy of God and with the help of Saint Sophia,

[67] For the reliquary photos, see Tsarevskaya, "Relics of Anthony," p. 441, ill. 2; Владислав Петрович Даркевич [Vladislav P. Darkevich], *Художественное ремесло средневекового Запада (X–XIV вв.), По материалам раскопок в Восточной Европе* [Artistic craft from the medieval West (X–XIV centuries), on the materials from excavations in Eastern Europe] (Moscow: Krasand, 2010), pp. 57, 96, cat. no. 51, table 20.

[68] George Majeska promised to publish an edition of the *Pilgrim Book* of Anthony of Novgorod with an English translation and commentary first in 1986 and again in 2000 and 2003. See George P. Majeska, "Russian Travelers to Constantinople in the Fourteenth and Fifteenth Centuries," *Dumbarton Oaks Studies* 19 (Washington, DC: Dumbarton Oaks Research Library and Collection, 1984), n.p.; George P. Majeska, "St. Sophia in the Fourteenth and Fifteenth Centuries: The Russian Travelers on the Relics," *Dumbarton Oaks Papers* 27 (1973), 69–87 (p. 74); George P. Majeska, "Russian Pilgrims in Constantinople," *Dumbarton Oaks Papers* 56 (2000), 93–108; George P. Majeska, "Russian Pilgrims and the Relics of Constantinople," in *Eastern Christian Relics*, ed. by Alexei Lidov (Moscow: Progress-Tradition, 2003), pp. 387–97. Recently, an English translation of the text was published by Snezhana Rakova, *The Fourth Crusade in the Historical Memory of the Eastern Orthodox Slavs*, trans. by Peter Skipp (Sofia: Tendril, 2013), pp. 177–214 (unfortunately, I was not able to consult this publication). Two old French translations are still relevant: "Antoine, Archeveque de Novgorod, Description des lieux-saints de Constantinople (1200)," in *Itineraires russes en orient*, ed. by Basile de Khitrowo, *Publications de la Société de l'Orient Latin, serie Geographique* 3 (Geneva: Imprimerie Jules-Guillaume Fick, 1889), pp. 85–111, and Marcelle Ehrhard, trans., "Le livre du pèlerin d'Antoine de Novgorod," *Romania* 58 (1932), 44–65.

[69] A number of copies of Anthony's text survived; these can be divided into three codicological families. The earliest manuscript copy is dated to the sixteenth century, but in spite of a chronological gap of more than three hundred years, research is unanimous as to the high degree of authenticity and precision of the information it recalls regarding Anthony's visit to Constantinople around 1200. There are three earlier versions of this text: two longer versions and one shorter version. Алексей Михайлович Лидов [Alexei M. Lidov], ed., *Реликвии в Византии и Древней Руси: Письменные источники* [Relics in Byzantium and Medieval Russia: Written sources] (Moscow: Progress-Tradition, 2006), pp. 190–91.

which means Wisdom, ever-existing Logos, when I came to Constantinople, first I bowed to Saint Sophia, and kissed two slabs of the most Holy Tomb of the Lord and the seals of the tomb."[70] The second note locates the relic in the eastern end of the church:[71] "In a vestibule behind the great altar inserted inside the wall is the upper slab from the tomb of the Lord."[72] Thus, this source claims that around the year 1200, in the Hagia Sophia in Constantinople, there were at least two[73] slabs (*doska*, "boards" in George Majeska's translation)[74] from the tomb of the Lord, one of which was the upper slab (*верхняя доска*)[75] with the "seals of the tomb" on display for veneration (Anthony kissed the slabs and the seals). These relics from Hagia Sophia are not mentioned by any other source before or after 1204. Since it is not likely that relics of such importance would be so widely neglected, this passage of Anthony of Novgorod warrants further study.[76] Meanwhile I propose a number of possible explanations for the information found in the Novgorodian source.

First, Anthony may have confused some other relics with the tomb of Christ. The source of his confusion could be the relic mentioned in an early twelfth-century source known as the Mercati Anonymous, probably a Latin adaptation of an eleventh-century Greek original.[77] In the text, an English pilgrim describes

[70] This is according to the longer version, as in Елена Ивановна Малето [Elena I. Maleto], *Антология хожений русских путешественников XII–XV века: Исследования, тексты, комментарии* [Anthology of the itineraries of Russian travelers of the XII–XV centuries: Research, texts, commentaries] (Moscow: Russian Academy of Sciences, Institute of Russian History, Nauka, 2005), pp. 221–35 ("Се аз недостойный, многогрешный Антоней, архиепископ Новгородский, Божиим милосердием и помощию святыя Софии, иже глаголется Премудрость, присносущное Слово, приидохом во Царьград, преже поклонихомся святей Софеи, и пресвятаго гроба Господня две досце целовахом, и печати гробныя).

[71] Although it is not clear exactly where it was.

[72] Maleto, "Anthology," p. 225: "Во притворе же за великим олтарем вчинены во стене гроба Господня верхняя доска." In the short version of Anthony's book, this passage does not appear.

[73] Aynalov claims they should be understood as three different slabs and not just two, mentioned twice ("Annotations to the Text of the 'Pilgrim Book,'" pp. 247–61 [p. 261]).

[74] Majeska, "Russian Pilgrims and the Relics of Constantinople," pp. 389, 392.

[75] Compare with *doska okonechnaja* brought by Dionisi to Novgorod in 1134, mentioned above.

[76] This study will be provided, I believe, by Majeska with the publication of Anthony of Novgorod's itinerary. John Wortley doubted the information of Anthony regarding the relics of the tomb of Christ in Hagia Sophia: "The Russian visitor makes claims which are very difficult to believe and rarely substantiated elsewhere" ("Relics and the Great Church," *Byzantinische Zeitschrift* 99 (2006), 631–47 [p. 637]).

[77] Krijnie N. Ciggaar, "Une description de Constantinople traduite par un pèlerin anglais," *Revue des Études Byzantines* 34 (1976), 211–67. For the comparative studies of the relics

a relic of the measurement of Christ on display in Hagia Sophia in Constantinople.[78] Alternatively, there could be some conflation with a relic of a stone from the tomb of Christ kept in the Pharos chapel,[79] also in Constantinople, recorded by other sources and not mentioned by Anthony in his list of the relics in the "Royal Golden Palace" (*во царских златых полатах*).[80]

Second, the mention of the slabs from the tomb of Christ in Hagia Sophia in Constantinople might be a later extrapolation of the original text. This assumption should be assessed in light of the widespread agreement about the high degree of authenticity and precision of information in Anthony's book, which obviously went through some editing processes after it was finished by its author. Thus, for example, the name of Anthony himself and his status as archbishop, which he received only in 1210, almost a decade after his pilgrimage, were probably added to the original text at some later date.

Third, I suggest it is possible that Anthony "sees" (whether consciously or not) early thirteenth-century Novgorodian or "Russian" features in the Hagia Sophia of Constantinople. In other words, apart from what can be understood as "the tomb of Christ," he also saw the liturgical Jerusalem vessel,[81] icons of the Russian saints Boris and Gleb, and a paten presented to the Hagia Sophia by Princess Olga, mother of St. Vladimir, the baptizer of Rus'. Thus he "sees" Novgorodian Jerusalem manifestations (such as recognizing a reliquary or an altar with a tomb-measurement relic as a "tomb of Christ," similar to what he was familiar with back home) rather than actual Constantinopolitan evocations.

In any case, the mention of the slabs from the tomb of Christ as the first and therefore most precious relic Anthony venerated in the Constantinopolitan Hagia Sophia indicates the importance of these relics as a distinctive feature of Russian medieval culture, even if his account does not necessarily reflect

mentioned by medieval Latin pilgrims versus Anthony of Novgorod, see Majeska, "Russian Pilgrims in Constantinople," table 1; Majeska, "Russian Pilgrims and the Relics of Constantinople," tables 1–2; *Le trésor de la Sainte-Chapelle*, ed. by Jannic Durand and Marie-Pierre Laffitte (Paris: Réunion des Musées Nationaux, 2001), pp. 32–33.

[78] It was Alexei V. Zherve who first proposed that what Anthony of Novgorod saw in Hagia Sophia in Constantinople were "measures" (меры) of the Jerusalem Holy Tomb sealed on both sides with wax seals on display in the church; see Алексей Владимирович Жервэ [Alexei V. Zherve], "Мера святого Гроба Господня: Традиция перенесения святыни на Руси в XII–XVII вв" [Measure of the Holy Tomb of the Lord: Tradition of the translation of the holy relic to Rus' in the twelfth–seventeenth centuries], *София* 4 (2000), 8–12; and 1 (2001), 19–22.

[79] This is different from the Stone of Unction, which Anthony specifically mentions in the monastery of the Pantokrator.

[80] Maleto, "Anthology," p. 226.

[81] On the liturgical Jerusalem, see the discussion below.

historical reality on the eve of the crusader plunder. For the medieval Russian capable of reading the *Pilgrim Book*, the Hagia Sophia of Constantinople and no other was the model for its Novgorodian namesake. Moreover, in the medieval Russian narrative, the Constantinopolitan relic of the tomb was the source of the Novgorodian one.

The parallel of Hagia Sophia of Novgorod with Constantinople is strengthened by the fact that, in addition to the measurement of the tomb of Christ just discussed, Anthony also brought a relic of the True Cross from the Byzantine capital to Novgorod.[82] The relic was incorporated into a reliquary cross that stood upon the main altar in the manner of the monumental *crux gemmata* of Justinian, which, according to Anthony, was "higher than two people" and stood behind the great altar in Constantinople.[83]

Thanks to Anthony's relics, medieval Novgorod also became the first manufacturer of what might be called "Jerusalem relics," *staurothekai* with pieces of the contact relics of the True Cross and the Holy Tomb, in the manner of Jerusalem crusader prototypes.[84] Sometimes, these reliquaries even reached Europe, such as the Jerusalem Cross (*Jerusalemkreuz*) from the cathedral treasury of Hildesheim,[85] made in Novgorod in the thirteenth century, which also held relics of the Holy Tomb and the True Cross.[86] The aforementioned stone icons may also be seen as contact relics made at the Holy Tomb in Novgorod.

[82] This is according to the First Nogorodian Chronicle mentioned above; Tsarevskaya, "Relics of Anthony."

[83] According to Tsarevskaya, the cross stood in Novgorod until the mid-nineteenth century (when it was repaired and lost its original look); see Tsarevskaya, "Relics of Anthony," pp. 399–400. The cross had an inscription running on its side: "God, help your servant Anthony, Archbishop of Novgorod, who gave this cross to Saint Sophia" (Господи, помози рабу своему Антонию архиепископу Новгородскому давшему крест святой Софии).

[84] On the crusader reliquary crosses, see especially Heribert Meurer, "Kreuzreliquiare aus Jerusalem," *Jahrbuch der Staatlichen Kunstsammlungen in Baden-Württemberg* 13 (1976), 7–18; Heribert Meurer, "Zu den Staurotheken der Kreuzfahrer," *Zeitschrift für Kunstgeschichte* 48 (1985), 65–76, Anastasia Keshman Wasserman, 'The Cross and the Tomb: The Crusader Contribution to Crucifixion Iconography', in Between *Jerusalem and Europe: Essays in Honour of Bianca Kühnel*, ed. by Renana Bartal and Hanna Vorholt (Leiden: Brill, 2015), pp. 13–33.

[85] For good reproductions, see Claudia Höhl, "Sogennantes Jerusalemer Kreuz," in *Imperator Caesar Flavius Konstantin—Constantinus der Grosse; Ausstellungskatalog*, ed. by Alexander Demandt and Josef Engemann (Mainz am Rhein: Philipp von Zabern, 2007), cat. no. III.7.4.

[86] In his groundbreaking study on the connection of Rus' with European lands during the Middle Ages, Alexander Nazarenko claims that these were the relics brought from the Holy Land that found their way to Germany inside the Novgorodian reliquary ("International Relations of Ancient Rus'," p. 635). I disagree with this assertion and think that they were rather contact relics produced in Novgorod.

"Jerusalem" Liturgical Vessels and Other Furnishings

Jerusalem's presence in Novgorod is further attested by liturgical vessels used in the cathedral of Hagia Sophia in medieval Novgorod under the name of "Jerusalem" (Иерусалим) and, from the mid-seventeenth century on, as "Zion" (Сион). Two such vessels are still preserved in Novgorod: the first is called the "Small Jerusalem," and the second, the "Large Jerusalem."[87] Irina Sterligova suggests a Byzantine attribution to the former, the earliest extant example dated on stylistic grounds to the eleventh century.[88] This object was constructed of a number of components of Byzantine origin that were, however, not assembled simultaneously: the *discos* (paten) with the image of Christ in its middle is the oldest part, to which a ciborium supported by six columns was added,[89] as well as a *spolia* metal disk with a Greek inscription to the joint of the cross to the cupola.[90] Sterligova is in no doubt that this object was, from the very start, a Byzantine liturgical implement that was presented by the grand prince of Kiev, Yaroslav the Wise (father of Vladimir, founder of the cathedral), to the Hagia Sophia of Novgorod on the occasion of its consecration. The "Jerusalem" function of the Novgorod Small Jerusalem is backed up by another Byzantine "Zion," made in Antioch and preserved since the Middle Ages in the treasury of the Palatine Chapel of Aachen.[91] The identification of this artophorion as a Zion

[87] Sterligova, "Jerusalems as Liturgical Vessels," p. 55 n. 7.

[88] Ирина Анатольевна Стерлигова [Irina A. Sterligova], "Малый Сион из Софийского Собора в Новгороде" [Small Sion from the Hagia Sophia Cathedral in Novgorod], in *Древнерусское Искусство: Художественная Культура X - первой половины XII вв.* (Moscow: Nauka, 1988), pp. 272–86.

[89] Originally on the places where the columns are connected to the base there were enamel(?) medallions, removed during the change from paten to ciborium structure, as in Sterligova, "Small Sion," pp. 275–76.

[90] According to Sterligova, the inscription that makes a monogram of the name Constantine reads ΠΡΟ-ΕΔΡȢ|ΜVCTI-ΚΟΫ́Κ|Μ ... ΤΡΟ|ΠΑΙ-ΟΦΟΡȢ; see ibid., p. 280. Sterligova rejects the interpretation of Valentina S. Shandrovskaya (Валентина Самойловна Шандровская), "Греческая Надпись 'Малого Новгородского Сиона'" [The Greek inscription of the "small Novgorod Sion"], *Византийский Временник* 38 [1977], 157–60) but accepts the reading of Nikolaos Oikonomides, "Κωνσταντίνου προέδρου μυστικοῦ κ(αὶ) μ(ε)γ(άλου) [οἰκ(ο)ν(όμου) τ(οῦ) Τροπαιοφόρου," in "St. George of Mangana, Maria Skleraina and the 'Malyi Sion' of Novgorod," *Dumbarton Oaks Papers* 34/35 (1980–81), 239–46.

[91] Sterligova, "Small Sion," pp. 283–84. Sterligova's argumentation is heavily influenced by the work of Andre Grabar, who suggested that the Aachen reliquary been seen as a Byzantine copy of Jerusalem and the Holy Sepulchre. Grabar did not accept its function as a liturgical Jerusalem vessel (as it was known in the Russian tradition) but considered it a lighter or censer ("Le reliquaire byzantin de la cathédrale d'Aix-la-Chapelle," in *L'art de la fin de l'antiquité et du Moyen Age*, ed. by André Grabar [Paris: Collège de France, 1968], pp. 427–33).

was made on the basis of its inscriptions citing Psalms that recall Mount Zion.[92] Research concurs that the second "Large Novgorod Jerusalem" was a copy of the first. It preserves the twelve opening and closing doors with the images of the twelve Apostles attached to the columns, missing from the earlier original. According to Sterligova, this object was made in Novgorod in the twelfth century and reveals a definite Western influence.[93] Sterligova holds that there was a third example, probably made prior to these two. The written source that discusses this third Jerusalem ought to be treated with due deliberation.[94]

It seems that the naming of the liturgical vessels as "Jerusalem" has unequivocally Russian, if not Novgorodian, origins. This practice is already seen in writing of the aforementioned Anthony of Novgorod, who saw "the radiant Jerusalem" (*светозареныи иеросалим*) during the Holy Communion in the liturgy in the Hagia Sophia of Constantinople.[95] Yet until liturgical vessels referred to as Jerusalem or Sion are found in contemporary non-Russian documents describing their use in the Byzantine liturgy, it is best to approach this phenomenon cautiously. In this respect, it would be useful to study the Novgorodian "Jerusalems" alongside their Western medieval parallels: the *tabernaculum* (tower reliquary), likely used to preserve the consecrated host, which

[92] *Treasures of Heaven: Saints, Relics and Devotion in Medieval Europe*, ed. by Martina Bagnoli, Holger A. Klein, C. Griffith Mann, and James Robinson (London: The Cleveland Museum of Art, The Walters Art Museum, The British Museum, London, 2010), pp. 98, 118, cat. no. 55 (with full Greek inscriptions, their English translations and further bibliography).

[93] The Second (Large) Novgorod Jerusalem was made already in Novgorod and has clear Western influences (in the form of the decorative interlace and the use of *niello*), according to Ирина Анатольевна Стерлигова and Лев Исаакович Лифшиц [Irina A. Sterligova and Lev I. Lifshitz], eds., *Декоративно-Прикладное Искусство Великого Новгорода: Художественный Металл XI–XV века* [Decorative and applied art of Novgorod the Great: Artistic metal of the eleventh to fifteenth centuries] (Moscow: Nauka, 1996), pp. 116–23, cat. no. 3.

[94] The historical events of 1068 are retold in the narrative of the year 1178 and were probably recorded at an even later date. See the "Hypathian Chronicle," in "Полное Собрание Русских Летописей" (St. Petersburg: Eduard Pratz, 1843), II, p. 608. The same source mentions three more Jerusalems that were ordered by Andrei Bogoliubsky in medieval Vladimir, in "Полное Собрание Русских Летописей," II, pp. 581–82 (year 1175). The liturgical Jerusalems are mentioned only in the Hypathian edition, in the additions to the original text of the *Primary Chronicle* written surely already in the twelfth century (after 1117). No liturgical Jerusalems were mentioned in the earlier parts of the chronicle or in the parallel narratives in the Laurentian Chronicle (the oldest, late fourteenth-century copy of the *Primary Chronicle*). Thus, written mention of the Hypathian Chronicle would be better seen as proof of the existence of this practice in twelfth-century Russian culture but not of its earlier existence.

[95] Maleto, "Anthology," p. 224. It also seems incorrect to refer to the Antiochian tenth-century artophorion as Sion, in spite of the inscription bearing this name, since this appellation is known in Russian sources only from the seventeenth century.

appeared in Europe at the same period and which are usually interpreted as representing the tomb of Christ on account of their form and decoration.[96] It is not enough to see this phenomenon from the Byzantine point of view alone since Novgorodian expressions of the Jerusalem cult show a strong mix of Eastern and Western traditions.

The Jerusalem cult in Novgorod developed further in the centuries that followed. A church dedicated to the Entry of Christ to Jerusalem was built in 1336 by order of Archbishop Vasili. The original church, excavated in 2010, was located opposite the southern entrance to the Hagia Sophia Cathedral, where the tomb of Christ stood. This fact reinforces the idea that the cathedral itself alluded to Jerusalem. There is also evidence that a "Donkey Walk" procession took place in Novgorod already in the fifteenth century. During this procession, the patriarch was led on horseback by the prince from the cathedral to the church of the Entry to Jerusalem.[97] This ceremony, first recorded in Novgorod, reveals a marked melding of Western and Eastern traditions. One can see traces of the European practice of pulling a three-dimensional sculpture of Christ on the ass in procession on Palm Sunday.[98] Nonetheless, the procession that granted the patriarch symbols of power from a secular ruler is of Byzantine origin. Andrei Korenevsky and Alexander Peliugin argue that this Russian tradition follows a ritual first known in the Byzantine liturgy in the thirteenth century and which was mostly practiced during the fourteenth and fifteenth centuries. The procession was part of the festive liturgy of initiation of a new patriarch of Constantinople.[99] The late Byzantine ritual was, in turn, derived from the Western *officium stratoris* (groom service, услужение конюшего), whose origins traditionally date to Emperor Constantine the Great and Pope Silvester (following the *Donatio Constantini*). The Novgorodian archbishop was seated on a horse, in the manner of the Byzantine

[96] Probably, such a Western reliquary or *tabernaculum* is preserved in Moscow's Large Jerusalem from the fifteenth century; see Darkevich, "Artistic Craft from the Medieval West," pp. 23–25, 91–92, cat. no. 41, tables 15–16. Research connects it to Vladimir, but it probably comes from Novgorod, which had strong connections with medieval Europe.

[97] Flier, "Image of the Tsar," pp. 538–41. Note that the Moscow early processions also took place in the "reverse" direction.

[98] Elizabeth Lipsmeyer, "Devotion and Decorum: Intention and Quality in Medieval German Sculpture," *Gesta*, 34, no. 1 (1995), 20–27.

[99] Андрей Витальевич Кореневский and Алексанр Юрьевич Пилюгин [Andrei V. Korenevsky and Alexander Y. Peliugin], "Officium stratoris и 'шествие на осляти': происхождение и семантика ритуалов" [Officium stratoris and the 'donkey walk': The Origins and semantics of rituals], *COGITO—Альманах истории идей* 5 (2011), 203–40 (p. 215).

patriarch, but the horse's dress of a white robe with a hood adorned with donkey ears was adopted from the biblical Easter narrative.

The sixteenth-century *Book of Liturgical Instructions of Archbishop of Novgorod and Pskov* (**Чин архиепископа Новгорода и Пскова**) illustrates a further fusion of Western and Eastern liturgical traditions. During Easter celebrations, a tomb of Christ was placed in the middle of Hagia Sophia and an *epitaphion* (плащаница) with a canvas depiction of a dead Christ was placed upon it.[100] This text reveals two major changes relative to the earlier practice: first, a movable tomb is used instead of a fixed one; and second, the newly introduced cloth with an image of the dead Christ evokes liturgical drama within the cathedral space. This second change may have been related to the adoption of a late Byzantine liturgical practice, namely, the use of the *epitaphion* during the Easter liturgy. As described in the mid-fourteenth-century *Order of the Divine Liturgy*[101] of Philotheos Kokkinos, patriarch of Constantinople, during the ceremonies of Holy Saturday morning (when Christ is dead in his tomb), the priest reenacts the burial of Christ, singing the prayer "The Noble Joseph" that describes the burial of Christ in the new tomb by Joseph of Arimathea. Then the priest fills the chalice with wine and places the bread (the body of Christ) on the paten, covered with a special cloth known by the name of *epitaphion* or *epitaphios* (from the Greek ἐπί [epí] for "on/upon," and τάφος (táphos) for "grave/tomb"). The *epitaphion* bore an image of the dead Christ after his Deposition from the Cross with other figures.[102] Most probable, the *epitaphion* with an image of the dead Christ was introduced into Byzantine liturgy due to Western influence, especially the late medieval Catholic feast of *Corpus Christi* (celebrated on the Thursday before Good Friday, the day of Christ's Crucifixion).[103] But even after such a dramatic change, the addition of a new liturgical imple-

[100] Александр Петрович Голубцов [Aleksandr P. Golubtsov], *Чиновник Новгородского Софийского собора* [Book of liturgical instructions of the Novgorod Sophia Cathedral], Чтения в Обществе истории и древностей Российских при Московском университете 2 (Moscow: Universitetskaya Tipografiya, 1899).

[101] Διάταξις, Diataxis.

[102] Pentkovskiy, "Jerusalemization," pp. 72–73.

[103] Ibid., p. 75, and probably from the appearance of Stone of Unction practice in Constantinople first and then in Jerusalem, as was suggested recently in Yamit Rachman-Schrire, "The Stones of the Christian Holy Places of Jerusalem and Western Imagination: Image, Place, Text (1099–1517)" (unpublished doctoral dissertation, Hebrew University of Jerusalem, 2015); Yamit Rachman-Schrire, "Christ's Unction and the Material Realization of a Stone in Jerusalem," in *Natural Materials of the Holy Land and the Visual Translation of Place, 500–1500*, ed. by Renana Bartal, Neta Bodner, and Bianca Kühnel (New York: Routledge, 2017), pp. 216–30.

ment, the symbolic tomb of Christ in Jerusalem remained the main altar in every late Byzantine church, following the traditional interpretation of Germanus. No special item of furniture was required in the Byzantium tradition. In Novgorod, contrary to the contemporaneous Byzantine practice, the *epitaphion* with the image of the dead Christ was placed on a portable tomb of Christ (instead of an altar).[104] The replacement of the medieval permanent tomb with a portable one in Novgorod in the early modern period, as can be clearly understood from the *Book of Liturgical Instructions*, still awaits explanation. One might hazard, though, the following guess. As mentioned by Batalov, the floors of Hagia Sophia in Novgorod were elevated in the fourteenth century, thus leaving at least the bases of the alleged twelfth-century permanent tomb of Christ preserved under floor level.[105] But there is no doubt that the tomb—possibly a portable one—still stood in the southwestern corner of Hagia Sophia Cathedral in the sixteenth century, on the place of the original one. During the Easter liturgy, I suggest that this tomb was moved from its regular place to the center of the church, and the *epitaphion* was placed on top of it.[106] What matters most is that by the sixteenth century in Novgorod the tomb had become a portable object. The outcome is a characteristic Novgorodian mix of Eastern and Western provenance that brings to life a novel form: a portable tomb of Christ upon which an *epitaphion* is placed for the Easter liturgy.

Thus, it seems that the cult of Jerusalem in Novgorod developed continuously from the earliest Christian history of that city until the sixteenth century. Starting out as an abstract and symbolic association with Jerusalem, it gradually became a material, figurative, and tangible copy. The Jerusalem cult in Novgorod was comprised of elements taken both from Western and Eastern traditions, from architecture, liturgy, relics, and art. The cult of Jerusalem was fully developed and functioned in Novgorod before it first appeared in Moscow.

[104] This *epitaphion* (плащаница in Russian) turned out to be a real burial shroud of Christ in Moscovite tradition, when according to written sources, this precious relic was brought to Moscow by Shah Abas and was put in a golden reliquary on top of the tomb of Christ already in the Dormition Cathedral (Gukhman, "Tale of the Gift of Shah Abbas").

[105] Batalov, "Holy Tomb within the Sacred Space of the Russian Church," p. 514. The other possible explanation can be connected to the transfer of the tomb to the "Martyrius Parvis" as was suggested above.

[106] As described in the *Book of Ceremonies of the Archbishop of Novgorod and Pskov* dated to the 1540s, cited in Batalov, "Holy Tomb in the Concept of the Holy of Holies of Boris Godunov," p. 160 nn. 40–41, according to Golubtsov, *Book of Liturgical Instructions*.

Transition of Jerusalem from Novgorod to Moscow

All of these singular Novgorodian features (except for the measurements of the main altar and the stone icons that remained unique to Novgorod) appear to have been transferred to the Moscow Dormition Cathedral in the late fifteenth century, following the conquest of Novgorod by the Grand Duchy of Moscow. The Moscow tradition developed at its own pace, and not all elements were translated from Novgorod at once. As can be reconstructed from the evidence, it seems that first the liturgical Jerusalem (represented by the Large Moscow Jerusalem) was built in 1486 by Ivan III.[107] From 1555 to 1560, the cathedral of the Veil of our Lady was built by Ivan the Terrible, with a church dedicated to the Entry to Jerusalem.[108] The formal similarity of the Entry to Jerusalem Church and the Large Jerusalem is not accidental, and the liturgical vessel could have served as a model for the monumental building. From the time of its construction, the whole church was called "Jerusalem" and was part of the "Donkey Walk."[109] The final goal of this procession was the Dormition Cathedral, where the first recorded tomb of Christ is known sometime before 1624.[110] The existence of the procession around the Dormition Cathedral already in the middle of the sixteenth century and its apparent parallels to Novgorodian practices, however, suggest that the tomb was in the cathedral earlier. Thus Moscow, in developing an ideology for the new state and laying claims on being the Third Rome, also aspired to become the center of the Christian universe, the New Jerusalem.[111]

[107] The inscription on the inner side of the door of the Jerusalem in Old Russian reads: "In the year of 6994 [1486] this Jerusalem was made by the order of the most-Orthodox and Christ-loving Great Prince Ivan Vasilievich [Ivan III], sovereign of entire Russia, in the 25th year of his rule, for the church of the Dormition of the most pure Virgin and for the tomb of the miracle-working Peter in Moscow [= in the prothesis?]" (В лето 6994 года сделан сей Иерусалим повелением благоверного и христолюбивого Великого князя Ивана Васильевича господаря Всея Руси в 25 лето господарства его в церковь Успения Пречистыя и ко гробу чудотворца Петра на Москве).

[108] Zelenskaya et al., *New Jerusalem*, pp. 264–68.

[109] Flier, "Image of the Tsar."

[110] At the time of Godunov, when the first Moscow tomb of Christ was made, the measurements of the Jerusalem tomb were first recorded in its cathedral treasury. One such measurement was contributed by Triphon Korobeinikov (Трифон Коробейников) at the end of the sixteenth century; see Batalov, "Holy Tomb within the Sacred Space of the Russian Church," pp. 519–20.

[111] Because of the unique position that Moscow sought to carve out for itself, the Donkey Walk was forbidden by the Church Council of 1678 in all cities (including Novgorod, Astrakhan, Ryazan, Kazan, Rostov, and Tobolsk) except Moscow, according to Flier, "Image of the Tsar," p. 554.

Conclusions

I have argued that the Russian tradition of copying the Holy Land in general and the tomb of Christ in particular blends Western and Eastern traditions to create a singular phenomenon that recalls, but also diverges from, all known parallels. Since the adoption of the Novgorodian tradition by Moscow from the fifteenth century, copies of the Holy Land and its sacred places became common in Russian visual culture. Through Moscow, the cult of Jerusalem became a pan-Russian tradition that would not have occurred had it remained confined only to Novgorod. One illustration of the expanded presence of Jerusalem can still be witnessed in modern Russian Orthodox practice. By merging the Middle Byzantine notion that every church is Jerusalem with the re-creations adopted specifically in the cathedrals of Novgorod and Moscow, every Russian church could have had its own tomb of Christ and Golgotha—something that was not true in the traditional Byzantine world.[112] Today, three-dimensional portable tombs and Golgotha crucifixes remain regular fixtures in Russian churches, used exclusively during the Easter liturgy but kept in the church throughout the year.[113]

It ought to be mentioned that, in the early modern period, too, monumental copies of the Holy Land were not automatically accepted by the Russian Orthodox church. Opponents of Patriarch Nikon objected to his "New Jerusalem" Resurrection monastery in the above-quoted *Historia mystagogica*: "Did not St.

[112] The construction of three-dimensional wooden tombs of Christ is known only from modern times outside Russia. One such example can be seen in Gračanica (Kosovo). But they are not evidence for such practice in the Byzantine period, according to Slobodan Ćurčić, "Late Byzantine *Loca Sancta*? Some Questions Regarding the Form and Function of Epitaphioi," in *The Twilight of Byzantium: Aspects of Cultural and Religious History in the Late Byzantine Empire; Papers from the Colloquium held at Princeton University, 8–9 May 1989*, ed. by Slobodan Ćurčić and Doula Mouriki (Princeton: Princeton University Press, 1991), 251–72 (p. 254).

[113] See, for example, the internet catalogues of church furniture that can be ordered online, including the "Tomb for the Epitaphion" (Гробница для плащаницы Христа) and "Golgotha" (Голгофа) of monumental dimensions; "Calvary" and "Tombs under the Shroud," in *Church Utensils Shop of Ecclesiastical Goods in Belarus*, http://cerkovnaya-utvar.by/category/golgofy, and http://cerkovnaya-utvar.by/category/grobnicy-pod-plashhanicu (accessed 3 February 2015). According to this site, "The presence of Calvary in the Orthodox Church is an absolute must, because this symbol indicates a complex spiritual symbolism of a certain period of Christianity. That is why it can be found even in a smallest church." One completely new feature in the Russian-speaking Orthodox practice is a relatively inexpensive "small Golgotha" (Малая Голгофа) made for private use at home: "Many ordinary Christians have in their homes a small Golgotha, which occupies a special place in the house" (edited by author), as it is explained in "Calvary in a New Orthodox Church," in *Church Utensils Shop of Ecclesiastical Goods in Belarus*, http://cerkovnaya-utvar.by/stati-i-novosti/golgofa-v-novom-pravoslavnom-xrame.html (accessed 3 February 2015).

Germanus, the Patriarch of Constantinople, say that the *proskomedia* [liturgy of preparation] creates Bethlehem while the Holy Table [altar] creates the God-receiving tomb of the Lord?" The text addresses Nikon himself: "Leave it, man, do not joke with holy deeds, and do not play with godly words, one is Jerusalem on Earth, and the second is in Heaven, and it is indestructible; a third Jerusalem nobody planned, only Nikon alone, and this should not be done."[114] Nikon defended himself and his New Jerusalem by using iconic terminology. The New Jerusalem should be seen as an iconic copy, not of Old Jerusalem but of God himself.[115] According to Nikon, the Holy Sepulchre in Jerusalem as well as the Resurrection Church in his New Jerusalem were both made as instruments for veneration of their prototype, the Holy Trinity. They should not be seen as an original and its copy but as two embodiments of the same idea: the entire Christian Church as Jerusalem (as expressed by Isaiah 2:3, "The law will go out from Zion, the word of the Lord from Jerusalem").[116] In this sophisticated way, Nikon was able to unite the Western tradition of the physical copy of the Holy Sepulchre with the Eastern one that considers every church as Jerusalem under the auspices of iconic terminology.

The contemporary project in Yasenevo seeks to bring this phenomenon to a new level within the Orthodox world. By titling the structure the "Icon of the Holy Land," the authors of the monumental project require the viewer to see the three-dimensional copies of the *loca sancta* in the framework of the well-known Orthodox paradigm of the holy prototype and its human-made copy, accepted by all Orthodox churches since the era of Iconoclasm in relation to two-dimensional icons. Applying the iconic relationship of prototype and copy

[114] Claim 14 against Nikon: "Не говорит ли святый Герман, Патриарх Цареградский, яко просвиромисание образует Вифлием и святый престол образует богоприемный Гроб Господень?" Claim 13 against Nikon: "Покинь человече, не шути святыми делы, не играй речми от Бога данными, един есть Иеросалим на земли, а вторый на Небеси, который никогда несказательный, сиречь нерушимый; третий Иеросалим никто не здумал, толко один Никон, и то не по достоинству." The New Jerusalem cost Nikon his ecclesiastical career since he was removed from the patriarchal seat and died a simple monk.

[115] On Jerusalem monumental translations being icons of Jerusalem, see Bianca Kühnel, "Jerusalem between Narrative and Iconic," in *Jerusalem as Narrative Space*, ed. by Annette Hoffmann and Gerhard Wolf, Visualising the Middle Ages 6 (Leiden: Brill, 2012), pp. 105–23.

[116] This is how Nikon explained the name Jerusalem given to his new monastery: "As from a father a son is born, the first one is called son, and also the second one is called son, and they are both called by this same name, because they are both sons of the same father," Nikon, "Refutation," Answers 13–14, in *Patriarch Nikon on Church and State. Nikon's "Refutation,"* ed. by Valerie A. Tumins and George Vernadsky, Slavistic Printings and Reprintings 300 (Berlin: Mouton, 1982), pp. 149–68 (pp. 162, 168) (my translation).

to three-dimensional architecture and church furniture and their physical replication is a new development in the Orthodox world. What can be seen in the contemporary Russian practice is an "orthodoxalization" of the centuries-old Western Catholic phenomenon,[117] which could give rise to new perspectives for other Orthodox denominations around the world.

[117] Of course, the Western Catholic and Protestant monumental representations of Jerusalem had different theological backgrounds as well as different cultic functions.

EPILOGUE

JERUSALEM IN THE STUDIO YARD: ADRIAN PACI'S VIA CRUCIS

Kobi Ben-Meir

In 2011, the Italian-based artist Adrian Paci installed fourteen photographic images in the church of San Bartolomeo in Milan (figs. 1 and 2). These depict the Passion of Christ and correspond to the fourteen Stations of the Cross in the church. This contemporary work of art continues premodern traditions of representing the Passion that took place in Jerusalem in European space; it certainly also exemplifies a continuum of the traditional European representational disparity between the narrative of the Passion and the physical space of Jerusalem.

Christian pilgrims to Jerusalem could easily feel confused when trying to reconcile what they knew about the city and what they saw during their visit, when the imagined Jerusalem known through the biblical text collided with a place that looked utterly different. Furthermore, the narrative of the life of Christ does not conform to a linear geographical sequence. As holy sites are abundant in Jerusalem, pilgrims could spend their time either going back and forth through the city spatially or back and forth through the biblical narrative temporally, while following a less tiresome geographical route. The second option was the general rule in premodern pilgrimage since pilgrims' guides to the Holy Land make clear that following a geographical order was the ruling principle of visits to Jerusalem.[1] However, the mixed-up sequence of the sites visited during pilgrimage actually weakened the coherence of the narrative of Christ's Passion.

A Way of the Cross emerged from the twelfth century onward in Jerusalem.[2] A specific set of fourteen Stations of the Cross was canonized by Pope Clement

[1] Mitzi Kirkland-Ives, "Alternate Routes: Variation in Early Modern Stational Devotions," *Viator* 40, no. 1 (2009), 249–70 (pp. 250–52); Zur Shalev, "Christian Pilgrimage and Ritual Measurement in Jerusalem," *Micrologus/La misura* 19 (2011), 131–50; Tsafra Siew, "Translations of the Jerusalem Pilgrimage Route at the Holy Mountains of Varallo and San Vivaldo," in *Between Jerusalem and Europe: Essays in Honour of Bianca Kühnel*, ed. by Renana Bartal and Hanna Vorholt (Leiden: Brill, 2015), pp. 125–28; Herbert Thurston, *The Stations of the Cross: An Account of Their History and Devotional Purpose* (London: Burns and Oates, 1914), pp. 77–84, 98–103.

[2] Sandro Sticca, "The *Via Crucis*: Its Historical, Spiritual and Devotional Context," *Mediaevalia* 15 (1985), 93–126.

Fig. 1. Adrian Paci, Via Crucis, 2011, installation views in the church of San Bartolomeo, Milan, an artache project curated by Stefania Morellato. Courtesy of the artist. Photo: Andrea Rossetti.

XII only in 1731, largely thanks to the activities of the Franciscan Saint Leonard of Port Maurice (1676–1751).[3] St. Leonard's set of stations created a uniform and coherent narration of the Passion, made it iconic, and facilitated devotion to it outside the Holy Land. As the stations in the church bore only textual reference to the Holy Land, orderly narrative undermined geography in a manner quite contrary to actual Jerusalem pilgrimage.

St. Leonard left an enduring mark on both Jerusalem and Europe. "His" fourteen stations are today the only stations of the Via Dolorosa visited by pilgrims to Jerusalem, and almost every Catholic church in the world includes along its walls indications of this set. They are marked through crosses, numbers, and

[3] Anthony Wallenstein, "St. Leonard of Port Maurice and Propagation of Devotion to the Way of the Cross," *Franciscan Studies* 12, no. 1 (1952), 47–70, esp. pp. 48, 53–58, 63–68.

Fig. 2. Adrian Paci, Via Crucis, 2011, installation views in the church of San Bartolomeo, Milan, an artache project curated by Stefania Morellato. Courtesy of the artist. Photo: Andrea Rossetti.

images, which underscore the narrative approach: the numbering is like that of chapters in a text, to be read and walked through from I to XIV, and the images are illustrations to a story, which hardly ever depict a concrete geography but concentrate on pictorial narration. While the believer in an European church imitates pilgrimage to Jerusalem by walking from one station to another, the city of Jerusalem does not necessarily spring to mind during this "journey." This movement is not a motion from one place to another but rather from one scene to another, like a premodern set of movie stills.

The Passion of Christ and the fourteen Stations of the Cross inspired numerous modern artists, each dealing differently with the notions of space and narrative. Barnett Newman, who painted the series of fourteen paintings titled *Stations of the Cross: Lema Sabachthani* (1958–66, National Gallery of Art, Washington, DC), eliminated narrative completely, as he did with pictorial space, creating abstract and highly expressive paintings of black vertical lines cutting through white canvases and focusing on the emotional aspect of what it

means to suffer.⁴ Conversely, the Israeli artist Motti Mizrachi, for his performance art piece *Via Dolorosa* of 1973, returned to the actual site of the Via Dolorosa in Jerusalem and walked through the fourteen stations while carrying a self portrait on his back, juxtaposing his own bodily suffering to that of Christ.⁵ Also in line with this long European tradition of narrating the Passion through images associated with text rather than geography, Adrian Paci made the work *Via Crucis* in 2011 to mark the Stations of the Cross in the church of San Bartolomeo, via della Moscova, in Milan. He was commissioned by curator Stefania Morellato of *artache*, a group of independent curators and producers of site-specific permanent artworks for sites in Milan, focusing especially on the city's churches. The work is composed of fourteen photographs, each depicting a scene from the Passion according to the canon of St. Leonard and corresponding to the stations in Jerusalem: 1) Jesus is condemned to death; 2) Jesus is burdened with the cross; 3) Jesus falls for the first time; 4) Jesus meets his mother; 5) Jesus is helped by Simon from Cyrene to carry the cross; 6) Veronica wipes the face of Jesus (fig. 3); 7) Jesus falls for the second time; 8) Jesus meets the women from Jerusalem; 9) Jesus falls for the third time (fig. 4); 10) Jesus is stripped of his garments; 11) Jesus is nailed to the cross; 12) Jesus dies on the cross (fig. 5); 13) Jesus is taken down from the cross; 14) Jesus is laid in the sepulchre (fig. 6).

The very specific commission of a photographic series of the *Via Crucis* confronted the artist with a dilemma: how to create contemporary art according to a traditional model, which would be relevant to the contemporary spectator and yet respectful of the past. Paci aimed for his new work to reach beyond pictorial tradition, represented by a couple of his favorite painters such as Masaccio and Piero della Francesca, who created some of the most illustrious cycles of paintings associated with the life of Christ in Italy.⁶ Thus Paci, a painter in his own right, decided to distance the new series from the traditional medium of painting, which is associated with both cycles of images and with images of the Stations of the Cross in churches. He chose a modern and

⁴ Ann Temkin, "Barnett Newman on Exhibition," in *Barnett Newman*, ed. by Ann Temkin (Philadelphia: Philadelphia Museum of Art, 2002), pp. 60–65.

⁵ Sarah Breitberg-Semel, *Artist—Society—Artist* (Tel Aviv: Tel Aviv Museum of Art, 1978), n.p.

⁶ Adrian Paci, "Adrian Paci Discusses His Work in the Church of San Bartolomeo with Paola Nicolin," trans. by Marguerite Shore, *Artforum* (July 2011), http://artforum.com/words/id=28580 (accessed 19 June 2015). Most information about this work is based on multiple discussions with the artist and the curator.

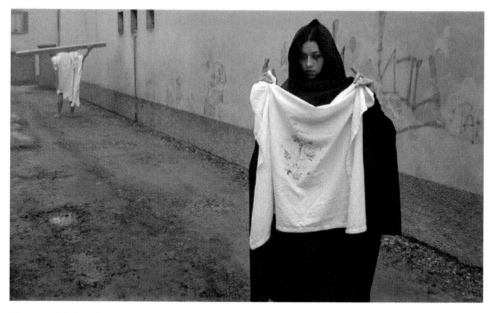

Fig. 3. Adrian Paci, Via Crucis #6, 2011, silver-print on aluminum dibond, 55 × 87 cm. Photo: Courtesy of the artist and kaufmann repetto, Milano/New York.

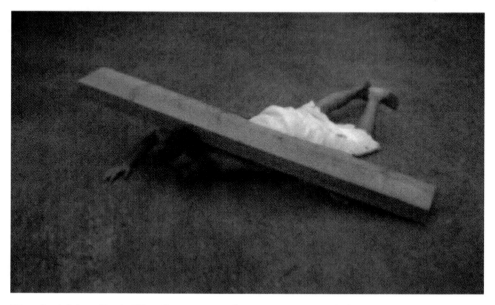

Fig. 4. Adrian Paci, Via Crucis #9. Photo: Courtesy of the artist and kaufmann repetto, Milano/New York.

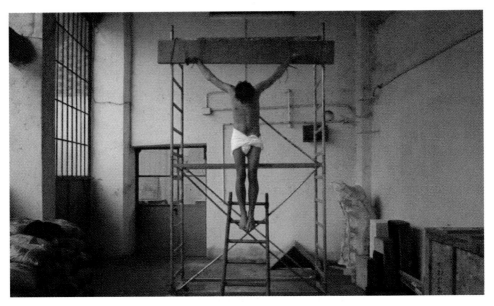

Fig. 5. Adrian Paci, Via Crucis #12. Photo: Courtesy of the artist and kaufmann repetto, Milano/New York.

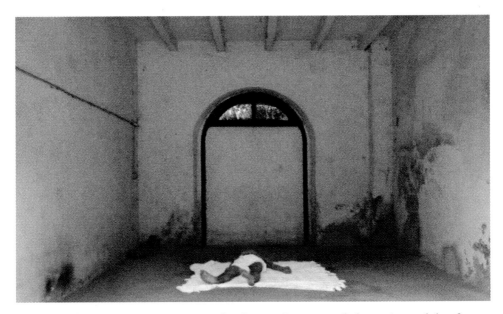

Fig. 6. Adrian Paci, Via Crucis #14. Photo: Courtesy of the artist and kaufmann repetto, Milano/New York.

exceptionally temporal medium for the work, namely video. Paci filmed his friends and their parents dressed in archaic-looking garments, portraying the different characters of the Passion according to the Gospels. The actors were filmed both in the yard outside his studio in Stezzano (stations 1 to 11), and inside the studio (stations 12 to 14).

Paci extracted fourteen still images from the film and printed them on dibond (aluminium sheets). These unframed prints hang along the walls of the church, serving as indications of the Stations of the Cross. Producing a film in order to remove still images from it—that is, using a temporal medium in order to eliminate its temporality—may seem rather paradoxical. Yet such a move actually accentuates the inherent qualities of film—a fast sequence of still images that creates an illusion of movement. Furthermore, this method showcases the qualities of the representation of the Passion through the fourteen stations. Each station, from the Latin *stare* (to stand), is associated with a specific place Jesus stood on the day of his Crucifixion; the fourteen stands embody the fourteen pauses to the savior's physical movement in Jerusalem and represent static points in the temporal movement of narrative and body. Hence, these fourteen stands parallel fourteen images removed from a sequence. As the photographs were removed from a sequence of a film, they were not directed and composed as still images, leaving unforeseen elements that impart an unpolished feel to them. Some parts of the photographs are out of focus while others are indistinct. In the depiction of the third fall, for instance, Jesus's body is blurry, highlighting movement and representing falling rather than only the fallen.

Paci's work then explores the relation between movement and stillness and between the different media of film, photography, and painting. Printing on aluminium sheets highlights the images' grey tonality, lending them the painterly quality of grisaille. Moreover, the aluminum reflects the dim light of the rather dark interior of the church and makes the images shine like miraculous spots of light. These light reflections appear as cooler and more subdued versions of those that appear on the gilded background of a Trecento Italian painting, alternately revealing and concealing parts of the images. The vibrating light reflections follow spectators as they move along the walls of the church from one image to the other, granting the images a dynamic and even lively quality. In this way, the photographs reflect their provenance and, on some level, even return to their cinematic origins.

Fluidity of medium is also salient in Paci's 2009 *Britma* ("Scream" in Albanian). In this work, the artist took a one-second-long video of two children running and slowed it down to nearly six minutes. The video dismantles "real"

time, and, in doing so, dismantles the inherent temporal and representational qualities of film.[7] By exposing the gaps and lack of representational information in the original, opaque depiction of two children and a meadow, Paci transforms the images into a set of paintings—some echoing Edvard Munch's famous *Scream*, others almost completely abstract—as the indefinite images seem to be comprised of expressive brushstrokes.

For *Via Crucis*, Paci directed a theatrical visualization of the narrative of the Passion, namely a novel version of the thousand-year-old custom of the Passion play. The positioning of the paraliturgical Passion dramas outside the regular Easter mass allowed them to evolve during the Middle Ages so that, by the fourteenth century, they had spread throughout Europe and grown to represent the entire Passion narrative, involving the recitation of hundreds of lines of hymns, accompanied by music.[8] Not entirely different from modern theatre productions, the large Passion plays of the High Middle Ages were aided by stage sets, props, costumes, and many actors including extras. As with the Stations of the Cross, the Jerusalem story was depicted in Europe, omitting most spatial and geographical references to the Holy Land, which was represented only by the narrative. The Passion play remains a prominent feature of modern Easter celebrations in many Catholic communities around the world. A spectacular contemporary example is the one mounted in Sordevolo in the Italian region of Piedmont. The play is put on every five years, when about four hundred actors participate in twenty-nine scenes.[9] Although the three-hour-long play is primarily set in an open-air theatre, it makes use of the town and its natural environment as the backdrop of the Passion, replacing the landscape of Jerusalem.

The cultural impact of these plays and, more broadly, the abiding interest in narrating the life of Christ are evident in commercial cinema. Modern films,

[7] Sara Arrhenius, "Still Moving: Some Notes on Adrian Paci's *Pasolini's Chapel*," in *Adrian Paci*, ed. by Angela Vettese (Milan: Charta—Galleria Civica, Modena, 2006), p. 138; Edi Muka, "Engendering Reality," in *Adrian Paci: Lives in Transit*, ed. by Paulette Gagnon and Marta Gili (Milan: Mousse, 2013), pp. 81–82.

[8] Neil C. Brooks, *The Sepulchre of Christ in Art and Liturgy, with Special Reference to the Liturgic Drama* (Urbana: University of Illinois, 1921), pp. 30–33; Donna L. Sadler, *Stone, Flesh, Spirit: The Entombment of Christ in Late Medieval Burgundy and Champagne* (Leiden: Brill, 2015), pp. 14–21; Wm. L. Smoldon, "The Easter Sepulchre Music-Drama," *Music & Letters* 27, no. 1 (1946), 1–17, esp. pp. 1–3, 14–17; Sandro Sticca, *The Latin Passion Play: Its Origins and Development* (New York: State University of New York Press, 1970), pp. 22–24.

[9] Stefania Cerutti and Elisa Piva, "Religious Tourism and Event Management: An Opportunity for Local Tourism Development," *International Journal of Religious Tourism and Pilgrimage* 3. no. 1 (2015), 55–65 (pp. 60–61).

such as Franco Zeffirelli's *Jesus of Nazareth* (1977), *Monty Python's Life of Brian* (1979), Martin Scorsese's *The Last Temptation of Christ* (1988), and Mel Gibson's *The Passion of the Christ* (2004) are some of the best-known adaptations of the story of the life and death of Jesus. Nevertheless, Paci's *Via Crucis* is influenced by a different one, namely Pier Paolo Pasolini's 1964 *The Gospel According to Matthew* (*Il Vangelo secondo Matteo*).

Both Pasolini and Paci give reference to the medium of painting. Pasolini, for his part, often quoted renowned Italian Renaissance paintings in his films.[10] *The Gospel According to Matthew* seems to draw special inspiration from paintings of Piero della Francesca (in the garb of the Pharisees, the priests and the soldiers, and in the depiction of the Baptism) and from Masaccio's *Tribute Money* (1425) in Capella Brancacci. Indeed, Pasolini composed his frames as if they were Renaissance paintings, highlighting a deep perspective by combining close-ups and long shots. Similar compositions appear also in the fifth and sixth images of Paci's *Via Crucis*, where, respectively, the figures of Simon from Cyrene and Veronica are represented in close-up while Christ is represented in the background, creating a dramatic perspectival composition. Some images, especially those of the *Crucifixion* and *Jesus in the Tomb*, are arranged around a central axis, in a symmetrical composition that underlines deep perspective, recalling fifteenth-century Italian paintings such as those of Masaccio. The image of Veronica itself pays homage to painting: the woman is supposedly holding the imprint of the face of Christ, the *Vera Icon*, but is actually holding a veil upon which the artist dripped red paint: though an abstract painting rather than an accurate copy, the inclusion of the action of painting by Paci on the veil pays homage to icons painters from the Middle Ages onward who copied the true image of Veronica.

Pasolini directed *The Gospel* as if it was a cycle of Renaissance paintings: scenes in the movie follow each other in the order of the biblical account, highlighting the gaps in the narrative, and creating a set of temporally and geographically disparate images much like a painted cycle with images that are narratively interwoven and yet separated temporally and spatially, both in regard to the represented story and to their position within the sequence. Paci demonstrates his strong affinity with Pasolini in his 2005 *Cappella Pasolini* (figs. 7–8). In a provisory shed made of leftover wood, metal, and fiberglass, a

[10] Naomi Greene, *Pier Paolo Pasolini: Cinema as Heresy* (Princeton: Princeton University Press, 1990), p. 45; Sam Rohdie, *The Passion of Pier Paolo Pasolini* (Bloomington: Indiana University Press, 1995), pp. 17–22.

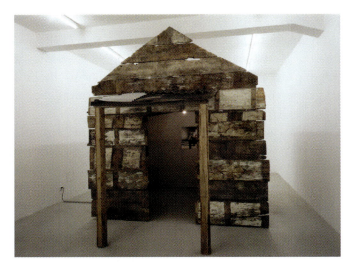

Fig. 7. Adrian Paci, Cappella Pasolini, 2005, wood, metal, fiberglass, bulb, 390 × 300 × 320 cm, MAXXI, Rome. Courtesy of the artist and kaufmann repetto, Milano/New York. Photo: Patrizia Tocci.

Fig. 8. Adrian Paci, Cappella Pasolini, 2005, 27 acrylic on wood paintings in various sizes, Rome. Courtesy of the artist and kaufmann repetto, Milano/New York. Photo: Patrizia Tocci.

patently unsuitable space for a chapel, Paci presents a cycle of acrylic-on-wood paintings that are, in fact, frames extracted from Pasolini's *The Gospel According to Matthew*. He isolated stills from the movie and painted them, thereby returning them to their original pictorial concept. The medial fluidity—stills to

paintings—is further underscored by his use of grisaille, which resembles silver-print photography. The images are thus rendered as still shots from a movie, rearranged to create an alternative narrative.[11]

While the two side walls of *Cappella Pasolini* represent various scenes from *The Gospel According to Matthew*, on the center of the wall, in front of the entrance, hangs a single image: a painting of a frame from Pasolini's 1962 *Mamma Roma*, taken from the final scene of the movie. Stripped of his clothes and tied to a prison hospital table, Mamma Roma's son Ettore dies while light is shining on him from above. Paci implemented a similar method of lighting through the single light bulb hanging in the center of the chapel. Ettore's body, which is likened to that of Christ, was filmed from a dramatically foreshortened angle at his feet, which recalls Andrea Mantegna's *Lamentation over the Dead Christ* (1483). By isolating this specific frame, Paci discloses the pictorial origins of Pasolini's film. Considering *Cappella Pasolini* as a whole—the chamber with an image of the dead Christ on an altar at its center and its surrounding walls occupied by narratives of his life according to Matthew's Gospel—Paci has indeed recreated an Italian Renaissance chapel. Paci returns to the same posture borrowed from Mantegna in the last images of the *Via Crucis* cycle, where Christ's body is depicted from his feet in extreme foreshortening.

Noting that cinema creates an illusion of movement through a series of still images, Paci elaborates on his connection to Pasolini:

> All my work with Pasolini has been similar to a process that tries to bring the film to its original state. In a certain sense, it's as if the editing is destroyed and a pictorial form of expression is recreated. Pasolini himself spoke about the editing by comparing it to death: death like a condition of expression, and editing like the instrument that transforms the infinity of the line of sequence shots into a finite segment…Another reflection is on the relationship between painting and cinema. I see painting almost as a primitive form of cinema—but not as costly.[12]

Paci approaches his own film of the Passion in precisely the way he treats the films of Pasolini—as a cycle of separate paintings rather than a continuous film. He also followed Pasolini in *Via Crucis* in dressing his actors in the stereotypical garments of biblical times. Above his white loincloth, Christ is wearing a thick white square of cloth, which is removed in the tenth image and which reap-

[11] Edna Moshenson, "Subjects in Transit," in *Adrian Paci*, ed. by Gagnon and Gili, pp. 62–63

[12] Adrian Paci, "Conversation between Angela Vettese and Adrian Paci," in Vettese, *Adrian Paci*, pp. 28, 30.

pears in the thirteenth, at the background of the *Deposition from the Cross*, and again in the fourteenth, where Christ lies on it as if it were the tomb, and the cloth serves as his shroud. The clothing serves as a cinematic prop, rearranged to suit the scene. Temporal disparity becomes obvious when these scenes and garments appear in a concrete studio with electric wires on the wall and in the paved yard with steel doors. Unlike Pasolini, who aimed for a realistic depiction of the life of Christ as it is written in the Gospel of Matthew, Paci has no interest in camouflaging the place and time of the production of his *Via Crucis*. His *Crucifixion* is not a realistic image, but one that references its own awkwardness: Christ is standing on a ladder that is conveniently placed under his feet, and he is crucified on a wooden beam that is awkwardly tied to a metallic stand. Props in full view, it is as if this image seeks to convey to the spectator the fact that it does not represent the original Crucifixion of Christ in first-century Jerusalem but its reenactment in contemporary Italy.

While serving as backdrop to the Crucifixion and burial of Christ, the studio of the artist in Stezzano—that is, the place where the artist created his images of Christ—remains a studio rather than Jerusalem, in every one of the fourteen images; there is hardly any effort done to dress the studio as Golgotha, hence stressing that the photographic images are outcomes of artistic construction. Most striking in this regard is the twelfth image depicting the *Crucifixion* (fig. 5), where the temporal disparity is thrown into sharp relief by the inclusion of bags of artistic materials and the mold of an earlier work. At the rear right corner of the room stands the mold of Paci's 2001 sculpture *Home to Go* (fig. 9), a marble powder-and-resin cast of the artist's body, carrying a terracotta tiled roof on his back. The simple roof he is carrying is echoed in the simplicity of the shed of *Cappella Pasolini*, both are architectures of refuge, devoid of any signs of excess, conveying the single simple need for shelter or prayer.

The apparently disingenuous inclusion of the mold of *Home to Go* in the *Crucifixion* in the *Via Crucis* cycle signals the self-identification of Paci with Christ: not only is the artist's studio the place of the Crucifixion and burial of the Messiah, but these scenes are enmeshed with the artistic legacy of the artist himself. *Home to Go* is a form of *imitatio Christi*: the artist represents himself naked in a loincloth, carrying a roof that weighs him down as if it were the cross. Paci here is referring to his own Via Dolorosa, namely, to his immigration to Italy in 1997 following riots, anarchy, and the collapse of state institutions in his native Albania. He follows modernist artistic tradition by reflecting on his struggles in light of those of Jesus. As such, the image of the *Crucifixion* in *Via Crucis* doubles the depiction of Christ, and both

Fig. 9. Adrian Paci, Home to Go, 2001, plaster, marble powder, resin, terracotta tiles, rope, variable dimensions, private collection. Photo: Courtesy of the artist and kaufmann repetto, Milano/New York.

"Christs" in the photograph allude to the artist: Jesus is imitated of the crucified actor in Paci's studio and again by the self-portrait of the artist in the mold of a sculpture.

Pasolini toured the Holy Land to research filming possibilities for *The Gospel According to Matthew*, after which, in 1965, he released his *Sopralluoghi in Palestina* (Location hunting in Palestine), in which he records his impressions of Israel and Jordan. As the movie opens, Don Andrea Carraro, who accompanied Pasolini on his visit to the Holy Land, suggests that the director look at the Arab peasant clearing his wheat in light of John the Baptist's prophecy of the coming of Christ: "His winnowing fork is in his hand, and he will clear his threshing floor, gathering his wheat into the barn and burning up the chaff with unquenchable fire" (Matthew 3:12). Thus Pasolini was advised to read the allegorical and mythical past into mundane reality.

The filmmaker was unable to see the physical landscape of Palestine unto itself and was fixated on comparative reflections: he could only subjectively perceive the landscape of the Holy Land during 1965 in comparison to his ideas of the time of Christ. Pasolini explained that he had expected to find in Palestine a biblical archaic world and was immensely disappointed: the landscape of Israel looked too much like Italy, too modern and industrialized to

be the setting of the Holy Land of Christ. The non-Jewish Arab, Druze, and Bedouin villages in Israel, for their part, which still held a sense of archaism, were too miserable and poverty-stricken for Pasolini. He complained that the smallness of the country's landscape offered him scenography unsuitable for filming the gospel account, which deserved a spectacular backdrop. Surveying Palestine, Pasolini expressed frustration that he encountered not a majestic, sublime landscape but rather a banal one: Israeli houses in the Galilee reminded him of those dotting the Roman countryside, and Mount Tabor was as ordinary, small, and humble as Mount Soratte, undeserving to be the site of a filmic Transfiguration. Gazing at dilapidated East Jerusalem, he decides that the scene of the entrance to Jerusalem in his movie will be quite the opposite: grandiose. Upon arriving in Jerusalem, the director concludes: "The thing that is most interesting to me is the landscape: that Christ should have chosen such an arid place, so bare, so lacking in every amenity—four barren hillsides, a bed of a lake, gloomy heat, and nothing else. All of this can be reconstructed elsewhere."[13]

Southern Italy was where *The Gospel* was eventually reconstructed. It seems that he took Don Andrea's advice, who, when confronted with the director's complaints about the miserable scenographic possibilities, advised him "to condense and absorb the spirit of the situation, and then, possibly relive it, reconstruct it, perhaps even invent it in another setting or in another place."[14] Don Andrea concludes that it is impossible to photograph the Holy Land, whose essence is spiritual rather than visual. Pasolini was pulled between the mental and visual images of a place. When the director, who grew up in the Italian environment of Jerusalem translocations, immersed in the tradition of recreating Jerusalem in different landscapes, was faced with unsatisfactory backdrop, he simply relocated the idea of the Holy Land to a more suitable space. Pasolini's *Sopralluoghi in Palestina* is a meditation of an artist on the need to visualize mental images by decontextualizing them from their geography. At the same time, it encapsulates the feelings of tourists who, upon visually encountering an imagined destination, may decide they prefer seeing the Fontana di Trevi in Rome through the eyes of Anita Ekberg or Marcello Mastroianni in Federico's Fellini's *La Dolce Vita* to standing amid a sea of tourists snapping selfies in the brutal summer sun.

[13] Pier Paolo Pasolini, *Sopralluoghi in Palestina*, 1965.
[14] Ibid.

Paci followed Pasolini in relocating the imagined idea of Jerusalem to Italy, and the temporal disparity of *Via Crucis* is accompanied by a geographical one. Maintaining that transposition is a key tactic for Paci, Edi Muka claims that "he strips his subjects bare of the time dimension, and you start experiencing them in a rather spatial one."[15] Elsewhere as well, Paci relocates holiness and juxtaposes different geographical places. One example is his 2005 video *pilgrIMAGE*, which centers on two pilgrimage sites, one in Genazzano, Italy, and the other in Shkodër, Albania. These two sites are entwined through a fifteenth-century legend about a miraculous flight of an icon of the Virgin during wartime from Shkodër to Genazzano, leaving the church in Shkodër bereft of an object of devotion. Paci filmed the icon in Italy, projected that film in the yard of the church in Shkodër, and after filming the Albanian believers watching the projection of the icon, he projected that scene in front of the icon in Genazzano. Moving back and forth from Albania to Italy, *pilgrIMAGE* presents the geographical disparity between Italy and Albania and "miraculously" bridges it. Paci translocates Italy in Albania and vice versa, allowing the Albanian believers and their worshipped icon to virtually reunite.

Both Paci and Pasolini ignore the geography of Jerusalem in order to sustain the idea of Jerusalem. But what is their idea of Jerusalem? It seems that the relocation of Jerusalem in Italy demonstrates that the idea of Jerusalem as the site of the Passion of God, who suffered and died for humankind, is not governed by geography but is, rather, resolutely universal. The harsh realism in *The Gospel According to Matthew*, particularly in regard to the character of Christ, allows an emotional identification of the spectator with God, who seems quite human. The Marxist, nonbelieving, gay Pasolini did not reject Christianity but rather upheld its most basic moral idea of compassion and saw it as a powerful tool in the struggle against capitalism. Pasolini's Jesus was a social revolutionary, and his condemnation of the Pharisees and the priests of the temple is a charge against political hegemony that betrays citizens.[16] Social commentary is even more apparent in Pasolini's 1962 *La Ricotta*, a self-reflective film in which Stracci, a starving man, acting as the good thief in a film about the Passion of Christ, is mocked by the pompous actors for his poverty and dies on the cross

[15] Edi Muka, "Transposition," in Vettese, *Adrian Paci*, p. 91.

[16] George Aichelle, "Translation as De-Canonization: Matthew's Gospel according to Pasolini," *Cross Currents* 51, no. 4 (2002), 524–34 (pp. 532–33); Greene, *Pasolini*, p. 71; Bart Testa, "To Film a Gospel... and Advent of the Theoretical Stranger," in *Pier Paolo Pasolini: Contemporary Perspectives*, ed. by Patrick Rumble and Bart Testa (Toronto: University of Toronto Press, 1994), pp. 183, 196.

on the set of the film. *The Gospel According to Matthew*, too, tackles modern politics and society, with the director stating, "I wanted to do the story of Christ plus two thousand years of Christianity."[17]

This vision holds true for *Via Crucis* as well, where archaism is confronted with contemporary reality, regular people are the protagonists in the life and death of Christ, and the nonspectacular setting of the Passion makes its drama strikingly approachable. Time and again in Paci's work, *Via Crucis* included, we are offered close-ups, rendering sensitive depictions of individuals. In the words of the artist, "although I am mainly known as a video artist, I am in fact a painter. More precisely, a portrait painter."[18] *Via Crucis* images strike the contemporary spectator as historical and contemporary, sacred as well as approachable. The artist had the spectator of his fourteen stations in mind, as he writes concerning this project:

> One of the goals I set in "removing" detail from the narration was to create a void, a space to be left for possible future development. The choice of video, which is in effect annulled through the decision to stop and use one frame, is also an attempt to allude to a moment that maintains the memory of what was there before and what could come later. Mine is a storyboard Via Crucis. They are stations that you are invited to fill.[19]

Adrian Paci sought to create a cycle of images that respects pictorial tradition without reducing the images to mere quotations, a cycle that, in its engagement with both tradition and present reality, allows for identification and not simply identifying. The voids in the narrative, inherent to the biblical story, are meant to be injected with the spectator's emotions, thereby creating a synthesis of mythical narrative and reality. Thus, like Pasolini, Paci is concerned with the intersectionality of the sacred and the political. It is not coincidental that Christ is not carrying a cross but a simple wooden beam. By removing Christianity's most important symbol, Paci implies that the narrative of the Passion is relevant to all of us: Christ, as the "Other" of first-century Jerusalem, who was persecuted and killed by the political and economic elites of his time, can be found in every place nowadays; the suppression and persecution of other, socially underprivileged individuals is far from a memory, and suffering and

[17] Pasolini, Pier Paolo, *Pasolini on Pasolini: Interviews with Oswald Stack* (Bloomington: Indiana University Press, 1969), p. 91.

[18] Adrian Paci, "Adrian Paci in a Conversation with Mirjam Varadinis," in *Adrian Paci: Electric Blue* (Zurich: Kunsthaus Zürich, 2010), p. 6.

[19] Paci, "Adrian Paci Discusses His Work in the Church of San Bartolomeo."

hope for redemption are common to all human beings. In other words, while looking at the face of Jesus in *Via Crucis*, spectators may simultaneously be looking at the Messiah, at a homeless man living on their street, or even at themselves. Along these lines, the Italian author Curzio Malaparte tells us in *Kaputt*, a novel depicting the suffering of World War II: "There is no need for another infant Jesus ... any one of us might save the world. Any woman might beget another Saviour; any one of us might climb his Calvary and whistling and singing, let himself be nailed to the Cross. It's not very difficult to be a Christ today."[20]

Paci, who dissolves geography when he shows visitors to the church in Milan Stezzano as a Jerusalem story, demonstrates that the images of *Via Crucis* reflect very little upon Jerusalem but rather provide the opportunity to reflect upon human suffering, past and present. The "here and now" is as important in Adrian Paci's *Via Crucis* as the "then and there". Much like medieval and early modern copies of Jerusalem, which addressed the material and spiritual needs and aspirations of their contemporaries through representations of Christ's suffering, Paci is using the visual and conceptual language of Jerusalem translations to Europe, well imbedded in European culture, to address the suffering of those overlooked and excluded during our own times.

[20] Curzio Malaparte, *Kaputt*, trans. by Cesare Foligno (New York: New York Review of Books, 2005), p. 267.

LIST OF ILLUSTRATIONS

PROLOGUE – Portable Jerusalems and the Aesthetics of Displacement
Alina PAYNE

Fig. 1. Edith Wharton, Title page to *Italian Backgrounds*, 1905, Biblioteca Berenson, London.
Fig. 2. View of Sacro Monte di Domodossola, Piemonte. Photo: Author.
Fig. 3. Attributed to Angelo Gabriello, Wax Effigy of architect Carlo Francesco Dotti, c. 1759, Palazzo Pepoli, Bologna.
Fig. 4. Niccolo dell'Arca, Lamentation, detail, 1463, Church of Santa Maria della Vita, Bologna. Photo: Author.
Fig. 5. Guido Mazzoni, Lamentation, detail, 1477-9, San Giovanni Battista, Modena. Photo: Wikimedia Commons.
Fig. 6. Mocking of Christ, Sacro Monte of Varallo. Photo: Wikimedia Commons.
Fig. 7. Marcel Duchamp, Boite en valise, Museum of Art, Cincinnatti.
Fig. 8. Stone of Unction, Church of the Holy Sepulchre, Jerusalem. Photo: Author.
Fig. 9. Bernard von Breydenbach, View of Jerusalem, *Peregrinatio in terram sanctam*, 1486.
Fig. 10. Sanctuary view, San Vivaldo, Montaione, 1505-15. Photo: Author.
Fig. 11. Christ before Ananias, San Vivaldo, Montaione. Photo: Author.
Fig. 12. Simon the Pharisee's House, San Vivaldo, Montaione. Photo: Author.
Fig. 13. Crowd gazing upon Christ before Pontius Pilate and Ecce Homo, San Vivaldo, Montaione. Photo: Author.
Fig. 14. Christ before Pontius Pilate and Ecce Homo, San Vivaldo, Montaione. Photo: Author.

The Toulouse Reliquary of the True Cross and the Transfer of Holy Power
Cynthia HAHN

Fig. 1. St. Helena Discovering the True Cross, Reliquary of the True Cross (view of short side), 1178-98, gilded copper and champlevé enamel, 13 × 29.2 × 14 cm, Saint-Sernin, Musée Saint-Raymond, Toulouse.
Fig. 2. Marys at the Tomb and other scenes of the Donation of a Cross, Reliquary of the True Cross, 1178-98, France, Haute Garonne, Toulouse. Photo: Hemis / Alamy Stock Photo.

Fig. 3. Pons Accepting Cross from Raymond, Reliquary of True Cross, 1178-98, Saint-Sernin, Musée Saint-Raymond, Toulouse. Photo: Author.

Fig. 4. Maiestas (Rev 12:15-19) and scenes of the Donation of a Cross, Reliquary of the True Cross, 1178-98, Saint-Sernin, Musée Saint-Raymond, Toulouse.

Fig. 5. Modern appearance of entry to Treasury, Saint-Sernin, Toulouse. Photo: Stephen Murray, 2011. Courtesy of the Mapping Gothic France Project, Media Center for Art History © The Trustees of Columbia University.

Fig. 6. The Seal of Count Raymond VII of Toulouse. Photo: Public Domain.

Fig. 7. Detail of Soldier at the Tomb, Reliquary of True Cross, 1178-98, Saint-Sernin, Musée Saint-Raymond, Toulouse. Photo: Author.

Fig. 8. Marys at the Tomb, detail from a tabernacle, probably from St. Pantaleon of Cologne, c. 1180, ivory, gilded silver, copper and champlevé enamel, height 54.5 cm, Victoria and Albert Museum, London. Photo: Victoria and Albert Museum, London.

Fig. 9. Jerusalem Cross, first half the twelfth century, wood, silver plate, approx. 20 cm, Conques Treasury. Photo: Author.

Fig. 10. Fresco in the North transept, Saint-Sernin, Toulouse. Photo: Chatsam, published under creative Commons Attribution-Share Alike 4.0 International license.

Translating Jerusalem into Anglo-Norman Lordship
Laura SLATER

Fig. 1. Little Maplestead, Essex, Church of St. John the Baptist, exterior view. Photo: Hanna Vorholt.

Fig. 2. Little Maplestead, Essex, Church of St. John the Baptist, interior view. Photo: Hanna Vorholt

Fig. 3. City of London, Temple Church, interior view. Photo: Author.

Fig. 4. City of London, Temple Church, exterior view. Photo: Author.

Fig. 5. Cambridge, Church of the Holy Sepulchre and St. Andrew ('Cambridge Round Church'), exterior view. Photo: Hanna Vorholt.

Fig. 6. Cambridge, Church of the Holy Sepulchre and St. Andrew ('Cambridge Round Church'), interior view. Photo: Hanna Vorholt.

Fig. 7. Northampton, Church of the Holy Sepulchre, interior view. Photo: Author.

Fig. 8. Northampton, Church of the Holy Sepulchre, interior view of clerestory level. Photo: Author.

Fig. 9. Northampton, Church of the Holy Sepulchre, exterior view. Photo: Author.

Fig. 10. Northampton, Church of the Holy Sepulchre, exterior view of the south side. Photo: Author.

Fig. 11. Shropshire, Ludlow Castle, Chapel of St. Mary Magdalene, exterior view. Photo: Glyn Coppack.

Fig. 12. Shropshire, Ludlow Castle, interior detail of the arcade of the Chapel of St. Mary Magdalene. Photo: Glyn Coppack.

Jerusalem in the Landscape of Catalan Romanesque Architecture: From Evocation to Presence
Gerardo Boto and Marc Sureda

Fig. 1. Map of churches or altars with Jerusalemite dedications in Catalonia, eleventh-twelfth centuries. Photo: Gerardo Boto.

Fig. 2. Girona, restitutive scheme (section and layout) of the Romanesque cathedral dedicated 1038: g) possible position of a first altar dedicated to the Holy Sepulchre, 1058-ca.–1100; b) altar of the Holy Cross in the westwork chapel, dedicated to the Sepulchre, ca. 1100–sixteenth century. Photo: Marc Sureda.

Fig. 3. Ripoll, façade and layout of the abbey church westwork, dedicated 1032 (towers and gable restored ca. 1890). The altar of the Saviour mentioned in 1066 was probably in the westwork's high chapel. Photo: Marc Sureda.

Fig. 4. La Seu d'Urgell, cathedral. Left: restitutive layout of the church dedicated in 1040; the altar of the Holy Sepulchre mentioned in 1057 was probably in the westwork's high chapel. Right: layout of the present church, ca. 1115-1175, without westwork. Black square: approximate position of the independent Holy Sepulchre Church. Photo: Gerardo Boto.

Fig. 5. Girona, Sant Pere de Galligants, layout, exterior view of the tower over the north transept and view of the acoustic channel. Photo: Gerardo Boto.

Fig. 6. Girona, Sant Pere de Galligants, external and internal view of the tower high chapel with two apses. Capital of the Holy Sepulchre in Saint–Nazaire (Auvergne). Photo: Gerardo Boto.

Fig. 7. Olèrdola, Church of the Holy Sepulchre, ca. 1058, layout and elevation of the current state.

Fig. 8. Sallent, Church of St. Sebastian, layout and view from East.

Fig. 9. Palera, Priory of the Holy Sepulchre, image of the now disappeared 'Western Galilea'. Photo: Joaquin Fort de Ribot. AHCOAC Girona. Palera, Sant Sepulchre, Reg. 36636. General layout of the priory (J. Domenech Mansana, 1913).

Fig. 10. Peralada, Church of the Holy Sepulchre, end of the twelfth century, section and axonometry.

The Chapel of the Holy Sepulchre in Medieval Saxony: Between Cloistered Community and Lay Parish
Lotem PINCHOVER

Fig. 1. Gernrode, St. Cyriacus, ground plan and building phases, founded 961, and the Holy Sepulchre Chapel, 1090–mid. twelfth century. After Jacobsen, 'Die Stiftskirche von Gernrode und ihre liturgische Ausstattung', p. 225, fig. 4.

Fig. 2. Gernrode, Holy Sepulchre Chapel, third phase, isometric plan (reconstruction). After Krause, *Das Heilige Grab in Gernrode*, p. 258, fig. 144.

Fig. 3. Diesdorf, Former Convent Church of St. Mary and the Holy Cross, founded 1161, and the Holy Sepulchre Chapel, before 1332. Ground plan after Borrmann, Stephan, and Schöfbeck, 'Diesdorf', p. 424, fig. 3.

Fig. 4. Diesdorf, Former Convent-church of St. Mary and the Holy Cross, Christ's Sarcophagus and Effigy, mid-fourteenth century, wood, ca. 100 centimeters length. Photo: Tilo Schöfbeck.

Fig. 5. Diesdorf, Former Convent-church of St. Mary and the Holy Cross, view from the nave towards north. Photo: Author.

Fig. 6. Wienhausen, Former Convent. After Maier, *Kloster Wienhausen*, p. 15, fig. 7a.

Fig. 7. Christ's Sarcophagus and Effigy, Lüneburg (?), 1448, painted oak wood, 1.75 × 0.775 × 2.52 meters; effigy: oak wood, ca. 1290, length: 2.45 meters, Convent of Wienhausen. Photo: Courtesy of the Convent of Wienhausen © Kloster Wienhausen.

Fig. 8. Wöltingerode, Former Convent, Christ's Sarcophagus and Effigy, second half of the fifteenth century, linden wood, length: 1.85 meters. Photo: Courtesy of the Klosterkammer Hannover © Klosterkammer Hannover.

LIST OF ILLUSTRATIONS

In honorem Sanctae Crucis et Sancti Sepulchri: On the Eichstätt *Schottenkirche* and its Significance
Shimrit SHRIKI-HILBER

Fig. 1. Attributed to Sigmund Holbein, The Raising of Lazarus, ca. 1503, oil painting on wood, 152 × 106.5 cm, Domschatz- und Diözesanmuseum Eichstätt, Inv. Nr. M 2009/3.
Fig. 2. Eichstätt, City-view from *Die Reisebilder Pfalzgraf Ottheinrichs aus den Jahren 1536-1537*, water colour on parchment, 28.7 × 41.5 cm, Universitätsbibliothek Würzburg, Delin. VI, fol. 49.
Fig. 3. Eichstätt Schottenkirche (ca. 1166–1611), Details from the Raising of Lazarus panel painting (l.) and the Ottheinrich aquarelle (r.).
Fig. 4. The Raising of Lazarus panel painting, detail: the Schottenkirche with the annexed building.
Fig. 5. Attributed to Ulrich Taler, A miniature in the feudal register of Bishop Gabriel von Eyb, ca. 1500, water colour on parchment, 37 × 26.5 cm, Staatsarchiv Nürnberg, Hochstift Eichstätt, Lehenbücher No. 8.
Fig. 6. The raising of Lazarus panel painting, detail: Moses.

A Singular Experience of Jerusalem: St. Sebald Church in Nuremberg
Maria E. DORNINGER

Fig. 1. Nuremberg, St. Sebald, Crucifixion. Photo: Author.
Fig. 2. Nuremberg, St. Sebald, St. Peter's Altar. Photo: Author.
Fig. 3. Jerusalem, Church of the Holy Sepulchre, view of the stairs down to the Chapel of St. Helen. Photo: Author.
Fig. 4. Eichstätt, Holy Tomb aedicule. Photo: Author.
Fig. 5. Görlitz, Holy Tomb. Photo: Author.
Fig. 6. Nuremberg, St. Sebald Church, ground plan with imagined path of pilgrims or of the procession in the Church of the Holy Sepulchre in Jerusalem, adjusted to St. Sebald. After Schwemmer and Lagois, *Die Sebalduskirche*, p. 14.
Fig. 7. Jerusalem, Ground plan of the Church of the Holy Sepulchre with path of pilgrims. After Gorys, *Heiliges Land*, p. 98.

Prague in Jerusalem and Jerusalem in Prague: Kristof Harant describes the Holy Sepulchre (1598)
Orit RAMON

Fig. 1. Kristof Harant (1564-1621) with the Church of the Holy Sepulchre (right) and St. Vitus Church (left) in the background, acrylic on canvas. Drawing: Avi Khatam © Open University Publishing House.
Fig. 2. Jerusalem, Church of the Holy Sepulchre. Drawing: Author.
Fig. 3. Prague, St. Vitus Church. Drawing: Author.
Fig. 4. Prague, 1400, town scheme. Drawing: Author.

Gijsbert Raet's Jerusalem Chapel in Late Medieval Gouda
Claudia A. JUNG

Fig. 1. Gouda, the present-day Jerusalem Chapel, 1504, view towards northeast. Photo: Author.
Fig. 2. G. Braun and F. Hogenberg, Map of Gouda, 1585, detail showing the Jerusalem Chapel (no. 14), St. Paul's Convent of the Brethren of the Common Life (no. 25) and St. John's church (no. 1). Photo: Public Domain.
Fig. 3. Gouda, Jerusalem Chapel, 1504, ground plan showing Gijsbert Raet's grave and the hypothetical position of the altar at the east wall. Photo: Collectie Rijksdienst voor het Cultureel Erfgoed, BT-022935, original drawing by A. Viersen, amended by author.
Fig. 4. Delft, late medieval Jerusalem Chapel, c. 1430, ground plan. Photo: Collectie Rijksdienst voor het Cultureel Erfgoed, BT-003806, drawing by Th. van Straalen.
Fig. 5. Amsterdam, foundations of the replica of the tomb aedicule within the foundations of the rotunda, former Jerusalem Chapel, c. 1498. Photo: Stadsarchief Amsterdam/Ino Roël.
Fig. 6. Gouda, Jerusalem Chapel, fragment of Gijsbert Raet's tombstone (d. 1511), showing the border inscription and the indents of three brasses. A glass plate, replacing the missing part of the slab, allows a glimpse into the original burial cavity. Photo: Author.
Fig. 7. Main brass of Gijsbert Raet's tombstone, Rijksmuseum, Amsterdam. Photo: Author.
Fig. 8. Gouda, the present-day Jerusalem Chapel, interior of the rotunda, view towards south-east, showing the original windows and circular blind niches. The door and cupboards are later additions. Photo: Author.
Fig. 9. Gouda, Jerusalem Chapel, interior of the rotunda, stellar vault with oculus. Photo: Author.

LIST OF ILLUSTRATIONS 323

Fig. 10. Stone model of the tomb aedicule as rebuilt in 1555, late sixteenth century, 13.2 cm high × 17 cm long, limestone, probably from the Jerusalem/Bethlehem area, Museum Catherijneconvent, Utrecht. Photo: Author.
Fig. 11. Augsburg, St. Anne's Church, replica of the tomb aedicule, 1508. Photo: Shimrit Shriki-Hilber.

The Presence of Jerusalem in Mantua
Neta BODNER

Fig. 1. Gabriele Bertazzolo, *Urbis Mantuae descriptio*, 1628. Photo: Bibliothèque nationale de France, GE BB-246 (XIII, 96-97 RES).
Fig. 2. Mantua, Church of San Lorenzo, ground plan. Drawing: Moriya Erman.
Fig. 3. Mantua, Church of San Lorenzo, exterior, view from North. Photo: Shimrit Shriki-Hilber.
Fig. 4. Mantua, Church of San Lorenzo, interior, view from gallery towards the east. Photo: Shimrit Shriki-Hilber.
Fig. 5. Gabriele Bertazzolo, *Urbis Mantuae descriptio*, 1628. Detail of top-center: the lost church of San Sepolcro. Photo: Bibliothèque nationale de France.
Fig. 6. *Mantova Assediata dall Essercito Imperiale 1629 1630* Photo: © Comune di Mantova, Musei Civici..
Fig. 7. Matthäus Merian, *Pianta topografica di Mantova*. Photo: © Comune di Mantova, Musei Civici.
Fig. 8. Mantua, Church of Sant'Andrea, ground plan. Drawing: Moriya Erman.
Fig. 9. Mantua, Church of Sant'Andrea, interior. Photo: Tango7174, published under GNU Free Documentation License.
Fig. 10. Mantua, Church of Sant'Andrea, exterior. Photo: Paolo Tralli at Shutterstock images.

From Novgorod to Rome via Moscow: On Translations of Jerusalem to Russia
Anastasia KESHMAN W.

Fig. 1. Yasenevo, The Church of the Veil of the Holy Virgin (Храм Покрова Пресвятой Богородицы в Ясенево), exterior view. Photo: Mos.ru. (The Government of Moscow Press centre), published under the Creative Commons Attribution 4.0 International license.

Fig. 2. Patriarch Nikon's "New Jerusalem" (Новый Иерусалим), founded in 1656 on the Istra River near Moscow, exterior view. Photo: Andrei Kolesnikov, published under the Creative Commons Attribution-Share Alike 3.0 Unported license.

Jerusalem in the Studio Yard: Adrian Paci's Via Crucis
Kobi Ben-Meir

Fig. 1. Adrian Paci, Via Crucis, 2011, installation views in the church of San Bartolomeo, Milan, an artache project curated by Stefania Morellato. Courtesy of the artist. Photo: Andrea Rossetti.
Fig. 2. Adrian Paci, Via Crucis, 2011, installation views in the church of San Bartolomeo, Milan, an artache project curated by Stefania Morellato. Courtesy of the artist. Photo: Andrea Rossetti.
Fig. 3. Adrian Paci, Via Crucis #6, 2011, silver-print on aluminum dibond, 55 × 87 cm. Photo: Courtesy of the artist and kaufmann repetto, Milano/New York.
Fig. 4. Adrian Paci, Via Crucis #9. Photo: Courtesy of the artist and kaufmann repetto, Milano/New York.
Fig. 5. Adrian Paci, Via Crucis #12. Photo: Courtesy of the artist and kaufmann repetto, Milano/New York.
Fig. 6. Adrian Paci, Via Crucis #14. Photo: Courtesy of the artist and kaufmann repetto, Milano/New York.
Fig. 7. Adrian Paci, Cappella Pasolini, 2005, wood, metal, fiberglass, bulb, 390 × 300 × 320 cm, MAXXI, Rome. Courtesy of the artist and kaufmann repetto, Milano/New York. Photo: Patrizia Tocci.
Fig. 8. Adrian Paci, Cappella Pasolini, 2005, 27 acrylic on wood paintings in various sizes, Rome. Courtesy of the artist and kaufmann repetto, Milano/New York. Photo: Patrizia Tocci.
Fig. 9. Adrian Paci, Home to Go, 2001, plaster, marble powder, resin, terracotta tiles, rope, variable dimensions, private collection. Photo: Courtesy of the artist and kaufmann repetto, Milano/New York.

BIBLIOGRAPHY

Abadal i de Vinyals, Ramón de, *Com Catalunya s'obrí al món mil anys enrera* (Barcelona: Rafael Dalmau), 1987.

Abadal i de Vinyals, Ramón de, *Com Catalunya s'obrí al mon mil anys enrera* (Barcelona: Dalmau, [1960] 1988).

Abadal i de Vinyals, Ramón de, "L'esperit de Cluny i les relacions de Catalunya amb Roma i Itàlia al segle X," *Studi medievali*, 372 (1961), 3–41.

Adell, Joan-Albert and Manuel Loosvelt, *Catalunya Romànica* (Barcelona: Enciclopèdia Catalana, 1992), XIX, *El Penedés: L'Anoia*, pp. 147–51.

Adrian Paci, ed. by Angela Vettese (Milan: Charta/Galleria Civica, 2006).

Adrian Paci: Lives in Transit, ed. by Paulette Gagnon and Marta Gili (Milan: Mousse, 2013).

Ahlers, Gerd, *Weibliches Zisterziensertum im Mittelalter und seine Klöster in Niedersachsen*, Studien zur Geschichte, Kunst und Kultur der Zisterzienser 13 (Berlin: Lukas, 2002).

Aichelle, George, "Translation as De-Canonization: Matthew's Gospel according to Pasolini," *Cross Currents*, 51, no. 4 (2002), 524–534.

Aist, Rodney, *The Christian Topography of Early Islamic Jerusalem: The Evidence of Willibald of Eichstätt (700–787 CE)*, Studia Traditionis Theologiae, Explorations in Early and Medieval Theology 2 (Turnhout: Brepols, 2009).

Akerboom, Jacques, ed., "Religieus erfgoed: De Jeruzalemkapel te Gouda," *Monumenten*, 27, no. 3 (March 2006), 16–17.

Albertario, Marco, "'Una gestualita resa imagine': Il Compianto sul corpo di Cristo tra i centri Padani e il Ducato Sforzesco," in *Il corpo e l'anima: Da Donatello a Michelangelo scultura italiana del rinascimento*, ed. by Marc Bormand, Beatrice Paolozzi Strozzi and Francesca Tasso (Milan: Officina Libraria, 2021), pp. 201–9.

Alturo, Jesús, *L'arxiu antic de Santa Anna de Barcelona del 942 al 1200 (Aproximació històrico-lingüística)* (Barcelona: Fundació Noguera, 1985).

Amico, Bernardino, *Plans of the Sacred Edifices of the Holy Land* (Jerusalem: Franciscan Printing Press, 1953 and 1997).

Andersen, Elizabeth A., Henrike Lähnemann and Anne Simon, "Introduction: Mysticism and Devotion in Northern Germany," in *A Companion to Mysticism and Devotion in Northern Germany in the Late Middle Ages*, ed. by Elizabeth A. Andersen, Henrike Lähnemann and Anne Simon, Brill's Companions to the Christian Tradition 44 (Leiden: Brill, 2014), pp. 1–19.

Anderson, William, "Menas Flasks in the West: Pilgrimage and Trade at the End of Antiquity," *Ancient West and East*, 6 (2007), 221–43.

Anthony of Novgorod, "Antoine, Archevêque de Novgorod, Description des lieux-saints de Constantinople (1200)," in *Itinéraires russes en orient*, ed. by Basile de Khitrowo, Publications de la Société de l'Orient Latin, serie Géographique, 3 (Geneva: Imprimerie Jules-Guillaume Fick, 1889), pp. 85–111.

Anthony of Novgorod, "Le livre du pèlerin d'Antoine de Novgorod," trans. by Marcelle Ehrhard, *Romania*, 58 (1932), 44–65.

Anthony of Novgorod, "Pilgrim Book", in Snezhana Rakova, *The Fourth Crusade in the Historical Memory of the Eastern Orthodox Slavs,* trans. by Peter Skipp (Sofia: Tendril, 2013), pp. 177–214.

Appuhn, Horst, "Der Auferstandene und das heilige Blut zu Wienhausen: Über Kult und Kunst im späten Mittelalter," *Niederdeutsche Beiträge zur Kunstgeschichte*, 1 (1961), 73–138.

Appuhn, Horst, *Einführung in die Ikonographie der mittelalterlichen Kunst in Deutschland* (Darmstadt: Wissenschaftliche Buchgesellschaft, 1979).

Appuhn, Horst, *Kloster Wienhausen*, 2nd ed. (Wienhausen: Kloster Wienhausen, 1986).

Arad, Pnina, "Pilgrimage, Cartography and Devotion: William Wey's Map of the Holy Land," *Viator*, 43, no.1 (2012), 301–22.

Architecture and Visual Culture in the Late Antique and Medieval Mediterranean: Studies in Honor of Robert G. Ousterhout, ed. by V. Marinis, A. Papalexandrou and J. Pickett (Turnhout: Brepols, 2020), pp. 147–61.

Arrhenius, Sara, "Still Moving: Some Notes on Adrian Paci's *Pasolini's Chapel*," in *Adrian Paci,* ed. by Angela Vettese (Milan: Charta/Galleria Civica, 2006)., ed. Vettese, pp. 135–38.

L'art de la fin de l'antiquité et du Moyen Age, ed. by André Grabar (Paris: Collège de France, 1968).

Asbridge, Thomas, "The Holy Lance of Antioch: Power, Devotion and Memory on the First Crusade," *Reading Medieval Studies*, (2007), 3–36.

Autobiography of Emperor Charles IV and His Legend of St. Wenceslas, ed. by B. Nagy and F. Schaer (Budapest: CEU Press, 2001).

Avilés, Alejandro García, "*Transitus*: Actitudes hacia la sacralidad de las imágenes en el Occidente medieval," in *Imágenes medievales de culto*, ed. by Gerardo Boto (Murcia: Conserjería de Cultura, 2010), pp. 25–35.

Avner-Levy, Rina, "The Recovery of the Kathisma Church and Its Influence on Octagonal Buildings," in *One Land—Many Cultures: Archaeological Studies in Honour of Stanislao Loffreda OFM*, ed. by Giovanni Claudio Bottini, Leah di Segni and Leslaw Daniel Chrupcala (Jerusalem: Franciscan Printing Press, 2003), pp. 173–86.

Aynalov, Dmitri V., Annotations to the Text of the 'Pilgrim Book' of Anthony of Novgorod, ["Примѣчания къ тексту книги 'Паломникъ' Антонія Новгородскаго] (part 1)" *Журнал Министерства народного просвещения*, n.s., 6, no. 3 (1906), 233–76.

Baart, Jan, "Jerusalem aan de Zeedijk," *Ons Amsterdam*, 43 (1991), 254–57.

Bacci, Michele, "Locative Memory and the Pilgrim's Experience of Jerusalem in the Late Middle Ages," in *Visual Constructs of Jerusalem*, ed. by Bianca Kühnel, Galit Noga-Banai and Hanna Vorholt (Turnhout: Brepols, 2014), pp. 67–76.

Bachelard, Gaston, *The Poetics of Space* (Boston: Beacon, 1994).

Badia, Joan, "El Sepulcre [de Peralada]," in *Catalunya Romànica* (Barcelona: Enciclopèdia Catalana, 1990), IX, *L'Empordà II*, pp. 620–21.

Baert, Barbara, "New Observations on the Genesis of Girona (1050–1100): The Iconography of the Legend of the True Cross," *Gesta*, 38 (1999), 115–27.

Balbín, Bohuslav, *Epitome historica rerum Bohemicarum* (Prague, 1677).

Baldovin, John F., *The Urban Character of Christian Liturgy* (Rome: Pontificio Istituto Orientale, 1987).

Bale, Anthony, *Feeling Persecuted: Christians, Jews and Images of Violence in the Middle Ages* (London: Reaktion, 2010).

Bale, Anthony, "God's Cell: Christ as Prisoner and Pilgrimage to the Prison of Christ," *Speculum*, 91, no. 1 (2016), 1–35.

Barber, Richard, *The Holy Grail: Imagination and Belief* (Cambridge: Harvard University Press, 2004).

Barbera, Mariarosaria, "Aspetti topografici e archeologici dell'area di Santa Croce in Gerusalemme nell'antichità," in *Gerusalemme a Roma: La Basilica di Santa Croce e le reliquie della Passione*, ed. by Roberto Cassanelli and Emilia Stolfi (Milan: Jaca, 2012), pp. 1–11.

Barlow, Frank, *William Rufus* (London: Methuen, 1983).

Baró, Robert, "Les esglésies d'Arraona: Aproximació a tres llocs de culte del segle XI," *Arraona*, 35 (2015), 192–207.

Barral i Altet, Xavier, "El Brodat de la Creació. Un vel de Quaresma mòbil per a la catedral romànica de Girona," in *El Brodat de la Creació de la Catedral de Girona*, ed. by Carles Mancho (Barcelona: Universitat de Barcelona, 2018), pp. 291–303.

Barral i Altet, Xavier, "Du Panthéon de Rome a Sainte-Marie la Rotonde de Vic," *Les Cahiers de Saint-Michel de Cuxa*, 37 (2006), 63–75.

Barral i Altet, Xavier, "Puig i Cadafalch: Le premier art roman entre idéologie et politique," in *Medioevo: Arte lombarda*, ed. by Arturo Carlo Quintavalle (Milan: Einaudi, 2004), pp. 33–42.

Bärsch, Jürgen, "Liturgy and Reform: Northern German Convents in the Late Middle Ages," in *A Companion to Mysticism and Devotion in Northern Germany in the Late Middle Ages*, ed. by Elizabeth Anderson, Henrike Lähnemann, and Anne Simon (Leiden: Brill, 2014), pp. 21–46.

Bartal, Renana, Neta Bodner, and Bianca Kühnel, "Natural Materials, Place and Representation," in *Natural Materials of the Holy Land and the Visual Translation of Place, 500–1500*, ed. by Renana Bartal, Neta Bodner, and Bianca Kühnel (New York: Routledge, 2017), pp. xxiii–xxxiii.

Bartolomé, Laura, "El St Sepulcre de Palera. Un lloc de pelegrinatge al comtat de Besalú," *Quaderns de les Assemblees d'Estudis de Besalú*, 1 (2014), 119–30.

Batalov, Andrey L., "Holy Tomb in the Concept of the 'Holy of Holies' of Boris Godunov" ["Гроб Господень в замысле 'Святая Святых' Бориса Годунова"], in *Иерусалим в Русской Культуре*, ed. by Андрей Леонидович Баталов and Алексей Михайлович Лидов (Moscow: Nauka, 1994), pp. 154–73.

Batalov, Andrey L., "The Holy Tomb within the Sacred Space of the Russian Church in the Sixteenth to Seventeenth Centuries," [Гроб Господень в сакральном пространстве русского храма XVI–XVII вв,] in *Восточнохристианские Реликвии*, ed. by Алексей Михайлович Лидов (Moscow: Progress-Tradition, 2003), pp. 513–32.

Beckmann, Johann Christoph and Bernhard Ludwig Beckmann, *Historische Beschreibung der Chur und Mark Brandenburg: Nach ihrem Ursprung* … (Berlin: Voß, 1751).

Beebe, Kathryne, "Reading Mental Pilgrimage in Context: The Imaginary Pilgrims and Real Travels of Felix Fabri's 'Die Sionpilger,'" *Essays in Medieval Studies*, 25, no. 1 (2008), 39–70.

Beliaev, Leonid, "Holy Tomb and relics of the Holy Land" [Гроб Господень и Реликвии Святой Земли], in *Христианские Реликвии в Московском Кремле*, ed. by Алексей Михайлович Лидов (Moskow: Radunitsa, 2000), pp. 94–102.

Beliaev, Leonid, "Russian Pilgrim Art from the 12th to the 15th Century: Archeological Elements and Problems of Romanesque Influence," *Journal of the British Archaeological Association*, 151 (1998), 203–19.

Beliaev, Leonid, "Space as Relic: On the Symbolic Meaning of Carved Stone Icons of the Holy Sepulchre" {Пространство как реликвия: о назначении и символике каменных иконок Гроба Споднря], in *Восточнохристианские реликвии*, ed. by Alexei Lidov (Moscow: Progress-Tradition, 2003), pp. 482–512.

Benešovská, Klára, "De la circulation des *'locis sanctis'*—le Mons Sion à Prague," *Convivium*, 1 (2014), pp. 50–62.

Biddle, Martin, "Old Minster at Winchester and the Tomb of Christ," in *The Middle Ages Revisited: Studies in the Archaeology and History of Medieval Southern England Presented to Professor David A. Hinton*, ed. by Ben Jervis (Oxford: Archaeopress, 2018), pp. 45–56.

Biddle, Martin, *The Tomb of Christ* (Stroud: Sutton, 1999).

Biddle, Martin, "The Tomb of Christ," *Ariel: The Israel Review of Arts and Letters*, 109 (1999), 17–31.

Biddle, Martin, Gideon Avni, John Seligman, and Tamar Winter, *The Church of the Holy Sepulchre* (New York: Rizzoli in cooperation with Israel Antiquities Authority, 2000).

Biller, Josef H., "Beschreibung der Darstellung von Eichstätt aus 'Die Reisebilder Ottheinrichs aus den Jahren 1536/1537,'" *Sammelblatt des Historischen Vereins Eichstätt*, 94 (2001), 25–35.

Bilsel, Can, *Antiquity on Display: Regimes of the Authentic in Berlin's Pergamon Museum* (Oxford: Oxford University Press, 2012).

Birkett, Helen, *The Saints' Lives of Jocelin of Furness: Hagiography, Patronage and Ecclesiastical Politics* (Woodbridge: Boydell and Brewer, 2010).

Bobersky, Wojciech, "Jerusalem in Post-Medieval Russian Architecture," in *Jerozolima w Kulturze Europejskiej*, ed. by Piotr Paszkiewicz and Tadeusz Zadrozny (Warsaw: Instytut Sztuki Polskiej Akademii Nauk, 1997). pp. 297–320.

Bockmann, Jörn, "Bemerkungen zum 'Wienhäuser Osterspielfragment' und zur Erforschung der geistlichen Spiele des Mittelalters," in *Passion und Ostern in den Lüneburger Klöstern*, ed. by Linda Maria Koldau (Ebstorf: Kloster Ebstorf, 2010), pp. 81–104.

Bodner, Neta, "The Baptistery of Pisa and the Rotunda of the Holy Sepulchre: a Reconsideration," *Visual Constructs of Jerusalem*, ed. by Bianca Kühnel, Galit Noga-Banai, and Hanna Vorholt (Turnhout: Brepols, 2014) pp. 95–105.

Bodner, Neta, "Transcending Geography: The Transportation of Sanctity from the Holy Land to the Homeland," in *United in Visual Diversity. Images and Counter-Images of Europe*, ed. by Benjamin Drechsel and Claus Leggewie, (Innsbruck: Routledge, 2010), pp. 238–49.

Bodner, Neta, "Why Are There Two Medieval Copies of the Holy Sepulcher in Pisa? A Comparative Analysis of San Sepolcro and the Baptistery," *Viator*, 48, no. 3 (2017), 103–24.

Boertjes, Katja, "The Reconquered Jerusalem Represented: Tradition and Renewal on Pilgrimage Ampullae from the Crusader Period," in *The Imagined and Real Jerusalem in Art and Architecture*, ed. by Jeroen Goudeau, Mariëtte Verhoeven and Wouter Weijers (Leiden: Brill, 2014), pp. 169–89.

Bolós, Jordi, "Vila fortificada i castell de Castellnou," in *Catalunya Romànica* (Barcelona: Enciclopèdia Catalana, 1993), XIV, *El Rosselló*, pp. 185–88.

Bolton, Timothy, "Was the Family of Earl Siward and Earl Waltheof a Lost Line of the Ancestors of the Danish Royal Family?," *Nottingham Medieval Studies*, 51 (2007), 41–71.

Bonnassie, Pierre, *Catalunya mil anys enrere* (Barcelona: Edicions 62, 1979), I.

Booth, Philip, "Seeing the Saviour in the Mind's Eye: Burchard of Mount Sion's Physical and Spiritual Travels to the Holy Land, c. 1174–1184," in *Soul Travel: Spiritual Journeys in Late Medieval and Early Modern Europe*, ed. by Jennifer Hillman and Elizabeth Tingle (Oxford: Peter Lang, 2019), pp. 181–206.

Borisova, Tatyana S., "On the Dating of the Oldest Preserved Inventory of the Dormition Cathedral of the Moscow Kremlin", [О датировке древнейшей из сохранившихся описей Успенского собора], in *Успенский собор Московского Кремля: Материалы и исследования*, ed. by Э. С. Смирнова (Moscow: Наука, 1985), pp. 246–59.

Borrmann, Eberhard, Joachim Stephan and Tilo Schöfbeck, "Diesdorf," in *Brandenburgisches Klosterbuch: Handbuch der Klöster, Stifte und Kommenden bis zur Mitte des 16. Jahrhunderts*, ed. by Heinz-Dieter Heimann et al., Brandenburgische historische Studien, 14, 2 vols (Berlin: be.bra-Wissenschaft, 2007), I, pp. 412–24.

Bosio, Luigi, "I Reliquiari del Preziosissimo Sangue Custoditi nella Basilica di Sant'Andrea in Mantova," in *Il Sant'Andrea di Mantova e Leon Battista Alberti: Atti del convegno di studi organizzato dalla Città di Mantova con la collaborazione dell'Accademia Virgiliana, nel quinto centenario della basilica di Sant'Andrea e della morte dell'Alberti, 1472–1972* (Mantua: Edizione della Biblioteca comunale di Mantova, 1974), pp. 409–24.

Bosman, Lex, "San Giovanni in Laterano and Medieval Architecture: The Significance of Architectural Quotations," in *Monuments & Memory: Christian Cult Buildings and Constructions of the Past; Essays in Honour of Sible de Blaauw*, ed. by Mariëtte Verhoeven, Lex Bosman and Hanneke van Asperen (Turnhout: Brepols, 2016), pp. 43–51.

Boto, Gerardo, "Articulación de los espacios cultuales en St Pere de Galligants: Indagación acerca de una arquitectura con nexos sonoros," *Lambard*, 19 (2006/07), 11–38.

Boto, Gerardo, "Capillas en alto y cámaras elevadas en templos románicos hispanos: Morfologías, usos litúrgicos y prácticas culturales," in *Espacios y estructuras singulares del edificio románico* (Aguilar de Campoo: Fundación Santa María la Real, 2008), pp. 93–119.

Boto, Gerardo, "Monasterios catalanes en el siglo XI: Los espacios eclesiásticos de Oliba," in *Monasteria et territoria: Elites, edilicia y territorio en el Mediterraneo medieval (siglos V–XI)*, ed. by Jorge López Quiroga, Artemio Manuel Martínez Tejera and Jorge Morín de Pablos (Oxford: British Archaeological Reports, 2007), pp. 281–320.

Boto, Gerardo, "Morfogénesis arquitectónica y organización de los espacios de culto en la catedral de La Seu d'Urgell: La iglesia de St María (1010–1190)," in *Material and Action in European Cathedrals (9th–13th centuries): Building, Decorating, Celebrating*, ed. by Gerardo Boto and C. García de Castro (Oxford: British Archaeological Reports, 2017), pp. 145–185.

Boto, Gerardo and Marc Sureda, "La cathédrale romane en Catalogne: Programmes, liturgie, architecture," *Les Cahiers de Saint-Michel de Cuxa*, 44 (2013), 75–89.

Bourne, Molly, "The Art of Diplomacy: Mantua and the Gonzaga, 1328–1630," in *The Court Cities of Northern Italy*, ed. by Charles M. Rosenberg (Cambridge: Cambridge University Press, 2010), pp. 138–95.

Bowman, Glenn, "Pilgrim Narratives of Jerusalem and the Holy Land: A Study in Ideological Distortion," in *Sacred Journeys: The Anthropology of Pilgrimage*, ed. by Alan Morinis (Westport: Greenwood, 1992), pp. 149–68.

Braghirolli, Willelmo., "Leone Battista Alberti a Mantova," *Archivio storico italiano*, ser 3, 9 (1869), 3–31.

Brandis, Wolfgang, "Wienhausen," in *Niedersächsisches Klosterbuch: Verzeichnis der Klöster, Stifte, Kommenden und Beginenhäuser in Niedersachsen und Bremen von den Anfängen bis 1810*, ed. by Josef Dolle, Veröffentlichungen der Historischen Kommission für Hessen 56, 4 vols (Bielefeld: Verlag für Regionalgeschichte, 2012), III, pp.1518–29.

Brasca, Santo, "Viaggio in Terrasanta," in *Viaggio in Terrasanta di Santo Brasca 1480. Con l'Itinerario di Gabriele Capodilista 1458*, ed. by Anna Laura Momigliano-Lepschy (Milan: Longanesi, 1966), pp. 45–150.

Breitberg-Semel, Sarah, *Artist—Society—Artist* (Tel Aviv: Tel Aviv Museum of Art, 1978).

Brightman, Frank Edward, "The Historia Mystagogica and Other Greek Commentaries on the Byzantine Liturgy," *Journal of Theological Studies*, 9 (1908), 248–67.
Brine, Douglas, *Pious Memories: The Wall-mounted Memorial in the Burgundian Netherlands* (Leiden: Brill, 2015).
Briusova, Vera G., "On the Consecration of Hagia Sophia of Novgorod" [О времени освящения Новгородской Софии], in *Культура средневековой Руси—Сборник статей, посвящается 70-летию М. К. Каргера*, ed. by Анатолий Николаевич Кирпичников and Павел Александрович Раппопорт (Leningrad: Nauka, 1974), pp. 111–13.
Briusova, Vera G., "On the Meaning of the Wall Paintings from the Eleventh to Twelfth Centuries in the Martyrius Parvis of the Hagia Sophia Cathedral of Novgorod" [О содержании росписей XI-XII вв. Мартирьевской паперти Софийского собора Новгорода], in *Древнерусское Искусство, Художественная культура X–первой половины XIII в.*, ed. by Алексей Ильич Комеч and Ольга Ильинична Подобедова (Moscow: Nauka, 1988), pp. 165–76.
Brom, Gisbert, *Archivalia in Italië* (The Hague: Nijhoff, 1909), I.2.
Brooks, Neil C., *The Sepulchre of Christ in Art and Liturgy, with Special Reference to the Liturgic Drama* (Urbana: University of Illinois, 1921).
Buchner, Franz X., *Archivinventare der katholischen Pfarreien in der Diözese Eichstätt*, Inventarien Fränkische Archive 2 (Munich: Duncker & Humblot, 1918).
Burch, Vacher, *Myth and Constantine the Great* (London: Humphrey Milford, 1927).
Burgess, Clive, "'Longing to be prayed for': Death and Commemoration in an English Parish in the Later Middle Ages," in *The Place of the Dead*, ed. by Bruce Gordon and Peter Marshall (Cambridge: Cambridge University Press, 2000), pp. 44–65.
Busch, Johannes, *Des Augustinerpropstes Johannes Busch Chronicon Windeshemense und Liber de reformatione monasteriorum*, ed. by Karl Grube (Halle: Hendel, 1886), vol. XXXII.
Buseva-Davidova, Irina L., "On the Ideological Concept of the 'New Jerusalem' of Patriarch Nikon" [Об Идейном Замысле 'Нового Иерусалима' Патриарха Никона], in *Иерусалим в Русской Культуре*, ed. by Andrei Batalov and Alexei Lidov (Moscow: Наука, 1994), pp. 174–81 (English translation: *Jerusalem in Russian Culture*, ed. by Andrei Batalov and Alexei Lidov [New York: A. D. Caratzas, 2005]).
Bynum, Caroline Walker, "The Blood of Christ in the Later Middle Ages," *Church History*, 71, no. 4 (2002), 685–714.
Bynum, Caroline Walker, "Foreword," in *Natural Materials of the Holy Land and the Visual Translation of Place, 500–1500*, ed. by Renana Bartal, Neta Bodner, and Bianca Kühnel (London: Routledge, 2017), pp. xix–xxii.
Calzado, M. Alba and Pedro Mateos, "El paisaje urbano de Emerita en época visigoda," in *Recópolis y la ciudad en la Época Visigoda*, ed. by Lauro Olmo Enciso, *Zona Arqueología* 9 (2008), pp. 261–273.
Capodilista, Gabrielle, *Itinerario in Terra Santa* (Perugia: Pietro da Colonia, 1475).

Capodilista, Gabriele, "Itinerario," in *Viaggio in Terrasanta di Santo Brasca 1480. Con l'Itinerario di Gabriele Capodilista 1458*, ed. by Anna Laura Momigliano-Lepschy (Milan: Longanesi, 1966), pp. 161–241.

Capuzzo, Roberto, "The Precious Blood of Christ: Faith, Rituals and Civic and Religious Meaning during the Centuries of Mantuan Devotion," *International Journal for the Study of the Christian Church*, 17, no. 4 (2017), 228–45.

Carlier, J. H., "Het Fraterhuis of Collatiehuis op de Jeruzalemstraat," in *Oudheidkundige Kring "Die Goude": Vijfde verzameling bijdragen* (Gouda: Oudheidkundige Kring 'Die Goude', 1947), pp. 50–77.

Carrero, Eduardo, "Iglesias y capillas del Santo Sepulcro: Entre el lugar común historiográfico y la norma y práctica litúrgica," in *Congreso Internacional Arte y Patrimonio de las Órdenes Militares de Jerusalén en España*, ed. by Amelia López-Yarto and Wifredo Rincon (Zaragoza: Centro de Estudios de la Orden del Santo Sepulcro, 2010), pp. 321–34.

Carrero, Eduardo, "La Seu d'Urgell, el último conjunto de iglesias: Liturgia, paisaje urbano y arquitectura," *Anuario de Estudios Medievales*, 40, no. 1 (2010), 251–91.

Carruthers, Mary, *The Craft of Thought: Meditation, Rhetoric, and the Making of Images, 400–1200* (Cambridge: Cambridge University Press, 2000).

Castiñeiras, Manuel, *El tapís de la Creació / El taipz de la Creación* (Girona: Capítol de la Catedral, 2011).

Cerutti, Stefania and Elisa Piva, "Religious Tourism and Event Management: An Opportunity for Local Tourism Development," *International Journal of Religious Tourism and Pilgrimage*, 3, no. 1 (2015), 55–65.

Chambers, D. S., "Sant'Andrea in Mantua and Gonzaga Patronage, 1460–1472," *Journal of the Warburg and Courtauld Institutes*, 40 (1977), 99–127.

Champagne, Marie Thérèse and Ra'anan S. Boustan, "Walking in the Shadows of the Past: The Jewish Experience of Rome in the Twelfth Century," in *Rome Re-Imagined: Twelfth-Century Jews, Christians and Muslims Encounter the Eternal City*, ed. by Louis I. Hamilton and Stefano Riccioni (Leiden: Brill, 2011), pp. 52–82.

Chareyon, N., *Pilgrims to Jerusalem in the Middle Ages* (New York: Columbia University Press, 2005).

Chroniques Anglo-Normandes: Recueil d'extraits et d'écrits relatifs à l'histoire de Normandie et d'Angleterre pendant les XIe et XIIe siècles / publié, pour la première fois, d'après les manuscrits de Londres, de Cambridge, de Douai, de Bruxelles et de Paris, ed. by Francisque Xavier Michel (Rouen, 1836), II.

Chumicheva, Olga V., "Solovetsky Monastery as an Old Believer's Alternative to the New Jerusalem of Patriarch Nikon" [Соловецкий Монастырь как старообрядческая альтернатива Новому Иерусалиму Патриарха Никона], in *Новые Иерусалимы—Иеротопия и иконография сакральных пространств*, ed. by Алексей Михайлович Лидов (Moscow: Indrik, 2009), pp. 829–36.

Ciggaar, Krijnie N., "Une description de Constantinople traduite par un pèlerin anglais," *Revue des Études Byzantines*, 34 (1976), 211–67.
Clark, George Thomas, *Medieval Military Architecture in England* (London: Wyman, 1884).
Classen, Albrecht, "Die Mystikerin als Peregrina: Margery Kempe—Reisende in corpore—Reisende in spiritu," *Studies in Spirituality*, 5 (1995), 127–45.
Claverie, Pierre-Vincent, "La dévotion envers les lieux saints dans la Catalogne médiévale," in *Chemins d'outre-mer*, ed. by Damien Coulon et al. (Paris: Sorbonne, 2004), pp. 127–37.
Codina, Daniel, "La chapelle de la Trinité de Saint Michel de Cuixà," *Les cahiers de Saint-Michel de Cuxa*, 36 (2005), 81–88.
Cohen, Esther, "Roads and Pilgrimage: A Study in Economic Interaction," *Studi Medievali*, 21 (1980), 321–41.
Cohen, Raymond, *Saving the Holy Sepulchre—How Rival Christians Came Together to Rescue their Holiest Shrine* (Oxford: Oxford University Press, 2008).
A Companion to Mysticism and Devotion in Northern Germany in the Late Middle Ages, ed. by Elizabeth A. Andersen, Henrike Lähnemann and Anne Simon, Brill's Companions to the Christian Tradition, 44 (Leiden: Brill, 2014).
Conrady, Ludwig, *Vier Rheinische Palaestina-Pilgerschriften des XIV., XV. und XVI. Jahrhunderts* (Wiesbaden: Feller & Gecks, 1882).
Constable, Giles, "Ideal of the Imitation of Christ," in *Three Studies in Medieval Religious and Social Thought*, ed. by Giles Constable (Cambridge: Cambridge University Press, 1995), pp. 143–248.
Coplestone-Crow, Bruce, "From Foundation to Anarchy," in *Ludlow Castle: Its History & Buildings*, ed. by Ron Shoesmith and Andy Johnson (Little Logaston: Logaston, 2000), pp. 21–34.
Coppack, Glyn, "The Round Chapel of St Mary Magdalene," in *Ludlow Castle: Its History and Buildings*, ed. by Ron Shoesmith and Andy Johnson (Little Logaston: Logaston, 2000), pp. 145–54.
Cosmas of Prague, *The Chronicle of the Czechs*, trans. by Lisa Wolverton (Washington, DC: Catholic University of America, 2009).
Cox, J. Charles and Robert Serjeantson Meyricke, *A History of the Church of the Holy Sepulchre, Northampton* (Northampton: William Mark, 1897).
Craig, Leigh Ann, "'That You Cannot See Them Comes Only from an Impossibility': Women and Non-Corporeal Pilgrimage," in *Wandering Women and Holy Matrons: Women as Pilgrims in the Later Middle Ages*, by Leigh Ann Craig (Leiden: Brill, 2009), pp. 221–60.
Craig, Leigh Ann, *Wandering Women and Holy Matrons: Women as Pilgrims in the Later Middle Ages* (Leiden: Brill, 2009).
Creighton, Mandell, *A History of the Papacy during the Period of the Reformation* (Cambridge: Cambridge University Press, [1882] 2011), VII.
Creighton, Oliver Hamilton, *Castles and Landscapes* (London: Continuum, 2002).

Godoy, Cristina and Miquel dels S. Gros, "L'oracional hispànic de Verona i la topografía cristiana de Tarraco a l'Antiguitat Tardana: possibilitats i límits," *Pyrenae*, 25 (1994), 245–58.

Crossley, Paul, "'Bohemia Sacra': Liturgy and History in Prague Cathedral," in *Études d'histoire de l'art du Moyen Âge en l'honneur d'Anne Prache* 5 (1999), ed. by Pierre Lumière, pp. 341–65.

Crossley, Paul, "Medieval Architecture and Meaning: The Limits of Iconography," *Burlington Magazine*, 130, no. 1019 (1988), 116–21.

Crossley, Paul, "Our Lady in Nuremberg, All Saints Chapel in Prague, and the High Choir of Prague Cathedral," in *Prague and Bohemia: Medieval Art, Architecture and Cultural Exchange in Central Europe*, ed. by Zoë Opačić (Leeds: Routledge, 2009), pp. 64–80.

Crossley, Paul, "The Politics of Presentation: The Architecture of Charles IV of Bohemia," in *Courts and Regions in Medieval Europe*, ed. by A. J. Minnis (New York: Boydell & Brewer, 2000), pp. 99–172.

Crossley, Paul and Zoë Opačić, "Prague as a New Capital," in *Prague—The Crown of Bohemia, 1347–1437*, ed. by Barbara Drake Bohm and Jiří Fajt (New York: Metropolitan Museum of Art, 2005), pp. 59–73.

Ćurčić, Slobodan, "Late Byzantine *Loca Sancta*? Some Questions Regarding the Form and Function of Epitaphioi," in *The Twilight of Byzantium: Aspects of Cultural and Religious History in the Late Byzantine Empire; Papers from the Colloquium held at Princeton University, 8–9 May 1989*, ed. by Slobodan Ćurčić and Doula Mouriki (Princeton: Princeton University Press, 1991), pp. 251–72.

Dale, Thomas E. A., "Transcending the Major/Minor Divide: Romanesque Mural Painting, Color, and Spiritual Seeing," in *From Minor to Major: The Minor Arts in Medieval Art History*, ed. by Colum P. Hourihane (University Park: Penn State University Press, 2012), pp. 22–42.

Dall'Acqua, Marzio, "'Storia di un progetto albertiano non realizzato: La ricostruzione della rotonda di San Lorenzo in Mantova'," in *Il Sant'Andrea di Mantova e Leon Battista Alberti: Atti del convegno di studi organizzato dalla Città di Mantova con la collaborazione dell'Accademia Virgiliana, nel quinto centenario della basilica di Sant'Andrea e della morte dell'Alberti, 1472–1972* (Mantua: Edizione della Biblioteca comunale di Mantova, 1974), pp. 229–36.

Dalman, Gustaf, *Das Grab Christi in Deutschland* (Leipzig: Dieterich, 1922).

Daniel the Abbot, "The Life and Journey of Daniel, Abbot of the Russian Land," in *Jerusalem Pilgrimage, 1099–1185*, ed. by John Wilkinson, Joyce Hill and William Francis Ryan (London: Hakluyt Society, 1988), pp. 170–71.

Darkevich, Vladislav P., "Artistic Craft from the Medieval West (X–XIV centuries); on the Materials from Excavations in Eastern Europe" [Художественное ремесло средневекового Запада *(X–XIV вв.)*, По материалам раскопок в Восточной Европе] (Moscow: Krasand, 2010).

David, Zdeněk V., *Realism, Tolerance and Liberalism in the Czech National Awakening: Legacies of the Bohemian Reformation* (Washington, DC: Woodrow Wilson Center and Johns Hopkins University Press, 2010).

Vita Mariani Scotti, in *Acta Sanctorum: Februarius* (Paris, 1864), II, *Editio novissima curante Ioanne Carnandet*, ed. by Ioannes Bollandus and Godefridus Henschenius, pp. 361–65.

de Blaauw, Sible, "En vue de la lumière: Un principe oublié dans l'orientation de l'édifice du culte paléochrétien," in *Art médiéval: Les voies de l'espace liturgique*, ed. by Paolo Piva (Paris: Picard, 2012), pp. 15–46.

de Blaauw, Sible, "Gerusalemme a Roma e il culto delle croci," in *Gerusalemme a Roma: La Basilica di Santa Croce e le reliquie della Passione*, ed. by Roberto Cassanelli and Emilia Stolfi (Milan: Jaca, 2012), pp. 27–39.

de Blaauw, Sible, "Jerusalem in Rome and the Cult of the Cross," in *Pratum Romanum: Richard Krautheimer zum 100. Geburtstag*, ed. by R. Colella et al. (Wiesbaden: Reichert, 1997), pp. 55–73.

de Boer, D. E. H., "Jherusalem in Leyden," *De Leidse Hofjes*, 8 (1979), 40–57.

De Dartein, Fernand, *Études sur l'architecture lombarde et sur l'origine de l'architecture romano-byzantine* (Paris: Dunod, 1865–82).

de Jongh, E. and J. A. L. de Meyerem, *Een schilderij centraal: de Jeruzalemvaarders van Jan van Scorel* (Utrecht: Centraal Museum, 1979).

de Palol, Pere, *El tapís de la creació de la Catedral de Girona* (Barcelona: Edicions Proa, 1986).

de Paoli, Massimo, "Rotonda di S. Lorenzo a Mantova rapporto tra apparato pittorico e membratura architettonica," in *Rotonde d'Italia: Analisi tipologica della pianta centrale*, ed. by Valentino Volta (Milan: Jaca, 2008), pp. 67–69.

Dehio, Georg et al., *Handbuch der deutschen Kunstdenkmäler: Sachsen-Anhalt*, I, *Der Regierungsbezirk Magdeburg*, compiled by Ute Bednarz and Folkhard Cremer (Munich: Deutscher Kunstverlag, 2002).

Dehio, Georg, *Handbuch der deutschen Kunstdenkmäler: Bayern*, IV, *München und Oberbayern*, compiled by Ernst Götz and Heinrich Habel, 3rd rev. ed. (Munich: Deutscher Kunstverlag, 2006)

Dehio, Georg and Gustav von Bezold, *Die kirchliche Baukunst des Abendlandes* (Stuttgart: Cotta, 1892–1901).

Demetz, Peter, *Prague in Black and Gold: A History of a City* (London: Penguin, 1997).

Denke, Andrea, *Konrad Grünembergs Pilgerreise ins Heilige Land 1486* (Cologne: Böhlau, 2011).

Deswarte, Thomas, "Rome et la spécificité catalane: La papauté et ses relations avec la Catalogne et Narbonne (850–1030)," *Revue historique*, 295 (1995), 3–43.

Devotional Cross-Roads: Practicing Love of God in Medieval Jerusalem, Gaul and Saxony, ed. by Hedwig Röckelein, Galit Noga-Banai, and Lotem Pinchover (Göttingen: University Press, 2019).

Diefenbacher, Michael, "Nürnberg, Reichsstadt: Verwaltung," in *Historisches Lexikon Bayerns* (2010), http://www.historisches-lexikon-bayerns.de/Lexikon/Nürnberg,_Reichsstadt:_Verwaltung.

Dierkens, Alain, "Avant-corps, galilées, massifs occidentaux: Quelques remarques méthodologiques en guise de conclusions," in *Avant-nefs et espaces d'accueil dans l'église entre le IVe et le XIIe siècle: Actes du colloque international du CNRS Auxerre*, ed. by Christian Sapin (Paris: CTHS, 2002), pp. 495–503.

Domesday Book, ed. and trans. by Ann Williams and G. H. Martin (London: Penguin, 2003).

Dorninger, Maria E., "Memory and Representations of Jerusalem in Medieval and Early Modern Pilgrimage Reports," in *Visual Constructs of Jerusalem*, ed. by Bianca Kühnel, Galit Noga-Banai, and Hanna Vorholt (Turnhout: Brepols, 2014), pp. 421–28.

Dorninger, Maria E., "St. Sebald Church and the Church of the Holy Sepulchre: Retracing the Path of Jerusalem's Holy Places in Nuremberg," in *Jerusalem Elsewhere—The German Recensions*, ed. by Bianca Kühnel and Pnina Arad (Jerusalem: Spectrum, 2014), pp. 83–90.

Douais, Célestin, *Docuents sur l'ancienne province de Languedoc 1. 2: Trésor et reliques de Saint-Sernin de Toulouse* (Paris, 1904).

Drijvers, Jan W., *Helena Augusta: The Mother of Constantine the Great and the Legend of the Finding of the True Cross* (Leiden: Brill, 1992).

Duff, E. Gordon, *Information for Pilgrims unto the Holy Land* (London: Lawrence & Bullen, 1893).

Duffy, Eamon, *The Stripping of the Altars: Traditional Religion in England, 1400–1580* (New Haven: Yale University Press, 1993).

Dümpelmann, Britta, "Visual—Textile—Tactile: Touching the Untouchable in the Easter Liturgy and Works of Art," in *"Noli me tangere" in interdisciplinary perspective: Textual, Iconographic and Contemporary Interpretations*, ed. by Reimund Bieringer, Barbara Baert and Karlijn Demasure (Leuven: Peeters, 2016), pp. 233–52.

Duncalf, Frederic et al., *The History of the Crusades* (Madison: University of Wisconsin Press, 1969), I: *The First Hundred Years,* ed. by M. W. Baldwin.

Duran-Porta, Joan, «Les cryptes monumentales dans la Catalogne d'Oliba: De St Pere de Rodes à la diffusion du modèle de crypte à salle," *Les Cahiers de Saint-Michel de Cuxa*, 40 (2009), 325–39.

Duran-Porta, Joan, "Santo Sepulcro de Olérdola," in *Enciclopedia del Románico en Cataluña: Barcelona* (Aguilar de Campoo: Fundación Santa María la Real, 2015), pp. 1959–63.

Early Scottish Charters: Prior to AD 1153, ed. by Archibald C. Lawrie (Glasgow: James MacLehose and Sons, 1905).

Eastern Christian Relics [Восточнохристианские Реликвии], ed. by Алексей Михайлович Лидов (Moscow: Progress-Tradition, 2003).

The Ecclesiastical History of Orderic Vitalis, ed. and trans. by Marjorie Chibnall, 6 vols. (Oxford: Clarendon Press, 1969), II.

Eichstätt, Kapuzinerkirche zum Hl. Kreuz und zum Hl. Grab Christi, ed. by Franz Xaver Hödl, Michael Schmidt, and Roman von Götz (Munich: Schnell & Steiner, 2000).

Ellger, Otfried, *Die Michaelskirche zu Fulda als Zeugnis der Totensorge: Zur Konzeption einer Friedhofs- und Grabkirche im karolingischen Kloster Fulda* (Fulda: Parzeller, 1989).

Els Comacini i l'arquitectura romànica a Catalunya, ed. by Pere Freixas and Jordi Camps (Barcelona: Generalitat de Catalunya, 2010).

Erdmann, Wolfgang et al., "Neue Untersuchungen an der Stiftskirche zu Gernrode," in *Bernwardinische Kunst: Bericht über ein wissenschaftliches Symposium in Hildesheim vom 10.10. bis 13.10.1984*, ed. by Martin Gosebruch and Frank N. Steigerwald (Göttingen: Goltze, 1988), pp. 245–85.

Erler, Mary C. and Maryanne Kowaleski, *Gendering the Master Narrative: Women and Power in the Middle Ages* (Ithaca: Cornell University Press, 2003).

Esch, Arnold, "Anschauung und Begriff: Die Bewältigung fremder Wirklichkeit durch den Vergleich in Reiseberichten des späten Mittelalters," *Historische Zeitschrift* 253, no. 2 (1991), 281–312.

Español, Francesca, "Massifs occidentaux dans l'architecture romane catalane," *Les Cahiers de Saint-Michel de Cuxa*, 27 (1996), 57–77.

Español, Francesca, "Panthéons comtaux en Catalogne à l'époque romane: les inhumations privilégiées du monastère de Ripoll," *Les Cahiers de Saint-Michel de Cuxa*, 42 (2010), 103–114.

Español, Francesca, *La Vera Creu d'Anglesola i els pelegrinages de Catalunya a Terra Santa* (Solsona: Museu Diocesà, 2015).

Español, Francesca and Joaquín Yarza, *El romànic català* (Manresa: Angle, 2007).

Europäische Reiseberichte des späten Mittelalters: Eine analytische Bibliographie, ed. by Christian Halm (Frankfurt am Main: Peter Lang, 1994), I.

Faensen, Hubert, "Patriarch Nikon als Bauherr: Das Kloster Neu-Jerusalem—Eine Grabeskopie des 17. Jahrhunderts," *Wiener Jahrbuch für Kunstgeschichte*, 44 (1991), 175–90.

Falk, Tilman, "Notizen zur Augsburger Malerwerkstatt des Älteren Holbein," *Zeitschrift des Deutschen Vereins für Kunstwissenschaft*, 30 (1976), pp. 3–20.

Faust, Ulrich, "Wöltingerode," in *Die Männer- und Frauenklöster der Zisterzienser in Niedersachsen, Schleswig–Holstein und Hamburg*, ed. by Ulrich Faust, Germania Benedictina 12 (Ottilien: EOS, 1994), pp. 797–831.

Felix Fabri, *Evagatorium in Terrae Sanctae, Arabiae et Egypti peregrinationem*, ed. by Cunradus Dietericus Hassler, 3 vols (Stuttgart: Soc. Litt. Stuttg., 1843–49).

Felix Fabri, *Die Sionpilger*, ed. by Wieland Carls (Berlin: Erich Schmidt, 1999).

Fernandez, Catherine, "*Quidem lapis preciousus qui vocatur Cammaheu*: The Medieval Afterlife of the Gemma Augustea" (unpublished doctoral thesis, Emory University, 2012).

Ferretti, Massimo, "Per la ricostruzione e la cronologia del 'compianto' di Santa Maria della Vita," in *Niccolò dell'Arca: Seminario di Studi*, ed. by Grazia Agostini and Luisa Ciammitti (Bologna: Nuova Alfa Editoriale, 1989), pp. 85–108.

First Novgorod Chronicle of the Early and Late Manuscript Copies [Новгородская Первая Летопись Старшего и Младшего Изводов], ed. by Arseny N. Nasonov [Арсений Николаевич Насонов], (Moscow and Leningrad: Academy of Sciences, 1950), p. 181.

Fitzgerald, G. M., *Beth-Shan Excavations, 1921–1923: The Arab and Byzantine Levels* (Philadelphia: Museum of the University of Pennsylvania, 1931).

Flachenecker, Helmut, "Das Schottenkloster Heiligkreuz in Eichstätt," *Studien und Mitteilungen zur Geschichte des Benediktinerordens*, 105 (1994), 65–95.

Flachenecker, Helmut, *Schottenklöster: Irische Benediktinerkonvente im hochmittelalterlichen Deutschland* (Paderborn: Schöningh, 1995).

Flier, Michael S., "The Image of the Tsar in the Muscovite Palm Sunday Ritual" [Образ государя в московском обряде Вербного Воскресенья], in *Пространственные иконы: Перформативное в Византии и Древней Руси*, ed. by Алексей Михайлович Лидов (Moscow: Indrik, 2011), pp. 533–62.

Flora, Holly, "'Pause Here for Awhile First': Imagined Pilgrimage, Holy Feasts, and Moral Models," in *The Devout Belief of the Imagination: The Paris Meditationes Vitae Christi and Female Franciscan Spirituality in Trecento Italy*, ed. by Holly Flora (Turnhout: Brepols, 2009), pp. 117–86.

Flórez, Enrique, *España Sagrada: Antigüedades civiles y eclesiásticas de las ciudades de Dertosa, Egara y Emporias* (Madrid, 1801), XLII.

Flórez, Henrique, *España Sagrada*, XV: *De la provincia antigua de Galicia* (Madrid: Antonio Marin, 1787).

Folda, Jaroslav, *Crusader Art in the Holy Land, From the Third Crusade to the Fall of Acre, 1187–1291* (Cambridge: Cambridge University Press, 2005).

Forsgren, Frida, "Topomimesis: The Gerusalemme at San Vivaldo," in *Urban Preoccupations: Mental and Material Landscapes*, ed. by Per Sivefors (Pisa: Fabrizio Serra, 2007), pp. 171–96.

Foster, C. W., ed. *The Registrum Antiquissimum of the Cathedral Church of Lincoln*, Publications of the Lincoln Record Society, 27 (Hereford: Hereford Times, 1931), I.

Fourth Novgorod Chronicle, "Полное собрание русских летописей" (St. Petersburg: Eduard Pratz, 1853).

Frauen–Kloster–Kunst: Neue Forschungen zur Kulturgeschichte des Mittelalters, Papers Presented at a Colloquium Held in May 13–16, 2005 in connection with a special exhibit "Krone und Schleier," ed. by Jeffery F. Hamburger et al. (Turnhout: Brepols, 2007).

Fried, Michael, *Art and Objecthood: Essays and Reviews* (Chicago: University of Chicago Press, 1998).

Fries, Walter, *Die St. Sebalduskirche zu Nürnberg* (Burg bei Magdeburg: August Hopfer, 1928).

Friske, Matthias, "Der Fund im Heiligen Grab von Gernrode—Ein Fixpunkt für die Datierung eines mittelalterlichen Kunstwerkes," in *Quedlinburger Annalen*, 16 (2014/15), 46–59.

Fudge, Thomas A., *The Crusade Against Heretics in Bohemia, 1418–1437* (Aldershot: Ashgate, 2002).

Fudge, Thomas A., *The Magnificent Ride—The First Reformation in Hussite Bohemia* (Aldershot: Ashgate, 1998).

Galobardes, Miguel, *El Sepulcre de Peralada* (Peralada: Biblioteca Palacio Peralada, 1955).

Ganz-Blättler, Ursula, "Unterwegs nach Jerusalem. Die Pilgerfahrt als Denkabenteuer," in *Symbolik: Von Weg und Reise*, ed. by Paul Michel (Bern: Peter Lang, 1992), pp. 82–107.

Gaposchkin, M. Cecilia, "From Pilgrimage to Crusade: The Liturgy of Departure, 1095–1300", *Speculum*, 88, no. 1 (2013), 44–91.

Gaposchkin, M. Cecilia, "The Place of Jerusalem in Western Crusading Rites of Departure (1095–1300)," *Catholic Historical Review*, 99, no. 1 (2013), 1–28.

Gaposchkin, M. Cecilia, *Invisible Weapons: Liturgy and the Making of Crusade Ideology* (Ithaca: Cornell University Press, 2017).

Gee, Loveday Lewes, *Women, Art and Patronage from Henry III to Edward III, 1216–1377* (Woodbridge: Boydell and Brewer, 2002).

Gehrcke, Carl, "Die Grafen zu Lüchow," in *Chronik der Stadt Lüchow*, ed. by Ernst Köhring (Lüchow: Köhring, 1949), pp. 10–21.

Gendering the Crusades, ed. by Susan B. Edgington and Sarah Lambert (Cardiff: University of Wales Press, 2001).

Gelfand, Laura D., "Holy Sepulchre, Architectural Copies of," in *Encyclopedia of Medieval Pilgrimage* (Leiden: Brill, first published online: 2012, http://dx.doi.org/10.1163/2213-2139_emp_SIM_00389).

Gerusalemme a Roma: La Basilica di Santa Croce e le reliquie della Passione, ed. by Roberto Cassanelli and Emilia Stolfi (Milan: Jaca, 2012).

Gervers, Michael, "Rotundae Anglicanae," in *Evolution Générale et Développements régionaux en histoire de l'art: Actes du XxiiFe Congrès International d'histoire de l'art*, ed. by György Rózsa (Budapest: Akadémiai Kiadó, 1972), pp. 359–76.

Gervers, Michael, "The Use and Meaning of the Twelfth- and Thirteenth-century Round Churches of England," in *Tomb and Temple: Reimagining the Sacred Buildings of Jerusalem*, ed. by Robin Griffith-Jones (Woodbridge: Boydell and Brewer, 2018), pp. 376–86.

Giovannoni, G., *Considerazioni sugli affreschi della Rotonda di S. Lorenzo a Mantova: In occasione del restauro* (Mantua: Museo Civico Polironiano, 1985).

Glaudemans, Ronald and Rob Gruben, "De bouwgeschiedenis," in *De Jeruzalemkapel in Gouda*, ed. by Chris Akkerman et al. (Gouda: Stichting Spoor, 1998), pp. 37–65.

Golubtsov, Aleksandr P., "Book of Liturgical Instructions of the Novgorod Sophia Cathedral" [Чиновник Новгородского Софийского собора], *Чтения в Обществе истории и древностей Российских при Московском университете 2* (Moscow: Universitetskaya Tipografiya, 1899).

Gonnet, C. J., "Bedevaart naar Jerusalem in 1525," *Bijdragen voor de geschiedenis van het Bisdom van Haarlem*, 11 (1884), 1–382.

"The Gospel of Nicodemus, or Acts of Pilate," in *The Apocryphal New Testament*, trans. By M.R James (Oxford: Clarendon Press, 1924), 16:7.

Göttler, Christine, "The Temptation of the Senses at the Sacro Monte di Varallo," in *Religion and the Senses in Early Modern Europe*, ed. by Wietse de Boer and Christine Göttler (Leiden: Brill, 2013), pp. 393–451.

Goudriaan, Koen, "Gijsbert Raet en zijn Jeruzalem," *Tidinge van die Goude*, 17 (1999), 15–29.

Goudriaan, Koen, "Kapellen, gasthuizen en andere instellingen van liefdadigheid," in *Gouda*, ed. by Wim Denslagen (Zeist: Rijksdienst voor de Monumentenzorg; Zwolle: Waanders, 2001), pp. 139–70.

Greene, Naomi, *Pier Paolo Pasolini: Cinema as Heresy* (Princeton: Princeton University Press, 1990).

Gretser, Jakob, *Philippi Ecclesiae Eystettensis XXXIX: Episcopi de eiusdem ecclesiae divis tutelaribus* (Ingolstadt, 1617).

Griep, Hans-Günther, "Das Heilige Grab in Goslar," *Harz-Zeitschrift*, 7 (1955), 101–28.

Groenendijk, Maarten and Diederick Habermehl, "Ondergronds," *Tidinge van die Goude*, 25 (2007), 63–68.

Groome, Francis Hindes, "Lithgow William," in *Dictionary of National Biography, 1885–1900*, XXX, pp. 359–61.

Gros Pujol, Miquel Dels Sants, "Arquitectura i litúrgia entorn de l'any 1000, in Catalunya a l'època carolíngia," in *Art i cultura abans del romànic (segles IX i X)* (Barcelona: MNAC, 1999), pp. 197–99.

Gros Pujol, Miquel Dels Sants, "El antiguo ordo bautismal catalano-narbonense," *Hispania sacra: Revista española de historia eclesiástica*, 28 (1975), 37–101.

Gros Pujol, Miquel dels Sants, "Epíleg," in *Les dotalies de les esglésies de Catalunya (segles IX–XII)*, ed. by Ramon Ordeig (Vic: Estudis Històrics, 1993–2004), IV, pp. 269–272.

Gros Pujol, Miquel Dels Sants, "La liturgia catalana dels segles X–XI: Una panoràmica general," *L'avenç. Història dels països Catalans*, 121 (1988), 34–38.

Gros Pujol, Miquel Dels Sants, "L'antic 'Ordo Nubentium' gallicà i les seves adaptacions romano-franques d'època carolíngia," *Revista catalana de teologia*, 29 (2004), 75–88.

Gros Pujol, Miquel Dels Sants, "L'ordre catalano-narbonés per a la benedicció dels sants olis," *Revista catalana de teologia*, 1 (1976), 231–58.

Grote, Ludwig, *Die Tucher: Bildnis einer Patrizierfamilie* (Munich: Prestel, 1961).

Grube, Karl, *Des Augustinerpropstes Iohannes Busch Chronicon Windeshemense und die Liber de Reformatione Monasterium* (Halle: Hendel, 1886).

Grünemberg, Konrad, *Pilgerreise ins Heilige Land 1486*, ed. and comm. by Andrea Denke (Cologne: Böhlau, 2011).

Gudiol, Josep, "De peregrins i peregrinatges religiosos catalans," *Analecta Sacra Tarraconensia*, 3 (1927), 93–120.

Gukhman, S. N., "Solvetsky Edition of the 'Documental' Tale of the Gift of Shah Abbas to Russia" [Соловецкая редакция 'Документального' сказания о даре шаха Аббаса Росси], in *Исследования по истории русской литературе XI–XVII вв.*, ed. by Дмитрий Сергеевич Лихачев, Труды Отдела древнерусской литературы (Leningrad: Nauka, 1974), pp. 376–84.

Günther, Christian, *Das Heilige Grab in der Stiftskirche Gernrode*, 2nd ed. (Halle a.d. Saale: Stekovics, 1998).

Günther, Christian, *Stiftskirche St. Cyriakus Gernrode* (Halle: Im Schulhaus, 1995).

Gussone, Nicholas, "Adventus-Zeremoniell und Translation von Reliquien: Vitricius von Rouen, De laude sanctorum," *Frühmittelalterliche Studien*, 10 (1976), 125–33.

Haas, Walter, "Das Grab des Bischofs Gundekar II. im Eichstätter Dom," *Ars Bavarica*, 4 (1975), 41–58.

Haastrup, Ulla, "Medieval Props in the Liturgical Drama," *Hafnia: Copenhagen Papers in the History of Art*, 11, (1987), 133–70.

Hahn, Cynthia, "Interpictoriality in the Limoges Chasses of Stephen, Martial, and Valerie," in *Image and Belief: Studies in Celebration of the Eightieth Anniversary of the Index of Christian Art*, ed. by Colum Hourihane (Princeton: Princeton University Press, 1979), pp. 109–24.

Hahn, Cynthia, *Strange Beauty: Issues in the Making and Meaning of Reliquaries, 400–circa 1204* (University Park, PA: Penn State University Press, 2012).

Hamburger, Jeffery F., "Art Enclosure and the Pastoral Care of Nuns," in *The Visual and the Visionary*, by Jeffery F. Hamburger (New York: Zone, 1998), pp. 35–109.

Hamburger, Jeffery F., Petra Marx and Susan Marti, "The Time of the Orders, 1200–1500: An Introduction," in *Crown and Veil: Female Monasticism from the Fifth to the Fifteenth Centuries*, ed. by Jeffery F. Hamburger and Susan Marti (New York: Columbia University Press, 2008), pp. 41–75.

Harant, Kryštof of Polžice and Bezdružicez, *Cesta z Království Českého do Benátek, odtud do Země Svaté, země Judské a dále do Egypta, a potom na horu Oreb, Sinai a Sv. Kateřiny v Pusté Arabii* [A Journey from the Czech Kingdom to Venice, from there to the Holy Land, the Land of Judea, and further on to Egypt, then to Mount Horeb, Sinai and St. Catherine in the Arabian Desert], ed. by Karel Jaromír Erben, (Prague: Czech Museum Pub., 1854), pp. 115–33.

Harrison, Martin Leigh, "Penitential Pilgrimage," in *Encyclopedia of Medieval Pilgrimage* (Leiden: Brill, first published online: 2022, http://dx.doi.org/10.1163/2213-2139_emp_SIM_00399).

Hartmann, Simone, "Das Bild der Stadt: Wie Städte darstellungswürdig wurden," in *Eichstätt: Stadtansichten des 15. Bis 19. Jahrhunderts*, ed. by Claudia Grund and Simone Hartmann, Begleitkatalog zur gleichnamigen Ausstellung 18. Juli bis 3. November 2013 Domschatz- und Diözesanmuseum Eichstätt (Regensburg: Schnell & Steiner, 2013), pp. 14–18.

Hartwieg, Babette, "Drei gefaßte Holzskulpturen vom Ende des 13. Jahrhunderts im Kloster Wienhausen," *Zeitschrift für Kunsttechnologie und Konservierung*, 2 (1988), 187–262.

Hassauer, Friederike, "Volkssprachliche Reiseliteratur: Faszination des Reisens und räumlicher Ordo," in *La littérature historiographique des origines à 1500*, ed. by Hans Ulrich Gumbrecht, Ursula Link-Heer and Peter-Michael Spangenberg, Grundriss der romanischen Literaturen des Mittelalters, XI.1 (Heidelberg: Winter, 1986), pp. 259–83.

Hauschild, Theodor, "Centcelles: Exploraciones en la sala de la cúpula," in *Centcelles: El monumento tardorromano. Iconografía y arquitectura*, ed. by Javier Arce (Rome: L'Erma di Bretschneider, 2002), pp. 51–57.

Haynes, Jonathan, *The Humanist as a Traveler—George Sandys's Relation of a Journey begun An. Dom. 1610* (Rutherford: Fairleigh Dickinson University Press, 1986).

Heidingsfelder, Franz, *Die Regesten der Bischöfe von Eichstätt: Bis zum Ende der Regierung des Bischofs Marquard von Hagel 1324*, Veröffentlichungen der Gesellschaft für fränkische Geschichte: Reihe 6, Regesten fränkischer Bistümer 1 (Erlangen: Palm & Enke, 1938) reg. no. 499.

Das Heilige Grab in Gernrode: Bestandsdokumentation und Bestandsforschung, ed. by Rainer Kahsnitz, Hans-Joachim Krause and Gotthard Voss, 3 vols (Berlin: Deutscher Verlag für Kunstwissenschaft, 2007).

Heitz, Carol, *Recherches sur les rapports entre architecture et liturgie à l'époque carolingienne* (Paris: Bibliothèque EPHE, 1963).

Heitz, Carol, "Sepulchrum Domini: Le sépulchre visité par les saintes femmes (IXe–XIe siècle)", in *Haut moyen-age: Culture, éducation et société. Études offertes á Pierre Riché*, ed. by Michel Sot (Nanterre: La Garenne-Colombes, 1990), pp. 389–400.

Hengevoss-Dürkop, Kerstin, *Skulptur und Frauenkloster: Studien zu Bildwerken der Zeit um 1300 aus Frauenklöstern des ehemaligen Fürstentums Lüneburg* (Berlin: Akademie Verlag, 1994).

Hengevoss-Dürkop, Kerstin, "Der Wienhauser Auferstehungs-Christus: Überlegungen zum Frauenkloster als Formgelegenheit," in *Studien zur Geschichte der europäischen Skulptur im 12./13. Jahrhundert*, ed. by Herbert Beck and Kerstin Hengevoss-Dürkop, 2 vols (Frankfurt am Main: Henrich, 1994), I, pp. 483–94.

Hennig, Ursula, "Die Beteiligung von Frauen an lateinischen Osterfeiern," in *Geist und Zeit: Wirkungen des Mittelalters in Literatur und Sprache; Festschrift für Roswitha Wisniewski zu ihrem 65. Geburtstag*, ed. by Carola L. Gottzmann, Herbert Kolb and Roswitha Wisniewski (Frankfurt am Main: Peter Lang, 1991), pp. 211–27.

Herz, Randall, "Briefe Hans Tuchers d. Ä. aus dem Heiligen Land und andere Aufzeichnungen," *Mitteilungen des Vereins für Geschichte der Stadt Nürnberg*, 84 (1997), 61–92.

Herz, Randall, "Hans Tuchers d. Ä. 'Reise ins Gelobte Land,'" in *Wallfahrten in Nürnberg um 1500*, Akten des interdisziplinären Symposions vom 29. und 30. September 2000 im Caritas Pirckheimer-Haus in Nürnberg, ed. by Klaus Arnold (Wiesbaden: Harrassowitz, 2002), pp. 79–104.

Herz, Randall, *Die "Reise ins Gelobte Land" Hans Tuchers des Älteren, 1479–1480: Untersuchungen zur Überlieferung und kritische Edition eines spätmittelalterlichen Reiseberichts*, Reihe Wissensliteratur im Mittelalter 38 (Wiesbaden: Reichert, 2002).

Herz, Randall, *Studien zur Drucküberlieferung der „Reise ins gelobte Land" Hans Tuchers des Älteren: Bestandsaufnahme und historische Auswertung der Inkunabeln unter Berücksichtigung der späteren Drucküberlieferung* (Nürnberg: Selbstverlag des Stadtarchivs Nürnberg, 2005).

Herzog, Erich, *Die ottonische Stadt: Die Anfänge der mittelalterlichen Stadtbaukunst in Deutschland*, Frankfurter Forschungen zur Architekturgeschichte 2 (Berlin: Mann, 1964).

Heutger, Nicolaus C., *Bursfelde und seine Reformklöster in Niedersachsen* (Hildesheim: Lax, 1969).

Hickson, Sally Anne, *Women, Art and Architectural Patronage in Renaissance Mantua: Matrons, Mystics and Monasteries* (Surrey: Ashgate, 2012).

Hippler, Christiane, *Die Reise nach Jerusalem* (Frankfurt am Main: Lang, 1987).

Hodgson, Natasha R., *Women, Crusading and the Holy Land in Historical Narrative* (Woodbridge: Boydell, 2007).

Hodoeporicon S. Willibaldi oder *S. Willibalds Pilgerreise*, trans. by Jakob Brückl (Eichstätt: M. Däuntler, 1880/81).

Hödl, Franz Xaver, *Eichstätt, Heilig Kreuz: Kapuzinerkirche zum Hl. Kreuz und zum Hl. Grab Christi in Eichstätt* (Munich: Schnell & Steiner, 1955).

Höhl, Claudia, "Sogennantes Jerusalemer Kreuz," in *Imperator Caesar Flavius Konstantin—Constantinus der Grosse; Ausstellungskatalog*, ed. by Alexander Demandt and Josef Engemann (Mainz am Rhein: Philipp von Zabern, 2007).

Holtz, Mark Daniel, "Cults of the Precious Blood in the Medieval Latin West" (unpublished doctoral thesis, University of Notre Dame, 1997).

Holum, Kenneth G. and Gary Vikan, "The Trier Ivory, Adventus Ceremonial, and the Relics of St. Stephan," *Dumbarton Oaks Papers*, 33 (1979), 115–33.

Homeyer, Joachim, "Zur Gründung des Stiftes Diesdorf im Jahre 1161," *Jahresbericht des Altmärkischen Vereins*, 73 (2001), 84–98.

Hood, William, review of *Il Sacro Monte sopra Varese*, by Piero Bianconi, Silvano Colombo, Aldo Lozito, Luigi Zanzi (Milano: Electa, 1981), *Art Bulletin*, 67, no. 2 (1985), 333–37.

Housley, Norman, "Holy Land or Holy Lands? Palestine and the Catholic West in the Late Middle Ages and Renaissance," in *The Holy Land, Holy Lands, and Christian History*, ed. by R.N. Swanson (New York: Boydell & Brewer, 2000), pp. 228–49.

Howard, Deborah, "Venice as Gateway to the Holy Land: Pilgrims as Agents of Transmission," in *Architecture and Pilgrimage, 1000–1500: Southern Europe and Beyond*, ed. Paul Davies, Deborah Howard and Wendy Pullan (Farnham: Ashgate, 2013), pp. 87–112.

Hubala, Erich, "L. B. Albertis Langhaus von Sant'Andrea in Mantua," in *Festschrift Kurt Badt zum siebzigsten Geburtstage: Beiträge aus Kunst- und Geistesgeschichte*, ed. by Martin Gosebruch (Berlin: De Gruyter, 1961), pp. 83–119.

Hundley, Catherine E., "A New Jerusalem in Four Parts: The Holy Sepulchres of Twelfth-Century London," in *Visualising a Sacred City: London, Art and Religion*, ed. by Ben Quash, Aaron Rosen and Chloe Reddaway (London: I.B. Tauris, 2017), pp. 52–65.

Hundley, Catherine E., 'The English Round Church Movement," in *Tomb and Temple: Reimagining the Sacred Buildings of Jerusalem*, ed. by Robin Griffith-Jones (Woodbridge: Boydell and Brewer, 2018), pp. 352–75.

Huntington, Joanna, "The Taming of the Laity: Writing Waltheof and Rebellion in the Twelfth Century," in *Anglo-Norman Studies: Proceedings of the Battle Conference 2009*, ed. by C.P Lewis (Woodbridge: Boydell and Brewer, 2010), pp. 79–95.

Puig i Cadafalch, Josep, Antoni de Falguera and Josep Goday, *L'arquitectura románica a Catalunya* (Barcelona: Institut d'Estudis Catalans, 1917), III.1.

Ingulph's Chronicle of the Abbey of Croyland, ed. and trans. by Henry T. Riley (London: G. Bell, 1908).

De imitatione Christi Libri Quatuor IV.1.38, ed. by Tiburzio Lupo (Vatican City: Libr. Ed. Vaticana, 1982).

"Inventories of the Moscow Dormition Cathedral, from the Beginning of the Seventeenth century up to 1701" [Описи московского Успенского собора, от начала XVII века по 1701 год включительно], in *Русская историческая библиотека*, т. 3 (St. Petersburg: Archaeological Commission, 1876), cols. 295–874.

Itinerary of the Abbot Daniel to the Holy Land at the Beginning of the Twelfth Century ['Хожение' игумена Даниила в Святую Землю в начале *XII* в.], ed. by Gelian M. Prokhorov, Древнерусские сказания о достопамятных людях, местах и событиях. Imperial Orthodox Palestine Society, Literary Museum of the Institute of Russian Literature (St. Petersburg: Oleg Abyshko Publishing House, 2007).

Jacobsen, Werner, "Die Stiftskirche von Gernrode und ihre liturgische Ausstattung," in *Essen und die sächsischen Frauenstifte im Frühmittelalter*, ed. by Jan Gerchow and Thomas Schilp, Essener Forschungen zum Frauenstift, 2 (Essen: Klartext, 2003), pp. 219–46.

Jacobus da Voragine, *Legenda aurea*, ed. by Th. Graesse (Leipzig, 1850), pp. 303–16

Jahn, Bernhard, *Raumkonzepte in der frühen Neuzeit: Zur Konstruktion von Wirklichkeit in Pilgerberichten, Amerikareisebeschreibungen und Prosaerzählungen* (Frankfurt: P. Lang, 1993).

Jansen, Virginia, "Light and Pure: the Templars' New Choir," in *The Temple Church in London*, pp. 45–66.

Jaspert, Nikolas, "Cataluña y Jerusalén en el siglo XI: Testamentos, piedad y conectividad transmediterránea," in *Movilidad y religiosidad medieval en los Reinos Peninsulares, Alemania y Palestina*, ed. by Nikolas Jaspert (Granada, 2020), pp. 13–73.

Jaspert, Nikolas, "Eleventh-Century Pilgrimage from Catalonia to Jerusalem: New Sources on the Foundations of the First Crusade," *Crusades*, 14 (2015), 1–47.

Jaspert, Nikolas, "Gedenkwesen und Erinnerung des Ordens vom Heiligen Grab," in *Wider das Vergessen und für das Seelenheil: Memoria und Totengedenken im Mittelalter*, ed. by Rainer Berndt S.J., Erudiri Sapientia, 9 (Münster: Böhlau, 2013), pp. 149–74.

Jaspert, Nikolas, "Military Orders and Urban History: An Introductory Survey," in *Les ordres militaires dans la ville médiévale (1100–1350)*, ed. by D. Carraz (Clermont-Ferrand: Presses Universitaires Blaise-Pascal, 2013), pp. 15–34.

Jaspert, Nikolas, "'Pro nobis, qui pro vobis oramus, orate': Die Kathedralkapitel von Compostela und Jerusalem in der ersten Hälfte des 12. Jahrhunderts," in *Santiago, Roma, Jerusalén: Actas del III Congreso Internacional de Estudios Jacobeos*, ed. by Paolo Caucci von Saucken (Santiago de Compostela: Xunta de Galicia, 1999), pp. 187–212.

Jaspert, Nikolas, "The True Cross of Jerusalem in the Latin West: Mediterranean Connections and Institutional Agency," in *Visual Constructs of Jerusalem*, pp. 207–22.

Jaspert, Nikolas, "Un vestigio desconocido de Tierra Santa: la Vera Creu d'Anglesola," in *Movilidad y religiosidad medieval en los Reinos Peninsulares, Alemania y Palestina*, ed. by Nikolas Jaspert (Granada, 2020), pp. 75–94.

Jaspert, Nikolas, "Vergegenwärtigungen Jerusalems in Architektur und Reliquienkult," in *Jerusalem im Hoch– und Spätmittelalter: Konflikte und Konfliktbewältigung, Vorstellungen und Vergegenwärtigungen*, ed. By Dieter Bauer, Klaus Herbers, and Nikolas Jaspert (Frankfurt am Main: Campus, 2001), pp. 219–97.

Jerusalem Elsewhere: The German Recensions; Proceedings of the Minerva-Gentner Mobile Symposium, October 2011, ed. by Bianca Kühnel and Pnina Arad (Jerusalem: Spectrum, 2014).

Jerusalem in Russian Culture, ed. by Andrei Batalov and Alexei Lidov (New York: A. D. Caratzas, 2005).

De Jeruzalemkapel in Gouda, ed. by Chris Akkerman et al. (Gouda: Stichting Spoor, 1998).

Jerusalem in Russian Culture (Иерусалим в Русской Культуре), ed. by Andrei Batalov and Alexei Lidov (Moscow: Наука, 1994).

Jezler, Peter, "Bildwerke im Dienste der dramatischen Ausgestaltung der Osterliturgie—Befürworter und Gegner," in *Von der Macht der Bilder,* ed. by Ernst Ullmann (Leipzig: Seemann, 1983), pp. 236–49.

Jezler, Peter, "Jenseitsmodelle und Jenseitsvorsorge: Eine Einführung," in *Himmel Hölle Fegefeuer: Das Jenseits im Mittelalter,* ed. by Peter Jezler (Zürich: Neue Zürcher Zeitung, 1994), pp. 13–26.

Jezler, Peter, "Ostergrab und Depositionsbild" (unpublished doctoral thesis, Universität Zürich, 1982).

Johns, Susan M., *Noblewomen, Aristocracy and Power in the Twelfth-Century Anglo-Norman Realm* (Manchester: Manchester University Press, 2003).

Johnson, Eugene J., *S. Andrea in Mantua: The Building History* (University Park, PA: Pennsylvania State University Press, 1975).

Jotischky, Andrew, "The Mendicants as Missionaries and Travelers," in *Eastward Bound: Travel and Travellers, 1050–1550,* ed. by Rosamund Allen (Manchester: Manchester University Press, 2004), pp. 88–106.

Junyent, Eduard, *Diplomatari i escrits literaris de l'abat i bisbe Oliba* (Barcelona: Institut d'Estudis Catalans, 1992).

Kabátník, M., *Cesta z Čech do Jerusalema a Kaira, r. 1491–92* [A Journey from the Czech Lands to Jerusalem and Cairo, 1491–1492], ed. by Justin V. Prášek (Praha: České Akademie Cisaře Františka Josefa, 1900), pp. 77–78.

Kahsnitz, Rainer, "Die Plastik," in *Das Heilige Grab in Gernrode: Bestandsdokumentation und Bestandsforschung,* 3 vols, ed. by Rainer Kahsnitz, Hans-Joachim Krause and Gotthard Voß (Berlin: Deutscher Verlag für Kunstwissenschaft, 2007), pp. 311–83.

Kehr, Paul F., *Papsturkunden in Spanien: Vorarbeiten zur Hispania Pontificia,* I, *Katalanien* (Berlin: Abhandlungen der Gesellschaft der Wissenschaften zu Göttingen, Philologisch–Historische Klasse, 1926).

Kempe, Margery, *The Book of Margery Kempe,* ed. by Lynn Staley (Kalamazoo: TEAMS, 1996).

Kenaan, Nurit, "Local Christian Art in Twelfth-century Jerusalem," *Israel Exploration Journal,* 23 (1973), pp. 221–29.

Kenaan-Kedar, Nurith, "Pictorial and Sculptural Commemoration of Returning or Departing Crusaders," in *The Crusades and Visual Culture,* ed. by Elizabeth Lapina, April Jehan Morris, Susanna A. Throop and Laura J. Whatley (Abingdon: Ashgate, 2015), pp. 91–104.

Kent Archaeological Society, "Ruins of a Round Church at Dover," *Archaeologia Cantiana*, 11 (1877), 45–46.

Kessler, Herbert L., *Spiritual Seeing: Picturing God's Invisibility in Medieval Art* (Philadelphia: University of Pennsylvania Press, 2000).

Kessler, Herbert L., "Rome's Place between Judaea and Francia in Carolingian Art," in *Roma fra Oriente e Occidente, Settimane di studio*, 49 (Spoleto: Centro Italiano sull'alto Medioevo, 2002), II, pp. 695–718.

Kiecker, Oskar, Carl Brochers and Hans Lütgens, *Die Kunstdenkmäler der Provinz Hannover* (Hannover: Selbstverlag der Provinzialverwaltung, 1937), II.

Kingsley Porter, Arthur, *Lombard Architecture* (New Haven: Yale University Press; London: Oxford University Press, 1917), VII, *Monuments: Abbazia di Albino-Milan*.

Kirkland-Ives, Mitzi, "Alternate Routes: Variation in Early Modern Stational Devotions," *Viator*, 40, no. 1 (2009), 249–70.

Klein, Holger, *Byzanz, der Westen, und das Wahre Kreuz: Die Geschichte einer Reliquie und ihrer künstlerischen Fassung im Byzanz und im Abendland* (Wiesbaden: Reichert, 2004).

Klein, Holger, "Eastern Objects and Western Desires: Relics and Reliquaries between Byzantium and the West," *Dumbarton Oaks Papers*, 58 (2004), 283–314.

Klein, Holger A., "Sacred Relics and Imperial Ceremonies at the Great Palace of Constantinople," in *Visualisierungen von Herrschaft: Frühmittelalterliche Residenzen, Gestalt und Zeremoniell*, ed. by Franz Alto Bauer, BYZAS, Veröffentlichungen des Deutschen Archäologischen Instituts Istanbul 5 (Istanbul: Ege Yayınları, 2006), pp. 79–99.

Kneller, Karl Alois, *Geschichte der Kreuzwegandacht von den Anfängen bis zur völligen Ausbildung* (Freiburg: Herder, 1908).

Koldinská, Marie, *Kryštof Harant z Polžic a Bezdružic: Cesta intelektuála k popravišti* [Kristof Harant of Polzice and Bezdruzice: An Intellectual's Way to the Gallows] (Paseka: Praha & Litomyšl, 2004).

Korenevsky, Andrei V. and Alexander Y. Peliugin, "Officium stratoris и 'шествие на осляти': происхождение и семантика ритуалов" [*Officium stratoris* and the 'donkey walk': The Origins and Semantics of Rituals], *COGITO*—Альманах истории идей, 5 (2011), 203–40.

Kosch, Clemens, "Zur zeichnerischen Veranschaulichung der sakralen Binnentopographie von St. Cyriakus in Gernrode während des 11. und 12. Jahrhunderts," in *Vom Leben in Kloster und Stift: Wissenschaftliche Tagung zur Bauforschung im mitteldeutschen Raum vom 7. bis 9. April 2016 im Kloster Huysburg; Festschrift für Reinhard Schmitt*, ed. by Elisabeth Rüber-Schütte, Arbeitsberichte des Landesamtes für Denkmalpflege und Archäologie Sachsen-Anhalt, 13 (Halle [Saale]: Landesamt f. Denkmalpflege u. Archäologie Sachsen-Anhalt, 2017), pp. 65–94.

Köhler, Neeltje et al., *Painting in Haarlem, 1500–1850: The Collection of the Frans Hals Museum* (Ghent: Ludion, 2006).

Krautheimer, Richard, "Alberti's Templum Etruscum," *Münchner Jahrbuch der Bildenden Kunst*, 4 (1961), 65–72, reprinted in Krautheimer, Richard, *Studies in Early Christian, Medieval and Renaissance Art* (New York: New York University Press, 1969), pp. 333–44.

Krautheimer, Richard, "Introduction to an 'Iconography of Mediaeval Architecture,'" *Journal of the Warburg and Courtauld Institutes*, 5 (1942), 1–33.

Krautheimer, Richard, "Santo Stefano Rotondo a Roma e la chiesa del Santo Sepolcro a Gerusalemme," *Rivista di archeologia cristiana*, 12 (1935), 51–102.

Kreutz, Jessica, *Die Buchbestände von Wöltingerode: Ein Zisterzienserinnenkloster im Kontext der spätmittelalterlichen Reformbewegungen* (Wiesbaden: Otto Harrassowitz, 2014).

Kreutz, Jessica, "Wöltingerode," in *Niedersächsisches Klosterbuch: Verzeichnis der Klöster, Stifte, Kommenden und Beginenhäuser in Niedersachsen und Bremen von den Anfängen bis 1810*, ed. by Josef Dolle, Veröffentlichungen des Instituts für Historische Landesforschung der Universität Göttingen 56, 4 vols (Bielefeld: Verlag für Regionalgeschichte, 2012), III, 1555–61.

Kroesen, Justin E. A., *The Sepulchrum Domini through the Ages: Its Form and Function* (Leuven: Peeters, 2000).

Krueger, Rita, *Czech, German, and Noble: Status and National Identity in Habsburg Bohemia* (New York: Oxford University Press, 2009).

Krüger, Jürgen, *Die Grabeskirche zu Jerusalem: Geschichte—Gestalt—Bedeutung* (Regensburg: Schnell & Steiner, 2000).

Krüger, Kristina, "Architecture and Liturgical Practice: The Cluniac Galilaea," in *The White Mantle of Churches*, ed. by Neil Hiscock (Turnhout: Brepols, 2003), pp. 138–59.

Kruse, Norbert, "Der Weg des Heiligen Bluts von Mantua nach Altdorf-Weingarten," in *900 Jahre Heilig-Blut-Verehrung in Weingarten, 1094–1994: Festschrift zum Heilig-Blut-Jubiläum am 12 März 1994*, ed. by N. Kruse and R. Schaubode (Sigmaringen: Jan Thorbecke, 1994), pp. 57–76.

Kühnel, Bianca, *From the Earthly to the Heavenly Jerusalem: Representations of the Holy City in Christian Art of the First Millennium* (Rome: Herder, 1987).

Kühnel, Bianca, "The Holy Land Beyond the Sea" (Hebrew), in *Ut videant et contingant— Essays on Pilgrimage and Sacred Space in Honour of Ora Limor*, ed. by Iris Shagrir and Yizhak Hen (Raanana: The Open University Press, 2011), pp. 249–66.

Kühnel, Bianca, "Jerusalem between Narrative and Iconic," in *Jerusalem as Narrative Space*, ed. by Annette Hoffmann and Gerhard Wolf, Visualising the Middle Ages 6 (Leiden: Brill, 2012), pp. 105–23.

Kühnel, Bianca, "Monumental Representations of the Holy Land in the Holy Roman Empire," in *Die Kreuzzugsbewegung im römisch-deutschen Reich (11.–13. Jahrhundert)*, ed. by Stefan Tebruck and Nicolas Jaspert (Sigmaringen: Thorbecke, 2014), pp. 322–48.

Kühnel, Bianca, "Virtual Pilgrimages to Real Places: the Holy Landscapes," in *Imagining Jerusalem in the Medieval West*, ed. by Lucy Donkin and Hannah Vorholt, (Oxford: Oxford University Press, 2012), pp. 243–64.

Kühnel, Gustav, "Heracles and the Crusaders: Tracing the Path of a Royal Motif," in *France and the Holy Land: Frankish Culture at the End of the Crusades*, ed. by Daniel H. Weiss and Lisa Mahoney (Baltimore: Johns Hopkins University Press, 2004), pp. 63–76.

Kühnel, Gustav, "Das restaurierte Christusmosaik der Calvarienberg-Kapelle und das Bildprogramm der Kreuzfahrer," *Römische Quartalschrift*, 92 (1997), 45–71.

Laarakkers, Ingeborg, "De Jeruzalemkapel," in *De Jeruzalemkapel in Gouda*, ed.by Chris Akkerman et al. (Gouda: Stichting SPOOR, 1998), pp. 23–36.

Laos, Nora, "The Architecture and Iconographical Sources of the Church of Neuvy-Saint-Sépulcre," in *Art and Architecture of Late Medieval Pilgrimage in Northern Europe and the British Isles Texts*, ed. by Sarah Blick and Rita Tekippe (Leiden: Brill, 2005), pp. 315–36.

Lasansky, Medina, "Beyond the Guidebook: Edith Wharton's Rediscovery of San Vivaldo," in *Edith Wharton and Cosmopolitanism*, ed. by Emily Orlando and Meredith Goldsmith (Gainesville: University Press of Florida, 2016).

Latour, Bruno, *The Pasteurization of France* (Cambridge: Harvard University Press, 1988).

Laurent, Macé, "Castel Narbones. La fierté monumentale des Raimond de Toulouse," *Patrimoines du Sud*, 10 (2019), 1–18.

Lawson, James, "The Extrinsic in the Architectural Thinking of Leon Battista Alberti: A Reading of Sant'Andrea in Mantua," *Renaissance Studies*, 27, no. 2 (2013), 253–69.

Leerhoff, Heiko, "Wienhausen," in *Die Männer- und Frauenklöster der Zisterzienser in Niedersachsen, Schleswig-Holstein und Hamburg*, ed. by Ulrich Faust, Germania Benedictina 12 (St. Ottilien: EOS, 1994), pp. 756–96.

Lenzi, S. A., *The Stations of the Cross: The Placelessness of Medieval Christian Piety* (Turnhout: Brepols, 2016).

Leon Battista Alberti, Opere Volgari, ed. by Cecil Grayson (Bati: Gius. Laterza & Figli, 1973), III, *Trattati d'arte, Ludi rerum mathematicarum, Grammatica della lingua toscana, Opuscoli amatori, Lettere*.

Lesser, Bertram, "Zwischen Windesheim und Bursfelde: Klosterreformen in Hildesheim im 15. Jahrhundert," in *Schätze im Himmel, Bücher auf Erden: Mittelalterliche Handschriften aus Hildesheim; Ausstellung der Herzog-August-Bibliothek Wolfenbüttel (Bibliotheca Augusta: Augusteerhalle, Schatzkammer und Kabinett) vom 5. September 2010 bis 27. Februar 2011*, ed. by Monika E. Müller (Wolfenbüttel: Herzog-August-Bibliothek, 2010), pp. 31–40.

Lester, Anne E., "What Remains: Women, Relics and Remembrance in the Aftermath of the Fourth Crusade," *Journal of Medieval History*, 40 (2014), 311–28.

Lester, Anne E., "Le trésor de Clairvaux," in *Clairvaux: L'aventure cistercienne; Catalogue de l'exposition organisée à l'Hôtel-Dieu-le-Comte à Troyes du 5 juin au 15 novembre 2015,* ed. by Arnaud Baudin et al. (Paris: Somogy-Éditions d'art, 2015), pp. 213–23.

Lewis, C. P., "Lacy, Gilbert de (*fl.* 1133–1163)," in *Oxford Dictionary of National Biography* (Oxford: Oxford University Press, 2004).

Lewis, C. P., "Waltheof, earl of Northumbria (c.1050–1076)," in *Oxford Dictionary of National Biography.*

Libellus Orationum, PL 80, cols. 135–36.

Lidov, Alexei, "A Byzantine Jerusalem: The Imperial Pharos Chapel as the Holy Sepulchre," in *Jerusalem as Narrative Space,* ed. by Annette Hoffmann and Gerhard Wolf, Visualising the Middle Ages 6 (Leiden: Brill, 2012), pp. 63–104.

Likhachev, Dmitry S. et al., Russia: History and Art in the Tenth to Seventeenth Centuries [Русь: История и художественная культура X–XVII веков] (Moscow: Iskusstvo, 2003).

Limor, Ora, "Willibald in the Holy Places," in *East and West in the Early Middle Ages: The Merovingian Kingdoms in Mediterranean Perspective,* ed. by Stefan Esders et al. (Cambridge: Cambridge University Press, 2019), pp. 230–44.

Linder, Amnon, "The Liturgy of the Liberation of Jerusalem," *Mediaeval Studies,* 52 (1990), 110–31.

Linder, Amnon, "The Myth of Constantine the Great in the West: Sources and Hagiographic Commemoration," *Studi Medievali,* ser. 3, 16 (1975), 43–95.

Linke, Hansjürgen, "A Survey of Medieval Drama and Theater in Germany," *Comparative Drama,* 27, no. 1 (1993), 17–53.

Lipphardt, Walther, *Lateinische Osterfeiern und Osterspiele (LOO),* 9 vols (New York: De Gruyter, 1975), V (1976), VIII (1990).

Lipphardt, Walther, "Die *Visitatio sepulchri* (III. Stufe) von Gernrode," *Daphnis,* 1 (1972), 1–14.

Lipphardt, Walther, "Die *Visitatio sepulchri* in Zisterzienserinnenklöstern der Lüneburger Heide," *Daphnis,* 1 (1972), 119–28.

Lipsmeyer, Elizabeth, "Devotion and Decorum: Intention and Quality in Medieval German Sculpture," *Gesta,* 34, no. 1 (1995), 20–27.

Lisy-Wagner, Laura, *Islam, Christianity and the Making of Czech Identity, 1453–1683* (Farnham: Routledge, 2014).

Lithgow, William, *The Rare Adventures and Painefull Peregrinations of Long Ninteene Yeares Travayles from Scotland to the Most Famous Kingdomes in Europe, Asia and Affrica* (Glasgow: Glasgow University Press, 1906).

Llansana, Eva, *La Santíssima Veracreu de Besalú: Història d'un millenari, 1017–2017* (Besalú: ELLB, 2017).

Luaces, Yarza, *Entre lo medieval y la tradición clásica: El 'tapiz' de la creación de Girona* (Barcelona: Amics de l'Art romànic, 2007).

Ludlow Castle: Its History and Buildings, ed. by Ron Shoesmith and Andy Johnson (Little Logaston: Logaston, 2000).

Ludolph Von Suchem's Description of the Holy Land and of the Way Thither, trans. by Aubrey Stewart (Cambridge: Cambridge University Press, 2013).

Lyman, Thomas, "The Sculpture Programme of the Porte des Comtes Master at Saint-Sernin in Toulouse," *Journal of the Warburg and Courtauld Institutes*, 34 (1971), 12–39.

Lyman, Thomas, "Theophanic Iconography and the Easter Liturgy: The Romanesque Painted Program at Saint-Sernin in Toulouse," in *Festschrift für Otto von Simson zum 65. Geburtstag*, ed. by Lucius Grisebach and Konrad Renger (Frankfurt am Main: Propyläen Verlag, 1977), pp. 72–93.

MacCormack, Sabine, *Art and Ceremony in Late Antiquity* (Berkeley: University of California Press, 1981).

Mäder, Renate, "'…dem Grab Christi gantz ähnlich und gleich': Die Tradition von Heilig-Grab-Bauten in Augsburg," in *Barfuß vor St. Max: Von der Klosterkirche der Franziskaner zur Pfarrkirche St. Maximilian. Katalog zur Sonderausstellung im Diözesenmuseum St. Afra, 18. Oktober 2013–12. Januar 2014*, ed. by Melanie Thierbach (Augsburg: Wißner, 2013), pp. 60–70.

Magallón, Manuel, "Templarios y Hospitalarios: Primer Cartulario en el Archivo Histórico Nacional," *Boletín de la Real Academia de la Historia*, 33 (1898), 257–66.

Mai, Nadine, "Place and Surface: Golgotha in Late Medieval Bruges," in *Natural Materials of the Holy Land and the Visual Translation of Place, 500–1500*, ed. by Renana Bartal, Neta Bodner and Bianca Kühnel (Oxon: Routledge, 2017), pp. 190–206.

Maier, Christoph T., "The Roles of Women in the Crusade Movement: A Survey," *Journal of Medieval History*, 30 (2004), 61–82.

Maier, Konrad, *Kloster Wienhausen: Geschichte, Architektur und bildene Kunst; Ein Überblick*, Kloster Wienhausen, 1 (Wienhausen: Kloster Wienhausen, 2007).

Maier, Konrad, *Die Kunstdenkmale des Landkreises Celle im Regierungsbezirk Lüneburg*, part 2, *Wienhausen. Kloster und Gemeinde*, Die Kunstdenkmale des Landes Niedersachsen, 34.2 (Hannover: Niedersächsisches Landesverwaltungsamt, 1970).

Majeska, George P., *Russian Travelers to Constantinople in the Fourteenth and Fifteenth Centuries*, Dumbarton Oaks Studies 19 (Washington, DC: Dumbarton Oaks Research Library and Collection, 1984).

Majeska, George P., "Russian Pilgrims in Constantinople," *Dumbarton Oaks Papers*, 56 (2000), 93–108.

Majeska, George P., "Russian Pilgrims and the Relics of Constantinople," in *Eastern Christian Relics*, ed. by Alexei Lidov (Moscow: Progress-Tradition, 2003), pp. 387–97.

Majeska, George P., "St. Sophia in the Fourteenth and Fifteenth Centuries: The Russian Travelers on the Relics," *Dumbarton Oaks Papers*, 27 (1973), 69–87.

Malaparte, Curzio, *Kaputt*, trans. by Cesare Foligno (New York: New York Review of Books, 2005).

Maleto, Elena I., Anthology of the Itineraries of Russian Travelers of the XII–XV centuries: Research, texts, commentaries [Антология хожений русских путешественников XII–XV века: Исследования, тексты, комментарии] (Moscow: Russian Academy of Sciences, Institute of Russian History, Nauka, 2005).

Mancho, Carles and Immaculada Lorés, "*Hec domus est sancta quam fecit domnus Oliva*: Santa Maria de Ripoll," *Les Cahiers de Saint-Michel de Cuxa*, 40 (2009), pp. 205–19.

Mango, Cyril, *The Art of the Byzantine Empire, 312–1453: Sources and Documents* (Englewood Cliffs: Prentice-Hall, 1972).

Marani, Ercolano, "Tre Chiese di Sant'Andrea nella storia dello svolgimento urbanistico mantovano," in *Il Sant'Andrea di Mantova e Leon Battista Alberti: Atti del convegno di studi organizzato dalla Città di Mantova con la collaborazione dell'Accademia Virgiliana, nel quinto centenario della basilica di Sant'Andrea e della morte dell'Alberti, 1472–1972* (Mantua: Edizione della Biblioteca comunale di Mantova, 1974), pp. 71–109.

Masnou, Josep M., "El bisbat de Vic durant l'Episcopat de Ramon Gaufred," *Revista catalana de teologia*, 27 (2002), 269–93.

Mason, Emma, "Invoking Earl Waltheof," in *The English and their Legacy: Essays in Honour of Ann Williams*, ed. by David Roffe (Woodbridge: Boydell and Brewer, 2012), pp. 185–203.

Material and Action in European Cathedrals (9th–13th centuries): Building, Decorating, Celebrating, ed. by Gerardo Boto and C. García de Castro (Oxford: British Archaeological Reports, 2017).

Mattern, Tanja, "Liturgy and Performance in Northern Germany: Two Easter Plays from Wienhausen," in *A Companion to Mysticism and Devotion in Northern Germany in the Late Middle Ages*, ed. by Elizabeth A. Andersen, Henrike Lähnemann and Anne Simon, Brill's Companions to the Christian Tradition 44 (Leiden: Brill, 2014), pp. 285–315.

Matthew, "Senlis, Simon (I) de, earl of Northampton and earl of Huntingdon (*d.* 1111x13)," in *Oxford Dictionary of National Biography* (Oxford: Oxford University Press, 2004), https://doi.org/10.1093/ref:odnb/25091.

Mayer, Annemarie C., "Most Precious Blood: Pilgrimage and Veneration of the Relic in Weingarten and Mantua," *International Journal for the Study of the Christian Church*, 17, no. 4 (2017), 208–17.

McCurrach, Catherine C., "'Renovatio' Reconsidered: Richard Krautheimer and the Iconography of Architecture," *Gesta*, 50/51 (2011), 41–69.

McKenna, J. W., "How God Became an Englishman," in *Tudor Rule and Revolution*, ed. by Delloyd J. Guth and John W. McKenna (Cambridge: Cambridge University Press, 1982), pp. 25–43.

McNamara, Jo Ann, *Sisters in Arms: Catholic Nuns through Two Millennia* (Cambridge, MA: Harvard University Press, 1996).

Mecham, June L., "A Northern Jerusalem: Transforming the Spatial Geography of the Convent of Wienhausen," in *Defining the Holy: Sacred Space in Medieval and*

Early Modern Europe, ed. by Andrew Spicer and Sarah Hamilton (Aldershot: Ashgate, 2005), pp. 139–60.

Mecham, June L., "Katharina von Hoya's Saint Anne Chapel: Female Piety, Material Culture, and Monastic Space on the Eve of the Reformation," in *Frauen—Kloster—Kunst*, pp. 177–85.

Mecham, June L., *Sacred Communities, Shared Devotions: Gender, Material Culture, and Monasticism in Late Medieval Germany*, ed. by Alison I. Beach, Constance H. Berman, and Lisa M. Bitel, Medieval Women: Texts and Contexts 29 (Turnhout: Brepols, 2014).

Mecham, June L, "Sacred Vision, Sacred Voice: Performative Devotion and Female Piety at the Convent of Wienhausen, circa 1350–1500" (unpublished doctoral thesis, University of Kansas, 2004).

Meischke, R., "De Oude Zijds Kapel," *Amstelodamum*, 43 (1956), 160–62.

Mella, Edoardo, *Elementi di architettura lombarda* (Turin: Bocca, 1885).

Mengel, David Ch., "Bones, Stones, and Brothels: Religion and Topography in Prague under Charles IV (1346–78)" (unpublished doctoral thesis, University of Notre Dame, 2003).

Mengel, David Ch., "From Venice to Jerusalem and Beyond: Milíč of Kroměříž and the Topography of Prostitution in Fourteenth Century Prague," *Speculum*, 79 (2004), 407–42.

Mengel, David Ch., "Emperor Charles IV (1346–1378) as the Architect of Local Religion in Prague," *Austrian History Yearbook*, 41 (2010), 15–29.

Mersch, Katharina Ulrike, *Soziale Dimensionen visueller Kommunikation in hoch- und spätmittelalterlichen Frauenkommunitäten: Stifte, Chorfrauenstifte und Klöster im Vergleich*, Nova Mediaevalia 10 (Göttingen: V&R Unipress, 2012).

Merzario, G., *I maestri comacini. Storia artistica di mille duecento anni (600–1800)* (Milan: Agnelli, 1893).

Messling, Guido, *Augsburger Maler und Zeichner Leonhard Beck und sein Umkreis: Studien zur Augsburger Tafelmalerei und Zeichnung des frühen 16. Jahrhunderts* (Dresden: Thelem, 2006).

Mestre, Jesús, ed., *Diccionari d'història de Catalunya* (Barcelona: Edicions 62, 1992).

Metropolitan Museum of Art, *Enamels of Limoges: 1100–1350*, ed. by Barbara Boehm (New York: Metropolitan Museum of Art, 1996).

Meurer, Heribert, "Kreuzreliquiare aus Jerusalem," *Jahrbuch der Staatlichen Kunstsammlungen in Baden-Württemberg*, 13 (1976), 7–18.

Meurer, Heribert, "Zu den Staurotheken der Kreuzfahrer," *Zeitschrift für Kunstgeschichte*, 48 (1985), 65–76.

Meyendorff, Paul, *St Germanus of Constantinople on the Divine Liturgy—Greek Text with Translation, Introduction and Commentary* (Crestwood: St Vladimir's Seminary Press, 1984).

Michel, Francisque Xavier, ed., *Histoire de Foulques Fitz-Warin* (Paris: Silvestre Librarie, 1840).

Miedema, Nine Robijntje, "Following in the Footsteps of Christ: Pilgrimage and Passion Devotion," in *The Broken Body: Passion Devotion in Late-Medieval Culture*, ed. by Alasdair A. MacDonald, Bernhard Ridderbos, and Rita Schlusemann (Groningen: Egbert Forsten, 1998), pp. 73–92.

Miedema, Nine Robijntje, *Rompilgerführer in Spätmittelalter und Früher Neuzeit: Die "Indulgentiae ecclesiarum urbis Romae"; Edition und Kommentar*, Frühe Neuzeit 72 (Tübingen: Niemeyer, 2003).

Mitchell, R. J., *The Spring Voyage—The Jerusalem Pilgrimage in 1458* (New York: C. N. Potter, 1964).

Mohn, Claudia, *Mittelalterliche Klosteranlagen der Zisterzienserinnen: Architektur der Frauenklöster im mitteldeutschen Raum* (Petersberg: Michael Imhof, 2005).

Moore, Kathryn Blair, *The Architecture of the Christian Holy Land: Reception from Late Antiquity through the Renaissance* (Cambridge: Cambridge University Press, 2017).

Mori, Masahiro, "The Uncanny Valley, " *Energy*, 7, no. 4 (1970), 33–35.

Morris, Colin, *The Sepulchre of Christ and the Medieval West: From the Beginning to 1600* (Oxford: Oxford University Press, 2005).

Moshenson, Edna, "Subjects in Transit," in *Adrian Paci: Lives in Transit*, ed. by Paulette Gagnon and Marta Gili (Milan: Mousse, 2013), pp. 56–67.

Movilidad y religiosidad medieval en los Reinos Peninsulares, Alemania y Palestina, ed. by Nikolas Jaspert (Granada: Editorial Universidad de Granada, 2020).

Mozer, Isolde, *Bernhard van Breydenbach: Peregrinatio in Terram Sanctam* (Berlin: De Gruyter, 2010).

Mühlmann, Heiner, "Albertis St.-Andrea-Kirche und das Erhabene," *Zeitschrift für Kunstgeschichte*, 32, no. 2 (1969), 153–57.

Muka, Edi, "Engendering Reality," in *Adrian Paci: Lives in Transit*, ed. by Paulette Gagnon and Marta Gili (Milan: Mousse, 2013), pp. 80–83.

Muka, Edi, "Transposition," in *Adrian Paci*, ed. by Angela Vettese (Milan: Charta—Galleria Civica, Modena, 2006), pp. 89–94.

Müller, Andreas, *Das Heilige Grab in der Stiftskirche St. Cyriakus zu Gernrode* (Passau: Kunstverlag Peda, 2014).

Müller, Hellmut, "*Insula Sanctae Mariae*: Zur Frühgeschichte des Augustiner-Chorfrauenstiftes Diesdorf," *Aus der Altmark*, 66 (1986), 127–50.

Muller, S., "Arnoldus Buchelius: *Traiecti Batavorum Descriptio*," *Bijdragen en Mededelingen van het Historisch Genootschap*, 27 (1906), 131–268.

Mummenhof, Ernst, "Hans Tucher," *Allgemeine Deutsche Biographe (ADB)*, 38 (1894), 765–67.

Murphy O'Connor, Jerome, *The Holy Land: An Oxford Archeological Guide, From Earliest Times to 1700* (Oxford: Oxford University Press, 2008).

Nagel, Alexander and Christopher S. Wood, *Anachronic Renaissance* (New York: Zone, 2010).

Natural Materials of the Holy Land and the Visual Translation of Place, 500–1500, ed. by Renana Bartal, Neta Bodner, and Bianca Kühnel (London: Routledge, 2017).

Naujokat, Anke, "Imitations of the Holy Sepulchre and the Significance of 'Holy Measures,'" in *Jerusalem Elsewhere—The German Recensions*, ed. by Bianca Kühnel and Pnina Arad, (Jerusalem: Spectrum, 2014), pp. 13–21.

Naujokat, Anke, "Kopie der Kopie: Das Heilige Grab von San Rocco, Sansepolcro," in *Raubkopie* (Aachen: Redaktion Archimaera, 2009), pp. 13–34.

Naujokat, Anke, *Non est hic: Leon Battista Albertis Tempietto in der Cappella Rucellai* (Aachen: Geymüller, 2011).

Nazarenko, Alexander V., International Relations of Ancient Rus': The multidisciplinary studies on the cultural, commercial, and political connections of Russia in the ninth to twelfth centuries [Древняя Русь на международных Путях: Междисциплинарные Очерки Культурных, Торговых, Политических Ссвязей IX-XII веков], *Studia historica* (Moscow: Languages of the Russian Culture, 2001).

Nerli, Antonio, *Breve Chronicon monasterii mantuani sancti Andree ord. Bened. 800-1431* (London: Forgotten Books, 2016).

Nerlius, Antonius, *Breve Chronicon Monasterii Mantuani Sancti Andreae ord. Benedict. Ab Anno MXVII usque ad MCCCCXVIII*, in *Rerum Italicarum Scriptores,* ed. by Ludovico Antonio Muratori (Milan, 1738), XXIV, pp. 1071–84.

Neun Hundert Jahre Heilig-Blut-Verehrung in Weingarten, 1094–1994: Festschrift zum Heilig-Blut-Jubiläum am 12 März 1994, ed. by Norbert Kruse and Rolf Schaubode (Sigmaringen: Jan Thorbecke, 1994).

New Jerusalem (Новые Иеруcалимы: Иероторпия и иконография сакральных пространств), ed. by Alexei Lidov (Moscow: Indrik, 2009).

Nicholson, Helen J., "Women's Involvement in the Crusades," in *The Crusader World*, ed. by Adrian J. Boas (London: Routledge, 2016), pp. 54–67.

Nicholson, Helen J., "Women on the Third Crusade," *Journal of Medieval History*, 23 (1997), 335–49.

Nicolini, Dino, "Il Ritrovamento e il Restauro delle testimonianze architettoniche del Monastero di Sant'Andrea in Mantova," in *Il Sant'Andrea di Mantova e Leon Battista Alberti: Atti del convegno di studi organizzato dalla Città di Mantova con la collaborazione dell'Accademia Virgiliana, nel quinto centenario della basilica di Sant'Andrea e della morte dell'Alberti, 1472–1972* (Mantua: Edizione della Biblioteca comunale di Mantova, 1974), pp. 51–70.

Nieberlein, Johann Adam, *Aufwarter und treue Diener deß Neuen Aychstättischen Jerusalem: Das ist, Lob- und Danck-Predig bey Feyerlicher Begehung deß Ersten Jubel-Jahrs, oder Hundert-Jährigen Welt-Gangs der P.P. Capuccinorum in Aychstätt* (Aychstätt: Strauß, 1725).

Niedersächsisches Klosterbuch: Verzeichnis der Klöster, Stifte, Kommenden und Beginenhäuser in Niedersachsen und Bremen von den Anfängen bis 1810, ed. by Josef

Dolle, Veröffentlichungen der Historischen Kommission für Hessen, 56, 4 vols. (Bielefeld: Verlag für Regionalgeschichte, 2012).

Niehoff, Franz, "Das Kölner Ostergrab—Studien zum Heiligen Grab im hohen Mittelalter," *Wallraf-Richartz-Jahrbuch*, 51 (1990), 7–68.

Niehoff, Franz, "Das Ostergrab in St. Michael," in *Der vergrabene Engel: Die Chorschranken der Hildesheimer Michaeliskirche; Funde und Befunde; Katalog zur Ausstellung des Dom- und Diözesanmuseums Hildesheim*, ed. by Michael Brandt (Hildesheim: Dom- und Diözesanmuseum Hildesheim, 1995), pp. 127–33.

Nikolajeva, Tatiana V., *Plastic Art of Old Russia: Small carvings and castings, eleventh to sixteenth centuries* [Древнерусская мелкая пластика из камня XI–XV вв], ed. by Boris A. Rybakov, vol. E1-60, Археология СССР, Свод археологических источников, E1-60 (Moscow: Nauka, 1983).

Noack, Werner, "Ein erstes Heiliges Grab in Freiburg," *Zeitschrift für Kunstgeschichte*, 23, nos. 3/4 (1960), 246–52.

Noonan, F. Thomas, *The Road to Jerusalem: Pilgrimage and Travel in the Age of Discovery* (Philadelphia: University of Pennsylvania Press, 2007).

Nova, Alessandro, "'Popular Art in Renaissance Italy: Early Response to the Holy Mountain at Varallo," in *Reframing the Renaissance*, ed. by Claire Farago (New Haven: Yale University Press, 1995), pp. 113–26.

Nusselder, E. J., "De Marthakapel te Delft: Een onderzoek," *Bulletin KNOB*, 79 (1980), 51–87.

Odložilík, Otakar, "The Chapel of Bethlehem in Prague: Remarks on its Foundation Charter," in *Studien zur älteren Geschichte Osteuropas*, ed. by Günther Stökl (Graz-Cologne: H. Böhlaus, 1956), pp. 125–41.

Oexle, Otto Gerhard, "Die Gegenwart der Toten," in *Death in the Middle Ages*, ed. by Herman Braet and Werner Verbeke (Leuven: Leuven University Press, 1983), pp. 19–77.

Oexle, Otto Gerhard, "Memoria und Memorialbild," in *Memoria: Der geschichtliche Zeugniswert des liturgischen Gedenkens im Mittelalter*, ed. by Karl Schmid and Joachim Wollasch (Munich: Fink, 1984), pp. 384–440.

Ogden, Dunbar H., *The Staging of Drama in the Medieval Church* (Newark: University of Delaware Press, 2002).

Ohler, Norbert, *Pilgerstab und Jakobsmuschel: Wallfahren in Mittelalter und Neuzeit* (Dusseldorf: Artemis und Winkler, 2000).

Oikonomides, Nikolaos, "St. George of Mangana, Maria Skleraina and the 'Malyi Sion' of Novgorod," *Dumbarton Oaks Papers*, 34/35 (1980–81), 239–46.

Olañeta, Juan Antonio, "San Sebastián de Sallent," in *Enciclopedia del Románico en Cataluña: Barcelona*, pp. 987–90.

Oldřich Prefát z Vlkanova: Cestaz Prahy do Benátek a odtud potom po moři až do Palestiny [Oldřich Prefát of Vlkanova: A journey from Prague to Venice, and then by sea to Palestine], ed. by Hana Bočková (Praha: Nakladatelství Lidové noviny, 2007).

Oliba episcopus, ed. by Marc Sureda, (Vic: Museu Episcopal de Vic, 2018) .

Oosterbaan, D. P., "Kroniek van de Nieuwe Kerk te Delft," *Haarlemse Bijdragen: Bouwstoffen voor de geschiedenis van het bisdom Haarlem*, 65 (1958), 2–336.

Oppenheimer, Michael, *Monuments of Italy: A Regional Survey of Art, Architecture and Archaeology from Classical to Modern Times* (London: Tauris, 2002).

Oracional visigótico e hispano-romanos, ed. by José Vives (Barcelona: Consejo Superior de Investigaciones Científicas, Instituto Enrique Flórez, 1966), p. 175, r. 523.

Orlandi, Silvia, "Elena e Santa Croce in Gerusalemme," in *L'impero costantiniano e i luoghi sacri,* ed. by Tessa Canella (Bologna: Il Mulino, 2016), pp. 273–92.

Osten, Friedrich, *Die Bauwerke der Lombardei: VII. bis XIV. Jarhundert* (Darmstadt: Osten, 1847).

Ousterhout, Robert G., "Architecture, Art, and Komnenian Ideology at the Pantokrator Monastery," in *Byzantine Constantinople: Monuments, Topography and Everyday Life*, ed. by Nevra Necipoğlu (Leiden: Brill, 2001), pp. 133–50.

Ousterhout, Robert G., "Architecture as Relic and the Construction of Sanctity: The Stones of the Holy Sepulchre," *Journal of the Society of Architectural Historians*, 62 (2003), 4–23.

Ousterhout, Robert G., "Building the New Jerusalem," in *Jerozolima W Kulturze Europejskiej / Jerusalem in European Culture: Akten der Tagung 14.–17. Mai 1996 in Warschau*, ed. by Piotr Paszkiewicz and Tadeusz Zadrozny (Warsaw: Institut Sztuki Polskiej Akademii Nauk, 1997), pp. 143–54.

Ousterhout, Robert G., "The Church of Santo Stefano: A 'Jerusalem' in Bologna," *Gesta*, 20, no. 2 (1981), 311–21.

Ousterhout, Robert G., "Flexible Geography and Transportable Topography," in *The Real and Ideal Jerusalem in Jewish, Christian and Islamic Art*, ed. by Bianca Kühnel, *Jewish Art*, 23/24 (1997/98), 393–404.

Ousterhout, Robert G., "Loca Sancta and the Architectural Response to Pilgrimage," in *The Blessings of Pilgrimage*, ed. by Robert G. Ousterhout (Urbana: University of Illinois Press, 1990), pp. 108–24.

Ousterhout, Robert G., "Sacred Geographies and Holy Cities: Constantinople as Jerusalem," in *Hierotopy—the Creation of Sacred Spaces in Byzantium and Medieval Russia*, ed. by Alexei Lidov (Moscow: Indrik, 2006), pp. 98–116.

Ousterhout, Robert G., "'Sweetly Refreshed in Imagination': Remembering Jerusalem in Words and Images," *Gesta*, 48, no. 2 (2009), 153–68.

Ousterhout, Robert G., "Visualizing the Tomb of Christ: Images, Settings, and Ways of Seeing," in *Visual Constructs of Jerusalem*, ed. by Bianca Kühnel, Galit Noga-Banai, and Hanna Vorholt (Turnhout: Brepols, 2014), pp. 439–50.

Paci, Adrian, "Adrian Paci in a Conversation with Mirjam Varadinis," in *Adrian Paci: Electric Blue* (Zurich: Kunsthaus Zürich, 2010), pp. 5–23.

Paci, Adrian, "Adrian Paci Discusses His Work in the Church of San Bartolomeo with Paola Nicolin," trans. by Marguerite Shore, *Artforum* (July 2011).

Paci, Adrian, "Conversation between Angela Vettese and Adrian Paci," in *Adrian Paci*, ed. by Angela Vettese (Milan: Charta—Galleria Civica, Modena, 2006) pp. 7–31.

Pánek, Jaroslav et al., *A History of the Czech Lands* (Prague: Karolinum, 2009).

Pánek, Jaroslav, "The Nobility in the Czech Lands, 1550–1650," in *Rudolf II and Prague—The Court and the City*, ed. by Eliška Fučíková (London: Thames & Hudson, 1997), pp. 270–86.

Pascual, Carlos, *Viaje de Egeria: El primer relato de una viajera hispana* (Madrid: La línea del horizonte, 2017).

Pasolini, Pier Paolo, *Pasolini on Pasolini: Interviews with Oswald Stack* (Bloomington: Indiana University Press, 1969).

Passion und Ostern in den Lüneburger Klöstern: Bericht des VIII. Ebstorfer Kolloquiums Kloster Ebstorf, 25. bis 29. März 2009, ed. by Linda Maria Koldau (Ebstorf: Kloster Ebstorf, 2010).

Patriarch Nikon on Church and State. Nikon's "Refutation," ed. by Valerie A. Tumins and George Vernadsky, Slavistic Printings and Reprintings 300 (Berlin: Mouton, 1982), pp. 149–68.

Paul, Nicholas L., *To Follow in Their Footsteps: The Crusades and Family Memory in the High Middle Ages* (Ithaca: Cornell University Press, 2012).

Payne, Alina, "From Riverbed to Seashore: An Introduction," in *The Land Between Two Seas: Art on the Move in the Mediterranean and the Black Sea, 1300–1700*, ed. by Alina Payne (Leiden: Brill, 2022).

Payne, Alina, "Materiality, Crafting and Scale," *Oxford Art Journal*, 32, no. 3 (2009), 365–86.

Payne, Alina, "Portable Ruins: The Pergamon Altar, Heinrich Wölfflin and German Art History at the *fin de siècle*," *RES. Journal of Aesthetics and Anthropology*, 54/55 (2008), 168–89.

Payne, Alina, "The Portability of Art: A Prolegomena of Art and Architecture on the Move," in *Territories and Trajectories: Cultures in Circulation*, ed. by Diana Sorensen (Durham: Duke University Press, 2018), pp. 91–109.

Payne, Alina, "Wrapped in Fabric: Florentine Facades, Mediterranean Textiles and A-Tectonic Ornament in the Renaissance, " in *Ornament: Between Local and Global*, ed. by Gulru Necipoglu and Alina Payne (Princeton: Princeton University Press, 2017), pp. 274–89.

Peig, Concepció, "St Maria de Ripoll: L'acta de consagració de l'any 977 i el problema dels *tituli*," in *Actes del Congrés Internacional Gerbert d'Orlhac i el Seu Temps: Catalunya i Europa a la fi del 1r. mil·leni, Vic-Ripoll, 10–13 de novembre de 1999*, dir. by Imma Ollich (Vic: Eumo, 1999), pp. 839–60.

Pentkovskiy, Aleksey M., "'Jerusalemization' of the Liturgical Space in Byzantine Tradition ['Иерусалимизация' литургического пространства в Византийской традиции], in *Новые Иерусалимы—Иеротопия и иконография сакральных пространств*, ed. by Alexei M. Lidov (Moscow: Indrik, 2009), pp. 58–77 (Russian with English summary).

Perina, Chiara, *La basilica di S. Andrea in Mantova* (Mantua: Istituto Carlo d'Arco per la Storia di Mantova, 1966).

Petrynko, Oleksandr, "Heiliges Grab aus Eichstätt wird in der Ukraine nachgebaut," in *Weitblick: Blog der Diözese Eichstätt*, 6 August 2018, http://weitblick.bistum-eichstaett.de/author/oleksandr-petrynko/page/3/.

Pevsner, Nikolaus and Bridget Cherry, *Northamptonshire* (Harmondsworth: Penguin, 1973).

Piccirillo, Michele, *La Nuova Gerusalemme. Artigianato palestinese al servizio dei Luoghi Santi; Edizioni custodia di terra santa* (Regione Piemonte: Centro di Documentazione dei Sacri Monti, Calvari e Complessi devozionali europei, 2007).

Pilgrim and Preacher: The Audiences and Observant Spirituality of Friar Felix Fabri (1437/8–1502), ed. By Kathryne Beebe (Oxford: Oxford University Press, 2014.

Pinchover, Lotem, "The Presence of Jerusalem in Medieval Saxon Convents: Art and Cult" (unpublished doctoral thesis, The Hebrew University of Jerusalem, 2020).

Pinchover, Lotem, "A Tale of Three Cities: Between Jerusalem and Gerusalemme – Gernrode of (St.) Scholastica," *21: Inquiries into Art, History, and the Visual*, 1, no. 1 (2020), 97–125.

Pinchover, Lotem, "The *via crucis* in Wienhausen: Visual Witnesses," in *Jerusalem Elsewhere*, pp. 91–98.

Pischke, Gudrun ed. *Geschichtlicher Handatlas von Niedersachsen* (Neumünster: Wachholtz, 1989).

Piva, Paolo, "Le copie del Santo Sepolcro nell'Occidente romanico: Varianti di una relazione problematica," in *Il Mediterraneo e l'arte nel Medioevo*, ed. by Roberto Cassanelli and Maria Andaloro (Milan: Jaca, 2000), pp. 97–118.

Pleticha-Geuder, Eva and Angelika Pabel, *Reise, Rast und Augenblick: Mitteleuropäische Stadtansichten aus dem 16. Jahrhundert*, Ausstellung der Universitätsbibliothek Würzburg (Dettelbach: J. H. Roll, 2002).

Poisson, Olivier, "L'église Saint-Michel de Cuxa, de Garin à Oliba," in *Le "premier art roman" cent ans après*, ed. by Eliane Vergnolle and Sébastien Bully (Besançon: Presses universitaires de Franche-Comté, 2012), pp. 287–98.

Poneß, Kirsten, *Klostergut Wöltingerode*, DKV–Kunstführer 650 (Munich: Deutscher Kunstverlag, 2011).

Ponsich, Pierre, "Roussillonnais, cerdans et catalans du haut moyen-âge sur les routes des grandes pèlerinages," *Les Cahiers de St Michel de Cuxa*, 3 (2000), 85–96.

Poppenrod, Andreas, "*Annales Gernrodensium*", in *Accessiones Historiae Anhaltinae*, ed. by Johann Christoph Beckmann (Zerbst: Zimmermann, 1716), pp. 27–82.

La portalada de Ripoll: Creació, conservació i recuperació, ed. by Marc Sureda (Rome: Viella, 2018).

Pounds, Norman John Greville, *The Medieval Castle in England and Wales: A Social and Political History* (Cambridge: Cambridge University Press, 1990).

Powell, Amy Knight, *Depositions: Scenes from the Late Medieval Church and the Modern Museum* (New York: Zone, 2012).

Pringle, Denys, "Architecture in the Latin East, 1098–1571," in *The Oxford Illustrated History of the Crusades*, ed. by Jonathan Riley-Smith (Oxford: Oxford University Press, 2001), pp. 160–83.

Pringle, Denys, *The Churches of the Crusader Kingdom of Jerusalem: A Corpus*, 3 vols. (Cambridge: Cambridge University Press, 1993–2007).

Pringle, Denys, "The Crusader Church of the Holy Sepulchre," in *Tomb and Temple: Reimagining the Sacred Buildings of Jerusalem*, ed. by Robin Griffith-Jones (Woodbridge: Boydell and Brewer, 2018), pp. 76–94.

Proto Pisani, Rosanna Caterina, *La Gerusalemme di San Vivaldo* (Livorno: Polistampa, 2006).

Puertas Tricas, Rafael, *Iglesias hispánicas (siglos IV al VIII): Testimonios literarios* (Madrid: Ministerio de Educación y Ciencia, 1975).

Quintilianus, Marcus Fabius, *Institutio oratoria* V.11.22–24, ed. and trans. by Helmut Rahn, *Ausbildung des Redners*, 12 vols. (Darmstadt: Wissenschaftliche Buchgesellschaft, 2011).

Rachman-Schrire, Yamit, "Christ's Unction and the Material Realization of a Stone in Jerusalem," in *Natural Materials of the Holy Land and the Visual Translation of Place, 500–1500*, ed. by Renana Bartal, Neta Bodner, and Bianca Kühnel (London: Routledge, 2017), pp. 216–29.

Rachman-Schrire, Yamit, "The Stones of the Christian Holy Places of Jerusalem and Western Imagination: Image, Place, Text (1099–1517)" (unpublished doctoral thesis, Hebrew University of Jerusalem, 2015).

Rainer A. Müller, "Friedrich von Dohnas Reise durch Bayern in den Jahren 1592/3," *Oberbayerisches Archiv*, 101 (1976), 301–13.

Rafart, Claustre and Joan-Albert Adell, "St Esteve d'Olius," in *Catalunya Romànica* (Barcelona: Enciclopèdia Catalana, 1987), XIII, pp. 220–31.

Rakova, Snezhana, *The Fourth Crusade in the Historical Memory of the Eastern Orthodox Slavs*, trans. by Peter Skipp (Sofia: Tendril, 2013).

Ramos, M. Lluïsa and Joan Adell, "St Sepulcre de Palera," in *Catalunya Romànica* (Barcelona: Enciclopèdia Catalana, 1990), IV, *La Garrotxa*, pp. 231–36.

Raymond d'Aguilers, *Historia Francorum qui ceperunt Iherusalem*, trans. by John Hugh Hill and Laurita L. Hill (Philadelphia: American Philosophical Society, 1968).

Regesta Regum Anglo-Normannorum, 1066–1154, ed. by Charles Johnson and Henry Alfred Cronne (Oxford: Clarendon Press, 1956), II: *Regesta Henrici Primi, 1100–1135*.

Die Reisebilder Pfalzgraf Ottheinrichs aus den Jahren 1536/1537 von seinem Ritt von Neuburg a.d. Donau über Prag nach Krakau und zurück über Breslau, Berlin, Wittenberg und Leipzig nach Neuburg, ed. by Angelika Marsch, Josef H. Biller and Frank-Dietrich Jacob (Weißenhorn: Konrad, 2001).

Das Reisebuch der Familie Rieter, ed. by Reinhold Röhricht and Heinrich Meisner, Bibliothek des Litterarischen Vereins in Stuttgart, 168 (Tübingen: Litt. Verein Stuttgart, 1884).

Reiß, Hans, "Die Ausgrabungen im Kapuzinerkloster," in *Eichstätt: 10 Jahre Stadtkernarchäologie, Zwischenbilanz einer Chance*, ed. by Karl H. Rieder and Ute Blenk (Kipfenberg: Hercynia, 1992), pp. 120–22.

Remembering the Crusades: Myth, Image, and Identity, ed. by Nicholas Paul and Suzanne Yeager, Rethinking Theory (Baltimore: Johns Hopkins University Press, 2012).

Remolà Vallverdú, Josep Anton and Meritxell Pérez Martínez, "Centcelles y el *praetorium* del *comes Hispaniarum* Asterio en Tarraco," *Archivo Español de Arqueología*, 86 (2013), 161–86.

Reudenbach, Bruno, "Holy Places and Their Relics," in *Visual Constructs of Jerusalem*, ed. by Galit Noga-Banai, Hanna Vorholt, and Bianca Kühnel (Turnhout: Brepols, 2014), pp. 197–206.

Riain, Diarmuid Ó, "An Irish Jerusalem in Franconia: The Abbey of the Holy Cross and Holy Sepulchre at Eichstätt," *Proceedings of the Royal Irish Academy*, 112C (2012), 1–52.

Riain, Diarmuid Ó, "Schottenklöster: The Early History and Architecture of the Irish Benedictine Monasteries in Medieval Germany" (unpublished doctoral thesis, University College, School of Archaeology, 2008).

Riedel, Adolph Friedrich, *Codex diplomaticus Brandenburgensis: Sammlung der Urkunden, Chroniken und sonstigen Quellenschriften für die Geschichte der Mark Brandenburg und ihrer Regenten* (Berlin: F. H. Morin, 1859), XVI, p. 418, no. 44

Rieter, Sebald, "Sebald Rieters Reisen," in *Das Reisebuch der Familie Rieter*, ed. by Reinhold Röhricht and Heinrich Meisner (Tübingen: Litt. Verein Stuttgart, 1884), pp. 9–36.

Riggert, Ida-Christine, *Die Lüneburger Frauenklöster*, Veröffentlichungen der Historischen Kommission für Niedersachsen und Bremen 37 (Hannover: Hahnsche Buchhandlung, 1996).

Riley-Smith, Jonathan, *The First Crusade and the Idea of Crusading* (Philadelphia: University of Pennsylvania Press, 1986).

Ritoók, Pál, "The Architecture of the Knights Templars in England," in *The Military Orders: Fighting for the Faith and Caring for the Sick*, ed. by Malcolm Barber (Aldershot: Variorum, 1994), pp. 167–78.

Ritscher, Ernst, *Die Kirche S. Andrea in Mantua* (Berlin: Wilhelm Ernst, 1899).

Rivoira, Giovanni T., *Le origini dell'architettura lombarda* (Milan: Ulrico Hoepli, 1901).

Röckelein, Hedwig, "The Cult of the Invisible—Relics in the Cistercian Houses Loccum and Wienhausen," in *Devotional Cross-Roads: Practicing Love of God in Medieval Jerusalem, Gaul and Saxony*, ed. by Hedwig Röckelein, Galit Noga-Banai and Lotem Pinchover (Göttingen: University Press, 2019), pp. 161–209.

Röckelein, Hedwig, *Schriftlandschaften, Bildungslandschaften und religiöse Landschaften des Mittelalters in Norddeutschland*, Wolfenbütteler Hefte 33 (Wiesbaden: Harrassowitz, 2015).

Rodighiero Astolfi, Luciana, "The History and Tradition of the Precious Blood of Christ in Mantua," *International Journal for the Study of the Christian Church*, 17, no. 4 (2017), 224–27.

Roffe, David, "The *Historia Croylandensis*: A Plea for Reassessment," *English Historical Review*, 110 (1995), 93–108.

Rohdie, Sam, *The Passion of Pier Paolo Pasolini* (Bloomington: Indiana University Press, 1995).

Romney, Paul, ed., *The Diary of Charles Fothergill 1805: An Itinerary to York, Flamborough and the North-Western Dales of Yorkshire*, Yorkshire Archaeological Society Record series, 142 (Leeds: The Yorkshire Archaeological Society 1984).

Rosario, Iva, *Art and Propaganda, Charles IV of Bohemia, 1346–1378* (Woodbridge: Boydell, 2000).

Royal Commission on Historical Monuments, *An Inventory of the Historical Monuments in the County of Northampton* (London: Her Majesty's Stationary Office, 1985), V: *Archaeological Sites and Churches in Northampton*, pp. 59–66 (henceforth: *RCHM*).

Rüdiger, Michael, *Nachbauten des Heiligen Grabes in Jerusalem in der Zeit von Gegenreformation und Barock* (Regensburg: Schnell und Steiner, 2003).

Rudy, Kathryn M., "A Guide to Mental Pilgrimage: Paris, Bibliotheque de l'Arsenal Ms. 212," *Zeitschrift für Kunstgeschichte*, 63, no. 4 (2000), 494–515.

Rudy, Kathryn M., *Virtual Pilgrimages in the Convent: Imagining Jerusalem in the Late Middle Ages* (Turnhout: Brepols, 2011).

Rummel, Peter and Konrad Rainer, *Das Heilige Grab in Maria Medingen* (Lindenberg: Kunstverlag Fink, 2000).

Rüthing, Heinrich, "Die mittelalterliche Bibliothek des Zisterzienserinnenklosters Wöltingerode," in *Zisterziensische Spiritualität: Theologische Grundlagen, funktionale Voraussetzungen und bildhafte Ausprägungen im Mittelalter*, ed. by Clemens Kaspar and Klaus Schreiner, Studien und Mitteilungen zur Geschichte des Benediktinerordens und seiner Zweige, Ergänzungsband 34 (St. Ottilien: EOS, 1994), I, pp. 189–216.

Ryndina, Anna V., Old Russian Small-scale Sculpture: Novgorod and Central Russia in Fourteenth to Fifteenth centuries [Древнерусская мелкая пластика: Новгород и Центральная Русь XIV–XV веков] (Moscow: Nauka, 1978).

Ryndina, Anna V., "Old Russian Pilgrim's Relics: An image of the Heavenly Jerusalem in small stone icons in thirteenth to fifteenth centuries" [Древнерусские паломнические реликвии: Образ Небесного Иерусалима в каменных иконах XIII-XV вв.], in *Иерусалим в Русской Культуре*, ed. by Andrei L. Batalov and Alexei M. Lidov (Moscow: Nauka, 1994), pp. 63–85.

Ryndina, Anna, "Old Russian Pilgrims' Relics: An Image of the Heavenly Jerusalem in Small Stone Icons in 13th to 15th Centuries," in *Jerusalem in Russian Culture*, ed. by Andrei Batalov and Alexei Lidov (New Rochelle: A. D. Caratzas, 2005).

Saalman, Howard, Livio Volpi Ghirardini and Anthony Law, "Recent Excavations under the 'Ombrellone' of Sant'Andrea in Mantua: Preliminary Report," *Journal of the Society of Architectural Historians*, 51, no. 4 (1992), 357–76.

Sacramentarium Rivipullense, ed. by Alejandro Olivar (Madrid-Barcelona: CSIC, 1964), piece 422-24.

Sadler, Donna L., *Stone, Flesh, Spirit: The Entombment of Christ in Late Medieval Burgundy and Champagne* (Leiden: Brill, 2015).

Sahler, Hildegard, "Architektur als Objekt der Verehrung: Entstehung und Wirkung der Grossreliquien in Loreto, Assisi und Jerusalem," in *Architektur als Objekt/ Architecture as Object* ed. by Ulrich Großmann and Petra Krutisch, in *The Challenge of the Object: 33rd Congress of the International Committee of the History of Art, Nuremberg, 15th–20th July 2012,* Section 20 (Nuremberg: Deutsches Nationalmuseum, 2013), vol IV, pp. 1420–24.

Salvadó, Sebastián, "Rewriting the Latin Liturgy of the Holy Sepulchre: Text, Ritual and Devotion for 1149," in *Liturgy and Devotion in the Crusader States*, ed. by Iris Shagrir and Cecilia Gaposchkin, Journal of Medieval History, 43/44 (special issue) (2017), pp. 403–20

Salvarani, Renata, *La fortuna del Santo Sepulcro nel Medioevo: Spazio, liturgia, archittetura* (Florence: Jaca, 2008).

Salvarani, Renata, "La reliquia del preziosissimo Sangue di Cristo conservata a Mantova: Aspetti politici e dottrinali tra IX e XI Secolo," *Studi Ecumenici*, 24 (2006), 563–84.

Sandys, George, *Relation of a Journey begun Anno Domini 1610* (London: Thomas Cotes, 1637).

Il Sant'Andrea di Mantova e Leon Battista Alberti: Atti del convegno di studi organizzato dalla Città di Mantova con la collaborazione dell'Accademia Virgiliana, nel quinto centenario della basilica di Sant'Andrea e della morte dell'Alberti, 1472–1972 (Mantua: Edizione della Biblioteca comunale di Mantova, 1974).

Schedel, Hartmann, Michael Wolgemut and Wilhelm Pleydenwurff, *Liber chronicarum 1493.07.12* (Nürnberg, 1493).

Schein, Sylvia, *Gateway to the Heavenly City: Crusader Jerusalem and the Catholic West (1099–1187)* (Aldershot: Ashgate, 2005).

Schein, Sylvia, "Jerusalem in Christian Spirituality in the Crusader Period," in *The History of Jerusalem: Crusaders and Ayyubids (1099–1250)*, ed. by Joshua Prawer (Jerusalem: Yad Ben-Zvi, 1991), pp. 213–63 (Hebrew).

Scheygrond, Arie, *Goudsche Straatnamen* (Alphen aan den Rijn: Canaletto, 1979).

Schmidt, Michael, "'Neues Aychstättisches Jerusalem': Das Heilige Grab in der Kapuzinerkirche von Eichstätt; Bau und Ausstattung," *Jahrbuch der Bayerischen Denkmalpflege* 58/59 (2007), 19–43.

Schneider, Wolfgang Ludwig, *Peregrinatio hierosolymitana: Studien zum spätmittelalterlichen Jerusalembrauchtum und zu den aus der Heiliglandfahrt hervorgegangenen nordwest-europäischen Jerusalembruderschaften* (Paris: Éditeur inconnu, 1980).

Schneider, Wolfgang, *"Peregrinatio Hierosolymitana"* (unpublished doctoral thesis, Freie Universität Berlin, 1982).

Schröter, Nicole, *Das Heilige Grab von St. Cyriacus zu Gernrode: Ausdruck der Jerusalemfrömmigkeit der Gernröder Stiftsdamen*, Quellen und Forschungen zur Geschichte Sachsen-Anhalts 11 (Halle [Saale]: Mitteldeutscher Verlag, 2017).

Schulze, Hans K., *Das Stift Gernrode* (Cologne: Böhlau, 1965).

Schulze, Heinz-Joachim, "Neuenwalde," in *Die Frauenkloster in Niedersachsen, Schleswig-Holstein und Bremen*, ed. by Ulrich Faust, Germania Benedictina 11 (St. Ottilien: EOS, 1984), pp. 429–46.

Schwarzweber, Annemarie, *Das Heilige Grab in der deutschen Bildnerei des Mittelalters* (Freiburg: Albert, 1940).

Schwemmer, Wilhelm and Lagois Martin, *Die Sebalduskirche zu Nürnberg* (Nuremberg: Alber Hofmann, 1979).

Scott, Forrest S., "Earl Waltheof of Northumbria," *Achaeologia Aeliana*, 4th ser., 30 (1952), 149–215.

Šedinová, Hana, "The Symbolism of the Precious Stones in St. Wenceslas Chapel," *Artibus et Historiae*, 20 (1999), pp. 75–94.

Segagni Malacart, Anna, "Cripte lombarde della prima metà del secolo XI," in *Medioevo: Arte lombarda*, ed. by Arturo Carlo Quintavalle (Milan: Einaudi, 2004), pp. 88–103.

Serjeantson, Robert Meyricke, "The Origin and History of the de Senlis Family, Grand Butlers of France and the Earls of Northampton and Huntingdon," *Northampton and Oakham Architectural and Archaeological Society: Associated Architectural Societies Reports and Papers*, 31 (1912), 504–17.

Seyama, Jun'ichiro and Ruth S. Nagayama, "The Uncanny Valley: Effect of Realism on the Impression of Artificial Human Faces," *Presence: Teleoperators and Virtual Environments*, 16, no. 4 (2007), 337–51.

Seyfried, Peter and Jutta Brüdern, *Die Klosterkirche zu Diesdorf*, Grosse Baudenkmäler 463, 3rd ed. (Munich: Dt. Kunstverlag, 1998).

Shagrir, Iris, "*Adventus* in Jerusalem: The Palm Sunday Celebration in Latin Jerusalem," *Journal of Medieval History*, 41(2015), 1–20.

Shagrir, Iris, "The 'Holy Women' in the Liturgy and Art of the Church of the Holy Sepulchre in Twelfth Century Jerusalem," in *The Uses of the Bible in Crusader Sources*, ed. by Elizabeth Lapina and Nicholas Morton (Leiden: Brill, 2017), pp. 455–75.

Shagrir, Iris, "The Visitatio Sepulchri in the Latin Church of the Holy Sepulchre in Jerusalem," *Al-Masaq: Islam and the Medieval Mediterranean*, 22 (2010), 57–77.

Shalev, Zur, "Christian Pilgrimage and Ritual Measurement in Jerusalem," *Micrologus/La misura*, 19 (2011), 131–50.

Shandrovskaya, Valentina S.,"The Greek Inscription of the 'Small Novgorod Sion'" [Греческая Надпись 'Малого Новгородского Сиона'], *Византийский Временник*, 38 (1977), 157–60.

Sheingorn, Pamela, *The Easter Sepulchre in England* (Kalamazoo: Medieval Institute Publications, 1987).

Shoemaker, Stephen J., *Ancient Traditions of the Virgin Mary's Dormition and Assumption* (Oxford: Oxford University Press, 2002).

Shoemaker, Stephen J., "The Cult of the Virgin in the Fourth Century: A Fresh Look at Some Old and New Sources," in *Origins of the Cult of the Virgin Mary*, ed. by Chris Maunder (London: Bloomsbury, 2008), pp. 71–88.

Siart, Olaf, *Kreuzgänge mittelalterlicher Frauenklöster: Bildprogramme und Funktionen* (Petersberg: Imhof, 2008).

Siew, Tsafra, "Translations of the Jerusalem Pilgrimage Route at the Holy Mountains of Varallo and San Vivaldo," in *Between Jerusalem and Europe: Essays in Honour of Bianca Kühnel*, ed. by Renana Bartal and Hanna Vorholt (Leiden: Brill, 2015), pp. 113–32.

Slater, Laura, "Recreating the Judean Hills? English Hermits and the Holy Land," *Journal of Medieval History*, 42, no. 5 (2016), 603–26.

Sloane, Barney and Gordon Malcolm, *Excavations at the Priory of the Order of the Hospital of St John Jerusalem, Clerkenwell, London* (London: Museum of London Archaeology Service, 2004).

Smith, Jonathan Z., "Constructing a Small Place," in *Sacred Space: Shrine, City, Land; Proceedings from the International Conference in Memory of Joshua Prawer*, ed. by Benjamin Z. Kedar and R. J. Zwi Werblowsky (New York: New York University Press, 1998), pp. 18–31.

Smith, Julia, "Eleventh-Century Relic Collections and the Holy Land," in *Natural Materials of the Holy Land and the Visual Translation of Place, 500–1500*, ed. by Renana Bartal, Neta Bodner, and Bianca Kühnel (London: Routledge, 2017), pp. 19–35.

Smoldon, W. L., "The Easter Sepulchre Music-Drama," *Music & Letters*, 27, no. 1 (1946), 1–17.

Sokolova, Irina M., "New Jerusalem in Kremlin: Unfinished Plan of Tsar Fyodor Alexeevich" [Новый Иерусалим в Кремле: Незавершенный замысел царя Федора Алексеевича], in *Художественные памятники Московского Кремля, Материалы и исследования*, 16 (Moscow: Moscow Kremlin Museum, 2003).

Somerville, Robert, "The Council of Clermont (1095) and Latin Christian Society," *Archivum Historiae Pontificiae*, 12 (1974), 55–90.

Spear, David S., "The School of Caen Revisited," *Haskins Society Journal*, 4 (1992), 55–66.

Sperling, Christine M., "Leon Battista Alberti's Inscriptions on the Holy Sepulchre in the Cappella Rucellai, San Pancrazio, Florence," *Journal of the Warburg and Courtauld Institutes*, 52 (1989), 221–28.

Splendours of the Gonzaga, ed. by David Chambers and Jane Martineau (London: Victoria and Albert Museum, 1981).

Sprokholt, Henkjan and Henny van Dolder-de Wit, *Op gewijde grond gebouwd* (Gouda: Stichting Open Monumentendag, 2005).

Stagl, Justin, *A History of Curiosity: The Theory of Travel, 1550–1800* (London: Routledge, 1995).

Stalley, Roger, *Early Medieval Architecture* (Oxford: Oxford University Press, 1999).

Stein-Kecks, Heidrun, "Bilder im heiligen Raum," in *Geschichte der bildenden Kunst in Deutschland*, ed. by Susanne Wittekind (Munich: Prestel, 2009), II, pp. 264–355.

Sterligova, Irina A., "Jerusalems as liturgical vessels in Old Rus'" ["Иерусалимы как литургические сосуды в Древней Руси"], in *Иерусалим в Русской Культуре*, ed. by Andrei Batalov and Alexei Lidov (Moscow: Nauka, 1994), pp. 46–62.

Sterligova Irina A. and Lev I. Lifshitz, eds., *Decorative and Applied art of Novgorod the Great: Artistic metal of the eleventh to fifteenth centuries* [Декоративно-прикладное искусство Великого Новгорода: Художественный металл XI–XV века] (Moscow: Nauka, 1996).

Stewart, Susan, *On Longing* (Durham: Duke University Press, 1993).

Sticca, Sandro, *The Latin Passion Play: Its Origins and Development* (New York: State University of New York Press, 1970).

Sticca, Sandro, "The *Via Crucis*: Its Historical, Spiritual and Devotional Context," *Mediaevalia*, 15 (1985), 93–126.

Stiehl, Otto, *Der Backsteinbau romanischer Zeit besonders in Oberitalien und Norddeutschland* (Leipzig: Baumgaertner, 1898).

Stolyarov, Vyacheslav P., "Images of the Holy Land on Solovetsky Islands" [Образы Святой Земли на Соловецких Островах], *Соловецкое море: Историко-литературный альманах*, 2 (2003), 99–112.

Strayer, J. R., "France: The Holy Land, the Chosen People, and the Most Christian King," in *Action and Conviction in Early Modern Europe*, ed. by Theodore K. Rabb and Jerrold E. Seigel (Princeton: Princeton University Press, 1969), pp. 3–16.

Stringer, Keith, "Senlis, Simon (II) de, earl of Northampton and earl of Huntingdon (d. 1153)," in *Oxford Dictionary of National Biography* (Oxford: Oxford University Press, 2004), DOI: 10.1093/ref:odnb/25092.

Subiranas, Carme, "L'església de Santa Maria de la Rodona," *Arqueologia Medieval*, 1 (2005), 8–31.

Suitner-Nicolini, Gianna, "Il Monastero Benedettino di Sant'Andrea in Mantova : L'evoluzione dell'Organismo ed il suo Ruolo nella Formazione della Città Medievale," in *Ill Sant'Andrea di Mantova e Leon Battista Alberti: Atti del convegno di studi organizzato dalla Città di Mantova con la collaborazione dell'Accademia Virgiliana, nel quinto centenario della basilica di Sant'Andrea e della morte dell'Alberti, 1472–1972* (Mantua: Edizione della Biblioteca comunale di Mantova, 1974), pp. 35–50.

Sullivan, Donald, "The Holy Blood of Wilsnack: Politics, Theology and the Reform of Popular Religion in Late Medieval Germany," *Viator*, 47, no. 2 (2016): 249–76.
Sumption, Jonathan, *The Albigensian Crusade* (London: Faber & Faber, 2011).
Sumption, Jonathan, *Pilgrimage: An Image of Medieval Religion* (London: Faber & Faber, 1975).
Sureda, Marc, "Architecture autour d'Oliba: Le massif occidental de la cathédrale romane de Gérone," *Les Cahiers de Saint-Michel de Cuxa*, 40 (2009), 221–36.
Sureda, Marc, "Els precedents de la catedral de St Maria de Girona" (unpublished doctoral thesis, University of Girona, 2008).
Sureda, Marc, "*Lauda Iherusalem Dominum*. Liturgie stationnale et familles d'églises en Catalogne, XIe–XIVe siècles," *Quaestiones Medii Aevi Novae*, 20 (2015), 336–63.
Sureda, Marc, "Oliba *sapiens architectus*," in *Oliba episcopus*, ed. by Marc Sureda (Vic: Museu Episcopal de Vic, 2018), pp. 57–65 (Catalan version).
Sureda, Marc, "Romanesque Cathedrals in Catalonia as Liturgical Systems. A Functional and Symbolical Approach to the Cathedrals of Vic, Girona and Tarragona (Eleventh-Fourteenth Centuries)," in *Romanesque Cathedrals in Mediterranean Europe. Architecture, Ritual and Urban Context*, ed. by Gerardo Boto and Justin E. A. Kroesen (Turnhout: Brepols, 2016), pp. 223–241.
Sureda, Marc, "Santa Maria de Ripoll: Liturgie, identité et art roman dans une grande abbaye catalane," *Les Cahiers de Saint-Michel de Cuxa*, 49 (2018), 211–29.
Sureda, Marc, "Sobre el drama pasqual a la seu romànica de Girona: Arquitectura i litúrgia (ss. XI–XIV)," *Miscel·lània litúrgica catalana*, 16 (2008), 105–30.
Sureda, Marc, "The Sacred Topography of Girona Romanesque Cathedral (11th–12th centuries): Architectural Design, Saintly Dedications and Liturgical Functions," in *Material and Action in European Cathedrals (9th–13th centuries): Building, Decorating, Celebrating*, ed. by Gerardo Boto and C. García de Castro (Oxford: British Archaeological Reports, 2017), pp. 31–43.
Sureda, Marc, "Un conjunt de relíquies del segle X a Santa Maria de Ripoll i a Santa Maria de Girona," *Miscel·lània litúrgica catalana*, 29 (2021),117–155.
Suriano, Francesco, *Il Trattato di Terra Sancta e dell'Oriente*, ed. by Girolamo Gulobovich (Milan: Tipografia Editrice Artigianelli, 1900).
Swanson, Rebecca, "Broderie de la Création ou broderie du Salut? Propositions de lectura iconographique du 'Tapis de Girona,'" *Les Cahiers de Saint-Michel de Cuxa*, 43 (2012), 95–100.
Taal, Jan, *De archieven van de Goudse kloosters* (The Hague: Ministerie van Onderwijs, Kunsten en Wetenschapen, 1957).
Taal, Jan, *De Goudse kloosters in de Middeleeuwen* (Hilversum: Paul Brand, 1960).
Taubert, Gesine and Johannes Taubert, "Mittelalterlichen Kruzifixe mit schwenkbaren Armen: Ein Beitrag zur Verwendung von Bildwerken in der Liturgie," in *Farbige Skulpturen: Bedeutung, Fassung, Restaurierung*, ed. by Johannes Taubert (Munich: Callwey, 1978), pp. 38–53.

Tavernor, Robert, *On Alberti and the Art of Building* (New Haven: Yale University Press, 1998).

Temkin, Ann, "Barnett Newman on Exhibition," in *Barnett Newman*, ed. by Ann Temkin, (Philadelphia: Philadelphia Museum of Art, 2002), pp. 60–65.

The Temple Church in London: History, Architecture, Art, ed. by Robin Griffith-Jones and David Park (Woodbridge: Boydell and Brewer, 2010).

Testa, Bart, "To Film a Gospel… and Advent of the Theoretical Stranger," in *Pier Paolo Pasolini: Contemporary Perspectives*, ed. by Patrick Rumble and Bart Testa (Toronto: University of Toronto Press, 1994), pp. 180–209

Thümmel, Hans Georg, "Das Heilige Grab: Liturgie und Ikonograpie im Wandel," in *Kunst—Kontext—Geschichte: Festgabe für Hubert Faensen zum 75 Geburtstag*, ed. by Tatjana Bartsch and Jörg Meiner (Berlin: Lukas, 2003), pp. 67–83.

Thurston, Herbert, *The Stations of the Cross: An Account of Their History and Devotional Purpose* (London: Burns and Oates, 1914).

Tomb and Temple: Re-imagining the Sacred Buildings of the Holy Land, ed. by Robin Griffith-Jones and Eric Fernie (Woodbridge: Boydell, 2018).

Treasures of Heaven: Saints, Relics and Devotion in Medieval Europe, ed. by Martina Bagnoli, Holger A. Klein, C. Griffith Mann, and James Robinson (London: The Cleveland Museum of Art, The Walters Art Museum, The British Museum London, 2010).

Le trésor de la Sainte-Chapelle, ed. by Jannic Durand and Marie-Pierre Laffitte (Paris: Réunion des Musées Nationaux, 2001).

Tripps, Johannes, *Das handelnde Bildwerk in der Gotik: Forschungen zu den Bedeutungsschichten und der Funktion des Kirchengebäudes und seiner Ausstattung in der Hoch- und Spätgotik*, 2nd ed. (Berlin: Mann, 2000).

Tsafrir, Yoram and Gideon, Foerster "Urbanism at Scythopolis-Bet Shean in the Fourth to Seventh Centuries," *Dumbarton Oaks Papers*, 51 (1997), 85–146.

Tsarevskaya, Tatiana Y., "Relics of Anthony" [О Царьградских реликвиях Антония Новгородского], in Восточнохристианские Реликвии, ed. by Alexei M. Lidov (Moscow: Progress-Tradition, 2003), pp. 398–414.

Tyerman, Christopher, *England and the Crusades, 1095–1588* (Chicago: University of Chicago Press, 1988).

Ueding, Gert and Bernd Steinbrink, *Grundriss der Rhetorik: Geschichte, Technik, Methode* (Stuttgart: J. B. Metzler, 1986).

Uffmann, Heike, "Inside and Outside the Convent Walls: The Norm and Practice of Enclosure in the Reformed Nunneries of Late Medieval Germany," *Medieval History Journal*, 4, no. 1 (2001), 83–108.

Uličný, Petr, "The Choirs of St. Vitus's Cathedral in Prague: Marriage of Liturgy, Coronation, Royal Necropolis and Piety," *Journal of the British Archeological Association*, 168, no, 1 (2015), 168–233.

Underhill, Frances A., *For Her Good Estate: The Life of Elizabeth de Burgh* (Basingstoke: Macmillan, 1995).

Unger, Simone, "Eichstätt in Stadtansichten: Von der graphischen Darstellung Eichstätts in Hartmann Schedels Weltchronik 1493 bis zu Maurizio Pedettis Stadtplan und -ansicht 1796" (unpublished master thesis, University of Eichstätt, 2006).

Untermann, Matthias, *Der Zentralbau im Mittelalter. Form—Funktion—Verbreitung* (Darmstadt: Wissenschaftliche Buchgesellschaft, 1989).

van Bueren, Truus, *Leven na de dood: gedenken in de late Middeleeuwen* (Turnhout: Brepols, 1999).

van Dasselaar, Marcel, "Resten van Raet," *Erfgoed*, 2 (2008), 54–55.

van den Berg, Bianca, *De Sint-Janskerk in Gouda* (Hilversum: Verloren, 2008).

Van Houts, Elisabeth M.C., *Memory and Gender in Medieval Europe, 900–1200* (Basingstoke: Macmillan, 1999).

Vergnolle, Éliane, "Josep Puig i Cadafalch et la Lombardie. La construction historique du 'premier art roman'," in *Architettura dell'XI secolo nell'Italia del Nord: Storiografia e nuove ricerche*, ed. by Anna Segagni Malacart and Luigi Carlo Schiavi (Pisa: ETS, 2013), pp. 3–8.

Viaggio in Terrasanta di Santo Brasca 1480. Con l'Itinerario di Gabriele Capodilista 1458, ed. by Anna Laura Momigliano-Lepschy (Milan: Longanesi, 1966).

The Victoria History of the Counties of England: A History of the County of Northampton, ed. by William Page, (London: Constable, 1930), III.

Videneyeva, Alla E., "Church-reliquary of the Spaso-Jakovlev Dimitriev Monastery" [Храм-Реликварий Спасо-Яковлевского Димитриева Монастыря], *Ярославский педагогический вестник*, 3 (2010), 260–65.

Vigué, Jordi, *Les esglésies romàniques catalanes de planta circular i triangular* (Barcelona: Edicions 62, 1975).

Vincent, Louis Hugues and Félix-Marie Abel, *Jérusalem: Recherches de topographie, d'archéologie et d'histoire* (Paris: Librairie Victor Lecoffre, 1914).

Vincent, Nicholas, *The Holy Blood: King Henry III and the Westminster Blood Relic* (Cambridge: Cambridge University Press, 2001).

Visual Constructs of Jerusalem, ed. by Bianca Kühnel, Galit Noga-Banai, and Hanna Vorholt, Cultural Encounters in Late Antiquity and the Middle Ages 18 (Turnhout: Brepols, 2014).

Vita Mariani Scotti, in *Acta Sanctorum: Februarius* (Paris, 1864), II, *Editio novissima curante Ioanne Carnandet*, ed. by Ioannes Bollandus and Godefridus Henschenius, pp. 361–65.

Vitas Sanctorum Patrum Emeretensium, ed. by Antonio Maya Sánchez (Corpus Christianorum, Series latina, CXVI) (Turnhout: Brepols, 1992), IV. IX, 3 and 7, pp. 41–43, p. 66.

Vogel, Cyrille, "Le pèlerinage pénitentiel," *Revue des Sciences Religieuses*, 38, no. 2 (1964), 113–53.

Voigtländer, Klaus, Hans Berger and Edgar Lehmann, *Die Stiftskirche zu Gernrode und ihre Restaurierung, 1858–1872*, 2nd ed. (Berlin: Akademie Verlag, 1982).

von Falckenstein, Johann H., ed., *Antiquitates Nordgavienses oder Nordgauische Alterthümer und Merckwürdigkeiten: Fortgesetzet in dem Hochwürdigen Dom-Capitel der Aureatensischen Kirche, oder Hochfürstlichen Hochstiffts Eichstett … Zweyter Theil* (Frankfurt: Johann Georg Lochner, 1733).

Vorbrodt, Günter Wilhelm, "Die Stiftskirche in Gernrode: Ein kunstgeschichtlicher Beitrag," in *Das Stift Gernrode*, ed. by Hans K. Schulze (Cologne: Böhlau, 1965), pp. 91–129.

Voyage en Egypte de Christophe Harant de Polžic et Bezdružic 1598, trans. by C. Brejnik and A. Brejnik (Cairo: Institut français d'archéologie orientale du Caire, 1972).

Wagner, Karen, "*Cum Aliquis Venerit ad Sacerdotem*: Penitential Experience in the Central Middle Ages," in *A New History of Penance*, ed. by Abigail Firey (Leiden: Brill, 2008), pp. 201–18.

Wallenstein, Anthony, "St. Leonard of Port Maurice and Propagation of Devotion to the Way of the Cross," *Franciscan Studies*, 12, no. 1 (1952), 47–70.

Waquet, Henri, ed. and trans., *Vie de Louis VI le Gros* (Paris: Champion, 1929).

Ward, Jennifer C., *English Noblewomen in the Later Middle Ages* (Harlow: Longman, 1992).

Warnke, Charlotte, "Das Kanonissenstift St. Cyriakus zu Gernrode im Spannungsfeld zwischen Hochadel, Kaiser, Bischof und Papst von der Gründung 961 bis zum Ende des Investiturstreits 1122," in *Studien zum Kanonissenstift*, ed. by Irene Crusius (Göttingen: V&R, 2001), pp. 201–74.

Wäschke, Hermann, *Regesten der Urkunden des Herzoglichen Haus- und Staatsarchivs zu Zerbst aus den Jahren 1401–1500* (Dessau: C. Dünnhaupt, 1909).

Watin-Grandchamp, Dominique, Patrice Cabau et al., "Le coffret reliquaire de la vraie croix de Saint-Sernin de Toulouse," *Les Cahiers de Saint-Michel de Cuxa*, 38 (2007), 37–46.

Watkins, Carl, "The Cult of Earl Waltheof at Crowland," *Hagiographica*, 3 (1996), 95–111.

Weber, Stefan, *Iren auf dem Kontinent: Das Leben des Marianus Scottus von Regensburg und die Anfänge der irischen "Schottenklöster"* (Heidelberg: Mattes, 2010).

Wehking, Sabine, *Die Inschriften der Lüneburger Klöster: Ebstorf, Isenhagen, Lüne, Medingen, Walsrode, Wienhausen* (Wiesbaden: Reichert, 2009).

Weichenrieder, Lukas, "Das Heilige Blut von Mantua," in *900 Jahre Heilig-Blut-Verehrung in Weingarten, 1094–1994: Festschrift zum Heilig-Blut-Jubiläum am 12 März 1994*, ed. by N. Kruse and R. Schaubode (Sigmaringen: Jan Thorbecke, 1994), pp. 331–36.

Weilandt, Gerhard, *Die Sebalduskirche in Nürnberg: Bild und Gesellschaft im Zeitalter der Gotik und Renaissance*, Studien zur internationalen Architektur- und Kunstgeschichte, 47 (Petersberg: Michael Imhof, 2007).

Weissman, Hope Phyllis, "Margery Kempe in Jerusalem: Hysteria Compassio in the Late Middle Ages," in *Acts of Interpretation: The Text in Its Contexts, 700–1160: Essays on Medieval and Renaissance Literature in Honor of E. Talbot Donaldson*, ed. by Mary Carruthers and Elizabeth D. Kirk (Norman: Pilgrim, 1982), pp. 201–17.

Wendehorst, Alfred, *Das Bistum Eichstätt: Die Bischofsreihe bis 1535,* Germania sacra: Die Bistümer der Kirchenprovinz Mainz, Neue Folge, 45 (Berlin: De Gruyter, 2006).

Werckmeister, O. K., "Cluny III and the Pilgrimage to Santiago de Compostela," *Gesta,* 27, nos. 1/2 (1988), 103–12.

Wharton, Edith, *Italian Backgrounds* (New York: Macmillan and Co, 1905).

Wheatley, Abigail, *The Idea of the Castle in Medieval England* (Woodbridge: Boydell and Brewer, 2004).

Wiechmann, Mai-Britt, "Witnesses of Passion in Cistercian Houses—The Veneration of Christ's Relics in Walkenried, Mariengarten and Wienhausen," in *Devotional Cross-Roads: Practicing Love of God in Medieval Jerusalem, Gaul and Saxony,* ed. by Hedwig Röckelein, Galit Noga-Banai and Lotem Pinchover (Göttingen: University Press, 2019), pp. 125–60.

Wigram, Spencer Robert, *Chronicles of the Abbey of Elstow* (Oxford: Parker, 1885).

Wilgeroth, Cai-Olaf, "Goslar—Johanniter," in *Niedersächsisches Klosterbuch: Verzeichnis der Klöster, Stifte, Kommenden und Beginenhäuser in Niedersachsen und Bremen von den Anfängen bis 1810,* ed. by Josef Dolle, Veröffentlichungen der Historischen Kommission für Hessen 56, 4 vols (Bielefeld: Verlag für Regionalgeschichte, 2012), II, vol. 2, pp. 519–22.

Williams, Ann, *The English and the Norman Conquest* (Woodbridge: Boydell and Brewer, 1995).

Williams, Ann, "The Speaking Cross, the Persecuted Princess, and the Murdered Earl: The Early History of Romsey Abbey," *Anglo-Saxon,* 1 (2007), 1–18.

William of Tyre, *Willemi Tyrensis Archiepiscopi Chronicon,* ed. by R. B. C. Huygens, 2 vols, *Corpus Cristianorum Continuatio Medievalis* 63 & 63a, (Turnhout : Brepols, 1986).

William Wey, *The Itineraries of William Wey, Fellow of Eton College* (London: J. B. Nichols and Sons, 1857).

Wilson, Christopher, "Gothic Architecture Transplanted: The Nave of the Temple Church in London," in *The Temple Church in London,* pp. 19–43.

Wittkower, Rudolf, *Architectural Principles in the Age of Humanism,* Studies of the Warburg Institute 19 (London: Warburg Institute, 1949).

Wortley, John, "Relics and the Great Church," *Byzantinische Zeitschrift,* 99 (2006), 631–47.

Ye oldest diarie of Englysshe ravel: Being the Hitherto Unpublished Narrative of the Pilgrimage of Sir Richard Torkington to Jerusalem 1517, ed. by W.J. Loftie (London, c. 1900).

Young, Karl, *The Drama of the Medieval Church,* 2 vols (Oxford: Clarendon, 1933).

Ytterberg, Michael, "Alberti's Sant'Andrea and the Etruscan Proportion," in *Nexus VII: Architecture and Mathematics,* ed. by Kim Williams (Turin: Kim William's Books, 2008), pp. 201–16.

Zaenker, Karl A., "The Cult of the Holy Blood in Late Medieval Germany," *Mosaic: An Interdisciplinary Critical Journal,* 10, no. 4 (1977), 37–46.

Zelenskaya, Galina M., *Sacred Sites and Objects of the New Jerusalem* [Святыни Нового Иерусалима] (Moscow: Severny Palomnik, 2002).

Zelenskaya, Galina M. et al., "New Jerusalem and Images of the Holy Land in Russia" [Новый Иерусалим и образы Святой Земли в России], in Zelenskaya et al., *New Jerusalem*, pp. 486–527.

Zelenskaya, Galina M., *The New Jerusalem—A Guidebook* [Новый Иерусалим—Путеводитель] (Moscow: Наука, 2003).

Zelenskaya, Galina M., *New Jerusalem: The Terrestrial and Celestial images* [Новый Иерусалим: Образы Дольнего и Горнего] (Moscow: Design, 2008).

Zelenskaya, Galina M. et al., *Новый Иерусалим: Альбом-Антология* [New Jerusalem: An anthology album] (Moscow: Feoria, 2010).

Zherve, Alexei V., "Measure of the Holy Tomb of the Lord: Tradition of the Translation of the Holy Relic to Rus' in the Twelfth–Seventeenth Centuries" [Мера святого Гроба Господня: Традиция перенесения святыни на Руси в XII–XVII вв], *София*, 4 (2000), 8–12; and 1 (2001), 19–22.

Zimmermann, Michel, "Le souvenir de Rome en Catalogne du IXe au XIIe siècle," in *La mémoire de l'Antiquité dans l'Antiquité tardive et le haut Moyen Âge*, ed. by Michel Sot (Paris: Picard, 2000), pp. 149–59.

Zwijnenburg-Tönnies, Nicky, "Die Kreuzwegandacht und die deutschen Pilgertexte des Mittelalters," in *Fünf Palästina-Pilgerberichte aus dem 15. Jahrhundert*, ed. by Randall Herz, Dietrich Huschenbett und Frank Sczesny (Wiesbaden: Reichert, 1998), pp. 225–60.

INDEX OF PLACES

(numbers in *italics* refer to pages with relevant images)

A
Aachen 289
 Palatine Chapel 289
Adriatic coast 15
Albania 310, 313
Alexandria 172
Altmühl 152, 164
Amposta 105, 113
 Church of the Holy Sepulchre of Amposta 105
Amsterdam 145, 216, 217, *226*, *227*, 231, 232, 233
 St. Olaf's Chapel 216
Andechs 264
Antioch 32, 43, 106, 289
Anzer Island 271
 Church of the Elevation of the Cross 271
 Resurrection Church 271
Aquileia 80
Aslackby 75
Atlit, Chastel Pèlerin 75
Augsburg 150, 155, 204, 232, 233, *235*

B
Banyoles 113
Barcelona 14, 45, 83, 86, 91, 97, 103, 106, 114
 Cahtedral 91
 Church of St. Anna 98, 106
 Monastery of St. Salvador de Mata 85
 St. Eulàlia del Camp 103
Bavaria 151, 163
Bedford 67
Bedfordshire 70
 Benedictine Nunnery of Elstow 70
Berguedà 85
Berlin 14, 124
Besalú 85, 97, 105, 111
Bethany 31, 162, 269
Bethlehem 100, 109, 169, 172, 211, 232, *234*, 267, 269, 271, 296
 Church of the Nativity 44-45, 236
 The Birth Cave 267, 271, 279
Bethpage 172
Bohemia 152, 191, 192, 206–213
 Horeb 212
 Klenová Castle 191
 Tabor 212
 Zion 212
Bologna *9*, *10*, 201, 248
 Church of Santo Stefano 201, 248
Bristol 75
Brittany 69
Burgos 106
Bystřice 193

C
Cairo 172
Cambridge *54*, 58, 80
 Church of the Holy Sepulchre and St. Andrew (The Round Church) *54*, 58
Cana 267
Cardona 95
Castle Rising 71
Castellnou dels Aspres 97, 112
 St. Peter, Holy Cross, and Holy Sepulchre of Castellnou 97, 122
Catalonia 79, 115
 Church of St. Pere de la Portella 80, 103
Celle 130
Cerdanya 97
Certaldo 5
Chartres 31
Cologne 39–40, *41*
Constance 149, 281
Conques 45, *46*
Constantinople 26, 33, 276, 284–288, 291, 292
 Hagia Sophia 276, 286–288, 290

Pharos Chapel 287
Crete 193
Crowland 60, 64, 68, 70
Cuxa/ Cuixà 84, 85, 97, 98, 100, 108, 109, 112, 113
 St. Miquel de Cuixà 84
Cyprus 169, 193

D
Dead Sea 272
Delft 216, 217, 223, 224, *226*, 229, 231
 St. Martha's Chapel 216
Diesdorf 117, 125–131, *127*, *137*, 138, *138*, 143
Dover 74, 75

E
Eichstätt 93, 145–164, *146*, *148*, *154*, *159*, 180, 181, 182, *183*, 232
Egypt 168, 192
Elne/Elna 83, 97, 106
Ely 61
Emmaus 135, 172
Erfurt 149

F
Ferrara 9
Florence 262
 Cappella Brancacci 607
 Rucellai tomb in San Pancrazio Chapel Santissima Annunziata 262
Fribourg 134
 The Easter Sepulchre from Maigrauge (Magerau) 134

G
Geisenberg 152
Gernrode 93, 117, 118, 120–125, *121*, *124*, 126, 127, 128, 137, 143, 281, 282, 283
 Convent Church of St. Cyriacus, Holy Sepulchre 124, *124*
Girona 83, 85, 86, 87, *88*, 91, 93, *94*, 101, 102, 103, *104*, 106, 108, 111, 112, 113
 Cathedral 87, 101
 St. Pere de Galligants 93, *94*, 110

Glasgow 40
Gouda 215–242, *218*, *219*, *227*, *230*, *232*
 Convent Church of St. Mary Magdalene 221
 Jerusalem Chapel 215–242
 St. John's Church 219, 220, 221, 222, 223, 237, 239

H
Harz 121
Hereford 71
Hildesheim 139, 288
Hohe Kreuz 152
Holborn 74
Huntingdon 58, 59, 61, 64

I
Iberian Peninsula 79
Innsbruck 192

J
Jaffa 169, 193
Jerusalem
 Dome of the Rock 75, 172
 Franciscan monastery of St. Savior 193
 Golden Gate 210
 Holy Sepulchre Church
 Anastasis Rotunda 55, 57, 65, 71, 78, 80, 96, 101, 117, 147, 148, 150, 152, 243, 245, 248, 249, 262
 Calvary 45, 174, 179, 189, 198, 203, 210, 235, 240, 315
 Chapel of Christ's Prison 195
 Golgotha 189, 243, 244, 249
 Stone of Unction 13, *13*, 18, 174, 175, 177, 178, 179, 267, 272
 Tomb of Christ 45, 119, 148, 151, 180 189, 215, 222, 225, 228, 229, 230, 239, 240, 271–274, 278, 279, 281, 282, 283, 284, 285
 Kidron (Cedron) Valley 201, 272
 Our Lady of Josaphat, Kidron Valley 27, 31, 40, 44, 46
 Mount of Olives 5, 18, 172, 201, 244, 254, 269, 271, 272

Mount Zion 5, 172, 179, 201, 212,
 272, 289, 290
 Templum Domini 75
 Valley of Josaphat/Jehoshaphat 172, 234,
 236, 237, 272
 Mary's Tomb *see Our Lady of Josaphat*
Jordan 33, 43, 69, 172, 269, 272, 311

K
Kelheim 149
Kiev 276, 289

L
La Charité-sur-Loire 63
La Grasse 102
La Portella 80
 Church of St. Pere de la Portella 80, 103
Le Puy 43
La Seu d'Urgell 87, 89, *92*, 112
 La Seu d'Urgell Cathedral 89, 105, 112,
 114
Leiden 216, 217, 221, 229, 231, 232, 233,
 235, 236
León 106
Lichtenthal 134
 The Easter Sepulchre 134
Lincoln 64
Lincolnshire 60
 Benedictine abbey of Crowland 60
Little Maplestead, Essex
 Church of St. John the Baptist 52
Lleida 83
Lodi 85
London 45, 206, 264
 New Temple Church 71, 75
 Temple Church 45–46, *53*, 202, 264
 Westminster 263
Loreto 15
 Holy House of the Virgin 15
Ludlow 71–76, *72*
 Chapel of St. Mary Magdalene, Ludlow
 55, 71, *72*, 73, 76
 Castle *72*, 73, 74
 Parish Church of St. Laurence 75
Lüneburg *133*, 135

Lyon 165

M
Magdeburg 128
Mantua 39–40
 Belfiore 250
 Column of St. Longinus 244, 253, 254
 Piazza Alberti 245
 Piazza delle Erbe 245
 Porta della Predella 250
 San Lorenzo 243–250, *246*, *247*, *249*,
 253, 254, 258, 260, 264
 San Sepolcro 243, 244, 248, 250–254,
 251, 258, 259
 San Vicenzo 253
 Sant'Andrea 243, 244, 245, 249, 250,
 254, 255–266, *256*, *257*
Martirano 43
Memmingen 149
Mérida 82
Milan 186, 302, *303*, 304, *308*, *311*, 315
 Basilica of St. Lorenzo 186
 Church of San Bartolomeo 299, *300*,
 301, 302
Modena 9, *11*
Mount Soratte 312
Moscow 267, *268*, 269, *270*, 271, 272–275,
 276, 283, 294, 295
 Alexeevsk Village 272
 Church of the Tikhvin Theotokos 272
 Tomb of Christ 272
 St. Basil Cathedral of the Veil of our
 Lady 273
 Church of the Entry to Jerusalem 291,
 294
 Church of the Veil of the Virgin on the
 Moat, see St. Basil Cathedral 273
 Dormition Cathedral 271, 273, 275, 294
 Istra River 269, *270*
 Kremlin 270, 273, 275
 Terem Palace of the Moscow Krem-
 lin, Replica of the Tomb and Gol-
 gotha 270
 Patriarch Nikon's "New Jerusalem" 269,
 270, 271

St. Frol, Savior Gate 273
St. Sergius Church of the Dormition of the Virgin 271
　　Trinity Lavra 271
　　　　Gethsemane 271, 272
Mount Tabor 269, 272
　　Church of the Transfiguration 272
Münster 201
　　St. Paul's Cathedral 201

N
Naples 9, 13
　　Cathedral 13
Narbonne 32
Nazareth 15
　　Holy House of the Virgin 15
Nièvre 64
Nîmes 106
Northampton 55, 56, 57, 58, 58–59, 61–67, 68, 70, 71, 75–78
　　Church of the Holy Sepulchre 55, 56, 57, 58, 62–66, 66, 70
　　Cluniac Priory of St. Andrew 54, 58, 59, 61–62, 67
　　Northampton Castle 61, 62, 67
Novgorod 267, 275, 276–279, 281, 282, 283, 284, 285, 286, 288, 287, 288, 289, 290, 291, 293, 294, 295
　　Church of the Entry of Christ to Jerusalem 291
　　Hagia Sophia of Novgorod Cathedral 276, 277, 278, 281, 283, 284, 288, 289, 291, 292, 293
　　Martyrius Parvis 278, 283, 284
Nuremberg 149, 150, 165–189, *170*, *176*, 193, 201, 203
　　St. Sebald, Parish Church 165, 167–168, 169, *170*, 172, 173, 174, 175, *176*, 177, 178, 179, 181, *185*, 186, 187, 188, 189, 201, 204
　　The Twelve Brothers' House 180

O
Olèrdola 85, 97–101, 112

Church of St. Salvador de les Gunyoles 85
　　Holy Sepulchre of Olerdola *99*, 101
Olius 93, 95, 113
　　St. Esteve d'Olius 95
Orvieto 264

P
Padua 186, 201
　　Church of St. Antonio 186, 201
Palera 80, 96, 102–105, *104*, 108, 110, 113
　　Church of Sant Sepulcro de Palera 102, 104
　　St. Sepulcre de Palera 102, *104*, 105
Paris 45
　　Tour Eiffel 22
Penedès 97
Penhill 75
Peralada 106, *107*, 114
　　Church of the Holy Sepulchre 107
Pergamon 14
　　Altar 14
Pevensey 71
Picardy 45
Piemonte 5, *7*, 17
　　Sordevolo 306
Pisa 248, 254
Prague 191, 198, 200, 201, 206
　　Cathedral of St. Vitus 194–200, *195*, *196*, 206, 207, 208, 209, 210, 211, 212, 213
　　　　Chapel of St. Anne 195
　　　　Chapel of St. Apollinář 197
　　　　Chapel of St. Elisabeth 198
　　　　Chapel of St. Sebastian 194
　　　　Chapel of St. Stanislav 199
　　　　"Golden Gate" (Porta Aurea) 210
　　　　St. Dorothy's Altar 199
　　　　St. Wenceslas's Chapel 209, 210, 212
　　Corpus Christi Rotunda 209
　　Hradčany 207, 208, 209
　　Church of Sts. Peter and Paul 208
　　Jerusalem Chapel 208
　　Karlštejn Castle 209

St. Wenceslas Rotunda 208, 209
 Višehrad 207
Pyrenees 96, 97

R
Ramla 193
Regensburg 149
 Irish Benedictine monastery of Regensburg, St. Jacob 149
Ripoll 85, 86, 89, *90*, 91, 103, 108, 111, 112, 113
Roda 103
 St. Maria de Tolba in the Diocese of Roda 103
Rome 84, 85, 87, 98, 108, 111, 212, 265, 294, *308*, 312
 Church of St. Mary ad Martyres *see* Pantheon
 Pantheon, Santa Maria Rotunda 98, 101, 201
 St. Croce in Gerusalemme 87
 St. Maria Maggiore 100
Rostov 271
 Spaso-Jakovlev Dimitriev Monastery 271
 Cave in Bethlehem 271
 Golgotha 271
 Prison of Christ 271
Rouen 64
Roussillon 97

S
Sacro Monte/ Sacri Monti 5–24
Safad 75
Sallent
 Church of St. Sebastian 102
Salzwedel 125
San Vivaldo 5, 16–20, *18*, *19*, *21–24*
Saxony 117–143, 193
Scheyern 45
Schwerin 264
Segovia 80
Seville 82
Sinai 168, 171, 172, 192, 222, 242
 St. Catherine's Monastery 171, 172

Sordevolo 306
St. Esteve de Sallent 100, 101
St. Petersburg 276
Stezzano 305, 310, 315

T
Tarragona 81, 82, 83, 105, 106, 111, 114
 Sancta Iherusalem 81, 82
Temple Bruer 75
Temple Ewell 75
Temple Guiting 74
Tianducheng 22
Toledo 106
Tolosa 30, 49
 Gates 49
Tomar 80
Tortosa 83, 105
Toulouse 25–30, 32–38, *34*, 40–42, 44–49
 Château Narbonnais 34
 Saint-Sernin, Monastery 25–31, *28*, *29*, *30*, *33*, 33–34, *41*, 46–47, *48*
 Porte Narbonne (Toulouse) 34
Tripoli 32, 74
Tuscany 5, 7, 17
Tyrol 192, 193

U
Urgell 83, 86, 91, 103
Utrecht 215, 216, 217, 220, 223, 229, 230, 231, 233, *234*, 236
 Nieuwe Weerd 215, 216, 217, 229, 231, 236

V
Valaam Island 272
Varallo 5, 9, *12*
Vatican Obelisk 15
Veneto 84
Venice 165, 166, 172, 186, 193, 201, 211
 San Marco 201
Vexin 64
Vic 83, 86, 89, 91, 93, 95, 98, 100, 101, 105, 112, 113, 115
Vienna 149, 191

W
Weingarten 264
Wienhausen 117, 118, 130, 131, *132*, *133*, 139, 143
 Holy Sepulchre of Wienhausen 135, 136, 137

Wilsnack 264
Wöltingerode 117, 130, 137, *138*, 139, 143
 Holy Sepulchre 137–140, *138*
Würzburg 149

ACKNOWLEDGMENTS

The studies gathered in this volume demonstrate, once again, the expansiveness and extraordinary energy of Jerusalem's visual culture as a topic of research. At the Hebrew University, the study of the visuality of Jerusalem started several decades ago in graduate seminars that resulted in separate research projects with a common denominator. This effort was generously funded by the Israel Science Foundation, the Israel Institute for Advanced Study, the German-Israeli Foundation, the Franz Thyssen-Stiftung, the Alexander von Humboldt-Stiftung, the Max Planck Society, and the European Research Council. The sponsorship of these institutions turned the art-historical study of Jerusalem into a broadly recognized branch of humanities, and we owe them a massive debt of gratitude. Lectures and conferences, in Israel and abroad, collaborative publications, and joint trips to various locations all led to lively exchanges; they brought us inspiration and highlighted the topic internationally. Through research groups dedicated to the study of Jerusalem formed in parallel and in cooperation with our own, in Florence, Oslo, Girona, York, and London, scholars all over the world are interwoven in a network of combined efforts; we are grateful for these steady and fruitful exchanges. At home, we were lucky to have a sustained, supportive framework in the European Forum at the Hebrew University of Jerusalem.

The richness of the project lies in the accomplishments of its scholars. Many of them started as graduate students and, within the timeline of the project, wrote master's and doctoral theses, published the results of their independent research, and became professors at various universities, with memberships in other research projects or leadership positions in museums and scholarly libraries. Some are among the authors of this publication, included among internationally renowned scholars. Many former students of the project developed tangential topics, taking the idea of 'Jerusalem Elsewhere' to new and related directions, proving its vitality. For example, Netta Amir explores the historical, local roots and circumstances of the *via crucis*, Yamit Rahman-Schrire looks at the sites dedicated to Saint Francis, Pnina Arad works on Jewish and Christian Holy Land maps, Shimrit Shriki-Hilber examines the modern reuses of medieval pilgrimage sites, Renana Bartal studies the *Meditationes vitae Christi* manuscripts, Lily Arad focused on the Austrian pilgrimage sites and stories, and Anastasia Keshman investigates the modern and contemporary memorial art and architecture of the Holy Land.

We are extremely grateful to Barbara Baert for accepting the manuscript in the 'Art & Religion' series at Peeters and to Ingemar Spelmans for taking it to the press; to Hadas Gabay and Alex Ripp for drafting the bibliography and index; to Sara Tropper for editing some of the essays in the volume, and to Annika Fisher for editorial work on the entire manuscript. Many thanks to Tel Aviv University and the Open University in Israel for their important contributions to the costs involved in the editing and publication of this volume.

Last but not least, we thank all the authors of the volume for their contributions and, especially, their patience: work on this volume has been particularly long and convoluted. From our perspective as editors, the task has been difficult but always interesting. We had lively discussions on almost every aspect relating to this publication, from its overall concept to minor grammatical issues, and we have debated until full agreement was reached. It was productive work, and we only hope that the decisions we have reached will prove as successful as our friendship has become in the process.

October 2022

Bianca Kühnel	Neta Bodner	Renana Bartal
The Hebrew University of Jerusalem	The Open University of Israel	Tel Aviv University